A HISTORY OF WOMEN PHOTOGRAPHERS

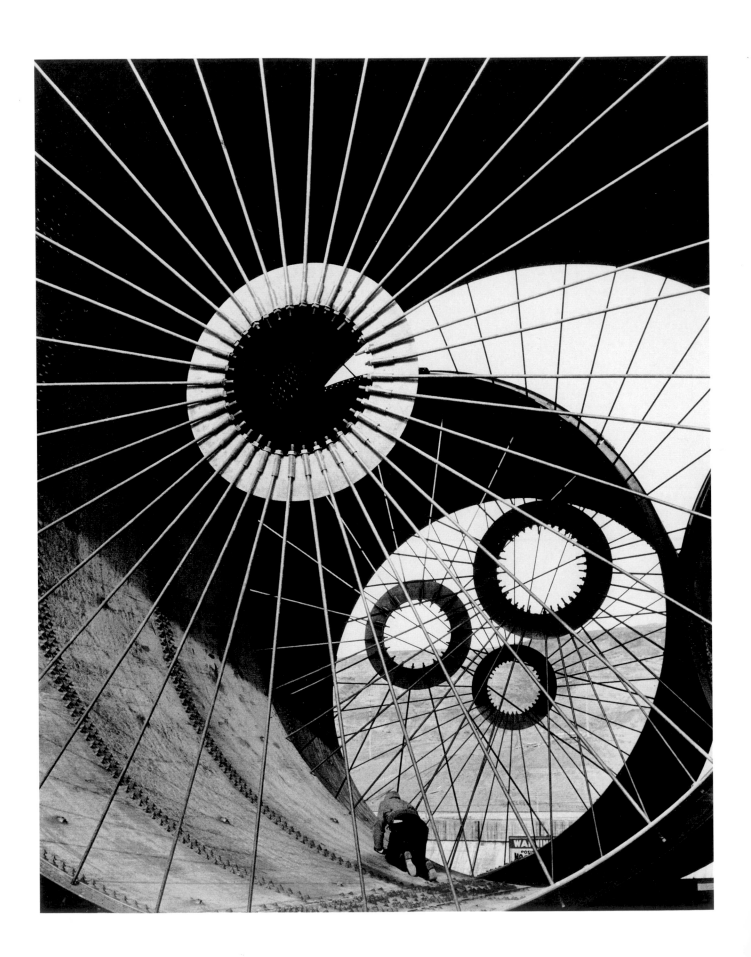

A HISTORY OF WOMEN PHOTOGRAPHERS

Updated and Expanded

NAOMI ROSENBLUM

ABBEVILLE PRESS PUBLISHERS
NEW YORK LONDON PARIS

FRONT COVER

Lotte Jacobi, *Head of a Dancer,* c. 1929. See plate 121.

BACK COVER

Frances Benjamin Johnston, *Self-Portrait* (as "new woman"), c. 1896. See plate 49.

FRONTISPIECE

Margaret Bourke-White (1904–1971). *Wind Tunnel Construction, Ft. Peck Dam,* 1936. Gelatin silver print. Margaret Bourke-White, LIFE Magazine © Time Inc.

A NOTE ABOUT THE CAPTIONS

Unless otherwise noted, all works reproduced in this volume are from the collections of the photographers, who hold copyright. Dimensions are provided for non-edition works that exist only in a unique version.

Editor: Nancy Grubb

Design: Rothschild Design and Barbara Balch (second edition)

Production Editor: Abigail Asher

Picture Editors: Paula Trotto and Jennifer Schlobohm (second edition)

Production Managers: Simone René and Louise Kurtz (second edition)

Second edition, 2000

10 9 8 7 6 5 4 3 2 1

The Library of Congress Cataloging-in-Publication Data

Rosenblum, Naomi.

 A history of women photographers / Naomi Rosenblum.—2nd ed., updated and expanded

 p. cm.

Includes bibliographical references (p.) and index.

ISBN 0-7892-0658-7

1. Women photographers—Biography. 2. Photography—History. I. Title.

TR139 .R67 2000

770'.82—dc21 00-036249

CONTENTS

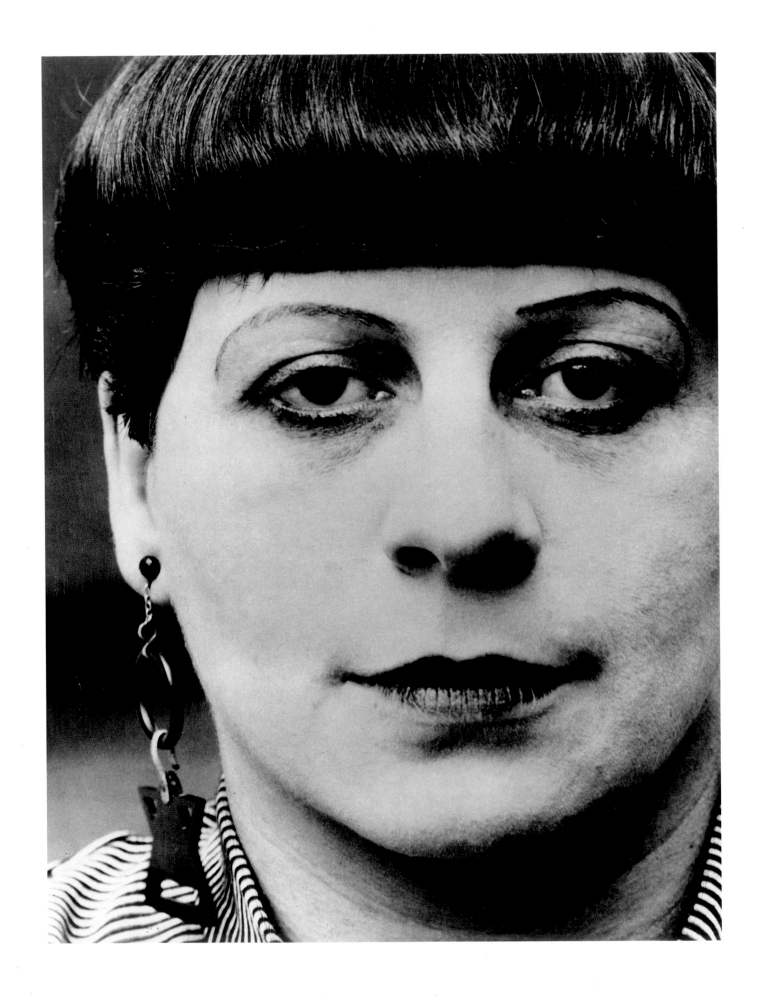

INTRODUCTION

WHY WOMEN?

Women have been actively involved with photography ever since the medium was first introduced in 1839. They were drawn to it professionally and personally, finding it an effective means both to earn a living and to express ideas and feelings. An easily achieved skill adaptable to a wide variety of uses, photography offered women a more congenial discipline than the traditional visual arts of painting and sculpture. The barriers to their participation in photography were lower, and recognition often came faster than in the other arts.

If women have fared comparatively well in photography, why do they merit a separate study? And why is it now necessary to revise and update this study, which first appeared in 1994? There are several answers to these questions and several more questions to ask. Have women and their photographs been as visible as they should be in view of their numbers and past influence? Have inquiries into their activities and their art been as rigorous and as insightful as the studies of their male colleagues? Have their contributions been understood in the context of the medium's overall development? And how has the situation changed over the past ten or so years?

Research suggests that until fairly recent times women's work in photography did not receive its due consideration. Because the selection of what shall be remembered had been done throughout most of photographic history by male scholars, women tended to be dismissed or slighted. This process obscured significant contributions by some once well known individuals, and it ignored entirely those who never made it into the spotlight. In 1958, for example, no women were named by leaders in the field of photography as among the "10 greatest photographers."[1] Women were never mentioned in connection with the prehistory of photography, although a Chinese woman scientist, Huang Lü, is said to have added a lens to the camera obscura in the early nineteenth century, and the German painter Friederike Wilhelmine von Wunsch announced a process for making portraits with light-sensitive materials in early 1839.[2] And images created by women or jointly by spousal teams are sometimes transformed by history into the work of a male only, as happened in the case of Rogi André, Harriet and Robert Christopher Tytler, and Carolyn and Edwin Gledhill.[3]

Women were consistently scanted in the general histories of the medium from which most people gained their knowledge of photography's development. For instance, Beaumont Newhall's 1982 revision of his influential *History of Photography from 1839 to the Present Day* lists fourteen women—three more than Newhall's 1964 revision, which had two fewer than the original 1949 edition. In *Masterpieces of Photography*, a 1986 compendium of highlights from the

George Eastman House collection, 8 of the 194 photographers are women; this imbalance has been redressed somewhat in that institution's latest catalog, which includes 39 women among approximately 300 photographers; that is, about 13 percent. In two of the publications that appeared in 1989 to mark 150 years of photography—Mike Weaver's *Art of Photography, 1839–1989* and John Szarkowski's summation, *Photography until Now*, women constitute fewer than 10 percent of those included. Representation has improved in *Nouvelle Histoire de la Photographie (The New History of Photography)*, edited by Michel Frizot, which appeared first in France in 1994. This compendium of essays makes reference to some 60 women and its bibliography includes work by 23.

Granted, these histories and surveys embrace the entire span of photography, including the beginning years when women were not as active as they would later become, but works dealing with the twentieth century have also neglected women. A 1950 summary of American work, entitled *Photography at Mid-Century*, included just 28 women among 225 men, or a little more than 12 percent. A signal improvement on these figures can be seen in a 1999 publication based on the Hallmark Collection; *An American Century of Photography: From Dry-Plate to Digital*, by Keith Davis, indexes about 100 women, with illustrations by some 80.

Another bias is revealed by the way women's contributions have been handled in text and illustrations in the historical and critical literature. In *American Photography* (1984), Jonathan Green's discussion of trends in the medium since 1945, 45 women photographers are mentioned but merit only 27 reproductions compared to 245 by the 195 men. The work of Walker Evans, for example, warrants eleven illustrations and forty-four text references compared to one reproduction of and four references to that of Dorothea Lange. More recently, in recognition of Lange's "enormous influence on photographers,"[4] *An American Century of Photography* evenhandedly gives Evans and Lange four illustrations each and fairly equal text space.

In the past, women seemed nearly invisible in photographic criticism and theory; even the compendia of writings that appeared during the 1970s and 1980s included work by few women photographers or theorists.[5] They are surprisingly underrepresented in the reams of critical writing about photography that took place in Europe during the 1920s and early 1930s, although, as the German photojournalist Ilse Bing noted, "many women participated in the creation of modern photography."[6] Particularly in Europe, the inaccessibility of their writings and of much of their work made it difficult until fairly recently to even begin to evaluate the extent and quality of women's contributions to the modernist era.

In terms of collecting and exhibiting photographs by women, the record at the Museum of Modern Art is revealing and fairly typical. In 1940 this institution became the first major art museum in the United States (as differentiated from those specializing in historical materials) to set up a photography department; a half century or so later 72 women were represented among a total of 1,226 individuals—not quite 6 percent.[7] Writing in 1973 in *Looking at Photographs* (in which 13 of the 100 examples from MoMA's collection are by women), John Szarkowski commended himself on this representation, claiming that it was "surely larger than that of women among those seriously committed to photography."[8] This

despite the fact that almost as many women as men were graduating from art and professional schools with advanced degrees in photography and that photography-industry statistics counted almost as many women camera users as men.[9] MoMA's exhibition record has been brighter: of the seventy one-person photography shows held there between 1943 and 1990, 28 percent were of work by women. Since 1990 women's work has accounted for about 21 percent of their acquisitions and purchases, and women have been given half as many one-person exhibitions as men.[10]

The effects of similar imbalances in acquisitions and exhibitions at other museums were reflected in the commercial market, which had expanded substantially by 1990. One result of museums' preference for work by male photographers was that private collectors were more eager to collect men's work. Prices, too, were inequitable: on average, work by men yielded about 50 to 60 percent more than that by women.[11] Since 1996 this has changed, and prices appear to have equalized, in part because of the active market for "art" photographs and in part because of greater awareness of photography by women. Prices now seem to relate more to the quality and scarcity of an individual image than to any other factor.[12] Mention should also be made of collections of women's work that have been made during the past two decades and of the archive started by Peter Palmquist, which now comprises nearly eleven thousand examples of work by women photographers.

From the late 1960s through the early 1990s, reaction by feminists to very real inequities inspired a number of polemical articles, books, and exhibitions that sought to illuminate women's place in photography. Though at times the most radical reinterpretations may have misread the historical record and oversimplified the sensibility of a particular era, these efforts were often informative and refreshing.[13] The belief, held by some feminists, that there are "fewer mediocre women photographers than . . . men" seems unprovable, but there can be little question that the feminist upsurge of this era had the salutary effect of directing attention to women's contributions to the medium.[14] Feminist art in general made visible the economic, psychological, and social conditions of women, leading to change on a number of fronts. That the movement subsequently splintered and its ideas now seem less compelling than before does not in any way negate feminism's substantial role in making the current situation more equitable.

One effect was the increase in the number of female historians of art and photography who established themselves in major institutions and helped redress past inequities in acquisitions and exhibitions. Those who have been largely responsible for a more balanced representation include Verna Curtis (Library of Congress), Ute Eskildsen (Folkwang Museum, Essen, Germany), Marianne Fulton and Therese Mulligan (George Eastman House), Sarah Greenough (National Gallery of Art), Maria Morris Hambourg (Metropolitan Museum of Art), Judith Keller (J. Paul Getty Museum), Susan Kismaric (Museum of Modern Art), Sandra Phillips (San Francisco Museum of Modern Art), Françoise Reynaud (Musée Carnavalet), Marie de Thézy (Bibliothèque Historique de la Ville de Paris), Anne Wilkes Tucker (Museum of Fine Arts, Houston), and Deborah Willis (National African American Museum Project,

Smithsonian Institution). They are only the best known among the large number of women who have become full or associate curators of photography. Denise Bethel and Daile Kaplan are consultants in photography to important auction houses, and many other women have become proprietors of the numerous commercial galleries that deal in images on light-sensitive materials. Women have also become increasingly vocal in the fields of criticism, history, and publishing; Julia Ballerini, Deborah Bright, Gail Buckland, Virginia Dodier, Vicki Goldberg, Jan Zita Grover, Melissa Harris, Carole Kismaric, Barbara Michaels, Martha Rosler, Abigail Solomon-Godeau, and Sally Stein are just a few of the many who have made major contributions. Their efforts have been crucial in bringing to light work by women that had long been "under-funded, under-exhibited, under-studied, under-represented."[15]

There are now and were in the past many more active women photographers than show up in the compendia, exhibitions, and monographs. One reason for the scarcity of historical work by women is that it often has been difficult to find. Frequently women themselves, reflecting the attitudes of their own eras, did not regard their images as important enough to inventory and save. Unless kept safe by spouses or descendants, women's photographs often were discarded, tucked away in the attic, or stored in a musty bin at the local historical society. Sometimes their disappearance was caused by misfortune: Mattie Gunterman's large body of work was destroyed by fire, and Adelaide Hanscom lost the contents of her studio in the aftermath of the San Francisco earthquake of 1906. Photographers fleeing Europe during the 1930s often had to abandon negatives and prints.

The work of other women became visible only with the development of a viable photographic market and increased interest in the medium's history. Alice Austen's photographs, for example, were tracked down, bought from their indigent maker, and given to the Staten Island Historical Society, thus preserving a unique document of New York life.[16] Lily White's ethereal landscapes of the Columbia River environs were discovered only recently by Terry Todtemeier, photography curator at the Portland (Oregon) Art Museum. The upsurge in feminist consciousness rescued the work of others from oblivion. Abbie Sewall and Rollie McKenna—female descendants of, respectively, Emma D. Sewall (in Maine) and Harriet V. S. Thorne (in Connecticut)—were inspired not only to restore their antecedents' reputations but also to become photographers themselves.[17]

If one agrees with Wallace Stegner that "history is an artifact . . . [that] does not exist until it is remembered and written down,"[18] then one compelling reason for a history of women photographers is to represent those who have helped shape the field of photography—to name them and to show as much of their work as possible. Another purpose is to discuss the contexts in which women have functioned as photographers. Most conventional histories of the medium and even many monographs have been concerned only with discrete contributions to technology, documentation, and art. Photographers of both sexes have usually been treated as isolated individuals, an approach that ignores the complex relationships between photography and society's need for differing kinds of expression and information at different periods. This approach has been unfortunate for the field in general and particularly problematic

with regard to women's work. To a greater degree than in the other visual arts, photography has played a role in determining how various aesthetic, political, and social issues have been perceived within a culture,[19] and among these issues has been the changing role of women.

One of the phenomena investigated in the pages that follow is how women photographers reacted at various times to male opinions of their contributions and how those opinions influenced their work and their own attitudes toward it. Why, for instance, after women's initial pleasure at being considered particularly well suited for photography, did so many of them then deny that their gender was gifted with any special "intuition" or "sensitivity"? (As Jill Freedman did when she echoed her older colleague Laura Gilpin's observation that camera images are "either good, bad, or mediocre . . . you can't tell the sex of the photographer by the photograph."[20]) Why did women claim again and again, in different phrases, that "the time has passed when women need to band together to break down the prejudice against the possibility of feminine accomplishment in art?"[21] And why was this tack repeatedly reversed? (In the 1970s, for example, Jill Krementz reiterated ideas that had been expressed more than sixty years earlier by women eager to compete in a male-dominated field when she argued that women needed to take their work and themselves seriously, whether or not they were considered too aggressive or "pushy.") And why, until recently, has a woman photographer, even when successful, been seen mainly as a great *woman* photographer? These problems encountered by women trying to fit into a field dominated by men are part of the social context that the following history seeks to explore. The changes that have occurred in women's relationship to this context also are important to note, for they suggest how initially unwelcome social change can become accepted.

Another reason for studying the evolving role of women as photographers is to gain an understanding of how they interacted with each other. In a field where competitiveness was usually the norm, women often adopted a different outlook. One need only recall the secretiveness surrounding the almost simultaneous discoveries of Louis-Jacques-Mandé Daguerre and William Henry Fox Talbot to recognize the degree to which competition shaped the evolution of the medium. In contrast, many women urged cooperation, actively supporting their female colleagues by offering advice on matters both practical and emotional. Advocating pride and self-knowledge, the women who entered the field in the late nineteenth century praised the medium's potential to grant them a measure of control and purpose in life. Some no doubt felt their work to be "unimportant" (as Emma Fitz wrote to Frances Benjamin Johnston in about 1900),[22] but many more were forthright about its value and the need to instill confidence in their female colleagues. A similarly supportive attitude character-ized the activities of many women photographers of the 1970s and 1980s.

Another mission for a book about women photographers is to suggest the diversity of those who found in photography a pastime, a profession, and in some cases, a passion. Women in the field have, not surprisingly, demonstrated a range of personality types. From genteel Alice Austen to forthright Margaret Bourke-White, from motherly Gertrude Käsebier to staid and sensible Catharine Barnes Ward, from retiring Helen Levitt

to politically active Tina Modotti—all seized on photography as a tool that would give them greater input into the life of their times. This diversity enabled them to enrich the medium and at the same time to demonstrate that women need not become undifferentiated stereotypes to function professionally and creatively.

Nor need they be victims of society's constraints. Uncovering women's contributions demonstrates that even though their success stories have not always been as common as they should have been, they were not as rare as they sometimes seemed. That photography enhanced women's own lives is an important lesson to be drawn from a history of their efforts. "Nothing," wrote one in 1902, "has revealed human nature, given me a chance to travel, [and] given me valued acquaintances and friends as much as photography."[23] Some eighty years later, another credited the medium with producing a "state of absorption and wonderment" that "nurtures . . . imagination and enriches life."[24] And now, even as digital cameras and computers transform the way women take photographs, the medium continues to enhance their lives.

The overview that follows surveys developments in the Americas and in Europe, although it is fair to say that the emphasis is on progress in the United States. The fact that there have been so many more women photographers in the past than are presently acknowledged and that the numbers in the field grew so mightily in the last quarter of the twentieth century has posed a difficult problem of selection. Confronted by this embarrassment of riches and by the need to keep this book a publishable length, for the first edition I had reluctantly decided not to include women born after 1950, except in a few cases where their work addressed a significant ethnic or feminist issue. Yet even with this limitation, choosing who to name and who to omit was a difficult process. In revising the book, the problem remains acute; even though I have added a few photographers from the next generation, their representation here remains, by necessity, quite limited. There are so many women currently active in so many different aspects of the medium—women working in traditional black and white, in color, with digitally generated images; women involved in artistic expression, in documentation, in photojournalism—that choosing whom to include has been a vexatious process. In addition, more women from the past have floated into view, and I have cited those whenever possible.

Those from the past who have been left out are in no position to protest; I hope that those active today who are not included will understand that factors other than the quality of their work have determined my choices. For both the original edition and for this revision my criteria were how visible the work once was or currently is, its acceptance or rejection by critics and institutions, its relationship to past or contemporary ideologies, and its role in advancing women's position in photography. I especially hope that young women will accept this survey as an attempt to recover and present to a wide public the work of women of the past, and that the individual stories and the interactions with the larger culture of the earlier pioneers in the field will prove inspiriting. I would like to think, also, that a greater understanding of women photographers, past and present, will encourage a more diverse and more comprehensive view by all persons of this multifaceted enterprise we call photography.

COLOR PLATES

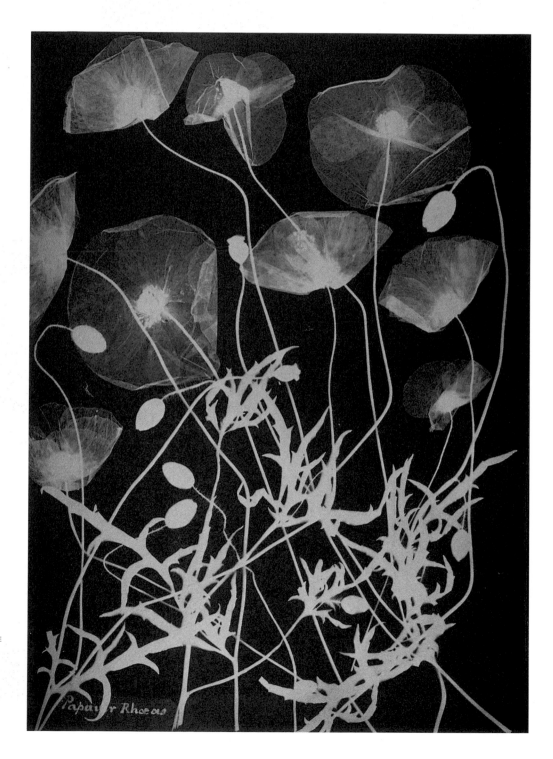

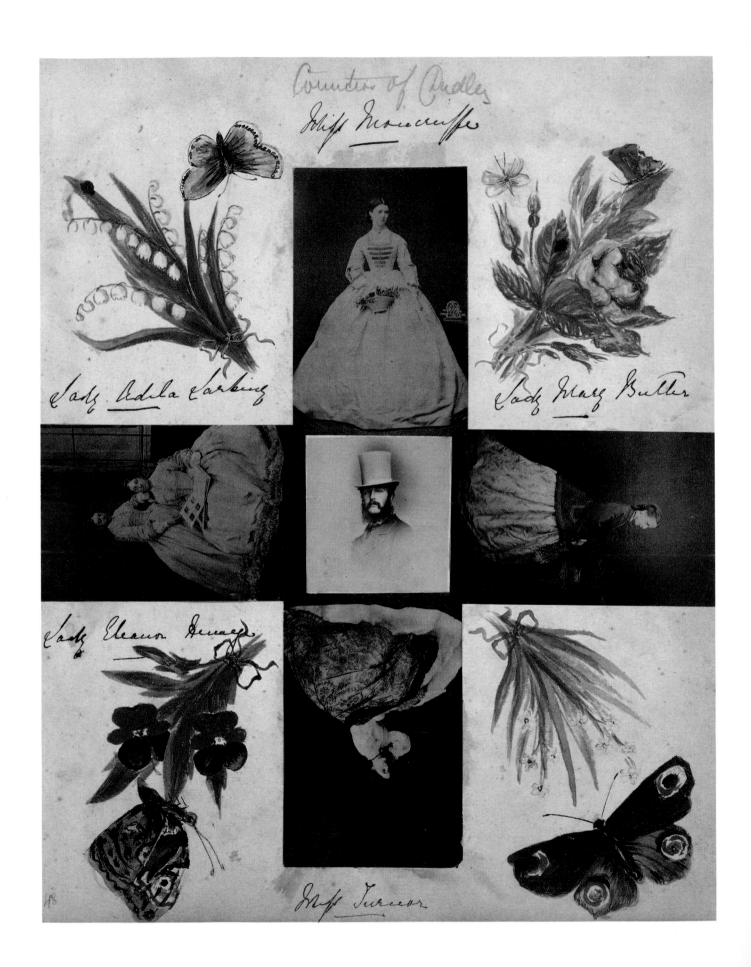

OPPOSITE

PLATE 3: LADY FILMER
(C. 1840–1903). *UNTITLED,*
C. 1864. WATERCOLOR WITH
COLLAGED PHOTOGRAPHS,
11¼ X 9 IN. (28.6 X 22.9 CM).
THE UNIVERSITY OF NEW MEXICO
ART MUSEUM, ALBUQUERQUE;
MUSEUM PURCHASE.

ABOVE, LEFT

PLATE 4: CAROLINE EVEN GLEDHILL
(1871–1935). *PORTRAIT OF KEITH,*
1917. PRINT FROM LUMIÈRE
AUTOCHROME. GEORGE EASTMAN
HOUSE, ROCHESTER, NEW YORK.

ABOVE, RIGHT

PLATE 5: MADAME YEVONDE
(1893–1975). *SELF-PORTRAIT,*
1940. DYE-TRANSFER PRINT FROM
THE ORIGINAL VIVEX COLOR NEGA-
TIVE. YEVONDE PORTRAIT ARCHIVE,
BATH, ENGLAND.

OPPOSITE
PLATE 6: LOUISE DAHL-WOLFE
(1895–1989). *THE COVERT LOOK,*
1949. COLOR (CHROMOGENIC
DEVELOPMENT) TRANSPARENCY.
COURTESY OF THE MUSEUM AT THE
FASHION INSTITUTE OF
TECHNOLOGY, NEW YORK.

ABOVE, TOP
PLATE 7: JEAN PAGLIUSO (BORN
1941). *UNTITLED,* 1986. 35 MM
COLOR SLIDE.

ABOVE, BOTTOM
PLATE 8: DEBORAH TURBEVILLE
(BORN 1937). *ITALIAN VOGUE,
PARIS, 1981,* 1981. FRESSON
PRINT. COURTESY OF STALEY-WISE
GALLERY, NEW YORK.

OPPOSITE, TOP
PLATE 9: ESTHER PARADA (BORN
1938). *AT THE MARGIN,* 1992.
COLOR INKJET PRINT (ONE OF
A FOUR-PANEL INSTALLATION)
DIGITALLY GENERATED ON
MACINTOSH COMPUTER,
33 X 55 IN. (83 X 140 CM).

OPPOSITE, BOTTOM
PLATE 10: SUSAN MEISELAS (BORN
1948). *DEMONSTRATING AGAINST
U.S. PRESENCE IN THE PHILIPPINES,*
DECEMBER 1985. 35 MM COLOR
SLIDE. MAGNUM, NEW YORK.

ABOVE
PLATE 11: MAGGIE STEBER (BORN
1949). *WHEN HUNGER OVERCOMES
FEAR (PHOTOGRAPHED IN HAITI),*
1986. 35 MM COLOR SLIDE.

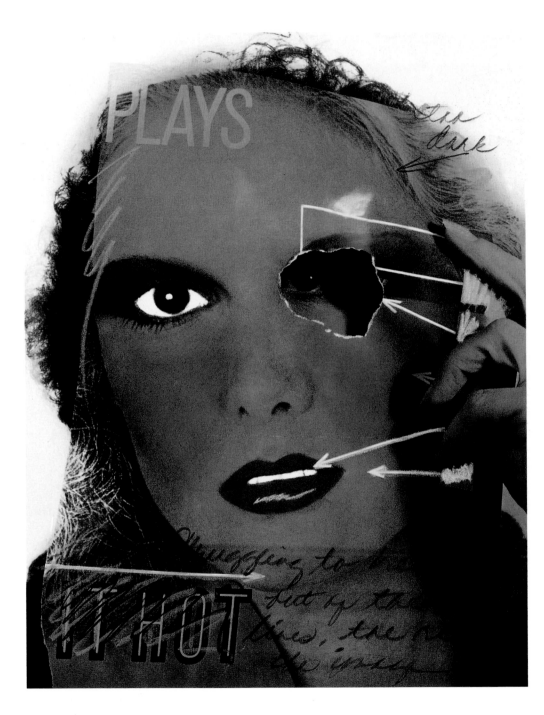

ABOVE

PLATE 12: JUDITH GOLDEN (BORN
1934). *PLAYS IT HOT*, 1977.
BLEACHED GELATIN SILVER PRINT,
PAINT, AND GRAPHITE, 14 X 11 IN.
(35.6 X 27.9 CM).

OPPOSITE

PLATE 13: JOYCE TENNESON (BORN
1945). *SUZANNE IN CONTORTION*,
1990. POLAROID PRINT, 24 X 20
IN. (61 X 50.8 CM).

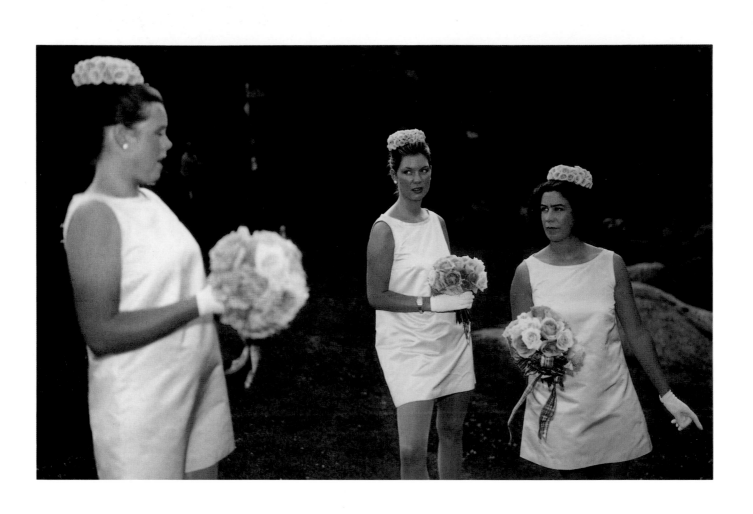

OPPOSITE
PLATE 17: TINA BARNEY
(BORN 1945). *THE BRIDESMAIDS
IN PINK*, 1985. CHROMOGENIC
COLOR PRINT. COURTESY OF JANET
BORDEN, INC., NEW YORK.

RIGHT, TOP
PLATE 18: JOYCE NEIMANAS
(BORN 1944). *UNTITLED NO. 12*,
1982. SX-70 (INTERNAL DYE-
DIFFUSION TRANSFER) PRINTS,
32 X 40 IN. (76.5 X 102 CM),
IRREGULAR. COURTESY OF
GALLERY 954, CHICAGO.

RIGHT, BOTTOM
PLATE 19: WANG MIAO
(BORN 1951). *SEARCHING*, 1980S.
EKTACHROME SLIDE. COURTESY
OF HK CHINA TOURISM PRESS.

OPPOSITE

PLATE 20: ROSAMOND W. PURCELL
(BORN 1942). *EXECUTION,* 1980.
DYE-TRANSFER PRINT FROM
POLAROID PRINT.

ABOVE

PLATE 21: MERIDEL RUBENSTEIN
(BORN 1948). *THE SWALLOW'S
HOUSE, PROGRESSO, NEW MEXICO,*
1982–83. EKTACOLOR PRINT.

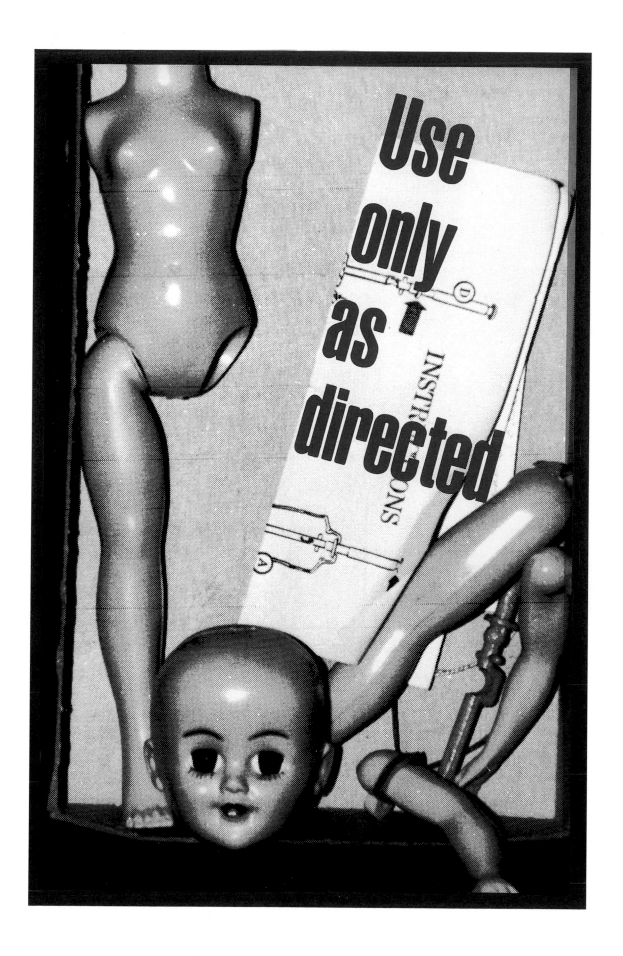

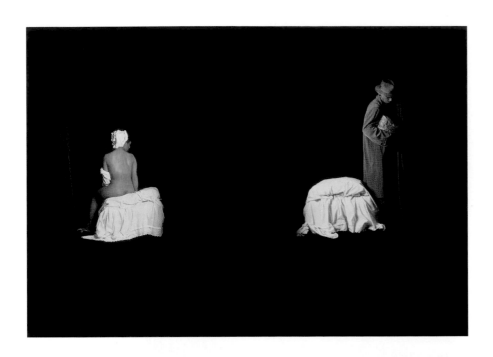

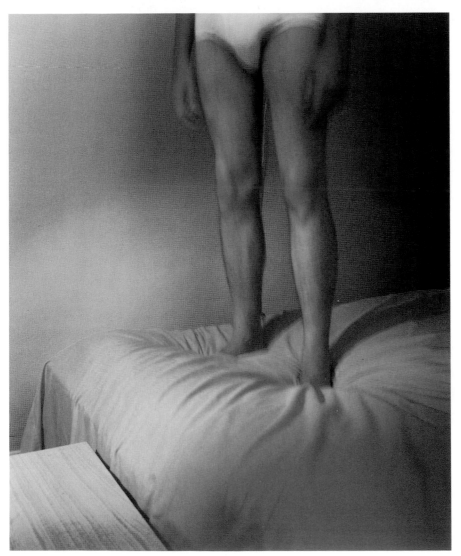

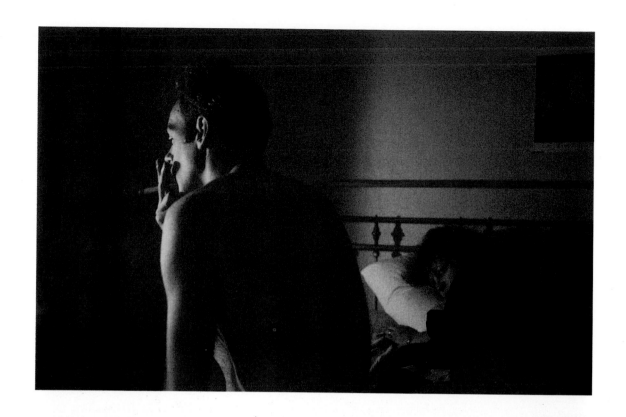

ABOVE, TOP
PLATE 34: MARGARETTA K.
MITCHELL (BORN 1935). *OLD ROSE*,
1991. PHOTO-ENGRAVING, 14 $7/8$ X
14 $3/4$ IN. (37.8 X 37.4 CM).

ABOVE, BOTTOM
PLATE 35: JUDITH HAROLD-
STEINHAUSER (BORN 1941). *DANC-
ING TULIPS*, 1982–84. GELATIN SIL-
VER PHOTOGRAM WITH ACRYLIC
AND OIL PAINT, 14 X 11 IN. (35.5 X
28 CM). COURTESY OF ANNE AND
JACQUES BARUCH COLLECTION, LTD.

RIGHT
PLATE 36: BETTY HAHN (BORN
1940). *ULTRA RED AND INFRA VIOLET*
1967. GUM BICHROMATE PRINT.
COURTESY OF ANDREW SMITH
GALLERY, SANTA FE, NEW MEXICO.

A HISTORY OF WOMEN PHOTOGRAPHERS

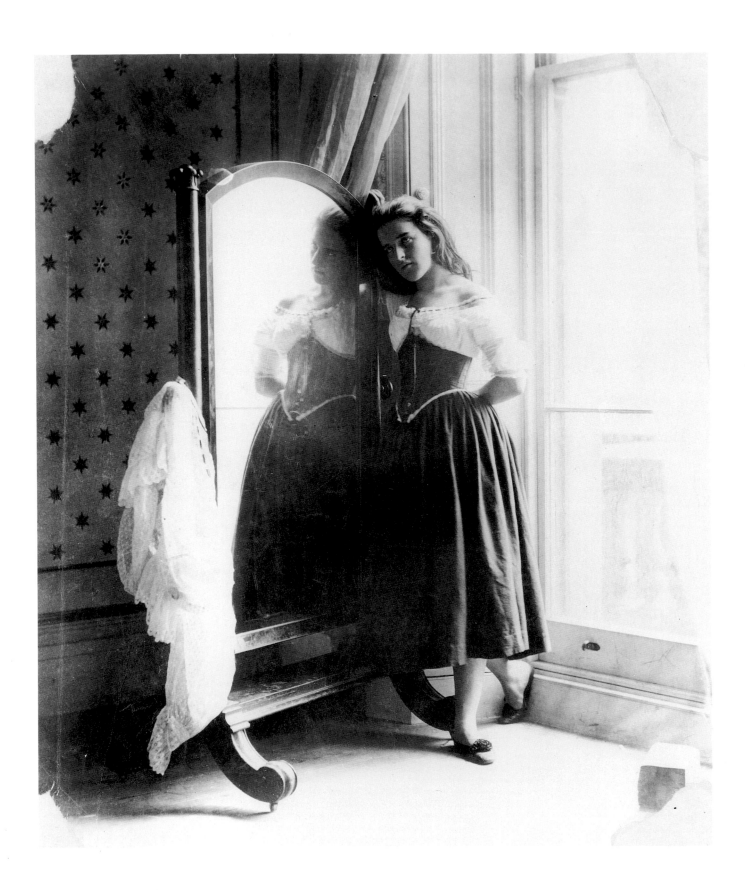

CHAPTER 1

AT THE BEGINNING, 1839–90

Photography aroused immense curiosity among people in all industrialized nations immediately following the announcement of its discovery in 1839. "Drawing with the aid of the sun," as the new medium was termed, quickly became a mania, inducing many who could afford it (and some who could not) to order equipment, purchase manuals and supplies, and set about making images—mainly daguerreotypes on metal, but also paper negatives and prints.

It was not yet clear whether photography could produce art or merely a record, whether it would be just a pastime or could fulfill more serious purposes, whether it was limited by its current technology or could be expanded in unforeseen ways. But from the start photography was perceived to be a different kind of picture making—an easier version of an activity that traditionally had required a degree of talent and training not available to many. Still more a potential than a codified medium, photography was unimpeded by many of the conventions that restricted the traditional arts. Who could become a photographer had not yet been defined, and there was more inclusiveness in terms of the age, class, and gender of its practitioners.

Most of those who participated in the invention and the early development of the new medium were men. One exception was Elizabeth Fulhame, who was involved with work on light-sensitive compounds; another was Friederike Wilhelmine von Wunsch (a German painter living in Paris), who claimed in 1839 to have come up with a "process permitting portraits to be made natural size as well as in miniature."[1] The documents that she gave to the German ambassador to France included no descriptive details, so one cannot ascertain whether her process was related to that of Louis-Jacques-Mandé Daguerre or William Henry Fox Talbot.[2]

Photography seems an unlikely pastime for middle-class females hemmed in by Victorian codes of behavior. In its earliest stage, taking photographs required manipulating a heavy, cumbersome mechanism. Processing involved puttering in the dark with malodorous substances that were likely to stain flesh and clothing, and the unfamiliarity of the procedures meant a high failure rate. Yet there was a precedent for female interest in this new technology. In the eighteenth century, changes in economic life had given women—both noble and bourgeois—more leisure time. Some of them filled that time by turning their attention to new scientific discoveries, stimulated by Francesco Algarotti's *Newtonianism for Ladies* (1739). Their interest in light and color as produced by prisms, lenses, and microscopes led to curiosity about cameras, optics, and chemical-fixing processes when those later developments were announced.[3]

PLATE 38: MARY DILLWYN
(1816–1906). *THE PICNIC PARTY*,
1854. SALT PRINT, 7 1/2 X 4 13/16 IN.
(19 X 12 CM). CHARLES ISAACS,
MALVERN, PENNSYLVANIA.

CALOTYPES, CYANOTYPES, AND DAGUERREOTYPES

In England several of the women who took an active interest in the new paper-negative process, or calotype, were Welsh friends and relations of its inventor, William Henry Fox Talbot. His wife, Constance Talbot, participated with her spouse in picture taking and on occasion made her own exposures and prints as well.[4] Her participation was little noted in a culture where men were expected to take active roles and women to be quietly supportive. The activities of other women in this group—among them Emma Llewelyn, Mary Dillwyn (plate 38), and Charlotte Traharne—have surfaced only recently. Emma Llewelyn wrote of being "sole printer for Mr. Llewelyn," and Traharne noted that "we [she and her husband] put a piece in the camera obscura but got only a feint [*sic*] outline."[5] Frances Dunlop Monteith used the calotype process, as did the unknown H. A. Tucker, whose prints were annotated "Calotype taken by Herself."[6]

It may no longer be possible to determine whether the camera images that have survived from Talbot's group were done in tandem or were exclusively the work of the women or the men. From its earliest days the finished photograph has resulted from cooperative efforts more often than is generally recognized. In commercial portraiture, for example, one person might arrange the sitter, another make the exposure, and still others finish the print. Following the Indian Mutiny of 1858, Harriet and Robert Christopher Tytler spent six months photographing sites devastated by the fighting. Although their work, on large paper negatives, was praised as "the finest that had ever been laid before [the Photographic Society]," Harriet's contribution was ignored by scholars, who indexed the images under Robert's name only.[7]

It is interesting that an activity that necessitated organizational ability, attentiveness to detail, and considerable patience with trial-and-error proceedings appealed so strongly to English women of means. Their engagement with the medium suggests that photography presented itself as a pastime through which those consigned to domestic life might step beyond it. Photography helped women express artistic ideas and made possible their greater participation in some aspects of modern life outside the usual womanly pursuits of stitchery, drawing, and painting in watercolors. Moreover, with the numbers of females who considered themselves artists increasing almost fourfold between 1840 and 1870, and with the art press "teeming with articles and comments on women and art," the appeal of photography as a form of expression becomes clearer.[8]

Interest in the medium was not limited to those of means seeking an absorbing hobby; it appealed also to women with serious purposes. In 1841–42, soon after Talbot's ini-

tial experiments with silver salts on paper, John Herschel discovered a method of producing an image by the action of light on paper brushed with a solution of ferric ammonium citrate and potassium ferricyanide. Called "cyanotype," or blueprint, this process—which was simpler, less expensive, and more permanent than Talbot's, as well as free of his patent restrictions—made possible more ambitious projects. The earliest and most thorough was that undertaken by Anna Atkins, who employed this cameraless method (now known by the term "light graphics") to record all the known species of algae in the British Isles (plate 2).[9] This technology was a significant advance over the traditional but expensive and not always accurate method of drawing botanical specimens by hand.

Beginning in 1843 and continuing for about ten years, Atkins collected algae and produced thousands of blueprints; happily, the intense blue of the cyanotype seems appropriate for these water plants. Eventually she made a selection of plates and distributed bound editions to friends and scientific bodies. For help in gathering specimens and producing prints, Atkins turned to another woman, Anne Dixon, who may have produced her own cyanotypes of algae and other plants.[10] Thereza Llewelyn, a daughter of Talbot's Welsh relations, used the technique of photogenic drawing (sometimes called shadow printing) to record seaweed specimens on salted paper, which she then labeled with their scientific names.

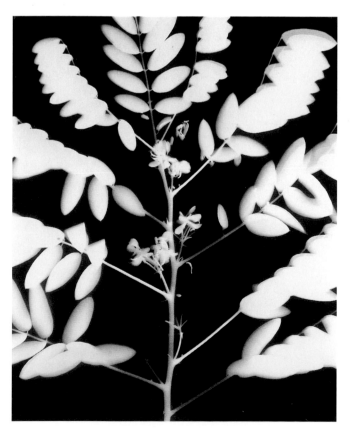

PLATE 39: BERTHA EVELYN JAQUES (1863–1941). *AMERICAN SENNA, CASSIA MARYLANDICA, SOUTH HAVEN RIVER BANK,* AUGUST 9, 1909. CYANOTYPE. LARRY GOTTHEIM FINE EARLY PHOTOGRAPHS, BINGHAMPTON, NEW YORK.

Atkins was the first person of either gender to use the light sensitivity of chemical compounds to produce a long-term scientific study of the natural world. Although Talbot had outlined this potential for the medium in his *Pencil of Nature* (a multivolume work issued between 1844 and 1846) and had himself made a number of botanical images, he never produced such an extended scientific work. Besides its scientific dimension, Atkins's oeuvre demonstrates a fine sense of visual composition. Her work is a testament to the great appeal to women of a pictorial process that called into play both scientific and aesthetic intelligence. That the cyanotype long remained an appealing procedure for botanical documentation is affirmed by the numerous examples of botanical material produced in the late nineteenth and early twentieth centuries; among the most elegant are those by the Chicago etcher Bertha Evelyn Jaques (plate 39).

Photography, like other technologies, often yielded simultaneous solutions to the same problem. In France the search for a way to produce images through the interaction of light and chemical compounds had led to a different discovery: how to permanently capture an image on a metal plate rather than on paper. The daguerreotype, as both the process and its results were called (after its inventor, Louis-Jacques-

Mandé Daguerre), produced a unique picture—either negative or positive, depending on how the plate was held in relation to the light. Usually small and with a delicate surface, daguerreotypes were difficult to view, apt to tarnish, and easily destroyed; therefore, they were enclosed in cases. Like the calotype, the daguerreotype required some mechanical ability, a willingness to handle noxious chemicals, and sensitivity to pictorial organization. But though the process was "mechanical and tedious," as one woman noted, she urged that "every lady in the land acquire an apparatus," for when the plate was taken from the camera, "the wonder begins."[11]

In 1839 the French government made the daguerreotype process available to the French public without franchise charges; although licenses were needed for commercial use outside France, the technique soon spread to the rest of the Continent and England. It was initially little more than a diverting pastime for those who could afford the cost of the equipment and the silver-plated copper sheets on which the image appeared. But with the reduction in exposure time and the improvement in lenses in the early 1840s, daguerreotype portraits became feasible. As a result, commercial studios were opened, frequently operated by artistically trained entrepreneurs who saw the technology as a new way to make a living in the very competitive art world. Many minor painters and craftsmen in Europe and the United States took lessons in the daguerreotype process, purchased manuals and equipment, and proceeded into the image-making business. Marie Chambefort was one of the few French women known to have made portraits, but those engaged in this business on the Continent and in England was relatively small; of the some 750 studios opened in England between 1841 and 1855, 22 were run by women.

Most frequently, a woman would help her spouse in a photography business and then take it over after his death, but a number did enter the profession independently. Among the earliest was Ann Cooke, a mother of nine, who purchased a license from the well-known London entrepreneur Richard Beard and opened a portrait studio in Hull, England, following the death of her husband in 1843. Jane Nina Wigley, a London artist who also purchased a franchise from Beard, operated studios first in Newcastle and later in London. She was one of the first to use a prism inserted in the camera to reverse the inverted daguerreotype image. After she switched to using the collodion process in 1852, Wigley was complimented for "her woman's obstinacy" in refusing to bow to Talbot's claims of patent infringement.[12]

The general economic viability of women's establishments is unknown, but the fact that Cooke attempted at one point to expand her business to include the cutting of cheap paper silhouettes and later converted part of the photographic studio into rental apartments suggests that hers, at least, was not very profitable. For a number of women, daguerreotyping seems to have provided a stopgap income until some other solution presented itself.

Until recently, little was known about early female daguerreotypists working in the German-speaking regions, but researchers are now discovering references to, records of, and images by early female enthusiasts. From inscriptions on extant daguerreotype portraits, it is known that Bertha Beckmann learned the process from a daguerreotypist in Prague and then worked with her husband, Enemann Eduard Wehnert, in Leipzig until his death, pro-

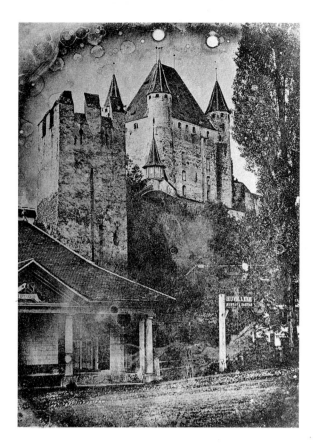

ducing both paper and metal images. In 1849 she journeyed to New York, where for several years she listed herself as a maker of "photo-types," first alone and then in partnership.

Other women daguerreotypists were making portraits during the early 1840s in the United States and Canada. About one hundred names have turned up—constituting, it is thought, about 2 percent of those pursuing the profession.[13] Often they were itiner-ants, traveling a circuit of small towns and outlying settlements and operating either from portable darkroom wagons or from rented spaces. In some instances they may have been the first to introduce camera portraiture to a particular area, prompting others to set up more permanent establishments. For example, in 1843 a Mrs. Davis arrived in Houston for a stay of "two to three weeks," during which the local populace was invited to obtain "accurate miniatures"; soon afterward, a daguerreotype salon was opened by a male resident.[14]

Regrettably few records have come down to reveal how women felt about their involvement in the new medium, and few of their photographs have been identified. The rare surviving references and advertisements suggest the grit required to build a commercial practice in the early days. In one instance, Sarah Holcomb, a student of Albert Sands Southworth in Boston, traveled to New Hampshire in the winter of 1846 to make daguerreotypes, only to find that the harsh weather had ruined her chemicals.[15] Reaction to their efforts by male colleagues can be surmised from the response of one critic, who claimed that "female Daguerreians are out of place, pants or no pants."[16]

From photography's infancy, the recording of landscape views by camera began to supplant handmade depictions in watercolor, pencil, or ink. In 1840, the year following the announcement of the daguerreotype in Paris, *Excursions daguerriennes: Vues et monuments les plus remarquables du globe* (*Daguerreian Travels: The Most Remarkable Views and Monuments in the World*) was published, with engraved and lithographed illustrations based on camera images, to which artists had sometimes added figures, decorative fillips, and color. Reproduced in printing ink, such imagery grew increasingly popular as more and more people could afford to travel beyond their own county seats.

The interest in landscape imagery displayed by the Swiss daguerreotypist Franziska Möllinger was unusual for a woman. Like her better-known countryman Johann Baptiste Isenring, Möllinger embarked on a project to portray the scenic vistas of her native land in daguerreotypes, which were translated by graphic artists into lithographic reproductions for published editions. She planned an edition of thirty such views, with proceeds from their sale to go to charity, but only half that number were published and only one of her daguerreo-type plates has survived (plate 40). Though far less ambitious than *Excursions*, Möllinger's work was intended for a similar clientele. That this project entailed traveling around with a darkroom

wagon suggests that Möllinger did not object to unconventional activities.

Even though women did not operate cameras or own enterprises as frequently as men, they did play a significant behind-the-scenes role in producing the finished images in well-capitalized daguerreotype establishments. The process was a labor-intensive enterprise that lent itself to a division of tasks; in fact, it was one of the first industries to employ what was called the "German," or belt-line, system. Daguerreotype studios needed dexterous workers to apply color to the images, to encase them in metal mats and glass, and to insert them in the leather-covered or thermoplastic cases that protected the fragile surface. Women, it appears, did many of these jobs. Mary Ann Meade, for example, was active in Meade Brothers, one of the better-known firms that opened for daguerreotype portraiture in New York City during the 1850s, though nothing in the record indicates her exact role in the family business. "Miss Claudet," working for Antoine Claudet, one of the prime portrait daguerreotypists in London, and Nancy Southworth, of the illustrious Boston firm of Southworth and Hawes, typify women whose artistry corrected the most unappealing aspect of the portrait on silver—its lack of natural color—by adding delicate flesh tones to the face, color to the eyes and garments, and gold paint to the jewelry. Women continued in this role when new technologies supplanted the calotype and daguerreotype.

THE COLLODION PROCESS

Both of the primitive technologies that produced images during the decade after the discovery of photography were supplanted in 1851 by collodion/albumen procedures. This process involved the use of a glass plate coated with sticky collodion (a gun-cotton derivative), to which a mixture of silver salts adhered as a support for the negative image; from this fragile base positive prints could be made on a variety of substances, the most common being albumen-coated paper. Despite the difficulties surrounding the use out-of-doors of this new "wet-plate" process (so called because the glass plate had to be exposed and processed while damp), all but a few artistic souls considered it greatly more effective than daguerreotyping and calotyping in producing a sharp image at low cost.

As a result of the improved and cheaper technology, women became more involved in both the professional and the recreational aspects of the medium. Knowledge of their recreational involvement is mostly indirect, based on references to their activities in the amateur societies in Great Britain and on observations by commentators such as Cuthbert

Bede (the Reverend Edward Bradley). This witty author of *Photographic Pleasures* (1855) noted that women were imploring chemists to find remedies for silver nitrate stains on flesh and clothing, which suggests that they were puttering around in darkrooms. Among those whose works have been preserved are the sisters Lady Caroline Nevill and Lady Augusta Mostyn (plate 41), who traded landscape views with other members of the Photographic Exchange Club, an organization of well-to-do Londoners who looked on photography as an artistic pastime.[17]

PHOTOGRAPHY AS COMMERCE

As for business ventures, portraiture remained the sphere in which women were most commonly involved; few were engaged in topographical or other documentation or in making images for the expanding trade in stereographs. (Stereographs are two photographs of the same scene taken with a special camera with lateral twin lenses. When mounted side by side and viewed through a special device called a stereoscope, the prints give an illusion of three dimensionality.) More and more frequently women worked on their own. According to one estimate, several thousand women were active throughout Europe and the United States in the second half of the nineteenth century, with surprisingly large contingents in Denmark and Sweden.[18] The logos of some three hundred women working in Europe, the United States, and even, surprisingly, the South Pacific have been found on the reverse of *carte-de-visite* portraits, but details about their work in the field are as yet unknown.[19] The extent of their activities can be gauged from an 1858 advertisement placed by one Julie Wittgens and directed mainly toward female sitters. In it she featured herself as photographer, retoucher, portrait painter, and expert in all formats, from *cartes de visite* to large-scale painted works. Alice Hughes and Danish-born Mary Steen photographed the British royal family as well as society women during the 1880s, demonstrating to later practitioners that it was possible for a woman with the proper connections to operate a profitable portrait business.

Equality in a partnership between men and women was probably not very common, but the logo of a Mr. and Mrs. Thomas S. Hicks of Sheffield, England, which indicates that they specialized in children's portraits, demonstrates that such arrangements were not unknown. Geneviève-Elisabeth Francart Disdéri, a partner in a French provincial portrait establishment with her eventually more famous husband (André-Adolphe-Eugène Disdéri, popularizer of the *carte de visite*), continued to operate a studio in Brest after his departure, ultimately to Paris. Between 1856 and 1858, using the

PLATE 42: GENEVIÈVE-ELISABETH FRANCART DISDÉRI (C. 1818–1878). *ABBAYE DE SAINT MATHIEU*, PLATE NO. 8 OF *VUES DE BREST ET SES ENVIRONS (VIEWS OF BREST AND ITS SURROUNDINGS)*, 1856–58. ALBUMEN. GEORGE EASTMAN HOUSE, ROCHESTER, NEW YORK.

new collodion/albumen technology, Mme. Disdéri produced a group of views of Brest landmarks (plate 42); later she too set herself up in Paris, maintaining a photographic establishment there until her death in 1878.[20]

Greater numbers of women were engaged in commercial photography in North America than in Europe during the collodion era. Recent investigations have turned up the names of some six hundred women who worked in Canada during the latter part of the nineteenth century.[21] Some opened portrait studios in the major cities of Montreal, Toronto, and Winnipeg; others, such as Geraldine Moodie and Gladys Reeves, used the camera to document the terrain and the indigenous populations of the Far West and North. Following an overland trip to California from Missouri, Eliza Withington set up a studio in 1857 in the mining town of Ione City, where she made stereograph and regular images of the town and its mining operations (plate 43), as well as portraits by the ambrotype method. She was the first woman to write in detail about the techniques of making landscape photographs in the Far West and Canada.[22]

One Canadian couple, Richard and Hannah Maynard, exemplify the kind of husband-and-wife enterprise that was frequently found throughout North America; in their case the female partner was the driving force. Emigrating with her husband from England to Ontario in the early 1850s, Hannah Maynard learned the rudiments of photography during her husband's absence on gold-panning ventures in western Canada and opened a studio on her own, eventually teaching him the skills. While Richard traveled extensively to document scenery and ceremonial events for the Canadian government, Hannah for the most part took portraits, only occasionally breaking off for a trip to photograph landscapes in some remote area of Canada. Toward the end of her career, she produced a number of multiple exposures (plate 44) that on one level reflect her spiritualist beliefs and on another could be considered "photographic amusements."[23]

Photography spread quickly throughout the parts of the Near East, India, and South America where Europeans and Americans had colonial interests. As might be expected, women professionals were a rare presence in these parts, but there were a few of them. In Beirut, Lydia Bonfils occupied a position in the establishment opened by her husband, Félix Bonfils, after the family relocated from France in about 1867. This enterprise not only exposed thousands of portraits and scenic views, but at times acquired negatives made in other establishments, which were then printed under the Bonfils logo. Exactly what Lydia

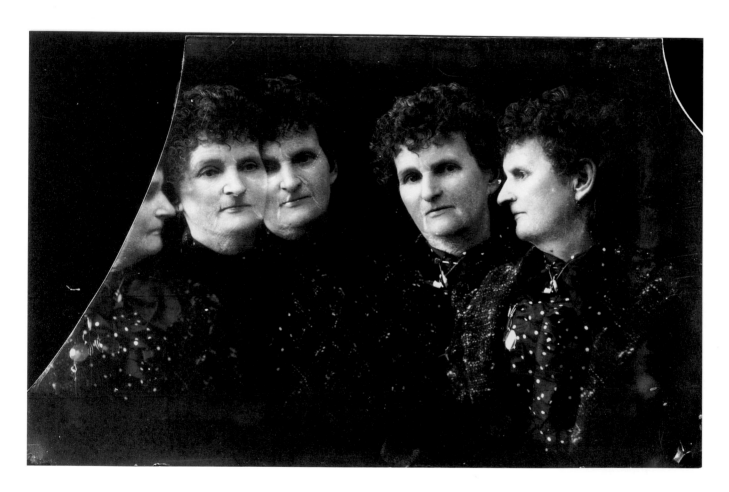

PLATE 44: HANNAH MAYNARD
(1834–1918). *SELF-PORTRAIT*
(MULTIPLE EXPOSURE), 1887.
MODERN GELATIN SILVER PRINT
FROM GLASS NEGATIVE. BRITISH
COLUMBIA ARCHIVES AND
RECORDS SERVICE, VICTORIA,
CANADA.

Bonfils contributed is a matter of conjecture, but it has been suggested that she must have been responsible for portraits of unveiled Moslem women, as a male photographer would have been proscribed from this activity. In addition, her pictures were used as the basis for engravings in a book of views of the Holy Land.[24]

An unusual visual proof of the partnerships that existed between husband and wife in the making of photographs is a woodblock of the 1860s by the Japanese artist Yoshikazu Issan (plate 45). It depicts a French couple in the act of photographing, with the man making the exposure under the dark cloth and the woman holding the slide that prevents light from affecting the plate before and after exposure. Since the slide could easily be managed alone by the operator of the camera, one could assume that the couple worked at photographing together, although whether for business or pleasure will never be known.

As the techniques for producing portrait photographs changed, women were called upon for retouching as well as coloring. This skill, taught in schools, remained women's work into the twentieth century, perhaps because, as one writer put it in the mid-1880s, a woman skilled in retouching "would have secured greater pay if she had been a man."[25] The fact that women provided cheap labor was openly acknowledged. Writing in the *Photographic Journal* in May 1873, Cornelius Jabez Hughes indicated that the three types of work open to women in photography could be compared to those of "maid-of-all-work," "shopwoman," and "governess." The lowest level was behind-the-scenes work in provincial establishments; the next rung up required women to make simple exposures, spot and paste up the images, keep records, handle cash, and take care of correspondence. The "governess" was considered more highly educated and competent, and therefore gave a certain "classiness" to an establishment, providing she knew her place and did not try to impose her taste and knowledge.

As technological processes changed, women began to be employed more frequently by printing and publishing enterprises (plate 46). Blanquart-Evrard in Lille, the Lumière Brothers in Lyons, the Anthony brothers in New York, and George Eastman in Rochester hired women to do dreary assembly-line work. They also figured prominently in the manufacture of albumen paper, dry plates, and Kodak and Lumière films. According to the photographer Eadweard Muybridge (who voiced the prejudices of the day), the tedium of the new processing procedure made it best suited to "women and chinks."[26]

佛
蘭
西

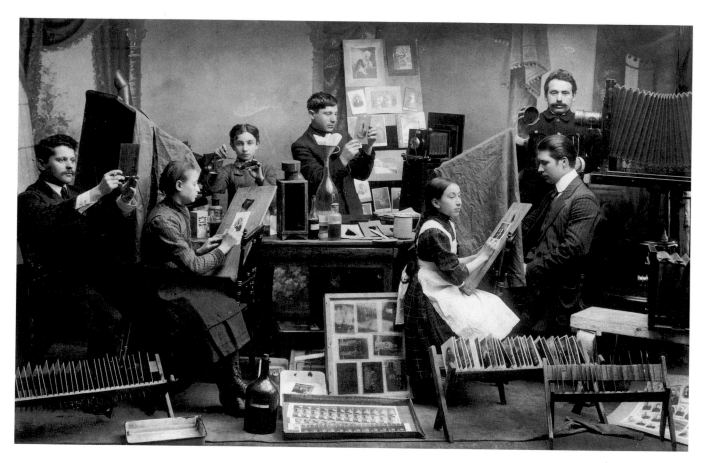

PHOTOGRAPHY AS PASTIME

Collodion/albumen photography also attracted British women of means, who found it an engrossing pastime rather than a source of income. Whether they were working on their own or within the framework of groups such as the Photographic Exchange Club, these women no doubt had their interest in photography reinforced by the support given to the medium by the British crown. Victoria and Albert commissioned innumerable images of themselves and the royal family, which they often exchanged for photographs of other European royalty; they collected photographs through gift and purchase; they even had darkroom facilities installed at Windsor Castle. In 1853 they gave their seal of approval to the newly established Photographic Society, thus bestowing a special cachet on the young art form.

Just as the profession of artist in Victorian England would have been unthinkable to any but women of means, so artistic photography during the collodion era was confined to well-to-do women who turned to the medium for its personal satisfactions. Ladies Lucy Bridgeman and Hariette St. Clair and Viscountess Fanny Jocelyn (Lord Palmerston's niece) were aristocrats active in the 1850s and 1860s in depicting their relatives, friends, and family estates. Not all were titled, but several—including Mary Lynn and the ladies Mostyn and Nevill—seem to have continued the tradition begun by the women members of the Photographic Exchange Club, focusing on the same sorts of picturesque subjects that had formerly appeared in amateur sketches and watercolors. The final resting

places for much of this work were the albums kept by women who undoubtedly took a cue from Victoria's delight in the royal picture albums. In general, these images have certain similarities: the sitters tend to be from the same social class as the photographers, and the works reflect the prevailing middle-class interest in family, idealized nature, theatrical genre, and biblical or mythological narrative.

Despite the homogeneity of sitters and subjects, the work by a number of these British women is notable for its individual style and expressive character. Lady Filmer, about whom little is known other than that she was an intimate of several members of Victoria's court, recognized that unusual camera portraits could be assembled into a single image by cutting and pasting them and, on occasion, adding watercolor wash to the whole (plate 3). It is not known if the Honorable Charlotte Milles made the exposures herself, but she combined and rearranged disparate cutout photographs with traditional watercolor painting of members of her family and of the royal court.[27] This treatment of the camera image undoubtedly derived from the nineteenth-century feminine diversions of making valentines and keeping scrapbooks in which all manner of printed material was given new form through decoupage—cutting and pasting, and at times adding color by hand. Such works, whether formed from graphic or photographic sources, were meant largely as decorative objects, without the political or social intent of the photocollages made during the 1920s. Nevertheless, the realism of the subject caught by the camera lens combines with fanciful scale and placement to produce an entirely new genre of imagery that prefigures the Dada disdain for spatial and temporal clarity.

Clementina Fleeming, Lady Hawarden, who was able to indulge her interest in photography after her marriage to the wealthy Cornwallis Maude, fourth viscount of Hawarden—photographed for her own pleasure for some seven years before her death in 1865 at age forty-two, turning out almost eight hundred images. Using the collodion/albumen process, she concentrated on her immediate surroundings—the wooded landscape around her home in Ireland and, after moving to London—her daughters and their friends in interior settings. Clad in stylish garments, her sitters, languidly posed and at times reflected in mirrors, usually were illuminated by strong sunlight streaming through open windows (plate 37). Clementina's early death, it has been suggested, may have been hastened by her exposure to photographic chemicals.[28]

Hawarden's compositions seem less concerned with capturing the sitters's individual character than with creating a sensual but somewhat enigmatic mood. To feminist eyes, the artificiality of pose and expression has suggested "a sense of entrapment within Victorian expectations for women."[29] To others, the images constitute evocative domestic idylls. Perhaps her elegant tableaux might be considered the forerunners of stylish fashion photography.

Why any of the titled "ladies" just discussed started photographing remains a mystery, but Julia Margaret Cameron's introduction to the camera as a stratagem for keeping her occupied is well known through her own description of her receipt, at age forty-eight, of a camera from her son and daughter-in-law.[30] Despite "beginning with no knowledge of the art"—not even knowing "where to place my dark box"—Cameron soon became dedicated to

the camera image as a transcendent artistic and psychological statement.[31] Since she produced a large number of visual works as well as written accounts of her ideas and intentions, no guesswork is required to understand either her artistic or her ideological objectives. These were in fact so closely bound together that any analysis of her portraits must take into account her profound conviction that beauty, intelligence, and spirituality were interrelated, and that the photographer's purpose was to reveal their manifestation in the faces of outstanding individuals. In pursuing this vision, Cameron was in the mainstream of transcendentalist thought of the time, which held that individual will and the love of beauty could make the invisible visible.

Cameron both embodied and opposed conventional ideas about feminine behavior. Born and raised in India, and married to a prominent jurist and wealthy plantation owner, she moved to England at age thirty-three. There she became part of an intellectual and

artistic elite that included John Herschel, the Tennysons, and her mentor in aesthetic matters, the painter George Frederick Watts (plate 47). This circle basked in each other's admiration, with Cameron acknowledging Watts's genius and Watts longing to be able to paint as beautifully as she photographed. Cameron was given to importuning friends and acquaintances to sit for her camera, encumbered at times by heavy costumes, and then urging them to maintain difficult poses while she prepared the wet plates and made the long exposures required by large-plate portraiture.

She was characterized as an eccentric because of her unconventional manner, but more accurately Cameron should be seen as a woman of exceptional energy and intelligence in profound need of challenging experiences—not easily available in Victorian society for those of her gender and class. By the 1860s the belief that a woman's only role was at home with her family had become integral to British middle-class ideology. As a noncontemplative

individual eager for lively social exchange, Cameron eventually was able to find in photography the fulfillment that writing, painting, and science offered to her male associates. No doubt the visual expression of beauty, religiosity, and high ideals also constituted for Cameron an antidote to both provincialism (she lived on the Isle of Wight) and encroaching industrialization.

Cameron's extensive body of work includes portraits and compositions in which figures are posed and costumed to illustrate biblical, mythological, or literary narratives (plate 48). The latter—which may strike contemporary viewers either as mannered and sentimental period pieces or as exciting forerunners of the photographic imagery known in the 1970s as the "directorial mode"[32]—were in the mainstream of then-fashionable Pre-Raphaelitism. Her photographs garnered prizes at expositions and were warmly acclaimed in the art press for having transformed a mundane medium into an art form. The largely male photographic establishment criticized what they perceived as her cavalier attitude toward sharp delineation and appropriate processing techniques. However, even some of these critics realized that she had stimulated them to think about the connection between art and the photographic image. Given the ridicule that greeted Cameron's ardent involvement in photography, it is pleasantly ironic that her portraits are still celebrated as among the most perceptive visual images of the era, whereas paintings by Watts and verse by her idol Tennyson have become somewhat diminished by time. And camera portraits by the most critical of her contemporaries, Henry Peach Robinson, and even by Lewis Carroll (another who found her work too intense for his taste) often seem bland in comparison.

Cameron's accomplishments aside, there is no question that women were less involved than men in artistic photography during the mid-nineteenth century. In both Britain and the United States, photographic societies (the main organizations promoting photography as a recreational expression) were mixed in their acceptance of women. Some were completely open, others limited access to women to certain times and occasions, and still others denied them membership altogether. Excuses for such restrictions revolved around the unladylike atmosphere of the club meetings, where male members smoked and used unacceptable language. Such strictures were eventually set aside when greater numbers of women came knocking at the society's doors.

More women than we yet know of were busy taking portrait likenesses, but before 1890 they were hardly ever to be seen in field or forest, or on battlegrounds where men with cameras (and guns) were testing the new medium as a way to authenticate reality and promote ideological positions. Women might follow soldier-husbands to distant

wars (in the Crimea or on American Civil War battlefields, for example) or join them on wide-ranging expeditions to foreign continents, but until late in the century few (other than Cameron, who moved to Ceylon in 1875) used a camera in such situations. Nevertheless, women's interest in photography from its earliest days is now affirmed, with many more active in portraiture and landscape than was previously acknowledged. In the early years Elizabeth Rigby (later Lady Eastlake), an astute critic and staunch defender of the medium, professed that women had special powers when it came to photography. The ways in which women used these powers to enhance photographic expression and secure for themselves professional standing is the subject of succeeding chapters.

NOT JUST FOR FUN: WOMEN BECOME PROFESSIONALS, 1880–1915

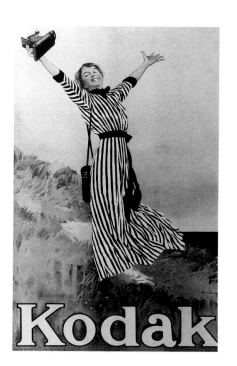

"The woman who does not understand the use of the camera . . . is an exception," a knowledgeable American commentator declared in 1901.[1] In the United States, especially, many more women turned to photography as a congenial professional or recreational activity during the last decade of the nineteenth century. Their increased numbers had to do with changes both in the procedures of photography itself and in the social and cultural sphere.

THE NEW CAMERA AND THE NEW WOMAN

Perhaps the most important technological development occurred in the late 1870s, when the manufacture of dry plates eliminated the need for portable darkrooms; now one could photograph in one's backyard or on a distant mountain peak without having to process the plate immediately thereafter. By the 1890s photographic apparatus, which previously had been so cumbersome that it often had to be toted around in specially designed barrows, had become lighter. And in the late 1880s the substitution of celluloid for glass as a negative base made photographing even easier. Hand cameras that used either plate film or the recently invented roll film did not require tripods, which relieved the bearer of still more weight. Standardization of film and printing papers removed some of the guesswork, so that taking photographs became less a matter of trial and error; the addition of shutters and the development of more carefully crafted lenses also ensured a better result.

The greatest boon to recreational photographers was the introduction in 1888 of the Kodak camera, which relieved the individual button-pusher of the need to determine focus and exposure time and also eliminated responsibility for processing; the film could now be sent off to Eastman (and, later, others) for developing. Stimulating a "fancy for amateur photography" that seemed to one observer to have "sprung up like a mushroom overnight,"[2] the Kodak enabled amateurs to make camera images without fear of failure and without any investment in darkroom equipment. And to ease women's fears about looking eccentric, George Eastman and other companies began to direct camera advertising specifically to female consumers (plate 50). In time, experience with simple mechanisms enabled some women to progress from being "mere snappers with a Kodak to lovers of the

art photographic," becoming accomplished amateurs whose work often was indistinguishable from that of the professional. As one writer put it, "the woman who began with the Kodak . . . is seldom satisfied until she is mistress of larger boxes and expensive lenses."[3]

Oddly enough, the promotion of bicycling as a sport for women helped propel them into photography as well. Both activities were commended as healthful pastimes for men and women in out-of-doors magazines such as *Outing* and photographic journals such as *American Amateur Photographer.* These publications touted the "endless varying incidents and delights" that the cyclist with a camera might encounter, promised a pleasant social life through clubs devoted to the sport, and pointed out the comfort of the new garments being designed for active women.[4]

Neither the bicycle nor the Kodak nor any other advance in technology could have induced large numbers of women to take up photography if developments of greater magnitude had not occurred simultaneously. The medium became acceptable for women because both their actual position in society and their perception of their position had changed. Increased leisure time for middle-class women in the United States in particular brought about a new outlook, perhaps best summed up in suffragist Elizabeth Cady Stanton's most famous address on the lecture circuit. In a talk entitled "Our Girls," this tireless lecturer on women's rights urged young women of the next generation to prepare themselves for independence and self-fulfillment; a woman, she announced again and again, had "duties to herself."[5] More women were beginning to acknowledge that, beyond their domestic obligations, they could indulge in a serious pastime or engage in a professional career. The public view of this "new woman" as one who smoked, drank, and bared her ankles is satirized in a self-portrait by Frances Benjamin Johnston (plate 49). Satire or not, Johnston's own activities and writings make it clear that she did consider herself emancipated for being a professional.[6]

Working-class women had, of course, labored outside the home for much of the nineteenth century; what was considered remarkable was the entrance of middle-class females into commerce. With the gradual increase in labor-saving canned foods and cheap domestic help (in part from the influx of immigrants), and with greater opportunities for education, women of this class discovered that they had other than domestic options open to them.[7] The enormous change in professional opportunities for women in the visual fields is evident in the following figures: in 1870 there were 14 women architects and designers, in 1900, over 1,000; during the same period the number of female artists and teachers of art rose from 418 to 11,031. More generally, fewer than 1,000 women in the United States were employed in office work in 1870; by 1900 the number had risen to over 100,000.[8]

To a generation engaged in debating the proper roles for women, photography seemed to have obvious advantages as a livelihood. Catharine Weed Barnes (later Ward) exemplifies the serious advocate who extolled the medium for its professional possibilities regardless of her own comfortable circumstances. Forced by family obligations to cut short her education at Vassar College, she discovered photography's allure in 1886 and insisted on making her own living by turning what had initially been a hobby into a profession. Her deci-

sion to be self-supporting was first considered a "mild sort of lunacy," but by the turn of the century she was judged by more than one writer to be "the foremost woman in the ranks of photography today."[9] Barnes's private means allowed her to construct a substantial studio and darkroom in which she made exposures, processed prints, and produced lantern slides, many of which were posed genre scenes (plate 51) that illustrated popular writings. In addition, she edited a special department for *Outing* and wrote about photography for *Frank Leslie's Weekly*. From 1886 on, she maintained membership in the major photographic societies, and she was an editor both of the *American Amateur Photographer* and (after her marriage to Britisher Henry Snowden Ward) of the *Photogram* in England.

Barnes promoted photography in numerous articles and speeches, declaring that it "appeals to [one's] artistic sense, embraces an endless variety of scientific interests, . . . cultivates the observing and reasoning powers, [and] . . . is elevating work when fully apprehended and respected."[10] Aware that many middle-class women were unused to the earnest pursuit of activities other than those of wife and mother, she emphasized that photography should not be regarded as a "mere pastime, to be taken up and dropped like a piece of embroidery"; the medium required "mental culture," willingness to learn, and the desire to do genuine work.[11] The extent of her own commitment is suggested by her description of a jaunt through England when she claimed to have carried "an 8 x 10 camera and all its belongings, several lenses, a dozen double plate-holders," acting as her own porter.[12]

Barnes's recommendations were directed to those who adopted the camera as a tool of artistic expression, but her assertion that "every woman, like every man in this country, should have a means of earning a living if obliged to do so" leaves little doubt that she was voicing the sentiments of the era's vigorous feminist movement.[13] At the same time, she maintained that photography was an activity that the "reasonably well-educated, naturally refined, more or less artistic" woman should undertake, which suggests a tacit acceptance of middle-class values rather than a radical sensibility.[14] Some writers found the medium suitable for women because it required "no great labor or other inconvenience."[15] Although this judgment was not universally shared by contemporary women photographers, the suggestion that the beginner would not be subjected to a "tedious course of study" undoubtedly was attractive.[16] Instruction from the numerous manuals then in print, advice from friends, even a short apprenticeship in a professional studio—any of these might suffice to get the neophyte started. In traditional forms of artistic expression, such as painting and sculpture, women had to compete with more thoroughly trained men, whereas in the new medium of photography all would theoretically be on equal terms. According to one optimist, there was "no weight of names to crush the aspirant, no standard of excellence to reach before recognition, for each worker creates his [*sic*] own standard with each new effort; men and women start exactly even."[17]

Addie K. Robinson, a Boston-area matron who became involved in the medium

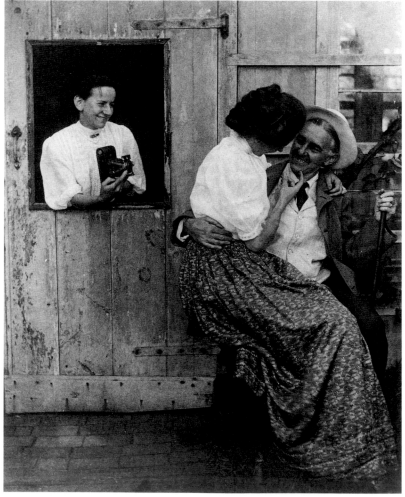

because her father was a photographer, first "observed" in one studio and then found a mentor in another portrait establishment to criticize her work. Beatrice Tonneson, who at age twenty-one was able in the 1890s to purchase (with family money) a flourishing photographic studio in Chicago, first undertook a year's apprenticeship, during which she learned to make exposures, develop, print, and retouch. Another Chicagoan, Sallie Garrity, assisted in a well-known studio there before opening her own successful enterprise in Louisville, Kentucky, where she eventually had sixteen assistants and as many as 150 clients a day.

Perhaps photography's greatest appeal was that it could be adjusted to one's individual temperament and schedule. As explained in *Godey's Magazine* just before the turn of the century, "Women who have little time to spend in acquiring the other arts and must snatch what time they have at odd moments" would find photography attractive.[18] In essence, they were being told that they could combine making camera images with their domestic obligations. As one former art student explained, she could not do "regular work" in painting due to family chores, and so she turned to photography to satisfy "the longing . . . to do something in the art line."[19] Furthermore, by using the camera only at home or in their immediate environment (plate 52), genteel women could avoid confronting the hazards of urban street life.

Another advantage of photography was the relatively small investment required to set up as a professional. In 1890 ten dollars (which represented about two weeks' wages for women factory workers) was deemed sufficient to cover the purchase of a small camera, tripod, lens, plates, and chemicals for a modest start in business, with the same amount put aside to replenish these materials. Building a skylight might cost between forty and seventy-five dollars, though the studio custom-built for Barnes cost about seven thousand dollars plus equipment and supplies.[20] Articles directed toward women often included detailed lists of materials to be acquired and plans for converting attics or other unused spaces into studio and darkroom.

The calls for women's involvement in photography must have fallen on exceptionally fruitful ground or else they reflected changes already transpiring, for between 1880 and 1910 the number of professional women photographers in the United States rose from a mere 271 to some 4,900, constituting over 15 percent of the field.[21] The percentage rose five points over the next ten years, as more than another 2,000 women joined the ranks of professional photographers.

NEW MARKETS, NEW SUBJECTS

Just what jobs were available in a field said to be "unoccupied, open to women who demonstrated good taste, artistic refinement, and fair business ability"?[22] Many involved recording architectural and landscape scenes (plate 56) or staging religious and genre compositions (plate 53) to serve as illustrations. With the increase in the 1890s in all kinds of printed matter—calendars, postcards, advertisements, magazines, and books—the demand for attractive illustrative material also increased. Much illustration was still produced by hand (often by women with artistic training), and photographers turned to the same sources for commissions. In fact,

photographs often lay hidden beneath layers of paint or chalk, as one commentator had noted earlier when she suggested that "easel art" was "under great obligations to photography."[23]

The advent of the illustrated magazine provided another market for photographers. Magazines had been incorporating images since the 1830s, but not until the end of the century did new printing technology make it possible to reproduce photographs with ease and accuracy. The increase in photographic illustration and the greater attention to lively writing enhanced the appeal of magazines, and their sales improved. By 1908 four types of subjects were recommended to women as profitable images to sell to magazines: portraits of prominent people, often taken in their homes; attractive women and children; architectural shots (for postcards as well); and product photographs for advertisements. Dramatic or religious narratives, featuring well-known individuals, made up another category of camera images reproduced in popular magazines.

Schools, both single-sex and coeducational, came into existence to teach the techniques of photography and retouching to those who could afford the tuition and the time away from household duties. In 1890, for instance, women accounted for more than a third of the students at the well-regarded Chautauqua School of Photography in upstate New York.

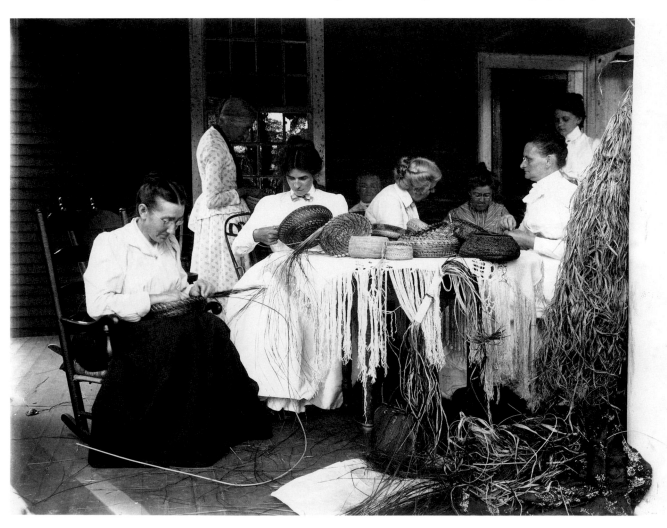

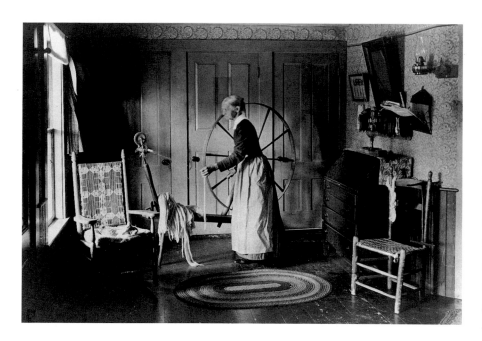

Training in the visual arts was also considered excellent preparation for photography. The high praise accorded the work of women who had been to art school reflected what many felt was a "crying need" for "a knowledge of composition, an appreciative feeling for color and line."[24] Photographers themselves pointed to the importance of artistic knowledge in preventing their work from becoming mechanical, while critics hoped that artistic training would raise the general level of all camera images. Many of the highly regarded women working in the medium had

artistic training, notably Gertrude Käsebier (at Pratt Institute in Brooklyn) and Frances Benjamin Johnston (at the Académie Julian in Paris and the Washington Art Students League). Others attended schools such as the Art Students League of New York, the Pennsylvania Academy of the Fine Arts, and the Mark Hopkins Institute in San Francisco.

Though esteemed, a background in the fine arts was not essential for entry into the photographic profession. Frances S. and Mary E. Allen, working mainly for profit, had little art training when they began to make camera studies (plate 53) in Deerfield, Massachusetts, in 1890. Involved in promoting American arts and crafts, they photographed colonial architecture and artifacts, helping to satisfy the widespread demand for camera depictions of historical sites, houses, and furnishings, which lasted into the 1920s. Their images of child-related subjects—perhaps the consequence of their experience as elementary school teachers—not only accorded well with the national revival of concern for children but also were considered to be a natural interest for women photographers. Little is known about the Allens' initiation into photography or about the equipment they used, other than that they probably owned two cameras of differing format. What can be ascertained is that their prices were high enough to be considered "an incentive for other women to follow in the same line of work."[25]

Country scenes not directly tied to colonial or literary history were marketable as well. Simple rural occupations—invariably depicted as pleasurable—such as feeding chickens, drawing well water, or spinning thread undoubtedly had potent nostalgic appeal for individuals recently relocated from farm to city. As the sociological problems associated with the influx of immigrants into American cities came under greater scrutiny, popular literature and illustrations emphasized the bucolic nature of Anglo-American small-town life.

Among the many whose work filled this need were Chansonetta Emmons and Marie Hartig Kendall. Supported by her brothers following her husband's early death,

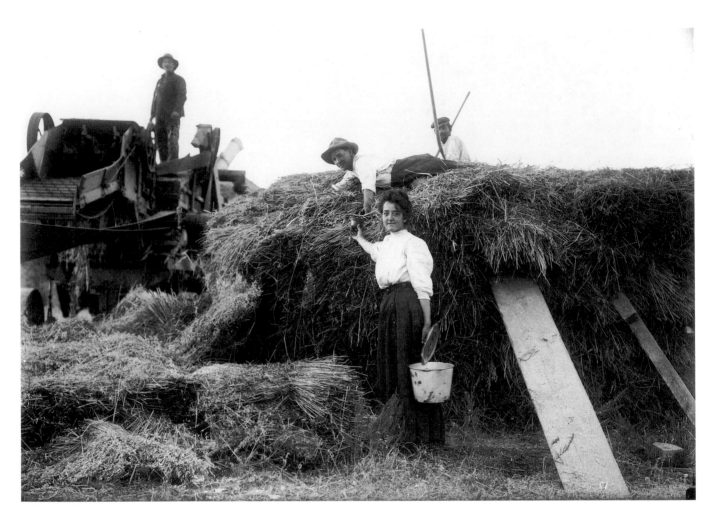

ABOVE

PLATE 55: EVELYN CAMERON
(1868–1928). *MABEL WILLIAMS
BRINGS WATER TO THE THRESHING
CREW*, 1909. GELATIN SILVER
PRINT. MONTANA HISTORICAL
SOCIETY, HELENA; COURTESY
OF DONNA LUCEY.

RIGHT

PLATE 56: MARIE HARTIG KENDALL
(1854–1943). *HAYCOCKS WITH
HAYSTACK MOUNTAIN*, C. 1890.
MODERN GELATIN SILVER PRINT
FROM A GLASS NEGATIVE. MARIE
HARTIG KENDALL COLLECTION
OF THE NORFOLK HISTORICAL
MUSEUM, NORFOLK, CONNECTICUT.

Emmons, originally trained as an artist in Boston, divided her time between Newton, Massachusetts, and her small hometown of Kingfield, Maine, where she augmented her meager allowance by selling photographs of costumed folk engaged in rural occupations (plate 54). Kendall, formerly a nurse (whose request for a watch instead of a wedding band was honored by her husband, a doctor), is typical of any number of small-town women photographers of the era. Besides documenting town events, copying works of art for the gentry, and making portraits, she depicted the pastoral scenery around her hometown of Norfolk, Connecticut (plate 56), selling such views to the New Haven Railroad Company for publicity and in sets as postcards, as well as entering them in photographic competitions. Her activities, which included writing an occasional piece for the photographic press, suggest that she, like many such practitioners, did not consider the demands of commerce and art to be antagonistic. Evelyn Cameron, a British woman whose first trip to the American West, in 1889, was for recreational purposes, settled in Montana and taught herself to photograph in order to augment the family income. Carrying a five-by-seven-inch Kodet camera and glass plates, she sometimes spent days on horseback in order to portray farm activities, people, and animals in a straightforward yet exceptionally lively manner (plate 55).

The taste for romantic evocations of provincial life survived past the first decade of the twentieth century mostly in rural communities, although sophisticated urban dwellers sometimes sought solace in such imagery as well. Nancy Ford Cones, an Ohio farm wife who initially assisted her photographer husband and then took over from him, used members of her immediate family as models, bestowing a bucolic aura on farm tasks, whether performed in the field or farmhouse (plate 57). She was so accomplished in this genre that from about 1902 through 1920 the images taken by her and processed by her husband, James, were used to advertise products for Eastman Kodak and Bausch and Lomb and were featured in magazines such as *Country Life in America* and *Women's Home Companion.*

Another new market was book illustration. With the gradual improvement of halftone reproduction after the turn of the century, literary works, children's stories, and books on travel, regional architecture, and folkways all began to use photographic illustrations, some of which were supplied by women. Gertrude Jekyll, an eminent English garden designer who took up photography in 1885, used her own images in several of her publications. Much of this material was descriptive rather than evocative, but the twenty-nine plates made by Adelaide Hanscom with the help of Blanche Cumming for Edward FitzGerald's *Rubáiyát of Omar Khayyám* are a singular exception. Created by posing friends and associates and then retouching the negatives, these hand-colored studies

PLATE 57: NANCY FORD CONES (1869–1962). *THREADING THE NEEDLE*, C. 1907. BLACK MULTIPLE GUM PRINT. WALT BURTON, CINCINNATI.

of seminude and costumed figures (plate 58) were tipped in to illustrate the elegant letterpress text.[26] Laura Adams Armer, a San Francisco colleague of Hanscom and Cumming, began as a portraitist but eventually turned to book illustration, producing eight books on western landscape and Native American life. Perhaps the most prolific woman in this field was the writer-photographer Mabel Osgood Wright; between 1893 and 1931 she wrote and/or illustrated thirty-two books of stories, mainly about nature and animal life.

The photographing of domestic interiors was promoted as work that would make use of women's special flair and skill. With greater attention being paid to home life in progressive and women's publications, a demand arose for illustrations of "tables laid for dinners, luncheons, breakfast, teas, etc.," of "flowers, shrubs, furniture," of "anything and everything under the sun" to accompany articles on domestic science.[27] Such domestic illustration might yield an annual income of as much as five hundred dollars.

Another source of income for women photographers was the sale of images for advertising purposes. Very little information exists about the number of women involved in this enterprise, how they went about locating the buyers of such pictures, or even whether they specialized in products designed for domestic consumption. It is apparent, however, that greater buying power among women consumers was creating a need for ad images that would appeal to female taste.

The career of Kate Matthews, an amateur photographer living in a small town near Louisville, Kentucky, received its initial boost when she won an advertising contest sponsored by the J. B. Williams Soap Company. Matthews went on to specialize in camera illustration, producing a series of photographs entitled *The Little Colonel.* Various oblique references suggest that a number of other women were more steadily engaged in advertising. In 1901, for example, the demand for advertising images by one Bertha M. Lothrop, a Philadelphian who made this a specialty, was so pressing that their overburdened maker claimed she had little time to join photographic societies or submit work to exhibitions. Then, as now, advertising images were unsigned, so Lothrop's photographs remain unidentified, despite the tantalizing suggestion, made by a prominent photographic writer of the day, that in any magazine one might find "at least a half dozen pictures which her [Lothrop's] fertile brain has thought out."[28] A pamphlet that Lothrop wrote in 1896 had as its subject indoor studies of children, suggesting that she may have photographed products designed for child care.[29] Her work was said to have commanded comparatively high prices, but the actual figures are unknown.

Women in the Midwest, Far West, and Canada responded to the growing public interest in dramatic events. Ida May Hutchinson, married and living in Cornersville, Ohio, exemplifies those who portrayed children and architectural subjects for the blossoming trade in picture postcards. Like Kendall, who marketed images of the blizzard of 1888 to newspapers, she also recognized the public's interest in newsworthy happenings and sold postcards of the first automobile wreck in her county. Canadian Harriet Amelie recorded the wreck of an artillery train at Enterprise, Ontario, in June 1903. Edith Irvine, a young woman employed as a schoolteacher near Sacramento, California, made some eighty glass plates of the San Francisco earth-

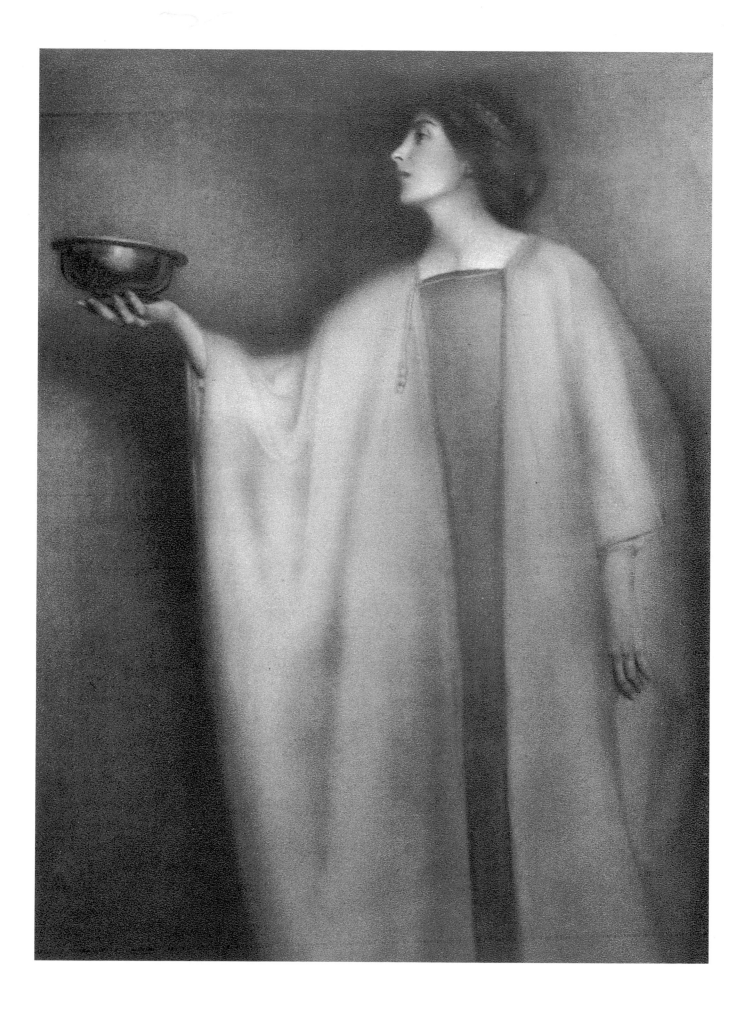

quake, which occurred while she was visiting that city in 1906 (plate 59). Upon her return home she continued teaching and also opened a professional photographic studio. Women's interest in depicting significant issues and events is also evident in an unusual group of images by Edith Hastings Tracy, a maker of fashionable portraits with a salon in New York. Traveling to the Isthmus of Panama in 1913 because it had occurred to her that she was capable of making pictures of "steam shovels as well as of children," Tracy took with her a view camera, a Graflex, and a pocket Premo.[30] She approached the huge canal-building project (plate 60) in the same spirit as the graphic artist Joseph Pennell, whose drawings of it she had found inspiring. What is more, she was conscious of setting out to record a subject that was thought to be the province of men, and she took exceptional delight in being aggressive and forthright in finding the best angles to show this industrial miracle at its most imposing. Tracy's documentation was reproduced in *Collier's* in 1913 and exhibited in New York the following year, where her work was judged a delight to spectators for its "fine disposition of line, of mass and of color."[31]

For a very small number of women—those blessed with "health, strength, and the ability to hustle"—photographing events for the periodical and daily press proved to be lucrative employment.[32] Frances Benjamin Johnston, whose photographic commissions came mainly from individuals and from magazines in need of celebrity portraits, was the first woman to document the workplace, in word and image, for periodicals. She later claimed that her success was due to her complete ignorance about photography, which meant she did not recognize "what could not be done."[33] Her connections in the Washington, D.C., political world must also have been helpful, and through them she gained access to the United

States Mint for photographs on its activities. Those and later pictures—including some shot in a Pennsylvania coal mine, on the Mesabi iron range, and in cigar-box and shoe factories in Massachusetts—appeared as engravings in *Demorest's Family Magazine, Harper's Weekly, Cosmopolitan,* and *Ladies' Home Journal.*

Just before 1900 Johnston completed a major documentation of Hampton Normal and Agricultural Institute (a school opened in 1868 with a mission to prepare African-Americans for vocational jobs), recording classes in mathematics, animal husbandry, and carpentry. Her efforts to make visible the improvement in skills and social demeanor that the education of young black and Native Americans would effect resulted in images that some criticized as stiff and others admired as dignified (plate 61). Johnston was briefly active in the art movement in photography, but her gift lay mainly in documentation. In 1913 she joined forces with recently divorced Mattie Edwards Hewitt to establish a successful business documenting architecture and interior decor in New York for such prestigious architects as Cass Gilbert and McKim, Mead and White. During the 1920s she went her own way and created a monumental record of significant architecture in the South. The recipient of back-to-back grants from the Carnegie Corporation between 1933 and 1940, Johnston produced more than seven thousand negatives of use to architects, historians, and sociologists.[34]

Johnston's approach to documenting social phenomena forecast the style favored by nearly all professional photojournalists, male and female. Her images describe activities and personalities with clarity but with little emotion. Whether depicting factory workers or

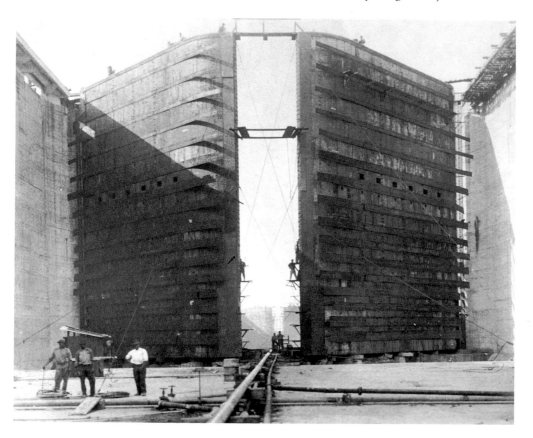

PLATE 60: EDITH HASTINGS TRACY (DATES UNKNOWN). *PANAMA CANAL CONSTRUCTION,* C. 1913. GELATIN SILVER PRINT, MARY MIX FOLEY, WASHINGTON, D.C.

students, she arranged the elements to suggest a sense of intrinsic dignity and maintained enough physical distance from her subjects to obscure any telling facial expression. This appearance of what has come to be termed *objectivity* contrasts with the more ardent style adopted by her contemporary Lewis Hine and, later, by Dorothea Lange, who frequently used closeups of features and gestures as a means to arouse compassion (plate 165).

Johnston's colleague Jessie Tarbox Beals (plate 62) worked as a photographer for the daily press. At that time it was a singular role for a woman, although women had previously been employed in newspaper offices to redraw photographic images in ink for the making of engraved reproductions. Trained as a teacher but finding the profession boring and underpaid, Beals discovered that (with the help of her husband, who did the processing) she could make money by providing photographs of newsworthy events to the local press. She opened a business at the Laurel Park Chautauqua Assembly in Massachusetts and went on to make a decent if occasionally precarious living as a press and portrait photographer in Buffalo and New York City, shedding her spouse along the way. Beals's unconventional attitudes about life, work, and politics drew her to Greenwich Village, where around 1918 she started a tearoom and art gallery. She eventually moved her portrait studio uptown but continued to find Village bohemian life so congenial that she produced a series of postcards of its more colorful denizens as well as full-size portraits of its artists and intellectuals. Eventually, she too specialized in photographing houses and gardens.

In England female professionals other than portraitists were less in evidence. One exception was Christina Broom (known also as Mrs. Albert Broom), whose photographs of some of the royal regiments were sold as postcards. Turning to photography at age forty, in 1903, and continuing until her death in 1939, she made her reputation as a press photographer. Broom and her daughter Winifred, who became her photographic assistant, were ardent supporters of the woman's suffrage movement, depicting its activities and meetings (plate 63). Nora Smyth, another advocate of women's causes, produced images of London East Enders that appeared in the feminist magazine *Dreadnought*.

As materials and processes continued to improve, exhortations appeared in the photographic press about opportunities for illustrating publications on botany, biology, and medical sciences, but few women who answered this call left an imprint. Elizabeth Fleischmann-Ascheim was an exception—not only in her choice of career but also in using a hyphenated name after marriage. In 1895, having learned about Röntgen's discovery of the X

ray, she mastered the technique of radiography and within a year set up an independent laboratory in San Francisco. Becoming California's earliest radiologist, she eventually was one of the most prominent radiographers in the United States; she died in 1905 from the then unsuspected effects of radiation poisoning.[35]

Exactly how much was paid for various kinds of photographs and what constituted a decent livelihood for a female commercial photographer is difficult to ascertain. During the first decade of this century, images ranging from soap and canned goods to gardens were said to fetch between one and ten dollars for a large print, while portraits of celebrities for use in magazines might garner between fifty and one hundred dollars.[36] For their "illustrations," the Allen sisters charged $2.75 for an eleven-by-fourteen-inch print, $2.50 for a nine-by-twelve-inch print, and 50¢ for a five-by-seven-inch print—all on platinum paper, unmounted.[37]

More than one writer referred to photographic illustration as congenial and well-paying employment, but more often the monetary returns for this kind of work were minimal. *The Woman's Book* of 1894 (a compendium that discussed all manner of artistic, domestic, and professional activities) noted that "photography offers an inviting field for women who are content with a small income."[38] It is not known whether the many women turning out postcard and book illustrations during the first decade of the 1900s were able to earn anything like the five-hundred-dollar annual income said to be common for men in the profession.

CRITICS AND CRITICISM

During the medium's early years, most commentators on photography had been men. One exception was Lady Elizabeth Rigby Eastlake (wife of Sir Charles Eastlake, director of the Royal Academy and the Photographic Society in London), who in 1857 published in *Quarterly Review* what is perhaps the period's most provocative article about the medium. In two parts, the article outlined photography's history, discussed the literature about it, and attempted to place it within the visual arts. Despite her own preference for aesthetically conceived works, Lady Eastlake concluded that photographs, having a different clientele and purpose, were not to be judged by the same standards as the older arts. In the United States, Anna L. Snelling published poems and translations of European articles in photographic magazines. As women became more prominent as photographers, more articles and features directed to them and written by them appeared in the specialized press. Charlotte Adams undertook a long dissertation on the aesthetics of photographic style in 1886, asserting that Americans formed a "distinct school, . . . grounded in realism and . . . love for hard positive

facts." Some years before Alfred Stieglitz started his campaign to elevate camera images to art, she held that "Americans . . . have a right to demand for photography equality of recognition with other kinds of work which are now classed under the generic head of 'art.'"[39] Between 1889 and 1908 Catharine Barnes Ward was an exceptionally active writer, contributing some sixty articles on a range of subjects to photography magazines in the United States and England.[40] Though not nearly that prolific, Helen L. Davie, an amateur member of the Los Angeles Camera Club around the turn of the century, sought through her articles and lectures to inspire women on the West Coast to take up photography. During the same period Mrs. H. E. Newcomb was in charge of the publication *Photo-American.*

Professional photographers such as Frances Benjamin Johnston and Gertrude Käsebier wrote occasional articles; in fact, in 1901–2 Johnston published a series about women photographers in *Ladies' Home Journal,* in which she maintained that women were as adept as men in the medium. Johnston was particularly active in encouraging women photographers. She collected the work of twenty-eight women for an exhibition in Paris connected with the International Photographic Congress, which was scheduled for the same time as the Exposition Universelle of 1900 (at which her own documentations of the Hampton Institute and Washington public schools were to be shown). For this activity, the French government made her an *officier d'Académie,* a distinction awarded to only one other American woman of the period. The 142 prints in the show included work by well-known professional portraitists such as Käsebier and Zaida Ben-Yusuf as well as by barely known amateurs, among them Mary F. C. Paschall and Anne K. Pillsbury. As a result of the enthusiasm of the Russian delegate to the congress, the photographs traveled to Saint Petersburg and Moscow; they were then shown again in Paris but never found a sponsor in the United States.[41]

Other female practitioners—notably Rose Clark, Adelaide Skeel, and Elizabeth Flint Wade—became columnists offering advice on a regular basis to amateur photographers of both genders. Octave Thanet (the pen name of Alice French, author of numerous self-help and inspirational books) turned her experiences as an amateur photographer into a breezy volume that sought to reduce the medium's pretentiousness and "reveal the moral possibilities of photography as Educator."[42]

From the late 1880s until about 1914, photography presented a variety of opportunities for women. Teaching—the quintessential female occupation—had openings only for women instructors of retouching, but between 1910 and 1920 the number of professional women photographers increased more than 40 percent.[43] In 1895 the successful celebrity portraitist Napoleon Sarony noted that if women "only once start out and become photographers, there is no doubt they will succeed," because "the medium by its very nature" seems to invite them in.[44] Twenty years earlier, a newspaper illustration showing the most prominent photographers in the United States and Canada had included only men (among them Sarony).[45] By the time of his remarks, such single-sex representation would have been ludicrous. Having gained access to the field, women would continue to make their mark on it—commonly with less remuneration than men but certainly with as much talent and industry.

CHAPTER 3

PORTRAITURE, 1890–1915

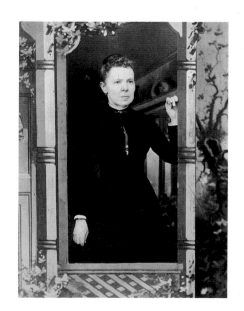

Portraiture, which was said to require "the eyes of Argus, and the patience of Job,"[1] attracted many women in the decade before the turn of the century, as one of the more easily managed yet most highly paid occupations. Its appeal to women reflected changing demographics; toward the end of the nineteenth century the wives and children of middle-class families emerged as the largest constituency for professional camera portraits and remained so throughout the first decade of the new century. No phase of the photographer's business, it was held, was "more profitable than . . . pictures . . . of mothers and children together."[2] Nearly all large studios in New York were said to employ women (although not necessarily to operate the camera), and the portrait business in smaller towns was at times entirely in their hands.

After many established studios run by men went out of business in the economic downturn of the early 1890s, the market for portraits of the affluent upper-class women and children who could still afford them became an acute concern for photographers.[3] One solution was home portraiture; beginning in the late 1890s and lasting through the first decade of the twentieth century, taking portraits in the home of the client instead of the studio became an acceptable role for women photographers, who may have been more welcome in private residences than their male counterparts. By 1910 the once-novel idea of home portraiture was being promoted by articles in the popular press as an activity for amateurs as well as professionals.

Cultural considerations joined these practical ones to encourage the expansion of opportunities for women in portrait photography. As middle-class patronage developed, a taste for refined and artistic representation emerged. For more than a quarter century, studios had been contentedly using the same painted backdrops, damask swags, and papier-mâché props with democratic impartiality, whether the sitters were bankers, burghers, or brides. Little attention was paid to evoking individual character through pose and lighting, and even less to aesthetic niceties (plate 65). Earlier sitters may have been content with uninspired records of their features and clothing, but by the late 1880s clients—especially those in major urban centers—were seeking something more. In fact, by the end of the 1890s the status of the cabinet photograph had declined to the point that it was considered suitable only in "tenement houses and in the country."[4]

By contrast, individualized portraits in which attention was paid to creating an artistic effect were seen as desirable status symbols, suggestive of the higher social standing and more elevated taste of the sitter. This new approach

became especially attractive to established studios as a way to counteract the depression of 1890–95. Clients with money and taste were offered sophisticated lighting effects, poses suggestive of higher status, and individually designed mounts with subtly toned borders and monograms that also proclaimed the purchaser's lofty economic standing. Frances Benjamin Johnston's observation that "the professional everywhere is *reaching out* for something new, something different" suggests that the need for new styles in portraiture was pervasive.[5]

Such changes were stimulated not only by the economic doldrums but also by a general sense among many that American products were ugly where they might be beautiful. With regard to portraiture, a prominent art teacher urged those in the visual arts to "see the difference between nature and art," inspiring professional photographers to explore how they might make their work aesthetically more pleasing while still satisfying the requirements of likeness.[6] Such efforts can be compared with attempts to improve the look and the function of utilitarian objects generally, attempts that were carried on under the banner of the Arts and Crafts movement during the same years that the artistic movement in photography known as Pictorialism was ascendant.[7] Adherents of both movements believed that functional objects, whether pots or photographs, should be pleasurable to look at and should, in addition, uplift the spirit and improve one's taste. Several of the women associated with Pictorialism also participated in Arts and Crafts activities—among them, Willamina Parrish, a Saint Louis portraitist who edited the *Potter's Wheel*, and the Allen sisters, who were members of the Deerfield

Society of Arts and Crafts. Both groups also found inspiration in the arts of the Far East, seeing in the spatial organization and the treatment of color values in Japanese prints a way to achieve visual harmony in their own work.

"WOMAN'S INTUITION"

Within this conjunction of art, craft, and enterprise, women were, according to Juan C. Abel, "peculiarly adapted as portrait takers" because they avoided the mechanical approach said to be characteristic of male camera operators.[8] One woman writing to Johnston maintained that portrait images made by "men with a woeful lack of ability and artistic sense" captured expressions of the "rather-go-to-the-dentist class."[9] By contrast, Sarah E. Slater commented a few years later that "women's work in portraiture is the apotheosis of photography, a revelation of its artistic possibilities, hitherto unguessed by the commercial and bucolic operators of the camera."[10] Women were supposed to have an "intuitive" knack of furnishing studios with taste, of arranging hair and garments to good effect, of putting sitters at their ease. This was especially true for the increasing numbers of female clients, as one well-

regarded portraitist recognized when she wrote, "Women naturally feel more at ease in the presence of a delicately refined woman."[11] For those desiring wedding pictures that suggested something of both the promise and the uneasiness of the occasion, a female sensibility, exemplified by Sarah J. Eddy's *The Bride* (plate 66), was preferred.

Women were supposed to have an intrinsic artistry that enabled them to convey each individual's character and to understand the virtue of indefiniteness, which brought the camera image closer to hand-made art. The labeling of these qualities, along with the aptitude for graceful and imaginative presentation, as specifically female led to the certainty expressed by a number of turn-of-the-century writers that "good taste is much more common with women than men."[12]

From just before 1900 up through about 1915 the qualities that were said to make women peculiarly fitted for photography received unusually broad publicity in articles by both male and female writers. Throughout society women were being asked to tame the rude nature of industrialized life then emerging in the United States. To cite an example from a quite different profession: during the second half of the nineteenth century the nation's medical schools were urged to open their doors to women because, as the "moral housekeepers" of society, they would uplift and humanize the occupation of doctoring. The summons to women to soften discordant aspects of existence is cogently, if artlessly, summed up by a writer for a small California newspaper, who in 1907 claimed that "the uncouth hand of man scars and gnashes the beautiful face of nature ofttimes, but the smooth and gentle hand of woman can touch the wounds and heal them."[13] Even though women in England and on the Continent were not nearly as active in portraiture as their American counterparts, similar ideas about their abilities found expression there; as one British writer put it, they show more taste and "successfully hold their own against men" because they "bring sympathy and intuition," as well as "harmonious and carefully designed backgrounds."[14]

ARTISTIC PORTRAITS

Zaida Ben-Yusuf, an English woman who settled in the United States in 1896, was one of the first of her gender to take full advantage of the possibilities for artistic expression in professional portraiture. Like many of her colleagues, she became interested in photography through making snapshots with a borrowed hand camera. Encouraged by the English Pictorialist photographer George Davison to improve her technique while retaining her "originality," Ben-Yusuf eventually opened a portrait studio on lower Fifth Avenue in New York. She specialized in celebrity portraiture for publications such as the *Century* as well as portraits of individuals from the "better class of people," who were, she realized, "quite ready for a higher and broader quality of portrait than most professionals would admit."[15]

Ben-Yusuf recognized that effects inspired by contemporary painting would distinguish her work. At the time her approach was considered to be simple and effective without being overly artful, but there seems little doubt that the American salon painter John White Alexander (who was also her client) exerted a strong influence on her vision. For

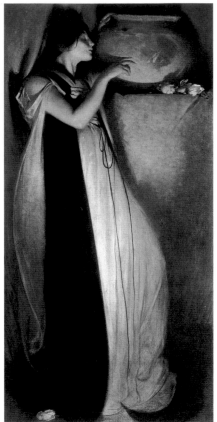

instance, her *Odor of Pomegranates* (plate 67) bears a telling resemblance to Alexander's well-known contemporaneous painting, *Isabella and the Pot of Basil* (plate 68). Like her more famous contemporary Gertrude Käsebier, and indeed like many others involved in art photography during the late nineteenth century, Ben-Yusuf had a keen eye for styles in painting that could be emulated to satisfy socially ambitious customers.

Käsebier, called the "dean of the 'new' photography" in 1915, is without question the most renowned of American women portraitists.[16] Society people, artists, Native Americans, and others all sat for portraits in her New York studio (plate 69) or in their own homes. She proposed to "make likenesses that are biographies, to put into each photograph . . . temperament, soul, humanity."[17] She disclaimed any desire for commercial success, though she eventually displayed a few examples of her work in a discreet showcase in front of her Fifth Avenue studio. Nonetheless, her prices were possibly the highest then charged by anyone, reflecting her awareness that the very rich would appreciate the considerable time she required to make a portrait—studying the sitter, suggesting the proper costume, posing the sitter, and adjusting the lighting to achieve special effects. For inspiration, she drew upon her knowledge of historical painting styles gained during her studies at Pratt Institute. In fact, she demonstrated such extraordinary skill in mimicking the compositional strategies and lighting effects of well-known old masters that she attracted both praise for her love of the picturesque and criticism for inordinate "feeding on the past" (plate 70).[18] That she was also sensitive to

OPPOSITE, LEFT

PLATE 67: ZAIDA BEN-YUSUF
(ACTIVE C. 1896–1915). *THE
ODOR OF POMEGRANATES*, C.
1899. PLATINUM PRINT. LIBRARY
OF CONGRESS, WASHINGTON, D.C.

OPPOSITE, RIGHT

PLATE 68: JOHN WHITE ALEXANDER
(1856–1915). *ISABELLA AND
THE POT OF BASIL*, 1897. OIL ON
CANVAS, 75 1/2 X 35 3/4 IN.
(192 X 91 CM). MUSEUM OF FINE
ARTS, BOSTON; GIFT OF ERNEST
WADSWORTH LONGFELLOW.

RIGHT

PLATE 69: A. K. BOURSAULT.
UNDER THE SKYLIGHT (GERTRUDE
KÄSEBIER PHOTOGRAPHING
HARRIET HIBBARD, HER STUDIO
ASSISTANT FROM C. 1901–7),
C. 1903. PROOF FOR REPRODUC-
TION IN *THE PHOTOGRAPHER*,
MAY 7, 1904. PHOTOMECHANICAL
REPRODUCTION, 4 3/8 X 5 1/2 IN.
(10 X 14 CM). THE MUSEUM OF
MODERN ART, NEW YORK; GIFT
OF MISS MINA TURNER.

contemporary artistic developments can be gauged by her adept use of elements from Japanese woodblocks and her handling of the decorative style then in vogue in graphic illustration. Her conviction that artistic handling would appeal to her wealthy clients led her to choose individual mounts that harmonized with the tonality of each image, rather than using ready-made mats. Besides individual commissions, Käsebier provided portrait and other illustrations to popular journals such as *McClure's* and *World's Work,* altering her style when necessary. For instance, the strong contrasts and simple settings seen in her dramatic portraits of the realist painters associated with New York's Ash Can School (plate 64), made in 1910 for the *Craftsman,* are quite unlike her earlier gauzy evocations of familial bliss.

Similar attitudes about artistic portraiture informed the highly regarded work by Alice Austin of Boston and by Eva Watson (later Eva Watson-Schütze) and Mathilde Weil, both of Philadelphia and both known as highly paid artist-photographers. Watson-Schütze's purposefulness is indicated by her treatment of the monogram with which she signed her photographs. The monogram was then considered the preeminent sign of individuality in a work of camera art, and her own went through six changes over a twenty-year period as she struggled to find the best version. Her portraits of friends and associates in Philadelphia and later Chicago (plate 72), where she moved in 1901 after her marriage, are marked by delicacy and special attention to placement and silhouette. Weil's portrait work (plate 71) was included with that of Käsebier, Emily V. Clarkson, and Emma J. Farnsworth in an 1899

Portfolio of Pictorial Portraits, which featured images by the most prominent art photographers of the era—F. Holland Day, Alfred Stieglitz, and Clarence White. Many more women worked on a less exalted level: for example, until about 1915 Louise Halsey, a former student of Clarence White with a studio in New Brunswick, New Jersey, made a modest living by making good home portraits in platinum.

Efforts to upgrade portraiture were not confined to the East Coast. Among the many California women involved in this quest was Carolyn Even Gledhill (associated at first with her sister Emma M. Even), who produced portraits in an artistic style similar to the eastern product, emphasizing grace and naturalness while subduing fussy detail (plate 4). Following her marriage, Gledhill continued to exercise artistic control over the sittings, while her husband attended to the processing, often using the gum-bichromate process. The San Francisco portraitists Blanche Cumming, Adelaide Hanscom, and Emily H. Pitchford adapted their training in the fine arts to portraits of each other (plate 73) and of prominent members of Bay Area families, conceived in the advanced artistic style.

Women working in smaller cities also adopted the style, although not to the same extent as their coastal counterparts. Jane Reece, a native of Ohio, is an example; after spending part of 1909 soaking up New York's cultural climate, she returned to open a studio in her hometown of Dayton. Like other portraitists of the time, Reece was a scavenger of styles, finding ideas both for portraiture and for salon work in Naturalist, Symbolist (plate 74), and on occasion, Cubist art.

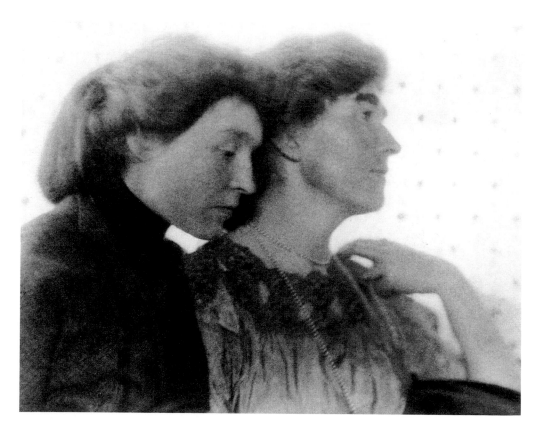

PLATE 72: EVA WATSON-SCHÜTZE (1867–1935). *PORTRAIT OF HANNI STECKNER JAHRMARKT AND LIESE STECKNER WEBEL*, C. 1909. PLATINUM PRINT. DEPARTMENT OF SPECIAL COLLECTIONS, UNIVERSITY OF CHICAGO LIBRARY.

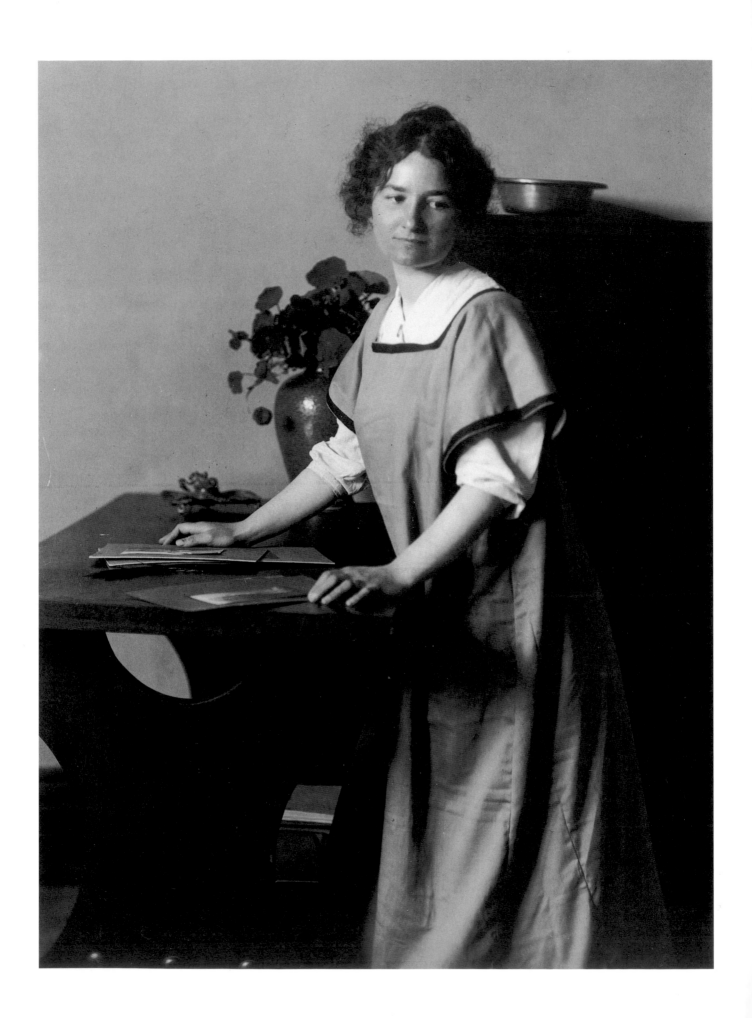

The high degree of sophistication demonstrated by these women seemed to justify the perception that they were more intuitive than men regarding composition, lighting, and the creation of emotional effect. In fact, however, their supposedly inborn artistic natures had been shaped by education. In the last quarter of the century, training in the arts—previously considered an essential part of the upbringing of cultured young women from well-to-do families—yielded more serious vocational results. According to an 1897 article, "thousands and thousands of girl art students and women artists," who had begun to look upon art as a profession rather than a pastime, were preparing themselves for careers in the decorative arts; by 1903 ten times as many women as in 1893 were active in design and advertising.[19] The lessons learned—the sense of design, the sensitivity to tonal values—were as applicable to making camera portraits as to producing graphic designs for textiles and wall-papers. Indeed, one young amateur, writing in the West Coast journal *Camera Craft*, bewailed the fact that since she had been unable to attend art school, her eye had not been trained to "see form, line, perspective, light and shade."[20] She claimed to have spent more on wasted materials than she would have laid out for an art course.

Johnston, Käsebier, Weil, Catharine Barnes Ward, and others credited their education in art as the most important factor in their ability to determine pose, lighting, and expression. Their familiarity with the masterworks of the past, from Hans Holbein through the Italian Renaissance, from the Dutch "Little Masters" to James McNeill Whistler and John Singer Sargent, proved to be exceptionally valuable in dealing with parvenu clients eager for the cachet of being portrayed in the grand manner.

Not all portraitists were taken with softness and suggestiveness or with the flattening of forms that characterized the so-called new photography, which was concerned less with sharpness and more with achieving painterly effects.[21] There were many accomplished portraitists who paid close attention to lighting and pose yet remained committed to greater definition of forms; their work has generally been overlooked by those tracing the evolution of artistic photography. One example is Frances Benjamin Johnston; her current reputation as a documentary photographer has obscured her fame in the 1890s as a portraitist (plate 75). Having access to centers of power in Washington, including the White House, Johnston turned out pleasantly composed and at times interesting portraits in the straight manner, for both private clients and magazines. These elicited admiration from contemporaries who considered her "posing, lighting, absence of accessories" to "show taste amounting to near genius," although followers of the new aesthetic direction in camera art were not as enthusiastic.[22]

Another straightforward portraitist was Mary Carnell. After nine years spent working her way up through the ranks in various portrait enterprises, she opened her own studio in Philadelphia and became the organizer of the Women's Federation of the main national trade group, the Photographers' Association of America (PAA). Her preference was for straight images in which neither facial

expression nor gesture was obscured by veils or a suggestion of mists. Nevertheless, as far as it is possible to tell from reproductions, her portraits seem to have had a lively spontaneity that lifted them above the ordinary product.

CHILDREN'S PORTRAITURE

"This is the age of the child," wrote Sadakichi Hartmann, and nearly all turn-of-the-century writers agreed that portraying children, either alone or with a parent (inevitably the mother), was an especially appropriate assignment for women.[23] In part, this subject matter was promoted for those tied to their homes, who could best work with the subjects closest at hand, but other factors were also significant. During the Progressive Era of reform politics—that is, roughly between 1890 and 1912—the mental and physical health of the young in all classes of the population was regarded as a precious national resource; education and child development were active topics on the agenda of those promoting a more rational social order. Women's skill in portraying the significance of nurturing in the formation of the "civilized" adult became highly valued. The era seemed consecrated to images of "tender mothers and healthy, clean, and beautiful" children, from the thousands of baby pictures turned out by small-town studios to the genre images of children by the Allen sisters in Deerfield or by

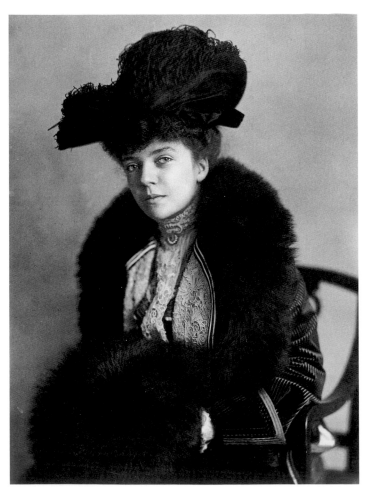

Mary Bartlett (Mrs. N. Gray Bartlett) in the Midwest to the expensive made-in-the-home portraits by Austin, Käsebier, and Weil.[24]

Considered more attuned than men to family relationships in general and to offspring in particular, women were expected to excel at portraits that embodied middle-class values about motherhood, family, and woman's role in the proper upbringing of children. Praise for Käsebier's images of mothers and children—a genre in which she specialized—was especially fulsome. In discussing *The Manger* (plate 76), a work highly acclaimed at the 1899 Philadelphia Salon, Joseph T. Keiley held that the depiction of familial love was impossible for a man, "howsoever gifted," because only "a woman whose whole being vibrated with the joy of a mother's love" could vitalize this sentiment.[25] The image that elicited this panegyric—a veiled woman dressed in white seated in a whitewashed stable supposedly holding an infant (no actual child was present)—suggests the influence of the religious themes then occupying Käsebier's newfound friend, F. Holland Day, as well as the photographer's own deep feelings about motherhood.

The consensus that male portraitists were

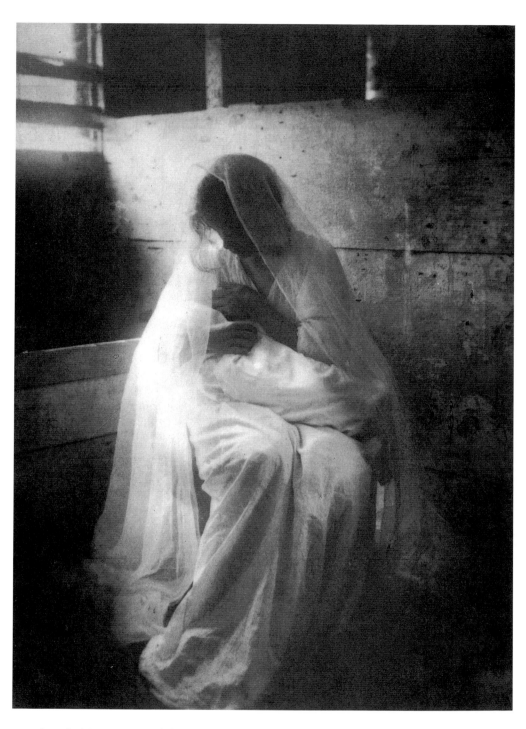

PLATE 76: GERTRUDE KÄSEBIER
(1852–1934). *THE MANGER*, 1899.
PLATINUM PRINT. J. PAUL GETTY
MUSEUM, MALIBU, CALIFORNIA.

somehow lacking in parental feeling, combined with the knowledge that men were usually not welcome in private residences where much portraiture was now being made, enabled women photographers to supply the market for this specialty. All six of Adelaide Hanscom's entries in a 1906 show of photographs by women were studies of children, and a special portfolio of her work on this subject was published in *Camera Craft*.[26] Grace Cook, who began to make camera studies of children to aid her in painting, found that she could earn a living from photographing children in their own environments. Her work was praised by several writers for its

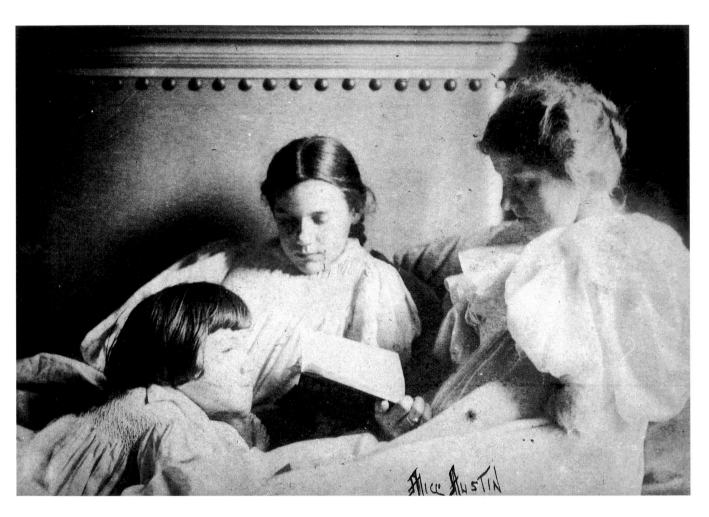

unusual naturalness, although now it seems almost indistinguishable from the bulk of such works being produced at the time by both men and women.

The now-forgotten Floride Green, who began as a landscape photographer, controlled the quality of light in her portraits of children by visiting their homes beforehand to select the best time of day to take the picture. One suspects that Austin and Weil may have done the same, for both were extravagantly acclaimed for the sensitivity to lighting and composition with which they portrayed youngsters in upper-class settings. Austin's studies of children, with or without their mothers, pictured the social relationships approved by forward-looking parents, for whom playing or reading together served as a genteel, uplifting, and easily depicted activity (plate 77).

Although not strictly portraiture, the images of children by Mary Bartlett and by the Allen sisters also reflected the era's values and priorities for the education of the young. Bartlett posed youngsters out of doors, printed the images on platinum, and gathered them into booklets with text; they were praised for their idealized vision of childhood. Work by the Allens, also printed on platinum, depicted little girls engaged in appropriately domestic activities and little boys shown in a wider variety of active out-of-doors pursuits.

REGIONAL PORTRAITURE

Women working in the South and Midwest tended to be somewhat more conservative in their strategies for combining artistic handling with the kind of definition that most of their sitters expected from a photograph. While Bayard Wootten, owner of a portrait business in first New Bern and then Chapel Hill, North Carolina, turned out much run-of-the-mill work, especially at the nearby army base, she also could produce more elegant and revealing portraits. Alta Belle Sniff, who opened a portrait studio in Missouri in 1899 after studying the chemistry of photography, wrote that although she worked for "pleasing likeness," she felt it "better to sacrifice some technical point in order to catch some of the real charac-ter."[27] Anxiety about keeping women in their traditional place is evident in a newspaper notice assuring readers that the well-regarded local portraitist Belle Johnson, of Monroe City, Missouri, "did not neglect duties at home" while improving her skills at photography

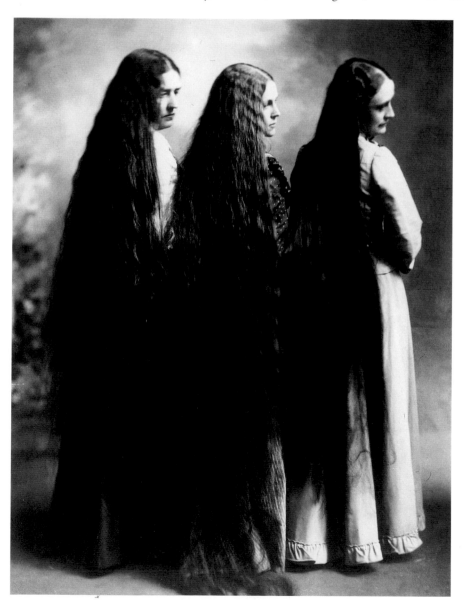

school in Saint Louis.[28] An image of three young women seen from the back (plate 78) indicates either that this photographer could rise above the conventional poses demanded by small-town clients or that her sitters were not as orthodox as one might suppose. Much of the work by the midwestern women professionals is no longer visible—sometimes discarded as insignificant, sometimes lost through accident, as when the three hundred portraits of Native Americans taken in 1904 by the Gerhard sisters of Saint Louis were consumed in a studio fire.

Around 1900, as the Pictorialist movement in photography began to fragment (see chapter 4), the group around Stieglitz and the journal *Camera Notes* voiced the feeling that work by many women was characterized by too much refinement. A strong believer in the idea that women's physical and psychological make-up induced them to create differently than men, Stieglitz nevertheless criticized images by Rose Clark, Virginia Prall, and Elizabeth Flint Wade for lacking indi-

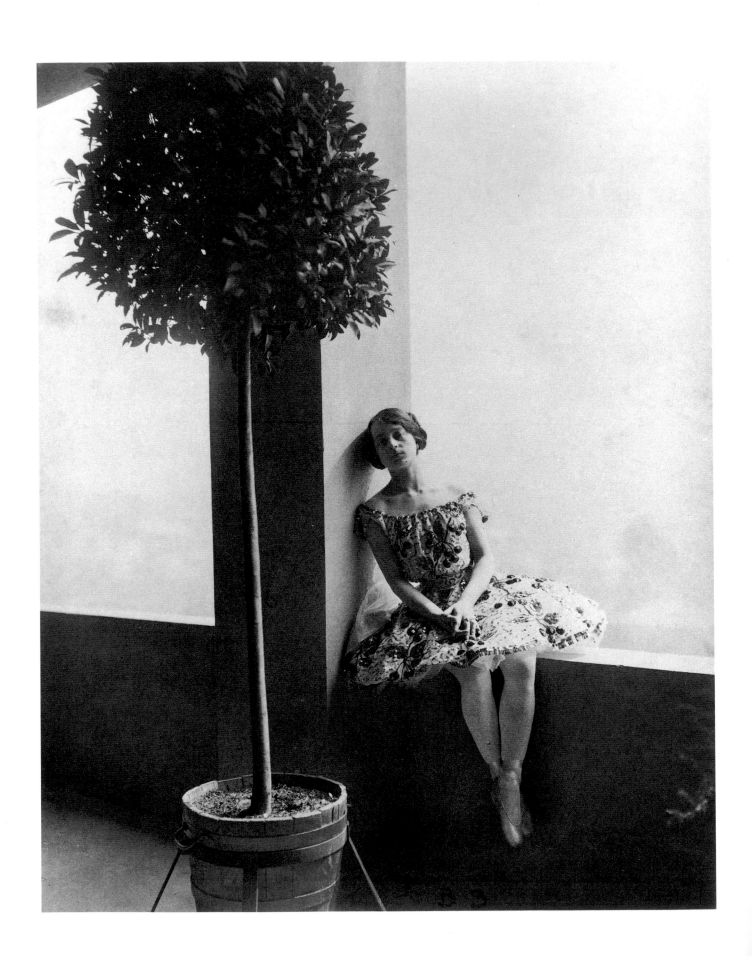

viduality and originality, implying that they suffered from an overdose of gentility. Somewhat later Sadakichi Hartmann echoed this idea in referring to work by the novice portraitist Elizabeth Buehrmann, although her portrait of Julie Hudak (plate 79) suggests otherwise. He believed that relatively few portraitists of either gender had come up with work that embodied vital ideas, but that women were generally less original than men.[29]

THE WOMEN'S FEDERATION

Around 1900 the differences between the old and new portraiture styles were apparent enough to elicit heated polemics, but ten years later such distinctions had diminished to the point that Käsebier, the leading proponent of the new, was invited by the Women's Federation of the conservative Photographers' Association of America (originally organized in 1880 and limited to men only) to hold weekly sessions of constructive criticism for women portraitists. This development reflected both the gradual adoption of new ideas by the more conservative sectors of the profession and the turning away from extremely aesthetic treatment by formerly avant-garde portraitists.

The Women's Federation was organized in 1910 by Mary Carnell, who recognized that greater numbers of women were entering the domain of portraiture; by 1913 thousands had become members. At its first meeting, women were asked to send three prints to show to other members, and throughout its existence (1910–19), the federation played an important role in education and promotion, continuing to purchase individual works in order to demonstrate women's progress in annual exhibitions. It also organized lectures, demonstrations, and exhibitions, which were presented in studios operated by women throughout the nation. Pearl Grace Loehr and the Selby sisters in New York, the Gerhard sisters in Saint Louis, Belle Johnson in Monroe City, Clara Louise Hagins in Chicago, and Bayard Wootten in North Carolina—all now forgotten—were officers or highly regarded active members promoting women's contributions. As the number of women in the federation increased, they began in the late 1910s to make demands for inclusion as equals in the PAA. The spirited discussion that ensued about whether women would be better off in their own group or integrated into the larger entity reflected a debate in feminist thought in general. In 1919 the Women's Federation opted for integration.

MINORITY PORTRAITURE

One branch of photographic portraiture specialized in the depiction of ethnic minorities, which took place either in connection with the expeditions sent to map western lands or as a commercial business set up at frontier outposts. European photographers usually made such images of their colonial subjects—whether in Africa, India, or Australia. Only a few women, all in the States, are known to have been involved in these activities. In 1889 Jane Gay Dodge served as a photographer on a Department of the Interior expedition to apportion lands among the Winnebago and the Nez Perce in Nebraska and the Idaho Territory. The painter Kate Cory journeyed to the Arizona Territory in 1905 equipped with both palette and camera, and she

ABOVE, LEFT
PLATE 80: KATE CORY
(1861–1958). *A YOUNG HOPI
GIRL*, 1905–12. MODERN GELATIN
SILVER PRINT FROM GLASS NEGA-
TIVE. MUSEUM OF NORTHERN
ARIZONA, FLAGSTAFF; KATE CORY
COLLECTION.

ABOVE, RIGHT
PLATE 81: EMMA B. FREEMAN
(1880–1927). *ALLEGIANCE VIVIAN
CHASE, HUPA*, 1914–15. GELATIN
SILVER PRINT. PETER E. PALMQUIST,
ARCATA, CALIFORNIA.

remained until 1912 to depict the Hopi in paintings and photographs (plate 80). Between 1913 and 1920 Emma B. Freeman, the owner (initially with her husband) of an art and photography business in Northern California, was attracted by the mystical qualities of American Indian culture. Romantically lighted and often hand-colored, her portrayals of these sitters are highly idealized and somewhat artificial (plate 81). In contrast, Ruth K. Roberts's images of the Yuroks of the same region were of such documentary naturalism that they provided anthropologists with a unique resource.

A combination of idealism and naturalness informs the portraits of Native Americans made by Käsebier between 1898 and 1912. Her sympathetic response to this vanishing aspect of American life is visible in the portraits she made of the Sioux during their visits to New York as members of Buffalo Bill's troupe. A sense of empathy is especially vivid in her studies of the young Sioux teacher and musician Zitkala-Sa (plate 82), a celebrated personality who objected strongly to the substitution of Western middle-class ideas for traditional Indian beliefs and behavior.

The large Asian population on the West Coast provided portraitists there with similarly "exotic" material. Around 1900 one San Francisco photographer, Hortense Schulze, specialized in portraying Chinese children, and her work was promoted as a souvenir of California.[30] Schulze's work also appeared in calendars featuring Chinese children; the examples reproduced in *Cosmopolitan* to illustrate the article "The Babies of Chinatown" suggest

that despite her taste for sentimental genre she handled the subject matter in a straightforward way. That her portraits were picturesque rather than empathetic undoubtedly reflected the prevailing uneasiness about the wave of new immigrants from Asia.

PORTRAITURE IN EUROPE

Prior to the 1920s, despite struggles to achieve suffrage and parity in occupations, women in England did not loom large in photography, either as serious hobbyists or as professionals. As one exception, the London portraitist Madame Yevonde, explained to the Congress of the Professional Photographers' Association in London, women's rarity in the photographic field in Europe was due to a lack of "opportunity for self-expression and development."[31] An ardent supporter of the feminist cause in Great Britain who had apprenticed with the noted woman portraitist Lallie Charles before opening her own studio in 1914, Yevonde acknowledged that the lives of most middle-class women in Europe during the *belle époque* were strictly circumscribed by rigid expectations of both gender and class. She excluded England from her list of countries where women's opportunities were limited, but Catharine Barnes Ward, married and living there after 1893, suggested that there were significant differences between the photographic opportunities for women in England and the United States. American women were vastly better off, she wrote, because many British photographic societies did not welcome women and because there were few communal facilities and little professional or psychological support for British women. One passport to success was a novel setting. Unlike most commercial establishments, the studio run by Garstin and Antrobus, two women trained at the Polytechnic School of Photography in London, was situated in a private house in a residential neighborhood "sacred to doctors and professional men."[32] Its accessibility and homey atmosphere gave this venture a special and, to some observers, a praiseworthy aura.

By the 1910s the small British market for portrait photography had begun to grow, and that expansion continued after World War I. In 1921, when Yevonde put together an exhibition of women's work from various countries, she included Lena Connell, who specialized in portraits of those engaged in the suffrage struggles in Great Britain (just as her American counterpart, Grace Woodworth, had recorded the career of Susan B. Anthony). Also occasionally mentioned in the photographic press of the 1910s were Compton Collier, who photographed the British well-to-do in their own surroundings; Catherine Edmonds; Agnes Jennings; and Marian Neilson, in whose studio apprenticed the young Dorothy Wilding.

PLATE 82: GERTRUDE KÄSEBIER (1852–1934). *ZITKALA-SA*, 1898. PLATINUM PRINT. DIVISION OF PHOTOGRAPHIC HISTORY, NATIONAL MUSEUM OF AMERICAN HISTORY, SMITHSONIAN INSTITUTION, WASHINGTON D.C.

An article in the August 1902 *Bulletin du Photo-Club de Paris* opened with the remark that "the professional woman photographer does not yet exist in France," although the author did acknowledge the presence of women amateurs (see chapter 4).[33] (There were exceptions, of course; Madame Albert Huguet was commended in 1905 for her remarkable seascapes and interior views, which were taken for the expanding trade in picture postcards.)[34] Attributing the lack of women portrait photographers to both conservative taste and a parsimonious clientele, the writer claimed that until portraits were made in the home and accepted without retouching—that is, until naturalness of pose and lighting became acceptable to clients—women would have little chance to do more than develop and process images, as they were presently doing in the larger studios. Indeed, an exhibition in France of work by American women, among them Käsebier and Mathilde Weil, elicited the hope that French women would turn their attention from graphic art to photography and infuse the commercial product with greater taste. The situation did not change in France until after World War I, when vocational expectations for middle-class women became more flexible.

Despite Yevonde's conviction that the same limitations held true for women portraitists in the rest of continental Europe, there were individuals actively producing artistic, professional portraits. Studio Adele, patronized by the Austrian nobility, was run by a woman who set up satellite establishments in Vienna's leading hotels. Minya Diez-Dührkoop—who had apprenticed with her father, Rudolf Dührkoop, in Hamburg, Germany, at age fourteen—eventually was responsible for the more artistic work produced by this durable partnership.

The Dührkoop touch favored the new style of indistinction and was in demand among artistic and literary figures as well as industrial leaders. Although Minya displayed greater creative imagination and was reputed to be especially gifted in dealing with female sitters (plate 83), her contributions were obscured by her father's name.

One of the most significant women photographers in Austria was Dora Kallmus, who gained experience in Nicola Percheid's studio in Berlin before setting up on her own (assisted by Arthur Benda) in 1907 as Madame D'Ora. Her clientele included notable literary and artistic figures, among them Gustav Klimt, Max Reinhardt, and Richard Strauss. Adept at copying the styles of master painters (whether as old-fashioned as Thomas Gainsborough or as up-to-the-minute as Klimt), by the 1910s D'Ora was renowned throughout Europe and the United States for the unaffected vigor of her character studies (plate 84).

With the exception of these few individuals and those in a handful in other countries, professional women photographers in *belle époque* Europe did not find an accom-

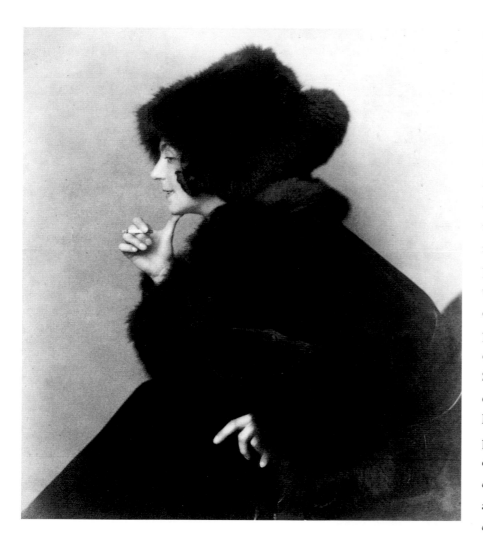

modating environment. The exigencies of war were required to propel them into commercial areas of photography. By 1915 the war had already affected commercial photographic practice to the point that a plea for women to serve as printers found its way into the august *British Journal of Photography.* In the United States, World War I was followed by a recession, in 1920–21, which caused a reduction in clients and prices in the photographic businesses. Women portraitists who had attained success in the earlier era seemed to disappear from public view, although in actuality many continued to operate studios. Sensibilities had changed along with the economy. Women of the 1920s no longer were urged to rescue commercial photography from seeming mechanical or vulgar, mother love seemed a less desirable element in picture making, and the aestheticizing style that had characterized much Pictorial photography was supplanted by a harder-edged approach more appropriate to an era that worshiped machinery and industrial production. The call for beauty, gentility, and grace—characteristics associated with the feminine sensibility—was replaced by an interest in clarity and precision—the hallmarks of modernism.

Changes in social values also played their part in making women's postwar contributions in the United States less honored. As four and a half million servicemen returned to a nation beset by an economic recession, professional women again took a back seat. Women's issues seemed less pressing, especially after the enactment of the Twenty-first Amendment granting them the vote, and women themselves were divided about the future direction of feminism. All of these factors could have meant that women photographers were losing ground, but in fact they not only continued to work but actually expanded their activities and became acclaimed in areas formerly considered to be the exclusive preserve of male photographers.

CHAPTER 4

ART AND RECREATION: PLEASURES OF THE AMATEUR, 1890–1920

In the years just before the turn of the century, large numbers of women took up photography for the first time, urged on by feminists who maintained that "the free unfolding of personality" was as necessary for them as for men.[1] These new amateurs were encouraged by the recognition given them in the photographic press and especially by the highly regarded female professionals to whom they apprenticed or from whom they sought advice and inspiration. Working either independently or as members of amateur societies, women transformed into an art what had begun for many as a fad, thus contributing significantly to the growth of artistic photography in the United States. This aspect of photography was initially known as Pictorialism.

PHOTOGRAPHY AS ART

In England and France the medium's role as art had been hotly debated throughout the 1850s and 1860s, but in the United States photography was considered a purely practical pursuit by most of its devotees until the 1880s. From the 1860s on, efforts in Europe to lift the medium into the sphere of art prompted photographers there to make still lifes and genre images or to stage scenes that could be worked into composites by joining several separately composed images into one picture, but their American counterparts largely ignored such themes and techniques.[2] For the most part, American photographers concentrated on documentation, and so the photographic press mostly dispensed advice about business and technical matters, with an occasional nod to the "art" of photography. On the pages of photographic journals and the walls of the numerous exhibitions held by photographic societies and at industrial expositions, images serving all purposes—portraiture, documentation, even an occasional genre scene—were displayed together.

By the mid-1870s, however, Americans had begun to recognize that photographs might have diverse objectives. The journal *Philadelphia Photographer*, which monitored events in Europe, took the lead in urging its readers to become more conscious of aesthetic matters. Nonetheless, the prejudice against photographs as expressions of mood or ideas did not begin to soften perceptibly until the next decade. Encouragement in this new direction came in part through the exhibitions from abroad that were shown at the Philadelphia Centennial Exposition of 1876 and in part from two major figures in the British photo-

PLATE 85: HARRIET V. S. THORNE (1843–1926). *MAN IN SHOWER*, C. 1900. GELATIN SILVER PRINT. ROSALIE THORNE MCKENNA, STONINGTON, CONNECTICUT.

93

graphic art movement: Henry Peach Robinson and Peter Henry Emerson, whose ideas reached the United States in the 1880s and 1890s through widely circulated articles and books.[3] The composite photography favored by Robinson (who called himself a Pictorialist) was not widely practiced in the United States. The theories put forth by Emerson—an advocate of Naturalism who disapproved of images made by manipulating multiple negatives—seemed to accord more closely than Robinson's with the traditional American respect for documentation. Straight photographs—in which artistry was achieved by attention to theme, composition, and lighting—became the paradigm. Starting in the 1880s this approach, which aimed to produce images as artful as paintings, was categorized as "Pictorialist," but to confuse matters this classification eventually also included camera works in which handwork had played a part.

Emerson's influence became especially apparent in the work by a group of camera enthusiasts from the Philadelphia region, among them a number of women. In the late 1880s this group (known as the Philadelphia Naturalists) set out to portray nature with greater sensitivity than documentarians to the qualities and effects of light. Usually they printed on platinum paper, an expensive material that (unlike silver albumen) could capture a

broad range of tones and was comparatively permanent, as befitted a work of art. Among these early Pictorialists were Mary F. C. Paschall, Mary T. S. Schaeffer, Eva Watson (later Eva Watson-Schütze), and Louise Deshong Woodbridge, each of whom had an individual approach to photography but shared the sense that it could be more than merely a record of objects.

Paschall, untrained and with barely adequate darkroom facilities, was limited to portraying farm implements and processes, whereas Schaeffer, who was able to travel with her botanist spouse, had an opportunity to depict unusual landscape and floral forms (plate 93). Before Watson married Martin Schütze and became a celebrated portraitist in Chicago, she photographed the bucolic scenery in the environs of Philadelphia (plate 86). Woodbridge was perhaps the most unwavering of Emerson's disciples. In works such as *The Outlet of the Lake* of about 1890 (plate 87), she followed Emersonian precepts by turning an unexciting scene with few dramatic features into a harmonious image that combines accuracy of description with a sense of transcendent grace. Although not part of the group, Jeanette M. Appleton, working on the coast north of Boston, followed similar prescriptions for a series of landscape views, while Lily White in Oregon produced lyrical images of the Columbia River from her photography studio aboard a riverboat (plate 88).

The Philadelphia Naturalists and other photographers throughout the nation who thought of themselves as Pictorialists flourished just before the turn of the century, usually as members of societies devoted to the pursuit of photography as art. Since producing artistic photographs was not an inexpensive pastime, the female Pictorialists generally came from the more privileged sectors of society. In some cases the membership of women of means gave distinction to such societies. This was true of the group in Buffalo, which counted among its four women members Charlotte S. Albright—daughter-in-law of the founder of the local art museum, student of Edward Steichen, and, later, member of the Photo-Secession.

This last-named group, which emerged around 1902, was a distinctive offshoot of the Pictorialist movement. Under the guidance of Alfred Stieglitz, this entity became a support structure for those exploring photography's potential as a medium for creating symbolic art. The Photo-Secessionists diverged from the Naturalists in two respects: they allowed a variety of interventions in creating the final print, among them working on the negative with a brush or burin and printing with color pigments, and they were more aware of the most recent trends in the graphic arts. Work embodying this approach had been referred to as "the new American photography" when exhibited abroad in 1900.

The contributions of women were recognized at the time as an important factor in raising the artistic standards of American photography. More than that, they represented, in the words of one of the era's feminists, an attempt to graft an appreciation of the "precious values of the spirit" onto the singleminded concern with "financial estimates and enterprises."[4] Indeed, despite the current obscurity of most of the women photographers involved, their role may have been crucial, as writer Helen L. Davie claimed when she declared in 1902 that the recognition of photography as an art "can be ascribed to the influence of women."[5]

PHOTOGRAPHY AS RECREATION

By 1890 thousands of women in the United States were involved in amateur photography. Their numbers included those who photographed only briefly; those who stayed with the medium and produced serious work for exhibition; and those who sold work occasionally but considered themselves recreational rather than professional photographers. The distinction between amateur and professional is further blurred by the fact that camera clubs, Pictorialist societies and their annual salons of photography, and the printed photographic annuals did not discriminate between the two. Women who had set themselves up in business—among them Zaida Ben-Yusuf, Frances Benjamin Johnston, Gertrude Käsebier, Catharine Barnes Ward, and Mathilde Weil—entered work in the same exhibitions and submitted it to the same publications as those who were photographing solely for pleasure. Images produced on commission were judged alongside those done for personal satisfaction, without regard for the

maker's professional status. Nevertheless, the issue was troubling to some. "Is it permissible," one amateur wondered, "to sell one's work occasionally?"[6]

Even the most aristocratic of the photographic societies—the Photo-Secession in the United States and the Linked Ring in Great Britain—did not at first distinguish between the differing goals of amateurs and professionals. This issue had begun to surface around 1900 in New York in the Camera Club circle around Alfred Stieglitz and in their publication *Camera Notes* and later became a subject in *Camera Work.* This faction—which eventually formed the nucleus of the Photo-Secession—became more and more convinced that art and commerce were as incompatible as oil and water; the dichotomy they established remained more or less in place among amateur Pictorialists until the late 1920s. Both of the two prominent Photo-Secessionists most affected by this disdain for commercial work— Frances Benjamin Johnston and Gertrude Käsebier—believed that to achieve stature in the public eye, they had to be professionals who at the same time produced personally satisfying work. First Johnston and later Käsebier dropped away from the Photo-Secession, though the latter stayed until she had seen her work exhibited at Stieglitz's Little Galleries of the Photo-Secession (or 291) and featured in both the inaugural issue and a later issue of *Camera Work.*[7]

Stieglitz also considered the large-format genre pictures by the Italian aristocrat Loredana da Porto Bonin (which he saw exhibited in Berlin in 1889) "exceptional" and called

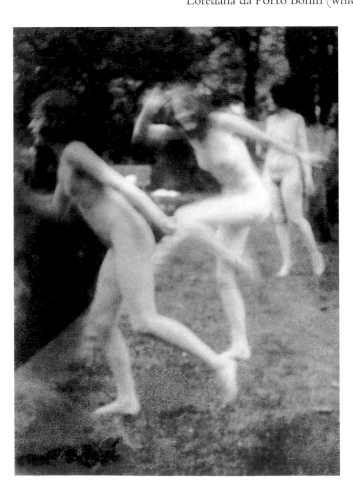

their maker "the first lady amateur of the day."[8] The activities of other aristocrats—among them, Princess (later Queen) Alexandra in Great Britain, Archduchess Maria Theresa of Austria, and Augusta Victoria, empress of Germany—also were mentioned in articles about amateur photography, which began to appear around 1890 in both the photographic and popular journals. Alexandra was said to have left unrecorded "few notable scenes at which she was present."[9] Her use of the Kodak resulted in good publicity for the camera maker and an extensive if not particularly illuminating record of official royal activities. The names of well-known upper-class American women, including Louisa (Mrs. Andrew) Carnegie, also surfaced in articles promoting photography as a hobby. One suspects that these highly visible women were singled out for praise at least in part because of their usefulness as celebrities in promoting trademarked photographic products, as well as for their role in elevating the medium's status. The appetite for recording the recreations of the privileged is exemplified by Lady Ottoline Morrell's snapshots of nude revelers around her swimming pool (plate 89).

According to one writer, the road to "arrival" for a woman amateur required first the acquisition of a cam-

era—often a Kodak—and then the production of enough images so that she could show her work to a professional; next came membership in a club and submission of work to competitions, followed, for some, by entry into professional ranks. Both all-female and mixed photographic societies were common. These groups were generally found in major urban centers, but smaller towns sometimes had unusually active organizations, although not all admitted women. Catharine Weed Barnes (Ward) applied for membership in the Society of Amateur Photographers of New York because she was barred from the Albany group. On the other hand, the club organized in Newark, Ohio (hometown of Clarence White before his move to New York), provided a haven for several gifted women—among them, Ema Spencer and Katherine and Mary Stanbery.

Aside from the Photographic Society of Philadelphia and the Society of Amateur Photographers of New York, the major groups open to women were the Camera Club of New York, the Boston Camera Club, the Photographers Club of New England, the Pittsburgh Amateur Photographers Society, the Chicago Camera Club, and several groups in Los Angeles and San Francisco. To suggest some idea of the ratio of women to men, in 1896 there were 11 women among 172 members in the Camera Club of New York; three years later, 21 of 270 members were women. In the Photo-Secession, women accounted for 21 of the 105 members.

English women constituted the largest group of female Pictorialists outside the United States; five of their number submitted work to the Philadelphia Salons of 1898–1901 and by the time of the *Northern Photographic Exhibition* in Manchester in 1913, they constituted just under one-quarter of the exhibitors. Two-thirds of the British Pictorialist clubs admitted women either as members in full or as associates; those that barred women claimed that the men's desire to smoke was inimical to female attendance.

The Linked Ring, which played a highly visible role in promoting art photography in Europe, numbered only one Briton among its eight women (of 114 members); the others were from the United States and Germany. One suspects that this member, Carine Cadby, was accepted because her husband, with whom she often worked, had already achieved membership and was able to put forward his wife. Cadby conceived her elegant flower images, which displayed a delicate, Japanese-like linearity with no distracting background elements (plate 90), as a means of consciously contravening the camera's "hard realism."[10] Her work was reproduced frequently in magazines in England and the United States; together with her husband, she also illustrated travel and children's books.

Certainly on the basis of style, other British women were worthy of membership in the Linked Ring. Agnes Warburg (a founding member of the Royal Photographic Society's Pictorial Group) concentrated on images that explored the relationship between tamed and untamed nature (plate 91). She and Kate Smith, who seemed transfixed by an idealized view of nature and people, are just two of the women whose themes seem to conform to the outlook championed by the Ring, so the reasons for their exclusion from the group must lie elsewhere. One may have been the necessity of being sponsored by a member, nearly all of whom were men. Another, more speculative reason is that the "male-oriented club atmosphere," which per-

vaded the arts in England in general, tended to exclude women from mixing in cultural life.[11] French Pictorialists were organized into the Photo-Club de Paris, which included three women—Louise Binder-Mestro, Antoinette Bucquet, and Céline Laguarde—among its fifty-six devotees of photography as art.

Between 1897 and 1925 the *American Annual of Photography* reproduced works by some 115 female photographers. Women participated in giant group shows, such as the collection of twenty-five thousand photographs of all kinds exhibited at New York's National Academy of Design in 1898, and in elitist events such as the 1900 show in London known as *The New American Photography,* where they constituted half of the thirty-two exhibitors.[12] At times, women showed together as a group or submitted to "women only" competitions: in 1906 the Camera Club of Hartford, Connecticut, sponsored *An Exhibition of Photographs: The Work of the Women Photographers of America.*[13] Exhibitions of work by several women photographers were held at 291 during its early years, and their photographs were reproduced in *Camera Work.*

Women's attitudes toward the segregated awards given at many major shows changed during this period. Initially accepting separate categories, they came to reject the idea of competing among themselves, and they agitated for genderless categories. "Good work is good work, whether it be by man or woman, and poor is poor by the same rule," wrote Barnes (a position that would be reiterated by women again and again throughout the twentieth century).[14] Barnes also condemned lower membership fees for women as demeaning.

The ardent feminism of the late 1890s not only sought equal rights and greater opportunities, it also proposed a women's network in support of these goals. This idea, as explained by Barnes, meant that every woman had a duty to help every other woman. "Knowledge," she wrote, "should not be kept as if in a mental safe deposit vault."[15] She advised women to learn to handle hammer and nails and to wear appropriate clothing, observing that women could not have been responsible for ads showing them processing film while encumbered by fashionable dress.

FLORAL, GENRE, AND RELIGIOUS SUBJECTS

Just what did women amateurs photograph? At first glance, their images seem limited by their gentility: landscapes, flowers, portraits, and genre scenes appear with almost tedious frequency

in journals and books. (In fact, Sadakichi Hartmann often faulted women for limiting them-selves to such themes, limitations that to him accounted for the ascendancy of Stieglitz and Joseph T. Keiley over Käsebier and Ben-Yusuf.) But when one factors in the work of women who were not Pictorialists and whose photographs were less widely exhibited or reproduced, a somewhat different picture emerges. In fact—with the exception of themes related to children and flowers, in which women excelled, and urban street scenes, which most avoided—their subject matter was not remarkably different from that of many male amateurs.

Like the professional female portraitists, women amateurs often portrayed chil-dren. Besides being welcomed by critics as "a decided relief from the eternal Brittany peasant," images of American children were seen as symbols of a promising future for the nation.[16]

Botanical illustration, which had been the first serious project in photography undertaken by a woman, was an endeavor that continued to appeal to them. Images of flowers, whether intended for scientific use or aesthetic pleasure, were favored not only in the United States but also in England (plate 90). The photographic journals of the time indicate that men usu-ally produced the scientific images of plants, while women (with some exceptions) specialized in purely decorative images of artfully arranged flowers in graceful holders. Floral still lifes of this sort, which followed a tradition established in painting and the graphic arts, were indications of their makers' interest in photography as art rather than document.

At times such subject matter also served as an indicator of economic status. For example, Mary F. C. Paschall wished to portray flowers more than almost anything else, but her "crude conditions" and lack of resources to buy "suitable camera and lens" made indulging this preference impossible.[17] At the other end of the economic spectrum was Sarah C. Sears, a Bostonian of comfortable means who was a member of the Camera Club and later of the Photo-Secession. She was able to indulge her taste for floral arrange-ments, paying careful attention to composition, tonality, and texture (plate 92). Not all photographs of flowers were as refined and elegant as hers. Mary T. S. Schaeffer's botanical images resulted from an interest in natural science shared with her husband, and her photographs were used to illus-trate his catalog of the flora of the Canadian Rockies (plate 93). After his death, Mary Schaeffer continued to explore the Rockies, eventually becoming recognized as an authority in her own right.[18]

Women found genre themes especially appealing, and represented them in a variety of ways. Rural genre scenes, in particular, satisfied not only traditionalists but also progressives who saw in country life an antidote to the problems of urban life. Genre scenes were frequently reproduced in photographic journals as examples of what amateurs might strive to achieve, and they were among the categories for which prizes were offered.[19]

Genre subjects could be found anywhere—on farms and in small towns, in Europe, on city streets. One could even set up a scene in one's own kitchen, as did the Oregon painter-photographer Myra Albert Wiggins. Her image *Hunger Is the Best Cook* (plate 94) was devised in her own home, using a simple but carefully composed background of table, wall, and window, with her small daughter, dressed in heirloom Dutch clothing, as model. Wiggins encountered similar scenes in real life when she traveled through Europe on the prize money she won for this picture. Although she claimed to have invented the category of Dutch-genre photographs, images of European peasants were common, taken not only by American women who had the means to travel abroad but also by innumerable men as well; Stieglitz and Louis Comfort Tiffany are just two of the many travelers who enjoyed photographing lower-class subjects. (It was doubtless somewhat easier as well as ultimately more picturesque to cajole a peasant group in Brittany into posing than a bourgeois family on the boulevards of Paris.)

Rural genre was especially attractive to women who were tied to small towns. The Allen sisters, Nancy Ford Cones, and Chansonetta Emmons were able to make this subject pay; many others—among them Sarah J. Eddy, Emma Fitz, and Helen P. Gatch—found both recreational pleasure and the stuff of art in the daily routines of farm wives and shopkeepers who lived nearby. Such works were sometimes given as gifts; Eddy donated hers to hospitals to relieve the monotony of undecorated walls. She suggested, also, that amateurs "furnish photos to strangers who were kind enough to pose."[20] Genre images by Cones were sold for book, calendar, and magazine illustration. For some women, interest in rural customs developed into more than a pleasant pastime. Scottish photographer Mary Ethel Muir Donaldson studied highland history,

became an authority on her nation's folklore, and authored nine works on this subject matter.[21]

Genre works varied widely in appearance. Not all were as rigidly formal as Wiggins's prizewinner; indeed, another of her highly regarded works—*The Forge* (plate 95)—seems a model of naturalness, despite the dramatic highlighting of the central motif. Photographers switched between styles according to the potential use of the image. For example, Emmons's images of children at play (plate 96), presumably made for her own pleasure, capture a sense of spontaneous delight without seeming in any way posed, whereas her genre works of old-time cus-

PLATE 95: MYRA ALBERT WIGGINS
(1869–1956). *THE FORGE*, 1897.
GELATIN SILVER PRINT. PORTLAND
ART MUSEUM, PORTLAND,
OREGON.

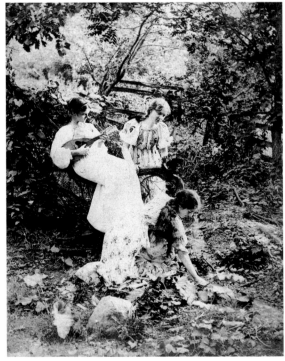

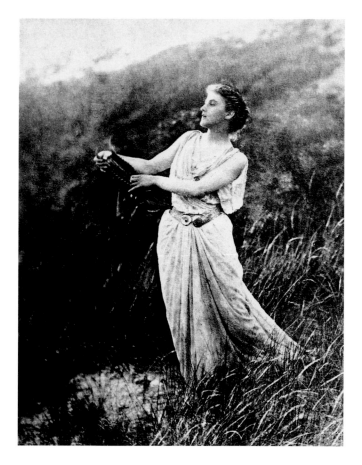

toms in New England (plate 54), produced for sale, are uncomfortably static. The stilted quality of many of the genre images reproduced in the photographic press was similar to and probably derived from the highly popular, and highly sentimental, narrative paintings of the era, such as those turned out in large numbers by John George Brown in the 1880s and 1890s; the fact that Brown frequently based his paintings on photographs that he made himself confounds the issue even more. Although today we tend to think of genre imagery as unsophisticated, it originally appealed to a range of tastes. Nonetheless, many award-winning studies must have seemed banal or mawkish even at the time, whereas the scenes of child's play made by Käsebier for her own pleasure were (and continue to be) considered spiritually and aesthetically satisfying.

A type of narrative genre in which women, usually young and usually dressed in flowing garments, seem to be communing with each other, with nature, or with their inner beings engaged the attention of a number of amateurs, such as Mary Bartlett (plate 97). Images such as these may now strike viewers as outdated or silly, but they are no more (or less) so than the costume pieces favored in the late 1880s by male Pictorialists, among them Charles Berg and Stieglitz. Indeed, for women, they may have conjured up a desired liberation in dress and spirit not possible in actuality. By the end of the nineteenth century the strictures imposed on movement by the bustles, stays, and tight lacings of women's clothing were being attacked, a development that was reflected in visual images as well as polemical statements. For example, the versatile oeuvre of Emma J. Farnsworth, a genteel Albany lady who probably never appeared uncorseted in public, includes images of models (were they friends?) in Grecian-style robes, often posed in flowering fields with arms outstretched toward nature and light (plate 98) or peering into the mirrorlike surface of a pond. Her figure studies received attention and awards when shown in Great Britain, India, and Canada as well as in the United States. Although a number of them illustrate slim volumes of stories and poetry, one senses that they are less illustrations of specific texts than generalized expressions of a desire to be free, at least occasionally, of constricting clothing and wearying domestic concerns. Women in the guise of nymphs or goddesses appealed to a few men as well, undoubtedly for other reasons; Berg produced work in this vein, but with less grace.

Women also created costume pieces based on religious themes. This genre, popularized by Julia Margaret Cameron in the 1860s, was brought to American attention in the 1890s.[22] Photographers such as Amelia C. Van Buren posed friends and associates as the Virgin Mary (plate 99) and other biblical characters, attempting through this choice of ele-

vated theme to invest the medium with the aura of serious art. *A Group of Studies in Artistic Photography*, a series by portraitist Alice Boughton published in *Good Housekeeping*, used as a model the famed actor Walter Hampden to portray scenes from the New Testament. Although little known today, Boughton's work looks backward to the religious depictions championed by Cameron and forward to the secular reenactments favored by photographers now working in the directorial mode (see chapter 8).

Virginia Prall—now forgotten but at one time a noted specialist in such subjects—was praised by her contemporaries for the spirituality of her portrayals of prophets and prayers. That these themes were not the exclusive specialty of women is clear from the images of prophets by F. Holland Day and Clarence Bloomfield Moore and of Mary Magdalene by Charles Berg. No woman went as far as Day did in picturing himself as the crucified Christ, but many no doubt agreed that photography should be able to "do what has so frequently been done by painters with as full a sense of reverence."[23]

In England, Eveleen Myers (Mrs. F.W.H. Myers) carried on the Cameron manner in her narrative and genre work (plate 100) and was praised for handling her subjects "with true aesthetic feeling."[24] A similar concept inspired photographs bearing such titles as *Saint Margaret* (plate 101), *The Lady of Shalott*, and *Soul of the Rose* by Mrs. G. A. Barton. A proper British matron (born Emma Rayson), she used her husband's name throughout her career. In the ten-year period starting in 1901 Barton exhibited as persona grata at numerous international salons, and her work was considered "a brilliant example of what a woman of talent, aided by perseverance and patience, could make of photography."[25] And, it was pointed out, she managed all of this without ever losing the feminine qualities of a lady. Engaged by artistic ideas similar to those that fascinated F. Holland Day, Barton tackled them with what appears to be equal competence but less fevered symbolism; Day's work is still accorded recognition, while hers has all but disappeared.[26] Such scenes remained popular in Great Britain through about 1920—as the awarding of many salon medals to the highly manipulated allegorical images by the little-known Morter sisters affirms.[27] Their sentimental messages undoubtedly provided a welcome balm particularly in the aftermath of World War I, when so many British soldiers had been killed.

THE PHOTO-SECESSION

By the first decade of the twentieth century, biblical and sentimental genre images were derided by critics as catering to the unsophisticated viewer, unlike the more aesthetic products of the

Photo-Secession. A number of the women who had been involved with the earlier manifestations of Pictorialism joined the Photo-Secession, including the most acclaimed figure in artistic portraiture—Gertrude Käsebier. Among other women Photo-Secessionists were Eva Watson-Schütze, Sarah C. Sears, and Mary Deven, whose work in bichromate was singled out by Alvin Langdon Coburn as "above criticism."[28] The work of West Coast photographer Anne W. Brigman proved especially appealing to Stieglitz, perhaps because her imagery expressed yearnings for freedom that accorded with his own comprehension of the female psyche.

Brigman's constancy of style and theme over a twenty-five-year period was unusual. Modernists regarded as sentimental her portrayal of women as untrammeled spirits communing with nature among the cypresses and rocks of the Pacific highlands (plate 102), but more recently the images have come to be considered as symbolic representations of feminist ideas. Adelaide Hanscom was also a West Coast member of the Photo-Secession, but other female Pictorialists from the region—among them, Blanche Cumming, Emily H. Pitchford, and Maude Wilson (who was praised as a "poet of sunshine and mist" by Stieglitz's one-time associate Hartmann)—remained outside the Secession even though their objectives and styles were not essentially different from those of the women involved in the group.[29]

Stieglitz's support for women photographers and for Pictorialism became steadily less forceful. From 1910 until his death in 1946, no female photographer other than his acolyte Dorothy Norman seems to have interested him enough to be shown in any of his several galleries. In fact, his interest in all contemporary photography diminished; besides his own work, only that of Ansel Adams, Eliot Porter, and Paul Strand was exhibited in his galleries after 1915.

No such lack of interest characterized Clarence White's attitude toward photography in general and women's work in particular. Involvement in the Photo-Secession had impelled him to move from Ohio to New York in 1906; after teaching at the Brooklyn Institute of Arts and Sciences and Columbia University, he opened his own school of photography in Manhattan in 1914. The large number of women who went on to pursue the medium seriously after studying with him there and at his summer schools in Connecticut and Maine suggests that White's approach must have provided female students with exceptional inspiration (plate 103). Women who attended his school during the teens constituted a veritable who's who of American woman photographers between 1925 and 1950; among them were Margaret Bourke-White, Laura Gilpin, Dorothea Lange, and Doris Ulmann. As Lange later recalled, White's approach to photography was poetic and consisted of giving "everyone a feeling of encouragement in some peculiar way, a nudge here, a nudge there."[30]

PLATE 104: ALICE AUSTEN
(1866–1952). *HESTER STREET,*
EGG STAND GROUP, 1895.
MODERN GELATIN SILVER PRINT.
COPYRIGHT © STATEN ISLAND
HISTORICAL SOCIETY,
RICHMONDTOWN, NEW YORK.

In addition to offering a sympathetic attitude, White hired a woman, Margaret Watkins, to teach advertising photography—at the time thought to be exclusively a male dominion. Further, he wrote about opportunities for women, and after his untimely death in 1925, his wife, Jane White, continued to promote professional careers for women photographers. Women also formed a significant proportion of the membership of Pictorial Photographers of America, organized by White and Margaret Rhodes Peattie in 1916; in the year after its founding 53 of the 157 members were women.

RECORDING DAILY LIFE

The urban street scene was, with rare exceptions, the preserve of men during the 1890s and into the new century's first decade. Pictorialist photographers—among them Robert Bracklow and the Secessionists Coburn, Stieglitz, Edward Steichen, Paul Strand, and Karl Struss—all approached the street with enthusiasm. The vitality of their urban work gave the Pictorialist movement in this country a unique character, quite unlike the misty nostalgia evident in the artistic images being made in Europe during the same era. This subject matter was off limits to most women (with or without a camera), since they were not supposed to appear unaccompanied in city streets. Besides the usual fears of being accosted by strange men or coming face to face with prostitutes, there was the problem of attracting too much attention to get on with the work. Catharine Barnes Ward, for example, complained of the hordes of small boys who pestered her whenever she attempted to work outside.

A notable exception to this proscription was the amateur Alice Austen, a well-bred young woman of Staten Island, New York. Having been given a camera and taught how to process film and make prints at an early age, Austen at first followed the pattern of such notables as Marion (Clover) Adams in portraying her house, its accoutrements, her circle of well-off friends, her own recreational activities and, occasionally, the natural landscape. But in the late 1880s she took advantage of the newly opened ferry line across New York Bay to travel to lower Manhattan and work in the streets around the Battery, Park Row, and the Lower East Side (plate 104)—an area housing large numbers of European immigrants. Unmarried, supported by an independent income, and seemingly without interest in the aesthetic issues that inflamed the Pictorialists, she was drawn to the drama of lower-class street life. Though she regarded her subjects with little emotion, her pictures are remarkable for their specificity, their compelling visual organization, and their overall sharp focus. Austen left no written record of her thoughts about photography, but one imagines that using a camera made it possible for her to confront aspects of American life that otherwise would have been entirely out-of-bounds for a woman of "breeding."

Few women were as singlemindedly involved in amateur documentation as Austen or as lucky to have had their work conserved, but throughout the United States, Canada, and to a much lesser extent Europe, women were engaged in recording, with varying degrees of sensitivity, the reality around them. The absence of sentimentality in Austen's approach also distinguished the work of many women who resided in rural areas and recorded

not just family members and friends but also the mundane activities of daily life. The curiosity displayed by Olive May Percival about her surroundings—the Chinese quarter and the fishing village of San Pedro, California—exemplifies this approach. A single woman employed as a secretary, Percival worked only with cyanotype, instead of the more expensive materials favored by Austen. The well-to-do Harriet V. S. Thorne, using as subjects family members and servants at her summer estate in Black Rock, Connecticut, produced intimate views of family life. Her image of a man showering (plate 85) is surprisingly modern in its lack of sentimentality and of the mannerisms that were often integral to this period's genre work. (By coincidence, Rollie McKenna, Thorne's great-granddaughter, became a professional portraitist.) Canadian Annie McDougall was typical of many late nineteenth-century amateurs who kept albums of unpretentious but lively images of family and friends engaged in daily tasks and country recreations.

Amélie Galup, the wife of a French magistrate posted to Cahors and Albi, photographed the different social strata of her milieu (plate 105), exhibiting a curiosity similar to that of Austen. Between 1895 and 1901 she produced more than thirteen hundred images of family, friends, fairs, marketplaces, festivals, and people—a veritable social record of the community in which she lived. In similar fashion, the more than five thousand images made by Jenny de Vasson, a sophisticated bourgeoise living in Varennes and Versailles, constitute an artistic yet unromantic record of everyday life in France (plate 106).

The reasons for taking up this kind of camera work varied from person to person. Emma D. Sewall, an extremely shy matron in an influential Maine family, began to photograph at age forty-eight, after her sons were grown. Her longstanding interest in American history and folklore prompted her to photograph the simple ways of life being replaced by industrialization. The landscapes, interiors, and activities (plate 107) pursued by ordinary citizens that she recorded in 1895 in the area surrounding the town of Bath, Maine, led to accolades. Sewall, the first woman admitted to the Boston Camera Club, was called "one of the foremost women amateurs" in the country.[31]

Just as a predilection for the exotic had prompted a number of professional portraitists to seek out Native Americans or Asians, so amateurs also took their cameras with them on travels to faraway regions. As early as 1890 Septima M. Collis had produced *A Woman's Trip to Alaska* with illustrations "kodaked by the author" and others in her party.[32] In Canada, Mattie Gunterman, an American who had relocated to British Columbia to cure a case of tuberculosis, recorded the families who had come to the region to make a living in logging or a fortune in gold mining (plate 108). Just as Austen had often inserted herself into her images depicting the milieu in which she felt most at home, so Gunterman appeared in many of her exposures made in the Arrow Lake district, where

she recorded "her love of Pioneer life and the characters who lived it," capturing a way of life that she evidently found socially satisfying and physically nourishing.[33] Geraldine Moodie, wife of a governor of the Hudson's Bay Company, depicted Native Americans in the western provinces, depositing the images with official bodies concerned with Canadian and Indian affairs (plate 109). Documentation by the American-born Edith S. Watson—who was exceptionally fond of travel, photography, Canada, and Canadians—included images of Mennonites, Doukhobors (plate 110), and Cape Breton Islanders.[34] Among those who combined an interest in anthropology with camera work were Frances Hubbard Flaherty, who helped her husband, the film maker Robert Flaherty, document the Inuit; and Miriam Elster, who voyaged from her native Austria to portray Europeans who had settled in Canada.

By the beginning of World War I, photography had achieved acceptance as a medium suited to expressing thoughts, feelings, and moods, whether in the highly symbolic style advocated by Stieglitz and understood by a small elitist circle, or in the more accessible style of the Camera Club Pictorialists. Women were acknowledged as having earned a share in "building the American school" and having raised the "standards of picture-making" by camera.[35] That such developments should have been centered mainly in the United States is understandable. In the final quarter of the nineteenth century, this country had become "the quintessential bourgeois" society, for which Pictorial photography was well suited as the most appropriate middle-class art medium.[36] Requiring a measure of leisure, a degree of education, and some sense of self-worth, photography fit well into a social scheme that had provided large numbers of women with just these attributes.

ABOVE

PLATE 108: MATTIE GUNTERMAN
(1872–1945). *TWO PROSPECTORS,*
EARLY 1900S. GELATIN SILVER
PRINT. VANCOUVER PUBLIC
LIBRARY, CANADA.

RIGHT

PLATE 109: GERALDINE MOODIE
(1853–1945). *GROUP OF ESKIMO
WOMEN AT FULLERTON HARBOUR,*
1905. GELATIN SILVER PRINT.
ROYAL CANADIAN MOUNTED
POLICE MUSEUM, REGINA,
CANADA.

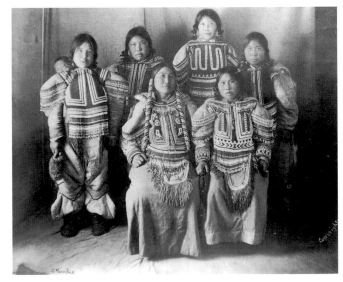

1933 QUEBEC RURAL SCENE

PLATE 110: EDITH S. WATSON (1861–1943). *QUEBEC RURAL SCENE*, C. 1920. GELATIN SILVER PRINT. NOTMAN PHOTOGRAPHIC ARCHIVES, MCCORD MUSEUM OF CANADIAN HISTORY, MONTREAL.

Women photographers in central Europe were far less visible. Photographic magazines there rarely reproduced the work of women and cited them by name even less frequently. The fact that twenty-eight women enrolled in 1890 in Berlin for a year's course offering both artistic and technical training in a special "photographic school for ladies" affirms that interest in the medium was expanding.[37] Its attractiveness may have been increased by the interest shown in camera work by Empress Augusta Victoria, who not only took pictures but was said to do the darkroom work as well. The paucity of facts about women and recreational photography in Germany and Austria-Hungary indicates the need for research in this area but also suggests that in the absence of both the basic conditions and the support structure that attended the emergence of American women into the field, involvement in photography as either a professional or an artistic pastime was not an option open to many women in Europe until after World War I. Then, in an explosion of creativity, women brought to the modernist vision a unique combination of empathy and stylishness.

PHOTOGRAPHY BETWEEN THE WARS: EUROPE, 1920–40

Photography flourished as never before in the period between the two world wars. It gained from the increased demand for images in advertising and journalism, from an attitude that regarded machine-made objects with pleasure rather than prejudice, and from an experimental climate that embraced and transformed all the visual arts. Photography also benefited from the "astounding improvement in the manufacture and operation of papers, presses and inks," which gave images greater brilliance and clarity when reproduced in the press.[1]

Women continued to look on photography as both a means of self-expression and a profession; in fact, they expanded the range of their professional expertise. This was as true in Europe, where fewer women had been active in the medium before World War I, as in the United States, where such developments were an extension of previous progress. In 1936, according to one writer, European women "rivaled" men in photography while remaining "inferior" in the other visual arts.[2]

As had been true of American women photographers around the turn of the century, professionals in Europe were supportive of one another, often taking in apprentices and students. Among those trained by Trude Fleischmann, for example, were Maria Wolfl and the Americans Helen and Marion Post (later Wolcott); Fleischmann herself had been helped by Madame D'Ora. (Helen and Marion were later to repay Fleischmann's generosity as a teacher by helping her reach the United States after the Nazi takeover of Austria.) Around 1930 the English photographer Peggy Delius apprenticed with Charlotte Rudolph in Dresden. In Paris, Lisette Seybert (Model) was guided by Rogi André, while Nora Dumas and Ylla were initiated into the mysteries of the medium by Ergy Landau. Not all such relationships were unfailingly positive, however; Gisèle Freund recalled being advised by Florence Henri to learn retouching because her teacher thought she lacked artistry; Ilse Bing remembered Henri as aloof.

Other women attended institutions where their mentors were men or found work in studios run by men; sometimes (as Berenice Abbott suggested) they were forced out when their work began to be perceived as competitive.[3] The prominence attained by women is to some extent affirmed by the exhibition record: for example, the First Independent Salon of Photography, held in Paris in 1928, displayed the work of five men and four women.

Even before the Nazi triumph deprived Germany of its foremost artists and intellectuals, the unsettled political and cultural situation on the Continent impelled many

women, in particular those championing new roles, to relocate. In Hungary, for example, because political and economic conditions did not encourage the growth of advertising or photojournalism after the failed revolution of 1919, many photographers of both sexes were obliged to emigrate. Ergy Landau, who had been born in Hungary, studied in Vienna, and worked in Berlin before landing in Paris, and Lucia Moholy, who moved from Hungary to Germany to England, are two women who exemplify the movement westward. The work of the few women who remained in Hungary, including Kata Kalman and Klara Langer, has come to light only recently.

As they scattered, women carried with them not only new visual strategies but also a psychosocial message. Cut loose from middle-class norms and expectations, they proclaimed that professional women could lead lives free from convention. The camera aided them in this quest, as it had others in the past. An especially outspoken example of this is Germaine Krull. Born of German parents in Poland, she trained at the Bayerische Staatslehranstalt für Lichtbildwesen (State School for Photography) in Munich, settled in Berlin, moved to Amsterdam with her companion (the noted film maker Joris Ivens), and then on to Paris. Active politically as well as in photography, she carried with her an avant-garde concept about how to convey in camera images the extraordinary power and strength of industrial components. Her images of metal pylons and structural elements, made in Holland and France, some of which were published in 1927 as the book *Métal* (plate 112), attest to Krull's facility with what was considered the essentially masculine subject of the industrial landscape.

Krull's work of the late 1920s parallels that of the American Margaret Bourke-White in its forceful approach to the artifacts of modern industry (page 2), and like Bourke-White, she eventually enlarged her scope to include more than mechanical reality. Krull's

PLATE 112: GERMAINE KRULL (1897–1985). *NO. 37 FROM THE BOOK "MÉTAL,"* 1927. COLLOTYPE PRINT. GEORGE EASTMAN HOUSE, ROCHESTER, NEW YORK.

unique vision, which turned industrial mechanisms into the stuff of art while still retaining a sense of verity, was precise and romantic at the same time. In this respect, her imagery differs somewhat from that of modernists Herbert Bayer, László Moholy-Nagy, and Aleksandr Rodchenko, whose extremely skewed angles and dizzying perspectives tend to confound the viewer's sense of tactile qualities and spatial relationships. Idealizing mechanized objects and industrial structures also attracted the German photographer Else Thalemann, but she was more conventional in her choice of angles and her respect for ordinary one-point perspective.

PORTRAITURE

Portraiture continued to be the easiest route for women to enter the field, both as a way to make a living and as a vehicle for expressing ideas and feelings about contemporary life. Nearly all those whose work eventually broadened to include advertising and photojournalism began as portraitists. In England and France the war itself was largely responsible for the acceptance of women as professional photographers, increasing the demand for images of loved ones while causing a shortage of men able to fulfill that need. The scarcity of male technical help forced London studios to hire women not only as studio assistants and retouchers (where a few were already employed), but as camera operators and sales personnel as well. What had been an "essentially masculine business"—with a few exceptions, notably Lallie Charles, Marian Neilson, and Olivia Wyndham—was greatly changed; by 1917 it was claimed that portrait studios could not do without women.[4] Madame Yevonde went even further, declaring that "portrait photography without women would be a sorry business."[5]

Women who had been apprentices during the early 1910s were opening their own establishments in the 1920s. In England at least eight such studios became highly respected, and several women connected with them gained reputations for the personal imprint their products displayed in the later 1920s and throughout the 1930s. Dorothy Wilding, who had first worked in the Neilson studio, was so highly acclaimed for her celebrity and fashion shots that she eventually owned studios in both London and New York. Women's success in this area often came after many years of networking with other female professionals. Early in Wilding's career, for example, the commissions she received from theatrical producer Hilda Sullivan to portray actors in her plays helped establish Wilding's idealizing style and paved the way for sittings by the British royal family. An outspoken supporter of women in the professions, Wilding employed only females on her staff, holding that women were "more conscientious" and better "natural psychologists."[6]

Helen Muspratt's portraiture was deemed interesting because of "its great versatility of ideas and techniques."[7] She and her partner, Lettice Ramsey, were among the first to make use of modern experimental processes, such as solarization, which had been taken up by advertising photographers but not yet by portraitists. Barbara Ker-Seymer, who became, in her own words, "a photographer quite by accident," started out as an assistant to Olivia Wyndham.[8] More interested in experimentation than in ordinary commercial portraiture, she eventually gained renown as a maker of high-society images (plate 130).

The transformation in the kind of work these women produced was a testament to their ability to change with the times. The work of Ursula Powys-Lybbe, whose portraits of British society figures consisted of a montaged bust surrounded by camera images of the individual's possessions and activities, was evidence of an unusual commercial application. At various points in her career Ker-Seymer emulated different avant-garde styles, including Helmar Lerski's large-scale close-ups and the solarizations of Man Ray, but she seems to have been unable to find a distinctive style of her own. Yevonde's continuing success up through the 1930s as a purveyor of personal portraits to high society was possible largely because she astutely turned to color photography (plate 5), which for that period was so unusual that she could play up its exclusivity by comparing it to the hand-painted portrait of the past. Then, recognizing that the individual portrait no longer commanded great respect or high prices, Yevonde styled herself as an advertising portraitist and illustrator in color and monochrome; in the 1930s she was considered among the more experimental commercial photographers in Great Britain. Such flexibility may have been profitable, but it seems to have diminished Yevonde's ability to sustain a high level of vigor in her work.

Even fewer French women had been acknowledged as portraitists in the early twentieth century, but this genre became one in which they excelled after World War I. As in England, the ground had been prepared earlier, with more than twenty feminist books and news magazines appearing in France toward the end of the nineteenth century. However, the French *nouvelle femme* was urged on the one hand to redirect her energy toward "internal cultivation" and on the other, to express femininity in personal adornment and interior decor.

Again as in England, the war altered the situation. Despite Yevonde's claim in 1921 that she knew of only one professional female portraitist in France (Genia Reinberg), a French correspondent of the time noted that women portraitists had "entirely replaced men during the war" and had remained involved after it, sometimes managing studios with their husbands.[9]

From about 1922 on, the Parisian photographer Laure Albin-Guillot portrayed famous figures in a manner that combined the misty atmospherics of Pictorialism with the close-up compositional strategies typical of modernism. Albin-Guillot, who in 1935 became the president of the French Société des Artistes Photographes, did not limit herself to portraiture. Regarded by a contemporary as "ingenious, open to all forms, and sensible to all the aspects of human intelligence," she produced a wide range of work (plate 113), including

illustrations for works of modern French poetry (among them images of male nudes), product advertisements for cosmetics and pharmaceuticals, and symbolic images much influenced by the arts of the Far East.[10] This diversity was typical of many photographers of the era, resulting from more flexible ideas about the photograph and its relation to art and utility. It also testifies to women's recognition that to succeed in the field would require emulating men in all specialties rather than carving out any distinctively "feminine" pathways.

Portraiture was the initial mainstay of the enterprises run by Madame D'Ora (Dora Kallmus)—originally in Vienna, where her work had been acclaimed for its stylish depiction of cultural and court figures (plate 114). Transplanted to Paris after 1925, she enlarged her scope to include fashion work for several of the leading European women's fashion magazines. Most fashion commissions during this era went to male photographers, so it is not surprising that it is their work that has remained highly visible (indeed, is recycled by each new generation), while the photographs by D'Ora (along with those by the Atelier Yva) have remained relatively unknown since World War II. Of Jewish origin, D'Ora spent the war years hiding from the Nazi occupiers of France; in a striking departure she afterward turned to photographing slaughterhouses, creating one of the few symbolic indictments of war and the Holocaust in the medium.

D'Ora recalled having to overcome "massive resistance" to her professional ambitions on the part of the male photography establishment in which she sought an apprenticeship during her early days in Vienna.[11] A less troublesome way to enter the arena of portraiture was through inheritance. For instance, in 1925 the Weimar studio of Louis Held was handed over to his daughter Ella, who was the first woman in her region (Thuringia) to work as a photographer; in Berlin in 1927 the Prussian-born Lotte Jacobi went into the family

studio set up by her forebears. Wanda Wulz and a sister, Marion, took the mantle of their father and grandfather, owners of a photographic establishment in Trieste, Italy.

By the mid-1920s women in Austria and Germany were making names for themselves as portraitists with less opposition. Among them was Trude Fleischmann, owner of a thriving studio in Vienna (plate 115) and later, after emigrating, in New York. She was celebrated for her adroit handling of the modernist idiom, becoming known to Europeans and Americans through the fairly frequent reproduction of her work in the most advanced journals of the period. Another German portraitist, Hanna Seewald, became a recognized teacher, counting Jacobi, Helmut Gernsheim, and Floris Neusüss among her students.

Appreciation was also accorded the now little-known German photographer Erna Lendvai-Dircksen, whose studies were of German vocational "types" (plate 116). Close-

up views of the head and upper torso fill the entire frame in her images, which were reproduced in magazines and books by various authors. In 1930 and 1944 Lendvai-Dircksen published her most ambitious series of photographs of vernacular architecture and portraits, entitled *Das deutsche Volksgesicht (German Folk Faces)* and *Das germanische Volksgesicht (Germanic Folk Faces)*, respectively. Her compositional strategies, which represented one response to the "call for a new humanism" articulated by the art historian Wolfgang Born in 1929 to counteract the effects of machine technology on the arts, were not uncommon.[12] In portraits by Aenne Biermann and Helmar Lerski, for example, the lens seems to examine every muscle, pore, and hair follicle. One possible influence on Lendvai-Dircksen's undertaking may have been August Sander's work. In 1924, abandoning his earlier soft-focus Pictorialist approach for one of greater clarity and objectivity, Sander undertook a challenging project to make portraits of Germans of all classes and occupations. His subjects included gypsies, circus entertainers, people of color, and others deemed non-Aryan and therefore undesirable by the Nazi regime, which prohibited his project in 1933. No doubt Lendvai-Dircksen's portraits were allowed because she joined the Nazi party and concentrated on the Germanic types acceptable to them.[13]

Other women from Germany and eastern Europe who took a modernist approach to their portraits (as well as their other work) included Eva Besnyö (plate 117), Anneliese Kretschmer (plate 118), and Grete Popper. This approach, which embraced a

detailed and precise description of the subject—whether portrait, mechanism, or building—was an antidote to the traditional Pictorialist techniques of soft focus and hand manipulation.

By 1925 Paris had become the home of numerous refugees, male and female, from eastern Europe. Unable at first to find work in advertising or for magazines, the refugee women photographers in particular specialized in certain types of portraiture. Whether they colluded on this strategy is unknown, but it undoubtedly represented an effort to avoid invading each other's terrain. Rogi André, Nora Dumas, Ergy Landau, and Ylla (Kamilla Koffler) were all Hungarian émigrés who set up shop as portraitists in Paris, carving out their own niches by specializing in the portrayal of artists, children, or animals. Several had been in charge of successful studios back home, but the fact that they were women, that they were foreigners, and that they charged less than established Parisian studios did not endear them to their French colleagues. As foreign newcomers and women, they found it difficult to attract enough portrait sittings to make themselves financially stable.

Artists and writers sat for a number of the women working in Paris—among them the Parisian Yvonne Chevalier and the German-born Gisèle Freund (plate 119). A scholar of art history and sociology who had escaped in 1933 to France (where she earned a Ph.D. from the Sorbonne and studied photography with Florence Henri), Freund became active as a writer and a photojournalist. At first making portraits only to pay for her studies, Freund returned to portraiture again and again in the belief that "everything is summed up in the human face."[14] This is not a specifically female perception but does have a marked similarity to Julia Margaret Cameron's desire to reveal "the greatness of the inner as well as the features of the outer man"; it also suggests that even during the period of high modernism Freund remained sensitive to the

relationship between character and facial expression.[15] Eventually Freund, who took up journalistic reportage and then joined the Magnum agency in 1947, discovered the difficulty of involvement in what she called "two métiers"—that of photographer and that of "woman."[16]

A few women operated successful studios even in smaller and less technologically advanced nations. Atelier Nelly's, in Athens, was owned by Elli Seraïdari, who returned to her homeland in 1925 after studying art and photography in Germany. During the late 1920s, this studio, which filled a range of photographic needs, brought new ideas about pose, lighting, and spontaneity to Greek photography (plate 139). Modern to the core, Nelly was the first Greek photographer to use work she had done in the Greek countryside to call attention to her country's plight in the war; one of her images appeared on the cover of *Life* magazine.[17] Even more unexpected was the portrait studio opened in Osaka in 1931 by Eiko Yamazawa, who after studying painting in California had assisted the American photographer Consuelo Kanaga before returning to Japan. Australia and New Zealand provided a more accommodating climate for women photographers. At least twenty women were active in these years, mainly as portraitists, but also in depicting interiors and newsworthy events.

MODERNISM

During the early 1920s the modernist pictorial vocabulary established itself throughout Europe as a style not just for portraiture but for all genres of photography. In sophisticated circles, the term *modernism* encompassed the choice of unconventional themes, a preference for close-ups and other unusual angles, attention to effects of light, and experimentation with media—all strategies thought appropriate to an age consecrated to burying the past. The modern style developed in two main directions—the veristic and the expressionistic—during the 1920s in Europe, first in Germany and the Soviet Union, later in England and France.

The veristic branch was marked by its emphasis on sharp definition. Objects were depicted without sentimentality or atmosphere—the very qualities that had given turn-of-the-century Pictorialism its distinctive appearance and its supposedly feminine appeal. Interest in silhouette; in line, texture, and tonality; in the extreme close-up and the unusual angle for portraying the commonplace characterized modernist realistic imagery. That these characteristics, which had been made possible by new developments in optics, were also special attributes of camera vision may be one explanation for photography's unparalleled popularity with artists during the 1920s and 1930s.

The concurrent and seemingly antagonistic aspect of modernism can be seen as

PLATE 120: AENNE BIERMANN (1898–1933). *CHILD'S HANDS (HELGA)*, 1928. GELATIN SILVER PRINT. FOTOGRAFISCHE SAMMLUNG, MUSEUM FOLKWANG, ESSEN, GERMANY.

a variant of expressionist art. Surfacing first as Dada in central Europe, this photographic mode used all kinds of manipulative strategies that included collage, montage, and the production of light-created images without a camera. These strategies were designed to express complex ideas, to reveal what some artists termed "documentary truth," to engender psychological disquiet, and to command attention by seemingly illogical juxtapositions.[18] Initially—in the early 1920s—graphic, photographic, and typographic elements were combined to produce collaged or montaged works. Images also were produced by illuminating objects placed directly on sensitized paper; this technique could be expanded by moving the light source or the objects or by exposing the paper to light while it was in the developer bath. These "ultra-modern" strategies were used for personal and political expression as well as for advertising photography.

The new photography in both its veristic and expressionistic modes came to public notice under a variety of labels, referred to as the New Realism, the New Vision, the New Objectivity (Neue Sachlichkeit), and Precisionism.[19] Whether associated with movements that espoused Constructivism, Dada, or Surrealism, artists created such images not only to present reality in an unfamiliar light but also to embody satirical or ironic responses to the confused political and social scene in Europe. Modernism in general usually venerated technology and prescribed an aggressive approach to materials—predelictions traditionally associated with the male character. In photography, though, the idiom proved exceptionally attractive to women in both its veristic and expressionistic aspects because it could be made to express the connections between the new industrial societies and "the new woman." The "new" women were those who recognized that as a consequence of the prodigious mechanization and changed attitudes after World War I, they were no longer automatically consigned to domestic life. They used the arts to comment on their new roles in the cultural and political spheres.

In modernist portraiture women embraced the close-up—perhaps the most typical veristic strategy—with notable creativity and vigor. Biermann, Henri, Jacobi, Klara Wachter, and Berenice Abbott (an American expatriate working in Paris) all used it in distinctive ways. Biermann's approach was prototypical in that the camera was brought extremely close to features, hair, or limbs, which frequently were cropped in a way that forces the viewer to see these elements in a new light (plate 120). As Biermann herself noted, under such scrutiny barely noticed everyday faces or objects "took on [their] own unique life on the focusing screen."[20] Henri's portraits (plate 125)—pre-

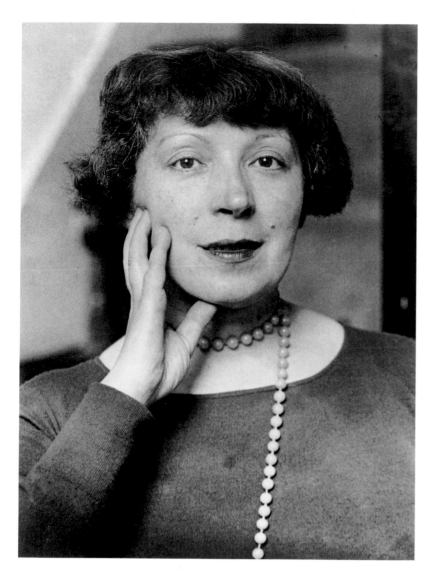

ponderantly of women—explore the same vein, achieving their suggestion of a superreal presence by rigorous attention to the interrelationship of forms and the pictorial geometry.

Jacobi, too, was drawn to the modernist style despite her later claim that "none of the styles current in Germany in the 1920s" engaged her interest.[21] The strong tonal contrasts, unusual cropping, and accent on design in her portrait of Nura Nurskaya, entitled *Head of a Dancer* (plate 121), suggest her responsiveness to strong silhouette. Other of her portraits from this early period emphasize psychological character as well as design elements, but her later experiments with cameraless imagery, undertaken in 1946 (long after she had relocated to New York), indicate a preoccupation with form that had undoubtedly been nurtured by the earlier climate of artistic experimentation.

Abbott's cool and restrained portraits, made in her Paris studio in the late 1920s (plate 122), stress silhouette and neutral, uncluttered backgrounds. Later praised for her "grafting of a European aesthetic" onto American "sturdiness and integrity," Abbott believed that portraiture required "an even more strenuous re-education of the eye than other kinds of photography."[22] She could hardly have avoided coming in contact with modernist precepts during the mid-1920s, when she assisted Man Ray in Paris and spent a year studying photography in Berlin.

PLATE 122: BERENICE ABBOTT (1898–1991). *MARIE LAURENCIN, PARIS*, 1926. GELATIN SILVER PRINT. COMMERCE GRAPHICS LTD., INC., EAST RUTHERFORD, NEW JERSEY.

THE BAUHAUS

Modernism did more than deconstruct conventional ways of representing reality. In theory at least, it was an ideology that permitted women to participate on equal terms in the same experiments, movements, and exhibitions as their male colleagues. A vital impulse in this direction came from the Bauhaus, a school of architecture and design started by Walter Gropius in Weimar, Germany, in 1919; it lasted until the Nazis took power in 1933. Incorporating within its ideological base elements of Russian Constructivist theory and practice, the Bauhaus denied the hierarchy in the visual arts that had conventionally assigned greater merit to painting than to crafts. (Women, of course, traditionally had been more engaged in the crafts than in art.) Stressing the usefulness of the finished object rather than its

decorative aspects, the school encouraged its students to use all media, photography included, with equal facility. It promoted use of the camera as a tool for documenting events within the Bauhaus community and projects in other media, as well as for creating illustrations to be used as elements of graphic design.

That Bauhaus adherents were staunchly anticapitalist yet still used their graphic and photographic talents to promote industrial products seems contradictory, but a profound belief in the efficacy of technology, when controlled by artistic intelligence for humane ends, lay behind this seeming inconsistency. That belief promoted a desire to look at common objects in uncommon ways and to introduce a mass audience to new ways of seeing. (This, in turn, inspired experimentation with images produced by light alone—without lens or apparatus.) One consequence of thinking about photographs as neither exclusively artistic nor stubbornly utilitarian was that numbers of women felt free to make camera pictures during their Bauhaus experience as students or faculty wives. Several appear to have considered photography to be little more than an interesting way of solving class problems, recording school activities, or simply helping their more renowned spouses. Irene Bayer, for example, decided to learn photography "in order to assist her husband [Herbert Bayer] with his work."[23]

The photographs turned out by the Bauhaus faculty and students do not often transcend mere problem-solving experimentation, and women's work was no exception. Only a very few of the women students—who included Gertrud Arndt, Irene Bayer, Lotte Beese (Charlotte Stam-Beese; plate 123), Katt Both, Marianne Brandt, Lotte Gerson, and Lucia Moholy—went on to make full-fledged contributions to the medium. These exceptions were Ellen Auerbach, Florence Henri, Edith Suschitzky (later Edith Tudor Hart), Grete Stern, and the Czech national Irene Blühova, who turned to sociological documentation in her native country after completing her studies at the Bauhaus.

The differing critical treatment accorded László Moholy-Nagy and his wife, Lucia, suggests that the equality promoted by the Bauhaus community may have been more theoretical than actual; certainly it did not penetrate the world outside.[24] In recent years a number of Lucia Moholy's large-scale portraits have been acclaimed for their strong psychological and visual presence (plate 1). However, her part, along with Moholy-Nagy's, in the Bauhaus experiments with photograms (cameraless images), which became such a significant aspect of the school's approach to the study of light, has received little attention. Equally little research has been done on her contribution to the theoretical texts published under Moholy-Nagy's name. There is no documentation in English of her curatorial work on the section of historical photographs in the 1929 *Film und Foto* exhibition in Stuttgart, and her history of photography, published in 1939 and for its time as significant a contribution as the far-better-known work by Beaumont Newhall, has been largely ignored.[25]

Among the few Bauhaus-trained artists who remained committed to the camera as a tool for working out formal problems was Florence Henri. Born in New York to a French father and Silesian mother, Henri spent her early years in England, Germany, and Italy, finally settling in Paris in 1924. A gifted pianist as well as a painter, she was unrelenting in her

PLATE 123: LOTTE BEESE
(CHARLOTTE STAM-BEESE)
(1903–1988). *SPHERES IN GLASS*,
C. 1929. GELATIN SILVER PRINT.
GALERIE RUDOLPH KICKEN,
COLOGNE, GERMANY.

OPPOSITE

PLATE 124: FLORENCE HENRI
(1893–1982). *STILL LIFE WITH
LEMON AND PEAR*, C. 1929.
GELATIN SILVER PRINT. THE
METROPOLITAN MUSEUM OF ART,
NEW YORK; FORD MOTOR
COMPANY COLLECTION, GIFT
OF THE FORD MOTOR COMPANY
AND JOHN C. WADDELL, NEW
YORK, 1987.

BELOW

PLATE 125: FLORENCE HENRI
(1893–1982). *WOMAN WITH THREE
BRACELETS*, 1930. GELATIN SILVER
PRINT. NATIONAL GALLERY OF
AUSTRALIA, CANBERRA.

efforts to adapt the precepts of Cubism and Purism to the camera image (plate 124). Initially intrigued by solving problems of space, volume, and balance using still-life objects, mirrors, and architectural details in the studio, in the 1930s she shifted to portraits, still lifes, and eventually montages that became less rigorously geometric. Her portraits may have been inspired by the large-scale heads done by Lucia Moholy, one of which Henri sat for while attending the Bauhaus (plate 1). Henri sometimes placed her subjects frontally, at other times in reclining or three-quarter positions (plate 125), but often with the head occupying most of the pictorial space.

Frequently reproduced in the better photographic periodicals of the time, Henri's work was also included in the 1929 *Film und Foto* exhibition and shown in 1932 at the Julien Levy Gallery in New York, along with that of Herbert Bayer, André Kertész, Alice Lex-Nerlinger, and Man Ray. Despite being the most prominent photographer to apply the style of late Cubism to the camera image, Henri was ignored for many decades; finally, the upturn in the marketplace during the 1980s initiated a revival of interest in her work, leading to a major retrospective exhibition in 1991.[26]

The Bauhaus was not the sole source of new ideas in photography; Russian Constructivists held similar views concerning the need for a fresh vision. Yet despite the Soviet ideals of equality between the sexes in the workplace, surprisingly few women were involved in efforts to reinvent photography there. Exceptions included Olga and Yelizaveta Ignatovich (the sister and wife of Boris Ignatovich, respectively); all three were influenced by Rodchenko and worked together, signing themselves as the Brigade of B. Ignatovich. Yelizaveta specialized in genre scenes and portraits; Olga eventually became a photojournalist on the *Moscow Evening News.*

DADA AND SURREALISM

During the period of political turmoil in central Europe after World War I, the expressionist pole of modernism became particularly apt for dealing with social and psychological discord. Several Dada artists followed the expressionist route in the late 1910s, using photomontage and collage, which they transformed from a Victorian recreational activity for women with

time on their hands to a powerful means of social comment, especially when used with typography.

Hannah Höch, the only woman in the inner circle of the Berlin Dada group, used photomontage exclusively in 1919–20 to create works that decreed that art was finished at the same time that they rejected traditional middle-class cultural and gender expectations. Optimistic about the potential of technology to improve society, Höch combined mechanically produced camera images from magazines, newspapers, and trade journals (in her words, "elements borrowed from the world of machines") to create a visual analog for the confusions and ironies of European postwar society—in particular, those relating to androgyny and gender attributes (plate 126).[27] That she was well aware of work by women photographers is affirmed by the inclusion in her scrapbooks of annotated magazine images by Margaret Bourke-White, Tina Modotti, and Hedda Walther. Less overtly political than that of Raoul Hausmann and John Heartfield—the better-known progenitors of Dada—Höch's oeuvre was the only Dada work to deal directly with the emergence of the "new woman" and to do so with wit and originality.[28] Seventeen of her montages were included in *Film und Foto*, but as early as 1931 her name had already been omitted from discussions of the origins of photomontage and only recently has her work received the attention it merits.

Another aspect of avant-garde photography was stimulated by the impact of Sigmund Freud and Carl Jung on the intellectual and artistic communities. Surrealism, which embraced these new ideas about the workings of the mind, appealed to artists as a flexible way to express a wide range of perceptions. Women's interest in the subconscious, the automatic, and the unspoken was understandable to the male art world because tradition held women to be inward-looking and more emotional

than rational. Such emotion could be conjoined with social commentary, as is evident in Alice Lex-Nerlinger's suggestive montage of the wearisome labor of the seamstress (plate 127).

That customary ideas about the female personality might be simultaneously evoked and countered in a single visual image is apparent in *Cat and I* by Wanda Wulz (plate 111). Allied initially with the Italian Futurists, for whom machismo was a given, Wulz played with the convention of woman as inconstant by presenting a half-human, half-feline figure. Suggestive of the changeability of all human nature in its combination of sleekness and malevolence, Wulz's seamless montage also alludes to woman's supposed cattiness.

Surrealism appealed to artists seeking to counter the abstract spatial formulas of Cubism with a sense of the eternal and the mysterious. Among the women drawn to this combination of rationality and intuition, Lee Miller is probably best known, although by no means unique, in that regard. Born in the United States, trained in the arts, and experienced as a model for Edward Steichen and Arnold Genthe, she arrived in Europe in 1929 to become assistant and model for Man Ray. In this role, she claimed to have accidentally stumbled on the solarization effect that he was to use so effectively.[29] Her own work, comprising some forty thousand negatives, has a chameleon-like quality—sometimes distinctive, sometimes simply eclectic. Eventually, when Miller was commissioned by *Vogue* magazine and the United States Army to photograph concentration camps at Buchenwald and Dachau, the surreal terrain of her imagination coincided with the horrors of the real world; these images remain her most forceful statements (plate 175).

Less celebrated than Miller were Eileen Agar, Claude Cahun (Lucy Schwob), Winifred Casson, Edith Gérin, Jacqueline Lamba, Emily Medkova, and Meret Oppenheim, all of whom followed the Surrealist muse with equal ardor. Lamba, involved with the French Surrealists between 1935 and 1945 (and married to André Breton), was published in the first issue of the American cultural review *VVV*. Nusch Eluard (Maria Benz—wife of the Surrealist writer Paul Eluard) and Dora Maar (born Theodora Markovic)— both experimented with distortion and unusual juxtapositions in direct camera images and in collage (plate 128). Each produced an occasionally arresting image, but no sustained body of definitive work. During the early 1930s Cahun was active in Paris with Breton and Georges Bataille in the Surrealist collective Contre-Attaque, and she contributed to the ongoing debate within the group about the interrelationship of artists, intellectuals, and revolutionaries. In the 1940s the fact that she was Jewish and a lesbian, combined with her resistance activity against the Nazis on the Isle of

Jersey (to which she had moved in 1939), led to her incarceration, about which little is known. Cahun's photomontages (plate 129), along with their accompanying texts (by herself and others), present the female body as a biological entity rather than the erotic object so frequently celebrated in the work of male Surrealists. Recently rediscovered, Cahun's work has been embraced by contemporary feminists as deeply complex in terms of its relationship to "the symbolic order [of] language, reason, custom."[30]

In England—usually thought of as less welcoming to avant-garde ideas—the dreamlike aspect of Surrealism appears to have filled the vacuum left by the demise of old-fashioned Pictorialism. By the late 1920s a group of British photographers inspired by experimental graphic art being done on the Continent briefly embraced Surrealist strategies. Among the women in the group, Barbara Ker-Seymer began a series of negative portrait prints (plate 130), working with the Surrealist painter John Banting (a friend of Man Ray); these were considered to reveal "a mystical light of purity."[31] Eileen Agar photographed the strange natural formations of the ancient stones of Ploumach in Brittany to conjure up a world of forceful beasts and delicate figures; such images can be read as a comment on the relationship between the sexes. Winifred Casson, stimulated by the work of Jean Cocteau

BELOW

PLATE 128: NUSCH ELUARD (1906–1946). *BOIS DES ILES*, C. 1936. PHOTO-COLLAGE, 5³/₈ X 3³/₈ IN. (13.7 X 8.6 CM). TIMOTHY BAUM, NEW YORK.

OPPOSITE

PLATE 129: CLAUDE CAHUN (1894–1954). *UNTITLED*, 1936. GELATIN SILVER PRINT. SAN FRANCISCO MUSEUM OF MODERN ART; GIFT OF ROBERT SHAPAZIAN.

and Giorgio de Chirico, experimented not only with avant-garde techniques such as solarization and hand coloring but also explored the ideas of alienation and displacement that were central to Surrealism.

The allure of Surrealism was short-lived for most of the women photographers who experimented with it; few other than Cahun produced definitive bodies of work in this mode. Casson worked as a photographer for only about five years. Ker-Seymer soon returned to straight portraiture. Madame Yevonde, who had recognized the potential of Surrealism for selling products, superficially incorporated its props into her publicity photographs, as did her British contemporaries Angus McBean and Peter Pulham.

Expressionist photographers recognized that in capturing the traces of motion they could suggest heightened reality without resorting to manipulative techniques, which some rejected as extraphotographic means. Attempts to portray time and motion became an especially significant aspect of expressionist photographs of the dance and drama by the Vienna-based photographer Charlotte Rudolph (plate 131). Rudolph wished to convey the energy and trajectory of dance movement without resorting to the double exposures and montage techniques that would later engage Barbara Morgan (plate 230). Although not the only female dance photogra-

pher working in Europe between the wars—Ida Nappelbaum, Lotte Jacobi, Ursula Richter, Anna Riwkin, and Merlyn Severn also were so engaged—Rudolph may have been the most influential, laying the groundwork for Morgan's work of the late 1930s and even for the contemporary work of Lois Greenfield (plate 260).

ADVERTISING

A number of European women found jobs and commissions in advertising and photojournalism. With the gap between art and utility narrowed by the Bauhaus, expressive photographers eagerly sought useful applications for their ideas. They were fortunate in that both the veristic and expressionistic aspects of modernism seemed custom-made for the advertising and publicity industries that were emerging in the 1920s. The veristic approach enhanced the tactile qualities of ordinary objects—animate and inanimate—through sharply defined close-ups and presentation under new and different light, while the expressionistic approach could

PLATE 132: ELLEN AUERBACH
(BORN 1906). *THREADS*, 1930.
GELATIN SILVER PRINT. COURTESY
OF ROBERT MANN GALLERY,
NEW YORK.

evoke deep-seated longings for personalities and products. Photomontage played an especially important role in advertising—one that remains viable to this day.

The preference for photographic rather than graphic images evinced by advertising agencies in the late 1920s and early 1930s was based on their "element of surprise and the power to carry conviction."[32] Advertising photography was promoted in Germany by the publishing empire known as the House of Ullstein, which needed good photographs to illustrate the ads in its numerous magazines and advertising brochures. For women, advertising was one of the most difficult branches of the medium in which to succeed because, as the photographer Germaine Krull noted, agencies for selling photographs "seem to have been reserved for men."[33] Nonetheless, a pioneer of the new commercial photography was Elsbeth Heddenhausen, director of the photographic studio for the Ullstein publishing enterprise.[34] The increase in advertising in Germany in the late 1920s and early 1930s made it possible for a number of women to achieve renown in the field. Among them were the former

Bauhaus students Ellen Auerbach (plate 132) and Grete Stern (plate 133), who formed a Berlin studio known as "foto ringl + pit" in 1930 and later became partners in a studio in London. The two were acclaimed by one critic for their "inborn womanly instinct for the delicate nuances of textiles"; a contrasting view held that their images provided a "characteristic" rather than a "flattering" (that is, feminine) look at such stuffs.[35]

Although not associated with the Bauhaus, Aenne Biermann, working in Gera, Germany, was perhaps the most resolute in her devotion to the appearance of the object.[36] Her advertising images, whether of organic or manufactured objects, transformed those substances into seductive enticements. Florence Henri, working in Paris, adapted her configurations of spheres and mirrors into arresting designs using Lanvin perfume bottles and other products, although it is not clear whether these images were actually used as ads.[37] Nora Dumas joined her husband in the Parisian studio Dumas-Satigny to supply a range of advertising images; Laure Albin-Guillot, considered the doyenne of French women professionals by the 1930s, also supplied such images to agencies and periodicals.

She, Ilse Bing, and Genia Reinberg were recognized in the 1930s by Emmanuel Sougez (the influential art director of *L'Illustration*) as having greatly contributed to the vigor of French advertising imagery. In England the work of Joan Craven, one of the relatively few British women besides Madame Yevonde involved in advertising during the 1930s, was acclaimed for its dramatic lighting and unusual compositional strategies. Whether she was as adept as the leading male photographers of the period—Cecil Beaton and Edward Steichen—is difficult to ascertain because their images are well documented and often emulated, whereas hers have been ignored.

The modernist style could be easily adjusted to the needs of the product, as can be seen in the work produced by Atelier Yva, a Berlin advertising studio run by Else Simon (known as Yva). Using all the strategies of the genre, she softened forms and edges to suggest a kind of velvety opulence when dealing with luxury products such as jewelry or perfumes (plate 134), but employed crispness for articles such as glassware and men's clothing. Yva could also adapt the precepts of expressionism when appropriate, as in images depicting a number of views taken from different angles and mixed-up levels. Called "synoptic" photographs, they presented an "everchanging appearance of the object . . . captured within the compass of a single . . . representation."[38]

Interest in modernist advertising was promoted by exhibitions as well as by articles in trade journals and specialized magazines.[39] The *Exhibition of Foreign Advertising and Industrial Photography*, organized in New York City in 1931 by advertising executive Abbott Kimball, was one of the first to bring the work of Trude Hamburg, Florence Henri, and Germaine Krull to the attention of Americans; it was soon followed by others. The concepts and vocabulary of both the veristic and expressionistic aspects of modernism were conveyed

PLATE 134: YVA (ELSE SIMON) (1900–1942). *HANDS STUDY*, C. 1920. GELATIN SILVER PRINT. SAN FRANCISCO MUSEUM OF MODERN ART; PURCHASE.

throughout Europe and the United States at least in part by photographic magazines. In the late 1920s and into the next decade, well-designed and skillfully printed annuals— among them *Modern Photography, Das deutsche Lichtbild,* and the *Photographies* issue of *Arts et métiers graphiques*—brought the work of women photographers to readers on both sides of the Atlantic. For instance, from 1931 to 1933 *Das deutsche Lichtbild* reproduced the work of some thirty-six women, mainly from Germany and Austria; the British and French publications also on occasion included the work of women from central Europe.

PHOTOJOURNALISM

By the late 1920s the upswing in popular journals, with their illustrated news and "human interest" stories, in combination with the advent of the 35 mm camera (invented in 1913 but not marketed until 1925), had transformed news photography into photojournalism. No longer used just to illustrate the written texts, photographs—frequently laid out in sequences depicting a number of aspects of a situation—now carried the narrative and evoked the emotional response. Photojournalism was interconnected with the other genres of the period, such as portraiture and advertising. For example, the new magazines appearing in Europe in the late 1920s began to fill their pages with images of celebrities from sports, high society, and the theater. This meant that taking portraits of the famous became a viable profession for a large number of photographers, male and female. Nor would advertising photography have been able to come into its own had not improved technology made picture stories in magazines easier to look at. Of even greater significance is the fact that advertising frequently covered the expenses of picture journalism; the cost of publishing the *Berliner illustrierte Zeitung,* for example, was "about ten percent higher than the income from sales"; the shortfall was more than offset by advertising income.[40]

The relatively minor role of women in the expanding area of photojournalism in Weimar Germany was interrupted because the onset of Nazism radically altered both editorial policy and the attitudes toward women professionals. Those who had begun to make names for themselves in the field were forced to look elsewhere. Ursula Wolff Schneider's picture stories, which revealed how the Nazi government manipulated public opinion between 1931 and 1934, have completely disappeared. Eva Besnyö and Edith Suschitzky (later Edith Tudor Hart) found magazine work in Holland and England, respectively; Yolla Niclas and Marion Palfi sought new lives and work in the United States. Also forced to move on were various women who performed editorial tasks for German magazines. Vilma Frielingsdorf was the photography editor at one of the Ullstein publications, and Lily Becher (also called Lily Corpus) edited the leftist periodical *Arbeiter illustrierte Zeitung (AIZ).*

AIZ, one of the few magazines not dependent on advertising, was distributed in nations with German-speaking majorities and minorities; it made frequent use of images produced by members of workers' photography clubs. Set up in 1926 under the auspices of Workers' International Relief, a short-lived international front organization of the Comintern, these clubs eventually existed throughout central Europe, the Low Countries,

England, and the United States; their purpose was to promote camera work with a proletarian point of view that would counter the middle-class bias of mainstream imagery. Women were among the club members, but little attributable work by them has been preserved.

The small camera, in particular the Leica, turned the casual and the spontaneous into an intrinsic aspect of photojournalism. Germaine Krull was one of the first to transform that new potential into publishable picture stories. In the late 1920s she began an association with the recently started French picture publication, *Vu.* Her reportage on a wide variety of subjects, from fashion and industrial sites to portraits and nudes, demonstrated that such options were now open to women photojournalists. As photojournalism evolved in France, it took on different characteristics from the German version: images did not necessarily carry a narrative but at times were revelations of singular moments in time, captured because the photographer found something unusual or ineffable in a particular scene or facial expression.

For Krull, shooting in the field with a small camera turned out to be more satisfying than studio work; for the remainder of her career she worked as a photojournalist, fol-

lowing the Allies' thrust from southern France to Alsace in 1944, then traveling to Southeast Asia in 1945, where for the next fifteen years she was a war correspondent. Like many other Europeans whose lives were disrupted by the chaos of the war years, Krull lost her early negatives, which disappeared after she stored them with a colleague when she left France for Rio de Janeiro in 1941. This may explain in part the relative obscurity of a figure who was judged by Henri Cartier-Bresson to have "opened new roads" for a generation of photographers.[41]

Ilse Bing, who was dubbed "Queen of the Leica," compared the camera to a musical instrument, upon which "one must play . . . sympathetically."[42] Born and educated in Frankfurt, Bing was another of the wave of foreign photographers who invaded Paris in the late 1920s, remaining there until she emigrated to the United States in 1941. In her earliest photojournalistic work, images, text, and layout tell the story, with the captions nailing down the details. After her contacts with avant-garde artists and photographers in Paris, she reassessed the medium, concluding that the image itself could express ideas and feelings without relying on descriptive texts (plate 135). Bing's picture stories appeared frequently in German and French periodicals between 1929 and 1935, but after the war she found that while magazine photography was becoming a true profession, "publications preferred men to women photographers."[43]

Rogi André and Nora Dumas also were attracted to the new photojournalism as it developed in France. Using a Rolleiflex camera to stalk subjects on the streets of Paris, André was interested in more than commercial success; when she later introduced this equipment to the young Lisette Model, her instructions were not to photograph anything unless she was completely absorbed by the subject.[44] Dumas applied her modernist vision to the most traditional of themes (plate 136); her pictures of French peasantry often suggest the influence of contemporary cinema in the unusual angles and vantage points used to frame the farm animals and implements she captured on film.

Marianne Breslauer, another devotee of the small camera, began her career as a photojournalist with a story about Parisian life along the banks of the Seine (plate 137) for the women's supplement of the *Frankfurter Zeitung* in 1929. From then until 1937, when she became an art dealer, Breslauer worked for a variety of periodicals, first in Germany and later in Switzerland. Her interest in expressive gesture conferred upon even her early images a welcome offhandedness that counteracted the conspicuously designed quality apparent in so many modernist photographs. This casualness became more pronounced in Breslauer's magazine work done in North Africa, the Near East, and Spain during the 1930s. A similarly spontaneous approach to everyday life characterized the work of Margarete Willinger, which was reproduced in several English and German annuals of the

PLATE 137: MARIANNE BRESLAUER
(BORN 1909). *PARIS*, 1929.
GELATIN SILVER PRINT. COURTESY
OF BERLINISCHE GALERIE, BERLIN;
PHOTOGRAPHIC COLLECTION.

1930s before she and her photographs vanished from view. Other European women journalists traveled extensively, and often to exotic locales. During the 1930s Hélène Hoppenot photographed in China, Thérèse LePrat and Denise Colomb in Indochina, and in 1940 Gertrude Blom worked in Mexico. In Sweden, Russian-born Anna Riwkin turned away from her specialization in dance photography in the late 1930s to become a much-traveled photojournalist specializing in children's activities throughout the world.

In Great Britain the situation in photojournalism was initially less welcoming for women. Up until World War I, photographs had generally been used in British magazines as single illustrations rather than as sequential stories. At times women were commissioned to provide pictures related to "women's issues"—domestic life, childhood health care, education,

and home decoration (but not usually fashion). Just prior to 1914 Nora Smyth, merging her involvement in the feminist movement with an interest in documentary photography, provided suffragist and other journals with pictures of women's lives.

The situation in England changed with the arrival of experienced German émigrés of both sexes. In the late 1930s Edith Tudor Hart (born Edith Suschitzky) became one of the more successful documentarians cum photojournalists; her images of slums, children's health facilities, and refugees began to appear in a broad range of British journals and publications soon after her arrival from Germany earlier in the decade. Some ten years later her work was featured in the magazine *Picture Post*, an internationalist publishing venture of liberal outlook, which employed refugees from Germany as editors and reporters when it first won notice in 1938. Unusually receptive to work by women photographers, *Picture Post* gave free-lance work to Gerti Deutsch, also a refugee. During the 1930s and especially during World War II, the "woman's eye" was seen to be more optimistic and arresting in dealing with ordinary events.

The burgeoning need for photographic illustration in publishing brought into being picture agencies in several major cities. The most famous in Paris—Alliance-Photo— was created in 1934 by Pierre Boucher, René Zuber, and Maria Eisner. Another wanderer who settled in France in the early 1930s, Eisner had been born in Milan and educated in Germany; she worked in Berlin as a photo researcher for the review *Atlantis* until the Nazis came to power and she was forced out of her job. Under her direction, Alliance-Photo—the forerunner of Magnum, which she later established in her Paris apartment after World War

II—was so well run that it assured the renown of its photographers both in France and elsewhere. Gerda P. Taro (born Gerda Pohorylles) was associated briefly with the agency before departing for Spain to film battlefield action. Denise Bellon, whose career as a photographer did not start until the 1930s, saw her work appear in *Art et médecine, Coronet, Lilliput*, and *Paris-Magazine*, as a result of her association with the agency. Like the other members—among them Pierre Boucher; Suzanne Laroche and her husband, René Zuber; and Juliette Lasserre— Bellon approached her subject matter with a modernist's eye, but a strong attraction to Surrealist strategies gave her commissioned work an atypical emphasis on the incredible (plate 138). Laroche (at times working with her husband) supplied travel and eventually fashion images. Lasserre, who had attended photographic school in Berlin and then worked in

Paris for Krull, provided the agency with a range of material.

The blurring of the line between art and applied photography, always a somewhat ambiguous distinction, enabled European and United States women to consider their journalistic and commercial work as part of the mainstream of modern art rather than as merely disposable applications of camera technology. In consequence, they submitted both commissioned and personal work to the major photography annuals and sought to have it exhibited at galleries and expositions where modern photography was shown.

THE NUDE

The nude was a subject that attracted many independent European women of the interwar period. Feminists now may regard the female nude as a voyeuristic object for males or as a totem of self-discovery for themselves, but women photographers of the modernist era considered the unclothed female (and on occasion, male) figure to have the same interest as any other animate or inanimate object.[45] Not only was photographing the nude an assertion of their right to portray the same subjects as their male counterparts, it also embodied a revolt against Victorian attitudes about modesty and passivity. In 1930 the left-leaning Krull, for example, issued *Etudes de nu*—twenty-four studies of nude figures, made because she came to the sudden realization that the nude figure was a thing of beauty. Even earlier, Danish photographer Mary Willumsen had issued a series of postcard-size images of nude and partially clothed women. Taken at a female bathing establishment in Copenhagen between 1914 and 1922, they combine spicy eroticism, humor, and romanticism. Nelly (Elli Seraïdari), who wanted to infuse Greek society with more modern concepts of womanhood, photographed the dancers Nikolska (plate 139) and Mona Paiva, both veiled and in the nude, on the Acropolis; one of her images was reproduced in the French magazine *L'Illustration*.

Judging from the examples reproduced in the photographic journals of the period, the British photographers Joan Craven, Yvonne Gregory, and Dorothy Wilding (plate 140) were obviously drawn to this theme. From similar sources, one recognizes that the French photographers Laure Albin-Guillot, Nora Dumas, Florence Henri, and Ergy Landau, as well as the German photographer Yva, also produced nudes. Gertrude Rösslerova, who had apprenticed with Frantisek Drtikol before marrying photographer Jaroslav Rössler, was one of the few Czech women to photograph the subject.

The discreet poses and the carefully adjusted lighting employed on occasion to soften the nude form and create atmospheric effects suggest that a number of these photographers were looking backward to the Pictorialist style even as they sought to establish their modernity by choosing this subject. Most treated the body as an aesthetic object and some avoided depicting the face of the model. Some circumvented the problem of salacious appeal by providing the nude image with a narrative context; Pandora and her box was a favorite theme. Compared with the purely aesthetic treatments of this subject by Edward Weston, for example, nude images by Dumas, Henri, Krull, and Yva retain a human dimension in their depiction of the softness of flesh.

In the mid-1930s, in the face of increasing political instability and repression, European artists (photographers among them) began making their way westward and ultimately across the Atlantic. By 1939 many of those who had lingered were propelled in the same direction by the no-longer-avoidable realization that Europe was once again on the brink of war. On reaching the Western Hemisphere, ideas about camera work that had been nurtured in Europe were transformed to accord with the very different histories and circumstances of countries as disparate as Argentina, Canada, Chile, Mexico, and the United States. Women played a significant part in this process, achieving renown as practitioners, teachers, and role models for a generation of American women.

PLATE 140: DOROTHY WILDING (1893–1976). *THE SILVER TURBAN*, C. 1930. GELATIN SILVER PRINT. ROYAL PHOTOGRAPHIC SOCIETY, BATH, ENGLAND.

CHAPTER 6

PHOTOGRAPHY BETWEEN THE WARS: NORTH AMERICA, 1920–40

On the eve of the modernist era, an American commentator declared it "beyond dispute . . . that female intelligence and appetite have taken full possession of the field [photography] . . . , not only among amateurs, but in the ranks of professional and pictorialist as well."[1] This unusual assertion was related to a larger truth: in the United States women had been a major element in the reform coalition that had awakened the nation to social and feminist issues before World War I. After the war, however, perceptions of women's role changed again. With the nation traumatized by inflation, labor unrest, and fear of Bolshevism, women became less visible in public discourse and their specific needs were ignored. In photography, for example, a 1927 article in a prestigious annual on the status of professional activity in the United States omitted any discussion of women, although images by a dozen or so were reproduced.[2]

On the one hand, women recognized that events had "liberated [them] . . . from old molds and stereotypes."[3] Their presence in labor and the professions continued to increase, their educational opportunities to expand, they were able to participate in social and recreational activities formerly considered the exclusive province of men, and as the decade progressed they gained previously unheard-of personal freedoms. Indeed, Frances Benjamin Johnston would only have had to don more up-to-date garments to make her ironic self-portrait as "the new woman" of the 1890s (plate 49) applicable to the postwar era; smoking and drinking in public, showing ankle (and knee), and competing in business and politics were becoming acceptable behavior for women.

On the other hand, despite gaining such personal freedoms, American women still found that "even the least prejudiced" men were not able, as one writer put it, "to think the feminine past"—that is, to pay serious attention to the contributions women had made.[4] The reasons advanced for this indifference are varied. Some observers blamed the refusal to take female social objectives and contributions seriously on women's defiant demeanor, on their newly revealing mode of dress, and on their desire to work side by side with men. Others scorned women as having been "hypnotized by advertising, leisure, and luxury," and having chosen to live without "ideals."[5] To still others, the era's passionate interest in Freudian psychoanalytic theory was responsible for a male obsession with women as sex objects rather than as intellectual or professional powerhouses. According to one authority on the period, the conjunction of aggressive women and greater knowledge about psychosexual matters triggered a panicked reaction among males, who then turned a blind eye to women's other real needs

and desires.[6] Whatever the rationalizations, while women were gaining unprecedented freedoms (including the right to vote) public and critical attitudes toward their "feminine" virtues seemed to become less accommodating.

These contradictions became evident in photography in various ways. At the same time that women photographers saw their numbers increase and commercial possibilities expand, the empathetic qualities that formerly had been highly valued in photography ceased to be considered important. Gone were the exhortations to enter the field and transform camera expression into an aesthetic experience rather than a utilitarian trade. Gone, the accolades heaped on their idealizing vision. In this new era, as women abandoned demure manners and restrictive garments, they also turned their backs on the "note of grace and femininity" formerly expected of their photography and, indeed, of their contribution to society in general.[7] Instead, during the prosperous years of the mid-1920s women photographers began to demand "recognition as individuals first,"[8] coming closer to attaining what Catharine Barnes Ward had advocated almost a half-century earlier when she asked to be judged as a photographer first and a female second.

This is not to claim that women had by any measure achieved parity with male photographers or that the same opportunities existed for them as for men. Far from it: their pay and their working conditions were still not equal, and as late as 1937 an all-female photography salon was proposed because some camera clubs still barred women from membership. Nevertheless, the gains that had been made during the previous quarter-century (1890–1915) were too significant to be obliterated. In fact, the perception arose that women's photographic accomplishments had become such an accepted fact that they no longer required special nurturing.

Increasingly, women were being offered jobs in photography, as indicated by Clarence White's call for them to apply for work in museums, medical and technical institutes, newspapers and periodicals, advertising, and government agencies.[9] Growing numbers of women free-lanced as photographers for architects and galleries, and by the 1930s several women who had been active as journalists and portraitists earlier in the century were considered outstanding as documenters of houses and gardens. Numerous women continued to take up photography as a medium for personal expression and to participate in camera clubs and Pictorialist salons. This involvement with the medium in a wide variety of commercial applications and on differing levels of personal expression made women's work of the interwar period exceptionally rich and suggests anew that the medium itself was particularly adaptable to changing social roles and needs.

PORTRAITURE

Despite the spread of the snapshot and of department-store photo studios, commercial portraiture remained an option for single and married women, especially in rural communities. Prewar ideas often held sway in this branch of photography; for example, women were still

PLATE 142: ELISE FORREST HARLESTON (1891–1970). *PORTRAIT*, N.D. GELATIN SILVER PRINT. PRIVATE COLLECTION.

advised that photography was "one of the most pleasant professions . . . especially appealing to the wife and mother who longs to make money independent of her husband's earnings" and yet "not neglect her home."[10] Another prevailing idea was that "in no other profession could a wife be as much assistance to her husband without technical knowhow," and women became increasingly active partners in "mom-and-pop" studios.[11]

In the South, especially, these relatively unsophisticated ventures offered the sole opportunity at this time for African-American women to become professional photographers. Two examples indicate the nature of these enterprises. At the Teal Portrait Studio, which existed in Houston from 1919 to 1965, Elnora Teal was in charge of the studio sittings, while Arthur Teal traveled throughout the state to take photographs in black college communities. A studio opened in 1922 by Edwin and Elise Forrest Harleston in Charleston, South Carolina, was less typical in that Mrs. Harleston, who had studied the medium in New York City and at Tuskegee Institute, took the photographs (plate 142), and her husband turned out both painted portraits and genre scenes—either after or directly upon the camera image. While Edwin Harleston's work was acclaimed, Elise's contribution went unremarked.

In a few instances African-American women were able to run urban portrait studios on their own. Winifred Hall Allen took over a flourishing business in New York's Harlem, taught her husband the necessary techniques, and documented the faces and streets of the neighborhood before retiring to another profession in 1950. By 1930 more than a

hundred black women were listed as portraitists across the country.[12] A small number of African-American men had earlier found employment in photographic areas other than straight portraiture, but not until serving in the military during World War II were black women able to gain the training and experience needed to enlarge their professional vistas.

Camera portraits of celebrities had been a feature in American magazines since just before the opening years of the century, when Frances Benjamin Johnston and Gertrude Käsebier, among others, had supplied them to periodicals. After World War I, improvements in printing techniques made celebrity images even more popular—and even more profitable for photographers. During the 1920s producing celebrity portraits usually required investment in a studio with sophisticated camera and lighting equipment and assistants, which in turn required doing enough business to warrant such an outlay, so anyone who maintained a practice in this field must have reached a high level of accomplishment. Men provided most of these portraits, but work by Helen MacGregor, Marcia Stein, and Florence Vandamm was bylined in *Vanity Fair*. Like Alice Boughton, who remained active

into the 1920s, Vandamm specialized in all aspects of theater activity (as did her husband,
George R. Thomas—who took up the medium on his wife's recommendation). She usually
did the studio sittings (plate 143), he, the location shots, but it was her by-line that virtually
guaranteed acceptance by drama editors of the period.

Portraiture remained the starting point from which many women later branched
out into quite different kinds of work. Berenice Abbott, Imogen Cunningham, Laura Gilpin,
Dorothea Lange, Jane Reece, and Doris Ulmann all began their careers in studios either
owned by themselves or others before finding a chance to expand in other directions. For oth-
ers, straight portraiture remained the most congenial and the most remunerative of undertak-
ings. Some ascribed larger significance to portraiture. Clara Sipprell, who opened a portrait

studio in Greenwich Village in 1915 and made most of her income from this activity, was convinced that her efforts to "suggest pictorially a meaning of wider significance" than mere physical appearance entitled her to think of herself as a Pictorialist.[13]

Doris Ulmann first discovered her own voice by making portraits of contemporary literary figures in her social circle. Renouncing the conventional landscape subjects favored by her husband, Dr. Charles H. Jaeger (a then-admired Pictorialist), during the early 1920s she worked in her well-appointed Park Avenue apartment for pleasure rather than for profit—that is, she regarded portraiture as a means of expressing her feelings rather than of accommodating the sitter's needs. When this subject matter ultimately proved unsatisfying, she took herself to the Appalachian Mountains (plate 144) and the South Carolina coast in search of more meaningful human visages. In seeking "a face that has the marks of having lived intensely, that expresses some phase of life, some dominant quality of intellectual power," Ulmann's intent was not only to explore the expressive potentials of the medium in the tradition of Julia Margaret Cameron and Käsebier but also to conserve what she construed as an indigenous American heritage.[14]

In recording the passing way of life among those of English and Scots-Irish ancestry whose families had settled in Appalachia in the eighteenth century, Ulmann created an idealized portrait of a people, their customs and their artifacts. Her undertaking forecast the rising interest in regional American culture, which produced such works as Allen H. Eaton's book *Handicrafts of the Southern Highlands* (1937), for which Ulmann supplied the photographic illustrations. North Carolina portrait photographer Bayard Wootten was inspired to embark on a similar project in the same region during the mid-1930s (plate 145).

The notion that women portraitists were more sympathetic than men still held sway, even among photographers. Dorothea Lange arrived without resources in San Francisco in 1918, and by the following year she was able to open her own portrait studio and bask in the acclaim of the region's most prestigious journal; in 1919 she was quoted as saying that portraiture was "a profession to which women are especially adapted."[15] At the same time Imogen Cunningham, who had entered the field earlier in Seattle, when taking professional portraits in the home was still a highly regarded innovation, denied any special feminine talent for portraiture, claiming that excellence in this area was "a matter of individuality, not of sex."[16]

Taken as a whole, studio

PLATE 145: BAYARD WOOTTEN (1875–1959). *HANDS OF NELL COLE GRAVES, STEEDS, NORTH CAROLINA*, 1930S. GELATIN SILVER PRINT. NORTH CAROLINA COLLECTION, UNIVERSITY OF NORTH CAROLINA LIBRARY, CHAPEL HILL.

portraits produced by illustrious American women certainly equaled and in some cases surpassed the work of their male colleagues. With the exception of Edward Steichen's dramatic publicity images for *Vogue* and *Vanity Fair*, the portraits turned out in New York by the Bachrach family, by the acclaimed Arnold Genthe, by Pirie MacDonald, even by Carl Van Vechten are no more formally inventive or psychologically penetrating than those by women.

PICTORIALISM

Modernism took hold in the visual arts in the United States during the 1920s as it had in Europe, but in terms of the photographs produced by women as personal expression, it did not immediately vanquish the Pictorialist vocabulary. Instead, new ideas seeped into the lexicon slowly, resulting at first in sharper definition, then in less-conventional subject matter, and finally in forays into experimentation. The stately pace of the transformation may have been due in part to the perception that women's intuitive feeling for beauty, which had been influential in establishing the Pictorialist style, continued to characterize their work even after it was no longer a fashionable attribute.

Some women may have been loath to change aesthetic gears abruptly because of their warm welcome in the organization known as the Pictorial Photographers of America (PPA). Founded in 1916 by Clarence White and Margaret Rhodes Peattie, and numbering among its members Alvin Langdon Coburn and Gertrude Käsebier, this group sought to counter what they perceived as the extremes of modernist art expression promoted by Alfred

Stieglitz and Paul Strand. The club's supporters adhered to compositional ideas that had been considered advanced when elucidated earlier in the century by protomodernists such as Arthur Wesley Dow, but they also held beauty to be of paramount significance in pictorial expression. Guided by White's egalitarian, socialist principles—the same that had made his school so agreeable for female students—the PPA generated a hospitable atmosphere for women that prevailed even after the founder's death in 1925.

As explained by White's successor, Ira Martin, the "high standing" that women had achieved in Pictorialist photography was due to their special "psychology." Martin believed that a specifically female visual sense enabled them to communicate their inner visions in a simple, beautiful, yet individualized and contemporary way. In what must be taken as a slap at the modernist photography establishment, Martin advised women not to rely on male colleagues for critical reaction to their work because such "'fathers' . . . have no sympathy for anything that is not the accepted type."[17] Not every member shared Martin's belief in the uniqueness of

female inspiration. Laura Gilpin, an energetic supporter of the modernist style and a member of the PPA, saw no difference between the work of men and women. While admitting that the medium "fits women very well," she insisted that quality had nothing to do with gender—"either you're a good photographer or you're not."[18]

That women did find a haven in the PPA is confirmed by the large numbers who consistently submitted work to the association's exhibitions. Many were alumni of the Clarence White School; in an exhibition in 1925 of the work of former students, fourteen women and four men were represented. Between 1920 and 1929, sixty-one women accounted for about one-third of the contributors to the association's annual, *Pictorial Photography in America*—a generous representation in comparison with other journals of the time. Photographers as disparate in their goals and styles as Marjorie Content, Cunningham, Gilpin, Margrethe Mather, Kate Matthews, Jane Reece, Clara Sipprell, and Ulmann all made images available for publication throughout the 1920s. Less well known women—among them Antoinette Hervey, Sophie Louisa Lauffer, and Stella Simon (plate 146)—not only were represented in the publication but also served on the various committees that governed the group. In 1934 Hervey, whose own photographic project centered on recording the Cathedral of Saint John the Divine in New York, became honorary vice-president, a position previously held by Käsebier.

The work by the women in the association spans a wide spectrum of styles and themes. They range from conventional costume and genre pieces by Matthews (who had been photographing inspirational southern genre scenes since the 1880s); to semiabstractions by Content, whose admiration of Stieglitz is clearly visible in her cloud pictures (plate 147); to evocative landscapes by Marie Riggins (whose 1943 Ph.D. dissertation was on modern photography); to spare landscapes by Gilpin. Lauffer, who had taken up photography to prove to herself and to her male camera-club associates in Brooklyn that "a woman could show something better," eventually became an expert in color printing using the complicated carbro process.[19]

Of course, the American Pictorialist camp encompassed a much wider con-

stituency than just the PPA. In the more conservative camera clubs and salons throughout the nation, women generally accounted for about 10 percent of the amateurs who participated in the regularly held exhibitions; one, Eleanor Parke Custis, was considered the second most

prolific salon contributor in the country. Women tended to submit genre images, portraits, still lifes, and animal pictures, while men's offerings inclined toward portraits, landscapes, and industrial scenes. In the First Annual National Photographic Salon for Women, held in Philadelphia in 1937, and in numerous other exhibitions of Pictorial photography, subjects ranged from portraits and images of dolls, such as that by Ethel M. Smith (plate 149); to canine portraits by Rowena Brownell; to fruit-filled still lifes by Christine B. Fletcher (plate 150); and landscapes by Virna Haffer. Reproduced frequently in American and European Pictorialist journals such as *Camera Craft* and *Modern Photography*, these images indicate the differing levels of sophistication and accomplishment among American women photographers. Many works undoubtedly were shallow and sentimental, but some did transcend the limitations that characterize naive art in any medium.

The hardiness of genre imagery as a category in salon entries up through the 1940s surely can be attributed to women. Those working in rural communities especially must have seen in such images both a statement of the medium's artistic potential and a means of income, minor as it undoubtedly was. Besides the work of Nancy Ford Cones (plate 57), which had become commercially successful in the 1920s, that of Katherine Bingham and Emily H. Hayden garnered praise in the traditionalist journal *Photo Era*. Perhaps the most accomplished practitioner of this kind of *retardataire* imagery (plate 148) was the photographer Minna Keene, who was the first Canadian woman to become a full member of the Royal Photographic Society of Great Britain. Keene attributed her choice of photography as a medium of expression to the fact that it called for "an appreciation of line and space, patience and practice,"[20] but the still lifes, portraits, and interior scenes that she produced from the early 1900s onward clearly reveal the distance between what was considered praiseworthy in provincial communities and in sophisticated photography circles.

On this level of Pictorialism most of the photographs by women were as lacking in aesthetic merit or human insight as the work submitted to the salons by male amateurs. Such parity, however, did not prevent some camera clubs from barring women, and those barriers surely account for attempts in the 1930s and 1940s to organize women-only salons. Mixed and single-gender Pictorialist

OPPOSITE, TOP
PLATE 148: MINNA KEENE
(1861–1943). *ELIZABETH,* C. 1924.
GUM PRINT. PHOTOGRAPHIC HISTORY
COLLECTION, NATIONAL MUSEUM OF
AMERICAN HISTORY, SMITHSONIAN
INSTITUTION, WASHINGTON, D.C.

OPPOSITE, BOTTOM
PLATE 149: ETHEL M. SMITH
(1886–1964). *MARCH,* C. 1945.
GELATIN SILVER PRINT. THE
MINNEAPOLIS INSTITUTE OF ARTS;
GIFT OF ELSIE MASON.

ABOVE
PLATE 150: CHRISTINE B. FLETCHER
(BEFORE 1900–AFTER 1945).
MUSCATS, C. 1938. CHLORO-BROMIDE
PRINT. ROYAL PHOTOGRAPHIC
SOCIETY, BATH, ENGLAND.

clubs continued to function through the 1950s, but with less and less energy, having been overtaken by the unparalleled growth, starting in that decade, of photography courses emphasizing personal expression.

Camera documentation of buildings, gardens, and interiors also expanded in the 1920s; such illustration, which attracted several women specialists, increasingly found its way into magazines and books. Sipprell photographed houses and gardens for the wealthy, as did Emilie Danielson, a portraitist who convinced several magazine editors of her ability to document architecture and interiors. She thereby launched herself into a career as a specialist in this field, and numerous trips to Europe resulted in magazine pieces illustrated with her photographs of royal dwelling places.

ADVERTISING

Initially, modernism's most significant advocates in the United States had regarded art and commerce as discrete entities, but in the 1920s many photographers (including several former members of the Stieglitz group) no longer recognized the validity of such boundaries. As a result, concepts that originally had been of interest almost exclusively to art photographers now invaded commercial practice. Indeed, advertising and publicity photographers became more disposed to use up-to-date, modernist strategies, while many Pictorialists maintained their fidelity to the older concepts of harmony and beauty.

As photographs became more acceptable to the advertising industry in the late 1920s, the style in which they were conceived became an issue. Forward-looking people in the industry recognized the effectiveness of unusual angles, close-ups, highly defined textures, and even montage, for selling products and concepts. This new visual vocabulary was laid out for American advertising interests during the 1930s in several large exhibitions in the United States of foreign advertising imagery—both graphics and photographs—as well as a series of articles in the trade journals *Printer's Ink* and *Printer's Ink Monthly*. As the American version of photographic modernism took shape, emphasis initially centered on the object itself—its appearance, surface qualities, and its connotations of luxury, masculinity, or whatever—rather than on experimental effects of light and montage, which some European advertisers were willing to underwrite.

Little is known about the working methods, frequency of commissions, or pay scale of the women pioneers in advertising photography; even those who wrote memoirs usually omitted such mundane information. It is known that the advertising industry was dominated by men, with few women reaching the topmost positions during the 1920s, or indeed for a long while after; their numbers (above the secretarial level) have been estimated at about one in ten.[21] On the other hand, because so much advertising was directed at the female consumers of household goods, women may have had more influence in the advertising profession than in almost any other male-dominated one of the time. Certainly they were depended on to supply the women's point of view at a time when female consumers were growing in number.

Canadian-born Margaret Watkins became one of the first women during the 1920s to find a position with a major advertising firm—the J. Walter Thompson agency. This former student at the Clarence White School, who was so accomplished that White hired her to teach advertising photography, was also a member of the Pictorial Photographers of America. In the spirit of the times, Watkins made little distinction between the portraits and nudes done for her own pleasure and the product images she made for commercial purposes (plate 151). She submitted the advertising images she produced for the agency and for R. H. Macy and Co. to exhibitions and for reproduction in the society's annual, of which she was briefly editor.

Watkins's work garnered extravagant praise for her striking sense of design in organizing the elements of ordinary domesticity—pots, pans, kitchen sinks, glassware—into abstract compositions. The modern strategies that she employed for her commissioned work signaled her recognition that businessmen perceived their products to be "enhanced by fine tone-spacing and the beauty of contrasted textures."[22] As the teacher of such photographic advertising luminaries as Anton Bruehl, Paul Outerbridge, and Ralph Steiner, whose imagery took a similar direction, Watkins played a largely unacknowledged role in translating the precepts of Cubism into a usable language for advertising products.

Ironically, although able to compete successfully in a male-dominated profession, Watkins was unable to turn her back on the demands traditionally made on women by their families. In 1928, at midcareer, she returned to her ancestral home in Glasgow, Scotland, and remained there the rest of her life in a "state of curdled despair," unwilling to ignore the obligation to care for ailing female relatives yet eager to return to New York, whose artistic community she recalled as having "a strange gleam of vision, something worth striving

after."[23] In 1930 she took photographs during a brief trip to the Soviet Union but apparently found no outlet for this work, even though she had joined the Glasgow and West of Scotland Camera Club—the first woman to do so.

Sara Parsons also ignored the division between the commercial and the self-expressive aspects of photography. Twice winner of the New York Art Directors Club award for excellence, Parsons championed modern art as "the greatest thing that has ever happened to photography" because it created "in the lay mind the demand for the abstract interpretation of nature."[24] Ruth Bernhard, who began work in advertising photography in the mid-1930s, made use of similar abstract design strategies before moving to California in 1936, where she turned to portraiture to support her personal work.

Abstraction was a crucial element in the work of Wynn Richards, who went north from Mississippi to study at the Clarence White School in Canaan, Connecticut, in 1918. After an unsuccessful attempt to pursue her muse back in her hometown, she settled in New York, where further study at the White School enabled her to master techniques of lighting that led to a successful free-lance career. Connections between the Pictorial Photographers of America and the Art Center, a New York organization that sponsored activities in the applied arts and was home to the Art Directors Club, undoubtedly helped Richards make the needed contacts for commissions. Her still-life images for Gulden's mustard and Old Gold cigarettes (on which she worked with the barely known Bettie Frear) exhibit what is probably the most rigorous application of geometric design principles by any photographer of the time (plate 152). Disregarding the boundaries between art and commerce, Richards exhibited her commercial work at the Delphic Studios in 1931 and at the Julien Levy Gallery in 1934.

Clara Sipprell was another whose career encompassed applied and personal work. This uncommonly talented photographer had been schooled in the genteel Pictorialist tradition that emphasized refined taste (plate 153). Combining this attribute with contemporary compositional devices, Sipprell earned commissions for product images of household items in particular, several of which received awards from the Art Directors Club of New York. Nevertheless, it was to portraiture that she looked for income, perhaps because only a

few women in advertising were able to support themselves by this means alone. However, the achievements of all these women contradict the notion that women lacked the ability to think in the abstract or that they invariably took a subjective approach, which prevented the creation of work that would appeal to the masses. This opinion, expressed in 1936 by *Art Digest* critic Harry Muir Kurtworth, was rebutted in an editorial pointing out that abstract thinking and creativity were not exclusively male characteristics.[25]

Experience in advertising prompted several women to turn in the 1920s to fashion photography, which until then had been the preserve of men. Wynn Richards worked in both areas, making suggestive fashion images that were softer and more delicate than her ads for products such as cigarettes. Later, Tony Horn employed unusual angles in her fashion work, while Toni Frissell and Carola Rust found that using a small camera for fashion yielded more spontaneous results. Frissell should be credited (along with Martin Munkacsi) with transforming the polished fashion mannerisms of Steichen, Horst, and George Hoyningen-Huene into a more active and natural-looking mode (plate 154). "Being a woman shouldn't interfere with the job," she declared, and in her case it never did—she went everywhere "just like a man."[26]

Louise Dahl-Wolfe, perhaps the most renowned female fashion photographer in the immediate postwar years, began in the 1930s photographing interiors for a design firm, then made food still lifes for *House Beautiful* and fashion images for Saks Fifth Avenue before joining the staff of *Harper's Bazaar*. Recognizing her special gifts and ability with color images, the magazine allowed her the unusual privilege of working out of her own New York studio; from 1936 on, it featured her work on eighty-six covers and used over six hundred of her color photographs (plate 6) and thousands of her black-and-whites on its pages. Dahl-

Wolfe, a Californian whose initial interest in photography had been inspired by a visit with Anne W. Brigman, attributed her success to years spent at the California School of Design rather than to any inborn female traits. The photographer herself made it apparent that she also recognized her husband's willingness to help with her work and to perform domestic chores as an enabling factor in her achievement.[27]

By the mid-1920s the modernist idiom started to attract individuals outside the advertising profession who shunned the traditional Pictorialist organizations and concepts,

although they continued at times to take advantage of their salons and publications. Both men and women endeavored to employ the language of modernism in ways that were personal and idiosyncratic, that expressed inner conviction and passion. Women, however, were especially committed to photography as personal expression rather than as commercial enterprise: a 1924 survey of their vocational aspirations reported that almost half of those questioned hoped for careers in the arts.[28]

OUT WEST

The West Coast provided an especially welcoming environment to women photographers seeking personal expression through modernist style. Imogen Cunningham, for example, established her own individual mode through photographing indigenous organic forms, especially the plants found in her own and neighboring gardens. She transformed this typically "feminine" material into abstract entities by employing sharply delineated close-up views with no indication of context or surroundings (plate 141). Many of her plant images share the stark patterning visible in work by the contemporary German veristic modernists Karl Blossfeldt and Albert Renger-Patzsch and by Cunningham's California compatriot Edward Weston. Others are more tender, with softer forms and less abrupt tonal transitions, and like her photographs of the nude human body (plate 155), they suggest that her approach to modernism did not entirely efface her Pictorialist beginnings. Cunningham, who defied the purist preferences of the Californians in her early experiments with montage, herself observed that her "taste lay somewhere between reality and dreamland."[29]

PLATE 154: TONI FRISSELL (1907–1988). *MODELS AGAINST SKY,* N.D. GELATIN SILVER PRINT. GEORGE EASTMAN HOUSE, ROCHESTER, NEW YORK.

PLATE 155: IMOGEN CUNNINGHAM
(1883–1976). *TWO SISTERS*, 1928.
GELATIN SILVER PRINT. COPYRIGHT
© 1974 AND 1994 THE IMOGEN
CUNNINGHAM TRUST, BERKELEY,
CALIFORNIA.

Damned by critics in her hometown of Seattle for portraying the male nude, yet determined to be recognized as a photographer for whom womanhood had specific meaning, Cunningham continued her interest in the subject after moving to the San Francisco area in 1917. She, Laura Armer, Anne W. Brigman, Louise Dahl-Wolfe, and Dorothea Lange were among those in California in the 1920s and 1930s who either posed for each other nude or photographed friends in the nude. This cooperation was necessary for several reasons. For one thing, professional artists' models often were loath to pose in front of a camera due to the unidealized character of the final result. However, the main consideration was aesthetic: for the image of the nude to be considered a "picture" rather than just a photograph, the model, according to one authority, had to be "right mentally and physically, and have the grace and imagination to follow the photographer's intention."[30] This was never a simple prescription to follow, but it was somewhat more easily achieved when photographers themselves were the models.

Of course, interest in the nude among women was not limited to the West. Studies by Chansonetta Emmons in the 1920s and a portfolio of thirty studies of nude women in sylvan settings by East Coast photographer Arundel Holmes Nicholls suggest that Pictorialists throughout the United States were inspired by this quintessentially artistic subject. In fact, Nicholls's work, now almost completely forgotten, is stylistically similar to that of Albert Arthur Allen, whose consignment to oblivion is not nearly as complete. Nevertheless, the popularity of this subject among women in the West implies that the region itself fostered an approach that was less celebratory of industry and more involved with the depiction of natural forms.

That the western landscape lent itself to the modernist style is clearly evident in the work of Laura Gilpin. Portraits and flower pieces of the early 1920s (plate 156), made soon after her return to Colorado from New York, look back to the decorative approach favored at the Clarence White School (where she studied in 1916–18). Her exposure to the brilliant light, indigenous peoples, and stark landscape of the West resulted in the transformation of her genteel, derivative style into a more highly defined, personal one (plate 157). Unlike Cunningham, who to some extent looked to the male photographic community for approbation, Gilpin went her own way, scouting out new terrain and subject matter, arranging for her own publications, and eventually working as a photographer in an aircraft factory during World War II. Although her work is as essential as that of Edward Weston or Ansel Adams to understanding the catalytic role of the West in creating the American modernist style, Gilpin was not represented in the major American photographic histories before the 1970s.

Alma Lavenson, whom Weston encouraged to change from a soft-focus Pictorialist approach to more delineated and sharper

PLATE 157: LAURA GILPIN
(1891–1979). *BRYCE CANYON*,
1930. PLATINUM PRINT. COPYRIGHT
© AMON CARTER MUSEUM,
FORT WORTH; COLLECTION OF
SAN FRANCISCO MUSEUM OF
MODERN ART.

PLATE 158: ALMA LAVENSON
(1897–1989). *SELF-PORTRAIT,*
1932. GELATIN SILVER PRINT. ALMA
LAVENSON ASSOCIATES; PRIVATE
COLLECTION, CALIFORNIA.

representation in the early 1930s (plate 158), was interested in the forms, textures, and tonalities both of flowers and of mechanical structures. In her eyes, all subject matter constituted "a composition of some sort,"[31] even though her approach to people and plants seems less distanced and less formally designed than her depictions of geometric structures. Florence B. Kemmler, an amateur active in Southern California, where she often collaborated with her spouse, Dr. Roland Schneider, incorporated modernist ideas of design and pattern into traditional scenes of ships and aerial circus acts (plate 159).

In effect, these women, along with male photographers such as John Paul Edwards and the relatively large contingent of Japanese-American photographers active on the coast, helped rescue the genre of soft-focus, sentimental Pictorialism from the doldrums into which it had fallen during the 1910s by giving it a more modern aspect. Their ability to do so implies that although less convinced of the benefits of industrialism than their counterparts in the East, they still accepted that photographs should be clean and crisp in technique.

It also is true that during the 1920s and 1930s there were limited opportunities in commercial photography in the West, aside from portraiture. This was especially so for women, who only rarely were able to sell work for advertising or publicity purposes. As a result, they photographed for their own pleasure, turning their cameras to the material close at hand. The results, though not entirely dissimilar to the fare served up in Pictorialist salons for almost a decade, were energized by the incorporation of the latest modernist stylistic strategies.

Of course, certain jobs in commercial photography were available and indeed had been for a while. Besides making portraits—which sustained a great many California women, often in conjunction with husbands or siblings—women worked mainly as retouchers and colorists; a few produced architectural shots and others supplied illustrations. Images by Laura Armer, one of the few who sold her work for publication, appeared on magazine covers, as bookplates, and as book illustration during the 1920s. Change was coming, however. Olga Dahl, writing in the mid-1920s, suggested that with women's "good taste and tact," commercial photography would be "a congenial and profitable field open to them"—one in which, with persistence, they would be able to achieve success.[32] She herself had started as photographer for a San Francisco jewelry firm, then eventually became a partner in a commercial photography enterprise and treasurer for several professional associations in Northern California.

Few women photographers were employed in the film industry

PLATE 159: FLORENCE B. KEMMLER (1900–1972). *THE TRAPEZE ACT*, 1928. GELATIN SILVER PRINT. MARGOT AND WARREN COVILLE PHOTOGRAPHIC COLLECTION, BLOOMFIELD HILLS, MICHIGAN.

before 1940. Shirley Vance Martin provided stills of sets, and Maureen Loomis took over George Hurrell's studio specializing in star portraiture in the early 1940s. Ruth Harriet Louise, who worked for MGM between 1925 and 1930, transformed celebrity portraiture by creating an informal atmosphere and eliciting more individualized expressions from her sitters (plate 160). As Greta Garbo's exclusive portraitist for a number of years, she was so highly thought of by this star that she was allowed not only to shoot Garbo but also to choose her publicity shots on her own despite this being the prerogative of the studio's publicity department.

Only a very few women were employed as photographers for the print media, the center for this sort of work for both men and women being the East Coast. Trying to make a living as a newspaper photographer, Consuelo Kanaga traveled between California and New York during her early working life. And when Imogen Cunningham finally did receive a commission from *Vanity Fair*, she had to travel east in order to execute it, causing a permanent rupture in her marriage. The West had a nurturing influence on Barbara Morgan, even though her career as an innovative photographer unfolded in New York. Realizing that family obligations precluded a profession as a serious painter, she took up photography in 1930 with the expectation of applying the design precepts she had learned while a student at the University of California, Los Angeles.

Without the competition so palpable in New York, many men and women in the West found ways to support each other with ideas for exhibitions, loans of studios, suggestions for whatever few jobs existed. Group f/64, an association formed in 1932 of West Coast photographers who realized that concreteness and sharp delineation had become significant attributes of contemporary photography, was a welcome, though limited, source of support. Just as the earlier Pictorialist movement around Clarence White and his school in the East had nurtured and sustained a number of women, so this later, less-structured and much smaller association based in San Francisco facilitated interactions among photographers, introductions to collectors, and exhibitions at galleries and museums regardless of gender. Cunningham and Sonya Noskowiak were among the original members; Kanaga and Lavenson never joined but received invitations to exhibit with the group. Dorothea Lange did not join either, but she gained techni-

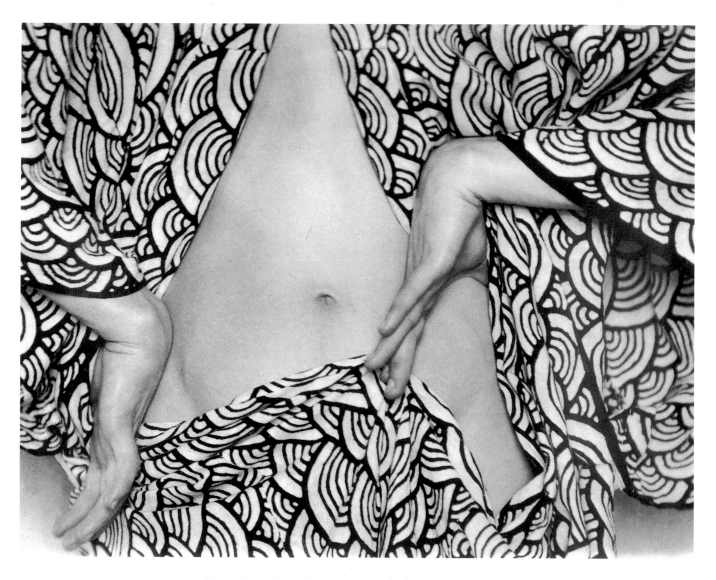

cal know-how through associating with the group. The portraits she took of Ansel Adams, Willard Van Dyke, and Weston (all associated with f/64 at its inception) attest to her contacts with members, even if her own objectives lay elsewhere. Other supportive groups for West Coast women were camera clubs in Los Angeles, San Francisco, and San Diego.

Edward Weston provided a center for several women in the field, becoming mentor and/or lover of Noskowiak, Margrethe Mather, and Tina Modotti, among others. Writing to him in 1920, Cunningham confided that she unburdened herself to him because he could "understand and appreciate what and why the 'Rune of Women' is."[33] Mather, an early (and, according to one commentator, essentially platonic) companion who first met Weston around 1912, eventually took over the prestigious Glendale studio, near Los Angeles, in which they had worked together.[34] Her sophisticated sense of artistry, which may well have influenced Weston, who was then more commercially oriented, inspired a number of unusual images that are both highly decorative and poetic (plate 161); these foreshadow later studies of isolated parts of the human body by Weston and by several East Coast photographers.

Despite having her work shown and acclaimed at prestigious salons in the early 1920s, Mather was ultimately unable to find her own style in the medium; by the early 1930s she had given up photography almost entirely.

Influenced more directly by Weston, Sonya Noskowiak became his assistant and lover. Attracted to both organic and mechanical forms, which she captured from close vantage points, she produced images in which composition and texture are paramount. Although her work was characterized at the time as feminine in approach,[35] images such as *White Radish* (plate 162) actually seem more aggressive and energetic, as well as more mysterious, than many such close-ups by Weston or other male associates. Noskowiak eventually made her way as a professional, working for the Works Progress Administration (WPA) and then at the Oakland army base during World War II, but difficulties dogged her efforts to earn a living from her own photography rather than as a printer of someone else's work.[36]

Of Weston's acolytes, Tina Modotti was the most successful in finding her own style—especially during the years between 1926 and 1930, after which she seems not to have taken anything other than snapshots, despite the stories circulating to the contrary.[37] Originally taught by Weston, she at first shared his interest in the paradigmatic modernist idea: the beautifully conceived image of the thing itself, printed in platinum. While working with him in Mexico on a joint photographic enterprise that she was later to take on alone and on Anita Brenner's book *Idols behind Altars*, Modotti eventually became more involved in political action. That new interest and Weston's departure made it possible for her to find her own themes and means of realizing them, resulting in images of people (plate 163) and objects that transcend the decidedly decorative character of her early efforts.

Modotti's ideas about her engagement with photography disclose some of the issues that even rebellious women found confusing during the 1920s. The most significant revolved around whether she could, as Modotti wrote to Weston, "solve the problem of life by losing myself . . . in the problem of art."[38] Criticizing women as "too petty," she claimed that they lacked the ability to become absorbed wholly by any one thing and hence could not be as creative as men—thereby defining creativity in the terms formulated by her male mentor. After Modotti left Mexico in 1930 for Berlin, she realized that this city was full of fine portraitists and did not need her services; her problem then became to determine what kind of photography she *could* do. It is surprising to discover that this ardent revolutionary, active in the Spanish Civil War and the relief organization International Red Aid, considered reportage as "a man's work" for which she claimed not to be "aggressive enough."[39]

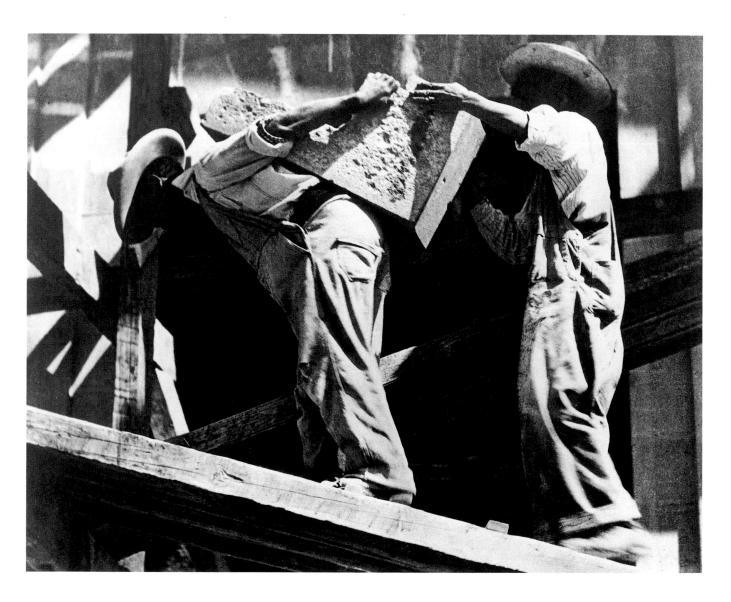

PLATE 163: TINA MODOTTI
(1896–1942). *WORKERS, MEXICO,*
1924. GELATIN SILVER PRINT.
AMON CARTER MUSEUM, FORT
WORTH.

reflected the fact that the images frequently were commissioned by state and federal agencies as a means of introducing the public to the need for reform projects. With this aim in mind, image makers emphasized the human element, without ignoring the need for coherent visual structure. This was especially true of Lange, whose portrayals throughout her career of individuals caught up in catastrophe utilize the modernist style to call attention to gesture, facial expression, and even inner turmoil. In her photographs, the textures of earth and skin, the organization of forms in field and field hand is no less rigorous than that encountered in work by 1920s modernists, but the emphasis is on the human dimension of experience rather than on design as a way to see the world anew. Lange's ability to engage with her subject matter prompted Roy Stryker, director of the FSA Historical Section, to consider her the paradigmatic photographer on the project, but she can also be seen as a bridge figure who humanized the often cold formalism of modernism to create a model of 1930s documentary style.

Lange was probably the most renowned of the women working on socially concerned projects, but during the Depression and into the 1940s surprisingly large numbers of women were employed on such endeavors by government agencies. Esther Bubley, Marjory Collins (plate 167), Pauline Ehrlich, Marion Post (Wolcott), Martha McMillan Roberts, Ann Roesner, Louise Rosskam (who worked alone and with her husband, Edwin), and Eudora Welty all were engaged on federally funded projects. While in some cases their tenure may have been brief and their experience not wholly positive, they gained valuable experience working in the field and made contacts that were important to their later professional careers. Several made significant contributions in terms of providing both information and an emotional tone that continued to mark documentary style throughout the early 1940s, when the Office of War Information (OWI) took over reportage for propaganda purposes. Welty's participation was unusual; hired by the WPA as a junior publicity agent for the state of Mississippi, she made photographs for her own gratification rather than for state purposes. In recognizing that the camera "may have been a shy person's protection," Welty articulated one aspect of the camera's historical appeal to women.[42]

As men were called into the armed services during the war years, women—among them, Maria Esland, Gretchen Van Tassel, and Barbara Wright—became more active in supplying images of home-front activities to agencies now devoted to collecting photographs in support of the conflict. To one recent commentator these images display a shift in sensibility in that they reject the unambiguous view

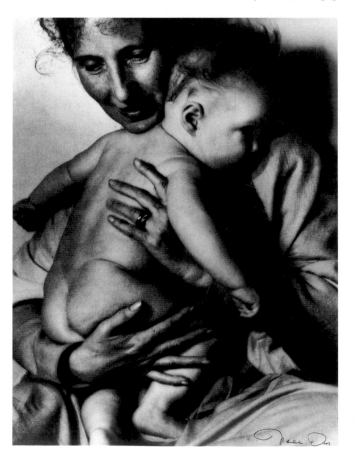

PLATE 167: MARJORY COLLINS
(1912–1985). *PHOTOGRAPHER'S
DISPLAY ON BLEEKER* [SIC]
STREET, 1942. GELATIN SILVER
PRINT. LIBRARY OF CONGRESS,
WASHINGTON, D.C.

characteristic of FSA imagery; instead, their effect is unsettling and enigmatic, "provok[ing] a sequence of disparate responses."[43] The portrayal of people in "melancholic reverie" may have been a function of the photographer's gender, as this thesis proposes, but it also undoubtedly reflects the pervasive somberness of civilians in a nation at war.

For the most part, the urban documentation produced under the aegis of federal agencies lacked coherent purpose and stylistic distinctiveness. A significant exception was the documentation of New York undertaken by Berenice Abbott, initially independently, then under the aegis of the Federal Art Project (FAP) of the WPA. Seeking to reveal "the inevitable effect of mankind's control of his material world," Abbott, in concert with her companion the art historian and critic Elizabeth McCausland, convinced federal authorities that a visual record of the architecture of the city was relevant to an understanding of urban history (plate 168).[44] Their efforts culminated in both a 1937 exhibition at the Museum of the City of New York titled *Changing New York* and a publication of the same name, which appeared in 1939.

Abbott's project may have been inspired initially by Eugène Atget's comprehensive photographic documentation of Paris (much of which she had purchased after his death

in 1927). Like him, she looked upon the urban scene as a challenge to the camera artist who must extract an aesthetically compelling statement from a chaotic field and still capture the city's distinctive character. However, the bold forms and strong contrasts in these images and in the photographic mural she submitted to a 1932 exhibition at the Museum of Modern Art reveal her vision to be entirely her own.

The nature of the support women received in their efforts to gain experience and do high-quality work in government agencies is an area about which relatively little is known. Those working for the FSA were backed by Stryker but at the same time were subject to a double standard. While encouraging professionalism, he displayed a conventionally protective attitude about women's welfare, evidenced by the restrictions he placed on Marion Post's activities in the field, even as she was supplying the agency with much-praised material (plate 169). Unmarried and traveling alone for months at a time during the three years she was employed by the FSA, Post was restricted both by southern prejudice against unaccompanied working women and by Stryker's

PLATE 169: MARION POST
WOLCOTT (1910–1990).
*PAHOKEE "HOTEL" (MIGRANT
VEGETABLE PICKERS' QUARTERS,
NEAR HOMESTEAD, FLORIDA)*,
1941. GELATIN SILVER PRINT.
LINDA WOLCOTT MOORE FINE
ART PHOTOGRAPHY, SAN
FRANCISCO; COURTESY OF
HOWARD GREENBERG GALLERY,
NEW YORK.

continual admonitions about proper behavior and dress and against socializing with men. Discovering later that the FSA photographer Russell Lee had been allowed to travel with his companion prior to their marriage, Post commented that had she done the same, "Roy would have *killed* me."[45] Such limitations may have prompted this gifted photographer to marry, raise children, and give up professional photography shortly after completing her stint with the FSA.

Stryker's "overly protective" attitude toward the female members on his staff may also have played a role in the decision by Martha McMillan Roberts, who worked at the agency in 1941, to become a photographer at the Washington bureau of the *Chicago Sun-Times*. Esther Bubley, who had apprenticed at *Vogue* before joining the FSA as a lab technician just as it was being transferred to the OWI, was able to use her experiences to participate in Stryker's next large-scale documentation—the Standard Oil (N. J.) Project, initiated in 1943.[46] Despite the pioneering efforts of these women, however, a speaker at a Washington, D.C., conference on opportunities in photography declared that resistance on the part of men meant that public service was still not full of openings for women.[47]

PLATE 170: CONSUELO KANAGA
(1894–1978). *MOTHER WITH
CHILDREN*, FOR THE *NEW YORK
AMERICAN* CHRISTMAS AND RELIEF
FUND, 1922–24. GELATIN SILVER
PRINT. BROOKLYN MUSEUM; GIFT
OF ESTATE OF CONSUELO KANAGA.

THE EMERGENCE OF PHOTOJOURNALISM

The rise to prominence of the documentary style in the 1930s coincided with the appearance of the slick picture magazines, most notably *Life* and *Look*, which provided an important outlet for documentary photographs. During the 1920s newspapers in the United States had provided scant opportunities for women photographers. Consuelo Kanaga, one of the few to follow in Jessie Tarbox Beals's footsteps, had seized the opportunity to become a feature photographer for the *San Francisco Chronicle* in 1918. Four years later, her experiences there enabled her to find work on the *New York American*, where her photographs of the destitute were featured in the campaigns run by the Hearst Christmas and Relief Fund (plate 170). These socially concerned images were only one expression of Kanaga's deep interest in social and political issues, which continued to absorb her throughout the 1930s. Nevertheless, during a trip to Italy and Morocco with Louise Dahl-Wolfe in 1927–28, in the course of which her feminist sensibilities were sorely tried, Kanaga realized that men's attitudes toward women were vastly more enlightened in the United States than abroad.

The greater role that women would play in photojournalism in the coming decades was forecast in 1936 with the first issue of *Life* magazine, which featured a cover and inside story by staff photographer Margaret Bourke-White (page 2). The fact that her work reconciled the two main elements of a new vision—the celebration of American might and the media's new emphasis on people—made Bourke-White an ideal advocate for the Luce organization.

Women active in photography during the 1920s and 1930s left an indelible imprint on the medium. They made the public aware that they had a significant role to play in a visual scene that was making use of photographic images to a far greater extent than ever before. In his foreword to the 1930 edition of the prestigious *U.S. Camera Annual*, which published images by Bourke-White and Lange, Frank Crowninshield (editor of *Vanity Fair*) predicted: "It may be women who will lead our coming revolution for, already, many of them have shown amazing originality and depth of feeling."[48] Whether or not they became the flag bearers he envisioned, they certainly more than held their own in the front ranks of photographic activity and ideology in the years ahead.

CHAPTER 7

PHOTOGRAPHY AS
INFORMATION, 1940–2000

W ars tend to affect social practices and change artistic sensibilities; the conflict that the United States entered in 1941 was no exception. Even before war was declared, women were urged to take on assignments previously given to men. At one photography conference held in 1940, Berenice Abbott, Wynn Richards, Edward Steichen, and Florence Vandamm, among others, outlined the roles that women might play in advertising, theatrical photography, photojournalism, and industrial and scientific documentation.[1] These distinctions were not as clear-cut as the speakers made them sound.

Documentary photography and photojournalism were, and still are, especially difficult to separate. The former had come to prominence under the auspices of United States government agencies, which had sent photographers into the field during the 1930s to cast light on social conditions in need of change. In addition to their use in publicly sponsored exhibitions, such images frequently appeared in print media. After World War II, as the government withdrew from the business of underwriting photographic projects, private entities (such as large corporations and not-for-profit foundations) and illustrated periodicals took over the function of revealing circumstances and events through socially oriented camera documentation (the civil-rights struggles in the South during the 1960s, conditions in Africa and eastern Europe in the following decades). At the same time, the responsibility for inform-ing the public about social conditions through still camera images was taken up by books, galleries, and museums (and, of course, television). Photographers who have focused on social issues—poverty, child labor, wartime dislocation, and spousal abuse, for instance—often consider the two genres of social documentation and photojournalism "to be pretty much the same thing," as Mary Ellen Mark noted.[2]

The number of women professional photographers, which had expanded from under five thousand in 1920 to more than eight thousand in 1937, grew again after the United States was drawn into the war; by the mid-1940s another two thousand women were added to the ranks. The manpower drain during the war forced the armed services to train noncombatants for jobs as photographers (as well as other professions, such as aviator). African-American women especially benefited from the need for a large staff to supply the demand for pictures of military hardware, personnel, and operations. Enlisted in the National Security Women's Corps and (after 1942) the Women's Auxiliary Army Corps (later, the Women's Army Corps, or WAC), black women photographers were, for the first time, able to

engage in a wider range of professional activities than just portraiture. Elizabeth "Tex" Williams, who had made the army her career from 1944 on, documented air and ground maneuvers, recorded medical procedures, and provided images for intelligence. In 1949 she became the first black woman admitted to the Signal Corps photography school at Fort Monmouth, New Jersey, graduating at the top of her class. Other African-American women photographers who benefited from programs to broaden professional skills included Emma Alice Downs and Grendel A. Howard.

PHOTOJOURNALISM

World War II had an almost immediate impact on women photojournalists. The military's attitudes toward documenting this war differed greatly from those that had prevailed during World War I. Then, civilians had been virtually barred from photographing on the battle-fields, and images by service personnel were strictly censored. Women war correspondents were entirely unacceptable to the military and the media, even though photographs by women of World War I battlefields do exist. British photographer Olive Edis, for one, made idealized

images of women volunteers in the ambulance corps and the Voluntary Aid Detachments in Belgium as well as document-ing that country's ruined landscape.[3]

During World War II the U.S. government had come to realize the value of promoting the war effort through publicity; at the same time, picture magazines and daily newspapers in Europe and the Americas eagerly sought camera images to illustrate their reports. Women profited from this greater latitude; as early as 1937 Kati Horna and Gerda Taro documented incidents in the Spanish Civil War. Horna (who also made collages) produced an album of propaganda images for the Spanish Republican government, and Taro, whose work appeared in the French newspapers *Ce Soir* and *Regards,* was herself a battlefield casualty.[4] When the armed conflict widened to include the Soviet Union, the Russian former industrial photographer Galina Sankova was allowed to photograph the military action on the eastern front (plate 172); she was one of five Russian women photo-journalists covering the war. Kari Berggrav, a Norwegian professional who was assigned by her nation's high command to cover the German blitzkrieg at Narvik (April 9, 1940), made more than six hundred exposures—most of them lost when she escaped to the United States. Constance Stuart (later Larrabee), who was born in England but spent her youth in South Africa, was sent by South African military

intelligence to photograph in Egypt; she became the official war photographer for the South African publication *Libertas* (plate 173). Later she free-lanced for *Life* magazine and settled in the United States, becoming a citizen in 1953.

Gwen Dew, traveling in the Far East in 1941, captured the fall of Hong Kong on film before she herself was captured and imprisoned for more than six months by the Japanese, losing in the process thousands of negatives and several reels of motion-picture film. Julia Pirotte, a Polish photographer living in France, recorded street fighting in Marseilles in 1939, at times under fire. Somewhat later Toni Frissell was asked by the United States Army Air Corps to record activities on its bases in England. Thérèse Bonney, an American living in Paris, was the first foreign photojournalist to cover the Russo-Finnish War of 1939–40 and the only one given complete access to the Battle of France, by General Maxime Weygand, the supreme Allied commander. Her 25,000 negatives—including her images of children displaced by war (plate 174), made for various relief organizations—constitute a little-known record of World War II.

Admittedly, the number of women photographing on battlefronts was still minuscule, but the barrier against their covering war had been irreparably breached. Throughout the remainder of the century, women photographers were to be found on the battlefields of Vietnam, Lebanon, Bosnia, Rwanda, and Kosovo. In the early years, women also were commissioned by relief agencies and by picture magazines in Europe and the United States to make visible the war's effects on civilians. Lee Miller photographed war-ravaged villages and concentration camp inmates (plate 175) for *Vogue*. Before Frissell began photographing for the Army Air Corps, the Red Cross had sent her to England to make promotional images for them, and at war's end it sent Hazel Kingsbury to France to document conditions there.

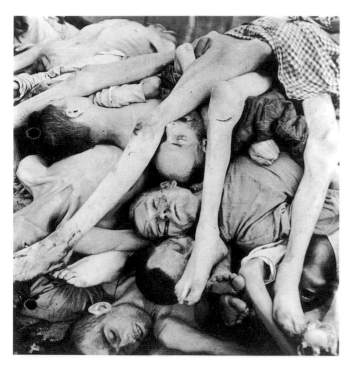

The most widely acclaimed woman journalist of the era was Margaret Bourke-White, who was assigned by *Life* to cover the bombardment of Moscow in July 1941; shortly afterward she became an accredited war correspondent for the magazine and the Defense Department (plate 176); and in 1942 she was the first woman to fly on bombing missions from North Africa. Bourke-White's pictures, which combined clarity and strong visual design with attentiveness to human activity and expression, suited *Life*'s objectives, whether the focus was on the "good war" or Henry Luce's "American Century" ideology. In addition, Bourke-White popularized the vocation of photojournalism itself by writing several books that combined autobiography, commentary on topical issues, and photographs.

Photojournalism had become, as the Swiss-born photographer Sabine Weiss explained, "an alibi"—a way that women might "see everything, get everywhere, talk to everybody."[5] This was especially true for the thirty or so women who had their coverage of far-flung people and places reproduced in *National Geographic* since the early years of the century.[6] For these individuals, as for women photojournalists in general, the conflicting demands between marriage and career have remained a potent factor in making photojournalism, with its incessant travel, a difficult choice. Bourke-White, for one, chose not to be bound by "golden chains."[7] Others in the field agreed that being constantly away on assignment was hard on a marriage and even harder on their children. "Men," noted one part-time photojournalist, "can just devote themselves to their work alone, but women are called upon to be many things at often inconvenient times."[8]

Credit for making photojournalism more

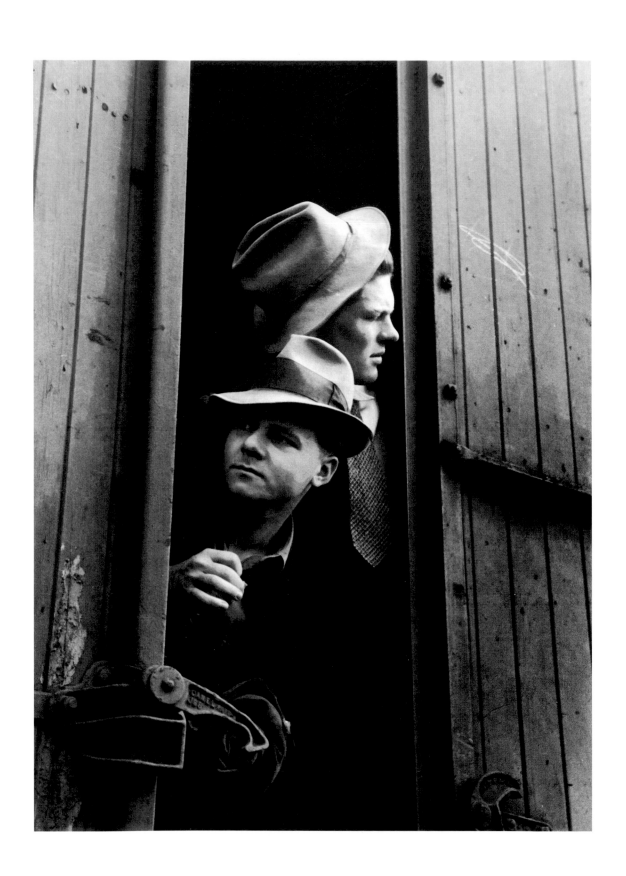

attractive to women must go in part to the female photojournalists who had worked for European periodicals before fleeing the war. For all its nationalistic emphasis on American virtues, *Life* put to use the talents of a number of these refugee editors and photographers. Lisa Larsen, Nina Leen, and Hansel Mieth (working at times with her free-lancing photographer husband, Otto Hagel)—all from Germany—worked as free-lancers and on the magazine's staff, providing strong, positive images of American life. Mieth's valuable contributions (plate 177), which earned her a staff position, have become known only recently, although in 1941 she was considered "one of America's top-notch photographers."[9] Starting in 1940 as a free-lancer, Leen became a staffer in 1945, covering a wide range of diverse events in over six hundred assignments. Her preferred subject matter was animal life, and the magazine featured her picture essays on bats, dogs, and reptiles. Before Lisa Larsen's death in 1959 at only age thirty, she was acclaimed for her overseas camera reportage, receiving the National Press Photographers Association award as the outstanding photographer of 1958.

A few European-born women free-lanced for other American periodicals. Following their arrival in the United States in the late 1930s, Lisette Model, Yolla Niclas, Marion Palfi, and later Eva Rubinstein and Suzanne Szasz published work intermittently in a variety of places. Of course, not all European women émigrés wanted to or were able to make a living in photojournalism; several, among them Trude Fleischmann and Lotte Jacobi, continued as portraitists, while Gerda Peterich turned to architecture as a theme for personal expression.

Women represented only a tiny proportion of the photographers whose works were reproduced on *Life*'s pages. Of the sixty-nine photographers featured in a 1979 roundup of the magazine's first ten years, only four women were included: Bourke-White, Mieth, Leen, and Berenice Abbott, whose pictures of New York were reproduced even though they had not been commissioned by the magazine.[10] Other women whose photographs appeared in *Life* between 1940 and 1970 included Esther Bubley, Pat English, Marie Hansen, Martha Holmes, Ruth Orkin, Nina Howell Starr, and Elizabeth Timberman; most worked as free-lancers, but Hansen and Holmes were on staff. Women working for picture agencies—among them, Eileen Darby, Mary Edwards, Carola Gregor, and Betty Kirk—also had their work reproduced in *Life*. In 1951 *Look* magazine hired its first female staff photographer, Charlotte Brooks, who had served an apprenticeship with Barbara Morgan and *Life* photographer Gjon Mili.

OPPOSITE

PLATE 177: HANSEL MIETH (1909–1998). *BOYS ON THE ROAD,* 1936. GELATIN SILVER PRINT.

BELOW

PLATE 178: EVE ARNOLD (BORN 1913). *OWNER OF THE 711 BAR,* 1952. GELATIN SILVER PRINT. MAGNUM, NEW YORK.

This early support for women proved tenuous; by the late 1950s the work of male photographers dominated the pages of *Life*, and women found themselves commissioned mainly to handle domestic subjects for the magazine. In the first half of 1969, for example (the same year that the magazine eulogized Bourke-White on her retirement), only five individual images and one spread by women appeared.[11] However, as Time, Inc. (publisher of *Life*), expanded its roster of magazines to include *People* and *Sports Illustrated*, it made use of a greater number of women photographers, both on staff and free-lance; an exhibition mounted in 1993 featured the work of some fifty-nine women whose images had appeared in Time, Inc., publications over the years.[12]

In general, magazine reportage and commercial work in advertising have little staying power, and the work of women photographers of the 1940s and 1950s was no exception. Gloria Hoffman (winner in 1949 of the Condé Nast award for art and photography), Doris Day, Pat Liverwright, Ruth Alexander Nichols, Carola Rust, and Lena Towsley were all professionally active during the 1940s, and their work has all disappeared from view. This obscurity resulted from a number of factors, most notably the pedestrian quality of the images and the absence of an art market for them—factors that affected not only women but also many men active both in day-to-day photojournalism and in advertising. Women, however, did have the additional problem of overcoming the resistance of their male colleagues. On assignment in Florida in 1943, Constance Bannister, an acclaimed photographer of "babies, ballet, and news," preferred to print in a hotel bathroom after discovering that male competitors had actively sought to destroy her work by putting "hypo in the developer" and scratching her negatives.[13] A few years later Vera Jackson found that male colleagues would sometimes "nudge [her] out of position for a good camera angle with a snide remark," and Jeanne Moutoussamy-Ashe recalled being shoved and physically abused in the 1960s by male colleagues competing for the best vantage points from the steps of the Federal Court House in Foley Square in New York.[14]

Melissa Farlow noted in an interview that mistakes by women were less acceptable than those by men, and Ruth Orkin recognized that besides having to work harder, women often received "half of what a beginning man would have gotten."[15] As early as 1943 Bannister claimed that her need to "do better than men" made competition stressful.[16] And when Eve Arnold began her career in magazine photography in the early 1950s, she was considered just a token woman. Sent to do stories about other women and minority groups—topics considered less important by assigning editors—she eventually discovered that the

supposedly insignificant theme of women's work was of interest to a wide readership (plate 178). Inge Morath (plate 179) and Rollie McKenna were able to avoid consignment to women's subjects by initially concentrating on portraits of artists and writers.

As in the United States after the war, no sharp distinction existed in Europe between documentary photography and photojournalism, and the same photographers were to be found in both genres. Government support of photographic projects had not been common in Europe before World War II, and it was not forthcoming in the immediate post-war years; even later it was only sporadic, varying from country to country. Some photographers financed such projects themselves, others solicited support from regional bodies and publications, still others were eventually commissioned by central authorities. As publication of photographic books became more common, they gave women (and men) another outlet for documentary work.

In Britain photo documentation almost never received the support of the central government. Activity in the various military services during the war had expanded women's skills and opportunities there, as it did in the United States, but expectations for civilian jobs afterward were not fulfilled. The photographic scene remained constricted and

PLATE 181: IDA KAR (1908–1970). *IRIS MURDOCH*, LATE 1950S. GELATIN SILVER PRINT. COPYRIGHT © MONIKA KINLEY; COURTESY OF MARY EVANS PICTURE LIBRARY, LONDON.

PLATE 182: DOROTHY BOHM
(BORN 1924) *NEAR GLOUCESTER
ROAD UNDERGROUND STATION,*
1960S. GELATIN SILVER PRINT
FOCUS GALLERY, LONDON

unfocused for a number of years, with female photojournalists employed only rarely. Merlyn Severn, the only full-time woman on the staff of *Picture Post* after the war, continued in that role for only two years, after which she joined the staff of the *Central African News Review* in Rhodesia. Severn, whose real passion was dance photography, ascribed her success as a photojournalist to such conventional feminine attributes as instinct and inspiration—indeed, to a mystical "airborne state."[17]

The down-to-earth Grace Robertson, who started a career with *Picture Post* in the 1950s, was more attuned to that publication's social agenda. She did not resent commissions that dealt largely with women (plate 180) because she felt that if sympathetically edited, her picture stories "would be unique" and "reassuring to women."[18] Male critics claimed, with Robertson in mind, that women "don't need a disaster to get a punch picture."[19] Robertson has continued to pursue photojournalism with a recent project about women who must cope both with working and with raising children, and her accomplishments were recognized in 1999 with an Order of the British Empire (OBE)—the first received by a woman photographer. Gerti Deutsch had also provided domestic stories to *Picture Post* during the 1940s, further reinforcing popular expectations that women would photograph for women.

Ida Kar was among those who suffered from the limitations of the British photographic scene. Highly regarded as a portraitist of celebrated artists and writers (plate 181), she was unable to attract the same kind of attention when she switched to animal studies and street life, and by the 1970s her work had faded from view. In the 1960s and '70s her compatriot Dorothy Bohm had greater success with street imagery, often combining compassion with irony (plate 182). Thematic typecasting continued to bedevil British female photojournalists, but a few women were able to carve out other specialties in the domain of applied photography—notably, Zoë Dominic in the theater; Margaret Harker, who specialized in architectural documentation (before becoming the first woman director of the photography school at Regent Street Polytechnic College and a noted historian of the medium); and Jean Perry, who took up medical illustration.

As civic and cultural life on the Continent regained its equilibrium during the 1960s, women found positions as photojournalists and in advertising photography. Some who had entered the field earlier remained active. Swiss-born Ella Maillart—recognized

during the 1930s for her documentation of Soviet Asia, Manchuria, and India for the French press—continued to provide such images. From the 1950s through the 1980s Denise Colomb (who had found it necessary to change her name from Cahen to escape persecution during the Vichy regime) photographed for periodicals, although her greatest interest—what she termed "the leitmotif of my career"[20]— was in portraying artists in their own environments (plate 183).

By the 1970s awareness of the revolution in feminist sensibilities had become visible in the work of a number of Continental photojournalists. Portraying women artists became the focus of Belgian-born Martine Franck, who had honed her skills as an assistant to photojournalists Eliot Elisofon and Gjon Mili before settling in Paris as a free-lance photographer for *Life, Fortune,* and *Vogue* and a member of the cooperative agency Magnum (plate 184). Also inspired by feminism was Janine Niepce, who produced several publications dealing with the lives of women from infancy on (plate 185); many of her projects were supported by the French government.

Suzanne Lafont and Sophie Ristelhueber were among the sixteen photographers involved in a government-supported documentary project during the 1980s. Entitled *Paysages photographiés (The Landscape Photographed),* this endeavor was designed to explore the results of industrialization on the French landscape and social structure and to call attention to the historical role of the government in supporting such ambitious photographic ventures.[21] Lafont and Ristelhueber concentrated on the way industrial development alters the landscape and destroys resources, but even though their images of such sites may recall the work of earlier modernists such as Germaine Krull, their response to industrialization was decidedly less optimistic. More recent photojournalists in France and Belgium have included Dominique Anginot, Martine Barrat, Marie-Laure de Decker, and Lise Safarti (currently an associate member of Magnum).

Women photographers in Holland also received government commissions on occasion. Dutch photographer Emmy Andriesse, who had been exposed to the modernist experimentation of the 1930s but preferred a lyrical approach, produced a series of portraits of artists (plate 186) for the Stedelijk Museum and was at work on a book of images of places where Vincent van Gogh had painted when she died at age thirty-nine. Emigré women photographers working in Holland after World War II included Eva Besnyö and Maria Austria, a native of Bohemia who did fashion, portrait, and theatrical work in Amsterdam. Active in the resistance during the war and determined to improve working conditions for photographers, Austria also agitated for recognizing photography as an art form at a time when many Europeans ignored this dimension of the medium. More recently, Marie Bot has produced some interesting documentary work.

In Italy, where almost no women had been involved in any kind of photography before the 1970s, a number of women photojournalists have become prominent. Political and ecological activist Letizia Battaglia was the 1985 winner of the W. Eugene Smith Grant

for Humanistic Photography (which, incidentally, has counted six women among its honorees since its inception in 1980). Battaglia has courageously chronicled the activities of the Mafia in her native Palermo for the news media in Italy, demonstrating special interest in the impact of this male-dominated organization on the lives of Sicilian women (plate 187). The Sicilian photographer Shobha (Battaglia's daughter), who in 1980 began to work for the Palermo daily paper *L'Ora,* has portrayed the aristocracy of her native region to telling effect.

Even in Spain, where modern ideas were thwarted by the quarter century of insularity imposed by the Falangist government, and in Greece, where tradition and dictatorship together curtailed women's entry into the professions, women have begun to take a place among photography professionals. Color photographs by Marta Sentís portray the life of Africans and Asians both in their homelands and as immigrants in Spain. In Greece between 1895 and the 1980s there appear to have been only five women who considered themselves professional photographers. Surprisingly, one of them, Voula Papaianou, was able to travel throughout the countryside in the 1950s to provide relief organizations with a pictorial record of the effects of the civil war. Since then some sixty Greek women have become active in the media, supported in many instances by the Photography Circle in Athens. None of these young women, who have been trained mainly in Athens and London, seem to be especially focused on women's issues; instead their work runs the gamut of photojournalist and documentary themes. Sue Papadakas, for example (an accomplished diver and pilot as well as photographer), has produced articles and a book with images of underwater flora. Christina Vazou has worked for Médecins sans Frontières (Doctors Without Borders); Maro Kouri has traveled on assignment to South Africa, Spain, and Southeast Asia photographing people and events for the press.

In Germany documentary and journalistic photography took time to reestablish itself, both in the east and the west. Of the relatively few women photographers who had been active during the Nazi period, Marta Hoepffner and Liselotte Strelow remained, and Hanna Seewald returned to teaching in Munich in 1948. Gertrude Fehr, on the other hand, continued

her interest in montage and solarization in France. Leni Riefenstahl, whose active participation in producing propaganda stills and films for the Nazis had resulted in her brief internment following the war, worked in the Sudan after being released. Her interest in portraying indigenous African peoples (plate 188) may seem curious in view of Riefenstahl's ardent celebration of the so-called Aryan master race, but idealization blended with an antirationalist worship of the primeval can be said to characterize all of her work.

In the 1950s, as the periodical press in West Germany stabilized itself, a photographic publishing industry evolved and some photographers returned from abroad while other younger ones emerged. Regina Relang resumed her fashion work for periodicals; in 1972 she won the David Octavius Hill Medal, given by the Photographic Society of Germany for photographic excellence. Ruth Hallensleben specialized in industrial scenes, while Angela Neuke-Widman, Fee Schlapper, and Karin Székessy were active photojournalists from the late 1960s through the 1980s. During the same years, women living in East Germany produced a considerable and diverse body of work. To some extent, all of European photography was influenced not only by unique national conditions but also by the growing internationalization of media and styles.

In fact, internationalism is a key concept in contemporary photojournalism. American-born Jane Evelyn Atwood resides in France but works throughout Europe, for the

PLATE 187: LETIZIA BATTAGLIA (BORN 1935). *WOMAN WATCHING FUNERAL OF PIO LA TORRE, MAY 5, 1988, PALERMO.* GELATIN SILVER PRINT. APERTURE, NEW YORK.

periodical press and on documentary projects funded by government and private agencies; among them has been an extensive study of women in prison (plate 189). In 1980 Atwood's contribution was recognized by the first Grant for Humanistic Photography awarded by the W. Eugene Smith Foundation, and in 1998 she received the Alfred Eisenstadt Award for Magazine Photography. Korean-born Yunghi Kim lives and works in the United States but has traveled extensively in Africa, Indonesia, and South Korea. In 1999 her photographic skills were recognized by first-place awards from both the World Press and the Pictures of the Year competitions. After completing her art studies in Italy, German-born Bastienne Schmidt settled in the United States, but she travels widely to photograph cultural and sociological processes that interest her (plate 190). From her home base in France, Italian-born Giorgia Fiori, who studied and worked in the United States, has traveled to Algeria, Italy, and Russia on assignments and projects. Similarly, Nadia Benchallal, who was born in France of Algerian parents and also has studied in the United States, has been photographing Muslim women throughout the world, starting in the 1990s.

PLATE 188: LENI RIEFENSTAHL (BORN 1902). *NUBA DANCER*, 1975. HIGH-SPEED EKTACHROME.

The work by these photographers (and by many other women photojournalists as well), which has appeared in the periodical press in the U.S. and Europe and has received numerous awards, is not solely focused on women. Atwood and Fiori, for example, have unhesitatingly taken up male themes, among them boxing, workers in the mining and steel industries, and life in the Foreign Legion. One opinion has it that contemporary women photojournalists have greater courage and skill in shooting in difficult situations than their male colleagues.[22]

Developments in Latin American photography differed substantially from those in Europe. As might be expected in societies in which women traditionally had difficulty gaining recognition as creative individuals before the 1940s, very few (other than displaced or visiting Americans and Europeans) had worked as professional photographers or had chosen the medium for personal expression. One exception was Herminia de Mello Nogueiro Borges, a member of the Photo Club Brasiliero in the 1920s, whose Pictorialist images resemble those by salon photographers elsewhere.

As camera images began to assume greater significance in journalism and advertising, the examples set by émigré women working in Central and South America demonstrated that accomplishment in the medium need not be limited to men. The Mexican photographer Lola Alvarez Bravo, who had initially worked with her husband, Manuel, credited Tina Modotti with inspiring her in the late 1920s

to take on an independent persona as a portraitist of artists and writers; eventually she headed the photography department of the Instituto Nacional de Bellas Artes in Mexico City. Through her role as teacher, she passed on a sense of strength to a younger generation of women photographers, including Mariana Yampolsky, an American who took up residence in Mexico in 1945 and continues to photograph there (plate 191). Yampolsky, in turn, served as mentor to Flor Garduño (plate 192), with whom she worked on a government-sponsored project to provide illustrative materials for indigenous-language readers.

More than thirty Mexican women participated in documentation and photo-journalism during the late 1970s as photography in this region assumed greater importance.[23] Among them, Graciela Iturbide recorded religious and matriarchal folkways (plate 193); Yampolsky concentrated on the works of muralists and graphic artists but was also interested in village life; and Lourdes Grobet documented the hugely popular phenomenon of female wrestlers (plate 194). Panamanian Sandra Eleta has concentrated on matriarchal mystery rites in her country (plate 195).

Women in several Latin American nations carved out a niche in anthropological and archaeological documentation; in their depictions of indigenous peasant and popular cultures, they made significant contributions both to photography and to cultural history. In the course of some seventy expeditions to the Lacandon villages on the border between Mexico and Guatemala, Gertrude (Loertscher) Blom, a Swiss expatriate who settled in Mexico and became a free-lance journalist in 1940, documented the ecological ruin caused by unchecked logging in the region. Claudia Andujar and Maureen Bissilliat, who photographed Amazon tribespeople in Brazil (plate 196) and Indian women in Bolivia, respectively, regarded their work as a means to rescue these cultures from extinction. Latin American women also were drawn to the urban scene, as demonstrated by the work of Helen Hughes in Chile and Marucha (María Eugenia Haya) in Cuba (plate 197), who also was at work on a comprehensive history of Cuban photography at the time of her death in 1991.

The growth of popular magazines and illustrated books in the large urban centers of Central and South America in the 1950s made a career as a free-lance photojournalist somewhat more feasible, although access by women to good assignments was limited. Making a living from the medium has remained difficult, with only a very few women photographers able to find employment or to undertake projects on their own. Surveys during the 1980s of contemporary photography in Latin America indicated that the number of women actively showing work was small; in the next decade their representation in such shows increased somewhat. Four of the eleven photographers in a 1999 exhibition of Argentine work were women, a greatly improved representation.

Adriana Lestido has produced compassionate documentation about those incarcerated in women's prisons. Overall, it is probably accurate to say that even in the more industrially developed countries of Central and South America, women may have breached the walls that kept them out of the field of photography but they still have not attained parity with their male colleagues.

In a development made especially surprising by their earlier scarcity, significant numbers of Chinese women have taken up photography within the past thirty or so years. A few women had documented political activities before the establishment of the People's Republic in 1949—the most notable being Gu Shu Xing, who photographed the revolutionary unrest occurring in 1917–19. Yang Ling, who had joined the Eighth Route Army in 1939, took courses in photography in 1945 and became the only woman to photograph the liberation struggles of 1947–49 (plate 200). During the 1950s increases in university course offerings in journalism presented women with opportunities to become acquainted with the medium, with the result that by the mid-1980s some seventy had become teachers and writers as well as working members of the Chinese Photographers Association. The work of Li Lanying, one of China's most prolific photographers and a highly regarded teacher of the medium, has been reproduced in numerous periodicals and books and has gained prizes when exhibited in her native land and abroad. Nevertheless, for a long period, attitudes toward women photographers did not keep pace with their admission into the profession. Si Ma Xiao Meng, who was on the staff of the *Beijing Evening News*, noted that Chinese women "still have to struggle with feudal ideas and conventions left over from thousands of years of history."[24]

That Chinese women were able to regard the medium as a means of personal expression as well as a source of income was affirmed by a large-scale national exhibition of women's work held in Beijing in 1985 in which some three hundred examples by both professionals and amateurs were displayed. Whether commissioned or working for their own pleasure, Chinese photographers—men and women both—tend to romanticize their human

PLATE 194: LOURDES GROBET (BORN 1940). *DOUBLE WRESTLING,* C. 1980. GELATIN SILVER PRINT.

subjects and to find the decorative elements in nature, as demonstrated in the work of Wang Miao, a photographer for the China News Agency and the Historical Press (plate 19).

As might be expected of a society in which women's behavior is strictly codified, few Japanese women in the past found the means or the opportunity to become a photographer. One exception, Eiko Yamazawa, appears to have been the first women to open a commercial studio in Japan, remaining in charge of this enterprise through the early 1950s. She also established an institute for photographic education in Osaka, which specialized in

PLATE 199: SARA FACIO (BORN
1932). *WOMEN OF BOLIVIA*, N.D.
GELATIN SILVER PRINT.

denied access to the sidelines of college football games as a cub photojournalist in college. A number of women did manage to penetrate this largely male domain: Gwen Dew free-lanced for the *Detroit Free Press;* and Mary Morris worked for the Associated Press Feature Service before becoming one of the first staff photographers and later the picture editor on the liberal tabloid *PM,* in New York.

Just as the heyday of big-picture-magazine photojournalism was relatively short-lived, so newspapers, too, have faced decreasing numbers of readers. Nevertheless, in the mid-1960s, even as television took over the role of picturing topical news, the number of women employed as photographers for newspapers and magazines continued to grow (partly as a result of affirmative-action regulations). Press photography remained a male bastion in which women had to "work twice as hard to prove themselves,"[27] but several women became convinced that, in some respects, their gender was an advantage. Melissa Farlow of the *Pittsburgh Courier,* Janet Klott of the *Boston Globe,* and Iris Schneider of the *Los Angeles Times* all agreed that "people are less threatened" by a woman with a camera, especially in situations (such as family trauma) where a man might be perceived as less sensitive.[28]

Diana Walker, a Washington-based photographer for *Time,* commented that although women in the press-photographers corps had been uncommon in the 1960s, two decades later "it had become half men, half women" covering political events.[29] In the 1970s and 1980s several women became picture or graphics editors at influential publications, among them Carolyn Lee at the *New York Times,* Mimi Fuller Foster at the *Atlanta Constitution,* and Dixie D. Vereen at *USA Weekend.* In the 1980s many women photographers in the field still felt that they were not taken seriously and that their assignments were gender oriented (being given a preponderance of children and of older people as subjects, for example);

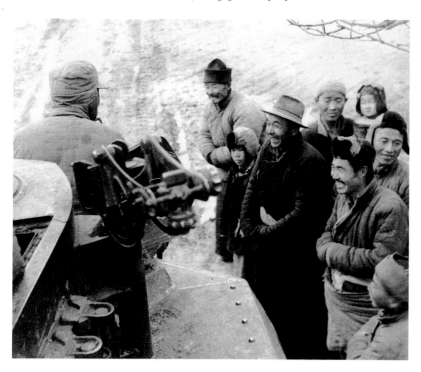

nonetheless, during those years women's pictures constituted between one-quarter and one-third of those selected as superior by the National Press Photographers Association (NPPA). Among the many women honored on more than one occasion by the NPPA are Therese Aubin, Judy Griesedieck, Carol Guzy, Catherine Leroy, April Saul, and Brenda Ann Kenneally, who was winner of the NPPA's Year 2000 award for documentary photography.

Improved access to top assignments extended to African-American women, although just barely. Vera Jackson—staff photographer from 1944 to 1952 for the *California Eagle,* a newspaper owned by black activist Charlotta Bass—was in a frontline position to cover civil-rights activities in the Los Angeles

own perceptions of the truth of a situation—gave their work a longer life and the potential for greater influence.

Some women opted to live from book to book rather than await assignments from a dwindling number of magazines. Inge Morath has provided photographs for more than a dozen volumes illustrated with camera images (plate 179). Jill Krementz—who considered her start on the *New York Herald-Tribune* "the best training in the world" and who was able to place work in *Show, Time,* and *Fortune* in the 1960s—eventually chose to leave journalism.[33] She preferred to write and photographically illustrate books (plate 204), frequently for children—a choice also made by Sandra Weiner (plate 205) after she quit as a picture editor on *Sports Illustrated.* Jill Freedman, whose work appeared in the major news and popular journals of the 1970s, also finally settled on the book format because she believed that the limitations resulting from stereotypes about women photojournalists were not about to disappear.

A number of women photojournalists benefited significantly from the dissolution of barriers between art and applied photography, between what the press thought of as

information and what museums were willing to collect and exhibit. The career of Mary Ellen Mark exemplifies how this development upset preconceived categories. Possessing drive, courage, technical skills, and a progressive social outlook, Mark (whose training had been in the fine arts) chose the camera as her tool and society's castaways as her subjects (plate 206). She considers her magazine assignments as grants that enable her to work on "the fringes of society"; she has also received financial support for these projects from not-for-profit agencies.[34] Exhibitions in galleries and acquisitions by museums, as well as publication in book format, helped free her images from the strictly journalistic context that had swallowed the work of earlier picture journalists.

Mark's need to deal with her subjects in depth contrasts with the superficial treatments of deadline-driven journalists and is seconded by many women in the field, notably Atwood and Fiori. Implicit in her statement, "If . . . [the scene before the camera] does not touch you emotionally, you're not going to get your photograph,"[35] is Mark's understanding that significant documentation requires both close observation and deep feeling. The ideal of a concordance of journalism, documentation, and exhibition is shared by many women who hope that the emotional component in the work will not only inform viewers but also trigger change. Two who subscribe to these goals but hesitate to call what they do "art"

PLATE 205: SANDRA WEINER
(BORN 1921). *EASTER MORNING,
NINTH AVENUE*, 1973. GELATIN
SILVER PRINT.

are Donna Ferrato, who has revealed the desperation of battered wives (plate 207), and Wendy Watriss, who has focused on Vietnam War veterans (plate 208). They are not averse to using strategies such as exhibitions to reach a more artistically oriented public, but they urge photographers to find additional ways to make their work the instrument of change.

The relationship of documentation to art is complex, encompassing a broad spectrum of themes and ideologies espoused by members of both sexes. For some women, as for some men, documentation cannot be considered authentic if it embraces an aesthetic sensibility; others acknowledge a need for a unity of form and content that transcends record making.

SOCIAL DOCUMENTATION

Documentary photography had flourished during the 1930s mainly as a result of federal sponsorship. Such imagery continued to be commissioned through the 1940s by agencies such as the Office of War Information as well as by magazines, with a number of women documentary photographers able to convince government agencies, corporate donors, publishing houses, and charitable organizations of their skills in this area. No doubt the track record established during the previous decade by female photographers such as Margaret Bourke-White and Dorothea Lange (plate 209) was a factor. The traditional association of social concern with woman's caring nature may also have proved useful. For instance, Lange's photographs of Japanese-Americans being processed for internment were said to be marked by "maternal concern, . . . [a] woman's sense of care and tenderness."[36] Lange (whose experiences with the Farm Security Administration had led to a Guggenheim grant in 1941, the first given to a woman photographer) certainly expressed greater sensitivity to the realities of internment than Ansel Adams did in his treatment of the subject. Photographing in the Manzanar camp, Adams wished to show the detainees as "occupied, cheerful, and alert," avoiding "heavy reportage with repeated description of the obviously oppressive situation."[37]

Marion Palfi, born to Hungarian parents in Berlin, moved first to Holland, where she turned out typically modernist works, and then, in 1940, to the United States. Backed by the Council Against Intolerance and later the Julius Rosenwald Foundation, she documented social relations between African-Americans and whites and depicted children living in poverty (plate 210). In her words, she sought to merge "an art form with social research."[38] Palfi continued to work throughout the late 1940s and into the 1950s on social projects that concerned housing, civil rights in the South, aging, and at the end of her career, prison reform and the problems of Native Americans; in recognition she was awarded both Rosenwald and Guggenheim grants. Her interest in women's progress prompted her to chair the committee that organized the photographs for a 1948 *International Exhibition of, by, and about Women.*

Esther Bubley (plate 211), Charlotte Brooks (plate 212), Martha McMillan Roberts, and Louise Rosskam found documentary jobs on the Standard Oil (N.J.) Project in the mid-1940s; from this experience they were able to branch out either to photojournalism

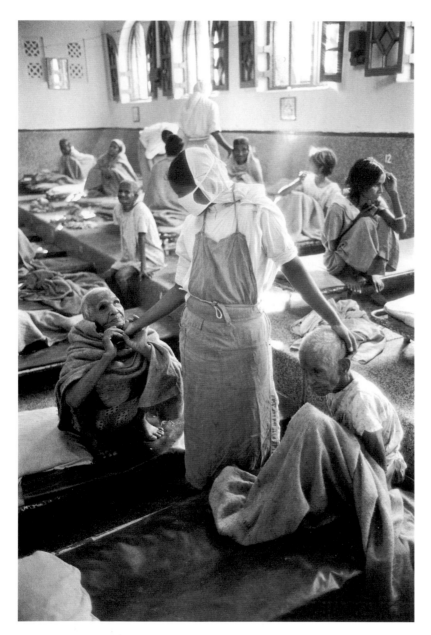

or to self-impelled projects. The fact that of the twelve photographers hired by Roy Stryker for the SONJ projects four were women suggests that despite his paternalistic attitude, he was more willing than most men in positions of power to help women gain experience in professional photography. Although Brooks considered her vision at that time to be "romantic" (as opposed to objective), by today's standards neither her images nor those of the other participants seem noticeably gender-determined.[39]

Few social documentary projects were being underwritten, exhibited, or published in the 1950s. Although photojournalistic essays about social circumstances continued to appear, social documentation was out of favor, at least temporarily. In this regard *The Family of Man*, an exhibition organized for the Museum of Modern Art in New York in 1955 by Edward Steichen (which included the work of some forty women and featured that of several— Consuelo Kanaga, for instance), can be seen as the summation of a style that was soon to be supplanted, at least temporarily, by a more astringent mode of seeing. It was hugely popular at the time, but critics of both sexes later criticized the exhibition, which proposed that all people everywhere share basic human needs, as an attempt to obscure class, gender, and cultural differences, while exploiting the subjects for the photographers' personal gain.

With money in short supply for documentary projects in the 1950s—especially those concerned with untried themes—Berenice Abbott was unable to find funding for a series of images of basic scientific phenomena (plate 213). Keenly aware of inequities between men and women in job opportunities and in pay scale, Abbott attributed the project's failure to attract support to the fact that she was a woman trying to do what was still considered a man's job. (Abbott had been more successful in an earlier invasion of the male domain, having published in 1941 *A Guide to Better Photography*, a well-written and influential manual of photographic instruction.)

Despite the arguments about and the lack of status and patronage for the older tradition of documentation, the genre was kept from vanishing by small groups active in various

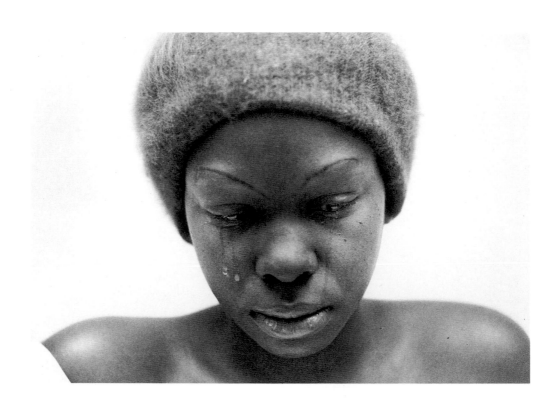

RIGHT, TOP
PLATE 207: DONNA FERRATO
(BORN 1949). *JACKIE—IN THE
HOSPITAL, COLORADO,* 1984.
GELATIN SILVER PRINT. DOMESTIC
ABUSE AWARENESS PROJECT,
NEW YORK.

RIGHT, BOTTOM
PLATE 208: WENDY WATRISS
(BORN 1943). *UNTITLED* (ONLY ONE
SON), 1987. GELATIN SILVER PRINT.
AKRON ART MUSEUM, AKRON,
OHIO; MUSEUM ACQUISITION FUND.

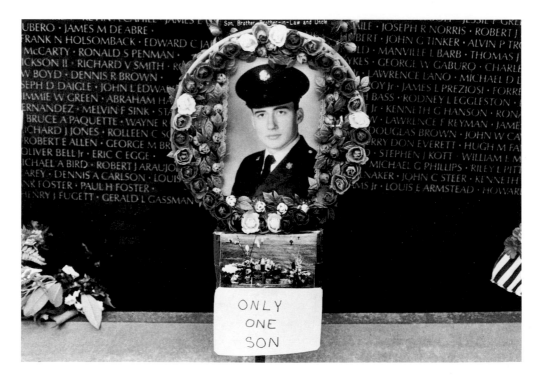

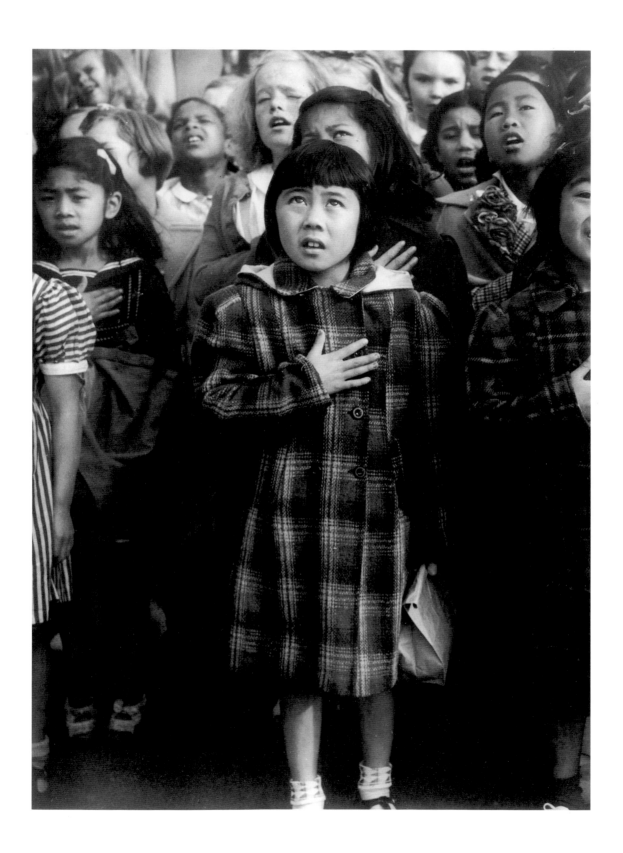

OPPOSITE

PLATE 209: DOROTHEA LANGE
(1895–1965). *PLEDGE OF
ALLEGIANCE, SAN FRANCISCO,*
1942. GELATIN SILVER PRINT.
COURTESY OF HOUK FRIEDMAN,
NEW YORK.

RIGHT

PLATE 210: MARION PALFI
(1907–1978). *SATURDAY,
LOUISVILLE, GEORGIA,* 1949.
GELATIN SILVER PRINT. CENTER
FOR CREATIVE PHOTOGRAPHY,
UNIVERSITY OF ARIZONA, TUCSON.

parts of the nation throughout the 1960s and 1970s, who felt that a pictorial record of ordinary lives had value. Also in the 1970s, a small number of labor unions emerged as a source of patronage for social documentary projects. Earlier, during the 1950s, the militant Hotel Workers Union had employed Mildred Grossman to portray its various activities. Some twenty years later, a commission from District 1199 of the National Union of Hospital and Health Care Workers enabled Georgeen Comerford to concentrate on documenting the range of skills and the ethnic diversity of the workforce in New York's hospitals rather than on the trauma of individual patients or the chaos of emergency procedures. On the West Coast, Reesa Tansey portrayed Mexican-American farm laborers, hoping that her images of families who owned or managed small cooperative landholdings would promote knowledge of options that might help migrants escape their conditions of near peonage.

The social documentary ethos was reinvigorated in the 1980s at a time when increases in homelessness, family disintegration, single parenthood, migrant-labor poverty, AIDS-related problems, and abusive conjugal or companionate behavior attracted attention from photographers. Active on a privately funded project in Chicago, Meg Gerken, Melissa Ann Pinney, and Angela Kelly (plate 214) infused objective reportage of social phenomena with a caring spirit that recalled the documentary images of the 1930s. On the same project, work and workers in urban situations engaged Kathleen Collins and Susan Crocker. Working independently, Debbie Fleming Caffery turned an empathetic camera eye on immigrant cane-field workers in rural areas of Louisiana (plate 215). While teaching photography in upstate New York, Andrea Modica began documenting a family living in the tiny rural community of Treadwell (plate 216), and she has continued the project following the family's move elsewhere. In the belief that social documentation can truly effect social change, Ferrato and Watriss, mentioned earlier, lectured and showed their images throughout the nation, and Ferrato set up a fund to aid battered women.

The documentation of various ethnic minorities, regional communities, and religious practices also attracted women. In the late 1960s West Coast photographer Michelle Vignes followed the struggles of Native Americans for their rights; she went on in the 1980s and early 1990s to portray the high spirits and satisfactions afforded African-Americans living in the Bay Area by their involvement in blues and jazz (plate 217). Among Rosalind Solomon's

many ethnographic interests, which have taken her to Guatemala, Peru, Nepal, and India, are the religious practices of those living on the Indian subcontinent (plate 218).

Italian photographer Marialba Rosso and Spanish photographer Cristina García Rodero, who specialize in recording the vanishing religious and folk festivals of their respective countries, have been concerned with tradition and change. García Rodero's documentation, numbering over 100,000 negatives of local and regional events and fiestas, is dedicated to capturing "the mysterious, genuine and magic soul of Spain"[40] (plate 219); it was recognized by a W. Eugene Smith grant in 1989. In France, Marie-Paul Nègre has focused on the immigrant life usually hidden from touristic eyes (plate 220). Trained in journalism and the social sciences in Prague, Markéta Lusckacová was initially drawn to photographing Czech religious festivals to illustrate her work in sociology. After a move to England in 1975, she became a photojournalist, but still considers her personal photographs of battered women and impoverished children to be a means of making others aware of these problems.

In recent times some members of the Native American, Latino, and African-American communities have come to feel that their lives are more insightfully revealed by those from similar backgrounds. Work by American Indian women photographers—among them Carm Little Turtle, Jolene Rickard, and Hulleah Tsinhahjinnie—recasts the signs and symbols of Indian culture using montage, hand toning, and the directorial strategies favored by many contemporary practitioners. In some cases, these images are intelligible only to those conversant with Indian spiritual ideas.

The images produced by many of these women documentarians contrast sharply with the style of documentation practiced in the early 1960s under the rubric "the social landscape."[41] With its focus on the consumerist values of the white American middle class and its distanced, uninflected vision of highways, signage, store windows, and suburban developments, this may have been one of the few photographic styles that can be said to reflect a distinctively male sensibility. Women played almost no role in representing this sense of alienation and disenchantment, which had been partly inspired by the writings of Jack Kerouac and the photographs of Robert Frank. Both Lisette Model and Diane Arbus, who were

PLATE 214: ANGELA KELLY
(BORN 1950). *MONICA IN HER
BEDROOM*, 1986. GELATIN SILVER
PRINT.

active at that time, avoided what they regarded as sentimental idealization in their depictions of American social life in urban settings, but neither was "cool" or detached from what she portrayed; in fact, Model deplored what she termed "lukewarmness."[42]

Nor were women much involved with a movement called the "new topographics," which surfaced in 1975 as the depiction of "a man-altered landscape."[43] The thrust of this variant of the social landscape genre initially was to expose the sterility in contemporary culture by objectively recording barren-looking utilitarian structures; by the 1980s, when its aesthetic intentions became more emphatic, this approach awakened interest among a small number of women, including Lynne Cohen and Catherine Wagner. However, Cohen's flattened, unpopulated exterior and interior views (plate 221) are more Minimalist than topographic, while Wagner, who considered photography to be "a problem-solving process in the arts,"[44] "feminized" the genre to some degree by depicting empty schoolrooms instead of factories and shopping malls. Candida Höfer's early projects were concerned with documenting the conditions of Turkish workers living in her native Germany, but she later turned her attention to revealing the impersonality of interior spaces in many public buildings in Europe (plate 222).

In the nineteenth century, photographic partnerships between husbands and wives were not uncommon, although women were often viewed by themselves and by others largely as helpmates in the portrait business. In the early years of this century, as documentary film-making, ethnographic and anthropological investigations, and archaeological digs became more systematic, spousal teamwork became more frequent. In 1913 Frances Hubbard Flaherty assisted her husband, film maker Robert Flaherty, by making stills of his film-making activities among the Aran Islanders and the Inuit, and later she performed the

same service in Louisiana (plate 223) and in India. Working in Africa in the 1920s, Mary Lee Jobe Akeley took still photographs of the big game animals captured by Carl Akeley's movie camera, and she continued to photograph there after his death. In the 1940s Osa Johnson recorded the large African game animals that she and husband Martin Johnson were intent on preserving from extinction. Gertrude Blom's first photographs in the Lacandon villages were made in conjunction with Franz Blom's archaeological excavations. Edwin and Louise Rosskam were employed as a team on Stryker's Standard Oil (N.J.) Project; according to Louise their collaboration produced a more natural-seeming result, because one person could relax the subject while the other made the exposure. Together, German photographers Hilla and Bernd Becher have produced an extraordinary documentation of industrial structures such as watertowers and mine tipples; they refer to these large-scale images (plate 224), which usually are mounted in groups of six or more, as "typologies," although there is little doubt that their work makes an aesthetic as well as a documentary statement. Such synergy is not, of course, limited to husbands and wives. A distinctive body of work has also been

PLATE 216: ANDREA MODICA (BORN 1960). *TREADWELL, NEW YORK*, 1986. PLATINUM/PALLADIUM CONTACT PRINT. COURTESY OF EDWYNN HOUK GALLERY, NEW YORK.

produced through the collaboration of companions, exemplified by *Changing New York*, with photographs by Berenice Abbott and research and texts by Elizabeth McCausland.

STREET PHOTOGRAPHY

By 1940 the documentary and photojournalistic ethos—with its emphasis on human activities, on perceived reality, and on the American scene—had a decided impact on those photographing for their own expressive reasons rather than as a means of livelihood. With few exceptions, work inspired by traditional Pictorial themes and atmospheric treatments now appeared tired and insipid. Instead, women started to depict the urban scene directly, often with a strong emphasis on the human drama being played out. This development can be attributed to several factors: the availability of small yet sophisticated apparatus (such as the Leica) that could be carried easily and used discreetly; the example set by women refugees who were accustomed to photographing in the streets of European cities; and the availability of more leisure time due to the economic upswing following World War II.

Even before the war, a small number of women had worked in the streets as members of the Photo League, a New York group formed in 1935 after the dissolution of the more radical Film and Photo League. The new organization welcomed all photographers dedicated to a progressive social agenda, a policy that in effect favored street photography

PLATE 219: CRISTINA GARCÍA
RODERO (BORN 1949). *PILGRIMAGE
FROM LUMBIER, SPAIN*, 1980.
GELATIN SILVER PRINT. COURTESY
OF GALLERY OF CONTEMPORARY
PHOTOGRAPHY, SANTA MONICA,
CALIFORNIA.

(including interiors, when the photographer could gain access to them) over other genres. The number of women members in the early years of the league's activities is difficult to determine, but after the war roughly between one-quarter and one-third of the members were women, with Abbott, McCausland, and Barbara Morgan on the advisory board. No woman was ever elected president, which may have provoked Abbott's later castigation of league policies as sexist,[45] but Elizabeth Timberman held the office of executive secretary and Maryann Older was responsible for organizing and conserving the Lewis Hine Collection, which was given to the league in 1941.

Among active participants were Consuelo Kanaga, who led a feature group (photographers who concentrated on a discrete neighborhood or theme) during one of her sojourns on the East Coast; Nancy Newhall and Morgan, supporters until their resignation in the late 1940s, when the league was declared a subversive organization; and Lucy Asjian and Beatrice Kasofsky, who were among those who worked on the Harlem Document (for which Aaron Siskind eventually took sole credit).[46] Both McCausland and Newhall wrote for the league's journal, *Photo Notes,* which at various times was edited by Asjian and Rosalie Gwathmey. Ruth Bernhard, Margaret Bourke-White, Lotte Jacobi, Dorothea Lange, Helen Levitt, Lisette Model, Ruth Orkin, and Marion Palfi were either members or were invited to exhibit, lecture, or write for *Photo Notes.* Lange, for example, visited on a trip east in 1939,

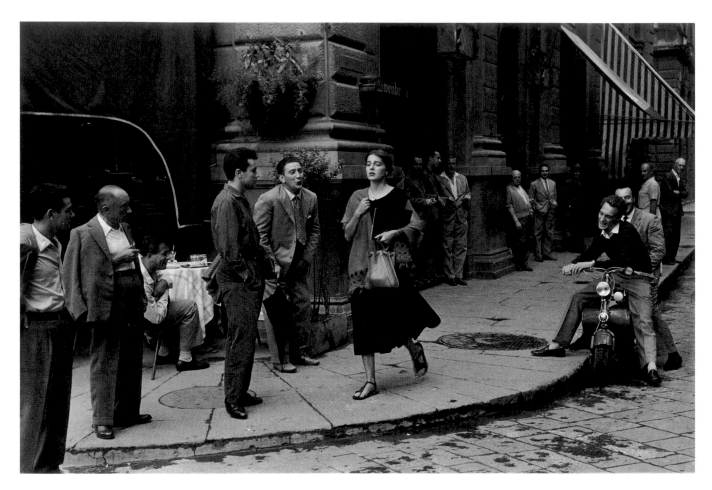

its agenda of changing styles in fashion work between 1919 and 1979, eight were women—
only one of whom predated 1940.[49] At the magazine's centennial exhibition in 1992, eight
women figured among the fifty-two photographers featured, but the imbalance in the relative
numbers of their images reproduced in *On the Edge: Images from 100 Years of Vogue*, the accompa-
nying publication, is startling. Fourteen photographs by the eight (not all fashion images)
were included, but just four male photographers accounted for more than half of the two
hundred works.[50]

 Few women photographers were on staff at *Harper's Bazaar* in the 1930s and
1940s, but their input had an exceptionally strong impact on the magazine's appearance.
Certainly the exacting standards and sophisticated color sense brought to *HB* by the fashion
photographer Louise Dahl-Wolfe (who started her fashion career at Saks Fifth Avenue around
1935) transformed the look of its color pages (plate 6), which had begun to supplant black-
and-white in all periodicals during the late 1940s. Her color work also gained Art Directors
awards in 1939 and 1941. For more than a quarter of a century, Lillian Bassman, an art stu-
dent turned photographer who shared the art directorship of *Junior Bazaar* with Alexey
Brodovitch, produced a wide variety of consumer products as well as fashion images—"every-
thing but cars."[51] Bassman, like several of the other groundbreakers in photojournalism and

fashion photography, claims to have encountered no obstacles from sexist attitudes. Indeed, she maintains that being a woman had advantages in certain kinds of fashion work; models, for instance, often were more relaxed in front of women photographers, resulting in greater naturalism of pose and expression. Among other early female contributors to *Harper's Bazaar* were Naylor, who had moved over from *Vogue*, and Evelyn Hofer, who moved to New York from Mexico to work with Brodovitch. Naylor, whose photographs of Brazil for the U.S. State Department had led to work for the fashion magazines, was commissioned by *McCall's* to make portraits of Eleanor Roosevelt (plate 231) during a four-year period (1954–58). Hofer went on to produce six books of evocative photographs depicting urban and regional cultures.

At about the same time that Dahl-Wolfe began a career in fashion, German photographer Regina Relang turned from free-lance photojournalism to fashion. Working on contract for *Vogue,* Relang traveled throughout Europe until 1939, when she returned to Germany and for the next thirty or so years provided fashion images for *Die Dame* and other major European publications. Categorizing early fashion work by gender is difficult unless one agrees with Dahl-Wolfe that men, with their "standard sense of color," were less creative in that regard than women.[52] Little in the way that models were posed and presented can be called distinctively feminine either in aesthetic sensibility or social attitudes, largely because fashion images in the editorial section (as opposed to the ads, which were more varied, if less artful) were expected to project a more or less uniform look of costly sophistication. In more recent times, however, as fashion photographers have been given greater leeway, work by women

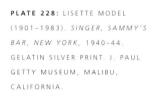

PLATE 228: LISETTE MODEL (1901–1983). *SINGER, SAMMY'S BAR, NEW YORK,* 1940–44. GELATIN SILVER PRINT. J. PAUL GETTY MUSEUM, MALIBU, CALIFORNIA.

has produced the impression of being decidedly less aggressive than that by male colleagues, who still constitute the majority of those in the field.

If, as *Vogue* art director Alexander Liberman has said, "a fashion photograph is not a photograph of a dress, . . . [but] of a woman," then the contributions of Sheila Metzner, Sarah Moon, Elizabeth Novick, Deborah Turbeville, and others certainly communicated less hostility toward their own gender.[53] They generally avoided the erotically suggestive poses and sometimes lunatic props favored by, say, Richard Avedon, Helmut Newton, and Irving Penn that present women as objects. Instead, women tended to create dreamlike scenes that suggest a female understanding of high fashion as essentially a world of harmless fantasy (plate 8). Moon's work in particular is filled with emblems of luxury and nostalgia, which generate a sense of mystery (plate 232). Of course there are exceptions: Jean Pagliuso continued the tradition of elegant chic initiated by the male fashion photographers of the 1930s (plate 7), while Bettina Rheims and Ellen von Unwerth (French and German, respectively) played with the same erotic resonances favored by many male fashion photographers. And being female did not prevent women fashion photographers from indulging in a certain pretentious-

PLATE 229: FRANCES MCLAUGHLIN-GILL (BORN 1919). *AT THE GALERIE DES GLACES, VERSAILLES,* 1952. GELATIN SILVER PRINT.

ness of their own. Such mannerisms are just as visible in Turbeville's portrayal of Mayan and Aztec women as they are in Penn's appropriation of indigenous Peruvians as "fashion" models. Men and women both have gained from the breaching of strictly commercial boundaries. For example, works by Dahl-Wolfe, Metzner (who also photographs landscapes and still lifes), and Turbeville, as well as by Avedon and Penn, are displayed in galleries and acquired by museums.

Like fashion imagery, celebrity portraiture lends itself to a number of approaches. Each generation of portraitists has brought distinctive mannerisms to the genre, but here, too, stylistic differences between male and female portraitists are not easily discernible because there are so many diverse options available to them. The photographer can document a single person and place over a long period of time, as in Erica Anderson's study of

Albert Schweitzer at Lamboréné, in Gabon. The sitter can be treated in a painterly manner using rich colors and an amplitude of props, as in the work of Marie Cosindas (plate 25). Or the use of props can be far more quirky, as in the celebrity portraits by Annie Leibovitz (plate 233). She incorporates symbolic or bizarre objects to give her portraits a mystifying dimension and make them unusually eye-catching. A highly competent practitioner, Leibovitz is, as one observer noted, "the photographic equivalent of a first-rate studio musician" in that she adapts her style to the demands of each commercial commission.[54] This adaptability is characteristic of many commercial practitioners, male and female, because publicity portraiture relies on novelty and visual appeal. In Leibovitz's case, such adaptability has given her confidence to allow herself to set her own projects and make her own choices about what to photograph. Her later work—including a series of large-scale nude studies originally commissioned for a Pirelli calendar—effectively bridges the divide between art and commerce.

RIGHT
PLATE 231: GENEVIEVE NAYLOR
(1915–1989). *ELEANOR ROOSEVELT*,
1956. GELATIN SILVER PRINT.
PETER AND MICHAEL REZNIKOFF
PARTNERSHIP, NEW YORK.

BELOW
PLATE 232: SARAH MOON
(BORN 1940). *SUZANNE IN THE
TUILERIES*, 1974. SEPIA-TONED
GELATIN SILVER PRINT.

Architectural documentation, which bears "the same relationship to real buildings as fashion photographs bear to women,"[55] is an area of documentation that has attracted women since early in the century; nevertheless, the field remains dominated by men. A few women have managed to make a reputation: before the outbreak of World War II Thérèse Bonney concentrated on modernist architecture in France, Germany, and Switzerland, recording many of the less famous examples of the Art Deco and International styles. In the 1940s, Phyllis Dearborn Masser was probably the only woman in the United States to specialize in photographing houses—exteriors and interiors—and gardens for architects and the specialty magazines. Evelyn Hofer's many publications about urban sites attest to her excellence as a photographer of buildings (plate 234). Barbara Crane, hired in 1972 by the Commission on Chicago Historical and Architectural Landmarks, spent seven years producing architectural documentation that highlighted a structure's distinctive design elements without downplaying its relationship to site and other buildings. Judith Turner's abstractions, based on images of postmodernist buildings in Connecticut (plate 235) and Israel, have merited publication as aesthetic statements as well as architectural documentation.

In the related field of interior-design photography, which traditionally has been considered a domain of female interest, relatively few women have achieved acclaim, with the exception of Lizzie Himmel (Lillian Bassman's daughter, who is now engaged in general advertising work), Barbara Karant, and Karen Radkai. Although some fifteen magazines devoted to architectural and interior design were published in the United States during the 1970s and 1980s, their photographic illustrations were mainly the work of men. In the past, this scarcity of women might have been due to the fact that traveling to locations with a great deal of heavy equipment is necessary for on-site pictures of interior decor, but that does not explain the fact that there are still few women specializing in this aspect of photography.[56]

Entering the field of product advertising and fashion in the 1970s was trying for women, partly because there were more applicants than formerly. That generation—which included Tana Hoban, Maureen Lampray, Susan McCartney, Doris Pinney, Mary Ann Reinmiller, Cheryl Rossum, and Suzanne Szasz, to name only a handful—experienced greater difficulties than their female predecessors in gaining the apprenticeships necessary for ascendance into the higher-paying advertising accounts. Established commercial studios were reluctant to employ women as assistants because (like their counterparts in newspaper photography) they were perceived as too frail to handle heavy equipment. When women did find jobs in photography, some discovered that

PLATE 233: ANNIE LEIBOVITZ (BORN 1949). *ISABELLA ROSELLINI AND DAVID LYNCH*, 1986, COURTESY OF CONTACT PRESS, NEW YORK.

they were not taken seriously. At a meeting in 1972 of women professionals, some participants claimed that sexist conduct could actually work to the photographer's advantage, but some of the younger women present voiced objections to "playing the hairy line between sex and art."[57] The difficulties that these photographers experienced undoubtedly reflected both the larger numbers of women competing for commissions and the ongoing hesitancy on the part of the male establishment to correct past inequities. As photography editor Julia Scully observed, a new generation of women were "taking for granted their rights and abilities to enter a field of their choice with the same options as men," but in so doing they may not have stepped through the minefields of male prejudice as carefully as their forerunners had been forced to do.[58]

As greater numbers of women became aware of the divergences between their own views and economic rewards and those of the male-dominated establishment, their attitudes toward gender-specific images changed. For some, being female was again seen as a distinct advantage; subjects, males in particular, were perceived as more willing to express emotions when confronted by someone who was not viewed "as a competitor."[59] Women certainly became more conscious of bias, as in Jill Krementz's recollection that when out on assignment, her male assistant was usually assumed to be the photographer and she, the assistant. Women recognized, too, that despite the marked increase in their numbers behind cameras, the important figures in front of the lens, on the political scene especially, were "still almost exclusively men."[60] Clearly, these perceptions do not suggest a way of seeing that is biologically specific to females but do reflect a greater awareness of the conventional roles of the sexes in an industrial society.

Women's increased participation in all aspects of magazine photography—news, fashion, travel, and celebrity portraiture—was evident in the increased number of female members in the American Society of Magazine

Photographers (ASMP), founded in 1944, and now called the American Society of Media Photographers. (Only a handful of women had belonged to the organization during its first two decades.) During the 1960s and 1970s the ASMP house organ, *Infinity,* occasionally featured articles on women, reproducing work by Marie Cosindas, Imogen Cunningham, Nell Dorr, Toni Frissell, Dorothea Lange, Lisette Model, and Tina Modotti. Among early members were Jane Bryant, Patricia Caulfield, Joan Liffring, Elaine Mayes, Lilo Raymond, and Ann Zane Shanks— the last-named became a trustee of the organization. An exhibition in 1969 commemorating the twenty-fifth anniversary of the ASMP included the work of seven women among eighty photographers. By the mid-1970s, when membership had risen to over twelve hundred and the organization had opened chapters outside New York, some seventy-six women were members, a ratio that appears to have remained fairly constant.[61] When giving its first Lifetime Achievement award to women in 1979, the ASMP felt it necessary to divide the honor in half, naming both Eve Arnold and Louise Dahl-Wolfe as recipients. Arnold sardonically cited a parallel in the Arabic world, where "by law, two witnesses who are women are the equivalent of one man."[62] A more open acceptance of female professionals in the field was reflected in the election in 1979 of Barbara Bordnick to the presidency of ASMP, a position later held by Helen Marcus for three consecutive terms starting in the mid-1980s.

The expansion in photographic activity that occurred after World War II embraced personal expression as well as commercial photography, documentation, and photojournalism. It brought with it new aesthetic ideas, which inspired an outpouring of creativity and provided women with a variety of forms and symbols for the expression of innermost feelings, many of which came to the fore in the resurgent feminism of the 1960s.

CHAPTER 8

THE FEMINIST VISION, 1970–95

"The presence of a persistent women's voice" was, according to an observer, "one of the most salient aspects of . . . postmodern culture."[1] Reemergent feminism—which surfaced in the 1950s with Simone de Beauvoir's *Second Sex* and acquired momentum in the United States during the 1960s with Betty Friedan's book *The Feminine Mystique*—germinated, flowered, lay fallow, and assumed divergent forms throughout the following decades. By the mid-1990s the movement's focus had become diffuse and its strengths were to be found mainly in academia, but over a quarter of a century the new consciousness it had generated gave rise to a number of varied ideological positions about women's role in society and the arts. Imprinting itself on the work of many women photographers, first in the United States and eventually in Europe, feminism influenced those who were drawn to aesthetic experimentation as well as those for whom polemical content always was paramount. Awareness of their inequitable position in relation to cultural, economic, political, and social matters had impelled women to review the ways they had been neglected in the past, to investigate societal causes, and to look inward in order to consider how they had related to the world while growing up.

One early manifestation of the new feminist consciousness in the United States can be seen in the numbers of publications in which women tried to examine, through image and word, their relationship to their own upbringing and to their chosen medium. Exemplified by Abigail Heyman's *Growing Up Female: A Personal Photo-Journal* (1974), such books demonstrated that women had become aware of the effects of stereotyped roles and behavior instilled in female children by gender-oriented expectations and games. Publications concerned with this issue ranged from *Re-Visions,* Marcia Resnick's 1978 satire about conventional expectations for white middle-class young women, which deals with adolescent fantasies in a format mimicking grade-school readers, to Bea Nettles's *Skirted Garden* (1990)—a catalog of twenty years of feminist-oriented photographs and texts in a variety of processes, in which she presented "themes of woman's strengths and ways of knowing about the world."[2]

As aroused feminist consciousness made itself felt, what once might have been considered a purely personal or introspective gaze by a woman into her own feelings and expectations developed political and social dimensions. Straight portraits, narratives, landscapes, composites, montages, and serial works all began to reflect the new concern for making apparent women's sensibilities and the issues they deemed significant. Wendy Snyder MacNeil's image *Marie Baratte* (plate 236) evokes the then prevalent feminist issues of looking, seeing, the passage of time, and the domestic roles assigned to women. Increasingly, photography became for many women an effort to communicate visually their own self-images, to respond to the

persistent self-questioning taking place. That these issues, along with that of male voyeurism, were crucial to many American women is affirmed by the magnitude of response to an invitation to submit images for a book entitled *Women See Women*, which resulted in the submission of over ten thousand photographs from around the United States. Feminist theory enlarged the meaning of "seeing" to refer not only to what is being seen but also to how it is seen and to the power that accrues to the individual who is doing the seeing. Representation, according to feminists, depicted more than how women looked; it affected how others viewed them and ultimately how they lived.

Although fewer in number and less vocal than their colleagues in the United States, women in other parts of the world also became sensitive to the urgencies of the feminist movement and responsive to their cultures' specific historical attitudes toward women. A British dictum that held it to be "a medical fact that the female constitution is less able to withstand" conditions in "unhygienic darkrooms," and, further, that "dimly lit confined spaces with several men" were unfit workplaces for females, helped provoke the emergence of active feminist photographers' groups.[3] In the 1970s and 1980s these groups not only sought to counter prevailing ideas about appropriate jobs and subjects for women but also to advocate a kind of political photography that went beyond social documentation, which they claimed showed only appearances while ignoring underlying causes or dynamics. That the general British attitude about women in the medium has changed somewhat is exemplified by the public acclaim for the 1999 award of an OBE to Grace Robertson, a first for a female photographer.

The feminist call in Mexico prompted the well-known photographer Graciela Iturbide to return again and again to the village of Juchitán, a community where women are

PLATE 237: STARR OCKENGA (BORN 1938). *MOTHER AND DAUGHTER*, 1974. GELATIN SILVER PRINT. SHELDON MEMORIAL ART GALLERY, UNIVERSITY OF NEBRASKA–LINCOLN; F.M. HALL COLLECTION.

healers and conveyors of wisdom. In offering a "personalized view of the female experience in the less urbanized regions of Mexico," the photographer sought to idealize matriarchal culture (plate 193), in particular the aspects dealing with marriage and virginity.[4] Following extensive documentation of all the people of Portobelo (plate 195), the Panamanian photographer Sandra Eleta also was drawn to specifically matriarchal themes, photographing just three women in the valley of Tonosi. The claim made for the naturalness of this work—that "because she is a woman, she is not perceived as a threat"—became a familiar judgment, as did the belief that "male photographers could not develop the same relationship."[5] These depictions of women's communal activities were regarded as the kind of material that only women photographers would be able to see as having any significance for the larger world.

A look at what women have produced throughout the history of photography suggests that the answer to whether they see differently from men is not easily determined. Women have seen differently at different times and, as the foregoing chapters have shown, their outlook has spanned an uncategorizable diversity. Women's work can be strong as well as sentimental, it can focus on exterior as well as interior spaces, on mechanisms as well as organisms. Women can be engaged by the practical problems of producing a marketable body of work as well as inspired by aesthetic, cultural, or social matters. What and how women photograph reflects the psychological and social contexts of their lives and the ideologies that drive their work. It was no accident that an outpouring of images by and about women materialized in the wake of the feminist awareness that began to emerge in the late 1960s, any more than it had been luck that promoted women's ideas and productions during the Progressive Era at the beginning of the century.

FEMINIST RESPONSES TO TRADITIONAL SUBJECTS

Reflecting this changed and charged climate, women photographers of the 1970s approached the portrait with fresh ideas. They turned to depicting the full range of appearances and personalities of members of their own sex, as in the work of Starr Ockenga (plate 237), and in so doing they revealed a diversity of age and type and of relationships often ignored in the past by both male and female photographers. Anne Noggle, for one, drew on the classic documentary portrait tradition to subvert masculine ideas of beauty (plate 238). Ann Meredith portrayed women workers, the aged, the ill, and those with alternative sexual styles, as did the British activist Jo Spence. However, for Spence the documentary mode became too limited to convey feminist ideology, and eventually she turned to montage and text-image combinations to express these ideas. Judy Dater sought to demonstrate women's dreams and fallibilities by allowing her female sitters to costume themselves according to their own fancy and by including objects and backgrounds within the frames of her portraits to suggest not only the outward appearance of her sitters but also how they regarded themselves (plate 239).

The self-portrait was transformed as well, because with their new-found feminist sensibilities, women photographers found themselves more accepting of how they actually looked. Noting that the self-portrait is far more common among women photographers than among men, some feminists have suggested that this was so because "women tend to trust subjective knowledge more implicitly than men."[6] Both Dater and Noggle, among others, also portrayed themselves as part of their efforts to investigate character and life process. Earlier in the century the self-portrait had frequently been seen as a way to assert a woman's professional status, as in Alma Lavenson's forceful image of her hands manipulating her camera (plate 158).

The photographers mentioned above are but a small number of the many who by the mid-1970s had sought to recognize their own worth and to question how they might fulfill their sense of humanity. The flowering of portraits by, for, and of women was accompanied by an increase in exhibitions and publications on this theme; eventually it developed into a genre known as visual autobiography.

What traditionally had been considered feminine subjects also were transformed by feminist awareness, gaining new stature in the eyes of women who may not have regarded the camera as a weapon in a political struggle but still sought to express a sense of being female. Montagist Judith Harold-Steinhauser, for one, found herself attracted both to flowers as symbols of "openness and warmth" (plate 35) and to "women in repose as . . . the metaphor of the muse"—both themes recall the outlook and work of turn-of-the century women Pictorialists.[7] Similarly, Betty Hahn, engaged by a variety of both contemporary and traditional manipulative and straight processes (plate 36), found the portrayal of flowers to be a path to what was "beautiful, curious, and had some sense of mystery."[8] This trend, which mirrored a similar preoccupation in the handmade visual arts, also embraced the handicrafts customarily associated with women. Hahn sometimes applied stitchery to her images, and Deborah Willis joined the traditional craft of quilting with photographic technology by imprinting images of African-American life onto pieces of fabric and stitching them into a coverlet.

PLATE 239: JUDY DATER (BORN 1941). *CONSUELO CLOOS*, 1980. GELATIN SILVER PRINT.

Feminism's unique impress on the photography of the 1980s and early 1990s went well beyond reassessing themes and forms once considered either sentimental or insignificant by the largely male photographic establishment. Feminist thought, in tandem with the postmodernist concepts of deconstruction and structuralism, "added a whole new dimension to the critique of high modernism and to the emergence of alternative forms of culture."[9] These ideas, which had surfaced in the mid-1970s, were applied to various forms of expression and differ for each, but in the visual arts they were called upon to attack modernist assumptions about the role of art in culture. Both deconstruction and structuralism (the theory on which deconstruction is based, which in turn is based on linguistic studies known as semiotics) hold that images cannot be understood without being decoded, that what you see in a picture are signs (or signifiers) of a deeper meaning (or the signified). However, what is important are the signs and how they relate to one another—the structure of the work—and not the underlying meaning. For instance, installations such as those created by Annette Messager (plate 265), which use an array of photographs and objects, seek to uncover hidden structures and to make the point that appearances are not reliable.

Further, deconstruction theory does not distinguish between levels of excellence in a work, and in the words of a spokesman, it "is indifferent to the cultural value of an object."[10] Because modernism was believed by some women photographers to have promoted patriarchal concepts of beauty and humanism, which they considered as deriving from centuries-old male systems of representation in the high arts, they turned instead to the popular arts of advertising, cinema, video, and performance for their strategies. That they chose to undermine male authority by appropriating tactics from fields that were essentially male dominated may seem ironic, but individuals with styles as divergent as Sophie Calle, Eileen Cowin,

Barbara Kruger, Lorie Novak, Esther Parada, and Cindy Sherman have all looked to the magazine ad, the billboard, the television commercial, and the motion picture for ways to convey their messages about women's feelings and frustrations.

Describing herself as an artist rather than a photographer, Sherman makes large-scale color images (plate 30) that are depictions of herself (and, more recently, dolls and mannequins), costumed and deployed in postures derived from magazine ads, horror films, art history, and soap operas. Rather than autobiography, these works are preoccupied with the

ways that women have been objectified. They are meant to reveal how women have been victimized by history, by the male power structure, and by the popular culture from which the photographer draws her inspiration. Paradoxically, this work, which its maker admits is compounded of the desire to shock and to satirize, has been commercially and critically successful, appealing to the very public that Sherman has said she scorns.[11] The recent acquisition by the Museum of Modern Art in New York of a large body of Sherman's work underscores the contradictions inherent in antiestablishment art. Of course, the bizarre as a mode for visual statements about specifically feminist issues is not entirely new; it permeated with particular force the unsettling montages made by Hannah Höch and Claude Cahun (Lucy Schwob) in the 1920s and 1930s (plates 126 and 129) and the strange creations by Ellen Carey in the 1970s.

That the popular-entertainment culture invaded a wide spectrum of feminist photographic expression is evident in staged images produced by Laurie Simmons and Eileen Cowin (plate 27), both of whom have worked with figurines and fabricated domestic (rather than theatrical) sets to make their points about male-female relationships. In fact, the large number of domestic scenes in camera imagery of the 1980s and early 1990s is a potent indication of the influence of feminism on photographic practice as a whole. Triggered perhaps by Diane Arbus's interest in symptoms of alienated family life as well as by current reality,

feminist photographers have highlighted the discrepancy between the myth of the dominant nuclear family and the reality that this particular domestic arrangement of working father, homemaker mother, and children accounted for fewer than 25 percent of American families. The previously mentioned work of British photographer Jo Spence also was aimed at reexamining women's self-identity in relation to motherhood and parental or sibling tensions.

By the 1980s one preferred strategy for the domestic genre—which began to attract more attention with the recognition that family images were fabrications in which aesthetic, political, and social elements were combined—was either to use or to approximate the lowly family snapshot. The snapshot had long been thought of as the insignificant province of females who annotated and kept the family albums. Now it became a tactic for revealing the real but unacknowledged relationships between women, their spouses, their children, and their possessions. This genre is exemplified by Tina Barney's seemingly casual documentations of domestic life among the well-to-do (plate 17), in which she presents greatly enlarged views of what once were considered the private affairs of family members. Adults and children, performing routine or extraordinary activities in the bathroom, in bed, at the table, or at leisure, are shown in works that have been greatly scaled up for exhibition (as well as being published in book format).

One of the more ambitious examples of a revisionist approach to family history is *Traces,* a site-specific reconstruction by Lorie Novak of her familial past that makes use of multiple-image projections. Combining snapshots of moments of special personal meaning with images of violent political happenings (plate 240), Novak sought to transform an enclosed space into a metaphor for the mind—to create an experience that includes personal memories interlinked with societal ones.[12] The transformation of "family values" into a

PLATE 242: CLARISSA SLIGH
(BIRTH DATE UNAVAILABLE). *HE
WAS HER HUSBAND WHEN THEY
PLAYED "HOUSE,"* 1984. GELATIN
SILVER PRINT.

He was her husband when they played "HOUSE".

Jim, if you choose to accept, the mission
is to land on your own two feet.

PLATE 243: CARRIE MAE WEEMS
(BORN 1953). "JIM, IF YOU
CHOOSE TO ACCEPT, THE MISSION
IS TO LAND ON YOUR OWN TWO
FEET," 1987. GELATIN SILVER
PRINT. COURTESY OF P.P.O.W.,
NEW YORK.

political issue for both conservative and radical forces makes it understandable that images dealing with this idea would end up on view in museums. What may seem less understandable is the postfeminist return to "the sanctity of the private," but perhaps the gaining of greater equality made it possible for women to again celebrate the family and child care.[13] One example of this more benign attitude toward family relationships can be seen in photographs taken by Marianna Cook showing the intimate connections of daughters with either their fathers or mothers.

WOMEN OF COLOR

Feminism has sometimes been regarded as a white middle-class phenomenon, but during the 1980s growing numbers of Native American, Asian-American, African-American, and Hispanic-American women photographers sought to fuse its concepts with a sense of ethnic specificity. With increased access to education as well as more personal freedom in recent years, more women of color found it possible to study, travel, and gain experience as they explored the various dimensions of photography. In the process, these women discovered and invented ways to combine feminist messages with ethnic concerns. Because black women of the past had largely been involved in establishing portrait businesses or professional accounts, few had had the leisure to focus on themes that did not generate income. Eventually, a number were able to turn to subject matter of their own choice, among them Marilyn Nance, who has recorded (among other themes) the rituals of a community of African-American women (plate 241), bringing to light the particularities of a multi-ethnic culture. Feminist consciousness combined with postmodernist strategies and with the African-American tradition of storytelling provided a foundation for the restaged memories of childhood and youth depicted by Clarissa Sligh in the form of serial images to which are appended texts based on actual conversations (plate 242). Carrie Mae Weems has fashioned works from staged events in order to expose the stereotyping that has habitually marked images of black men and women in the popular media (plate 243). A different strategy characterizes the statements by Elisabeth Sunday. Working in central Africa—Kenya, Mali, and Senegal—she has made use of distorting lenses that merge woman and landscape to suggest the indivisibility of this relationship (plate 244). Other aspects of African-American experience are revealed in more traditional formats, as in Coreen Simpson's large-scale portraits concerned with contemporary street culture (plate 245).

Similarly, young Latina women began to look to their own ethnic heritage for inspiration. For example, Kathy Vargas, a Chicana photographer from Texas, has montaged such typical symbols as skeletons, masks, and figurines with other less sacred objects to reflect her own particular memories of a culture in which the Day of the Dead (which is also the name of her series) plays a profound role. Martina Lopez conjures up memories of her Latina heritage through a series of composites of family portraits combined with dreamlike landscapes (plate 246). The costumed and scripted images by Native American photographers Jolene Rickard, Hulleah Tsinhnahjinnie, and Carm Little Turtle involve ideas about how

PLATE 244: ELISABETH SUNDAY (BORN 1958). *BASKET OF MILLET*, 1987. GOLD-TONED GELATIN SILVER PRINT.

253

PLATE 245: COREEN SIMPSON
(BORN 1952). *DOO RAG*, 1985.
GELATIN SILVER PRINT. JOHN
BENNETT COLLECTION, NEW YORK.

others see Native Americans, how natives see themselves, and the nature of relationships between men and women.

Feminist emphasis shifted, according to one commentator, from the "politics of representation" to the "politics of self-representation."[14] This development inspired women of various ethnic backgrounds and diverse sexual allegiances to create images dealing with personal history, most commonly through combinations of images and texts. Tee Corinne and Laura Aguilar, for example, used such combinations to investigate lesbian relationships; Young Soon Min overlaid her own silhouette on images of significant events in Korean history; Betty Lee combined artifacts of Western culture with images of Asian peoples to explore her dual ethnicity.

THE BODY

No aspect of existence has seemed more reflective of feminism's message than sexuality and the nude. Because many women have wished to circumvent the systems of meaning that male authority has invested in the human body—in particular, the female nude—they have attempted to recast the way it is represented and to redefine its symbolic meanings. To recapitulate briefly: At the beginning of the century, some female Pictorialists viewed the female nude as a symbol of the unfettered spirit. During the modernist era, this subject was viewed as a way for women to proclaim photography as art by choosing a typical high-art theme at the same time that they

PLATE 246: MARTINA LOPEZ (BORN 1962). *REVOLUTIONS IN TIME, I*, 1994. CIBACHROME PRINT. SCHNEIDER GALLERY, CHICAGO.

PLATE 247: RUTH BERNHARD
(BORN 1905). *TWO FORMS*,
1963. GELATIN SILVER PRINT.

investigated their own corporeal being (plate 247). Writing in 1935, one female commentator articulated the modernist credo in holding that the photographic nude should be "idealized" and dealt with "abstractly."[15] In the 1960s and 1970s the nude presented itself as a learning experience for those interested in taking photography beyond its descriptive capabilities. This typical art-school subject was photographed, cut apart, remounted in a variety of ways, or montaged with other forms to serve avant-garde aesthetic ideas, as in montages and collages by Barbara Blondeau (plate 248) and Barbara Crane. Throughout all periods, women have used paid models, family members, and friends as subjects for images that at some times have been conventional and at others formally adventurous. Few ventured beyond the confines of what was considered good taste by suggesting erotic or sexual overtones; that was left to men engaged in both legitimate and illicit enterprises.

Such primarily aesthetic treatments were supplanted in the 1970s by images with more-complex resonances and more-political overtones. The conventionally beautiful female body, a commonplace of the genre, was joined by nude photographs of less perfectly proportioned women and by those of males, children, and the elderly. Women allowed themselves freedom to acknowledge their interest in the male body and to signal their awareness of gay and adolescent sexuality.

An early step in this direction was taken in the 1960s by Diane Arbus, whose exploration of sexual duality embodied in portraits of transvestites (plate 249) seemed to free up these areas for the coming generation of women photographers. Arbus's work was invested with a psychological significance that removed this kind of vulgar seminudity from the realm

PLATE 248: BARBARA BLONDEAU
(1938–1974). *UNTITLED*,
C. 1966–67. COLLAGE OF POSITIVE
AND NEGATIVE SILVER GELATIN
PRINTS MOUNTED ON BOARD.
DIAMETER: 7 5/8 IN. (19.5 CM).
VISUAL STUDIES WORKSHOP,
ROCHESTER, NEW YORK.

of pornography. Taking a cue from Arbus as well as from Larry Clark (who made more explicit documentations of unusual sexual conduct), Nan Goldin created a diaristic portrayal of sexual relationships among young prostitutes, addicts, transvestites, and transsexuals (plate 29), at a time when less stringent attitudes about sex were unfolding in society as a whole. In addition to traditional gallery exhibitions, Goldin showed her images in slide presentations accompanied by text and music, enabling her, as she said, "to make political points more clearly . . . [to] clarify my intentions through the juxtaposition of the lyric of the soundtrack and the image."[16] Goldin's work demonstrated that a theme formerly reserved for men could be undertaken by women, but her sense that her work derives from an emotional collaboration between her subjects and herself may be

uniquely feminist. Certainly the acceptance of her work by the art establishment has made possible a genre devoted to contemporary adolescent behavior, exemplified by Lauren Greenfield's sexually less explicit investigations of young people in the currents of today's popular culture.

The aggressive interest in the socio-sexual dimension of life—exemplified also by images of strippers by Joyce Baronio and Susan Meiselas, of drag queens by Sylvia Plachy (plate 250), and of youthful prostitutes by Mary Ellen Mark—demonstrates a sea change in women's attitudes. The freedom to celebrate sexuality in its many manifestations prompted some women, among them Barbara De Genevieve and Carolee Schneemann, to use the camera image in conjunction with performance to portray what formerly would have been considered private erotic moments. The freedom to make, exhibit, perform, and sell works with explicit sexual content constituted one significant difference from earlier feminism.

On another level, women used camera images to expose the objectification to which they had been subjected by male photographers—in particular, by men working for the media but also those engaged in personal creative expression during the modernist era.

PLATE 249: DIANE ARBUS (1923–1971). *SEATED MAN IN BRA AND STOCKINGS*, 1967. GELATIN SILVER PRINT. COPYRIGHT © 1972 ESTATE OF DIANE ARBUS; COURTESY OF ROBERT MILLER GALLERY, NEW YORK.

PLATE 250: SYLVIA PLACHY
(BORN 1943). *TRANSVESTITE*,
1988. GELATIN SILVER PRINT.

Postmodern feminists have employed the female nude to counter the transformation of shapely female anatomies into aesthetic objects and into sales pitches for products. The responses ranged from Nancy Hellebrand's large-scale images of portions of the female body to the staged dramas of a single cowering woman enacted by photographer Francesca Woodman for her own lens to Ana Mendieta's use of her own body as the central element in the earth-works she created. Other scenarios commented, at times in lurid colors, on male obsessions and fantasies, as in work by Sherman (plate 30) and Jo Ann Callis (plate 28).

Women inspired by the new feminism sought also to overcome what they perceived as a taboo against the representation of the male nude by female photographers. Such images, although rare, had been made in earlier eras by, among others, Yvonne Gregory and Willamina Parrish in Britain, by Laure Albin-Guillot in France, and Imogen Cunningham in the United States. Some contemporary male nudes appear to be primarily aesthetic, like those by Marsha Burns and Eva Rubinstein. Echoing the modernist creed, Burns claimed to approach nude sitters as "still lifes,"[17] but her representations (plate 251) also suggest the

fluidity of gender characteristic of the times. To others, the ability to deal with the male nude without embarrassment was a psychological achievement, making the process just the reverse of men looking at women. Still others recognized a more political dimension to their efforts to upset long-established patriarchal conventions.

Once again, the West Coast provided a congenial ambience for this exploration. Both Judy Dater and Joan Murray (plate 252) photographed the male figure as a way of demonstrating that, in Murray's words, "men were as sensual to women, as women to men."[18] Murray's 1969 exhibition in San Francisco, entitled *Man,* is thought to have been the first and largest show of such images by a woman. The purpose behind the nude images by Dianora Niccolini, Barbara Pfeffer, and Karen Tweedy-Holmes (plate 253) may have been no more complex than a desire "to reverse the one-sided trend of figure photography,"[19] but some feminists criticized this turnabout as resulting in images that are too playful and sympathetic. According to this opinion, since all looking was considered to be a "politically and psychically invested act," female photographers could not "turn the tables" and expect that their images would turn men into sex objects, because images of white male nudes do not yield the same fragmentation of identity as do nude shots of women by men.[20] However, nude images of men by women reflect a variety of attitudes and styles, ranging from the aggressive to the soft and mysterious.

No single aspect of the current interest in the human body has elicited as much controversy as the depiction of children in the nude. The outraged reaction to the work of Robert Mapplethorpe was aroused not only by his blunt portrayal of male sex acts and organs but perhaps even more by his frontal images of nude children. Similarly, the suggestiveness of adolescent sexuality in Jock Sturges's portraits of prepubescent teenagers led to legal action against him.[21] In a much less publicized case, in 1988, obscenity charges were lodged against Alice Sims because she had portrayed her own children in the nude in camera images intended as studies for her drawings. To a lesser degree, Sally Mann's portraits of her own children in the nude (plate 254) have evoked criticism in publications intended for the art world as well as for a general audience.

At the turn of the century (plate 255) and even up through the 1970s (plate 256), children in the nude were envisaged as symbols of a healthy and optimistic future. Now, however, the naked child has become a complex metaphor for adult desires. In a culture whose unhealthy sexual and social proclivities have become increasingly visible to all through the media, it may not always be possible to make clear that child pornography and art are not the same.[22] In a period marked by

PLATE 256: ABIGAIL HEYMAN
(BORN 1942). *PASSOVER SEDER*,
1979. GELATIN SILVER PRINT.

federal legislation against child pornography, by accusations of molestation and court actions against parents and child-care personnel, and by the increasing power of family-values sentiments, photographs of nude children have played an ambiguous role. Such imagery can be seen as a contemporary manifestation of a long tradition in the visual arts, going back to classical times when the youthful nude body (usually male) served as a symbol of ideal beauty. It can also be used to counter sexual puritanism and attempts to control artistic expression. But although often cast in terms of puritanism and censorship, the controversy over images of nude children has had many resonances. Some of the apprehension about the depiction of nude children is evoked by other less easily labeled anxieties, among them how children should be educated and how much personal and religious freedom should be allowed individuals in a multicul-tural, multiethnic society in which electronic media exert such tremendous force.

The ardent feminism that emerged in the late 1960s and informed women's photography through the early 1990s has recently encountered some successes and some set-backs. Women's professional activities certainly have expanded and become recognized. Women's studies courses and publications have continued to thrive in academic circles, but whether women's status as teaching professionals has kept pace in terms of their number and their rank is open to question. Among feminists themselves, there has been much discussion and some disagreement about theoretical issues. The alliance of feminist ideas and postmod-ernist visual theory has led to a diverse range of statements and practices that increasingly favor installations and media-and-performance-related events rather than straight photography.

The practice of photography has changed and expanded over time, reflecting both radical and subtle transformations in technology as well as in ideology. The camera's impact on the collective psyche, made possible through worldwide systems of communication, has been enormous and will become even more profound as computer-generated imagery becomes a commonplace method of producing visual information. How women will fit into the future's imaging structures is uncertain, but in the past they have shown themselves adept at using the most current technology to endow feminist ideas with significance and vitality. It may still be "a radical idea," as Susan Sontag noted, that women should be able to fulfill their individuality "in the same measure as men," but it has at least come to seem plausible.[23]

CHAPTER 9

PHOTOGRAPHY AS ART, 1940–2000

"Much of the large future of photography," Edward Steichen is reported to have remarked, "may be accounted for by women's perceptivity."[1] Whatever this statement may have meant to its maker, women's role in expressive photography in the last half of the twentieth century certainly was notable. The medium has increasingly been seen both as an instrument for the expression of personal insights and as a means for making aesthetic statements. Practices such as staging a scene to be photographed, multiple printing, hand coloring, and using a variety of techniques (among them pinhole exposures and light graphics) to produce images without either lens or camera have been revived. Photographic abstractions and surreal compositions have appeared with greater frequency as photographers have sought to use their medium in ways related to what was happening in the visual arts in general. To this diversity of photographic means must be added the digital capabilities that are making image manipulation even more attractive because of their ease and seamlessness.

The expressive possibilities of the medium were initially acknowledged less eagerly in Europe, where, according to one British observer, photography had ceased in the early 1950s to function as an "imaginative, persuasive and stylistic tool."[2] An art market for photographs, which enabled photographers of both genders to flourish in the United States, did not materialize in Europe until fairly recent times. This factor prevented women's development as self-expressive artists from being quite as rapid or as widespread there as in the United States, but by the mid-1990s similar concepts and strategies about creating photographic art characterized women's work everywhere.

WOMEN'S STATUS

The extraordinary growth in the number of women involved with photography in the United States after World War II was partly due to changes in the way photography was included at institutions of higher learning. Because of the so-called G.I. Bill, through which the federal government underwrote access to advanced education for personnel returning from World War II, hitherto reluctant university art departments began to offer courses in photography as a way to attract applicants. Thus, women—who traditionally had constituted a significant proportion of art students—now were exposed to this means of visual expression in the context of art rather than of commercial or scientific applications. This is not to suggest that courses in art photography had not been given in colleges or that women had not studied it before, for some women's schools and vocational institutions had included photography among

EXPERIMENTATION

Before mid-century, experimentation with unusual ideas and techniques was relatively uncommon among women, but throughout the final three decades of the twentieth century it gained extraordinary momentum. Seeking innovative ways to stimulate students' interest in the world around them, in the 1940s Carlotta M. Corpron concentrated on using the camera to explore the play of light rather than to describe how objects look. Introduced to the teachings of Gyorgy Kepes and László Moholy-Nagy, Corpron took up their suggestion to make photograms and to use a light modulator—a device that breaks up the rays of light as they illuminate objects. She created a distinctive body of work by fusing abstract patterning (from the modulator) with the formal qualities of natural objects such as rocks and shells, and by taking advantage of the reflective properties of plastic materials (plate 258).

Just as Corpron's role as a teacher of art was the catalyst in her turn toward experimentation, so others' experiences as students prompted them to take new routes to creativity. Barbara Morgan, for example, was trained as an artist and took up photography in

the late 1930s only after recognizing that painting was not a feasible vocation for a wife and mother. Her knowledge of and sympathy for the arts of China and Japan, gained while a student at the University of California, Los Angeles, convinced her that "art is an abstraction born of understanding the pattern of things," that artists must add to nature rather than merely "steal" from it.[5] In both commercial and personal projects she employed abstract light patterns (formed by exposing sensitized paper to a moving light source), double images (plate 259), and solarizations; these techniques also served her in images dealing with the social issues that engaged her attention in the 1940s.

The sense of dramatic movement that Morgan was able to express in her dance imagery (one of her first commissions was for the Martha Graham Dance Company, in 1936), which was prefigured in the 1920s work of European photographer Charlotte Rudolph (plate 131), caused a reassessment of this genre in the United States at a significant moment in the evolution of the art of dance. Morgan's influence has been evident on later dance imagery, even on images that rely on "straight" techniques rather than montage or light graphics. For example, the clarity and brio of performers seemingly detached from their physical surroundings and from gravity itself, visible in the much more recent work of Lois Greenfield (plate 260), can be seen as Morgan's legacy. Ernestine Ruben's dance imagery of the 1980s took an even more experimental direction when she projected images on live performers moving behind and in front of fabric screens; eventually this photographer redirected her energies to more traditionally conceived photographs of landscape and the human body and to more traditional platinum printing techniques.

Although unlike Morgan's, dance photographs by the portraitist Lotte Jacobi also incorporated montage and photograms. Taught how to make cameraless images by artist Leo Katz, at first Jacobi montaged the figures of dancers against abstract patterns produced by moving a light source on sensitized paper. Eventually she preferred to make only the light-generated abstractions, which she called "photogenics" (plate 261). In their suggestion of movement and their subtle gradations of tones, these works reflect the growing appetite in the 1950s for abstract expression in American visual art.

Montaging strategies had appealed to Imogen Cunningham in the 1920s and to Ruth Bernhard, especially after her move to California in 1936 (following a career in advertising photography on the East Coast) allowed her more time for personal projects. Bernhard's deepening fascination with the workings of the subconscious aroused her curiosity about montage technique in particular, because it led her, as it had many of the European

Surrealists, to regard the camera image as a way to visualize interior states of being (plate 262). At a time of renewed popular interest in psychoanalysis, Bernhard found in photography the means of reaching dimensions that words or real scenes could not touch; the medium became for her "a gift, pushing itself into my consciousness."[6]

The strategies of Naomi Savage, another early proponent of "stretch[ing] photography through personal interpretation,"[7] were quite different. Transferring camera images of figures and still lifes to metal plates, she printed them by conventional etching techniques (plate 263), but also regarded the plate itself in its various states of being etched as a finished artistic entity, thereby dissolving the distinctions between the photograph and other media. Increasing attention to spatial installations and multimedia projections in the art and photographic communities helped further obliterate the traditional distinctions between the handmade and the camera arts.

These photographers were in the vanguard of visual experimentation, but not all women who were intent on expanding photography's boundaries in this period felt the need to intervene so radically either in setting up the image or in processing it. Barely known today, Rose Mandel, who emigrated from Poland and started working in California in the late 1940s, created semi-abstractions from found objects and organic substances (plate 264). Preferring the straight style championed by her teacher Minor White, Mandel looked for camera angles and conditions of light that might produce images with few recognizable references to actuality.

These forerunners in creative manipulation may have worked in isolation, but they did not create in a vacuum. In the 1940s photography was already being positioned in schools and among individual photographers to reflect general trends in the arts, which embraced abstraction, experimentation, and eventually pastiche. This approach to the medium predominated among those teaching at Chicago's Institute of Design and eventually at other institutions—notably, Harry Callahan, Arthur Siegel, Aaron Siskind, Henry Holmes Smith, and Minor White. Photographers who investigated on their own the possibilities offered by montage and other manipulations included Robert Disraeli, Clarence John Laughlin, Frederick Sommer, Val Telberg, and Edmund Teske. Whether currently celebrated or obscure, the creations of all these individuals—Corpron, Morgan, Jacobi, Bernhard, Savage, and Mandel, as well as the men listed above—can be seen as a disavowal of photography's traditional connection with replicating visible reality.

As significant as women's contributions were, credit for moving photography closer to the other visual arts was not forthcoming for them at the time. In fact, in the United

became widely used in advertising, journalism, and art photography, the technology began to interest the makers of photographic art. Computerized imagery for which there is no actuality represents the ultimate visual expression of contemporary media-based culture. The strategies involved in the production of images through digital means, which may combine a variety of visual elements besides photographs and which may be printed on a variety of materials in ink rather than on light-sensitive paper, clearly approach the synthetic modes of painting while retaining an intimation of documentary authority. The employment of such technologies by artists will undoubtedly bring even greater complexity to discussions about the relationship between images and reality.

Between the extremes of moderate and total intervention, between mechanical and electronic generation, exists a grand array of manipulative strategies; many have been employed to give form to feminist concerns. Those related to traditional women's handcraft are exemplified by Betty Hahn's camera images, several of which are printed on fabric to which

she added stitchery (plate 36). Others have been inspired by primitive electronic duplicating techniques, such as the xerography used by Joan Lyons to produce artists' books—one-of-a-kind creations employing text and image. Bea Nettles has used Kwikprint, a type of bichromate process (plate 15). Before the widespread use of computer imaging programs, these more primitive processes not only allowed for the melding of images from many sources but also produced a grainy print that appeared less precious than the traditional long-scale platinum or silver one.

Montage—the traditional term for this melding—which was the most common method of pushing the image beyond naturalistic depiction, has a long history of appealing to women. Bringing together pictures from various sources—whether snippets or full frames, whether made by the photographer or culled from the work of others—to create an entirely original image has served a variety of aesthetic, Surrealist, feminist, nostalgic, and

Conceptual impulses for modernists and their successors. In the 1960s and '70s, former Institute of Design students Barbara Blondeau and Barbara Crane cut apart and reassembled both negatives and positive prints to expand the aesthetic possibilities of the typical art-student theme of the female nude. In so doing, Crane (along with male colleagues) pioneered the use of repetition to convey the mechanical character of much of contemporary life, even in its recreational aspects (plate 268). Montage served different purposes in the work of Ellen Land-Weber, Olivia Parker, and Alice (later Alisa) Wells, all of whom used it to summon up a sense of the ephemeral nature of experience or of longing for the past. Combining negative and positive images or fabricated and organic matter—feathers, foliage, tools, and so forth— Parker's works were to be seen, in her words, either "as strange projections of reality or colorful projections of dreams."[11] Later, working in monochrome, Parker constructed and photographed assemblages that explore the relationship between planetary science and the mystic spirit (plate 269). Rosamond W. Purcell, who came to photography by way of languages and literature, was similarly involved with creating intangible effects through montage (plate 20). She referred to this work as "the memory of being adrift,"[12] but her later work seems more firmly tied to ecological issues, in particular the loss of animal life through pollution and land mismanagement.

Whether mannerisms that evolved to sell products can be employed to reveal portentous concepts or indeed even lesser truths about individual, familial, and societal relationships is a question that often has been debated and still remains to be determined. Of course, not all such staged imagery mimics advertising practice; the work of French photographer Irina Ionesco, for example, is inspired by mythology and theater. In her highly mannered creations, models may be costumed and posed as odalisques or as figures from Greek myths.

Sequential imagery is another strategy that suggests the influence of advertising techniques and of moving-image technologies—cinema and video—although its purpose also can be to question the modernist concept that a single decisive moment most tellingly reveals the essence of an object or situation. By mounting side by side two images of the same subject taken at different times or from slightly different vantage points (plate 22), Eve Sonneman suggests that no single view of reality should be considered more truthful than any other; this concept has engaged Marcia Resnick as well. Multiple images have also served to reject the notion of the photograph as an object to be revered, as in Joyce Neimanas's assemblages of different unaltered square Polaroid SX-70 views, including their white borders (plate 18), of the same subject. Put down in what seem to be random patterns, these works, too, question the so-called reality of the single camera image because the subject is presented in a variety of postures and angles. At the same time that Niemanas, who has worked with a number of mediums and techniques, was commenting on the replicability of camera images, she was also dealing with society's attitudes about womanhood and sexuality—themes she finds impossible to express in straight descriptive photographs.

Others have used sequences to make the point that it is not the single camera image that is the high point of photographic achievement but the series, because works seen

in context with others (rather than singularly) alter and enrich one's understanding of objects and events. In fact, the commonplace experience of seeing photographs in sequences—in magazines, books, and as motion pictures—has had a profound effect on photographic art in terms of both concept and presentation. These sources, along with the series of motion photographs made in the late nineteenth century by Eadweard Muybridge, underlie serial works by several teams of photographers—among them, Marion Faller and Hollis Frampton, and the duo called Manual (Suzanne Bloom and Ed Hill). The latter have employed a series of images sequenced in spatial installations to make known their concerns about ecological matters. Taking another direction, Lorna Simpson's almost identical serial images along with their disjointed texts make the point that misconceptions about race, gender, and class do not change much over time.

The influence of current commercial merchandising methods can also be seen in work that reflects the postmodernist recognition that "objects of every sort are materials for the new art . . . [which] will disclose entirely unheard of happenings and events."[16] In scavenging and assembling images in "a catalog structure [that] . . . put[s] things together that feed into the idea of the arbitrary," Judy Fiskin suggested that no order existed in modern merchandising methods.[17] Similarly, Susan Eder, who has formed pyramids of color prints based on the monetary value of the objects pictured, and Louise Lawler, who has assembled cartoons and montages into serial format to point up the power of institutionalized presentation, deal with concepts about the intersection of contemporary media, merchandising techniques, and feminist ideology. These photographers have not been involved with the texture, the surface qualities, or the artistic aspects of the print, but have been intrigued by the medium's potential for infinite repetition of the same image, in numerous formats, to make ideological statements.

INSTALLATIONS

The opening of photography's confining boundaries also has prompted a reexamination of the intersection between the camera image and three-dimensional objects, taking this genre well beyond the confines of naturalistic photo-sculpture. Early enthusiasts of photo-objects, among them Robert Heinecken, Sol LeWitt, and Joan Lyons, had looked back to the Constructivists and Dadaists for inspiration. Their work was inspired by aesthetic concerns, by a need to emphasize that photographic art involves interpretation and craftsmanship, not just record making. By the 1980s women recognized that this direction might serve various feminist and postmodernist purposes; the investigations into the interface between politics and images in the work of Claire Pentecost and Elaine Reichek, and the examination of the relationship of image to language by Annette Lemieux are examples of this approach. The exploration of psychic memories by the French photographers Sophie Calle and Annette Messager (plate 265) involve three-dimensional arrangements of camera-generated and other images, often combined with actual artifacts. Surrounded in this manner, the viewer might experience a more enveloping and intimate relationship with the work.

Installations combined with performances in which camera images play an integral part stretch the medium in yet another direction. Laurie Anderson, for example, has worked in a variety of forms, mixing together photographic images and texts as well as doing site-specific installations and performances, which she has documented in photographs. Work that features this melding of media strategies and messages about popular culture is subject to the same contradictions that bedevil all visual artists who aim to undermine contemporary political and cultural ideas and at the same time seek acceptance in the marketplace. Just as the avant-garde artist in Weimar Germany had to balance a vision of an ideal communist society with commissions from capitalist businesses, so contemporary artists face similar incongruities. Such works ordinarily appeal to a very small sector of the gallery-going public, often not so much for their messages as for their cutting-edge style. As was true in the past, the careers of many postmodern artists have demonstrated that marketplace hype may obliterate the distinction between pure idea and commercial image or push work to the foreground just because it seems new.

PHOTOGRAPHY FOR PHOTOGRAPHY'S SAKE

In the last thirty or so years the heavy conceptual freight carried by many images has undermined the status of the photograph as a purely aesthetic creation. Nevertheless, the desire to use the medium primarily to solve formal problems posed by space, shape, light, and texture and the need to translate these elements into two-dimensional harmonies was not entirely vanquished and indeed has gained strength in recent times. Much of the imagery that might be considered intentionally aesthetic has been produced by women. Working with still lifes, nature, and botanical materials—the quintessential Pictorialist subjects—Lilo Raymond and Margaretta K. Mitchell have taken what is perhaps the most traditional approach, although Mitchell sometimes blends graphic and photographic media in her productions (plate 34). The work of Jan Groover and Barbara Kasten represents more contemporary stylistic expressions of the same urge to deal with creative photography almost entirely in terms of form. The use of color film, large-format printing, and in Groover's case sometimes unorthodox artifacts (from street architecture and the kitchen) give their images a contemporary look. Groover, who has denied "the relevance of any particular content" because "associations in the real world simply do not matter in photographs,"[18] arranges and illuminates still-life objects that are fairly meaningless even though some deconstructionists might wish to read portent in the kitchen utensils that she has favored on occasion (plate 14). Though based on architecture, Kasten's large-scale, seemingly nonobjective compositions (plate 16) communicate even fewer connotations than do Groover's objects. The sensual pleasures of her strong-hued, highly structured geometric abstractions, which devolve from her rigorous technical skills, are evoked by the careful positioning of reflective geometric forms before the lens. Kasten's skill in placing these elements, the lights, and the colored filters gave the final images their vibrancy.

The search for visual balance and harmony does not preclude an interest in other content, and a number of women have achieved a fusion of formalist proclivities and

PLATE 272: LINDA BUTLER (BORN
1947). *MAGIC GARDEN, AICHI-KEN,
JAPAN*, 1987. GELATIN SILVER PRINT.

curiosity about social life. By transforming mundane objects, scenes, and events into evocative and even sensual experiences, the work of Linda Butler might be said to represent this approach. Her artful images of built structures, commonplace objects, and nature (plate 272)— whether in rural America, Italy, or Japan—have created a vision of an ordered, ritualized, deeply satisfying existence. Like much photography that seeks to present the ordinary in its most beautiful guise, Butler's work is meant to be seen sequentially, in book format. Her imagery, along with that of the many others who work in a similar vein and for publication— among them Paula Chamlee and Flor Garduño (plate 192), to name but two—is difficult to categorize because it balances so delicately between documentary exposition, sociological discovery, and transcendent aesthetic experience. Aesthetic considerations join with sociological curiosity in Lois Conner's panoramas of dwellings and landscapes in the Far East. Aesthetic delight augmented by a sense of the bizarre infuses Sandi Fellman's photographs of tattooed bodies (plate 33). Her images are another example of the crossover between art and commerce, since art directors have discovered the attraction of Fellman's richly colored arabesques for selling cosmetic products and women's wear.

A similar balancing, with the occasional addition of a political component, is evident in much contemporary landscape photography by women. Historically, this genre had been considered a male domain and its outstanding images the accomplishment of those

PLATE 273: LYNN GEESAMAN (BORN 1938). *PARC DE CANON*, FRANCE, 1995. GELATIN SILVER PRINT. COURTESY OF YANCEY RICHARDSON GALLERY, NEW YORK.

who accompanied exploratory and colonizing expeditions to all parts of the world; such individuals were almost without exception men. Several women did photograph the sparsely settled western regions of North America, but their focus was on settlements, on their own daily lives, and on the local native people rather than on pristine nature. Following the Civil War a large body of western landscape photographs was produced in connection with federally or privately funded expeditions that did not ordinarily employ women. Nevertheless, a query about the absence of nineteenth-century women landscape photographers, first raised in the early 1980s, presupposed a definition of landscape photography limited to images that capture sublime grandeur.[19] But when depictions of immediate surroundings of a domestic nature are

included, a somewhat different historical picture emerges. Besides unassuming views of nature by such late nineteenth-century practitioners as the previously mentioned Allen sisters, Marie Hartig Kendall, Mary T. S. Schaeffer, Catharine Barnes Ward, and Louise Deshong Woodbridge, there exist considerable numbers of landscape scenes, both by women once recognized but now forgotten and by undocumented women who took cameras with them to record their excursions to natural sites or scenic landmarks. For example, in the 1890s Jeanette M. Appleton's photographs of the coastal areas north of Boston were elegantly reproduced in journals and portfolios. Around the turn of the century, the Oregon photographer Lily White, working from a riverboat with a darkroom aboard (built by her father), lovingly portrayed the pellucid landscape of the Columbia River in daylight, at dusk, and at night (plate 88). Shortly thereafter, Anne W. Brigman, Adelaide Skeel (who wrote a column on landscape imagery for *Photo Era*), and Clara Sipprell focused their cameras on the natural world, and certainly Laura Gilpin captured the sublimity of the western scene (plate 157).

Throughout the past century documentary photographers also would occasionally record the landscape's tranquility, as in the work of Alice Austen, or its social aspect,

as in the images of barren furrows by Dorothea Lange and fertile fields by Marion Post Wolcott. Nevertheless, the perception that women were uninterested in photographing the natural landscape inspired an effort by women to claim this theme for themselves. The resulting images conjoined description and metaphor and revealed that women often regarded the landscape with transcendent intentions. In the same way that the male approach to landscape in the years following the Civil War went beyond descriptive recording, so women's current views of the land are meant to stand for ideas such as fecundity and the acceptance of nature's gifts. Some considered feminist and ecological concerns to be profoundly interrelated, and they attributed the despoiling of natural wonders and ordinary sites to men.

Landscape images by women have frequently dealt with the relationship of people to the land and to its other animal inhabitants. Viewing a landscape in danger of disappearing because of development inspired Joan Myers, working in New Mexico, to capture a sense of the past as a dream. A flourishing garden gave rise to a lyrical paean to fertility (plate 24) in Gretchen Garner's work at Weir Farm in Connecticut. The lyrical aspect of the landscape seems to be especially compelling for many women. It has infused the work of Barbara Bosworth, Sally Gall, and Lynn Geesaman with a sense of mystery and yearning, as in Geesaman's elegant evocations of watery landscapes in France and Belgium (plate 273). A collaborative series by Laura McPhee and Virginia Beahan extolling the beauty and immensity of natural settings in Hawaii reveals an awesome spectacle of muted colorations and abstract patterns. Awe and mystery are also present in Lynn Davis's images of natural and fabricated immensities, notably

icebergs (plate 274) and ancient Egyptian pyramids. Melancholy imbues Liliane De Cock's elegiac visions (plate 275) with a special character.

In contrast to these captivating and at times monumentalizing visions, Barbara Norfleet's images of animals among human detritus (plate 23) deal with the intersection of land, life, and destructive technologies. She has been one of the few women to portray facilities for manufacturing and testing nuclear weapons, joining such well-known male photographers as Emmet Gowin and Richard Misrach in an endeavor to make apparent the destruction of the western landscape. The later work of Rosamund W. Purcell focuses on a similar theme.

The relation of the land to the spiritual as well as the geological and social history of human life seems to fascinate many women photographers. Linda Connor, who has traveled extensively in search of petroglyph markings (plate 276), concluded that landscape imagery bearing such signs allows people to balance their interest in actuality with their sense of the sacred. Marilyn Bridges has concentrated on land formations that reveal the venerable marks imposed upon the earth by previous cultures (plate 277). Photographing such scorings from the air, she has made visible what she conceives as truths etched upon stone and earth that reveal the sacred ideas of ancient peoples. In effect, such work refutes the hubristic notion, long prevalent in Western thought, that the majesty of the New World landscape was discovered by white men, was pictured first by them in the mid-nineteenth century, and was destined to be exploited by them solely for their own benefit. Also working from the air, Terry Evans has portrayed the expansive emptiness of the midwestern prairie lands in images that she hopes will reveal the beauty and usefulness of this seemingly unspectacular landscape.

PLATE 276: LINDA CONNOR (BORN 1944). *DOTS AND HANDS, FOURTEEN WINDOW RUIN, BLUFF, UTAH*, 1987. GELATIN SILVER PRINT.

PLATE 277: MARILYN BRIDGES
(BORN 1948). *ARROWS OVER
RISE, NAZCA, PERU,* 1979. GELATIN
SILVER PRINT. COURTESY OF
FELICIA MURRAY.

Perhaps the most extreme ideological position with regard to landscape imagery is that taken by women who believe that their gender has given them "an age-old affiliation with nature" with which they have retained a close identity.[20] Ana Mendieta's photographs of earth-body sculpture were meant to position the female body as "an omnipresent force . . . an extension of nature."[21] While seemingly on the cutting edge of contemporary feminist belief, this viewpoint has been recurring since the late nineteenth century, when men were seen as makers of artifacts and culture and women as embodying nature. Certainly Anne W. Brigman's studies early in the century of female figures communing with rocks and trees along the wild California coast (plate 102) seem to forecast this contemporary stance. (It may come as a surprise to feminist supporters of the untouched wilderness that Brigman herself altered nature, clipping off superfluous branches and cleaning up debris where necessary.)

It is apparent that women's attitudes about and ability to portray the landscape have broadened considerably since the turn of the century. Nevertheless, whether women have looked to landscape photography as a means of countering the aggressive approach to nature embraced by the historical concept of Manifest Destiny (which permitted unregulated exploitation of western lands by cattle, railroad, and mining interests), or as a means to change attitudes about the protection of the land, such endeavors are not gender specific. Women's images that address questions of ecological destruction and land misuse do not differ significantly from those by male photographers with similar ideologies. But despite the large numbers of women engaged in landscape work and indeed in all aspects of contemporary photography during the past quarter of a century, for a long period it was the products by men that were most often seen on exhibit or in reproduction. Although changing, such exclusion undoubtedly triggered images by women in which ideological content was paramount. It is not style, technique, or commercial potential but the feminist convictions discussed in chapter 8 that have distinguished such women's photography from that by their male counterparts.

Women, of course, are inhabitants not just of a female body but of a specific place in the world and a specific time in history. Issues of age, class, race, religion, and political ideology have intervened throughout their connection with photography, at times influencing their ability to maintain lifelong commitments to the medium. Such issues can be said to have given women's work its richness and significance. "To be good," Dorothea Lange said, "photographs have to be full of the world."[22] At various times, women photographers were deeply involved with the particularities of womanhood, but for far longer they have focused on the outside world to a greater degree and with more varied perspectives than most people suspected. As active participants in transforming camera and light-sensitive images into an encompassing visual language, they have accounted in large part for the richness and complexity of photography today.

ACKNOWLEDGMENTS

Any historian who seeks to recover the contributions of women and to situate those accomplishments in a larger context must be especially grateful to those who earlier had similar aspirations. To an extent, my work has been stimulated by these forerunners, nearly all of whom have been women. In 1973, in *The Woman's Eye*, Anne Tucker raised the question of whether work by women reflected a specifically female quality of vision, an issue that any writer on the subject certainly must address. Two years later, *Women of Photography: An Historical Survey*, an exhibition and catalog by Margery Mann and Anne Noggle, brought to light the work of thirty-nine women and supplied short biographical entries about them. *Viewfinders: Black Women Photographers* by Jeanne Moutoussamy-Ashe made available little-known facts about African-American women in the field. Two publications, *Recollections: Ten Women of Photography*, edited by Margaretta K. Mitchell, and *Women of Vision: Photographic Statements by Twenty Women Photographers*, edited by Dianora Niccolini, were helpful because they presented the thinking of a wide range of women photographers. Several other works provided insightful discussions of work produced in a specific period or location; they include *The Positive Image: Women Photographers in Turn of the Century America*, by C. Jane Gover; *Let Us Now Praise Famous Women*, by Andrea Fisher, which deals with American women photographers employed by federal agencies between 1939 and 1944; *Women Photographers*, by Val Williams, which covers various aspects of the field in England from 1900 until the present; and Peter E. Palmquist's directories of California women photographers and bibliographies of writings about women in the field. With its more than two hundred elegantly printed images, *Women Photographers*, edited by Constance Sullivan with an essay by Eugenia Parry Janis, was serviceable in making visible less well known images. Besides these full-length publications, numerous articles on specific aspects of women's experiences as photographers that have appeared in the last three decades have helped shape my thoughts and sharpen my ideas. In addition, I have attended and participated in a number of conferences in which discussions of women's role in photography have helped clarify my thinking.

No one can embark on a project of this nature without the help of a great many individuals. On hearing about my enterprise, many offered assistance, suggesting where work might be found, pointing out little-known sociological facts, sending clippings from out-of-print journals—in short, supplying information that an unaided researcher might have needed a lifetime and a half to uncover. For their cooperative spirit in this regard, I thank Hilda Bijur, Machiel Botman, Georgeen Comerford, Madeline Fidell-Beaufort, George Gilbert, Carole Glauber, Thomas Gunther, Margaret Harker, Lizzie Himmel, Michiko Kasahara, Panayiotis Lamprou, Lin Shaozhong, Jean-Claude Martin, Yukimi Masui, and Ed Putzar.

Several libraries and archives provided fundamental resource materials for this survey. I am grateful for the unstinting assistance of Sharon Frost, Tony Troncale, and Julia Van Haaften at the Photography Collection of the New York Public Library; Tracey Lemon, Becky Simmons, and Rachel Stuhlman of the library at George Eastman House; Terence R. Pitts and Amy Rule at the Archives of the Center for Creative Photography; and Robert Pledge and Gregoire Sauter of Contact Press Images. Other librarians, curators, dealers, and individual collectors have been invariably helpful with images and biographical information, in particular Steven Cohen, Margot and Warren Coville, Verna Curtis, Evelyne Daitz, Virginia Dodier, Amy Doherty, Kathleen A. Erwin, Howard Greenberg, John and Susan Edwards Harvith, Edwynn Houk, Charles Isaacs, Michelle Jackson, Brooks Johnson, Hans P. Kraus, Jr., Sandra Levinson, Janet Mahdu, Robert Mann, Harvey Miller, Barbara Millstein, Sarah Morthland, Monique Moulin, Dale Neighbors, Arthur Ollman, Randy Plummer, Jill Quasha, Toby Quitslund, George R. Rinhart, Theresa Rowat, John Rudy, Janet Russek, Joanna Cohan Scherer, Ruth Silverman, Marthe Smith, Jane Staley, Barbara Tannenbaum, David Travis, Stanley Triggs, Bodo Von Dewitz, Stephen and Mus White, Michael Wilson, and Virginia Zabriskie. During my three-month fellowship at the J. Paul Getty Museum in 1990, arranged by Weston Naef, looking at images and finding documentation in the Department of Photography was greatly expedited by staff members Gordon Baldwin, Joan Dooley, Michael Hargraves, Judith Keller, Andrea Logan, and Katherine Ware.

I am grateful to others for opportunities to discuss various aspects of the field; among them are my colleagues from the Graduate Center of the City University of New York: Julia Ballerini, Barbara Michaels, Sarah W. Peters, Sandra Phillips, and Susan Fillin Yeh. I knew several working women photographers and sought out others in an effort to get a sense of their professionalism; they include Lillian Bassman, Helen Gee, Frances McLaughlin-Gill, and Helen Marcus.

Nancy Grubb, my editor at Abbeville Press, could not have offered more sober assistance or more spirited support. The task of obtaining illustrations was made pleasant and productive by Laura Straus, Abbeville's director of photography, and the very able free-lance photo researcher Paula Trotto; Jennifer Schlobohm acquired images for the second edition. I am grateful to Jain Kelly for the enthusiasm with which she undertook to provide the biographies for both editions—a process that required considerable detective work. Peter E. Palmquist has provided an extensive bibliography, updated and expanded for this edition, and we hope that both of these will prove to be major resources. My thanks go to Mitchell Kahane and Barbara Tannenbaum of the Akron Art Museum for their encouragement. I am grateful also to Tina LaPorta, who helped organize the masses of papers and data that such an enterprise generates, and to Joe Klene, my computer's best friend.

None of my endeavors would have been possible without the reassurance of two highly motivated daughters and the ardent encouragement of a loving and supportive husband, to whom I dedicate this work.

NOTES

INTRODUCTION: WHY WOMEN?

1. Keith Davis, *An American Century of Photography: From Dry-Plate to Digital* (Kansas City: Hallmark Cards, 1999), p. 296.

2. Lin Shaozhong, president of the Chinese Photographers Association, Beijing, letter to author, December 1993. Pierre G. Harmant, "Apropos: Anno Lucis 1839," 2d part, *Camera* 8 (August 1997): 37.

3. Rogi André became André Rogi; see *Coronet* 2 (October 1937): 108–9. See also the entry for Robert Christopher Tytler in Richard R. Brettell et al., *Paper and Light: The Calotype in France and Great Britain, 1839–1870* (Boston: David R. Godine, 1984), p. 204; and *Portfolio of the Work of W. Edwin Gledhill* (Santa Barbara, Calif.: Harold Gledhill, 1975), which includes the uncredited work of Carolyn Even Gledhill.

4. Davis. *American Century of Photography*, p. 288.

5. Vicki Goldberg, ed., *Photography in Print: Writings from 1916 to the Present* (New York: Simon and Schuster, Touchstone, 1981) includes sixty-three signed articles by men, eight by women; Christopher Phillips, ed., *Photography in the Modern Era: European Documents and Critical Writings, 1913–1940* (New York: Metropolitan Museum of Art; Aperture, 1989) has sixty-eight articles by male authors and one by a woman.

6. Bing, in "Ilse Bing: Une Pionnière de la photographie des années 30," *Photographies*, April 1983, p. 29 (my translation).

7. This and other statistics about MoMA's holdings are in Deborah Bright, "Women, Photography, and the Art Establishment: How Far Have We Come?" Symposium at the Art Museum, Rhode Island School of Design, March 2, 1991, transcript published in *Photographic Insight* 2 (April 1991): 4.

8. John Szarkowski, *Looking at Photographs: 100 Pictures from the Collection of the Museum of Modern Art* (New York: Museum of Modern Art, 1973), p. 52.

9. *WAC Stats: The Facts about Women* (New York: Women's Action Coalition, 1992), p. 8.

10. These figures were compiled in October 1999 by the author on the basis of the record of exhibitions and acquisitions kindly made available by the Museum of Modern Art's Photography Department.

11. Bright, "Women, Photography, and the Art Establishment," p. 4.

12. Conversations with Daile Kaplan, Director of Photography, Swann Galleries, New York, September 27, 1999, and with Denise Bethel, Director of Photography, Sotheby's, New York, September 30, 1999.

13. See, for example, Sally Stein, ed., *Marion Post Wolcott: F.S.A. Photographs* (Carmel, Calif.: Friends of Photography, 1983).

14. Amy Conger, *Campañeras de Mexico: Women Photograph Women* (Riverside: University Art Gallery, University of California, Riverside, 1990), p. 9.

15. Bright, "Women, Photography, and the Art Establishment," p. 5.

16. Austen's work was rediscovered by Oliver Jensen, then editor of *American Heritage*, while Austen was living in the Staten Island Farm Colony, a state-run home for the poor. Jensen succeeded in finding funds from sales of the publication rights to Austen's pictures that made it possible for the photographer to spend her last years in more dignified surroundings. Her former home, Clear Comfort, has since become a land-marked site.

17. See Abbie Sewall, *Message Through Time: The Photographs of Emma D. Sewall, 1836–1919* (Gardiner, Maine: Harpswell Press, 1989; reprint, Albuquerque: University of New Mexico Press, 1990); and *The Photographs of Harriet V. S. Thorne* (New Haven, Conn.: Yale University Art Gallery, 1979).

18. Wallace Stegner, foreword, in A. B. Guthrie, *The Big Sky* (New York: Houghton Mifflin Co., 1965), p. x.

19. For a discussion of these issues, see Vicki Goldberg, *The Power of Photography: How Photographs Changed Our Lives* (New York: Abbeville Press, 1991).

20. Freedman, in Dianora Niccolini, ed., *Women of Vision* (Verona, N.J.: Unicorn Publishing House, 1982), p. 46.

21. Margaret Breuning and Helen Appleton Read, in "Women Art Critics Attack Organization of Modernist Women," *Art Digest*, March 1, 1929, p. 9.

22. Fitz to Johnston, c. 1900, Frances Benjamin Johnston Papers, Library of Congress, Washington, D.C.

23. Myra Albert Wiggins, in Helen L. Davie, "Women in Photography," *Camera Craft* 5 (August 1902): 138.

24. Linda Connor, in "Notes," *OVO* (International Issue) 15 (1986): 153.

1. AT THE BEGINNING, 1839–90

1. Pierre G. Harmant, "Apropos: Anno Lucis 1839," 2d part, *Camera* 8 (August 1977): 37, nn. 25, 27, 28.

2. These papers were discovered in 1929 by Erich Stenger in the Preussischen Geheim-Staatsarchiv, Berlin.

3. Carolyn Merchant, *The Death of Nature: Women, Ecology, and the Scientific Revolution* (New York: Harper and Row, 1980), p. 273.

4. "I have been labouring hard at photographs without much success. . . . " (Constance Talbot to William Henry Fox Talbot, May 21, 1839; in H.J.P. Arnold, *William Henry Fox Talbot: Pioneer of Photography and Man of Science* [London: Hutchinson Benham, 1977], p. 120.)

5. Traharne, in Grace Seiberling, *Amateurs: Photography and the Mid-Victorian Imagination* (Chicago and London: University of Chicago Press, 1986), p. 8.

6. *The Will Weissberg Collection of Rare Photographs, Cameras and Related Devices* (New York: Parke-Bernet, May 16, 1967, sale no. 2570).

7. See entry in Richard R. Brettell et al., *Paper and Light: The Calotype in France and Great Britain, 1839–1870* (Boston: David R. Godine, 1984), cat. nos. 139, 140, pp. 204, 205.

8. Pamela Gerrish Nunn, *Victorian Women Artists* (London: Women's Press, 1987), p. 2.

9. A previous project by Mary Wyatt, consisting of four volumes of mounted specimens of seaweed, may have served as Atkins's inspiration. See Larry J. Schaaf, *Sun Gardens: Victorian Photograms by Anna Atkins* (Millerton, N.Y.: Aperture, 1985), p. 30.

10. Ibid., pp. 34–36.

11. An Amateur, "The Daguerreotype," *Art Union* 1 (December 1840): 87.

12. "The Photographic Patents," *Art Journal* (London) 6 (August 1854): 238. Information about British women photographers in Bernard V. and Pauline F. Heathcote, "The Feminine Influence: Aspects of the Role of Women in the Evolution of Photography in the British Isles," *History of Photography* 12 (July–September 1988): 259–73.

13. See William Culp Darrah, "Nineteenth-Century Women Photographers," in Kathleen Collins, ed., *Shadow and Substance: Essays on the History of Photography* (Bloomfield Hills, Mich.: Amorphous Institute Press, 1990), pp. 89–103.

14. David Haynes, "Woman Was Houston's (Texas) First Photographer," in Peter E. Palmquist, ed., *The Daguerreian Annual 1993* (Eureka, Calif.: Daguerreian Society, 1993), p. 3.

15. William Welling, *Photography in America: The Formative Years, 1839–1900* (New York: Thomas Y. Crowell, 1978), p. 56. See also Amy S. Doherty, "Photography's Forgotten Women," *AB Bookman Weekly,* November 4, 1985, p. 3282.

16. Reprinted from *The Daguerreotype Director, Reese & Co.'s German System of Photography and Picture Making* (New York, 1854), in *Daguerreian Society Newsletter* 5 (January 1993): 10.

17. Other women involved with the (London) Amateur Photographic Association and the Photographic Exchange Club are mentioned in Seiberling, *Amateurs,* p. 92.

18. William C. Darrah, *Cartes-de-Visite in Nineteenth Century Photography* (Gettysburg, Penn.: William C. Darrah, 1981), p. 22.

19. Michael Hargraves, who has been cataloging a large collection of *cartes de visite* for the J. Paul Getty Museum, found an 1885 portrait from the studio of Mrs. S. Hoare, in Papeete, Tahiti. A number of *carte-de-visite* portraits by women turned up, but the name of only one woman was found on a stereograph logo—part of the team of Geschwister Pauly in Berlin.

20. Elizabeth Anne McCauley, *A.A.E. Disdéri and the Carte-de-Visite Portrait Photograph* (New Haven, Conn., and London: Yale University Press, 1985), pp. 15, 215.

21. Laura Jones, *Rediscovery: Canadian Women Photographers, 1841–1941* (North London, Canada: London Regional Art Gallery, 1983), p. 3.

22. Peter E. Palmquist, *Shadowcatchers I: A Directory of Women in California Photography before 1901* (Arcata, Calif.: Peter E. Palmquist, 1990), p. 238.

23. David Mattison, "The Maynards: A Victoria Couple," *Photographic Canadiana* 2 (March–April 1986): 4.

24. Louis Vaczek and Gail Buckland, *Travelers in Ancient Lands: A Portrait of the Middle East, 1839–1919* (Boston: New York Graphic Society, 1981), p. 191.

25. George J. Manson, "Work for Women in Photography," *Philadelphia Photographer* 20 (February 1883): 37.

26. Muybridge, in Charles Leroux, "Kindlers of Ancient Love Affairs with Light," *American Photographer* 1 (November 1978): 73.

27. Since the first edition of this book, information about Milles has appeared; see Michael Charlesworth, "The Group Portraits of Mrs. Milles: Staging by Photo-Collage," *History of Photography* 23 (Autumn 1999): 254–59.

28. See Virginia Dodier, *Clementina, Lady Hawarden: Studies from Life, 1857–1864* (New York: Aperture, 1999), p. 35.

29. Whitney Chadwick, *Women, Art, and Society* (London: Thames and Hudson, 1990), p. 172. Virginia Dodier, *Domestic Idylls: Photographs by Lady Hawarden from the Victoria and Albert Museum* (Malibu, Calif.: J. Paul Getty Museum, 1990).

30. Julia Margaret Cameron, "Annals of My Glass House" (1874), in Helmut Gernsheim, *Julia Margaret Cameron: Her Life and Photographic Work* (London: Fountain Press, 1948), pp. 67–72.

31. Ibid., p. 68.

32. A. D. Coleman, "The Directorial Mode: Notes toward a Definition," in Coleman, *Light Readings* (New York: Ridge Press, Summit Books, 1977), p. 72.

2. NOT JUST FOR FUN: WOMEN BECOME PROFESSIONALS, 1880–1915

1. Juan C. Abel, "Women Photographers and Their Work—Part I," *Delineator* 58 (September 1901): 406; Abel went on to say that the vast majority were "button-pushers."

2. Margaret Bisland, "Women and Their Cameras," *Outing* 17 (October 1890): 37.

3. C. A. Mera, "Pastime Photography," *Godey's Magazine* 134 (March 1897): 227.

4. H. Smith, "Photography and Cycling," *Amateur Photographer,* in Barbara Lynn Ricca, *Camera and Bicycle: The Camera, Bikes, and Bloomers,* History of Photography Monograph Series (Tempe: Arizona State University, 1983), n.p.

5. Elizabeth Griffith, *In Her Own Right: The Life of Elizabeth Cady Stanton* (New York and Oxford: Oxford University Press, 1984), p. 165.

6. Johnston's image served as a model for a poster of the "new woman" by Albert Morrow for *Punch*. (Whitney Chadwick, *Women, Art, and Society* [London: Thames and Hudson, 1990], p. 235.)

7. By 1890, for example, more girls than boys were graduating from secondary schools. (Barbara Miller Solomon, *In the Company of Educated Women* [New Haven, Conn., and London: Yale University Press, 1985], p. 46.) See also Lois Rudnick, "The New Woman," in Adele Heller and Lois Rudnick, eds., *1915: The Cultural Moment* (New Brunswick, N.J.: Rutgers University Press, 1991), p. 70.

8. Janet M. Hooks, *Women's Occupations Through Seven Decades*, U.S. Department of Labor, Women's Bureau, bulletin no. 218 (1947; reprint, Washington, D.C.: Government Printing Office, 1978), p. 176.

9. Richard Hines, Jr., "Women and Photography," *Photographic Times* 31 (May 1899): 242. "A Woman Worth Knowing," reprinted from the *New York Recorder* of May 2, 1891, in *Photographic Times* 21 (May 1891): 262.

10. Catharine Weed Barnes, "Women as Photographers," *American Amateur Photographer* III (September 1891): 338; text of a talk to the Working Women's Club of Syracuse, New York. Barnes expressed similar ideas in an address to the Association for the Advancement of Women in 1891.

11. Catharine Weed Barnes, "Women as Photographers," *Photographic Mosaics Annual*, 1891, pp. 117–25.

12. Catharine Weed Barnes, "A Camera Trip Through Great Britain," *American Amateur Photographer* 5 (January 1893): 203.

13. Catharine Weed Barnes, "Photography as a Profession for Women," *American Amateur Photographer* 3 (May 1894): 176.

14. Barnes, "Women as Photographers," *American Amateur Photographer*, p. 338.

15. Frederick Felix, "Young Women and Photography," *American Amateur Photographer* 8 (January 1896): 3.

16. "Editorial Department: Women Photographers," *Photo Era* 12 (June 1904): 101.

17. Henrietta S. Breck, "California Women and Artistic Photography," *Overland Monthly* 43 (February 1904): 89.

18. Marmaduke Humphrey, "Triumphs of Amateur Photography—Mrs. N. Gray Bartlett," *Godey's Magazine* 136 (April 1898): 368.

19. Virginia G. Sharp to Frances Benjamin Johnston, n.d. [1900], Frances Benjamin Johnston Papers, Library of Congress, Washington, D.C.

20. "Miss Barnes' Studio," *American Amateur Photographer* 1 (December 1889): 219.

21. Hooks, *Women's Occupations*, p. 176. See also Eleanor Flexner, *Century of Struggle: The Women's Rights Movement in the United States* (Cambridge, Mass.: Harvard University Press, Belknap Press, 1959), pp. 230–31; Joseph A. Hill, *Women in Gainful Occupations, 1870–1920*, Census Monograph No. 9 (Washington, D.C.: Government Printing Office, 1929), p. 56.

22. "Editorial Department: Women Photographers," *Photo Era* 13 (September 1905): 102.

23. Charlotte Adams, "An Answer to Mr. W. J. Stillman's Opinion of Photo Art," *Philadelphia Photographer* 16 (March 1886): 156.

24. C. A. Johnson, "Miss Virginia Prall and Her Work," *Photographic Times* 33 (March 1901): 109.

25. Juan C. Abel, "Women Photographers and Their Work," *Delineator* 58 (November 1901): 750.

26. Peter E. Palmquist, "Books by and about Women Photographers," *American Bookman*, March 1, 1993, pp. 845–46, notes two editions published in 1905 by Dodge Publishing Company, New York, and one in 1910. Some editions list Blanche Cumming as well as Adelaide Hanscom as photographer.

27. Sarah E. Slater, "Profitable Industries for Women—Photography," *Woman's Magazine* 10 (February 1904): 29.

28. Abel, "Women Photographers and Their Work," November 1901, p. 749.

29. Bertha M. Lothrop, *Indoor Photography and Flash-Light Studies of Child Subjects* (London: Percy Lund and Co., 1896), on file at the New York Public Library.

30. Edith Hastings Tracy, in untitled, undated typescript, courtesy of Mary Mix Foley, Washington, D.C.

31. "In the Man-Made Canyons of Culebra— A Woman Camera Artist as Reporter," *Collier's National Weekly*, June 14, 1913, pp. 10–11; typescript of untitled review, *New York Globe*, April 1914.

32. Beals, in Alexander Alland, Sr., *Jessie Tarbox Beals* (New York: Camera Graphic Press, 1978), p. 53.

33. Johnston, in Constance Glenn and Leland Rice, *Frances Benjamin Johnston: Women of Class and Station* (Long Beach: Art Museum and Galleries, and the Center for California Studies in the Visual Arts, California State University, Long Beach, 1979), p. 10.

34. The Frances Benjamin Johnston Archive at the Library of Congress contains a complete set of her negatives and prints; other sets of prints are at the Huntington Library in San Marino, California; the Carnegie Institute in Pittsburgh; the Baltimore Museum of Art; the Virginia Museum of Fine Arts in Charlottesville; and the universities of Virginia and North Carolina.

35. Peter E. Palmquist, *Elizabeth Fleischmann, Pioneer X-Ray Photographer* (Berkeley, Calif.: Judah L. Magnes Museum, 1990), p. 8; Theodore Kytka, "Radiography," *Camera Craft* 3 (June 1901): 2, 57.

36. I. W. Blake, "Profitable Camera Work for Women," *Photo Era* 20 (March 1908): 145.

37. *Photographs by Frances and Mary Allen, Deerfield, Massachusetts* (Deerfield, Mass.: Pocumtuck Valley Memorial Association, 1904), n.p.

38. Philip G. Hubert, "Occupations for Women," in *The Woman's Book*, vol. I (New York: Charles Scribner's Sons, 1894), p. 11.

39. Adams, "Answer," p. 157.

40. Peter E. Palmquist, *Catharine Weed Barnes Ward: Pioneer Advocate for Women in Photography* (Arcata, Calif.: Peter E. Palmquist, 1992), pp. 86–90.

41. For information about Johnston's collection of photographs by women, see Toby Quitslund, "Her Feminine Colleagues: Photographs and Letters Collected by Frances Benjamin Johnston in 1900," in Josephine Withers, *Women Artists in Washington Collections* (College Park: University of Maryland Art Gallery and Women's Caucus for Art, 1979), pp. 111–43. See also Frances Benjamin Johnston, "The Foremost Women Photographers in America," *Ladies' Home Journal* 18 (May, June, July, August, October, November, 1901; January, 1902).

42. Octave Thanet [Alice French], *An Adventure in Photography* (New York: Charles Scribner's Sons, 1893), p. 2. Thanet also wrote *A Missionary Camera* (Boston: Two Tales Publishing Co., 1892), as well as twenty-five books on varied topics.

43. Hooks, *Women's Occupations*, p. 179.

44. Sarony, in Laura Jones, *Rediscovery: Canadian Women Photographers, 1841–1941* (North London, Canada: London Regional Art Gallery, 1983), p. 2.

45. "Prominent Photographers of the United States," *Daily Graphic* (New York), December 30, 1875, p. 1.

3. PORTRAITURE, 1890–1915

1. Catharine Weed Barnes, in Frances Stevens, "The Camera and Its Devotees," *Homemaker* 6 (May 1891): 132; see also Helen L. Davie, "Women in Photography," *Camera Craft* 5 (August 1902): 130.

2. "Posing Mother and Child," *Abel's Photographic Weekly*, January 8, 1910, p. 35.

3. F. M. Sommers, "The Ladies and How to Deal with Them"; Wilkie G. Closs, "Handling Young People"; "Handling Sitters"; all in *Photographic Mosaics Annual*, 1895, pp. 240, 250, 251.

4. Sadakichi Hartmann [Sidney Allan, pseud.], "Zaida Ben-Yusuf: A Purist," *Photographic Times* 31 (October 1899); reprinted in Hartmann, *The Valiant Knights of Daguerre*, ed. Harry W. Lawton and George Knox (Berkeley, Los Angeles, and London: University of California Press, 1978), p. 167.

5. Frances Benjamin Johnston, "Gertrude Käsebier, Professional Photographer," *Camera Work* 1 (January 1903): 20.

6. Otto Walter Beck, "Portrait Photography and Art Education," *Camera Craft* 14 (November 1907): 475.

7. For a discussion of the relationship between these two movements, see Christian A. Peterson, "American Arts and Crafts, The Photograph Beautiful 1895–1915," *History of Photography* 16 (Autumn 1992): 189–234.

8. Juan C. Abel, "Women Photographers and Their Work," *Delineator* 58 (September 1901): 407.

9. Fannie L. Elton to Johnston, 1900, Frances Benjamin Johnston Papers, Library of Congress, Washington, D.C.

10. Sarah E. Slater, "Profitable Industries for Women: Photography," *Woman's Magazine* 10 (February 1904): 28.

11. Floride Green to Johnston, June 1900, Johnston Papers.

12. Philip G. Hubert, "Occupations for Women," in *The Woman's Book*, vol. 1 (New York: Charles Scribner's Sons, 1894), p. 11.

13. "Work of Eureka's Women," *Humboldt Times*, February 26, 1907; in Peter E. Palmquist, *With Nature's Children: Emma B. Freeman (1880–1928)—Camera and Brush* (Eureka, Calif.: Interface California, 1976), p. 121.

14. Fred Miller, "A Note on Some Lady Photographers with Selected Examples of Their Art," *Art Journal* (London), n.s., 1 (December 1902): 367.

15. Ben-Yusuf, in Richard Hines, Jr., "Women in Photography," *Photographic Times* 5 (May 1899): 142.

16. "Five Striking Silhouettes by Gertrude Käsebier: An Attempt at Elimination of Detail in Portrait Photography," *Vanity Fair*, March 1915, p. 34. For an extensive bibliography on Käsebier, see Barbara L. Michaels, *Gertrude Käsebier: The Photographer and Her Photographs* (New York: Harry N. Abrams, 1992).

17. Käsebier, in Giles Edgerton [Mary Fanton Roberts], "Photography as an Emotional Art: A Study of the Work of Gertrude Käsebier," *Craftsman* 12 (April 1907): 88; reprinted in *Image* 15 (December 1972): 9–12.

18. Sadakichi Hartmann [Sidney Allan, pseud.], "Gertrude Käsebier," *Photographic Times* 32 (May 1900): 198.

19. Candace Wheeler, "Art Education for Women," *Outlook* 55 (January 1897): 82; "Women in Commercial Art," *Current Literature* 35 (March 1903): 291. Hubert ("Occupations for Women," p. 4) estimated that ten thousand women were engaged in art jobs nationwide.

20. Winifred M. Gardner, "The Studio vs. the College as a Means of Learning Photography," *Camera Craft* 10 (June 1905): 361.

21. "Old Versus New Methods in Portraiture," *Photographic Journal of America* 37 (January 1900): 7.

22. "Miss F. B. Johnston's Exhibit," *Photo Era* 2 (April 1893): 292. Reviews in *Camera Notes*, whose commentaries usually reflected those of Stieglitz, noted that the quality of Johnston's work was adversely affected by her "onerous professional life." (See Joseph T. Keiley, "The Philadelphia Salon—Its Origin and Influence," *Camera Notes* 2 [January 1899]: 130; William M. Murray, "Miss Frances B. Johnston's Prints," *Camera Notes* 2 [April 1899]: 168.)

23. Sadakichi Hartmann [Sidney Allan, pseud.], "Children as They Are Pictured," *Cosmopolitan* 43 (July 1907): 235.

24. Josephine Gear, "The Baby's Picture: Woman as Image Maker in Small Town America," *Feminist Studies* 13 (Summer 1987): 420.

25. Keiley, "The Philadelphia Salon," p. 127; see also "How Women Won Fame in Photography," *Wilson's Photographic Magazine* 51 (May 1914): 202.

26. *Exhibition of Photographs: The Work of the Women Photographers of America* (Hartford, Conn.: Camera Club of Hartford, 1906), nos. 71–76. See also *Camera Craft* 7 (May 1903): 13–16.

27. Alta Belle Sniff to Johnston, Frances Benjamin Johnston Papers.

28. Dean Howd, "The Photography of Belle Johnson from Monroe City, Missouri," *Western Illinois Regional Studies* 10 (Fall 1987): 36.

29. Sadakichi Hartmann [Sidney Allan, pseud.], "Bessie Buehrmann: Under the Influence of the Secession," *Photographic Times* 39 (November 1907): 434.

30. "Books and Magazines," *Camera Craft* 2 (May 1900): 27, mentions Schulze's illustrations for "Babies of Chinatown" (in *Cosmopolitan* 28 [April 1900]). In "Notes," *Camera Craft* 2 (January 1902): 159, the Schulze collection of pictures of Chinese children is said to be the largest in the United States.

31. Madame Philonie Yevonde, "Photographic Portraiture from a Woman's Point of View," *British Journal of Photography*, April 29, 1921, p. 252. Yevonde was born Yevonde Cumbers; she sometimes signed herself Philonie Yevonde.

32. H. Snowden Ward, "The Portrait and the Studio," *Wilson's Photographic Magazine* 41 (December 1904): 553.

33. L. Gastine, "La Femme Photographe," *Bulletin du Photo-Club de Paris* 139 (August 1902): 267.

34. "La France inédite: Expositions de photographies destinées à la carte postale," *L'Art photographique*, August 1, 1905, p. 2.

4. ART AND RECREATION: PLEASURES OF THE AMATEUR, 1890–1920

1. George Burman Foster, "The Philosophy of Feminism," *Forum* 52 (July 1914): 17.

2. Exceptions include the Boston firm of Southworth and Hawes, Abraham Hesler of Chicago, and Gabriel Harrison of New York, all of whom recognized that the camera image could transcend description and suggest ideas.

3. Henry Peach Robinson, *Pictorial Effect in Photography* (London: Piper and Carter, 1869) and *The Elements of a Pictorial Photograph* (London: Percy Lund and Co., 1896). Peter Henry Emerson, *Naturalistic Photography for Students of Art* (London: Sampson Low, Martson Searle and Rivington, 1889); 2d ed. (New York: E. F. Spin, 1890); 3d ed. enlarged, revised, and rewritten in parts (New York: Scoville and Adams Co., 1899). Numerous articles by both photographers appeared in American and British publications.

4. Mary Kavanaugh Oldham Eagle, ed., *The Congress of Women* (Chicago: International Publishing Co., 1894), p. 423.

5. Helen L. Davie, "Women in Photography," *Camera Craft* 5 (August 1902): 130.

6. Kate Harrison, "The Amateur Question," *American Amateur Photographer* 16 (November 1904): 478.

7. *Camera Work* 1 (January 1903); *Camera Work* 10 (April 1905); in all, twelve images by Käsebier were reproduced.

8. P. H. Emerson, "The Berlin Exhibition: Amateurs—(Notes Written by Alfred Stieglitz)," *American Amateur Photographer* 1 (November 1889): 203.

9. "Ladies as Photographers," *British Journal of Photography*, August 25, 1905, in Pamela J. Eisenberg, *Alexandra*, History of Photography Monograph Series, no. 5 (Tempe: Arizona State University, 1983), n. 15, n.p.

10. Carine Cadby, in Margaret Harker, *The Linked Ring: The Secession Movement in Photography in Britain, 1892–1910* (London: William Heinemann; Royal Photographic Society, 1979), p. 148.

11. Margaret Harker Farrand (professor emerita of photography, Central London Polytechnic) to author, January 26, 1993.

12. "Exhibition of Photographs at National Academy of Art," *Critic* 32 (January 1898): 31; Alvin Langdon Coburn, "American Photographs in London," *Photo Era* 6 (January 1901): 209.

13. *Exhibition of Photographs: The Work of the Women Photographers of America*, Camera Club of Hartford, April 6–9, 1906. Thirty-two women from throughout the United States showed 156 images, among them portraits, still lifes, figure studies, and genre scenes.

14. Catharine Weed Barnes, "Photography from a Woman's Standpoint" (paper read before the Society of Professional Women, December 10, 1889), *American Amateur Photographer* 2 (January 1890): 10.

15. Catharine Weed Barnes, "A Woman to Women," *American Amateur Photographer* 5 (May 1890): 185.

16. Marmaduke Humphrey, "Triumphs of Amateur Photography: Mrs. N. Gray Bartlett," *Godey's Magazine* 136 (April 1898): 368.

17. Paschall, in Toby Quitslund, "Her Feminine Colleagues: Photographs and Letters Collected by Frances Benjamin Johnston in 1900," in Josephine Withers, *Women Artists in Washington Collections* (College Park: University of Maryland Art Gallery and Women's Caucus for Art, 1979), p. 133.

18. Mary Panzer, *Philadelphia Naturalistic Photography, 1865–1906* (New Haven, Conn.: Yale University Art Gallery, 1982), p. 42.

19. For example, the Round Robin Guild, a department started in 1905 by Rose Clark and Elizabeth Flint Wade in the magazine *Photo Era*, offered monthly prizes for the best photograph in specific categories. The award consisted of having the work reproduced in the magazine.

20. Sarah J. Eddy, "A Good Use for the Camera," *American and Photographic Times Almanac for 1894* (New York: Scovill and Adams Co., 1894), pp. 186–87.

21. John Telfer Dunbar, *Herself: The Life and Photographs of M.E.M. Donaldson* (Edinburgh: William Blackwood and Sons, 1979).

22. V. C. Scott O'Connor, "Mrs. Cameron, Her Friends and Her Photographs," *Century* 1 (November 1897): 3–10.

23. Frederick Evans, introduction to *Seven Last Words*, portfolio by F. Holland Day (London: Frederick Evans, 1912), n.p.

24. John Addington Symonds, "Mrs. F.W.H. Myers," in W. Arthur Boord, *The Literature of Photography* (New York: Arno Press, 1973), p. 53; first published in *Sun Artists* 7 (April 1891).

25. Cyrille Menard, "Mrs. G. A. Barton," in *Les Maîtres de la photographie* (Paris, c. 1912), p. 138 (my translation).

26. A recent article by Peter James, "Mysteries of Shade and Shadow: Discovering Mrs. G. A. Barton," *Photographica* 22 (July 1993): 7–9, suggests a revival of interest in her work.

27. Recently discovered work by the Morter sisters, whose given names are unknown, was exhibited by Houk Friedman, New York, September 23–November 6, 1993.

28. Alvin Langdon Coburn, "American Photographs in London," *Photo Era* 6 (January 1901): 210.

29. Sadakichi Hartmann [Sidney Allan, pseud.], in Peter E. Palmquist, *Shadowcatchers II: A Directory of Women in California Photography, 1900–1920* (Arcata, Calif.: Peter E. Palmquist, 1991), p. 330.

30. Lange, in Lucinda Barnes, ed., *A Collective Vision: Clarence White and His Students* (Long Beach: University Art Museum, California State University, 1985), p. 44.

31. Uncited source in Abbie Sewall, *Message Through Time: The Photographs of Emma D. Sewall, 1836–1919* (Gardiner, Maine: Harpswell Press, 1989; reprint, Albuquerque: University of New Mexico Press, 1990), p. 11.

32. Septima M. Collis, *A Woman's Trip to Alaska* (New York: Cassell Publishing, 1890).

33. *The Photographs of Mattie Gunterman* (Saskatoon, Canada: Photographers Gallery, 1977), n.p.

34. Laura Jones, *Rediscovery: Canadian Women Photographers, 1841–1941* (North London, Canada: London Regional Art Gallery, 1983), p. 10.

35. Herbert Whyte Taylor, "The New Movement in Photography," *Photo Era* 4 (October 1900): 96.

36. Peter Gay, *Education of the Senses*, vol. 1 (New York and Oxford: Oxford University Press, 1984), p. 5.

37. "A Photographic School for Ladies," *Photographic Times* 20 (December 1890): 617.

5. PHOTOGRAPHY BETWEEN THE WARS: EUROPE, 1920–40

1. Hiram Blauvelt, "When the Modernist Invades Advertising," *Printers' Ink Monthly* 10 (May 1925): 65.

2. Hélène Gordon, "Les Femmes Photographes au Pavilion de Marsan," *La Revue de la photographie* 35 (February 1936): 5.

3. Although Abbott credited Man Ray with getting her started, she acknowledged that he objected to her being given independent portrait commissions while working as his assistant. See Hank O'Neal, *Berenice Abbott: American Photographer* (New York: McGraw-Hill, Artpress, 1982), p. 10.

4. "The Studio Assistant," *Camera* 21 (December 1917): 616.

5. Madame Philonie Yevonde, "Photographic Portraiture from a Woman's Point of View," *British Journal of Photography*, April 29, 1921, p. 251.

6. Wilding, in Terence Pepper, *Dorothy Wilding* (London: National Portrait Gallery, 1991), p. 18.

7. Review in *Professional Photographer*, December 1930, in Val Williams, *Women Photographers* (London: Virago Press, 1986), p. 106.

8. Ker-Seymer, ibid., p. 99.

9. L. P. Clerc, "Paris Notes," *British Journal of Photography*, April 15, 1921, p. 218.

10. Paul Léon, preface to *Micrographie décorative: Laure Albin-Guillot* (Paris: Draeger Frères, 1931).

11. D'Ora, in Monika Faber, *D'Ora: Vienna and Paris, 1907–1957: The Photographs of Dora Kallmus* (Poughkeepsie, N.Y.: Vassar College Art Gallery, 1987), p. 10.

12. Wolfgang Born, "Photographic Weltanschauung," *Photographische Rundschau*, 1929; in Christopher Phillips, ed., *Photography in the Modern Era: European Documents and Critical Writings, 1913–1940* (New York: Metropolitan Museum of Art; Aperture, 1989), p. 155.

13. Josef Gross, "Fallen Stars of Weimar," *British Journal of Photography*, June 8, 1989, p. 12. See also Claudia Gabrielle Philipp, "Erna Lendvai-Dircksen: 1883–1962," *Fotogeschichte* 3 (July 1983): 39–54.

14. Freund, in George Walsh, Michael Held, and Colin Naylor, eds., *Contemporary Photographers*, s.v. "Gisèle Freund" (New York: Saint Martin's Press, 1982). Freund's doctoral thesis was published in France as *La Photographie en France au XIXe siècle, essai de sociologique et d'esthetétique* (Paris: Maison des Amis des Livres, 1936). It was later revised and extended in *Photographie et société* (Paris: Editions du Seuil, 1974).

15. Cameron, in Brian Hall, *Julia Margaret Cameron: A Victorian Family Portrait* (London: Peter Owen, 1973), p. 127.

16. Freund, in interview, *High Heels and Ground Glass* (New York: June 29th Productions, 1990), videotape.

17. *Life*, April 16, 1940.

18. Varvara Stepanova, "Photomontage," in Phillips, ed., *Photography in the Modern Era*, p. 235.

19. Neue Sachlichkeit, or the New Objectivity, which emerged in Germany in the early 1920s, was a style of representation that emphasized veristic appearance. It embraced graphic art and painting as well as photography; its main proponents were the painters Otto Dix, George Grosz, and Christian Schad, and the photographer Albert Renger-Patzsch. Several of the painters had started as Dadaists but later turned to realism; for example, Grosz, a founder of German Dada, became part of the Neue Sachlichkeit movement around 1925.

20. Biermann, in *Aenne Biermann: Photographs, 1925–33* (London: Dirk Nishen, 1988), back cover.

21. Jacobi, in Sandra S. Phillips, "An Interview with Lotte Jacobi," *Center Quarterly* (Catskill Center for Photography, Woodstock, N.Y.) 3 (Fall 1981): n.p.

22. Elizabeth McCausland, in *The Photography of Berenice Abbott* (New York: Marlborough Gallery, 1976); first published in *Trend* 3 (1935) and Berenice Abbott, *A Guide to Better Photography* (New York: Crown Publishers, 1941), p. 132.

23. Bayer, in Van Deren Coke, *Avant-Garde Photography in Germany, 1919–1939* (San Francisco: San Francisco Museum of Modern Art, 1980; reprint, New York: Pantheon, 1982), p. 14.

24. I have to agree with Rolf Sachsse that until quite recently Bauhaus historiography kept to "patriarchalist models that allotted minor roles or inspirational functions to women." (Sachsse, "Notes on Lucia Moholy," in Jeannine Fiedler, ed., *Photography at the Bauhaus* [Cambridge, Mass.: MIT Press, 1990], p. 25.)

25. The biographical entry for Lucia Moholy in a catalog of photographic work at the Bauhaus, *Photographie und Bauhaus* (Hannover: Kestner-Gesellschaft, 1986), does not mention the publication of her *One Hundred Years of Photography, 1839–1939* (Harmondsworth, England: Penguin, 1939), but it does indicate that she started working on a history with Moholy-Nagy in 1922.

26. Diana C. du Pont, *Florence Henri: Artist-Photographer of the Avant-Garde* (San Francisco: San Francisco Museum of Modern Art, 1990).

27. Hannah Höch, in *The Twenties in Berlin* (London: Annely Juda Fine Art, 1978), p. 29.

28. Maud Lavin, *Cut with the Kitchen Knife: The Weimar Photomontages of Hannah Höch* (New Haven, Conn., and London: Yale University Press, 1993), p. 35.

29. Rosalind Krauss and Jane Livingston, *L'Amour fou: Photography and Surrealism* (Washington, D.C.: Corcoran Gallery of Art; New York: Abbeville Press, 1985), p. 222.

30. Honor LaSalle and Abigail Solomon-Godeau, "Surrealist Confession: Claude Cahun's Photo-montages," *Afterimage* 19 (March 1992): 12.

31. Oswell Blakeston, in David Mellor, *Modern British Photography, 1919–1939* (London: Arts Council of Great Britain, 1980), p. 10; untitled article first published in *Architectural Review* 71 (April 1932).

32. R. L. Dupuy, "Advertising Photo in France," *Gebrauchsgraphik* 6 (July 1929): 17.

33. Krull, in Christian Bouqueret, *Germaine Krull: Photographie, 1924–1936* (Arles, France: Musée Réattu, 1988), p. 12.

34. "Elsbeth Heddenhausen," *Gebrauchsgraphik* 8 (December 1931): 31.

35. Traigott Schalcher, "Camera Studies, ringl + pit," *Gebrauchsgraphik* 8 (February 1931): 2, 35.

36. Franz Roh, in "Photos by Aenne Biermann," in *Aenne Biermann: Photographs, 1925–33*, p. 16.

37. Du Pont, *Florence Henri: Artist-Photographer of the Avant-Garde*, p. 34. In researching the magazines of the period, du Pont has been unable to find examples of actual ads by Henri, although her compositions were praised at the time by Margaret Breuning in the *New York Evening Post* as exemplars of modern advertising style.

38. Albert Dresdner, "German Commercial Photography," *Commercial Art* 4 (April 1928): 177.

39. *Commercial Art and Industry* (London), *Gebrauchsgraphik* (Berlin), *Arts et métiers graphiques* (Paris), *Printers' Ink* and *Printers' Ink Monthly* (New York) were among the publications that promoted modernist vision in advertising photography in the late 1920s and throughout the 1930s.

40. Tim N. Gidal, "Deutschland: Beginn des modernen Photojournalismus," in Petr Tausk, *A Short History of Press Photography* (Prague: International Organization of Journalists, 1988), p. 93.

41. Cartier-Bresson, in Guy Mandery, "Germaine Krull, Pionnière de la photographie moderne," *Le Monde dimanche*, May 24, 1981, p. 11.

42. Bing, in Elizabeth McCausland, "Compares Her Camera to Musical Instrument," *Springfield Republican*, October 2, 1932. See also Nancy Barrett, *Ilse Bing: Three Decades of Photography* (New Orleans: New Orleans Museum of Art, 1985), p. 9.

43. Bing, in "Ilse Bing: Une Pionnière de la photographie des années 30," *Photographies*, April 1983, p. 29 (my translation).

44. Ann Thomas, *Lisette Model* (Ottawa: National Gallery of Canada; Chicago: University of Chicago Press, 1990), p. 44.

45. For a discussion of the current feminist point of view about the objectification of the female nude by male photographers, see Deborah Bright, "Reactionary Modernism: Lee Friedlander's Nudes for the Nineties," *Afterimage* 20 (January 1993): 6–9.

6. PHOTOGRAPHY BETWEEN THE WARS: NORTH AMERICA, 1920–40

1. Sadakichi Hartmann [Sidney Allan, pseud.], "The Light Interpretations of Clara Estella Sipprell," *Photo Era* 30 (June 1913): 267.

2. Louis Paul Flory, "The Status of Professional Photography in America," *American Annual of Photography* (Boston: American Photographic Publishing Co., 1927).

3. Harriet Stanton Blatch, in J. Stanley Lemons, *The Woman Citizen* (Charlottesville and London: University of Virginia Press, 1975), p. 15.

4. Dorothy Richardson, "Women and the Future," *Vanity Fair*, April 1924, p. 39.

5. Suzanne LaFollette, *Concerning Women* (New York: Albert and Charles Boni, 1926), p. 270.

6. William E. Leuchtenberg, "The Revolution in Morals," in William O'Neill, ed., *The American Sexual Dilemma* (New York: Holt, Rinehart and Winston, 1972), pp. 26–36.

7. "The Women's Fair at Olympia," *Art and Industry* 25 (December 1938): 256.

8. Beatrice Hinkle, in Dorothy M. Brown, *Setting a Course: American Women in the 1920s* (Boston: Twayne Publishers, 1987), p. 32.

9. Clarence H. White, "Photography as a Profession for Women," *News-Bulletin of the Bureau of Vocational Information* 7 (April 1924): 49–50, 54–55.

10. Grace R. Deppen, "Photography for Women," *Photo Era* 49 (August 1922): 71.

11. Alice W. Chambers, "Of Interest to Women," *Camera* 24 (August 1920): 436.

12. Jeanne Moutoussamy-Ashe, *Viewfinders: Black Women Photographers* (New York: Dodd, Mead and Company, 1986), p. 31.

13. "Pictorial Photography Has a Future as a Fine Art: An Interview with Clara E. Sipprell," *Abel's Photographic Weekly*, April 5, 1924, p. 371.

14. Ulmann, in Dale Warren, "Doris Ulmann's Photographs in Waiting," in William Clift and Robert Coles, *The Darkness and the Light: Photographs by Doris Ulmann* (Millerton, N.Y.: Aperture, 1974), p. 7.

15. Lange, in Carmen Ballen, "The Art of Dorothea Lange," *Overland Monthly* 74 (December 1919): 408.

16. Cunningham, in Anita Ventura Mozeley, "Imogen Cunningham: Beginnings," in James Alinder, ed., *Discovery . . . Recognition*, Untitled, no. 25 (Carmel, Calif.: Friends of Photography, 1981), p. 44.

17. Ira W. Martin, "Women in Photography," *Pictorial Photography in America* (New York: Pictorial Photographers of America, 1929), n.p.

18. Gilpin, in Margaretta K. Mitchell, *Recollections: Ten Women of Photography* (New York: Viking Press, Studio, 1979), p. 121.

19. Sophie Lauffer, "Why I Am a Pictorial Photographer," *Photo Era* 64 (February 1930): 63.

20. Keene, in Laura Jones, *Rediscovery: Canadian Women Photographers, 1841–1941* (North London, Canada: London Regional Art Gallery, 1983), p. 24.

21. Roland Marchand, *Advertising the American Dream: Making Way for Modernity, 1920–1940* (Berkeley, Los Angeles, and London: University of California Press, 1985), p. 33.

22. Margaret Watkins, "Advertising and Photography," *Pictorial Photography in America* (New York: Pictorial Photographers of America, 1926), n.p.

23. Watkins, in Joseph Mulholland, "Margaret Watkins," typescript for exhibition at Little Art Gallery, Glasgow, 1983, in the collection of Robert Mann.

24. Sara Parsons, "Photography in Aesthetics," *Société Anonyme Brochure Quarterly* 3 (July 1928): 23–24.

25. "Asking for It," *Art Digest*, October 15, 1936, p. 33.

26. Frissell, in Mitchell, *Recollections*, p. 104.

27. Louise Dahl-Wolfe, *Louise Dahl-Wolfe: A Photographer's Scrapbook* (New York: Saint Martin's Press, Marek, 1984), p. 85. I was introduced to Dahl-Wolfe in 1958 by her one-time assistant Hazel Kingsbury Strand, and over the years I had a number of conversations with her about her career; the last took place in the early 1980s.

28. Lorine Pruette, *Women and Leisure* (New York: E. P. Dutton and Company, 1924), p. 125.

29. Cunningham, in Mozeley, "Imogen Cunningham: Beginnings," p. 44.

30. Sigismund Blumann, "Nudes," in *The American Annual of Photography* (New York: American Annual of Photography, 1918), p. 46.

31. Lavenson, in Susan Ehrens, *Alma Lavenson: Photographs* (Berkeley, Calif.: Wildwood Arts, 1990), n.p.

32. Olga Dahl, "Women in Commercial Photography," *Camera Craft* 31 (December 1924): 577.

33. Cunningham to Weston, July 27, 1920, Weston Archive, Center for Creative Photography, University of Arizona, Tucson.

34. Lawrence Jasud, "Margrethe Mather: Questions of Influence," *Center for Creative Photography Journal: Margrethe Mather* 11 (December 1979): 54.

35. Willard Van Dyke to Noskowiak, September 4, [1933], Sonya Noskowiak Papers, Center for Creative Photography, University of Arizona, Tucson.

36. Noskowiak's account books, which record an average income of fifteen hundred dollars a year throughout the 1950s, suggest that commercial prospects on the West Coast were still not especially generous. Account book for 1955–59, Noskowiak Papers.

37. Margaret Hooks, "Assignment, Mexico: The Mystery of the Missing Modottis," *Afterimage* 19 (November 1991): 10. Hooks suggests, but offers no supporting evidence, that Modotti gave up photography after a visit to the Soviet Union because her work in the modern style was scorned by the leftist cultural establishment.

38. Modotti to Weston, July 7, 1925, in Amy Stark, ed., *The Letters from Tina Modotti to Edward Weston*, The Archive, no. 22 (Tucson: Center for Creative Photography, University of Arizona, 1986): 39.

39. Modotti to Weston, May 23, 1930, ibid., p. 74.

40. Lange, in Nat Herz, "Dorothea Lange in Perspective," *Infinity* 4 (April 1963): 5.

41. Dorr, in Mitchell, *Recollections*, p. 86.

42. Welty, in *One Time, One Place*, reprinted in *Images of the South: Visits with Eudora Welty and Walker Evans*, introduction by Bill Ferris, Southern Folklore Reports, no. 1 (Memphis, Tenn.: Center for Southern Folklore, 1977), p. 14.

43. Andrea Fisher, *Let Us Now Praise Famous Women* (London and New York: Pandora, 1987), p. 103.

44. Elizabeth McCausland, "Berenice Abbott . . . Realist," *Photo Arts* 2 (Spring 1948): 50.

45. Marion Post Wolcott, in F. Jack Hurley, *Marion Post Wolcott: A Photographic Journey* (Albuquerque: University of New Mexico Press, 1989), p. 57.

46. Revelations about this company's cartel arrangements with German industries during World War II resulted in such hostile public opinion that Standard Oil hired a public relations firm to create a better corporate image. The extensive photographic documentation directed by Stryker—the largest undertaken by a nongovernmental entity—was meant to improve the public's attitude toward the nation's leading source of oil and chemical products by depicting the positive aspects of oil use and manufacture.

47. Arch A. Mersey, "Women's Opportunities in Public Service Film and Photo Agencies" (paper presented at the Conference on Opportunities in Public Service, November 11, 1939, Washington, D.C.), n.p., George Eastman House Library, Rochester, New York.

48. Frank Crowninshield, foreword to *U.S. Camera Annual* (New York: William Morrow and Co., 1930), p. 11-A.

7. PHOTOGRAPHY AS INFORMATION, 1940–2000

1. *Proceedings of the Conference on Photography* (New London, Conn.: Connecticut College, 1940); the conference was held at the Biltmore Hotel, New York, on February 9, 1940.

2. Mary Ellen Mark, in *The Photo Essay: Photographs by Mary Ellen Mark* (Washington, D.C.: Smithsonian Institution Press, 1990), p. 5.

3. Val Williams, *Women Photographers* (London: Virago Press, 1986), p. 32.

4. After a day of shooting still and motion pictures at the battle of Brunete, Gerda (Pohorylles) Taro was wounded by an out-of-control Loyalist tank and died on July 26, 1937.

5. Sabine Weiss, in "Sabine Weiss," publicity release, Exhibitions Department, French Cultural Services, New York, n.d.

6. Work by thirty women appeared in *National Geographic* from 1914 on; most were free-lance photographers or relatives of authors or editors. Since 1953 there have been only four female staff photographers, compared with forty-three male staffers; today of the sixty photographers who work regularly for the magazine, twelve are women, with only one on staff (Jodi Cobb).

7. Margaret Bourke-White, *Portrait of Myself* (New York: Simon and Schuster, 1963; London: William Collins, 1964), p. 197.

8. Margaret Knox Morgan, "Women in Photojournalism," *Popular Photography* 54 (February 1964): 81.

9. Robert W. Brown, "Hansel Mieth Gets Them to Pose," *Popular Photography* 8 (April 1941): 23.

10. *Life: The First Decade* (New York: Time, 1979).

11. Ralph Graves, "An Incredible Will of Creativity," *Life*, June 27, 1969, p. 3; I determined the number of images by women by going through all issues of *Life* between January and June 1969.

12. *In Praise of Women Photographers (and Photographers Who Just Happen to Be Women)* (New York: Time, 1993), curated by Marthe Smith.

13. Kathryn Sullivan, "Constance Bannister: Camera Girl," *Popular Photography* 13 (September 1943): 77.

14. Vera Jackson to author, March 10, 1993; Jeanne Moutoussamy-Ashe, conversation with author, March 12, 1992, recollecting her experiences as a magazine photographer during the 1960s.

15. Farlow, in Kay Mills, *A Place in the News* (New York: Dodd, Mead, and Co., 1988), p. 230; Orkin, in Richard Whelan, "Are Women Better Photographers Than Men?" *Artnews* 79 (October 1980): 80–81.

16. Constance Bannister, letter to the editor, *Popular Photography* 12 (June 1943): 38.

17. Severn, in Williams, *Women Photographers*, p. 126.

18. Robertson, ibid., p. 138.

19. Oswell Blakeston, ibid., p. 136; by a "punch" picture, Blakeston meant something that would immediately arrest attention.

20. Colomb, in Michel Guerrin, "L'Atelier dans le chambre noir," *Le Monde*, July 3, 1992 (my translation).

21. *Paysages photographiés: La Mission photographique de la datar* (Paris: Hazan, 1985).

22. Robert Pledge (president of Contact Press Images), conversation with author, November 2, 1999.

23. *Hecho en Latinoamerica: Primera muestra de la fotografía latinoamericana contemporánea* (Mexico City: Consejo Mexicano de Fotografía, 1977).

24. Si Ma Xiao Meng, "My Life as a Woman Photographer," *China Reconstructs*, February 1984, p. 57.

25. Yoshitaro Sakanoue, "Eiko Yamazawa," *Bijutsu Techo*, February 1993; Yukima Masui, who made this material available, also supplied the translation.

26. Ishiuchi, in *Exploring the Unknown Self: Self-Portraits of Contemporary Women* (Tokyo: Tokyo Metropolitan Museum of Photography, 1991), p. 157.

27. Therese Aubin, in Jennifer Werner, "Being a Woman and a Photojournalist in 1986," in Beverly M. Bethune and Mimi Fuller Foster, eds., *Women in Photojournalism* (Durham, N.C.: National Press Photographers Association, 1986), p. 18.

28. Farlow, in Mills, *A Place in the News*, p. 230.

29. Walker, in Kathryn Livingston, "Diana Walker and Jill Krementz," *American Photographer* 16 (May 1986): 72.

30. Over the years Magnum has had various arrangements with its members; some women, like some men, have been associates rather than full members. Several women full members also dropped out, among them Abigail Heyman and Mary Ellen Mark; Lise Safarti is currently an associate member. Of the 120 images reproduced in *Magnum Landscape*, a 1996 publication (Phaidon Press), only 5 were by women.

31. Susan Meiselas, "Some Thoughts on Appropriation and the Use of Documentary Photographs," *Exposure* 27 (1989): 12. This message became the central motif of a feature film about a photojournalist in Latin America (*Under Fire*), in which the protagonist was cast as a male, played by Nick Nolte.

32. Maggie Steber, "An Island of Despair," *American Photographer* 20 (April 1988): 77.

33. Krementz, in "Inter-View: When the Photographer Is a Woman," *Infinity* 12 (January 1973): 5.

34. Steve Harper, "Interview with Mary Ellen Mark," *Photo Metro* 98 (April 1992): 8; see also Christian Walker, "Interview with Mary Ellen Mark," *Art Papers* 16 (May–June 1992): 18.

35. Mark, in Harper, "Interview with Mary Ellen Mark," p. 18.

36. A. D. Coleman, 1972, in Milton Meltzer, *Dorothea Lange: A Photographer's Life* (New York: Farrar, Straus and Giroux, 1978), p. 242.

37. Ansel Adams, with Mary Alinder, *Ansel Adams: An Autobiography* (Boston: New York Graphic Society, Little, Brown and Company, 1985), p. 260.

38. Palfi, in Elizabeth Lindquist-Cock, "Marion Palfi: An Appreciation," in *Marion Palfi*, The Archive, no. 19 (Tucson: Center for Creative Photography, University of Arizona, 1983), p. 10.

39. Stephen W. Plattner, *Roy Stryker, U.S.A., 1943–1950: The Standard Oil (New Jersey) Photography Project* (Austin: University of Texas Press, 1983), p. 83.

40. Emma Dent Coad, "Woman of La Mancha: Interview with Cristina García Rodero," *British Journal of Photography*, August 16, 1993, p. 16.

41. So named by Nathan Lyons for a show entitled *Contemporary Photographers: Towards a Social Landscape*, at the International Museum of Photography, George Eastman House, Rochester, New York, 1966; no women were included.

42. Model, in Ann Thomas, *Lisette Model* (Ottawa: National Gallery of Canada; Chicago: University of Chicago Press, 1990), p. 23.

43. *New Topographics: Photographs of a Man-Altered Landscape* (Rochester, N.Y.: George Eastman House, 1975); included were eight male photographers and the couple Bernd and Hilla Becher.

44. Wagner, in Anne Wilkes Tucker, "Catherine Wagner," *Photo Metro* 7 (September 1988): 23.

45. Abbott apparently was so persuaded that the league was sexist that her role on the advisory board was not included in Hank O'Neal, *Berenice Abbott: American Photographer* (New York: McGraw-Hill, Artpress, 1982). Her activities at the league can be found in *Photo Notes* (Rochester, N.Y.: Visual Studies Reprint Book, 1977).

46. The league's feature groups concentrated on neighborhoods throughout the city; one was Harlem, another Chelsea, and another the Lower East Side. The projects were called Documents when exhibited or published. Besides Asjian, Kasofsky, and Siskind, Morris Engel and Jack Mendelsohn (Jack Manning) were involved; none was mentioned in *Harlem Document—Photographs, 1932–1940: Aaron Siskind* (Providence, R.I.: Matrix, 1981).

47. Janet Murray, "For Women Only, " *Popular Photography* 7 (September 1940): 33; Mrs. F. S. Huntress, "A Wife's a Handy Photo-Gadget," *Popular Photography* 25 (December 1949): 97.

48. Kathryn Abbe, in Margaretta Mitchell, "Photography's Twin Sisters," *Popular Photography* 86 (January 1980): 118.

49. Alexander Liberman and Polly Devlin, *Vogue Book of Fashion Photography, 1919–1979* (New York: Simon and Schuster, 1979).

50. *On the Edge: Images from 100 Years of Vogue* (New York: Random House, 1992).

51. Lillian Bassman, conversation with author, New York, April 23, 1992.

52. Louise Dahl-Wolfe, *Louise Dahl-Wolfe: A Photographer's Scrapbook* (New York: Saint Martin's Press, Marek, 1984), p. 39.

53. Liberman, in *On the Edge*, p. vii.

54. A. D. Coleman, "Letter from New York No. 39," *Photo Metro* 11 (February 1993): 28.

55. John Szarkowski, "Photographing Architecture," *Art in America* 47 (Summer 1959): 84.

56. Lizzie Himmel, conversation with author, January 3, 1994.

57. Julia Scully, "Seeing Pictures," *Modern Photography* 37 (May 1972): 70.

58. Ibid., p. 118.

59. Mark, in *Photo Essay*, p. 15.

60. Walker, in Livingston, "Jill Krementz and Diana Walker," p. 75.

61. Grace D. Polk, "ASMP at 35: Strong to Serve," *Special Bulletin* (New York: American Society of Magazine Photographers, n.d. [1981]), p. 5. Of the more than forty-three hundred members in 1992, there were some six hundred women. (*Membership Directory* [New York: American Society of Magazine Photographers, 1992].) ASMP does not record the gender of its members, and so exact information on the percentage of women is not available.

62. Arnold, in April Rapier, "A Conversation Between Eve Arnold and April Rapier," *Photographic Insight* 2 (1992): 14.

8. THE FEMINIST VISION, 1970–95

1. Craig Owens, in Anne Friedberg, "Mutual Indifference: Feminism and Post-Modernism," in J. F. MacCannell, ed., *The Other Perspective in Gender and Culture: Rewriting Women and the Symbolic* (New York and Oxford: Columbia University Press, 1990), p. 43.

2. Bea Nettles, *The Skirted Garden* (Urbana, Ill.: Inky Press Productions, 1990).

3. Edward G. Southey, *Photographic Careers*, in Judy Goodwin, "Women and Photography," *British Journal of Photography* (October 19, 1979), p. 1004.

4. Iturbide, in *Graciela Iturbide* (San Francisco: Museum of Modern Art, 1990), n.p.

5. Amy Conger, *Campañeras de Mexico: Women Photograph Women* (Riverside: University Art Gallery, University of California, Riverside, 1990), p. 12.

6. Barbara Hershey, "The Uncommon Chord," *Reflections: Woman's Self-Image in Contemporary Photography* (Oxford, Ohio: Miami University Art Museum, 1988), p. 15.

7. Harold-Steinhauser, in "Women and Their Models," *Center Quarterly* (Catskill Center of Photography, Woodstock, N.Y.) 4 (1983): 5.

8. Hahn, ibid., p. 4.

9. Andreas Huyssen, in Friedberg, "Mutual Indifference," p. 43.

10. Terry Eagleton, *Literary Theory: An Introduction* (Minneapolis: University of Minnesota Press, 1983), p. 96.

11. Larry Frascella, "Cindy Sherman's Tales of Terror," *Aperture*, no. 103 (Summer 1986): 49.

12. Diana C. du Pont, *Lorie Novak*, Centric, no. 42 (Long Beach: University Art Museum, California State University, Long Beach, 1991), n.p.

13. Marsha Meskimmen, *Women Artists' Self-Portraiture in the Twentieth Century* (New York: Columbia University Press, 1996), p. 241.

14. Abigail Solomon-Godeau, "Re-presenting Women: The Politics of Self-Representation," in Diane Neumaier, ed. *Reframings: New American Feminist Photographers* (Philadelphia: Temple University Press, 1995), p. 296.

15. Nora E. Reisman, "The Photographic Nude," *American Photography* 39 (June 1935): 338.

16. Goldin, in Mark Holborn, "Nan Goldin's Ballad of Sexual Dependency," *Aperture*, no. 103 (Summer 1986): 38.

17. "Marsha Burns: Sensual Studies," *Camera Arts* (November–December 1980): 56.

18. Murray, in Darwin Marable, "Interview with Joan Murray," *Photo Metro* 11 (April 1992): 24.

19. A. D. Coleman, "Karen Tweedy-Holmes: A Portfolio," *Infinity* 19 (June 1970): 6.

20. Deborah Bright, "Reactionary Modernism: Lee Friedlander's Nudes for the Nineties," *Afterimage* 20 (January 1993): 7.

and the California Law," *Photo Metro* 8 (June–July 1990): 20, points out that possessors of photographs of nude children under fourteen years old can be subject to prosecution under California law, as was the case with photographer Jock Sturges in 1990.

22. See Edward De Grazia, "The Big Chill: Censorship and the Law," *Aperture*, no. 121 (Fall 1990): 50. The entire issue, entitled *The Body in Question*, is devoted to issues of nudity and censorship.

23. Susan Sontag, in Annie Leibovitz, *Women* (New York: Random House, 1999), p. 36.

9. PHOTOGRAPHY AS ART, 1940–2000

1. Edward Steichen, in Grace M. Mayer, "Nell Dorr," *Infinity* 12 (December 1963): 5.

2. Val Williams, *Ida Kar: Photographer, 1908–1974* (London: Virago Press, 1989), p. 35.

3. Forty-seven percent of MFA degrees in photography are awarded to women; women are believed to constitute 30.7 percent of all photographers. See *WAC Stats: The Facts about Women* (New York: Women's Action Coalition, 1992); figures cited are from 1990 Statistical Abstract of the United States and U.S. Department of Education, National Center for Education Statistics, 1989–90. See also "Survey of Women and Persons of Color in Post Secondary Photographic Education, Special Report, Women's Caucus," *Exposure* (Society for Photographic Education) 26 (1989): 41–87.

4. Barbara Crane, conversation with author,

June 1992, regarding Aaron Siskind's sexist attitudes at the Institute of Design. For a general history of the school, see Charles Traub, ed., *The New Vision: Forty Years of Photography at the Institute of Design* (Millerton, N.Y.: Aperture, 1982).

5. Morgan, in Diane Emery Hulick, "Sung, Chu, Mei; The Pine, The Bamboo, The Plum: The Work of Barbara Morgan," *Photographic Insight* 2 (1992): 12.

6. Bernhard, in George Walsh, Michael Held, and Colin Naylor, eds., *Contemporary Photographers*, s.v. "Ruth Bernhard" (New York: Saint Martin's Press, 1982).

7. Savage, in *Naomi Savage: Photographic Disclosures* (Princeton, N.J.: Squibb Gallery, 1982), n.p.

8. For example, no women are represented in Cynthia Wayne, *Dreams, Lies, and Exaggerations: Photomontage in America* (College Park: University of Maryland Art Gallery, 1991).

9. Ess, in P. C. Smith, "Complex Vision," *Art in America* 10 (March 1993): 69.

10. Tenneson, in "Exposures: Joyce Tenneson," supplement to *Photo Design* 6 (January–February 1989): 37.

11. Parker, in *Under the Looking Glass: Color Photographs by Olivia Parker* (Boston: New York Graphic Society, Little, Brown and Company, 1983), n.p.

12. Purcell, in *Contemporary Photographers*, s.v. "Rosamond Wolff Purcell."

13. Claire Williamson, *"Digitalis Australis: The Recent Hybrid in Australian Photography,"* *History of Photography* 23 (Summer 1999): 107.

14. Rubenstein, in John Bloom, "Interview with

Meridel Rubenstein," *Photo Metro* 6 (September 1988): 6.

15. Skoglund, in Cate McQuaid, "Close-Up: Sandy Skoglund," *PRC Newsletter* (Photographic Resource Center, Boston) 17 (March 1993): n.p.

16. Kaprow, in Charles Stainback, *Special Collections: The Photographic Order from Pop to Now* (New York: International Center of Photography, 1992), p. 24.

17. Fiskin, in "Judy Fiskin Interviewed by John Divola," in William Bartman, ed., *Judy Fiskin* (Beverly Hills, Calif.: A.R.T. Press, 1988), pp. 13–14.

18. Groover, in *Jan Groover* (Purchase, N.Y.: Neuberger Museum, 1983), n.p.

19. Linda Connor, "Why Were There No Nineteenth-Century Women Landscape Photographers?" *Aperture*, no. 93 (1982): n.p.

20. Gretchen Garner, "Reclaiming Paradise: American Women Photograph the Land," and Elizabeth Hampsten, "Land in Time and Space," in *Reclaiming Paradise: American Women Photograph the Land* (Duluth: Tweed Museum of Art, University of Minnesota, 1987), p. 6, p. 10.

21. Mendieta, in John Perreault, "Earth and Fire: Mendieta's Body of Work," in *Ana Mendieta: A Retrospective* (New York: New Museum of Contemporary Art, 1987), p. 10.

22. Lange, in John Benson, "The Dorothea Lange Retrospective," *Aperture*, no. 12 (1965): n.p.

BIOGRAPHIES

BY JAIN KELLY

The following biographies are for those photographers whose work is illustrated in the text. The biographies incorporate original research as well as information obtained from diverse published and unpublished sources in several languages. In some cases, little information was available on historical figures, and it is to be hoped that this volume will inspire new detective work regarding these women.

A History of Women Photographers—an exhibition organized by the Akron Art Museum, Akron, Ohio, and curated jointly by Naomi Rosenblum and Barbara Tannenbaum—opened in October 1996 at the New York Public Library; traveled to the National Museum of Women in the Arts, Washington, D.C.; Santa Barbara Museum of Art, Santa Barbara, California; and closed at the Akron Art Museum in November 1997. It encompassed the work of 214 women, almost all of whom are represented here.

I wish to extend my thanks to several people who generously shared their original, previously unpublished research. These include: Jeanie Cooper Carson, graduate student and instructor, Boston University (on Marjory Collins); Jerry Cotten, Wilson Library, University of North Carolina at Chapel Hill (on Bayard Wootten); Gillian Greenhill Hannum, Manhattanville College, Purchase, New York (on Mathilde Weil); Peter E. Palmquist (on Eliza Withington); Terry Toedtemeier, curator of photography, Portland Art Museum, Portland, Oregon (on Lily White); and Alkis Xanethakis, Athens Cultural and Technological Institute (on Nelly). The following people kindly provided information from their files and general knowledge: Beverly

Brannan, Library of Congress, Washington, D.C. (on Toni Frissell); Barbara L. Michaels (on Alice Austin); Christian A. Peterson, Minneapolis Institute of Art (on Ethel M. Smith); and Nancy Roth (on Alice Lex-Nerlinger). In addition, thanks are due my husband, George W. Kelly, for much patient typing and retyping.

KATHRYN ABBE
Born 1919, New York City
Resides Brookville, New York
Advertising images and magazine work. Twin sister of FRANCES MCLAUGHLIN-GILL. Spent childhood in Wallingford, Connecticut. B.F.A. in art and design, Pratt Institute, Brooklyn, 1941; studied photography with Walter Civardi there and painting with Yasuo Kuniyoshi at the New School for Social Research, 1939–41. After winning Vogue magazine's "Prix de Paris" contest, 1941, worked as assistant to Vogue fashion photographer TONI FRISSELL, 1942–44. Married photographer James Abbe, Jr. (an art historian and dealer in antiques), 1946; had Tom, 1948; Lucinda, 1950; and Eli, 1952. Photographer for magazines, including Good Housekeeping, Better Homes and Gardens, and Parents, 1944 to present. Known for photographs of children, including well-known Kienast quintuplets, for whom she was exclusive photographer on assignment from Good Housekeeping, 1970s–'80s. Photographed television personalities, actors, actresses, and musicians. Did photography for book on evangelist Billy Graham, God Bless You Real Good, 1967. Rescued and printed negatives of early Hollywood actors and actresses taken by father-in-law, James Abbe, 1960s; coauthored book of his work, Stars of the Twenties, 1975. Spent three years working with McLaughlin-Gill on book on twins, published 1980. With sister exhibited photographs of twins at Neikrug Galleries, New York, 1981, and Washburn Gallery, New York, 1988.

BERENICE ABBOTT
Born 1898, Springfield, Ohio
Died 1991, Monson, Maine
Portraits, documentation, and scientific studies. Attended Ohio State University, Columbus, 1917–18. Moved to New York City to study journalism, 1918, but switched to sculpture and painting. Traveled to Paris, 1921; studied with sculptor Emile Bourdelle. Attended Kunstschule, Berlin, 1923. Took job as assistant to Man Ray in Paris, 1923–25. Saw work of photographer Eugène Atget, 1925; met him, 1927. Opened own portrait studio in Paris, 1926. Photographed Jean Cocteau, James Joyce, André Gide, among others. First exhibition at avant-garde gallery Au Sacre du Printemps, Paris, 1926. Moved to New York, 1929, taking collection of Atget's work, which she had purchased after his death. For the next several decades worked to introduce Atget's work to the United States; sold her collection of it to the Museum of Modern Art, New York, 1968. Met art historian and critic Elizabeth McCausland, who wrote for Springfield (Massachusetts) Republican, and became her companion, early 1930s on. Embarked on ambitious plan to photograph New York, 1929–39, obtaining financial aid from Federal Art Project of Works Progress Administration, 1935. Made portraits for Fortune magazine, 1930s. Became member of, and served on board of, Photo League, late 1930s. Had exhibition, Changing New York, at Museum of the City of New York, 1937; book of same title published, 1939. Began to photograph scientific phenomena, 1939, but was unable to find financial sponsorship for that work until 1950s. Published A Guide to Better Photography, an influential manual of photographic instruction, 1941. Left New York for health reasons to live in Maine, 1968.

LAURE ALBIN-GUILLOT
Born c. 1880, presumably France
Died 1962, Nogent-sur-Marne, France
Portraits, nudes, and photomicrography.
Married Dr. Albin Guillot, scientific researcher,
1901. Together they spent thirty years amassing
collection of micrographic specimens: crystal-
lizations, plant cells, animal organisms. Laure
was at center of Parisian photographic circles,
1920s–'30s. Her soft-focus portraits and nude
studies frequently published in such magazines
as *La Photo pour tous, Arts et métiers graphiques*, and
Vu. Received gold medal in contest sponsored by
La Revue française de photographie, 1922. First one-
person exhibition, with forty prints, in Paris,
1925. Wrote articles on photomicrography,
1930. After Albin died, 1931, she continued
photomicrographic research and as a tribute to
him created book of photogravures of twenty pho-
tomicrographs, some on colored metallic papers.
The book, *Micrographie décorative*, was published in
1931 in an edition of 305 copies, Paris. Appointed
head of photography, Archives Service, Beaux-
Arts, Paris, 1932. Became president of the French
Société des Artistes Photographes, 1935. Illustrated
Paul Valéry's book *Le Narcisse*, 1936. Illustrated
Douze Chansons de Bilitis by Pierre Louÿs, 1937.

FRANCES S. ALLEN
Born 1854, Wapping, Massachusetts
Died 1941, Deerfield, Massachusetts
AND
MARY E. ALLEN
Born 1858, Wapping, Massachusetts
Died 1941, Deerfield, Massachusetts
Portraits, genre, and scenic views. Grew up on
family farm in Wapping. Both went to State
Normal School in Westfield to become teachers,
1874–76, and obtained jobs. Both published
photographs in *Picturesque Franklin* (about
Franklin, Massachusetts), edited by Charles
Warner, 1891. By early 1890s both started
going deaf, probably as result of childhood ill-
ness. Realizing that teaching would become
impossible, they decided to support themselves
with photography. Father died, 1895; the sisters
moved with their mother to nearby Deerfield.
Allen sisters sold souvenir views of "Old
Deerfield" and typical scenes of New England
life; did not keep a formal studio open to pub-
lic. Represented by four of their photographs in
FRANCES BENJAMIN JOHNSTON's exhibition of
1900–1901; also two of the seven women
Johnston wrote about in "The Foremost
Women Photographers of America" series for

Ladies' Home Journal, 1901–2. Frances is said to
have posed and photographed most of the
children. Sisters remained active through early
1930s. Frances almost blind by 1932. She died
February 14, 1941, followed by Mary four days
later.

EMMY ANDRIESSE
Born 1914, The Hague
Died 1953, Amsterdam
Primarily portraits; also advertising and fashion.
Attended Koninklijke Academie voor
Beeldende Kunsten, The Hague, 1932–37;
studied graphic design and photography with
Dutch avant-garde teachers Gerrit Kiljan and
Paul Schuitema, also Piet Zwart. Worked with
EVA BESNYÖ , Carel Blazer, and Cas Oorthuys,
1937. Photographed during travels and did
portraits of artists; also free-lance commercial
work, including fashion and advertising, 1937.
During German occupation, member of group
of photographers using disguised cameras
(Ondergedoken Camera), 1940–45. Married
Dilck Elffers, 1941. Traveled to Paris, pho-
tographed artists and singers. Invited by director
of Stedelijk Museum, Amsterdam, to photo-
graph thirteen sculptors in Paris and Belgium,
1951. Contributed to periodicals like *U.S.
Camera*. Two photographs included in Edward
Steichen's show *The Family of Man* (Museum of
Modern Art, New York) and accompanying
book, 1955. Began photography for book on
artist Vincent van Gogh, 1951; published
posthumously as *The World of Van Gogh*, 1953.
Exhibition of work at Van Gogh Museum,
Amsterdam, 1975. Archives at Printcabinet of
University of Leiden, the Netherlands.

CLAUDIA ANDUJAR
Born 1931, Neuchâtel, Switzerland
Resides São Paulo, Brazil
Ethnographic documentation and photojour-
nalism. Arrived in Brazil, 1955, and began to
photograph. First major work concerned Carja
Indians in central Brazil, 1957. Free-lanced for
Time, Life, Look, and *Esquire*, 1964. Photographed
Bororo Indians in central Brazil, 1965. Free-
lanced in Brazil, 1966–71. Began ongoing
project with Yanomami Indians along Catrimani
River in northern Brazil, 1970s, examining
their daily life as well as rituals. More recently
has recorded effects on the Yanomami of
increased contact with white men as discovery
of minerals and construction of highways have
taken place in their territory. Served as chair-

person of commission for creating a park for
Yanomami; goal realized when Brazilian gov-
ernment set aside nineteen-million-acre reserve,
1983. Published books dealing specifically with
the Indians, including *Yanomami*, 1978, and
Amazonia, 1979. Guggenheim fellowships, 1972
and 1976.

DIANE ARBUS
Born 1923, New York City
Died 1971, New York City
Primarily documentary portraits. Born Diane
Nemerov. Educated at progressive private
schools, Ethical Culture and Fieldston, New
York, through 1940. Married Allan Arbus,
1941; had daughters Doon, 1945, and Amy,
1954. Husband and wife established themselves
as team of fashion photographers (he as pho-
tographer, she as stylist); published in *Vogue*,
Glamour, and elsewhere. Dissolved business
partnership, c. 1957; separated, 1959; divorced,
1969. Diane studied photography with LISETTE
MODEL, 1955–57. Did commercial free-lance
assignments throughout career. Received
Guggenheim fellowships, 1963 and 1966, to
photograph "American Rites, Manners, and
Customs." Instructor, Parsons School of Design,
New York, 1965–66; Cooper Union, New
York, 1968–69; and Rhode Island School of
Design, Providence, 1970–71. John Szarkowski
included her work in *New Documents* exhibition,
Museum of Modern Art, New York, 1967,
with Garry Winogrand and Lee Friedlander.
Arbus committed suicide, 1971. First photog-
rapher to have work exhibited at Venice
Biennale, 1972. Major retrospective, Museum
of Modern Art, New York, 1972 (toured
United States and Europe through 1975).

EVE ARNOLD
Born 1913, Philadelphia
Resides London
Documentation. Born to Russian immigrant
parents; maiden name unavailable. Initially
planned to be a doctor, but was given a camera
while she was studying medicine. Studied pho-
tography with *Harper's Bazaar* art director Alexey
Brodovitch at New School for Social Research,
New York, 1947–48. Photographed fashion
shows in Harlem for class; Brodovitch liked the
pictures and sent her back; resulting photos
published in *Picture Post*, London, 1951. Became
first woman to photograph for Magnum Photos,
1951; made associate member, 1955, and full
member, 1957. During 1950s often did stories

on women, the poor, the elderly, and African-Americans, as well as celebrities. Moved to London, 1961. Made first of five trips to Soviet Union, 1965. Traveled in Afghanistan and Egypt, photographing veiled women and their daily lives, 1967–71; made film *Behind the Veil* on the harem, 1973. Did six-month study of life in China, 1979; published book *In China*, 1980, for which she received National Book Award. *In China* photographs shown in traveling exhibition, originating at the Brooklyn Museum, 1980, and touring major museums for three years. Lifetime Achievement Award, shared with LOUISE DAHL-WOLFE, American Society of Magazine Photographers, 1979. Did three-year project on Americans; published *In America*, 1983. Photographs of British shown in exhibition *Eve Arnold in Britain*, at National Portrait Gallery, London, 1991. Elected Fellow of the Royal Photographic Society, London, 1995; and Master Photographer by the International Center of Photography, New York, 1995. Awarded honorary Doctor of Science degree, University of St. Andrews, Scotland, 1997; Honorary Degree of Letters, Staffordshire University, England, 1997; and Doctor of Humanities, American International University of London, 1997. *Eve Arnold: In Retrospect* received Kraszna-Krausz award for best photographic publication, London, 1996.

ANNA ATKINS
Born 1799, Tonbridge, England
Died 1871, Halstead Place (near Sevenoaks), England
Scientific illustration. Born Anna Children. Father, John George Children, was respected scientist and fellow and secretary of the Royal Society; had extended career with British Museum. Anna made drawings for his translation of Jean-Baptiste-Pierre-Antoine de Monet de Lamarck's *Genera of Shells*, 1823. Married John Pelly Atkins, railway promoter and owner of Jamaican coffee plantations, 1825. Father retired from British Museum to spend time with them in Kent, 1840. Father was one of the first to learn about mechanics and potential of photography. Anna created privately produced book containing original cyanotypes, *British Algae: Cyanotype Impressions* (meant as a companion to William Harvey's *Manual of British Algae*, 1841). Completed first part, 1843; produced twelve parts before end of decade. In 1850 switched over to more substantial volumes, completing publication in 1853 with three volumes meant

to contain a total of fourteen pages of text and 389 captioned photographic plates. Number of known copies is at least a dozen. Father died, 1852. Anna produced presentation album entitled *Cyanotypes of British and Foreign Flowering Plants and Ferns*, 1854 (her friend Anne Dixon may have participated in its production); also made album of lace, feathers, and botanical specimens, 1856 (perhaps with Dixon).

JANE EVELYN ATWOOD
Born 1947, New York City
Resides Paris
Social documentation. Moved to Paris, 1971. Began photographing, 1976. Interested in photographing people on the edges of society, she developed technique of following subjects for long periods of time to create intimate portraits, 1970s on. First recipient of W. Eugene Smith Grant in Humanistic Photography, 1980, for project on blind children. Won World Press prize for "Jean-Louis: Living and Dying with AIDS," 1987. For work on women's prisons in the U.S.S.R., received *Paris Match* Grand Prix du Photojournalisme, 1990, and Canon Photo Essay award, 1991. Retrospective exhibition, *Documents*, premiered in Paris as part of the annual Mois de la Photo, 1990. Received grant from Hasselblad Foundation in Sweden and Ernst Haas award from Maine Photographic Workshops to continue her work on female incarceration around the world, 1994. Received Oskar Barnack prize from Leica, 1997. For her story "Babies Behind Bars" received one of the first Alfred Eisenstaedt awards from *Life* magazine and Columbia University, 1998. Exhibited work on women in prison at Maison de la Villette, France, 1998. Published the book *Too Much Time: Women in Prison*, 2000.

ELLEN AUERBACH
Born 1906, Karlsruhe, Germany
Resides New York City
Advertising images, documentation, experimental work, and portraits. Born Ellen Rosenberg. Studied sculpture at Kunstakademie, Karlsruhe, 1924–27. Continued studies in Stuttgart, 1928; received first camera. Dropped sculpture and went to Berlin for private lessons in photography with Bauhaus professor Walter Peterhans, 1929. Opened photography studio "foto ringl + pit" with friend GRETE STERN, Berlin, 1930 (*ringl* was Grete's childhood nickname; *pit* was Ellen's); specialized in avant-garde advertising. Emigrated to Palestine, 1933;

opened studio Ishon ("eyeball") to photograph children. Moved to London, where she took over Stern's studio, 1936; could not obtain work permit. Married stage designer Walter Auerbach and moved to United States, 1937. Worked at Lessing Rosenwald Print Collection, Philadelphia, with her husband, using photography as restoration tool, 1937–44. Traveled and photographed in Argentina, Greece, Majorca, Germany, and Austria, 1946. Worked with Menninger Foundation, Kansas, using film and still photography to study behavior of young children, 1946–49. Taught at Junior College for Arts and Crafts, Trenton, New Jersey, 1953. Worked on collaborative photographic odyssey with Eliot Porter, traveling eleven thousand miles throughout Mexico, documenting church art and religious celebrations in color, 1955–56. Stopped working as photographer and became educational therapist at Educational Institute for Learning and Research, New York, 1965 on. Solo exhibition, Robert Mann Gallery, New York, 1994; major retrospective, *Ellen Auerbach: Berlin/Tel Aviv/London/New York*, Akademie der Künste, Berlin (with book and tour), 1998.

ALICE AUSTEN
Born 1866, Staten Island, New York
Died 1952, Staten Island
Documentation, primarily of family and friends and social milieu. Born Elizabeth Alice Munn to Edward Stopford Munn and Alice Austen Munn. Father deserted family, and mother resumed the name Austen for self and child; they returned to her family's mansion, named Clear Comfort, on Staten Island. At age ten Alice received camera from a Danish sea captain married to her mother's sister Mary; was rarely without one thereafter. For a few years attended Miss Errington's School for Young Ladies. By age eighteen was serious photographer with professional standards. Photographed family and house; friends; picnics, masquerades, and musical evenings; and sports like bicycling and lawn tennis. Began photographing in Manhattan: documenting working people and immigrants of varied ethnic backgrounds. Spent more than twenty summers abroad. Family members died. After losing all her money in the stock market crash of 1929, she lost her home and was forced to move, 1945; Staten Island Historical Society saved 3,500 of her glass plates, 1945. Reduced to living at Staten Island Farm Colony—a "poorhouse"—by 1950.

Historian Oliver Jensen interested magazines such as *Life*, *Pageant*, and *Holiday* in publishing her work, 1951. With funds thus obtained, Austen moved to private nursing home on Staten Island for last year of her life. Retrospective exhibition, Staten Island Historical Society, Richmondtown, 1951. Solo exhibition, Neikrug Galleries, New York, 1978.

ALICE AUSTIN

Born n.d., presumably United States
Died n.d., presumably United States
Primarily portraits. Active from c. 1899. Studied at Boston Normal Art School, Boston Museum of Fine Arts, and Pratt Institute, New York, n.d. While amateur photographer in Brooklyn, met and worked with GERTRUDE KÄSEBIER. Had studio in Boston for over twenty years. Represented by seven prints in FRANCES BENJAMIN JOHNSTON's exhibition of 1900–1901. Exhibited four photographs at Society of Arts and Crafts, Boston, 1907, and may have been active in this society. Photographs exhibited were *The Young Violinist*, *Portrait of My Father*, *Portrait of Mr. James A. S. Monks*, and *Landscape*. Name mentioned by Richard Hines, Jr., in *Photo Era* magazine, September 3, 1906, as one of approximately twenty professional women photographers (including Käsebier) who had achieved success.

CATHARINE WEED BARNES—*see* CATHARINE BARNES WARD

TINA BARNEY

Born 1945, New York City
Resides Watch Hill, Rhode Island
Portraits. Born Tina Isles, to wealthy family. Attended Spence School in Manhattan, graduated 1963. Family owned "The Lindens," country house on Long Island, New York. Her mother's father had been amateur photographer. Her mother had had a career in fashion and gave Tina scrapbooks with photos by fashion photographers Horst P. Horst, LOUISE DAHL-WOLFE, and George Hoyningen-Huene. Tina was married to John Barney, 1966–83; had two sons: Timothy, 1967, and Philip, 1969. Saw her first Ansel Adams photograph, 1972. Took photography classes at Sun Valley Center of Arts and Humanities, Sun Valley, Idaho, 1976–79. Primary teachers there were Peter deLory and Mark Klett; workshop teachers included Robert Cumming, Nathan Lyons, Roger Mertin, Duane Michals, JOYCE

NIEMANAS, John Pfahl, and Frederick Sommer, among others. Became known for large-format color photographs of family and acquaintances in their Park Avenue apartments and Long Island estates, at parties and country clubs. Guggenheim fellowship, 1991. Selected recent solo exhibitions at Denver Art Museum, 1989; Janet Borden Gallery, New York, 1989, 1990, 1992, 1993, 1995, 1997, 1998, and 1999; Museum of Modern Art, New York, 1990; Cleveland Center for Contemporary Art, 1990; International Museum of Photography at George Eastman House, Rochester, New York, 1991; Cokkie Snoei Gallery, Rotterdam, 1995; Norderlicht Gallery, Groningen, the Netherlands, 1997; Galerie Photo & Co., Turin, Italy, 1998; Columbus Museum of Art, Columbus, Ohio, 1999, and Folkwang Museum, Essen, Germany (and international tour), 1999–2001.

MARY BARTLETT

(MRS. N. GRAY BARTLETT)
Born n.d., possibly Chicago
Died n.d., possibly Chicago
Pictorialist images, primarily of young women and children; also landscapes. Active from about 1888. Won grand diploma in photography at Vienna Salon, 1891. Made photographs at summer home on Lake Geneva, Wisconsin; developed and printed at winter home, Chicago. Leading woman amateur in Chicago, 1890s. Member Chicago Camera Club, Chicago Lantern Slide Club, and Photographer's Society of Chicago. Earned special awards at a Chicago exhibition, 1889. Featured in *Godey's Magazine*, April 1898, in article entitled "Triumphs of Amateur Photography—V: Mrs. N. Gray Bartlett." Known for fine platinum and gold-toned silver prints; pioneer in use of platinum paper, which she herself sensitized. Represented by five prints in FRANCES BENJAMIN JOHNSTON's exhibition of 1900–1901. Produced book entitled *Mother Goose of '93: Photographic Illustrations by Mrs. N. Gray Bartlett*, which featured costumed children in a yard against a trellis fence; shown at World's Columbian Exposition, Chicago, 1893. Also illustrated *A Girl I Know*, with poetry by Marian L. Wyatt, 1894.

EMMA BARTON

(MRS. G. A. BARTON)
Born 1872, Birmingham, England
Died 1938, Isle of Wight, England
Portraits and allegorical studies. Born Emma Rayson, daughter of railway porter. Married solicitor, George Albert Barton; had three daughters and two sons. Family lived in Birmingham until moving to Isle of Wight, c. 1929. Period of peak activity, 1902–15; very well known and highly regarded in her day. Probably took up photography in early 1890s in order to photograph her children; did most of her work in and around own house. Began exhibiting, c. 1901. Joined Birmingham Photographic Society, n.d. Awarded medal for photograph *The Awakening* at Royal Photographic Society exhibition, 1903; same photograph appeared in British section of Louisiana Purchase Exposition, Saint Louis, 1904. Represented in numerous competitions and exhibitions in Britain, Europe, and United States; also published in many magazines. Made carbon, gum, and platinum prints after working with printing-out paper. Began working in autochrome process, c. 1910.

LETIZIA BATTAGLIA

Born 1935, Palermo, Italy
Resides Palermo
Social documentation. Father was in the Navy; during World War II family moved around Italy, from Palermo to Naples to Trieste. When she was ten, returned to Palermo, where society was dominated by macho attitudes and Mafia-driven economy and politics. Attended elegant school taught by nuns; to gain freedom, at age fifteen married a young man named Franco but found her life still extremely restricted. Had first daughter, Cinzia, at age sixteen; subsequently had Angela (now called Shobha) and Patrizia. Suffered a severe depression, 1967. Met Freudian psychoanalyst Francesco Corrao, who encouraged her independence, and she left husband, late 1960s. Began writing for left-wing Palermo newspaper *L'Ora*, 1969. Moved to Milan, where she wrote for newspapers, 1971, but also continued with *L'Ora*. Began making photographs to accompany her articles so they would be more salable; soon wanted to do photography only, early 1970s. *L'Ora*. asked her to return to Palermo to be its director of photography, 1974 until shortly before the paper folded in 1990. During visit to Venice, met avant-garde Polish theater director Jerzy

Grotowski, proponent of Theatre of Participation, and briefly joined his troupe, 1975. There met twenty-two-year-old Franco Zecchin, a photographer from Milan; had liaison, 1975–94. In Palermo, during an especially violent period of Mafia wars stimulated by growing illegal drug trade, Battaglia and Zecchin fought the criminals by putting up photographs of them and their crimes in public places, 1975–1980s. Battaglia and Zecchin set up photography school and gallery; Battaglia also studied directing at a theater school, 1980s. Motivated by both love and politics—Italy's public psychiatric hospitals were being closed—Battaglia made a film with psychiatric patients as well as actors, 1980s. Elected to Palermo's municipal council, 1985–97. With others of diverse political backgrounds, formed a new, anti-Mafia party, the Rete (Network), 1980s. Began a publishing house, Edizioni della Battaglia, to provide platform for women and others on subject of human rights, 1990s. Due to her many other activities, stopped photographing in 1993 but picked up the camera again in 1999. Has produced approximately 600,000 images of life in Sicily, a large percentage dealing with the Mafia.

JESSIE TARBOX BEALS
Born 1870, Hamilton, Canada
Died 1942, New York City
Press photography; also portraits, architectural documentation, landscapes, and gardens. Often called the first woman press photographer. Father, Nathaniel Tarbox, was inventor; lost wealth when Jessie was seven. Jessie became teacher in one-room schoolhouse near Williamsburg, Massachusetts, 1887; in Greenfield, Massachusetts, 1893. Pursued photographic portrait business during summers, 1890s. Married machinist Alfred T. Beals, 1897, and taught him to photograph; together they became itinerant photographers, 1900. Primarily Alfred did darkroom work; Jessie was photographer and business manager. Jessie hired by *Buffalo Inquirer* and *Buffalo Courier* in upstate New York, 1902. During sensational Edwin L. Burdick murder trial in Buffalo, New York, where no cameras were allowed in the courtroom, she scooped the nation by shooting picture through the door transom, 1903. Only woman with full press credentials at Louisiana Purchase Exposition, Saint Louis, 1904. Moved to New York City and established studio, 1905. Became participant in Greenwich Village bohemian life; wrote poetry. Marriage began to

fail. Documented children of New York slums, 1910–12. Had daughter, Nanette, with a lover, 1911, but Jessie and Alfred continued studio business together. Published work in *New York Herald, Harper's Bazaar, Town and Country*, and *Vogue*. Jessie left Alfred, 1917; they divorced. Went to Southern California with Nanette, 1928; photographed estates, gardens, and well-known people before returning to New York after stock market crash, 1929.

HILLA BECHER
Born 1934, Potsdam, Germany
Resides Düsseldorf
Documentation of industrial structures. Born Hilla Wobeser. As child, fled Russian troops during World War II. Family eventually returned to Potsdam. Was encouraged to enter teachers' training program; instead, apprenticed in commercial firm of photographer named Eichgrün, 1951–54. Worked as aerial photographer with a commercial studio in Hamburg, 1950s. Moved to Düsseldorf and obtained position with advertising agency that also employed future husband Bernhard (Bernd) Becher, 1950s. Enrolled at Staatliche Kunstakademie Düsseldorf, 1958. Made photographs of various mechanical objects and of structures such as towers and railroad stations. Shared interests of Bernd Becher, also an art student, who wanted to photograph industrial buildings. They began collaborating, 1959; married, 1961, and left academy to pursue their own work. They photographed in Siegen and Ruhr districts, Germany, and in the Netherlands and Belgium, 1961–65. Bernd worked as photographer for concrete company, 1963; as he and Hilla traveled for this work, they also photographed other structures, especially water towers, for themselves. Their son, Max, born 1964. Hilla did free-lance design work for industrial fairs and exhibitions. Guest professor at Hochschule für Bildende Künste, Hamburg, 1972. They received British Council Photo Study grant, 1966, to work in Great Britain and South Wales. Bernd made first trip to United States, 1968; both photographed in U.S., 1974–75, 1977, 1978, 1981, and 1986. Bernd obtained permanent teaching position, Kunstakademie Düsseldorf, 1976. Their work has been shown internationally in solo exhibitions since 1965; in group shows since 1969.

LOTTE BEESE
(CHARLOTTE STAM-BEESE)
Born 1903, Reisicht, Germany (now in Poland)
Died 1988, Krimpen, the Netherlands
Experimental work. At Bauhaus took courses with Josef Albers, Wassily Kandinsky, and Paul Klee; studied weaving there with Gunta Stölzl, architecture with Hannes Meyer, and also made photographs, 1926–28. Worked with architect Bohuslav Fuchs, Brno, Czechoslovakia, 1929. Traveled to Soviet Union as architect and town planner, 1930–34; met Dutch architect Mart Stam in Moscow. Moved to Amsterdam and married Stam, 1935. Established architect's office in Amsterdam, 1935–38. Received Dutch diploma in architecture, Amsterdam, 1944. Worked as architect for development of city of Rotterdam, 1946–68.

DENISE BELLON
Born 1902, Paris
Died 1999, Paris
Photojournalism and portraits. Born Denise Hulmann. Attended Sorbonne to obtain degree in psychology, but abandoned studies to marry Jacques Bellon; had Yannick, who became a film director, and Loleh, actress and writer. Divorced, early 1930s. Introduced to photography by Pierre Boucher. Originally with Studio Zuber; after its demise Maria Eisner reunited the group to create agency Alliance Photo, 1934. Bellon's work was widely published: *Art et médecine, Arts et métiers graphiques, Coronet, Paris-Magazine, Plaisir de France*, and *Vu*, among others. Passionately interested in Surrealism, she photographed all the group's exhibitions in Paris: 1938, 1947, 1959, and 1965. Made portraits of Marcel Duchamp, Joan Miró, Salvador Dalí, and others. Commissioned by *Paris Match* to do photojournalism in French Africa, n.d. Upon return married journalist Armand Labin and spent World War II in Lyons, where she had third child, Jérôme. Husband died, 1956; she returned to Paris.

NAIR BENEDICTO
Born 1940, São Paulo
Resides São Paulo
Documentation and magazine work. Took courses in radio and television at University of São Paulo, 1960s. After leaving there found that radio and television were so censored by government that she decided to turn to photography. Founder-member of Alpha Communications, 1972–74. Professor of visual language

at Anhembi Faculty, São Paulo. Professor of photography at Imagem-Ação School and in charge of visual communications in Telem Enterprise, São Paulo, 1976–78. Cofounder of F.4 agency, 1979; distributes her work through F.4 to media in Brazil and abroad. Produced photo-essay on abandoned children in state institutions and also began photographing popular street celebrations, 1979. Series on Amazon River and the Indians, 1980–81. Produced photo-essay on drought in northeastern Brazil, 1982–83. Ecumenical Action bought audiovisual document she produced on Amazonia, 1983.

ZAIDA BEN-YUSUF

Born n.d., England
Died n.d., presumably United States
Primarily portraits; also flowers, photographs of Japan. Moved to U.S. with her family, probably early 1890s. Began photographing, c. 1895. Showed work to George Davison, a leading British Pictorialist, 1896, who encouraged her. Opened portrait studio on Fifth Avenue, New York, 1897. Received first commission from *Century* magazine. Subsequently made portraits of notables, including New York governor Theodore Roosevelt. Wrote about millinery for *Ladies' Home Journal*. Attained great recognition in photography circles, 1897–1907, then disappeared from art world. Work appeared in solo exhibition at Camera Club of New York, 1898. Exhibited in Ohio, New York City, Philadelphia, London, Paris, Glasgow, and Vienna. Represented in FRANCES BENJAMIN JOHNSTON's exhibition of 1900–1901. Alfred Stieglitz frequently published her work in *Camera Notes* and included work in his private collection. Traveled to Japan and Europe, 1903, sending articles back to U.S. art magazines; for *Architectural Record* wrote and provided pictures for "Period of Daikan," 1906; also "Honorable Flowers of Japan," *Century*, 1907. Published seventeen photographs of artists in *American Art News*, 1905.

JEAN BERNARD—*see* JEANETTE VOGT

RUTH BERNHARD

Born 1905, Berlin
Resides San Francisco
Nudes, still lifes, and portraits; also advertising and fashion. Born to very young parents who divorced when Ruth was two. Father, Lucien Bernhard, was well-known graphic designer and typeface designer. Mother left for United States to remarry, leaving daughter in Germany with Lucien. Ruth reared in highly cultured atmosphere by two teachers in their forties, sisters Helene and Katarina Lotze. Enrolled in boarding school at eleven; studied at Akademie der Kunst, Berlin, 1925–27. Father moved to New York City for Pynson Printers, 1923, and asked Ruth to join him; she accepted, 1927. Worked for photographer Ralph Steiner, then head of photography section of *Delineator* magazine, 1929; fired for being "unenthusiastic." Bought camera equipment with severance pay. Freelance advertising and fashion photographer, 1930–36; worked for *New York Times, Advertising Art*, Macy's, and Sloane's, as well as father's friends. Became naturalized citizen, 1935. Met Edward Weston, who influenced her profoundly, 1935. Moved to Santa Monica, California, to study with him, 1936, only to find he had moved to Carmel. Free-lanced in Los Angeles, 1936–53. Photographed still lifes and female nudes. Interest in shells led to collaboration with conchologist Jean Schwengel, 1940s. Served in Women's Land Army, World War II, 1943. Moved to San Francisco, 1953. Taught at Utah State University, Logan; University of California Extension, Berkeley and San Francisco, 1960s–'70s. Exhibited in galleries; published two portfolios of original prints: *The Gift of the Commonplace* and *The Eternal Body*, 1970. Dorothea Lange award, Oakland Museum, Oakland, California, 1971. Major retrospective, Friends of Photography, San Francisco, fall 2000.

EVA BESNYÖ

Born 1910, Budapest
Resides Amsterdam
Documentation. Studied with Jozsef Pécsi, an established Budapest photographer, 1928–30. Went to Berlin and remained there two years, 1930–32, actively photographing for magazines and industry. Had met photographer Gyorgy Kepes her last year in Budapest and continued the friendship in Berlin. Represented in *Modern Spirit in Photography* exhibition, London, 1932. Liaison with Dutch cameraman John Fernhout, 1932–39; accompanied him to Amsterdam, 1932, intending to stay only briefly; remained there permanently. Took part in activities of Dutch Photographers' Society, Amsterdam, 1933. Exhibited at Van Lier Gallery, 1933. Did many kinds of commercial assignments, including architecture, portraits, and fashion. Published in *De Groene, Wereldkroniek, Wij, De Niewe Rotterdammer*, and *Het Handelsblad*, 1930s. Made large photo murals, 1930s. Helped organize *Foto 37* exhibition, Stedelijk Museum, 1937. After German takeover of the Netherlands in World War II, Besnyö (of Jewish background) used false papers and remained underground, 1942–45. After liberation of the Netherlands, had two children with graphic designer Wim Brusse and began working again; separated from Brusse, 1968. Became involved with, and began photographing, activist feminist group Dolle Mina, 1970–76. Retrospectives at Historisch Museum, Amsterdam, 1982, and Stedelijk Museum, Amsterdam, 1999. Erich Salomon award, 1999.

AENNE BIERMANN

Born 1898, Goch am Niederrhein, Germany
Died 1933, Gera, Germany
Still lifes (sometimes used in advertising), portraits, and montages. Born Anna Sibilla Sternefeld. Married Herbert Biermann, prosperous businessman and devotee of literature, 1920; had Helga, born within a year, and Gershon (Gerd), born 1923. Moved to town of Gera, which was a center for progressive German culture. Began to use name Aenne or Anne. Began to take family photographs. Family friendship with Walter Gropius. Began collaborating with geologist Rudolf Hundt on photographing minerals, 1927; also began close-up plant studies. Main body of work produced 1929–32; made about three thousand negatives; approximately four hundred prints survive. Represented in several important group exhibitions, including *Film und Foto*, Stuttgart, 1929, and *Die neue Fotografie*, Basel, 1930. Solo exhibitions held at Kunstkabinett, Munich, 1928, and Kunstverein, Gera, 1930. German art historian and photographer Franz Roh published her work in the monograph *60 Fotos*. Special section devoted to Biermann in group exhibition *Das Foto*, in Stadthalle, Gera, 1949.

ILSE BING

Born 1899, Frankfurt
Died 1998, New York City
Photojournalism; some advertising. Born into affluent bourgeois family; trained in music and art. Enrolled at Universität Frankfurt, 1920; pursued doctoral degree in history of art, 1924. Wrote dissertation on German architect Friedrich Gilly, 1928; began photographing to illustrate it. By 1929 purchased first Leica. Began photographing for *Frankfurter Illustrierte*,

1929. Gave up academic studies, to family's dismay, and went to Paris, 1930. Published in *Vu, Arts et métiers graphiques, Le Monde illustré, Le Sourire,* and others. Hendrik Willem Van Loon, author living in New York City, introduced her work in United States, 1931. Julien Levy included her in *Modern European Photography: Twenty Photographers* exhibition, New York, 1932. Visited New York, 1936; met Alfred Stieglitz; offered a staff position on *Life,* which she declined. Included in Museum of Modern Art's exhibition *Photography, 1839–1937,* New York, 1937. Married pianist and musicologist Konrad Wolff, 1937. War broke out; couple emigrated to New York, 1941. She stopped photographing, 1959, and work was forgotten until untitled group exhibition, Museum of Modern Art, New York, 1976, and major exhibition at Witkin Gallery, New York, also 1976.

BARBARA BLONDEAU
Born 1938, Detroit
Died 1974, Philadelphia
Primarily experimental work. B.F.A. in painting, School of the Art Institute of Chicago, 1961. M.S., Institute of Design, Illinois Institute of Technology, Chicago, 1968; studied photography there with Aaron Siskind and Joseph Jachna. Instructor, Saint Mary's College, Notre Dame, Indiana, 1966–68. Free-lance photographer in Chicago; Notre Dame, Indiana; and Philadelphia, 1966–74. A broken camera served as impetus to begin experimental work, 1968: when film advance on her camera broke, she wound roll of film past open shutter, then masked the open shutter enough to get printable negatives. She would place a sitter against a black backdrop and wind film through the camera; a white form appeared on the full length of film strip, which she printed in its entirety. Became widely known for these long strips. Instructor at Moore College of Art and Design, Philadelphia, 1968–70. Assistant professor at Philadelphia College of Art, 1970–71; chairwoman, Department of Photography and Film, Philadelphia College of Art, 1971–74.

DOROTHY BOHM
Born 1924, Königsberg, East Prussia
Resides London
Social documentation. Born Dorotea Israelit to Jewish Lithuanian family. Left Lithuania to attend girl's boarding school in Sussex, England, 1939. Studied photography during World War II, graduating from Manchester College of Technology, 1942. Married scientist Louis Bohm, 1945. Opened studio in Manchester, 1946. Moved to Paris, 1953. Returned to England, settling in London, 1956. Daughter Monica born, 1957; daughter Yvonne born, 1960. Traveled and photographed extensively in Europe, United States, and Mexico, 1950s–'60s. Participated in exhibition *Four Photographers in Contrast,* with Don McCullin, Tony Ray-Jones, and Enzo Ragazzini, organized by Institute of Contemporary Arts, London, 1969. Published first book, *A World Observed,* with foreword by Roland Penrose, 1970. Cofounded Photographers' Gallery, with Sue Davis as director and Bohm as associate director, London, 1973. Traveled in South Africa, 1974. Subject of BBC television documentary, "Dorothy Bohm—Photographer," 1980. Began color photography, 1980. Published books *Hampstead—London Hill Town,* 1981; *A Celebration of London,* 1984; *Egypt* (in color), 1989; *Venice* (in color), 1992; *Sixties London,* 1996; *Inside London* (in color), in progress. Opened Focus Gallery for Photography in Bloomsbury, 1998. Solo exhibitions include Il Diaframma Gallery, Milan, 1975; *Impressions of South Africa,* Photographers' Gallery, London, 1976; *A Sense of Place,* 250-black-and-white-photograph retrospective at Camden Arts Centre, London, 1981; major retrospective at Israel Museum, Jerusalem, 1986; major retrospective of color work at Photographers' Gallery, London, 1994; *Sixties London* at Museum of London, 1997.

THÉRÈSE BONNEY
Born 1894, Syracuse, New York
Died 1978, Neuilly-sur-Seine, France
Social and architectural documentation. Born Mabel Thérèse Bonney, daughter of Anthony and Addie Bonney. Grew up in California. Graduated from University of California; M.A. in romance languages from Harvard; prepared for Ph.D. at Columbia University but completed studies in Paris at Sorbonne, with honors. Original intention of becoming a professor replaced by desire to develop cultural relations between France and United States. Lived in Paris, wrote frequently for newspapers and periodicals in England, France, and U.S. Founded first American illustrated press service in Europe, the Bonney Service. Disgusted with lack of drama in most photographs she saw, took up photography herself. First venture was a behind-the-scenes series on the Vatican, published in *Life* magazine, 1938; resulted in book *The Vatican,* 1939. Went to Finland, 1939, to photograph Olympic games; wound up photographing outbreak of Russo-Finnish War. Returned to France, 1940; photographed Battle of the Meuse and Battle of France, retreating with Ninth Army to Bordeaux. Arranged exhibitions of her war photographs at Library of Congress, Washington, D.C., and Museum of Modern Art, New York; show toured U.S. Returned to Europe, 1941; photographed Spanish populace after Civil War; England during the blitz; people and artists of France. Published book *Europe's Children* herself after ten publishers turned it down, 1943; it created sensation in U.S. and the photographs toured to schools. Photographed liberation of a concentration camp, 1945. Lived in Paris after the war.

ALICE BOUGHTON
Born 1866, Brooklyn, New York
Died 1943, Bay Shore, New York
Portraits and theatrical work; also nudes; often photographed children. Studied painting in Paris and Rome, before 1902; assistant in studio of GERTRUDE KÄSEBIER, New York. Honorable mention at International Decorative and Fine Arts Exhibition, Turin, Italy, 1902. Listed as associate of the Photo-Secession in *Camera Work,* 1904. Published photographs in *Lamp* and *American Illustrated Magazine,* 1904 and 1905, respectively. Represented in opening exhibition of Alfred Stieglitz's Little Galleries of the Photo-Secession (291), New York, November 1905—a group exhibition of more than three dozen Secessionists. Elected fellow of the Photo-Secession, 1906. Painted and photographed nude figures on sand dunes, summer 1906. Had exhibition with William B. Dyer and C. Yarnall Abbott at 291, 1907; each photographer showed twenty-three prints. Published in *Camera Work,* 1909. Closed New York studio and moved to Brookhaven, New York, 1931.

MARGARET BOURKE-WHITE
Born 1904, New York City
Died 1971, Stamford, Connecticut
Industrial and social documentation, photojournalism; also advertising. Reared primarily in Bound Brook, New Jersey. Studied photography with Clarence White, Columbia University, New York, 1921. Attended six colleges before receiving B.A. at the seventh, Cornell University, Ithaca, New York, 1927. While student at University of Michigan, Detroit, met fellow student Everett Chapman; married to him,

1924–26. Moved to Cleveland to join widowed mother, 1927; worked as architectural and industrial photographer. Photographs caught eye of publisher Henry Luce; he invited her to work in New York for *Fortune* magazine, beginning 1929. Also did free-lance advertising work, through 1936. Created series of photomurals at RCA Building, Rockefeller Center, New York, for NBC, 1933. Photographed in Soviet Union several times for *Fortune*, 1930s. By mid-1930s turned attention to social issues. Became one of first staff photographers for *Life* magazine, 1936; contributed to it for approximately thirty years. With author Erskine Caldwell created books *You Have Seen Their Faces*, concerning plight of sharecroppers and tenant farmers of American South, 1937, and *Say, Is This the U.S.A.?*, on industrialization of the nation, 1941. Married to Caldwell, 1939–42. Only non-Russian photographer present when German air raids struck Soviet Union, 1941. First woman official photographer, United States Army Air Corps, 1942. During World War II photographed in Great Britain, North Africa, Italy, and Germany; correspondent at the front and in Korea. Photographed liberation of concentration camp in Buchenwald, Germany, 1945. Published book *Dear Fatherland, Rest Quietly*, 1946, on collapse of Hitler's Germany. Photographed Mahatma Gandhi and India, 1946–48; published *Halfway to Freedom*, 1949. Photographed in South Africa, 1949–50. Stopped photographing, 1957. Diagnosed as having Parkinson's disease, 1959.

MARIANNE BRESLAUER
Born 1909, Berlin
Resides Zurich
Urban documentation and portraits. Trained as photographer in Latvia House, Berlin, 1927–29. Pupil of Man Ray in Paris, 1929; photographed Paris extensively and made portraits of artists and dealers. Published in *Frankfurter Zeitung* women's supplement, *Für die Frau*, 1929. Returned to Berlin and entered Ullstein studio, under Elsbeth Heddenhausen, 1930. Photographs seen in *Frankfurter Illustrierten, Funkstunde, Weltkreir, Weltspiegel, Wochenschau*, and many other publications, 1930s. Took two-month trip to Palestine, 1931. Again in Paris, made portraits of Pablo Picasso and Ambroise Vollard, among others; worked with Mauritius agency, 1932. Traveled for Academia agency to Spain, 1933; also to Zurich, where she photographed the cabaret Pfeffermühle (The Peppermill). Work

restricted in Adolf Hitler's Germany, 1933. Worked with Kind agency under the pseudonym "Ipp," 1934. Emigrated from Germany via Netherlands to Switzerland, 1936; married art dealer Dr. Walter Feilchenfeldt, 1936. Became art dealer in Zurich, 1937; stopped making photographs.

MARILYN BRIDGES
Born 1948, Allendale, New Jersey
Resides Warwick, New York
Aerial photographs. Born Marylyn Davis. B.A., Rochester Institute of Technology, Rochester, New York, where she studied photography, archaeology, and language, 1979; M.F.A. in photography, 1981, also Rochester Institute of Technology. Began aerial work during a flight over the plains of Peru, 1976, photographing line markings and animal figures created by the pre-Columbian Nazca Indians. Made several more photographic trips to Peru, 1977–90. Subsequently photographed Mayan ruins in the Yucatán Peninsula, including Chichén Itzá, 1982. Photographed Native American ruins in the United States, 1982–83; ruins in Egypt, including the Sphinx and the Pyramids of Giza, 1984; temples and ruins in ancient Greece, 1984; ruins in Britain, including Stonehenge, 1985. Photographed contemporary American landscape, 1980–'90s. Guggenheim fellowship, 1982; Creative Artists Public Service (CAPS) grant, 1983; National Endowment for the Arts grant, 1984; Fulbright grant, 1988–89; Makedonas Kostas award (Greece), 1989. Elected fellow of the Explorers Club, 1988. Selected recent solo exhibitions at Royal Ontario Museum, Toronto, 1995; Jacksonville Museum of Contemporary Art, Jacksonville, Florida, 1996; Peabody Museum of Natural History, Yale University, New Haven, Connecticut, 1997; Indiana University Art Museum, Bloomington, 1998; Southeast Museum of Photography, Daytona Beach, Florida, 1999; Columbus Museum of Art, Columbus, Ohio, 1999; Musée de la Photographie, Charleroi, Belgium, 1999; Carleton College, Northfield, Minnesota, 2000; and Apex Gallery, Los Angeles, 2000.

ANNE W. BRIGMAN
Born 1869, Honolulu
Died 1950, Eagle Rock, California
Allegorical studies, nudes and draped figures in landscape; also portraits. Born Anne Wardrope Nott. Her mother's family had moved to Hawaii to be missionaries, 1828. Anne educated in Hawaiian schools, including well-known Punahou School, 1882–83. Family moved to Los Gatos, California, c. 1886. Married Martin Brigman, sea captain, c. 1894; lived in Oakland. Exhibited five prints at Second San Francisco Salon, 1902. Exhibited one print in Third San Francisco Salon, 1903, establishing link with Photo-Secession members Alfred Stieglitz, GERTRUDE KÄSEBIER, and Edward Steichen. Had several important exhibitions in 1904: Hamburg, Germany, with Photo-Secession; Corcoran Gallery of Art in Washington, D.C.; and Carnegie Institute in Pittsburgh. Took camping trips in Sierra Nevada almost every year, c. 1904–27. Elected fellow of the Photo-Secession, 1906. Developed strong friendship with Stieglitz, who actively promoted her work. Represented in opening show of Photo-Secessionists at Little Galleries of the Photo-Secession (291), New York, 1905–6. First published in *Camera Work*, 1909. Elected to Linked Ring, 1909; won gold medal at Alaska-Yukon-Pacific Exhibition, Seattle, 1909. Separated from husband, 1910. Published *Songs of a Pagan*, with poetry and photographs, 1949. Began second book, *Child of Hawaii*, but died before completing it. Major exhibition, *A Poetic Vision: The Photographs of Anne Brigman*, Santa Barbara Museum of Art, Santa Barbara, California (and tour), 1995.

CHARLOTTE BROOKS
Born 1918, New York City
Resides Holmes, New York
Documentation and photojournalism. B.A., Brooklyn College, 1940. Graduate work in psychology, University of Minnesota, Minneapolis–Saint Paul, 1941. While a social worker in a settlement house in New York, 1941–42, became interested in career as modern dancer; decided to photograph dance instead. Assisted photographer Gjon Mili, New York, 1942–43. With help of former Farm Security Administration photographer Arthur Rothstein, obtained apprenticeship with dance photographer BARBARA MORGAN, New York, c. 1944. Became staff photographer for chain of three newspapers in suburban New Jersey, 1944.

Accepted occasional assignments from Roy Stryker to photograph for Standard Oil (N.J.) Project; took almost one thousand photographs for it in New York and New England, 1945–46. Became first woman photographer on staff at *Look* magazine, 1951; remained through its demise, 1971. Free-lanced and taught photography thereafter. Photographed in Soviet Union, 1977. Participated in group exhibition entitled *Roy Stryker: U.S.A., 1943–1950* at International Center of Photography, New York (and tour), 1983. Solo exhibition, *A Poem of Portraits*, at New Britain Museum of American Art, New Britain, Connecticut, 1994; consisted of portraits done in Georgia, Soviet Union, in 1977.

CHRISTINA BROOM
(MRS. ALBERT BROOM)
Born 1863, probably London
Died 1939, probably London
Documentation and news photography. Sometimes called the first British woman press photographer. Born Christina Livingston. Married Albert Broom, who was later permanently injured in an accident; had Winifred and probably other children. Began photographing, 1903. Took first two photographs, with an old plate-box camera, of Prince and Princess of Wales opening tramways at Westminster. Next photographed winning horse and jockey on Derby Day at Epsom and found that neighbors wanted to buy prints. Quickly decided to earn living selling postcards of local views through stationery shops. Covered many national and international events: investitures and deaths of British monarchs, effects of World War I on the home front, and political incidents. A committed suffragist, she was especially known for photographing woman suffrage demonstrations and events, like bazaars and exhibitions, 1908–14; also photographed Oxford and Cambridge boat crews, first women police, the Royal Mews at Buckingham Palace and Windsor Castle. Official photographer of Senior Regiment of the First Life Guards until her death.

ESTHER BUBLEY
Born 1921, Phillips, Wisconsin
Died 1998, New York City
Documentation and photojournalism. Attended Superior State Teachers College, Superior, Wisconsin, 1937–38. Studied photography at Minneapolis College of Art and Design, 1939. Moved to New York City to begin career as photographer; secured free-lance

job shooting still lifes for *Vogue*, 1940. Moved to Washington, D.C., as microfilmer of rare books at National Archives, 1942. Promoted to staff photographer for Office of War Information under directorship of Roy Stryker, 1943. Assigned to photograph America's bus system and took six-week bus trip through southern United States, 1943. Worked on free-lance projects for Standard Oil (N.J.) Project, again under Stryker, 1945; documented Texas oil boomtowns. Photographed second bus series for Standard Oil, 1947. Featured in exhibition *In and Out of Focus*, curated by Edward Steichen, Museum of Modern Art, New York, 1948. Began photojournalism assignments for "How America Lives" series, *Ladies' Home Journal*, 1948; continued sporadically through 1960. Began photojournalist assignments for *Life* magazine, 1951 (through 1965). Throughout career also photographed for *McCall's*, *Woman's Day*, *Saturday Evening Post*, *Harper's Bazaar*, *Ingenue*, *Good Housekeeping*, *U.S. Camera*, and *Encyclopedia Britannica*. Represented in Steichen's exhibitions at Museum of Modern Art, *Diogenes with a Camera*, 1952, and *The Family of Man*, 1955. Traveled to Italy on photo assignment for Standard Oil of New Jersey, 1952; to Ireland, 1962. Solo exhibitions at Limelight Gallery, New York, 1956; Ledel Gallery, New York, 1982; and Kathleen Ewing Gallery, Washington, D.C., 1989. Two-person exhibition with MARION POST WOLCOTT, curated by Sylvia Wolf, at Art Institute of Chicago, 1989.

ELIZABETH BUEHRMANN
Born 1886, United States
Died after 1962, United States
Portraits; also advertising images. Active in Chicago and New York City before 1904 to at least 1917–18. Elected associate of Photo-Secession, 1904. Her business card noted that home portraiture was her specialty and listed her memberships in Photo-Club of Paris and Photo-Secession, New York. Exhibited sixty-one photographs at Art Crafts Exhibition, Art Institute of Chicago, 1908; all but fifteen were portraits. Contributed one photograph to group show of work by Photo-Secession members at Little Galleries of the Photo-Secession (291), 1908. Listed as foreign corresponding member in membership booklet of Photo-Club of Paris, 1911. Showed six photographs at each of the International Salons of Photography of the Photo-Club of Paris in 1910, 1912,

1913, and perhaps more. Showed at Annual Exhibitions of the Works of the Art Students' League of Chicago, Art Institute of Chicago, 1910 and 1911, and perhaps more. Did advertising photography for Corona typewriters, Mazda lightbulbs, Packard automobiles, Fatima cigarettes, Yuban coffee, and others; published in *Vogue* and *Vanity Fair*, c. 1917–19. Retired to Miami, 1950; contributed to Second Annual Ceramics Exhibition, Lowe Gallery, University of Miami, 1954.

MARSHA BURNS
Born 1945, Seattle
Resides Seattle
Nudes; also portraits. Born Marsha Hardy. Trained as painter; studied art, University of Washington, Seattle, 1963–65, and University of Massachusetts, Amherst, 1967–69. Took first photography course in Seattle, 1963. Married painter Michael Burns, 1967; moved with him as he taught painting at University of California, Berkeley; University of Denver; and West Texas State University, Canyon. In 1972 they returned to Seattle and she began commercial work; found new studio with inspiring side lighting through large windows. At first experimented with sequential photography. Became known for work, begun in 1977, using often androgynous male and female figures, both nude and clothed. National Endowment for the Arts grant, 1978 and 1988; Award in the Visual Arts, Southeast Center for Contemporary Art, Winston-Salem, North Carolina, 1983; and Recognition of Achievement award, Washington State Arts Commission, 1985. Worked with Polaroid 20-by-24-in. camera intermittently, 1983–89. With travel grant from Henry Art Gallery, University of Washington, Seattle, did series of portraits of teenagers in Rome, 1987. In United States began series of portraits of nonmainstream Americans, including African American, Hispanic, and Native American cowboys, 1987. Selected recent solo exhibitions at Charles Cowles Gallery, New York, 1992 and 2000; Bellevue Art Museum, Bellevue, Washington, 1993; G. Gibson Gallery, Seattle, 1991, 1994, 1996, and 1999; Gray Art Gallery, East Carolina University, Greenville, North Carolina (and tour), 1993; Diggs Gallery, Winston-Salem University, North Carolina, 1995; Mars Hills College, Mars Hills, North Carolina, 1995; and Norton Building, Seattle, 1999.

NANCY BURSON
Born Saint Louis, 1948
Resides New York City
Computer-generated imagery; also paintings. Studied art at Colorado Women's College, Denver, 1966–68; left to pursue painting career in New York. Had idea of showing how a person's face would change over years by using computer-generated art, 1969. Collaborated with scientists from Massachusetts Institute of Technology and developed technique called computer facial wrapping to make composite photographs, late 1970s; granted patent with Thomas D. Schneider, 1981. Feeds snapshots and mass-media pictures into computer via television scanner; can rejuvenate or age subject's appearance, combine features of various persons, alter facial color, etc. CAST award (Collaborators in Art, Science and Technology, in conjunction with New York State Council on the Arts and Syracuse University), 1977. Recent selected solo exhibitions include Jayne H. Baum Gallery, New York, 1990, 1992, and 1993; *Faces*, Contemporary Art Museum, Houston (and tour), 1992; The New Museum, New York, 1992; Fine Arts Center Galleries, University of Rhode Island, Kingston, 1993; retrospective, Rencontres Internationales de la Photographie, Arles, France, 1996; Museum of Contemporary Photography, Chicago, 1997; Ricco Maresca Gallery, New York, 1997; and interactive computer video installation, Millennium Dome, London, 2000. Also participated in group show, *Identity and Alternity*, Venice Biennale, 1995.

LINDA BUTLER
Born 1947, Appleton, Wisconsin
Resides Gates Mills, Ohio
Documentation. B.A. from Antioch College, Yellow Springs, Ohio, 1970; M.A. from University of Michigan, Ann Arbor, 1972. Photographed eight Shaker villages and museums in Kentucky, New York, Massachusetts, New Hampshire, and Maine, early 1980s. Began three-year photographic exploration of back country of Japan, 1986; traveled to Japan five times, spending many months documenting people and vanishing rural way of life of inhabitants on islands of Honshu, Shikoku, and Kyushu. Butler traveled extensively in northern and southern Italy, gaining access to obscure villages and private homes as well as famous historical sites to photograph interiors and still lifes, 1992–96. Published *Italy: In the Shadow of*

Time, 1998. Selected recent solo exhibitions at Denver Art Museum, 1985; University of Kentucky Art Museum, Lexington, 1985; Witkin Gallery, New York, 1986, 1992, and 1998; Cleveland Museum of Art, 1991; San Jose Museum of Art, San Jose, California, 1993; Royal Ontario Museum, Toronto, 1994; and Yokohama Museum, Yokohama, Japan, 1998.

CARINE CADBY
Born n.d., England
Died n.d., England
Pictorialist images, primarily of flowers and animals. Active probably 1890s through c. 1915. Member of Linked Ring with her husband, William A. Cadby. She and GERTRUDE KÄSEBIER were first women admitted to the society; their names were submitted for election and unanimously approved, October 30, 1900. Both Cadbys resigned in October 1909. Carine emphasized fragility and delicacy of flowers by using light-toned backgrounds and carefully controlled lighting; desired the effect of drawing. Is said to have talked to the flowers, photographing them as they responded. Her photographs reproduced extensively in *Photograms of the Year*, early 1900s.

DEBBIE FLEMING CAFFERY
Born 1948, New Iberia, Louisiana
Resides Franklin, Louisiana
Social documentation. B.F.A., San Francisco Art Institute, 1975. Known for photographs of both black and white sugarcane workers of rural Louisiana, 1972–present. Created long-term photo-essay, "Polly," on elderly rural African-American woman, c. 1984–89. Has recently begun photographing villagers and landscape in agricultural regions of Portugal: valley of Mondego River, 1990–present, and region of Douro River, 1992–present. Has three children: Joshua, born 1975; Ruth, born 1977; and Brennan, born 1981. Grants and awards include Louisiana State Arts Council and Division of the Arts fellowship, 1983–84; Southern Arts Federation Regional Visual Arts Photography fellowship, 1987; Outstanding Achievement in the Arts, Acadiana Arts Council, Lafayette, Louisiana, 1988; Governor's Art Award, Professional Artist of the Year, Louisiana, 1989; and the Lou Stoumen grant, Museum of Photographic Arts, San Diego, California, 1996. Selected recent solo exhibitions at Museum of Photographic Arts, San Diego, California, 1989; Quatrième Triennale

Internationale de la Photographie, Palais des Beaux-Arts, Charleroi, Belgium, 1990; Arthur Roger Gallery, New Orleans, 1981, 1989, 1991, 1994, and 1998; Photo Gallery International, Tokyo, 1992; Benteler-Morgan Galleries, Houston, 1992; *Vale do Mondego*, Encontros de Photographie, Montemor O Velho, Portugal, 1993; *Carry Me Home*, Greniers de César, Espace de Création et d'Expression Contemporaine, Amboise, France, 1994; Howard Greenberg Gallery, New York, 1994; Cleveland Museum of Art, 1996; Jackson Fine Arts, Atlanta, 1998; and Gremillion Fine Arts, Houston, 1998.

CLAUDE CAHUN
Born 1894, France
Died 1954, Jersey, England
Surrealist photographs and photomontages. Born Lucy Schwob to Jewish family; daughter of Maurice Schwob and niece of Marcel Schwob, sons of the publisher of *Le Phare* (*The Lighthouse*), a newspaper in Nantes, France. Created two-hundred-page Surrealist text *Aveux non avenus* (*Cancelled Confessions*), 1930, with ten photomontages. Wrote and published pamphlet *Les Paris sont ouverts*, 1934. Participated in *Surrealist Exhibition of Objects*, Galerie Charles Ratton, Paris, 1934, in which she showed mixed-media construction with an eye mounted on board, with a hand, a cloud, and gnomic text. Member of Georges Bataille's group Contre-Attaque, founded in 1935. Produced photographic illustrations for book of poems by Lise Deharme, *Le Coeur de pic* (*The Pick-Axe Heart*), 1937. Until recently it had been thought that Cahun died in a concentration camp in World War II. She is now known to have migrated to Jersey in the Channel Islands, 1939, where she was arrested by the Nazis in March 1944, indicted November 1944, and imprisoned until February 1945. Retrospective, *Claude Cahun, 1894–1954*, Zabriskie Gallery, New York, 1992; and *Inverted Odysseys: Claude Cahun, Maya Deren, and Cindy Sherman*, Grey Art Gallery, New York University (and tour), 1999.

JO ANN CALLIS
Born 1940, Cincinnati
Resides Culver City, California
Narrative images in color; creates staged and fabricated tableaux; combines sculpture with photography. B.A. in art, 1974, and M.F.A. in photography, 1977, University of California, Los Angeles; studied with Robert Heinecken

there, 1970s. Instructor of photography, California State University, Fullerton, 1977–78; instructor of photography, California Institute of the Arts, Valencia, 1976–present. Known for works in which anonymous models are staged in dreamlike scenes; has also worked with the nude. Ferguson grant, Friends of Photography, Carmel, California, 1978; National Endowment for the Arts fellowships, 1980, 1985, and 1991; Mellon leave grant, California Institute of the Arts, 1982; and Guggenheim fellowship, 1990. Selected recent solo exhibitions at Des Moines Art Center, Des Moines, Iowa (and tour), 1989–90; Dorothy Goldeen Gallery, Santa Monica, California, 1991 and 1992; Kyle Robert Gallery, San Francisco, 1991; G. Gibson Gallery, Seattle, 1993; Laurence Miller Gallery, New York, 1993; Cleveland Museum of Art, 1994; Craig Krull Gallery, Santa Monica, California, 1994, 1995, and 1999; Vernon Ezell Gallery, Chicago, 1995; and Rio Hondo College Art Gallery, Whittier, California, 1997.

EVELYN CAMERON

Born 1868, Furze Down Park (near Streatham), England
Died 1928, Glendive, Montana
Portraits, documentation of rural life, and landscapes. Born Evelyn Jephson Flower. Married Ewen Cameron, a Scottish man fifteen years older than she. On honeymoon went hunting in badlands of Montana Territory, 1889, partly to get away from Evelyn's wealthy and well-connected family, who disapproved of her marriage to this impecunious student of wildlife. Camerons remained in Montana, intending to become wealthy by raising horses, but Ewen made disastrous business decisions, such as raising polo ponies. Evelyn started to sell photographs as money-making scheme, 1894. For four decades photographed and kept diary concerning camping and hunting trips, ranching, shepherding, and raising cattle and horses. Photographed for book on birds to be written by Ewen. Wrote and illustrated one article for *Breeder's Gazette*, 1905, and two articles for *Country Life*, 1909–14. Ewen died, 1915. Evelyn maintained ranch until her death. Photographs and diaries preserved by friend and surrogate daughter, Janet Williams; she showed them to Donna M. Lucey, 1979, who became Cameron's biographer.

JULIA MARGARET CAMERON

Born 1815, Garden Reach, Calcutta, India
Died 1879, Kalutara, Ceylon (now Sri Lanka)
Portraits and allegorical studies. Born Julia Margaret Pattle to French mother, Adeline de l'Etang Pattle, and English father, James Pattle, employed by East India Company. As child was sent to grandmother for education in France. Married Charles Hay Cameron, a lawyer, 1838; eventually had five sons and one daughter. Upon honeymooners' return to Calcutta, he was named chairman of the India Law Commission; they returned to England, 1848. Charles made extended trip to Calcutta to oversee family coffee plantation, 1860; Julia moved family to Freshwater Bay on Isle of Wight, where her friend Poet Laureate Alfred, Lord Tennyson, and his wife had settled. Given a camera to occupy her during Charles's absence, c. 1863. Soon became obsessed with the new activity and pressed family (including husband after his return), servants, and famous friends to pose. Arranged with P. and D. Colnaghi to market individual prints, 1860s. Illustrated Tennyson's *Idylls of the King*, published in different formats in 1874 and 1875. After death of only daughter, Julia, in England, Charles, Julia, and their son Hardinge moved to Ceylon, where four other sons already worked, 1875. She photographed indigenous people there.

LYNNE COHEN

Born 1944, Racine, Wisconsin
Resides Ottawa, Canada
Architectural documentation (interiors and exteriors). B.S., University of Wisconsin, Madison, 1967. Attended Slade School of Art, University of London, 1964–65; and Ox-Bow Summer School of Painting, Saugatuck, Michigan, 1967. Attended University of Michigan, Ann Arbor, 1968. M.A., Eastern Michigan University, Ypsilanti, 1969. Taught at Eastern Michigan University, 1968–73; Algonquin College, Ottawa, 1973–75; and University of Ottawa, 1974–present. Taught at School of the Art Institute of Chicago, 1984 and 1992. Initially worked as sculptor and printmaker; turned to photography as principal medium by 1971. Is particularly known for photographing interiors, ranging from banal-to-the-point-of-surreal domestic and public locations to laboratories and military installations dominated by bizarre equipment and test dummies. Book, *Lost and Found*, published with assistance of government of Canada and

Canadian Embassy in Paris, 1993, in conjunction with exhibition at Fonds Régional d'Art Contemporain, Limousin, France. Received several grants, including Canada Council Victor Martyn-Lynch Staunton award, 1991, and Canada Council Senior Arts grant, 1987 and 1989. Selected recent solo exhibitions at P.P.O.W., New York, 1988 and 1992; Museum für Gestaltung, Zurich, 1989; and Hôtel des Arts, Paris, 1993.

MARJORY COLLINS

Born 1912, New York City
Died 1985, San Francisco
Social documentation and photojournalism. As child lived in Scarsdale, New York; Upper East Side of Manhattan; and Cannes, France. Attended Sweet Briar College, Sweet Briar, Virginia, 1929. Married art historian John Baur, 1931; divorced, 1935. Moved to Greenwich Village, New York, c. 1935. Studied informally with photographer Ralph Steiner; attended lectures and exhibitions sponsored by Photo League, 1930s. Worked briefly for Black Star, Associated Press, and other agencies, late 1930s. Worked for *U.S. Camera*, 1940–41. Worked for U.S. Office of War Information (OWI) and one of its predecessor agencies, the Foreign Service, making photographs for wartime propaganda and for Roy Stryker's Farm Security Administration—OWI files, 1941–43. Married briefly to a man named Johnsen, c. 1945. Married to John Preston, 1948–49 or 1950. After World War II was free-lance photographer in Alaska, Europe, and Africa for U.S. government agencies and commercial press, through 1950, when her photography career ended. During 1960s, 1970s, and 1980s was active in civil-rights, peace, and women's movements; founded *Prime Time*, an independent feminist publication for older women. Awarded B.A. by Antioch College West, San Francisco, 1984.

DENISE COLOMB

Born 1902, Paris
Resides Paris
Portraits and documentation. Born Denise Loeb. Studied music at Conservatoire National, Paris; trained as a cellist. Married Gilbert Cohen, 1926. Lived with husband in Indochina and photographed people of the hills, 1935–37. Changed name from Cohen to Colomb, 1945. Through her brother, art dealer Pierre Loeb, became familiar with post–World War II Paris art scene. Began photographing artists, 1947,

and continued through 1960s; exhibited portraits of Jean Arp, Alexander Calder, Max Ernst, Pablo Picasso, Saul Steinberg, and others. Commissioned to photograph French Antilles on the centenary of the abolition of slavery, 1948; returned in 1958 to photograph in color. Documentary projects, 1951–57, included *Paris Underground, Cohabitation,* and *Country Doctor in Paris.* Reportage on Ile de Seine, France, 1952. Traveled to Israel, 1959 and 1976. Traveled to Iran, 1972. Traveled to India, 1976; photographed dancer Malavika in study of sacred dance in the temples. Designated a *chevalier* of the Ordre des Arts et Lettres, 1981. Returned to subject of Paris, 1983. Her *Portraits d'artistes: Les années 50-60* won Prix Vasari for best photography book, 1987.

NANCY FORD CONES

Born 1869, Milan, Ohio
Died 1962, Loveland, Ohio
Portraits and genre; also advertising images. Daughter of a doctor; parents separated, 1876, and father kept all five children in Ashland, Ohio. Family moved to Fostoria, Ohio, where Nancy studied retouching at Waldo Studio and was encouraged by director to take photographs, 1895. Father bought half-interest in photography studio for her, in Mechanicsburg, Ohio, 1897. Partner was H. H. Stem; studio called Ford and Stem. She developed relationship with James Cones, photographer with another studio in Lebanon, Ohio, 1898; they obtained commissions to photograph Cincinnati's notable families. They married, 1900; had Margaret, 1905. They bought and operated studio in Covington, Kentucky, 1901–7. Nancy entered many competitions sponsored by manufacturers to promote products; Kodak purchased her photographs for ad campaigns, 1902–16. In Kodak competition of 1905, her *Threading the Needle* came in second to an Edward Steichen photograph; Alfred Stieglitz received third prize. Also exhibited work at Pictorialist salons in United States and abroad. They moved to farmland in Loveland, Ohio, 1907, and remained there. Nancy joined Women's Federation of Photographers, 1909. They posed draped "dryads" in the woods, 1917–1930s. Made filmstrips of fairy tales, 1923–24. Death of James, 1939, essentially ended Nancy's career.

LINDA CONNOR

Born 1944, New York City
Resides San Anselmo, California
Landscapes, architectural documentation, and portraits. Received family's Argus C3 camera, 1961, and decided to become a photographer. B.F.A., Rhode Island School of Design, Providence, 1967; studied with Harry Callahan there and used large-format camera. M.S., Illinois Institute of Technology, Chicago, 1969; studied with Aaron Siskind there. Professor, photography department, San Francisco Art Institute, 1969–present. Known for body of work that deals with manifestations of religious belief and myth in diverse cultures; has photographed sacred sites throughout the world. Awarded National Endowment for the Arts grant, 1976; photographed in Caribbean, Mexico, and Guatemala. Received Guggenheim fellowship, 1979; spent seven months photographing in Asia, including Bali, Nepal, and India. Photographer of the Year award, Friends of Photography, Carmel, California, 1986; Charles Pratt Memorial award, New York, and another NEA grant, both 1988; and Time Life Achievement award, Marin Arts Council, 1996. Selected recent solo exhibitions include *Spiral Journey,* Museum of Contemporary Photography, Chicago, 1990 (and two-year tour); *Earthly Constellations,* San Francisco Museum of Modern Art, 1992 (and two-year tour); *Sacred Places from around the World,* Cuesta College Art Gallery, San Luis Obispo, California, 1993; *Visits,* Light Works, Syracuse, New York, 1996; *The Heavens,* G. Gibson Gallery, Seattle, 1998; *Linda Connor,* Glenn Horowitz Bookseller, East Hampton, New York, 1998; and *India,* Sepia International and the Alkazi Collection of Photography, New York, 1999.

MARJORIE CONTENT

Born 1895, New York City
Died 1984, Doylestown, Pennsylvania
Portraits, still lifes, flowers, cityscapes, and landscapes. As teenager often visited Alfred Stieglitz's Little Galleries of the Photo-Secession (291) in New York. Married to Harold Loeb, 1914–21; he became editor of *Broom,* a journal of literature and art. They had two children: Harold Albert (who legally changed his name to James), 1915, and Mary Ellen (who legally changed her name to Susan), 1916. With Harold, briefly owned Sunwise Turn bookstore, New York City, 1921. Lived partly in New City, New York, where artists

including Stieglitz and Georgia O'Keeffe were frequent visitors, early 1920s. Became good friend of CONSUELO KANAGA, early 1920s on. Married Michael Carr, artist and set designer, 1924; he died, 1927. Began photographing seriously, late 1920s. Married to Leon Fleischman, 1929–34. Traveled intermittently in the West with children while photographing Native American life, 1931–37; photographed for Bureau of Indian Affairs, 1933–34. Several photographs reproduced in the Parisian photography annual, *Photographie,* 1932 and 1935. Married Jean Toomer, Harlem Renaissance poet and novelist, 1934 to his death in 1967. Moved to Doylestown, in Buckingham Township, 1934; became member of Buckingham Meeting, 1940, and later transferred to Doylestown Monthly Meeting of the Religious Society of Friends.

CARLOTTA M. CORPRON

Born 1901, Blue Earth, Minnesota
Died 1988, Denton, Texas
Experimental work. Moved to India, 1905, with mother, sister, and missionary-surgeon father. Attended English boarding school in Himalayan Mountains. Returned to United States, 1920, to attend Michigan State Normal College (now Eastern Michigan University), Ypsilanti; B.S. in art education, 1925. Moved to New York to attend Teacher's College of Columbia University; M.A., 1926. Taught at universities in Alabama and Ohio, 1926–35. Bought first camera, 1933, as aid in classroom. Accepted position teaching art history and advertising design at Texas State College for Women (now Texas Woman's University), in Denton, 1935. Was asked to teach course in photography and spent summer of 1936 studying photography at Art Center, Los Angeles. Early work concerned lighting of nature studies done with coral, starfish, leaves, and plants. Eventually decided to experiment with light on negative. Assisted László Moholy-Nagy, who was a visiting instructor at Texas Woman's University, 1942. Developed informal association with Gyorgy Kepes, who taught at North Texas State University, Denton, 1944; Kepes was an important influence on her work. Represented in Edward Steichen's ground-breaking exhibition, *Abstraction in Photography,* Museum of Modern Art, New York, 1952. Solo exhibitions at Dallas Museum of Fine Arts, 1948, and Art Institute of Chicago, 1953. Health deteriorated, 1950s, but continued

teaching until retirement, 1968. Represented in *Women of Photography: An Historical Survey*, San Francisco Museum of Art, 1975.

KATE CORY
Born 1861, Waukegan, Illinois
Died 1958, Prescott, Arizona
Ethnographic documentation. Daughter of James Y. Cory—editor of *Waukegan Weekly Gazette*, organizer of Underground Railroad, and friend of Abraham Lincoln. Kate studied art at Cooper Union and Art Students League, New York, probably 1880s. Met Louis Akin, painter, 1904, who persuaded her that Hopi mesas of northern Arizona were perfect place for an artists' colony. Traveled to Canyon Diablo, Arizona, 1905; decided to remain, though artists' colony never materialized. Became one of few outsiders admitted to Hopi life; lived in Oraibi and Walpi villages, 1905–12. Photographed their daily activities and ceremonial rituals, working under difficult physical conditions and achieving technical mastery through trial and error. Also painted and wrote articles about the Hopi for *Border* magazine. Kept diary of events, 1907 and 1908; made dictionary of Hopi language. After leaving the mesas, 1912, settled in Prescott and continued painting. Probably stopped photographing after 1912.

MARIE COSINDAS
Born Boston
Resides Boston
Portraits and still lifes mainly in Polaroid color. Graduated from Modern School of Fashion Design, Boston; also attended evening classes in painting, drawing, and graphics, Boston Museum School. Became illustrator and designer, 1955. In late 1950s began to use camera as creative, rather than recording, tool. Visited Greece, where her photographic activity increased, 1960. Worked mostly in black-and-white, 1960–65. Free-lance photographer, Boston, 1965–present. Attended photography workshops taught by Ansel Adams, c. 1961; he said she thought in color and urged her to work in color. Began working with Polaroid Polacolor film; also used 35 mm color film. Attended workshops with Minor White, 1963 and 1964. Established reputation with solo exhibition at Museum of Modern Art, New York, 1966; Boston Museum of Fine Arts gave her their first solo exhibition of work by a living Boston artist, 1965. Other solo exhibitions at

Art Institute of Chicago, 1967; *Marie Cosindas: Moments of Affection*, International Center of Photography, New York, 1978; *Marie Cosindas: Color Polaroid Photography*, Fine Arts Museums of San Francisco, 1980; *Color Photographs by Marie Cosindas*, Cincinnati Art Museum, 1981; *Marie Cosindas—Retrospective*, Santa Barbara Museum of Art, Santa Barbara, California, 1986; and retrospective, Cal-Polytechnical State University, San Luis Obispo, California, 1994. Guggenheim fellowship, 1967–68; honorary doctorate of fine arts, Moore College of Art and Design, Philadelphia, 1967. Work has appeared in *Life*, *Newsweek*, *Vogue*, and *Esquire*. Has worked on motion pictures, photographing actors and actresses in *Scrooge*, *The Sting*, *The Great Gatsby*, *Glory*, and others, 1970–present.

EILEEN COWIN
Born 1947, Brooklyn, New York
Resides Santa Monica, California
Narrative images. B.S. in education, State University of New York College at New Paltz, 1968. M.S., Illinois Institute of Technology, Chicago, 1970. Known for creating color photographs of staged autobiographical tableaux of domestic dramas, 1970s–early 1980s. Began using models to create images and scenes influenced by literature (particularly short stories) and film (particularly film noir), 1980s–'90s. Also creates installations and utilizes video in exhibitions. National Endowment for the Arts grants in photography, 1979, 1982, and 1990–91; Art Matters, Inc. artist fellowship, New York, 1994; individual artist's grant, City of Los Angeles, 1997. Selected solo exhibitions at Los Angeles County Museum of Art, 1985; Viviane Esders Gallery, Paris, 1985; Min Gallery, Tokyo, 1987; Center for Photography, Osaka, Japan, 1987; Cleveland Museum of Art, 1988; Jayne H. Baum Gallery, New York, 1988, 1991, and 1993; Roy Boyd Gallery, Santa Monica, California, 1989 and 1991; Museum of Contemporary Photography, Columbia College Chicago, 1991; Gallery 954, Chicago, 1994; *domestic settings*, Los Angeles (collaboration with Louise Erdrich), 1995; University Art Museum, California State University, Long Beach, 1998; *deep river*, Los Angeles, 1999; and Amory Center for the Arts, Pasadena, California (major retrospective, with book and tour), 2000.

BARBARA CRANE
Born 1928, Chicago
Resides Chicago
Documentation and experimental work utilizing various approaches, including sequences and composites in black-and-white and color; also architectural documentation and portraits. Born Barbara Dell Bachman. Attended Mills College, Oakland, California; studied art history, 1945–48. B.A. in art history, New York University, 1950. M.S., Illinois Institute of Technology, 1966. Married and moved to New York City, 1948; had Beth, 1951; Jennifer, 1953; Bruce, 1956. Worked as freelance portrait photographer based in New York, 1950–52. Lived in Chicago and freelanced, producing extensive series on businessmen for Centrex Industrial Park, 1960–65. Attended Institute of Design, Illinois Institute of Technology, Chicago, 1964–66; studied with Aaron Siskind there. Chairperson, photography department, New Trier High School, Winnetka, Illinois, 1964–67. Divorced, 1966. Became assistant professor, School of the Art Institute of Chicago, 1967; full professor, 1978. Official photographer for Commission on Chicago Historical and Architectural Landmarks, 1972–79. National Endowment for the Arts grant, 1974; Guggenheim fellowship, 1979. Series include: People of the North Portal, 1970–71; Chicago Beaches and Parks, 1972; Unexpected and Random Relationships, Chicago Repeat Series, 1974; Wrightsville Beach, North Carolina, 1974; Chicago Loop, 1976–78; Commuter Discourse, 1978; Monster Series, Chicago Dry Docks, 1983; Objets Trouvés, 1982–88.

IMOGEN CUNNINGHAM
Born 1883, Portland, Oregon
Died 1976, San Francisco
Portraits, still lifes, plants, industrial landscapes, and allegorical studies. Moved from Portland to Seattle, 1889. Inspired by GERTRUDE KÄSEBIER's work, decided to become a photographer, 1901. Studied chemistry at University of Washington, Seattle; graduated, 1907. Assistant in studio of Edward Curtis, photographer of Native Americans, 1907–9. Studied photographic chemistry at Technische Hochschule, Dresden, Germany, 1909. Before returning to Seattle met Käsebier and Alfred Stieglitz in New York, 1910. Opened portrait studio, Seattle, 1910. Early work in soft-focus Pictorialist style, consisting of staged allegories

using artist friends in woodsy settings, 1910. Married etcher Roi Partridge, 1915; had Gryffyd, 1915; twins, Randal and Padraic, 1917. Family moved to San Francisco, 1917; to Oakland, 1920. Cunningham made plant studies in her garden, 1920s. Met Edward Weston 1923; he placed ten of her plant studies in *Film und Foto* exhibition, Stuttgart, Germany, 1929. Experimented with double exposures. Founding member of Group f/64; represented in its first exhibition, at M. H. de Young Memorial Museum, San Francisco, 1932. Photographed political figures and Hollywood stars for *Vanity Fair*, 1932–34. Divorced Partridge, 1934. Moved to San Francisco, where she remained. Photographed poets of the beat generation and flower children in San Francisco's Haight-Ashbury district, 1950s–'60s. Received Guggenheim fellowship, 1970, to print from early negatives. At ninety-two began project to photograph people over ninety; culminated in her book *After Ninety*, published posthumously, in 1977.

LOUISE DAHL-WOLFE
Born 1895, San Francisco
Died 1989, Allendale, New Jersey
Fashion, still lifes, and portraits; also documentation. Attended California School of Design (now the San Francisco Art Institute); influenced by Rudolph Schaeffer, an expert on color, and studied painting with Frank Van Sloan, 1914. Became interested in photography after meeting ANNE W. BRIGMAN, 1921. Designed electric signs in New York, 1921–23; worked for decorator in San Francisco, 1924. Traveled in Italy and Morocco with CONSUELO KANAGA, 1927–28, and bought two cameras. Met sculptor Meyer (Mike) Wolfe in Tunisia, 1928; married him in New York, 1928. Returned to San Francisco, 1929, and became professional photographer; shot rooms designed by interior decorator. Moved to cabin in Great Smoky Mountains of Tennessee and photographed still lifes and mountain people, 1932. Went to New York, 1933, and met Frank Crowninshield, publisher of *Vanity Fair*. He reproduced her pictures of mountain people, which received much favorable notice, 1933. Secured Crown Rayon advertising account, 1934. Free-lanced for *Women's Home Companion* and department stores including Saks Fifth Avenue, Bonwit Teller, and others. Became staff photographer for *Harper's Bazaar*, 1936 (through 1958). Traveled to North and South America,

Europe, Africa, Hawaii, the Caribbean, and elsewhere for photo shoots. Known for exquisite color work and "feminine" delicacy of style. Also worked for *Sports Illustrated*, 1957–62, and *Vogue*, 1959. Retired to New Jersey, 1960. Lifetime Achievement Award, shared with EVE ARNOLD, American Society of Magazine Photographers, 1979. Husband died, 1985.

JUDY DATER
Born 1941, Hollywood
Resides Berkeley, California
Primarily portraits. Born Judy Rose Lichtenfeld. Enrolled as student of drawing and painting at University of California, Los Angeles, 1959; transferred to San Francisco State University, 1962; received M.A. in photography there, 1966. Married to Dennis Dater, 1962–64. At San Francisco State, studied with Jack Welpott, to whom she was married, 1971–77. Dater and Welpott often photographed women, sometimes the same ones. Dater known for intense, psychologically revealing black-and-white portraits, especially of women. Formed friendships with photographers Ansel Adams, Wynn Bullock, IMOGEN CUNNINGHAM, and Brett Weston. After death of Cunningham, in 1976, photographed and interviewed her relatives and friends. Influential solo exhibition at Witkin Gallery, New York, 1972. Photographed in color in Egypt, 1979–80. Began making self-portraits, 1980. Photographed disabled artists for Institute of Art and Disabilities, Richmond, California, 1984. Recent work includes installation and performance art, as well as work with painted backgrounds and double exposures. Represented in numerous solo and group exhibitions in several countries. Major retrospective, *Judy Dater: Twenty Years*, de Saisset Museum, University of Santa Clara, Santa Clara, California (and national tour), 1986. Dorothea Lange award, Oakland Museum, Oakland, California, 1974; National Endowment for the Arts grants, 1976 and 1988; Guggenheim fellowship, 1978; visiting artist, American Academy, Rome, 1998; and Djerassi Artist in Residence, Woodside, California, 1999. Instructor, San Francisco Art Institute, 1992–2000; instructor, University of California Extension, San Francisco, 1996–2000; and instructor, California College of Arts and Crafts, Oakland, 1999.

LYNN DAVIS
Born 1944, Minneapolis
Resides New York City
Natural formations and man-made structures; also nudes, photojournalism, portraits, fashion, and movie stills. Studied at University of Colorado, 1962–64, and University of Minnesota, 1964–66. Began photographing, 1965. Received B.F.A., San Francisco Art Institute, 1970. Apprenticed to photographer BERENICE ABBOTT, summer of 1974. Worked with nudes, mid-1960s–1984. Worked in photojournalism for *Ms., Esquire, Time,* and *Harper's Bazaar*, among numerous other magazines, 1969–74. Continued with other kinds of commercial work, including portraits, fashion, and movie stills, through 1985. Began photographing icebergs on a trip to Greenland, 1986; icebergs proved to be first subject in a series conceived as monuments, 1986–present. As part of another series, photographed man-made and natural monuments in Egypt and India, 1989; Burma, Cambodia, and Thailand, 1992; and elsewhere. Published book, *Lynn Davis: Monument,* 1999. Created photographic survey of African culture and monuments, 1998; published book *Wonders of the African World,* 1999. Married Rudolph Wurlitzer, 1989. Had son, Ayrev Davis, 1970, who died in 1992. Selected recent solo exhibitions at Fine Arts Center, University of Rhode Island, Kingston, 1992; Cleveland Museum of Art, 1992; Hirschl and Adler Modern, New York, 1992; Gerald Peters Gallery, Santa Fe, New Mexico, 1993; Akira Ikeda Gallery of Art, Overland Park, Kansas, 1994; James Danziger Gallery, New York, 1994; Kohn/Turner, Los Angeles, 1995; Houk Friedman, New York, 1995; and Edwynn Houk Gallery, New York, 1998 and 2000; Center for Creative Photography, University of Arizona, Tucson, 1999, and J. Paul Getty Museum, Los Angeles, 1999.

LILIANE DE COCK
Born 1939, Antwerp, Belgium
Resides Pound Ridge, New York
Landscapes and still lifes. Studied art, film, history, and literature in Belgium during youth. Emigrated to United States, 1960; remained in New York City six months before going to Los Angeles. Began spotting prints for Ansel Adams in California, 1963; stayed as his assistant through 1972. Helped manage Yosemite Valley Workshops and became trustee of Friends of Photography, founded in 1967. Adams lent

her 4-by-5-in. view camera; she began photographing landscape, 1963. Took photographic trips throughout western and southwestern states, including California, Montana, and New Mexico, 1960s; photographed in East, 1967 and 1970. Became known for beautifully printed black-and-white, classical large-format landscapes with full tonal scale. Became United States citizen, 1968. Married publisher Douglas Morgan (son of photographer BARBARA MORGAN) and moved to East Coast, 1972; had Willard, 1974. Recent work involves still-life photography with found objects. Selected solo exhibitions at International Museum of Photography at George Eastman House, Rochester, New York, 1970; Massachusetts Institute of Technology, Cambridge, 1971; Amon Carter Museum, Fort Worth, 1973; Milwaukee Center for Photography, 1977; Ansel Adams Gallery, Yosemite, California, 1982; Boston Athenaeum, 1986; and Museum of Photography, Antwerp, 1991. Edited and designed numerous books on photography for publishers Morgan and Morgan, Inc. (now closed).

JENNY DE VASSON

Born 1872, La Châtre, France
Died 1920, Varennes, France
Portraits and social documentation. Born Jenny-Marie-Nannecy Girard de Vasson. Father, Paulin Girard de Vasson, a magistrate from an aristocratic French family, was a freethinker and a liberal. Jenny educated at home, primarily by mother, Nannecy de Constantin. Family had soirées where Jenny met artists, industrialists, politicians, landowners, and others who shared a liberal outlook. Affected by being very overweight from childhood on, she early decided not to marry and dedicated herself to intellectual pursuits and piano. With family, took voyages to other countries each year, 1890–1914; traveled to Switzerland, Greece, Italy, and Belgium. Family bought camera, 1899; Jenny began to make souvenir photographs. Family began to divide their time between Versailles in winter and Varennes in summer, 1900. Jenny photographed family, friends, and servants; also inhabitants of town near Varennes. A few days before death she destroyed her writings, considering them mediocre; did not consider her photographs important enough to destroy. A large part of her work disappeared in 1942 during German occupation of France; about 4,900 glass plates and negatives still exist.

MINYA DIEZ-DÜHRKOOP

Born 1873, Hamburg, Germany
Died 1929, Hamburg
Portraits. Born Minya Julie-Wilhelmine Dührkoop. Daughter of Rudolf Dührkoop, owner of photographic portrait studio in Hamburg, which he opened in 1883. Rudolf taught her photography; she joined him in studio as more than an assistant, 1887. Married photographer Luis Diez, of Málaga, Spain, 1894. Changed her professional name to Diez-Dührkoop. Divorced, 1901. Responsible in later years for some of the studio's most impressive portraits and provided much of the partnership's aesthetic and artistic judgment. Traveled with father to Paris and London, 1900–1901, to become familiar with Pictorialism. They went to United States, 1904; met GERTRUDE KÄSEBIER. Minya became legal partner in studio, 1906. She and Rudolf elected to Linked Ring, October 22, 1908. They were invited by Photographers' Association of America to lecture and demonstrate at convention in Saint Paul, 1911. George Eastman allowed Minya to make portrait of him. Rudolf died in Hamburg, 1918; Minya took over studio. One of first women to belong to Gesellschaft Deutscher Lichtbildner in Germany, 1919.

MARY DILLWYN

Born 1816, Wales
Died 1906, presumably Wales
Portraits and family scenes in outdoor settings. Born to Lewis Weston Dillwyn and Mary Llewelyn Dillwyn; youngest sister of John Dillwyn Llewelyn, who has been called the first photographer in Wales. Her brother John married Emma Thomasina Talbot, cousin of William Henry Fox Talbot, the inventor of photography on paper. The Dillwyn, Llewelyn, Talbot, and Maskelyne family connections (John's daughter Thereza, also a photographer, married Nevil Story-Maskelyne) were of great significance in early years of British photography. The families pursued a wide range of scientific interests, including photography, astronomy, and botany. Mary made drawings of her family members; she was a student of artist Peter de Wint. Heard about advances in photography immediately, as did the rest of her family. Father took her to studio of Antoine Claudet in Cheltenham on September 18, 1841, to have daguerreotype likenesses made. Mary made photographic portraits of family members. Married the Reverend Montague Earle Welby, n.d.

GENEVIÈVE-ELISABETH FRANCART DISDÉRI

Born c. 1817, presumably France
Died 1878, Paris
Portraits and scenic views. Married André-Adolphe-Eugène Disdéri, 1843. They had six children, 1843–51; all died in childhood except Jules, born 1851. Husband tried several professions. Family moved to Brest, 1848. With help of Geneviève's brother, Prosper Francart, they opened daguerreotype studio, 1848 or 1849. Two early daguerreotypes of military men credit photographers as "M. et Mme. Disdéri, 42 rue du Château, Brest." Husband left Brest, 1852, probably due to political and financial problems (regarded by authorities as dangerous socialist and had debts from unsuccessful diorama show). Geneviève produced *cartes de visite* in her studio and views of the environs of Brest. For a time was one of financial backers of husband's successful and fashionable Paris studio. Geneviève moved to Paris, 1872; set up own studio, which she maintained until her death in a Paris public hospital. Listed on death certificate as "sans profession, âgée de 61 ans" (without profession, 61 years old).

MADAME D'ORA

(DORA KALLMUS)
Born 1881, Vienna
Died 1963, Paris
Portraits and fashion. Apprenticed with photographer Nicola Perscheid, Berlin, 1907. Opened own studio in fashionable area of Vienna with Arthur Benda, 1907, and began calling herself Madame D'Ora, perhaps to circumvent anti-Semitism (Kallmus was a recognizably Jewish name). Partnership flourished for twenty years; extroverted Madame D'Ora arranged sitters and props, and technically oriented Benda took the photos. Gustav Klimt, Karl Kraus, Gustav and Alma Mahler, and Alban Berg were among their sitters, as well as Hapsburg aristocrats and military and government personnel, 1916–18. Also documented dancers and entertainers, including Anna Pavlova, Josephine Baker, and Mistinguett. Spent summers with Benda at international resort, Karlsbad, Czechoslovakia, 1921–26. D'Ora decided she would be better paid and more appreciated in Paris and moved there alone, 1925, after selling Vienna studio to Benda. Became highly successful fashion and beau monde photogra-

pher; chronicled Parisian fashion for *Die Dame* magazine of Berlin, 1930s. During World War II survived Nazi occupation by hiding in remote French village; sister died in concentration camp. Did series of color close-ups of animals slaughtered in Paris's abbatoirs in reaction against horrors of war and imprisonment, 1950s, as well as portraits and dance photographs. Died in motorcycle accident.

NELL DORR
Born 1893 or 1895, Cleveland
Died 1988, Washington, Connecticut
Primarily portraits; also photomurals, nudes, flowers. Born Virginia Nell Becker, daughter of pioneer of photography John Jacob Becker. Father cofounded Pieffer and Becker, Cleveland, one of the largest, most respected photographic studios of late 1800s. He married after age fifty and took young wife to Massilon, Ohio; began small photography business. Taught daughter photography in childhood. She married businessman Thomas A. Koons, 1910; had Virginia, 1911; Elizabeth, 1912; and Barbara, 1913. Moved to Miami Beach, 1923. After death of brother and financial losses in 1926 Florida real-estate crash, had nervous breakdown. Father helped her back to health through their joint experiments with an early German field camera. She opened successful professional studio; photographed important visitors for *Gondolier* magazine. Divorced, 1931. Exhibition of photomurals at Marie Sterner's International Gallery, New York, 1932. During 1933–34 season in New York became part of group around writer George Jean Nathan; met Alfred Stieglitz and came to know Edward Steichen well. Exhibited thirty-six portraits of famous men at Delphic Studios, New York, 1934. Married one of them: chemical engineer, metallurgist, and inventor Dr. John Van Nostrand Dorr, 1935. Published several books of photographs, usually accompanied by brief, poetic texts. Eventually dropped commercial business and after death of her daughter Barbara, 1954, concentrated on photographs of mothers and daughters. Moved to Washington, Connecticut, 1950s. Solo exhibition at Marcuse Pfeifer Gallery, New York, 1981.

NORA DUMAS
Born 1890, Budapest
Died 1979, Ile de France
Portraits and rural documentation. Maiden name unavailable. Moved to Paris, 1913. Interned as enemy alien, 1914–17. Married Swiss architect Adrien Dumas, who signed photos "Dumas-Satigny." Started working with Rolleiflex camera, 1928. Met compatriot portrait photographer Ergy Landau (known as "E. Landau") and became her assistant in Paris. She and husband bought farm in Ile de France, 1928; she photographed village people, creating an extensive document on peasant life in France, c. 1928–38. Participated in important international exhibition *Das Lichtbild*, Munich, Germany, 1930, with FLORENCE HENRI, André Kertész, GERMAINE KRULL, and others. Published in *Vu*, *Bifur*, and *Photographie*, 1931. Became member of photo agency Rapho, Paris, 1945.

SARAH J. EDDY
Born n.d., presumably Rhode Island
Died n.d., presumably Rhode Island
Genre and portraits, specialized in child life, animals, and flowers. Born Sarah Jane Eddy. Resident of Providence, Rhode Island, and Bristol Ferry, Rhode Island. Became active in photography, c. 1889. Studied at Art Students League, New York. Member of Providence Camera Club. Used photography in connection with her philanthropic work. Represented by four prints in FRANCES BENJAMIN JOHNSTON's exhibition of 1900–1901.

SANDRA ELETA
Born 1942, Poland
Resides Panama City
Social documentation. Became interested in photography as a young student in Panama. Attended Elizabeth Seton High School in New York, 1959–60; student of art history, Finch College, New York, 1961–64. Painted in Spain, 1964–67. Worked in Department of Arts, Campagnani and Quelquejeu, Panama, 1968–69. Studied literature at New School for Social Research and worked as lecturer and guide at Museum of Modern Art, New York, 1970–71. Studied photography at International Center of Photography, New York, 1970 and 1977. Instructor in photography, Universidad Nacional, San José, Costa Rica. Has freelanced in Panama since 1974; first photo-essay was on Nicaraguan poet Ernest Cardenal.

Photographed Portobelo, a small historic village with black residents and Spanish fortresses on Atlantic coast of Panama, 1976–80. Began series on people of Madrid, 1983. Became a founder-member of Consejo Latinoamericano de Fotografía, 1970s.

NUSCH ELUARD
Born 1906, Mülhausen, Germany (now Mulhouse, France)
Died 1946, Paris
Surrealist photomontages. Born Maria Benz in Alsace, a region then annexed to Germany. For a few years was actress in Berlin, using Nusch as stage name. Moved to Paris, late 1920s. Met writers Paul Eluard and René Char, 1930. Modeled for sentimental postcards and acted at Théâtre du Grand Guignol; modeled for Man Ray and Pablo Picasso, 1930s. Knew Surrealists well; often participated in their games and meetings. Married Eluard, 1934. Created photomontages primarily using the female nude, 1934–36. Remained in Paris during World War II; she and Paul active in Resistance. They took refuge for a few months in psychiatric hospital at Saint-Alban in Lozère region, 1943. Nusch, always of delicate health, was weakened by hardships of the Occupation and died suddenly.

CHANSONETTA STANLEY EMMONS
Born 1858, Kingfield, Maine
Died 1937, Newton, Massachusetts
Genre and images of rural New England. Born Chansonetta Stanley. Enrolled in Western State Normal School at Farmington to train to become teacher, 1876. Became artist; taught drawing. Learned photography from brother Francis Edgar Stanley. (Brothers Francis Edgar and Freelan O. Stanley invented both the Stanley Dry Plate photography process and the Stanley Steamer, becoming rich and internationally famous.) Moved to Boston, 1885 or 1886, and taught in public-school system. Studied painting with John G. Brown, late 1880s. Married James Emmons, in retail boot business, 1887; had Dorothy, 1891. Husband died, 1898. Emmons accepted financial help from brothers; divided her time between Kingfield and Newton. Taking camera, made trips throughout New England and occasionally elsewhere, including Colorado, the Carolinas, Europe, and Canada, 1900–1928. Began to exhibit work, 1901, when accepted by Sixth Annual Photography Show, sponsored

by *Youth's Companion* magazine. Joined Guild of Photographers of the Society of Arts and Crafts, Boston, 1920s. Put over one hundred photographs on glass lantern slides to be shown during tour lecturing on the beauties of New England, mid-1920s. Many photographs of family and friends showed life in upper-middle-class New England. Fewer than one hundred of her plates exist today.

SARA FACIO
Born 1932, San Isidro, Buenos Aires
Resides Buenos Aires
Primarily photojournalism; later, experimental work. Attended the Escuela Nacional de Bellas Artes, Buenos Aires. Qualified as professor of drawing and painting, 1953. Took study trips to France, Italy, Britain, Switzerland, and Germany, 1955. Received first camera, 1955. Extensive photography-oriented travels in Argentina, South America as a whole, Europe, and Africa, 1955 on. Studied photography in studio of Luis d'Amico, Buenos Aires, 1957–59. Studied at Annemarie Heinrich studio, Buenos Aires, 1960. Partner of Alicia d'Amico in commercial studio, producing advertising, news photos, and portraits, 1960. Received prizes in several international competitions, 1960–65. Worked for numerous magazines and newspapers, 1964 on: *Acontecer fotográfico*, *Clarín*, *La Nación* (for which she is photographic editor), *Autoclub*, *Vigencia*, etc. Bifota medal, Berlin, 1965. First book, *Buenos Aires, Buenos Aires*, published, 1967; won book prize, Vienna Book Congress, 1969. Olivetti-Communidad award, 1969. Published work on Jorge Luis Borges and Pablo Neruda, 1970s. Awards from Argentina Federation of Photography, 1970 and 1972. With Alicia d'Amico and María Cristina Orive, founded publishing house, La Azotea, 1973. With several other photographers, founded Consejo Argentino de Fotografía, 1979.

EMMA J. FARNSWORTH
Born 1860, Albany
Died 1952, Albany
Allegorical and narrative studies. Born Emma Justine Farnsworth. Trained as artist. Received first camera as Christmas present, 1890; began to photograph the following summer. Period of activity, 1890–1900. Member of Camera Club of New York; had club's second solo exhibition, 1898. Fellow member George M. Allen published *In Arcadia*, a book of her figure studies accompanied by classical verse, 1892. *Munsey's Magazine* noted that "bold" figure studies, classically draped, were her specialty, 1894. Her photographs appeared at World's Columbian Exposition, Chicago, 1893. Won almost thirty medals in exhibitions in England, Canada, Italy, Germany, India, France, and elsewhere, by 1899. Frequently published in *Camera Notes*. Represented by six prints in FRANCES BENJAMIN JOHNSTON's exhibition of 1900–1901; also was one of seven women Johnston wrote about in "The Foremost Women Photographers of America" series for *Ladies' Home Journal*, 1901–2.

SANDI FELLMAN
Born 1952, Detroit
Resides New York City
Advertising and commercial work, figure studies in Polaroid color. Attended Sir John Cass College of Fine Arts, London, 1972. B.S. in art, 1973; M.F.A. in art (photography), 1976, both University of Wisconsin, Madison. Known for richly textured photographs reflecting interest in the human body and its adornment; also for interest in social groups outside mainstream of society. At invitation of Polaroid Corporation, began photographing with Polaroid 20-by-24-in. camera, 1981. Produced work on full-body tattoos, making three trips to Japan to photograph for this project; project culminated in book *The Japanese Tattoo*, 1986. Did series on fans, c. 1986; subsequently began series Pronatura, late 1980s, concerning fragility of animals and nature in an anthropocentric world. Latest work is a series of split sepia-toned photographs of flowers, 1990s. Recent solo exhibitions at Museum of Contemporary Photography, Columbia College Chicago, 1987; Jayne H. Baum Gallery, New York, 1991 and 1994; Images Gallery, Cincinnati, 1992; Southeast Museum of Photography, Daytona Beach, Florida, 1994; and Edwynn Houk Gallery, New York, 1998.

DONNA FERRATO
Born 1949, Lorain, Ohio
Resides New York City
Social documentation and photojournalism. Graduated from Laurel School, Cleveland, 1968. Attended Garland College, Boston, 1968–70. Became free-lance photojournalist, 1976. Traveled extensively. Based in Paris and Belgium, 1976–78. Best known for ongoing series on domestic violence, 1982–present. Series began inadvertently while she was working in United States on a story about the "ideal" American couple for a Japanese magazine; the self-made millionaire husband forgot about her presence and started to beat his wife. Ferrato subsequently traveled across U.S. to photograph battered women in shelters, in prisons, and in hiding. Received W. Eugene Smith Grant in Humanistic Photography, 1985, for documentation of domestic violence; series culminated in book *Living with the Enemy*, 1991. Began nonprofit foundation called DAAP (Domestic Abuse Awareness Project), 1991, to supply exhibitions to battered women's shelters around the U.S. for fund-raising purposes. Received Robert F. Kennedy Humanistic Award for two-part series on domestic violence published in *Philadelphia Inquirer*, 1987. Story of domestic violence published in *Life* magazine won first place in two categories, "Magazine Picture Story of the Year" and "Documentary Picture of the Year," in the Pictures of the Year Competition, University of Missouri, Columbia, 1988. Received Crystal Eagle presented by Kodak for exploring subject of significant social concern, 1990. Received Crystal Eagle for courage from International Women's Media Foundation, Washington, D.C.; was first photographer to receive award and only second American, 1993.

LADY FILMER
Born c. 1840, England
Died 1903, England
Portraits, collages. Little is known of Lady Filmer except her family background. Originally Mary Georgiana Caroline Cecil, eldest daughter of Arthur Marcus Cecil, third Lord Sandys. Married Sir Edmund Filmer—ninth baronet of East Sutton, a member of Parliament from Kent, and a captain in Grenadier Guards—1858. Family close to Queen Victoria's court; Lady Filmer photographed Prince of Wales (later Edward VII) and his equerry, Major Teesdale. Cut up photographs and affixed them to sheets of paper that often had background sketches and watercolor paintings. Although her technique was similar to that of many people who made Victorian valentines, she was probably the first person to employ photographs in the collages.

FRANCES HUBBARD FLAHERTY
Born c. 1886, Cambridge, Massachusetts
Died 1972, Dummerston, Vermont
Documentation. Graduated from Bryn Mawr College, Bryn Mawr, Pennsylvania, 1905. Met Robert Joseph Flaherty, son of a prospector, 1902–3, while he was student at Michigan College of Mines (now Michigan Technological University), Houghton. He began career as prospector and supervisor for Canadian Grand Trunk Railway and other companies, 1904. He became member of four exploratory expeditions sponsored by Sir William Mackenzie, president of Canadian Northern Railroad, 1910–16. During expeditions Flaherty photographed geological formations and made documentary films of aspects of life in the North. Frances and Robert married, 1914; had Barbara, 1916; Francis, 1917; and Monica, 1920. Frances assisted Robert on many films, including *Nanook of the North*, 1924; made still photographs documenting their production. Also made photographs depicting landscapes surrounding filming sites, working-class people, and tribal people struggling with the elements. Coedited *Moana*, 1926; served as photographer on *Man of Aran*, 1934; cowrote *Louisiana Story*, 1948—all films by Robert. He died, 1951. She cofounded Robert J. Flaherty Foundation (now International Film Seminars), 1951.

TRUDE FLEISCHMANN
Born 1895, Vienna
Died 1990, Brewster, New York
Portraits; also fashion and urban documentation. Born to a comfortable Viennese Jewish family; father a merchant. Took up photography at age nine. Studied art history briefly in Paris. Returned to Vienna and worked in photographic portrait studio, c. 1918; rented own portrait studio, 1920. Portraits of this period soft and brown-tinted. Sitters included actresses Katharine Cornell and Hedy Lamarr; architect Adolf Loos; conductor Bruno Walter; dancers Tilly Losch, Claire Bauroff, and Grete Wiesenthal; and others. Her atelier developed into meeting place for artists, musicians, actors, and dancers. After Germany annexed Austria in 1938, Fleischmann left Vienna, going first to Paris for six months, then London. Both MARION POST WOLCOTT and her sister Helen Post Modley (who had studied photography with Fleischmann) persuaded her to go to United States; before leaving Paris destroyed all but forty-one glass-plate negatives. After

two years in U.S. resumed photographic career in New York City, c. 1940. Photographed composer Gian Carlo Menotti, singer Lotte Lehmann, physicist Albert Einstein, writer Sinclair Lewis, conductor Arturo Toscanini, and others; style became sharp-focused and more "modern." Received fashion assignments for *Vogue* and other publications. Retired, 1969, and moved to Lugano, Switzerland. Died at nephew's home in U.S.

CHRISTINE B. FLETCHER
Born before 1900, possibly California
Died after 1945, probably San Francisco
Primarily still lifes. Maiden name unknown. Married to Charles O. Fletcher, by 1917; lived in California. Period of activity, 1914–45. Wrote articles about photography; participated avidly in salons and photographic contests. Wrote "Flower Photography," illustrated with own photographs, published in *Camera Craft*, February 1914. Submitted photograph *Loving Mother*, to *American Photography*, published August 1917. Husband died, by 1932–33; she was listed as living in San Francisco. Won fifth prize in thirteenth Annual Competition of *American Photography*, 1933, a significant accomplishment considering that 459 contestants submitted 1,672 photographs. Continued to exhibit and to publish in such journals as *American Annual of Photography*, *Photo Art Monthly*, and *American Photographer*.

MARTINE FRANCK
Born 1938, Antwerp, Belgium
Resides Paris
Documentation and photojournalism. Reared in United States and England, 1942–54. Studied at University of Madrid, 1956–57, and Ecole du Louvre, Paris, 1958–62. Began working as photographer in China, Japan, and India, 1963; published two articles in *Eastern Horizons*, Hong Kong. Worked in Time-Life Photo Laboratories, Paris, 1964; assistant to photographers Eliot Elisofon and Gjon Mili. Began free-lancing, 1965. Work has been published in *New York Times*, *Life*, *Fortune*, *Sports Illustrated*, *Vogue* (Paris), and many other magazines. Began photographing well-known Théâtre du Soleil, Paris, 1965. Married photographer Henri Cartier-Bresson, 1970. Joined photo agency Vu, 1970 (through 1971). Cofounded the agency Viva, 1972, with photographers Michel Delluc, Hervé Gloaguen, Guy de Querrec, Claude Raimond-Dityvon, and others,

whose aim was to produce socially oriented photography. Franck's subject matter concerns contemporary way of life of ordinary French people: how they raise their children, conduct themselves on the street and at ceremonies, and spend their leisure. Has also photographed well-known artists and scientists. Solo exhibition, *Le Quartier Beaubourg*, at Centre Georges Pompidou, Paris, 1976. Became associate member of Magnum Photos, 1980; full member, 1983. Recent exhibitions at Galerie FNAC, Paris, 1994; Eric Franck Fine Arts, Paris, 1997; Maison Européenne de la Photographie, Paris, 1998; Gallery of Photography, Dublin, 1998; Galleria Carla Sozzani, Milan, 1999; Magazzini del Sale, Venice, 1999; and Howard Greenberg Gallery, New York, 2000.

EMMA B. FREEMAN
Born 1880, Nebraska
Died 1927, San Francisco
Primarily portraits. Born Emma Belle Richart. Married Edwin R. Freeman, salesman for garment industry, Denver, 1902. Moved to San Francisco; opened art goods and handcrafts shop. Attended drawing and painting classes. Shop destroyed by earthquake, 1906. Moved to small town of Eureka, California, 1907. Edwin became photographer. Opened Freeman Art Company; offered art supplies and his scenic views. Emma began to make photographic portraits, 1910. Created local scandal by taking train ride to San Francisco with former governor of Illinois Richard B. Yates, who had been speaking in Eureka, 1913. After the ensuing divorce, 1915, Emma maintained Freeman Art Company. Developed friendships with part-white, part–Native American young people and began photographing them in native dress; also visited Klamath and Hoopa tribes. Full set of Emma's Indian studies numbered two hundred images; known as Northern California Series. Displayed selections to acclaim at Panama-Pacific International Exposition, San Francisco, 1915. Achieved spotlight in male-dominated world of photojournalism with her photographs of sinking of USS *Milwaukee* when it attempted to salvage the submarine *H-3* in Eureka Bay, California, 1916. Opened art company in San Francisco, 1919; went bankrupt, 1923. Married Edward Blake, bookkeeper, 1925.

GISÈLE FREUND
Born 1912, Berlin
Died 2000, Paris
Portraits and photojournalism. Studied sociology and art history, Albert-Ludwigs-Universität Freiburg, Breisgau, Germany, 1932–33. Emigrated to France, 1933; became naturalized citizen, 1936. Studied at Sorbonne, Paris, 1933–36, receiving Ph.D. in sociology and art. Married to Pierre Blum, 1937–48. Became free-lance photojournalist and writer based in Paris for *Life, Weekly Illustrated, Vu, Picture Post, Paris Match, Du,* and elsewhere, 1935–40, 1946–50, and from 1953 on. First exhibition, *Ecrivains célèbres (Celebrated Writers),* Galerie Adrienne Monnier, Paris, 1939. Photographed Colette, James Joyce, André Malraux, and Virginia Woolf, among others; many portraits done in color as early as 1938. To escape Nazis, moved to Lot, France, 1940–42; then was photographer and assistant film producer for Louis Jouvet Theater Company, Argentina and Chile, 1943–44. Worked for France Libre in Argentina, 1944–45. Lived in New York City, 1947–49. Lived and worked in Mexico, 1950–52. Member of Magnum Photos, Paris, 1947–54. Kulturpreis, Deutsche Gesellschaft für Photographie, 1978; Grand Prix National des Arts, France, 1980.

TONI FRISSELL
Born 1907, New York City
Died 1988, Saint James, New York
Fashion, documentary, and sports images for magazines. Graduated from Miss Porter's School, Farmington, Connecticut, 1925. Took up photography seriously during the Depression, in 1931, as self-devised therapy after older brother Varick was lost at sea while making documentary film. Her series, Beauties at Newport, published in *Town and Country,* 1931. Fashion photographer for *Vogue,* 1931–42. Married Francis McNeill ("Mac") Bacon III, 1932; had Varick, 1933, and Sidney, 1935. During World War II became official photographer for Red Cross in United States, England, and Scotland, 1941–43. Worked for *Harper's Bazaar,* 1941–50. Toured Europe as photographer for American Fifteenth Air Force Squadron; was also official photographer of Women's Army Corps and photographed for Office of War Information, 1945. Began working for *Sports Illustrated,* 1953. Represented in Edward Steichen's *Family of Man* exhibition, Museum of Modern Art, New

York, 1955. As interest in fashion photography evolved in art world during 1970s, her work was included in *Fashion Photography: Six Decades,* sponsored by the Emily Lowe Gallery, Hofstra University, Hempstead, New York, 1975–76, and *History of Fashion Photography,* International Museum of Photography, George Eastman House, Rochester, New York (and tour), 1977–78. Gave collection of prints and negatives to Library of Congress, Washington, D.C., 1970.

AMÉLIE GALUP
Born 1856, Bordeaux, France
Died 1943, Paris
Portraits and social documentation. Born Suzanne-Albertine-Amélie Faure to Protestant family of wine merchants and shippers; one of nine children. Father died, 1864. Family moved to Amélie's eldest brother's house in Paris. Mother died, 1868. Amélie lived with sisters in Bordeaux during siege of Paris and Commune, 1870–71. Moved back to Paris, 1874. Refused arranged marriage, 1876; instead married Albert Galup, magistrate at Cahors, 1879; had Jean, 1880; Marie, 1884. Husband became magistrate at Albi, 1891. Amélie installed darkroom in their house at Saint-Antonin, where she made her first photographs, 1895. From 1895 to 1901 produced over thirteen hundred portraits of family and friends, spontaneous shots of local festivals and marches, posed photographs of townspeople at work. Husband named president of tribunal of Saint Gaudens; he died, 1901. Amélie settled in Paris, photographing her grandchildren and writing memoirs.

CRISTINA GARCÍA RODERO
Born 1949, Puertollano, Spain
Resides Madrid
Documentation, primarily of folk and religious festivals. Degree in painting, Universidad Complutense de Madrid, 1968–72; also studied photography at Escuela de Artes Aplicadas y Oficios Artísticos de Madrid, 1970–71. Funded by Ministry of Education and Science to make landscape photographs in Segovia, 1971; received bronze medal in exhibition of work by fellowship recipients. Studied teaching methods, Instituto de Ciencias de la Educación, Universidad Complutense de Madrid, 1972. Plastic arts fellowship, Juan March Foundation, Madrid, 1973. Received fellowship, Castellblanch Art Endowment, Barcelona, 1971; utilized it at

Instituto Statale d'Arte (Fotografia), Florence, 1973. While in Italy conceived body of work on popular festivals, customs, and traditions of Spain; has traveled thousands of miles in Spain to record small-town festivals and events. Professor of photography, Universidad Complutense de Madrid, since 1983. Several awards and grants outside Spain, including W. Eugene Smith Grant in Humanistic Photography, 1989, and Dr. Erich Salomon award, Deutsche Gesellschaft für Photographie, 1990.

FLOR GARDUÑO
Born 1957, Mexico City
Resides Mexico City
Portraits and landscapes. Studied visual arts at Escuela Nacional de Artes Plásticas at the Universidad Nacional de Mexico, 1970s. Worked in the photography studios of Kati Horna and Manuel Alvarez Bravo, 1978–80. Under sponsorship of Instituto Nacional Indigenista, traveled with team of photographers organized by MARIANA YAMPOLSKY to photograph rural villages throughout Mexico, 1981–82. Presently works in both Mexico City and Stabio, Switzerland. Published books *Magia del juego eterno,* 1985; *Bestiarium,* 1987; and *Testigos del tiempo/Witnesses of Time,* 1992. Solo exhibitions include Galería José Clemente Orozco, Mexico City, 1982; Museum Volkenkunde, Rotterdam, 1989; Field Museum, Chicago, 1990; and *Witnesses of Time,* Americas Society, New York, 1993.

GRETCHEN GARNER
Born 1939, Minneapolis
Resides Santa Fe, New Mexico
Urban and rural landscapes; also portraits. B.A. in art history, University of Chicago, 1965; M.F.A. in photography, School of the Art Institute of Chicago, 1975. Visiting instructor at Institute of Design, Illinois Institute of Technology, Chicago, 1979, and at Columbia College Chicago, 1978 and 1982. Assistant, then associate, professor at Saint Xavier College, Chicago, 1974–82; chairperson, Department of Art, 1982–84. Editor, *Exposure* (journal of Society for Photographic Education), 1981–82. Associate professor, School of Communications, and director, Calder Art Gallery, at Grand Valley State College, Allendale, Michigan, 1987–89. Professor and head, Department of Art, University of Connecticut, Storrs, 1989–94. Academic dean, Moore College of Art, Philadelphia,

1994–97. Began work on photographic "catalog" of visual phenomena—i.e., shapes, colors, and objects in ordinary urban world, 1975. Visual categories include animals, arrows, cocktails, corners, green, stripes, windows, and so on. Book containing over two hundred color photographs arranged in twenty-seven categories published as *An Art History of Ephemera: Gretchen Garner's Catalog*, 1982. While first visiting artist at J. Alden Weir Farm, Wilton, Connecticut, 1991–92, produced series of color landscapes; shown in solo exhibition at Lyme Academy of Fine Arts, Old Lyme, 1992.

LYNN GEESAMAN
Born 1938, Cleveland
Resides Minneapolis
Landscapes, primarily European formal parks and gardens and tree landscapes. B.A. in physics and mathematics, Wellesley College, Wellesley, Massachusetts, 1960. Married Donald Geesaman, now a retired professor, 1962; had two daughters: Rachel, 1967, and Sarah, 1968. Grants and awards include MacDowell Colony Residency fellowship, Peterborough, New Hampshire, 1983, 1984, 1985, and 1987; McKnight Foundation Fellowship for Photography (3M Foundation), Minneapolis, 1983 and 1987; Minnesota State Arts Board fellowship, 1984, 1986, and 1990; Jerome Foundation Visual Arts Travel and Study grant, Saint Paul, 1989; Bush Foundation Artist fellowship, Saint Paul, 1991; Bernheim Artist fellowship, Clermont, Kentucky, 1992; and Arts Midwest/National Endowment for the Arts Regional Visual Arts fellowship award, 1993–94. Selected solo exhibitions include Southeastern Center for Contemporary Art, Winston-Salem, North Carolina, 1991; Center for Contemporary Art, Chicago, 1991; Tweed Museum of Art, University of Minnesota, Duluth, 1993; Robert Koch Gallery, San Francisco, 1993, 1995, and 1998; Thomas Barry Fine Arts, Minneapolis, 1993, 1995, 1997, and 1999; Catherine Edelman Gallery, Chicago, 1995 and 1999; Yancey Richardson Gallery, New York, 1996 and 1998; Espace Parallèle, Brussels, 1995 and 1997; Cedar Rapids Museum of Art, Cedar Rapids, Iowa, 1997; Elliot Brown Gallery, Seattle, 1997; Stephen Cohen Gallery, Los Angeles, 1998; Jackson Fine Arts, Atlanta, 1998; and University of Kentucky Art Museum, Lexington, 1999. Published book, *Poetics of Place*, 1998.

ÉDITH GÉRIN
Born 1910, Lorraine, France
Died 1997, Paris
Documentation and experimental work in Surrealistic mode; also land- and cityscapes. After studying law in Paris became journalist dealing with social issues, 1941–82. Joined Photo-Club of Bièvres, 1950. Photographed strange aspects of nature in forest of Fontainebleau, 1947–50. Photographed the city of Paris extensively. Traveled widely, photographing in Greece, Crete, Cyprus, Israel, Ireland, Netherlands, Belgium, Germany, Italy, Algeria, Egypt, many areas of France, the Alps, and elsewhere. Also photographed crystalline formulations, using macrophotography. Selected recent solo exhibitions at Musée de Moret-sur-Loing (Seine and Marne), France, 1989 and 1990; Bibliothèque Municipale de Laon, Laon, France, 1993.

LAURA GILPIN
Born 1891, Austin Bluffs, Colorado
Died 1979, Santa Fe, New Mexico
Documentation, portraits, and landscapes. Received Brownie box camera, 1903. Mother took her and her brother Francis to New York to be photographed by GERTRUDE KÄSEBIER, 1905. Laura attended schools in Pennsylvania and Connecticut, 1907. In Colorado Springs made autochromes, beginning 1908. Photographed in Grand Canyon, 1916. On advice of Käsebier, studied at Clarence White School, New York, 1916–18. Showed prints in photographic salon in Copenhagen, 1920; three photographs accepted into International Exhibition at London Salon of Photography, 1921. Photography instructor at Broadmoor Art Academy, Colorado Springs, 1921. Traveled in London and France, 1922. Obtained commercial assignments, 1920s on. Solo exhibition held under auspices of Pictorial Photographers of America, Art Center, New York, 1924. Photographed ruins throughout southern Colorado and New Mexico, 1924. Created and financed booklet, *The Pikes Peak Region*, 1925, followed by *Mesa Verde National Park*, 1927. Represented in group exhibitions in Buffalo, Los Angeles, Pittsburgh, New York, and Edinburgh, 1929. Fifty-print solo exhibition at Milwaukee Art Institute, 1930. Elected associate of Royal Photographic Society of Great Britain, 1930. Photographed Navajos of Red Rock, Arizona, 1931–34. Became photographer for Boeing aircraft,

Wichita, Kansas, 1942–45. Photographed Rio Grande, from source to mouth (also stopping in Yucatán), partly from airplane, beginning 1945; book published 1949. Moved to Santa Fe, 1945. Photographed Navajo intensely for proposed book, 1950–54; book not published until 1968. Major exhibition of her Navajo work, Amon Carter Museum, Fort Worth, 1968. Honorary doctorate from University of New Mexico, Albuquerque, 1970. Important solo exhibition at Witkin Gallery, New York, 1973–74. Retrospective at Museum of New Mexico, Santa Fe (and tour), 1974–75. Governor's Award for Excellence in the Arts, New Mexico, 1975. Received Guggenheim fellowship, 1975, upon fifth application since 1930.

CAROLYN EVEN GLEDHILL
Born 1871, Morris, Illinois
Died 1935, Santa Barbara, California
Portraits. Father, Joseph Even, and mother, Emma Malcolm Even, operated photographic studios in Illinois; Carolyn and sister Emma M. Even learned profession from them. After father's death, Carolyn and Emma moved to Santa Barbara; opened portrait studio together, 1903. Carolyn married Edwin Gledhill, 1907; they opened Gledhill Studios same year. Son Keith (later a tennis star) born, 1911. They belonged to community of writers, painters, actors, and dancers; most famous was painter Thomas Moran. Gledhills created portraits together: Edwin worked with sitter and coaxed the right expression, also developed the prints; Carolyn worked behind the camera, creating the composition, also retouched and made proofs. Experimented with color photography (autochrome), 1910–17. Fire destroyed local Potter Hotel, damaging tourist business, 1921; Gledhill Studios suffered due to lack of vacationing easterners. Studio badly damaged by Santa Barbara earthquake, 1925; Gledhills moved studio one block away. Carolyn died, July 16, 1935; Edwin remarried, 1936, and continued studio into late 1940s.

JUDITH GOLDEN
Born 1934, Chicago
Resides Tucson, Arizona
Mixed-media work and photomontages. B.F.A., School of the Art Institute of Chicago, 1973; M.F.A., University of California, Davis, 1975. Visiting lecturer, University of California, Los Angeles, 1975–79. Associate professor,

University of Arizona, Tucson, 1981–88; and professor, 1989–present. Has combined photography with painting, various print-making techniques, appropriated images, and stitchery, to create primarily one-of-a-kind pieces. Early work in black-and-white primarily self-portraits dealing with issues of female identity, 1973–c. 1980. More recent work in color concentrates on portraits of other women; examines archetype of women in relation to myth and fantasy, c. 1980–present. Selected honors and grants include National Endowment for the Arts fellowship, 1979; Arizona Commission on the Arts fellowship, 1984; Moore College of Art and Design, Philadelphia, honorary doctorate in art, 1990; and University of Arizona Faculty Research grant, 1993. Selected recent solo exhibitions at Etherton/ Stern Gallery, Tucson, Arizona, 1985, 1989, and 1991; Friends of Photography, Carmel, California, 1987; Museum of Contemporary Photography, Chicago, 1988; Gallery 954, Chicago, 1993; and Scottsdale Center for the Arts, Scottsdale, Arizona, 1993. Major retrospective, Museum of Photographic Arts, San Diego, California (and tour), 1986–87.

NAN GOLDIN

Born 1953, Washington, D.C.
Resides New York
Portraits and documentation. At age thirteen ran away from home; eventually was placed in foster care. Lived in various communes and attended an alternative school in Wellesley, Massachusetts, where she took up photography, c. 1971. Performed slide show of seven-hundred-odd images, set to rock-and-roll soundtrack, in clubs in United States and Europe in mid-1980s; photos showed herself and friends using drugs, having sex, getting tattooed, displaying bruises from beatings. Published series of these photos in *The Ballad of Sexual Dependency*, 1986. Entered rehabilitation center in Boston, 1988. After moving to a halfway house, did series of harsh self-portraits dealing with restructuring of identity. Exhibited self-portraits and grids of images of lovers, Pace/MacGill Gallery, New York, 1990. Published book *The Other Side*, 1993, a collection of her photographs of transsexuals and transvestites; exhibited this series at Pace/MacGill, 1993. Exhibited *The Family of Nan, 1990–92*—Cibachrome prints of beloved people in her life, some hospitalized and dying of AIDS—at Whitney Biennial, Whitney Museum of American Art, New

York, 1993. Recent selected solo exhibitions: Matthew Marks Gallery, New York, 1995, 1996, 1998, and 2000; *I'll Be Your Mirror,* Whitney Museum of American Art, New York (major retrospective with tour), 1996; National Gallery of Iceland, Reykjavik, 1999; Contemporary Art Museum, Houston, 1999; and Scalo, Zurich, 2000. Selected recent awards and fellowships: Mother Jones Documentary Photography award, San Francisco, 1990; Art Matters, Inc. artist fellowship, New York, 1990; National Endowment for the Arts, Washington, D.C., 1991; DAAD, Artists in Residence Program, Berlin, 1991; Louis Comfort Tiffany Foundation award, 1991; and Brandeis Award in Photography, 1994.

LOIS GREENFIELD

Born 1949, New York City
Resides New York City
Primarily dance photographs. B.A. in anthropology and minor in film making, Brandeis University, Waltham, Massachusetts, 1970. Originally considered becoming ethnographic film-maker, but after graduation began taking photographs for alternative newspapers, including *Boston Phoenix* and *Real Paper*. Occasional assignments to cover dance concerts redirected her career. Returned to New York and began photographing dance companies to accompany Deborah Jowitt's dance reviews in *Village Voice*, 1973 (to the present). Also published in *New York Times, Newsweek, Elle, Rolling Stone*, and elsewhere. Met two dancers, David Parsons and Daniel Ezralow, who became her foremost collaborators, 1982. Experimented with 2¼-in.-format camera and found that the square negative (which tended to crop limbs more than the rectangular 35 mm negative), combined with synchronized flash, created startling "flying" images that became her trademark. Published *Airborne: The New Dance Photography of Lois Greenfield*, 1998. Selected recent solo exhibitions at International Center of Photography, New York, 1992; Museum of Photographic Arts, San Diego, 1994; New Zealand Festival of the Arts, Wellington, 1994; Right Gallery, Tokyo, 1995; Musée de l'Elysée, Lausanne, Switzerland, 1998; Philadelphia Art Alliance, 1999; David Scott Gallery, Toronto, 2000; and Coplan Gallery, Boca Raton, Florida, 2000.

LOURDES GROBET

Born 1940, Mexico City
Resides Mexico City
Social documentation. Attended Universidad Ibéroamericana, Mexico City, 1960–62; Cardiff College of Art, Cardiff, Wales, 1975–76; and Derby College of Art and Technology, Derby, England, 1976–77. Recorded Mexican colonial architecture, 1977; did a series on Mexico's popular wrestling matches, with emphasis on female wrestlers, 1980; and worked with members of Laboratorio de Teatro Campesino e Indígena (initiated in Tabasco, but now including many regions in Mexico), 1985. Traveled with Teatro Campesino to New York to photograph their presentation of Federico García Lorca's *Blood Wedding*, 1986; winner of Juan Pablos publishing award for book based on these photographs, 1988. Photographed Oaxaca for Unesco project, 1986. Began photographing in Tijuana, 1988. Selected recent solo exhibitions at Galería del Sur, Xochimilco, Mexico; Galería de Arte Fotográfico, Mexico City; Museo Estudio Diego Rivera, Mexico City; Museo de Arte Alvar y Carmen T. de Carillo Gil, Mexico City, all in 1990.

JAN GROOVER

Born 1943, Plainfield, New Jersey
Resides Montpon-Menesterol, France
Primarily still lifes; also portraits and landscapes. B.F.A. in painting, Pratt Institute, Brooklyn, 1965; M.A. in art education, Ohio State University, Columbus, 1970. Assistant professor, Hartford Art School, University of Hartford, Hartford, Connecticut, 1970–73; member of adjunct faculty, State University of New York College at Purchase, 1979–91. Began living in New York City, 1973. Began taking photographs, 1970s; gained recognition for color diptychs and triptychs of cars and trucks on highways and city streets. Began to make single images, 1978; created large color close-ups of kitchen utensils, plants, and vegetables, printed larger than life. Concentrated on formalist tabletop still lifes utilizing vases, goblets, and so on, 1980s; also experimented with platinum-palladium processes. Recent work involves use of banquet camera to create extremely horizontal image. Moved to France with husband, Bruce Boice, 1990s. Awards and grants include Creative Artists Public Service (CAPS) grants, 1975 and 1978; National Endowment for the Arts, 1978 and 1990; and

Guggenheim fellowship, 1979. Selected recent solo exhibitions at Robert Miller Gallery, New York, 1988, 1990, and 1992; Michael H. Lord Gallery, Milwaukee, 1990; Betsy Rosenfield Gallery, Chicago, 1991; Nancy Drysdale Gallery, Washington, D.C., 1993; Fahey/Klein Gallery, Los Angeles, 1993; Fraenkel Gallery, San Francisco, 1993; Jacksonville Art Museum, Jacksonville, Florida, 1993; and Janet Borden, New York, 1996.

MATTIE GUNTERMAN
Born 1872, La Crosse, Wisconsin
Died 1945, Beaton, Canada
Documentation. Born Ida Madeline Warner. Traveled to Seattle, c. 1890, where she met Bill Gunterman, a candy maker. They married, 1891; had Henry, 1892. Discovered photography via George Eastman's new invention, the Kodak snapshot camera, known as the Brownie; her brother-in-law Frank Gunterman also taught her to use 5-by-7-in. dry-plate camera, early 1890s. Mattie developed what seemed to be tuberculosis and was advised to go to drier climate, 1898. With flip of a coin, family decided to go to Thompson's Landing (later called Beaton), British Columbia, where Mattie's cousin lived. They walked most of the five hundred miles, getting jobs along the way; her "tuberculosis" seemed to be cured by the grueling trip. Cleared land and built log cabin with adjoining darkroom. Bill briefly got job on sawmill. Mattie photographed friends, landscape, and the work and social life in local mining and logging camps. Worked as cook at Nettie-L mine, 1902; she and Bill worked at logging camp, 1903–4. Boom in the area ended, 1910. Fire destroyed house and Mattie's negatives, though not glass plates, 1927. Bill died, 1936.

BETTY HAHN
Born 1940, Chicago
Resides Albuquerque, New Mexico
Experimental work in mixed media and non-silver processes. B.A. in art, 1963, and M.F.A. in photography, 1966, Indiana University, Bloomington; studied with photographer Henry Holmes Smith there. Studied with photographer Nathan Lyons, Visual Studies Workshop, Rochester, New York, 1967–68. Assistant professor of photography, Rochester Institute of Technology, 1969–75. Became associate professor of photography, University of New Mexico, Albuquerque, 1976; currently professor of art there. Known for employing such diverse processes and equipment as gum bichromate on canvas with stitchery, Vandyke brown prints, cyanotypes, lithographs, color photographs (chromogenics), Polaroids, hand-painted prints, and toy cameras. Recurring subjects include flowers and the Lone Ranger. Created photographs with theme of detective and police surveillance, 1980s. Photographed in Japan, 1980s. Visited Berlin, 1990, during pro-democracy demonstrations; created images related to city's role as military power during World War II and as spy capital during Cold War. Grants and awards include National Endowment for the Arts grants, 1978–79 and 1983–84; Polaroid Artists on 20″ x 24″ Camera fellowship, Visual Arts Research Institute, Arizona State University, Tempe, 1988; and purchase award, NM '93, Juried Biennial, Museum of Fine Arts, Santa Fe, New Mexico, 1993. Recent solo exhibitions: *Passing Shots: A Travel Series by Betty Hahn,* University of New Mexico Art Museum, Albuquerque, 1994 (and tour through 1999); and *Betty Hahn: Photography or Maybe Not,* a thirty-year retrospective organized by Museum of Fine Arts, Santa Fe, New Mexico, 1995 (and tour through 1999).

ADELAIDE HANSCOM
Born 1876, Empire City, Oregon
Died 1932, California
Portraits and narrative tableaux. Studied at Mark Hopkins Institute of Art, San Francisco, c. 1892. Won two second prizes in photography, Channing Club Exhibit, Berkeley, 1901. Took over photographer Laura Adams's portrait studio, San Francisco, 1902; clients were prominent Bay Area families. Became partner with Blanche Cumming in photography firm Hanscom and Cumming, San Francisco, 1904. Most productive years, 1904–7; exhibited in California and also published in magazines such as *Camera Craft.* Illustrated special edition of *The Rubáiyát of Omar Khayyám* with photographs, issued between 1905 and 1912. San Francisco earthquake and fire destroyed studio, *Rubáiyát* negatives, and most prints, 1906. Established studio in Seattle, 1906. Married Gerald Leeson, British mining engineer and former Canadian Mountie, 1908. Within six years had two children; family moved to Alaska, returned to California, then went to Idaho. After argument, Leeson left her, enlisted in Canadian army, and was killed in his first battle of World War I, 1915. Adelaide's mental health deteriorated. Did illustrations for Elizabeth Barrett Browning's *Sonnets from the Portuguese,* 1916. Moved to Danville, California, and set up darkroom, 1916. Lived in mental-health facility, Napa, 1922–24. Took inheritance and moved to England to be near husband's ancestors, 1924. Returned to California to be near daughter. Killed in hit-and-run accident.

ELISE FORREST HARLESTON
Born 1891, Charleston, South Carolina
Died 1970, Charleston
Portraits and genre. Met Edwin Harleston, in Charleston, before 1919. Edwin, a painter, left to study painting abroad; suggested that Elise study photography so that after his return they could marry and open portrait studio. Elise attended E. Brunel School of Photography, New York, 1919; was one of two African-Americans there, and the only female. Edwin insisted that she also enroll at Tuskegee Institute in Alabama; she took graduate courses in photography, 1921, with C. M. Battey, head of Photography Division. Edwin and Elise married and opened successful studio in Charleston, 1922. Edwin often painted from Elise's photographic portraits of clients and genre scenes. Edwin received recognition for his work, but Elise's role was seldom mentioned.

JUDITH HAROLD-STEINHAUSER
Born 1941, Niagara Falls, New York
Resides Philadelphia
Hand-colored floral and figurative images. B.S., State University of New York, Buffalo, 1963; M.S., Institute of Design, Illinois Institute of Technology, Chicago, 1967. Became assistant professor of photography, Moore College of Art and Design, Philadelphia, 1974; subsequently associate professor and since 1986, full professor. Known for large-scale oil-on-gelatin-silver prints of flowers, 1970s–'80s; has also made hand-colored photographs of figures since 1979. Recent work uses figures dressed in black against a black background; about half the series involves multiple exposures. Fellowships from National Endowment for the Arts, 1973, and Pennsylvania Council for the Arts, 1987 and 1993; grant from MacDowell Colony, Peterborough, New Hampshire, 1992. Artist in residence at School of the Art Institute of Chicago, 1982; at Light Work,

Syracuse, New York, 1986; and at Visual Studies Workshop, Rochester, New York, 1988. Selected recent solo exhibitions at Robert B. Menschel Photography Gallery, Syracuse University, Syracuse, New York, 1987; Jacques Baruch Gallery, Chicago, 1991; and More Gallery, Philadelphia, 1992 and 1994.

LADY CLEMENTINA HAWARDEN
Born 1822, near Glasgow
Died 1865, South Kensington, London
Posed figure studies. Born Clementina Elphinstone Fleeming (pronounced "Fleming") at Cumbernauld House, near Glasgow. Daughter of Admiral the Honourable Charles Elphinstone Fleeming and Spanish wife, Catalina Paulina Alessandro. Following death of Charles and subsequent loss of income, Catalina and daughters went to Rome, 1841–42. Clementina married Cornwallis Maude, future fourth viscount Hawarden (pronounced "Haywarden") and first earl de Montalt, 1845. Ten children born, 1846–64; seven daughters and one son survived infancy. Husband came into his inheritance, 1856. With increased financial resources, Clementina took up photography c. 1857; had eight highly productive years. Did most of her photography at family townhouse in South Kensington, London. Primary subjects were her three eldest daughters; also photographed landscape and activities at family's Irish estate, Dundrum. First woman to gain serious recognition in Photographic Society of London (later Royal Photographic Society of Great Britain). Exhibited there and won silver medals for best work by an amateur, 1863 and 1864; elected to the society, 1863. At peak of artistic powers died of pneumonia. Reputation fell into obscurity, but family saved albums of photographs; granddaughter gave 775 prints to Victoria and Albert Museum, London, 1939. Lady Hawarden reintroduced to the fine-art photography world in *From Today Painting Is Dead*, exhibition at Victoria and Albert Museum, 1972. Solo exhibition at J. Paul Getty Museum, Malibu, California, 1991.

MARIA EUGENIA HAYA—*see* MARUCHA

FLORENCE HENRI
Born 1893, New York City
Died 1982, Compiègne, France
Avant-garde work in Cubist style, portraits, and still lifes, occasionally used in advertising. Born to a French father; mother from Silesia (now part of Poland). After mother died, 1895, Florence traveled widely with father. In Paris began music studies, 1902, which she continued after moving to Italy after father's death, 1908, and in Berlin with Egon Petri and Ferruccio Busoni, 1912–14. Gave concerts in major German and British theaters, through 1918. Studied painting at Kunstakadamie, Berlin, 1914, and at atelier of Johannes Walter-Kurau, 1922–23. In Switzerland, married Swiss national Karl Anton Koster, 1924 (divorced 1954), to make possible her entry into France; moved to Paris, 1924. Studied with Fernand Léger and Amédée Ozenfant at Académie Moderne, 1925–26, where she developed Purist nonfigurative style. Enrolled as unmatriculated student in summer session at Bauhaus, Dessau, Germany, 1927; studied with László Moholy-Nagy, Paul Klee, and Wassily Kandinsky and developed interest in photography. First photographs, in innovative style that combined Bauhaus and Purist elements, included mirrors; these were published in Dutch journal *i10*, 1928, with critical assessment by Moholy-Nagy. Work represented in influential exhibitions *Fotografie der Gegenwart*, Essen, and *Film und Foto*, Stuttgart, both Germany, 1929. Did advertising, portrait, and fashion work. Photographs appeared in *Arts et métiers graphiques* and *Der Querschnitt* and were shown in *Foreign Advertising Photography* exhibition, New York, 1931. Spent war years in Paris; continued to photograph and to paint, taking lengthy trips to Ibiza, Spain. Moved to Bellival, France, 1962. Exhibited her paintings, photographs, and collages throughout the 1970s; major retrospective at San Francisco Museum of Modern Art (and tour), 1990.

ABIGAIL HEYMAN
Born 1942, Danbury, Connecticut
Resides New York City
Documentation, magazine work, and book illustrations. B.A., Sarah Lawrence College, Bronxville, New York, 1964. Decided to become photographer, 1967. Traveled around United States photographing people in towns and rural areas, especially women, 1968.

Published three books, 1974–87. Married Donald A. Bloch; had Lazar, 1976. Grant from Mexican-American Legal Defense and Education Fund, funded by National Endowment for the Arts, to photograph Mexican-American community throughout United States, 1977–79. New York Foundation for the Arts fellowship, 1985. Director of Documentary and Photojournalism Full-Time Studies Program at International Center of Photography, New York, 1986–88. Affiliated with, and associate member of, Magnum Photos, 1974–81; founded Archive Pictures agency, 1981. Photographs published in *New York Times Magazine, Life, Time, Esquire, Ms., Artforum*, and elsewhere. Guest cocurator of *Flesh and Blood: Photographers' Images of Their Own Families*, for Friends of Photography, San Francisco, 1993. On photography faculty, part time, Parsons School of Design, New York, 1998–present.

HANNAH HÖCH
Born 1889, Gotha, Germany
Died 1978, Berlin-Heiligensee, Germany
Photomontages. Enrolled in Kunstgewerbe-schule, Berlin, and studied glass design, 1912. Studied graphics at Staatlichen Lehranstalt des Kunstgewerbemuseums. Began liaison with artist Raoul Hausmann, 1915 (until 1922). Together they created avant-garde photomontages, inspired by popular photomontages from the World War I front, which they had seen during vacation on the Baltic Sea, 1918. Represented in first Berlin Dada exhibition, 1919. With Hausmann, George Grosz, Otto Dix, and others, signed the manifesto of the avant-garde Novembergruppe, published in *Der Gegner*, 1920. Exhibited in several November-gruppe annual exhibitions, 1921–31, as well as in other important exhibitions in Germany, Belgium, United States, Paris, Soviet Union, and elsewhere throughout her life. First visit to Paris, 1924. Married pianist Kurt Matthies, 1938; divorced, 1944.

CANDIDA HÖFER
Born 1944, Eberswalde, Germany
Resides Cologne, Germany
Interiorscapes and documentation. Photographed pinball machines in restaurants, gambling halls, and pubs in various European cities for a book project that was later discontinued, 1972. Began documenting the lives of Turkish

workers and their families in Cologne and other German cities, early 1970s. Studied at the Kunstakademie Düsseldorf, 1973–76. Studied photography with Bernd Becher, 1976–82. Best known for sharply focused interiors of different kinds of buildings all over Europe. Sometimes described as one of the "new generation" of German photographers. Work has appeared in many group exhibitions, the titles of which suggest the appearance of and themes in her work: *Foto/Realismen*, Kunstverein Munich, 1987; *German Photography: Documentation and Introspection*, Aldrich Museum of Contemporary Art, Ridgefield, Connecticut, 1990; *Perspectives on Place: Attitudes toward the Built Environment*, University Art Gallery, San Diego, California, 1990; *Aus der Distanz*, Kunstsammlung Nordrhein-Westfalen, Düsseldorf, 1991; and *Architektur in der Fotografie*, Galerie Wilma Tolksdorf, Hamburg, Germany, 1994. Selected recent solo exhibitions at Galerie Walcheturm, Zurich, 1991; Städische Galerie Haus Seel, Siegen, Germany, 1992; Galerie Johnen & Schottle, Cologne, Germany, 1992 and 1994; Portikus, Frankfurt, 1992; Nicole Klagsbrun Gallery, New York, 1992; Hamburger Kunsthalle, Hamburg, Germany, 1993; f-Stop Gallery, Bath, England, 1993; Leonhardi-Museum, Dresden, Germany, 1993; Galerie d'Ecole des Beaux-Arts, Valenciennes, France, 1994; Castello di Rivara, Turin, Italy, 1994; Galerie Rudiger Schottle, Munich, Germany, 1995; Sonnabend Gallery, New York, 1996; and Rena Bransten Gallery, San Francisco, 1996.

EVELYN HOFER

Born 1922, Marburg, Germany
Resides New York City
Portraits, architectural documentation, and book illustrations. Family left Nazi Germany when Evelyn was eleven because they were opposed to Hitler; went to Spain and Switzerland. Evelyn wanted to be pianist and enrolled at Conservatoire, Paris, at age fifteen; gave up idea of becoming musician during war. Apprenticed in two commercial photography studios in Zurich. Free-lance photographer in Mexico, 1942. Emigrated to United States, 1947, settling in New York City. Worked as fashion photographer for *Harper's Bazaar* (with art director Alexey Brodovitch), 1947; later, for *Vogue*. Noted for 4-by-5-in. view-camera work. Collaborated with writer Mary McCarthy on book *The Stones of Florence*, 1959. Subsequently

collaborated with V. S. Pritchett on books about London, Dublin, and New York; and with James Morris on Spain. Worked with Evelyn Barish, 1986–87, retracing the route taken through Italy in 1832 by American essayist and poet Ralph Waldo Emerson. Many photographic essays for Time-Life Books, 1960s; numerous assignments for *Life* Special Reports series, *New York Times Magazine*, and *Sunday Times Magazine* (London). Subjects of photographic essays include ghost towns; Gerald Ford's hometown of Grand Rapids, Michigan; life in English prisons; Michelangelo; Arthur Rubinstein; J.M.W. Turner's home in Petworth, England; and others. Solo exhibitions at Witkin Gallery, New York, 1977, 1982, 1986, 1988, and 1991; and Musée de l'Elysée, Lausanne, Switzerland, 1995.

EDITH IRVINE

Born 1884, Sheep Ranch, California
Died 1949, California
Documentation. Father, Thomas Irvine, was a miner and eventually became well off by acquiring mineral rights and real estate; lived in Mokelumne Hill, Calaveras County, California. A friend interested young Edith in photography. Received teacher's certificate, 1900. Photographed construction of Electra Powerhouse project on Mokelumne River for Standard Electric Company, 1898–1902. Probably planned trip around world; arrived in San Francisco on morning of April 18, 1906, day of the big earthquake. Grabbed an abandoned baby carriage, loaded it with camera equipment, and photographed ruins for three days. Avoided police and soldiers who had orders from city officials to confiscate photographs to conceal extent of damage. Back in Mokelumne Hill, showed pictures to only a few people; ran photo studio and taught school into the 1930s. Diagnosed as hemophiliac, 1939; attempted suicide. Became addicted to painkillers and alcohol. While visiting mother in hospital, drank bottle of rubbing alcohol and died a few days later. Nephew James Irvine donated her equipment and some eighty glass-plate negatives of the earthquake to Brigham Young University, Salt Lake City, 1988.

GRACIELA ITURBIDE

Born 1942, Mexico City
Resides Mexico City
Social documentation. The oldest of thirteen children born to an upper-middle-class family. Married an architect at age twenty and had three children; death of six-year-old daughter caused her to reassess her life. Studied film at Centro Universitario de Estudios Cinematográficos de la Universidad Autónoma, Mexico City, 1969–71. Began to take still photographs while working as assistant to Manuel Alvarez Bravo, 1970. Partly as result of Alvarez Bravo's influence, became committed to documenting indigenous cultures of Mexico; has photographed Mayo, Totonac, Tarasco, Kickapoo, Seri, and Nahua Indians. Early work sponsored by the Instituto Nacional Indigenista. Traveled to rural town of Juchitán, Oaxaca, 1979, and began photographing traditional matriarchal society there. Received W. Eugene Smith Grant in Humanistic Photography, 1987, which allowed her to finish work for book, *Juchitán de las mujeres* (*The Women of Juchitán*), published in 1989. Grants from Consejo Mexicano de Fotografía, 1983, and Guggenheim Foundation, 1988. In late 1980s began work on *Los cholos*, a projected book that documents life among people of Mexican descent in East Los Angeles and along United States–Mexico border, with emphasis on women gang members. Received Hugo Erfurth award, Leverküsen, Germany, 1989; International Grand Prize, Hokkaido, Japan, 1990. Major exhibition, *External Encounters, Internal Imaginings: The Photographs of Graciela Iturbide*, Museum of Modern Art, San Francisco, 1990. Invited by Médecins sans Frontières (Doctors Without Borders) to photograph in Madagascar, 1990. Exhibition *En el nombre del padre*, Galería Juan Martín, Mexico City (and tour), 1993. Major retrospectives: *Graciela Iturbide: La forma y la memoria*, Museo de Arte Contemporáneo de Monterrey, Mexico, 1996; and *Graciela Iturbide: Images of the Spirit*, Philadelphia Museum of Art, 1997–98.

LOTTE JACOBI

Born 1896, Thorn, Germany (now Toruń, Poland)
Died 1990, Concord, New Hampshire
Portraits, dance photography; also light-generated abstractions. Fourth generation of her family to become a commercial photographer; great-grandfather Samuel Jacobi had learned photography from Jacques-Louis-Mandé

Daguerre. Lotte studied art history and literature at academy in Posen, Germany, 1912–16. Married Fritz Honig, lumber merchant, 1916; had John Frank, 1917. Moved to Berlin, 1920. Divorced, 1924. Studied photography and film at Staatliche Höhere Fach Schule für Phototechnik; studied art history at University of Munich, 1925–27. Took over photography studio of father, Sigismund Jacobi, Berlin, 1927. Began to photograph artists, scientists, and politicians, often supplying portraits of important figures to magazines and newspapers. Traveled in Central Asia and Soviet Union, 1932–33. Ran photographic studio in New York City, 1935–55. Photographed famous German emigrants, including Albert Einstein and Thomas Mann. Married publisher Erich Reiss, 1940; he died, 1951. Photographed artists and photographers, including Marc Chagall, Alfred Stieglitz, Paul Strand, Edward Steichen, and BARBARA MORGAN; authors Theodore Dreiser and J. D. Salinger, poets Robert Frost and W. H. Auden; Eleanor Roosevelt; and others. Made photogenic drawings, 1946–55. Moved to Deering, New Hampshire, 1955. Received several honorary doctoral degrees from American universities, 1970s and 1980s.

BERTHA EVELYN JAQUES
Born 1863, Covington, Ohio
Died 1941, presumably Chicago
Etchings of landscapes, cityscapes, scenes of travels, flowers, and plant life; also cyanotypes. Born Bertha Evelyn Clauson. Studied at Art Institute of Chicago, but mainly self-taught. Created 461 prints between 1894 and 1940; also made over one thousand cyanotypes of plants, 1906–8, resulting from interest in botany. Organized Chicago Society of Etchers, 1910; active in organizing Philadelphia Print Club. Solo exhibition of prints at Chicago Society of Etchers, 1909; Paris Salon, 1912; Panama-Pacific International Exposition, San Francisco, 1915 (bronze medal); Art Institute of Chicago; Philadelphia Print Club, and others. Married, resided in Chicago with summer house in South Haven, Michigan. Traveled extensively: Japan, Netherlands, Spain, Italy, and London. Most photographs are unique images representing many endangered plants, which she sought, under aegis of Wild Flower Preservation Society, to preserve.

BELLE JOHNSON
Born 1864, Mendota, Illinois
Died 1945, Monroe City, Missouri
Portraits; also animals and floral still lifes. Attended Saint Mary's College, Notre Dame, Indiana, 1882–84. Settled with older sister Mary in Monroe City, Missouri; probably taught school, 1885–90. Answered advertisement for photographer's assistant at Rippey's local portrait studio, 1890. Three weeks later bought the studio; former owner stayed six months to help. Her studio a success almost from the beginning; in early years specialized in "cabinet" portraits. Achieved some prominence as photographer of animals, particularly cats; often posed animals with children. Became member of Photographic Association of Missouri, 1894, and placed third in competition at first convention she attended. Attended association conventions and participated in some juried salons, until at least 1907. After a fire almost put her out of business in 1899, she was a camera "operator" for C. S. Robertshaw; reestablished own studio by 1902. Attended photography school in Saint Louis, 1906–7. Remained active photographer until her death.

FRANCES BENJAMIN JOHNSTON
Born 1864, Grafton, West Virginia
Died 1952, New Orleans
Social documentation and magazine work, portraits, and architectural documentation. Studied art at Notre-Dame Convent, Govanston, Maryland, before 1883. Studied drawing and painting, Académie Julian, Paris, 1883–85. Enrolled in Art Students League, Washington, D.C., 1885; began experimenting with photography, 1885. Received formal training in photography from Thomas William Smillie, Smithsonian Institution Division of Photography, soon thereafter. Opened professional studio in Washington, D.C., 1890. Received assignments from many publications, often documenting industrial workers, 1890 on. Also photographed national celebrities and prominent members of Washington's political and social circles. Gained access to the White House under five administrations (Harrison, Cleveland, McKinley, T. Roosevelt, and Taft); especially helped by Mrs. Theodore Roosevelt. Became known as champion of women as photographers; published "What a Woman Can Do with a Camera," *Ladies' Home Journal*, September 1897. Photographed at Hampton

Normal and Agricultural Institute, where African-American and Native American youth trained in domestic work, arts and crafts, and agriculture, 1899, Organized important exhibition of 142 prints by twenty-eight American women photographers; presented it as a special exhibition held at same time as the Exposition Universelle, Paris, 1900; exhibition then went to Saint Petersburg and Moscow, fall of 1900, before returning for public exhibition at Photo Club of Paris, January 1901. Wrote series of seven articles on the women photographers in this exhibition for *Ladies' Home Journal*, 1901–2. Undertook first architectural commission, 1909; architectural photography became specialty of New York City studio she operated with Mattie Edwards Hewitt, 1913–17. After 1917 concentrated on photographing gardens and estates. Received funding from Carnegie Corporation of New York to undertake systematic photographic survey of early southern architecture, 1933–40. Spent final years in New Orleans. Donated her work to Library of Congress.

DORA KALLMUS—*see* MADAME D'ORA

CONSUELO KANAGA
Born 1894, Astoria, Oregon
Died 1978, Yorktown Heights, New York
Portraits, still lifes, documentation, and news photography. Grew up in small California towns like Salinas; father, a lawyer, published magazine on farming and irrigation. First job as writer-reporter for *San Francisco Chronicle*, 1915; with editor's encouragement, became newspaper photographer. Did portrait work, 1915. Became member of California Camera Club, whose membership included DOROTHEA LANGE, 1916. Married mining engineer Evans Davidson, 1919. Moved to New York by herself, 1922; became news photographer for *New York American*, 1922. Met Alfred Stieglitz, 1923. Divorced Davidson, 1926. Traveled in Italy and Morocco with LOUISE DAHL-WOLFE, 1927–28; then moved back to San Francisco. Friend of IMOGEN CUNNINGHAM, Edward Weston, and others of Group f/64. Represented in group's first exhibition, at M. H. de Young Memorial Museum, San Francisco, 1932, but never became a member. Moved to New York City, 1935, and became actively involved with political left. Did photographs for leftist publications like *New Masses, Labor Defender*, and

Sunday Worker, 1935–36. Worked on assignment for Index of American Design, a Works Progress Administration project, 1936. Married painter Wallace Putnam, 1936. Became involved with, and lectured at, New York Photo League, by 1938. She and husband purchased vacation home, the Icehouse, in Yorktown Heights, New York, 1940; moved there, 1950. Throughout 1940s they were part of artistic circle that included Sally and Milton Avery, the Adolph Gottliebs, the Mark Rothkos, and others. Represented in Edward Steichen's *Family of Man* exhibition, Museum of Modern Art, New York, 1955. Photographed civil-rights demonstrators, Albany, Georgia, 1964. Retrospectives at Brooklyn Museum, 1976–77 and 1993.

IDA KAR
Born 1908, Tambov, Russia
Died 1970, London
Portraits, Surrealist and documentary work. Born Ida Karamian. Spent early years in Russia, Iran, and from age thirteen, Egypt; family settled in Alexandria. Father sent her to Paris to study medicine and chemistry, 1928; instead, studied singing and violin and socialized with the avant-garde. Returned to Alexandria, 1933. Became receptionist-assistant at a photography studio. Married Edmond Belali, late 1930s. They moved to Cairo and opened photography studio called Idabel; they showed work in two Surrealist exhibitions, Cairo, 1943 and 1944. Divorced Belali; married Englishman Victor Musgrave, 1944. Moved to London, 1945. Made portraits of Marc Chagall, T. S. Eliot, Eugène Ionesco, Doris Lessing, Henry Moore, and others. Worked as photojournalist, making picture stories about London life for *Tatler* and *Observer*, late 1950s. Photographed in Armenia, Moscow, East Germany, and Sweden, later 1950s–'60s. Major exhibition at Whitechapel Art Gallery, London, 1960, did not bring employment and financial support. Eventually she was offered an opportunity to photograph regularly for *Animals* magazine, for about a year, 1963. Solo exhibition at House of Friendship, Moscow, 1962, resulted in invitation from Cuban government to attend Celebration of the Cuban Revolution, 1964. Always eccentric, she became mentally unstable toward end of life; separated from husband, 1969.

GERTRUDE KÄSEBIER
Born 1852, Fort Des Moines (now Des Moines), Iowa
Died 1934, New York City
Portraits and Pictorial photographs. Born Gertrude Stanton. Lived in Golden, Colorado Territory, 1860–64; family moved to Brooklyn, 1864. Married German immigrant Eduard Käsebier, who prospered as shellac importer, 1874. They lived in New Jersey; had Frederick William, 1875; Gertrude Elizabeth, 1878; Hermine Mathilde, 1880. Began photographing family, late 1880s. Moved back to Brooklyn and began courses at Pratt Institute, 1889–96, with goal of becoming portrait painter. Worked with chemist in Germany to master technical side of photography, 1893. Worked with Samuel H. Lifshey, portrait photographer in Brooklyn, to learn business side of running a studio, 1896. Solo exhibition at Boston Camera Club, 1896; showed same 150 photographs at Pratt Institute, 1897. Opened first portrait studio in Manhattan, late 1897 or early 1898. Photographed Sioux Indians in Buffalo Bill's Wild West Show, Manhattan, beginning 1898. Exhibited ten prints in important First Philadelphia Photographic Salon, 1898; was judge for, and exhibitor in, Second and Third Philadelphia Photographic Salons, 1899 and 1900. Alfred Stieglitz gave her solo exhibition at Camera Club of New York, 1899; she joined club. Stieglitz published five of her photographs in *Camera Notes*, 1899. She built successful portrait business, photographing such society notables as the Louis Comfort Tiffany family and heiress Theodate Pope. Represented in FRANCES BENJAMIN JOHNSTON's exhibition of 1900–1901. Represented in F. Holland Day's *New American Photography* exhibition in London, 1900, and Paris, 1901. One of first two women to become members of Linked Ring, 1900. Founding member of Photo-Secession, 1902. Stieglitz devoted first issue of *Camera Work* to her, 1903. Husband died, 1909. Gertrude resigned from Photo-Secession, 1912; continued producing important work after this break with Stieglitz. Became honorary vice-president of Pictorial Photographers of America, founded in 1916.

BARBARA KASTEN
Born Chicago
Resides Chicago
Experimental work. B.F.A., University of Arizona, Tucson, 1959; M.F.A., California College of Arts and Crafts, Oakland, 1970. Interest in crafts and traditional Native American arts motivated her to work with fiber sculpture. Received Fulbright Hays fellowship to work with fiber sculptor Magdalena Abakanowicz in Poland, 1971. Upon return to Los Angeles, started working with photography; began with abstract photograms of folded mesh. Made large-scale Polacolor prints of sculptural arrangements, 1970s. National Endowment for the Arts fellowship, 1977; also NEA Services-to-the-Field grant to create videotape documentaries of women photographers, 1980. Guggenheim fellowship, 1982; part of Polaroid Collection Program, 1982. Moved to New York, 1982; built sets to photograph. Created stage design based on abstract models for Margaret Jenkins Dance Company, San Francisco, 1985. Photographed existing modern architecture, 1986 (Architectural Sites series). Invited to make series of photographs based on nineteenth-century Pollock-Krasner House and Study Center, East Hampton, New York, 1988. Worked on New Mexico Site series, 1990, lighting ancient Puye cliff dwellings. Awarded Pont-Aven Artist-in-Residency, Musée de Pont-Aven, France, 1991; also received Apple photographic grant, 1991. Selected recent solo exhibitions at John Weber Gallery, New York, 1990, 1992 and 1999; Contemporary Art Center, Vilnius, Lithuania, 1995; Herbert F. Johnson Museum of Art, Cornell University, Ithaca, New York, 1996; Yancey Richardson Gallery, New York, 1996 and 1998; Frederick Spratt Gallery, San Jose, California, 1996; Gallery Luisotti, Bergamot Station, Santa Monica, California, 1996 and 1999; Small Works Gallery, Las Vegas, Nevada, 1997 and 2000. Teaches at Columbia College Chicago, 1999–present.

MINNA KEENE
Born 1861, Arolsen, Germany
Died 1943, Oakville, Canada
Portraits and Pictorialist genre. Born Minna Bergman. Moved to England and became governess, late 1870s or early 1880s. Married Caleb Keene, artist and craftsman; had Violet and Louis. Husband gave her a camera to take

her mind off a toothache. Began photographing stages of growth in plant life, before 1900. Did series of ornithological plates used as illustrations for English school books, c. 1900. Traveled throughout Europe. Family moved to Cape Town, c. 1903. During travels made photographic study of various racial and ethnic types; also photographed well-known people like Sir Leander Starr Jameson ("Dr. Jim"), whose failed raid on the Transvaal Republic in 1895 was a prelude to Boer War. Spoke English, French, Dutch, and German fluently. Proposed for election to Linked Ring, October 21, 1909; decision withheld because the society was in disarray (it was dissolved shortly thereafter). Migrated to Canada with family, c. 1912. Spent brief time in Montreal; several years in Toronto; moved commercial studio permanently to Oakville, n.d. Did portraits of Antarctic explorer Robert Scott, pianist Ignace Paderewski, and Lord and Lady Gladstone. First Canadian woman to become fellow of Royal Photographic Society of Great Britain, before 1914. Exhibited in Canada, England, Australia, United States, and South Africa. Received many medals and honorable mentions in competitions.

ANGELA KELLY

Born 1950, Belfast, Northern Ireland
Resides Oak Park, Illinois
Social documentation. Diploma in education, Mary Ward College, University of Nottingham, Nottingham, England, 1972; diploma in creative photography, Trent Polytechnic, Nottingham, 1975; M.A. in photography, Columbia College Chicago, 1989. Lecturer and assistant professor, Nelson (Lancashire) College of Further Education, England, 1975–78; lecturer and associate professor in photography, Department of Communication Arts and Design, Manchester Polytechnic, Manchester, England, 1978–80. Instructor, Loop College, Chicago, 1982–84; instructor, Columbia College Chicago, 1985–91. Visiting artist and instructor, School of the Art Institute of Chicago, 1980–92; associate professor adjunct there, 1992 to present. Over past two decades her photographic work has centered on issue of growing up female in patriarchal culture. Did series of photographs of teenage girls who attended Chrysalis Learning Center in Chicago, 1986–88. Solo exhibition of Chrysalis series at Rockford Art Museum, Rockford, Illinois,

1990, where she was also artist-in-residence, 1990. Arts Council of Great Britain individual award to artists, 1977 and 1978; Follett fellowship, Columbia College Chicago, 1984–86; Weisman Memorial Scholarship, Chicago Communications Foundation, 1985 and 1986; Focus Infinity Fund/Jack Jaffe grant, to document "Changing Chicago," 1987; Arts Midwest fellowship, National Endowment for the Arts, 1987; and grant to individual artist, Illinois Arts Council, 1988–89. Commissioned by Children's Museum, Chicago, to create installation about grandparents, 1993.

FLORENCE B. KEMMLER

Born 1900, Columbus, Ohio
Died 1972, United States
Pictorialist images with circus scenes, boats, and seascapes as subjects. Moved to San Diego, 1920. Took up photography, 1922; active until 1934. Worked with her husband, Dr. Roland Schneider, and exhibited both as Kemmler and as Schneider. Frequently showed work in camera clubs in California, 1930s. Member of Pictorial Photographers of America. Work published in *American Annual of Photography*, 1935.

MARIE HARTIG KENDALL

Born 1854, Mulhouse, France
Died 1943, Norfolk, Connecticut
Portraits, landscapes, and documentation. After France's defeat in Franco-Prussian War (1870), parents sold holdings in cotton and shoe factories and moved to United States. Marie and a sister trained as nurses at Bellevue Hospital, New York. Before graduation was dismissed because she got engaged to Dr. John Kendall, a resident physician there; completed training at Charity Hospital on Blackwell's Island. Married Kendall, late 1870s; they moved to Norfolk, Connecticut, 1884. Wanted to have photographic portraits made of their three children but could not afford it. Saved money and bought her own equipment, soon finding that townspeople wanted to buy photographs from her. Participated in camera club competitions. Sent photographs to World's Columbian Exposition, Chicago (won bronze medal), 1893, and Louisiana Purchase Exposition, Saint Louis, 1904. New Haven Railroad used her photographs of local scenery in advertising campaigns. Also active in temperance and woman suffrage movements;

taught classes in anatomy, nutrition, and sewing. In early 1930s destroyed 30,000 glass negatives; only about 250 images remain, at the Norfolk, Connecticut, Historical Society, including some of the blizzard of 1888.

BARBARA KER-SEYMER

Born 1905, probably England
Died after 1986
Portraits and experimental fashion images. Studied painting at Royal College of Art and Slade School of Art, London, mid-1920s. Trained in photography under Olivia Wyndham, London society portrait photographer, 1929. Worked on contract to *Harper's Bazaar*, photographing theatrical figures and society figures and events, from 1931. Also photographed "new intelligentsia" of England, including Frederick Ashton, Nancy Cunard, and David Garnett. Influenced by German cinema and avant-garde photography to experiment with posing and lighting, 1930s. Admired Helmar Lerski's book *Kopfe des Alltags* (*Everyday Faces*); began to make large close-ups of faces in her own portraits. Worked on photographic experiments with Brian Howard, 1930s. Did fashion photography for Jaeger and Elizabeth Arden while working with Colman Prentice Agency, 1930s. Abandoned still photography on eve of World War II; joined Larkin and Company, a film unit making instructional films for armed services. Withdrew from photography and film, 1947.

LEAH KING-SMITH

Born 1957, Gympie, Australia
Resides outside Brisbane, Australia
Multimedia photomontage. Received B.F.A. in photography, Victoria College, Melbourne, 1987; began Master of Arts program, Queensland University of Technology, Brisbane, 1998. Married to Duncan King-Smith, a musicologist; has two children. Known for Patterns of Connection series of dreamlike images featuring a mirror within which old photographs of Australian Aborigines are reflected; King-Smith then projected her own contemporary landscape photographs over the old photographs and painted over part of the landscape, 1990-91. Selected grants from the Stegley Foundation, Aboriginal Photograph Project, State Library of Victoria, Melbourne, 1989–90; Australia Council, for exhibitions at Victorian Centre for Photography, Melbourne,

and Camerawork Gallery, London, 1991–92; Overseas Travel grant, Aboriginal Arts Board of the Australia Council and Australian Centre for Photography, 1995; Australia Council fellowship, 1996; and Queensland Arts Office, ATSIA, and New Media Fund of the Australia Council for the Arts, 1997–98. Selected solo exhibitions at Victorian Centre for Photography, Melbourne, 1992; Australian Centre for Photography, Sydney, 1992; Camerawork Gallery, London, 1992; Southeast Museum of Photography, Daytona Beach, Florida, 1993; Webster University, Saint Louis, 1993; Embassy of Australia, Washington, D.C., 1993; New Zealand International Festival of the Arts, Wellington, 1994; Palmer Museum of Art, University Park, Pennsylvania, 1994; Adelaide Festival Centre, Adelaide, Australia, 1994; and Gallery Gabrielle Pizzi, Melbourne, 1994, 1995, and 1998.

MICHIKO KON

Born 1955, Kamakura, Japan
Resides Tokyo
Still lifes. Graduated from Sokei Art School, 1978. Attended Tokyo Photographic College, 1978–80. Became known for using such materials as raw fish, vegetables, and flowers to create objects or to transform ordinary objects like shoes, belts, jackets, and undergarments into surreal still lifes, 1980s on. Received Art Scholar prize, *Kanagawa Prefectural Art Exhibition,* 1984; New Artists prize, Higashikawa International Photography Festival, 1987; and Ihei Kimura Photography award, 1991. Recent solo exhibitions include *Michiko Kon: Still Life,* Gallery Raku, Kyoto University of Art and Design; and *Michiko Kon: Photographs 1998,* Photo Gallery International, Tokyo, 1998–99.

JILL KREMENTZ

Born 1940, New York City
Resides New York City
Documentation and portraits. Grew up in Morristown, New Jersey. Attended Drew University, Madison, New Jersey, 1958–59. Moved to New York City, 1959, intending to become journalist. Worked as secretary at *Harper's Bazaar;* became assistant to features editor at *Glamour,* early 1960s. Took pleasure trip around the world, 1960, with a camera. Upon return took job as reporter-photographer at *Show* magazine; *Show* went out of business, 1964. Hired by *New York Herald-Tribune* as their first female staff photographer, 1964–66.

Covered Winston Churchill's funeral in London, funeral of Freedom Riders in Mississippi, Paris fashion collections, etc. Took leave of absence to photograph war in Vietnam, 1965. Documented a black girl named Sweet Pea growing up in rural South, 1968. After brief stint with *Time* magazine decided to work independently and devote herself to photographing authors, 1970. Photographed over one thousand authors, including Saul Bellow, Jorge Luis Borges, Truman Capote, Lillian Hellman, Vladimir Nabokov, Katherine Anne Porter, Gore Vidal, and Tennessee Williams. Contributing photographer, *People,* since 1974. Continued writing and photographing for children's books, since 1976. Has published over a dozen books on subjects such as a young dancer, gymnast, circus flyer, gardener, musician, skier, and actress. Also created books on events and emotions in children's lives, dealing with issues of separation and loss. Married author Kurt Vonnegut, 1979; adopted Lily, 1983.

ANNELIESE KRETSCHMER

Born 1903, Dortmund, Germany
Died 1987, Dortmund, Germany
Portraits and still lifes. Maiden name unknown. Attended Kunstgewerbeschule, Munich, 1920–22. Studied in Essen with L. V. Kaenel, 1922–24. Studied in Dresden with Franz Fiedler, 1924–28. Married sculptor Sigmund Kretschmer in Dresden, 1928. They moved to Dortmund, 1934; opened photography studio that remained active until 1975. Work reproduced in European annuals of photography, 1930s.

BARBARA KRUGER

Born 1945, Newark, New Jersey
Resides New York City
Montages combining texts with found images. Attended Syracuse University, Syracuse, New York, through 1965; Parsons School of Design, New York, 1966. Worked for Condé Nast Publications as graphic designer and picture editor; became chief designer at *Mademoiselle.* Started making fiber art, 1969; painted abstractions, 1975. Stopped making art for a year, then started photographing and soon began incorporating words into her photographs. Has become known for photolithographs consisting of pronouncements dealing with economic power and male-female relationships. Works are large—six feet (1.8 meters) or more—and surrounded by red enamel frames.

Creative Artist Public Service (CAPS) award, 1976; National Endowment for the Arts fellowship, 1982; and New York Foundation for the Arts fellowship, 1985. Selected recent solo exhibitions at Mary Boone Gallery, New York, 1989, 1991, 1994, and 1997; Galerie Bebert, Rotterdam, the Netherlands, 1989; Fred Hoffman Gallery, Santa Monica, California, 1989; Duke University Museum of Art, Durham, North Carolina, 1990; Monika Spruth Galerie, Cologne, Germany, 1990; Rhona Hoffman Gallery, Chicago, 1990; Kölnischer Kunstverein, Cologne, Germany, 1990; Museum of Modern Art at Heide, Melbourne, Australia, 1996; Parrish Art Museum, Southampton, New York, 1998; Galerie Yvon Lambert, Paris, 1999; Museum of Contemporary Art, Los Angeles (major retrospective), 1999; and Whitney Museum of American Art, New York (major retrospective), 2000.

GERMAINE KRULL

Born 1897, Wilda-Poznań, Poland
Died 1985, Wetzlar, West Germany
Portraits and documentary work; also architectural, industrial, fashion, and advertising photography. Born to German parents. Studied photography at Bayerische Staatslehranstalt für Lichtbildwesen, Munich, Germany, 1916–18. Opened portrait studio in Munich, 1919; in Berlin, 1920. Free-lanced in the Netherlands, photographing architecture and industry, 1921–24. Married Dutch film-maker Joris Ivens, n.d. Free-lanced in Paris, doing advertising, fashion, and portrait photography, 1924–31; worked for *Vu, Arts et métiers graphiques, Marianne,* and other magazines. Industrial images reproduced in book *Métal,* 1927. Associated with BERENICE ABBOTT, André Gide, André Kertész, André Malraux, Man Ray, and other artists and writers. Represented in influential *Film und Foto* exhibition, Stuttgart, Germany, 1929. Lived in south of France after 1935 but made many trips in Europe, until 1939. Traveled to Rio de Janeiro, 1941. As part of war effort ran photography service for France Libre (Free France) in Brazzaville, Congo, Africa, 1941–43; worked in Algiers, 1943–44. Accredited as war correspondent by Allied headquarters. War correspondent for *Rafale, Libération,* and others; photographed in Italy, Indochina, and Germany, 1943–46. Entered France with U.S. Sixth Army, 1944. Left Europe after World War II; opened

Oriental Hotel in Bangkok, 1946. Also free-lanced; traveled extensively in Thailand, Burma, Nepal, India, Tibet, Europe, 1947–65. Lived among Tibetan refugees in northern India and was friend of Dalai Lama, 1965–early 1980s. Spent last years in Wetzlar.

DOROTHEA LANGE
Born 1895, Hoboken, New Jersey
Died 1965, San Francisco
Social documentation; also portraits. Born Dorothea Margaretta Nutzhorn; later took mother's maiden name, Lange. Polio, at age seven, left her with permanent limp. Hired by Arnold Genthe to work in his portrait studio, New York, c. 1913; then took various jobs in other studios. Studied photography under Clarence White at Columbia University, New York, 1917–18. Started to travel around the world hoping to make her living with a camera, 1918; stranded in San Francisco and opened portrait studio there, 1919. Married Maynard Dixon, painter of the West, 1920; had Daniel, 1925, and John, 1928. Continued with own photography and portrait commissions. Photographed bread line, 1932, in what turned out to be a pivotal work, *White Angel Bread Line*. Hired as photographer by Paul Taylor, professor of economics at University of California, who had been asked by California State Emergency Relief Administration to report on arrival of multitudes of migratory workers. Their joint report seen by Roy Stryker in Washington, D.C., who was helping to set up U.S. Resettlement Administration (RA; later renamed Farm Security Administration, or FSA), 1935. Lange transferred to RA payroll, 1935. Divorced Dixon and married Taylor, 1935. Traveled extensively for RA and FSA, photographing in every part of United States except New England, 1935–40. Awarded Guggenheim fellowship (the first to a woman), 1941. Photographed U.S. internment of Japanese-Americans, 1942. Created photo-essays for *Life* magazine and other publications, 1954–63. Before her death worked extensively on her major retrospective at Museum of Modern Art, New York, 1966. Major retrospective, San Francisco Museum of Modern Art (and tour), 1994; major exhibition, Oakland Museum, Oakland, California, 1995.

CONSTANCE STUART LARRABEE
Born 1914, Cornwall, England
Resides Chestertown, Maryland
Portraits, documentation, and photojournalism. Three months after her birth, family moved to Cape Town, South Africa; lived on tin mine in northern Transvaal. Moved to Pretoria, 1920. As a child, given Kodak Brownie camera. Attended Regent Street Polytechnic School of Photography, London; apprenticed in two portrait studios in Soho and Berkeley Square, 1933–35. Advanced studies at Bayerische Staatslehranstalt für Lichbildwesen, Munich, Germany; began using Rolleiflex camera, 1935–36. Established studio in Pretoria, 1936; opened second studio in Johannesburg, 1946. Began lifelong interest in photographing South Africa's vanishing ethnic cultures: Bushmen, Lovedu, Ndebele, Sotho, Swazi, Transkei, and Zulu, 1937. First of several solo exhibitions from 1940s through 1980s was *The Malay Quarter*, opened by Noël Coward in Pretoria, 1944. Became South Africa's first woman war correspondent, photographing for *Libertas* magazine, 1944–45. Served in Egypt, Italy, France, and England, 1944–45. Produced series on author Alan Paton and his book *Cry the Beloved Country*, 1948. Married Sterling Loop Larrabee of Warrenton, Virginia, United States military attaché to South Africa and other countries during World War II, 1949. Moved to farm near Chestertown, Maryland, 1950; became U.S. citizen, 1953. Free-lanced for *Life* magazine. Represented in Edward Steichen's *Family of Man* exhibition, Museum of Modern Art, New York, 1955. Solo exhibition, *World War II Photo Journal*, National Museum of Women in the Arts, Washington, D.C., 1989 (toured by Smithsonian Institution Traveling Exhibition Service [SITES] through 1994).

KRISTINE LARSEN
Born Alderwood Manor, Washington
Resides New York City
Photojournalism and portraits. B.A., Evergreen State College, Olympia, Washington, 1980. Free-lance photojournalist, 1980 to present. Also photographs for rap and rock-and-roll album covers. Work has appeared regularly in *Vogue, Village Voice, New York Times, Glamour, Rolling Stone, Metropolis, Ms., Seventeen, L.A. Weekly*, and elsewhere. Particularly known for photographic reportage published in *Village Voice*: "Tawana's Tough Town," 1988, a portrait of small-town Wappingers Falls, N.Y., in the wake of the purported kidnapping of Tawana Brawley; "Working Girls of Williamsburg," 1989, on drug-dependent street prostitutes; "The Unfit Mother," 1992, concerning a family divided by welfare bureaucracy. Published photographs of New York's homeless population, "Don't Look Now," in *Vogue*, 1988. Nine One One Arts Center, Work-in-Progress grant, New York, 1984. Selected recent solo exhibitions include *Kristine Larsen*, Martin Weber Gallery, San Francisco, 1986; and *Rolling the Bowl*, Easton Academy of the Arts, Easton, Maryland, 1992 (on the subculture of small-town, car-oriented teenagers in farm-country Maryland).

ALMA LAVENSON
Born 1897, San Francisco
Died 1989, Piedmont, California
Primarily still lifes and industrial and architectural images as personal expression. Born Alma Ruth Lavenson. Family moved to Oakland after San Francisco earthquake, 1906. B.A. in psychology, University of California, Berkeley, 1919. Took seven-month grand tour of Europe with family and began making tourist photographs, 1922. Early work exhibited at Pictorialist salons, 1920s. Met and was influenced by IMOGEN CUNNINGHAM, CONSUELO KANAGA, and Edward Weston, 1930. Although not a founding member of Group f/64, was represented in group's first exhibition, at M. H. de Young Memorial Museum, San Francisco, 1932. Married Matt Wahrhaftig, a lawyer, 1933; had Albert, 1935, and Paul, 1938. One-woman shows at the de Young and Brooklyn Museum, 1933. Began photographing ghost towns of Old West, c. 1933. Family moved to Piedmont, California, 1935. Alma received award at First Annual West of the Rockies Photographic Salon, San Francisco Museum of Art, 1941. Photographs published in Sydney B. Mitchell's book, *Your California Garden and Mine*, 1947. Represented in Edward Steichen's *Family of Man* exhibition, Museum of Modern Art, New York, 1955. Husband died, 1957. Alma represented in *F.64 and Before* exhibition, Oakland Museum, 1966. Traveled and photographed in Europe, Latin America, Asia, and elsewhere, 1960s and 1970s. Retrospective exhibitions, California Museum of Photography, University of California, Riverside, 1979; and Friends of Photography, Carmel, California, 1992.

ANNIE LEIBOVITZ
Born 1949, Westbury, Connecticut
Resides New York City
Portraits and advertising images. Began photographing for *Rolling Stone* magazine while a student of painting and photography at San Francisco Art Institute, 1970. B.F.A., San Francisco Art Institute, 1971. Officially became *Rolling Stone*'s chief photographer, 1973; known for striking portraits published there and elsewhere. Commissioned by rock-music group, the Rolling Stones, to document their concert tour, 1975. Worked on prototype of *Vanity Fair* magazine, 1981; became first contributing photographer, 1983. First solo exhibition, Sidney Janis Gallery, New York, 1985, also in 1989; both shows traveled in United States. Grammy award for Album Cover of the Year, 1983. Photographer of the Year award, American Society of Magazine Photographers, 1984. Series of posters for 1986 World Cup, Mexico, 1985. Exhibited at Rencontres Internationales de la Photographie, Arles, France, 1986. Created Portraits advertising campaign for American Express, 1987; it won Clio award and *Ad Age* Campaign of the Decade. Innovation in Photography award from American Society of Magazine Photographers, 1987. Commissioned by The Gap to create portraits for their Individuals of Style advertising campaign, 1988. Infinity Award in Applied Photography, International Center of Photography, New York, 1989. Commissioned by American Ballet Theater, New York, to do portraits for company's fiftieth-anniversary-tour book, 1989; documented White Oak Dance Project by dancers Mikhail Baryshnikov and Mark Morris, 1990. Series of artists' portraits for Mary Boone Gallery, New York, 1990. Major retrospective at International Center of Photography, New York, in conjunction with National Portrait Gallery, Smithsonian Institution, Washington, D.C., 1991 (international tour through 1996). Solo exhibition of White Oak Dance Project, James Danziger Gallery, New York, 1991. Major exhibition, *Women*, Corcoran Gallery of Art, Washington, D.C., 1999.

ERNA LENDVAI-DIRCKSEN
Born 1883, Wetterburg, Germany
Died 1962, Coburg, Germany
Portraits, landscapes, and photographs of vernacular architecture. Studied photography at Lette Haus, Berlin, 1910. Began photographic magnum opus, documenting the peasants, landscape, and popular architecture of all German regions, 1911; continued through World War II. Opened extremely successful portrait studio in Berlin, 1916; photographed many people prominent in German politics and culture. Became member of German photographic society, Gesellschaft Deutscher Lichtbildner (GDL), 1924. Published series of books between 1930 and 1944, first under series title of *Das deutsche Volksgesicht* (*German Folk Faces*) and, in the 1940s, as *Das germanische Volksgesicht* (*Germanic Folk Faces*); introductory texts to books emphasized unity and community as necessary to achieving goal of Germanic Europe. Became a formal member of the Nazi party, n.d. Studio and archives destroyed in air raid, 1943. Lived in Upper Silesia, 1943–45. Moved to Coburg, 1946. Began photographing landscapes, emphasizing mineral formations, traveling in Denmark and Brittany, France. Received the GDL's David Octavius Hill Medal for her life's work, 1953. Published last picture book, *Urgestalt in Kreide und Granite* (*Archetype in Chalk and Granite*), 1960. Published biographical volume, *Ein deutsches Menschenbild* (*Image of German People*), 1961.

REBECCA LEPKOFF
Born 1916, New York City
Resides New York City
Urban documentation. Known for photographs of New York City in 1940s–1950s, particularly of Jewish immigrants on Lower East Side. Born Rebecca Brody. B.A. in education, City College of New York, 1938. Participated in National Youth Administration photography program, 1939–41. Married Eugene Lepkoff, 1941; had Daniel, 1950; Jesse, 1952; and Tammy, 1962. Became member of Photo League, c. 1945; served on executive committee. Attended classes at Photo League, 1945–49, studying under Sid Grossman, Paul Strand, and Dan Weiner; participated in group exhibitions at Photo League. Photographed village life in Oaxaca, Mexico, 1945. Founded photography school at Educational Alliance, New York, 1947. Photographed Hispanic life on Lower East Side, 1950s, and in East Village, New

York, 1980s. Photographed effects of pollution on a river in Vermont, 1960s. Created portfolio of photographs for Daniel Wolf Gallery, New York, 1978. Solo exhibitions at Marcuse Pfeifer Gallery, New York, 1979; and Henry Street Settlement, New York, 1984 and 1985. Represented in group exhibition about Photo League, International Center of Photography, New York, 1979. Represented in group exhibitions at Howard Greenberg Gallery, New York, 1989 and 1993; *The Photo League*, Galería Telefónica, Madrid, 1999; another exhibition on the Photo League at John Cleary Gallery, Houston, 2000; and a forthcoming major show on the Photo League organized by the Stephen Daiter Gallery, Chicago, with book and nationwide tour, 2000–2001. Featured in video, *New York in the Fifties*, produced by David Cannon, 1993.

HELEN LEVITT
Born 1913, Brooklyn, New York
Resides New York City
Urban documentation. Born in Italian-Jewish neighborhood of Bensonhurst in Brooklyn; her family came from both heritages. Left high school one month before graduation, 1930. Worked for portrait photographer in the Bronx, 1931. Visited Photo League and used darkroom, 1930s. Met Willard Van Dyke, Ben Maddow, and other photographers. Strongly influenced by contact with Henri Cartier-Bresson, who lived in New York during 1935. Immersed herself in museum exhibitions, dance performances, and foreign films. Purchased lightweight Leica camera, 1936; photographed on street. Taught art to East Harlem children under Federal Art Project, 1937; began photographing children at play. Showed photographs to Walker Evans and James Agee, 1938; helped Evans with his exhibition *American Photographs* at Museum of Modern Art, 1938. Traveled to Mexico with Agee's wife, Alma Agee, 1941. Upon return took job as assistant film cutter with director Luis Buñuel, who was making pro-American propaganda films sponsored by Museum of Modern Art, New York. Worked as assistant editor in Film Division of Office of War Information, 1944–45. With Agee and painter–art historian Janice Loeb did film *In the Street*, 1945–46. With Loeb and Sidney Myers, did film *The Quiet One* (with commentary by Agee), about a troubled black child, 1946–47. After more than a decade of working in film, returned to still photography, 1959, using

color. Guggenheim fellowships, 1959, 1960, and 1981; New York State Council on the Arts Creative Artist's grant, 1974; National Endowment for the Arts Photography fellowship, 1976; Friends of Photography Peer Award for Distinguished Career in Photography, 1987; Master of Photography award, International Center of Photography, New York, 1997; and Outstanding Achievement in Humanistic Photography, Photographic Administrators, 1997. Taught at Pratt Institute, Brooklyn, mid-1970s. Returned to black-and-white, 1980s; presently uses both. Later photographs feature East Village, Lower East Side, and garment district of New York. Selected recent solo exhibitions at Laurence Miller Gallery, New York, 1987, 1989, 1991, 1992, and 1996; Fraenkel Gallery, San Francisco, 1990, 1994, and 1996; San Francisco Museum of Modern Art and Metropolitan Museum of Art, New York (and tour), 1992; Seattle Art Museum, 1993; and International Center of Photography, Midtown, New York (and tour), 1997.

ALICE LEX-NERLINGER
Born 1893, Berlin
Died 1975, East Berlin
Experimental work, frequently with photomontage. Studied art under Emil Orlik, Gewerbemuseum, Berlin, 1911–16. Worked as free-lance artist. Married painter-photographer Oscar Nerlinger, 1919. Joined group Die Zeitgemässen (The Contemporaries). Joined ASSO (Association for the Revolutionary Creative Artists of Germany). Created anti-Fascist art for political posters and brochures. Represented in a group show at Julien Levy Gallery, New York, 1932. Persecuted by Nazis and forbidden to work, 1933–45. After World War II continued as free-lance commercial artist, East Berlin.

MARTINA LOPEZ
Born 1962, Seattle
Resides Michigan City, Indiana
Digitally assisted photomontage. Born the seventh of eight children to first-generation Mexican-American parents; grew up in Seattle. Made drawings and paintings from an early age. Intended to become an engineer but instead took art course upon entering the University of Washington, Seattle, 1981. Received B.F.A., University of Washington, with a major in photography, 1985. Following death of father, 1986 (her brother had died in Vietnam in

1966), she turned to family photo album to review the past and was struck by the differences between her memories and the story told by pictures. Began to use computer to document family history with photomontage; also included images of other people to create a collective history accessible to viewers, late 1980s. Received M.F.A., School of the Art Institute of Chicago, 1990. Assistant professor of photography, University of Notre Dame, Notre Dame, Indiana, 1993–present. Married Dean Jacobson, film director and director of photography, 1994; had daughter Alexandra, 1997. Awards include Ruttenberg Foundation award, Friends of Photography, San Francisco, 1990; Arts Midwest/National Endowment for the Arts Regional Visual Arts fellowship, Chicago, 1991; Illinois Arts Council, Artist fellowship, Chicago, 1992 and 1996; and National Endowment for the Arts Visual Arts fellowship, 1992–93. Recent one- and two-person exhibitions: University of Toledo, Department of Art, Center for the Visual Arts, Toledo, Ohio, 1994; *Memory/Reference: The Digital Photography of Martina Lopez*, Art Institute of Chicago, 1995–96; *Martina Lopez: In the Way of Tradition*, Edwin A. Ulrich Museum of Art, Wichita State University, Wichita, Kansas, 1996; *Poetic Pasts: The Digital Photography of Martina Lopez*, Cleveland Museum of Art, 1997; and South Bend Regional Museum of Art, South Bend, Indiana, 2000.

RUTH HARRIET LOUISE
Born 1906, Brooklyn, New York
Died 1944, possibly California
Portraits. Born Ruth Harriet Louise Sandrich; dropped family name when she went into photography business at age seventeen. Opened commercial photography studio in New York City, 1923. Opened studio in Hollywood; became contract photographer at MGM Studios, 1925. Head of own portrait gallery at MGM, only woman to hold that post full time at a major studio, 1925–30. Became Greta Garbo's exclusive studio portrait photographer, through 1929. Asked by William Randolph Hearst to photograph Marion Davies, c. 1926. Known for sensitivity she evoked in her subjects' expressions and gestures. Photographed Lon Chaney, Joan Crawford, Ramon Novarro, Anna May Wong, and others. Married film director Leigh Jason, 1930. Free-lanced, photographing performers not under studio contracts, 1930 on.

FRANCES MCLAUGHLIN-GILL
Born 1919, New York City
Resides New York City
Fashion, advertising, and still lifes; also films. Began to pursue photography seriously at age eighteen. B.F.A. in art and design, Pratt Institute, Brooklyn, 1941. Studied painting at New School for Social Research and Art Students League, New York, 1940–42. Won *Vogue* magazine's Prix de Paris contest, 1941; worked on photography staff of Condé Nast magazines, 1944–54. Assignments included covers and editorial pages for *Vogue*, *Glamour*, and *House and Garden*; produced photographs of theater and film personalities, fashion and beauty shots, still lifes, portraits, and travel reportage in United States and abroad. Married photographer and artist Leslie Gill, 1948; had daughter Leslie, 1957. Husband died, 1958. Frances worked as independent film producer and director, 1964–73; made television commercials for Johnson and Johnson, Procter and Gamble, Lever Brothers, Revlon, Breck, and others. Won gold medal at International Film and Television Festival, New York, 1969, for *Cover Girl: New Face in Focus*, a one-hour film commissioned by Cover Girl make-up. Has taught photography seminars at School of Visual Arts, New York, since 1978. Published book *Twins on Twins* with her twin sister, KATHRYN ABBE, 1980. Continued doing photography for magazines, through 1985.

WENDY SNYDER MACNEIL
Born 1943, Boston
Resides Lincoln, Massachusetts
Primarily portraits. B.A. in history, Smith College, Northampton, Massachusetts, 1965. Special student in photography with Minor White, Massachusetts Institute of Technology, Cambridge, 1966–68. M.A., visual studies, Harvard University, Cambridge, 1967. Assistant professor of art, Wellesley College, Wellesley, Massachusetts, 1973–85; part-time faculty member, photography department, Rhode Island School of Design, Providence, 1976–present. Known for "straight" photographs in which she examines self and personal relationships. Guggenheim fellowship in photography, 1973–74; National Endowment for the Arts fellowships, 1974–75, 1978–79, and 1991; Massachusetts Arts and Humanities Foundation Photography fellowship, 1975–76; and National Endowment for the Arts/American

Film Institute New England Regional Film/Video fellowship, 1991. Selected recent solo exhibitions at Los Angeles County Museum of Art, 1984; Center for Contemporary Arts, Santa Fe, New Mexico, 1986; Ryerson Polytechnic Institute, Toronto, 1984 and 1988; Houston Center for Photography, Gallery X, 1990; and Museum of Contemporary Photography, Chicago, 1991.

ROSE MANDEL
Born 1910, Czaniec, Poland
Resides Berkeley, California
Abstractions, still lifes, portraits; also architectural documentation. Born Rose Reich. Married Arthur Mandel, early 1930s. Spent two and a half years in the Paris art world, 1930s. Of Jewish background, was torn between staying in Poland to help mobilize against the Nazis and traveling to Switzerland to find her husband, who was stranded there; went to Switzerland, 1939. Attended Institut des Sciences de l'Education; studied child psychology with Jean Piaget. After graduation, taught kindergarten and experimental school. Emigrated with husband to United States, 1942; settled in California. Unable to teach in U.S. because she did not speak English well. Met Edward Weston and decided to become photographer, 1945. He directed her to first photography classes given by Ansel Adams and Minor White at California School of Fine Arts (now San Francisco Art Institute), 1946–47; White, in particular, influenced her. Staff photographer for Art Department at University of California, Berkeley, 1948–67. First major solo exhibition, comprising sequence of twenty photographs, was *On Walls and behind Glass*, San Francisco Museum of Art, 1948. Guggenheim fellowship, 1967. Stopped photographing, late 1970s, to care for terminally ill husband, who died in 1983. Retrospective, Art Institute of Chicago, 1992–93. Group exhibitions: *Watkins to Weston: 101 Years of California Photography, 1849–1950*, Santa Barbara Museum of Art, Santa Barbara, California (and tour), 1992–93; *Pacific Dreams: Currents of Surrealism and Fantasy in California Art, 1934–57*, organized by U.C.L.A. at Armand Hammer Museum of Art and Cultural Center, Los Angeles (and tour), 1995; *Facing Eden: 100 Years of Landscape Art in the Bay Area*, Fine Arts Museums of San Francisco, 1995; *From Dry Plate to Digital: Photographs from the Hallmark Cards, Inc., Collection*, Kansas City, Missouri, 1999.

SALLY MANN
Born 1951, Lexington, Virginia
Resides Lexington
Portraits and family scenes. Born Sally Munger. Attended Bennington College, Bennington, Vermont, 1969–71. B.A., 1974, and M.A. in writing, 1975, Hollins College, Hollins College, Virginia, 1972–75. Married Larry Mann, 1970; had Emmett, 1979; Jessie, 1981; Virginia, 1985. National Endowment for the Humanities grants, 1973 and 1976; Ferguson grant, Friends of Photography, Carmel, California, 1974; Virginia Museum of Fine Arts Professional fellowship, 1982; National Endowment for the Arts fellowships, 1982, 1988, and 1992; Guggenheim fellowship, 1987; and Photographer of the Year award, Friends of Photography, San Francisco, 1995. Series of family portraits culminated in book, *Immediate Family*, and solo exhibitions of same title at Institute of Contemporary Art, Philadelphia, and Houk Friedman, New York, all 1992. Other selected recent solo exhibitions at Museum of Contemporary Photography, Chicago, and Photo Gallery International, Tokyo, both 1993; Barbican Art Gallery, London, and Contemporary Museum, Honolulu, both 1994; Picture Photo Space, Tokyo, 1996; Jane Jackson Gallery, Atlanta, 1996 and 1999; Christian Larsen, Stockholm, 1996; Edwynn Houk Gallery, New York, 1997 and 1999; University of Texas, Austin, 1998; Bowdoin College Museum of Art, Bowdoin, Maine, 1998; PhotoEspaña '98, Madrid, 1998; and Mount Holyoke College Art Museum, Mount Holyoke, Massachusetts, 1999.

MARY ELLEN MARK
Born 1940, Philadelphia
Resides New York City
Documentation and photojournalism. B.F.A. in art and art history, University of Pennsylvania, Philadelphia, 1962; M.S. in photojournalism, Annenberg School of Communications, University of Pennsylvania, 1964. Photographed in Turkey on Fulbright scholarship, 1965–66. Free-lanced in New York, 1966. Photographed in India, 1968, developing a lifelong interest in that country. Taught at Maine Photographic Workshop, Rockport, 1974; since then has taught numerous workshops in documentary photography, United States and abroad. Grant from U.S. Information Agency to lecture and exhibit work in Yugoslavia, 1975. Became associate member of Magnum Photos, 1976;

full member, 1977. Did series on hospital for the mentally ill; resulted in book, *Ward 81*, 1979. National Endowment for the Arts grant and Creative Artists Public Service (CAPS) grant, New York, both 1977. Photographed Mother Teresa in Calcutta, 1979–80; story appeared in *Life*, 1980. Page One Award for Excellence in Journalism, Newspaper Guild of New York, 1979. Other awards include 1982 Leica medal for excellence for book on prostitutes of India, *Falkland Road*; Philippe Halsman award for photojournalism from American Society of Magazine Photographers, 1986; named Photographer of the Year by Friends of Photography, Carmel, California, 1987; and received World Press award for outstanding life's work, 1988. Left Magnum, 1981; became a cofounder of cooperative Archive Agency. Associate producer of film, *American Heart*, directed by her husband, Martin Bell, 1992. Has published eleven books, most recently *Mary Ellen Mark: American Odyssey*, 1999, with exhibition originating at Philadelphia Museum of Art (and international tour), 2000.

MARUCHA
(MARIA EUGENIA HAYA)
Born 1944, Havana
Died 1991, Havana
Documentation. Studied history of photography under Mario Rodríguez Alemán at Instituto Cubano de Arte e Industria Cinematográfica, Havana, 1962–63; photographic theory with Adelaida de Juan at Biblioteca Nacional de José Martí, Havana, 1964–65; and graphic design with painter Raúl Martínez, 1965–66. Cartoon artist and animator with Instituto Cubano de Arte e Industria Cinematográfica, 1962–64; photographer for Chamber of Congress, Havana, 1970–78; and researcher and script supervisor with film-maker Tomás Gutierrez Alea, 1975 and 1978. Studied philology at Havana University, 1972–78. Married to Mario García Joya, director of photography at Instituto Cubano de Arte e Industria Cinematográfica; had Mayitín and María. Marucha organized history of Cuban photography exhibition in Mexico, 1979. Member of Unión Nacional de Escritores y Artistas Cubanos; won first prize in union's National Salon, 1978. Won first prize at National Salon, University of Havana, 1978. Pivotal organizer of Coloquio de Fotografía Latinoamericano, Havana, 1984.

MARGRETHE MATHER

Born c. 1885, in or near Salt Lake City
Died 1952, Glendale, California
Portraits, still lifes, and nudes. Adopted from
an orphanage by a professor of mathematics
named Mather and his common-law wife.
To escape unhappy home situation, as young
teenager Margrethe took train to San Francisco;
supported herself as prostitute, c. 1910. Began
lesbian liaison in Los Angeles with "Beau,"
who became her wealthy protector and edu-
cated her taste, c. 1911. Met photographer
Edward Weston, c. 1912–13, probably at Los
Angeles Camera Club; they worked together
in a small but prestigious studio in Glendale,
1914. According to Weston's diary, they
became lovers right before his departure for
Mexico, 1922. Margrethe continued commer-
cial photography through 1930, doing portraits
and work for interior decorators. Exhibited at
Sixth Pittsburgh Salon, where work was well
received, 1919; at Eighth Pittsburgh Salon,
1921. Participated in *Frederick and Nelson
Exhibition*, Seattle, 1919, and in Oakland
Photographic Salon, Oakland, California,
1921. Published in *American Photography* and
Camera Craft, 1919–21. Had platonic friend-
ship and lived with artist and designer William
Justema, 1923–27. Ran a gift shop for a
friend, "Rita," c. 1926. Worked in antique and
upholstery business of friend George Lipton,
1928–29, who cared for her in her declining
years. With Justema, created *Patterns by
Photography* show for M. H. de Young Memorial
Museum, San Francisco, 1931. Occasionally
made portraits of friends, 1934–52. Died of
multiple sclerosis.

HANNAH MAYNARD

Born 1834, England
Died 1918, probably Victoria, Canada
Portraits; also documentation of Canadian
environment and allegorical studies. Born
Hannah Hatherly. Married Richard James
Maynard, a shoemaker, in England, 1852; had
five children by 1867. Moved to Bowmanville,
Canada, in early 1850s. Richard went to
British Columbia, 1859, after hearing that
gold had been discovered in Fraser River.
Meanwhile, Hannah learned photography for
a trade. Upon Richard's return, c. 1860, they
made plans to settle permanently in Victoria.
Hannah opened photography studio there, 1862,
and Richard established boot and shoe store.
Richard learned photography by 1866. They
made numerous photographic trips, together
and singly, to Vancouver Island; Barkerville,
England; San Francisco; Alaska; Queen
Charlotte Islands of British Columbia; and
locations along the Canadian Pacific Railway.
Richard died, 1907. Hannah's work consisted
mainly of portraits, but she also went into the
field to photograph views of Canada. Also
made multiple-exposure allegorical tableaux
with grandson and herself, 1890s.

SUSAN MEISELAS

Born 1948, Baltimore
Resides New York City
Documentation and photojournalism. B.A.,
Sarah Lawrence College, Bronxville, New York,
1970; M.A. in education, Harvard University,
Cambridge, Massachusetts, 1971. Assistant
editor on Frederick Wiseman's film *Basic
Training*, 1971; photography adviser for
Community Resources Institute of New York
City Public Schools, 1972–74; and consultant
to Polaroid Corporation, hired to produce
source book of teaching ideas and projects
using Polaroid photography in the classroom,
1974–75. Her first major photographic essay
resulted in book *Carnival Strippers*, 1976. Became
associate member of Magnum Photos, 1977;
full member, 1980. Photographed civil strife
in Central America, on and off, 1978–1980s.
Edited book *Chile from Within*, regarding work
of Chilean photographers, 1990. Has published
photographs in *New York Times Magazine*, *London
Sunday Times*, *Geo*, *Time*, *Paris Match*, and *Machete*.
For her work in Nicaragua received Robert
Capa Gold Medal from Overseas Press Club,
1978. Leica Medal for Excellence, 1982;
Photojournalist of the Year award from
American Society of Magazine Photographers,
1982; Engelhard award from Institute of
Contemporary Art, Boston, 1985; National
Endowment for the Arts fellowship in photog-
raphy, 1984; MacArthur fellowship, 1992;
Erna and Victor Hasselblad award, 1994;
Rockefeller Foundation, Multimedia fellowship,
1995 and 1999; and News and Documentary
Emmy award, Electronic Cameraperson, 1997.
Solo exhibition at Leica Gallery, New York,
1998. Wrote book on history of Kurdistan in
photographs, *Kurdistan: In the Shadow of History*,
1997. Also created interactive Web site on
Kurdistan.

ANNETTE MESSAGER

Born 1943, Berck, France
Resides Malakoff (outside Paris), France
Multimedia presentations. Father, an architect,
encouraged Messager and her brother in the
arts. She enrolled in Ecole des Arts Décoratifs,
Paris, early 1960s; did not stay for graduation.
Her mother entered one of Annette's pho-
tographs in a Kodak contest; it won the grand
prize, a trip around the world, which Annette
took in 1964. French student rebellion of May
1968 was a turning point for her, giving her
the idea that art should be in the streets, not
museums. Not interested in radical feminism
at the time, although began to feel that being a
woman was closely linked to her art; explored
theme of woman as victim. Felt close to
Surrealists. Galerie Germain, Paris, asked her
to take part in exhibition with the theme of
wool, 1971; she knitted a wool wrap for a dead
sparrow. This led to series Les Pensionnaires
(The Boarders), with taxidermized birds wrapped
in wool, 1971–72. Earliest work incorporating
photographs are album collections, consisting
of small handwritten notebooks filled with
drawings, writing, and photos, c. 1971–74.
Became interested in work by Fluxus artists,
late 1960s and 1970s, and in Joseph Beuys,
1970s. Created series Chimères (Chimeras) in
which photography is combined with painting
on grand scale, early 1980s. Created series Mes
Voeux (My Vows) of many small black-and-
white photos (in acrylic and glass) of body
parts, hung close together by strings, 1988.
Messager's work encompasses painting, pho-
tography (hers and others'), sculpture, writing,
assemblage, collage, and cinematic montage.
Recent solo exhibitions at Musée de Grenoble,
Grenoble, France (and tour), 1989; Saint-
Martin du Méjean, Arles, France, 1989;
Galerie Crousel-Robelin BAMA, Paris, 1989
and 1990; Musée Départemental, Château de
Rochechouart, France, 1990; Galerie Wanda
Reiff, Maastricht, the Netherlands, 1991;
Mercer Union and Cold City Gallery, Toronto
(and tour), 1991; Kunstverein, Salzburg, Austria,
1992; University of Iowa Museum of Art,
Iowa City, 1992; Monika Sprüth, Cologne,
Germany, 1992 and 1994; Arnolfini, Bristol,
England, and Cornerhouse, Manchester,
England (and tour), 1992; Fonde Régional
d'Art Contemporain Picardie, Amiens, France,
1993; Josh Baer Gallery, New York, 1993;
Galerie Elisabeth Kaufmann, Basel, Switzerland,
1994; Musée d'Art Moderne de la Ville de

Paris, 1995; Museum of Modern Art, New York, Los Angeles County Museum of Art, and Art Institute of Chicago, 1995–96; and David Winton Bell Gallery, List Art Center, Brown University, Providence, Rhode Island, 1998.

HANSEL MIETH

Born 1909, Oppelsbohm, Germany
Died 1998, Santa Rosa, California
Photojournalism and social documentation. At age fifteen met local boy Otto Hagel in Fellbach, Germany; he persuaded her to run away with him to find "truth in life." They traveled to Vienna, Yugoslavia, Romania, Bulgaria, and Turkey; sold snapshots to newspapers, 1920s. Determined to leave Germany for United States; Otto arrived there in 1928; Hansel, 1930. Her first still photographs in U.S. were of "Hoovervilles"—shantytowns made by the homeless during the Great Depression. She got job with Works Progress Administration, first as seamstress then as photographer. *Life* hired her, and she moved to New York, 1937 (until 1941); did photo stories on birth control, yellow fever, mining, divorcees in Reno, social security, and animal experimentation, among others. She and Otto married, 1941; purchased sheep ranch near Glen Ellen, California, 1940s. Hansel worked out of *Life's* San Francisco office (through 1950); Otto worked for *Fortune* and other publications. They returned to photograph Fellbach after war; found only a few living relatives; published "We Return to Fellbach" in *Life*, 1950. During McCarthy era found themselves subject to political suspicion and lost work. Began breeding livestock on their farm. Otto died, 1974. Solo exhibition, International Center of Photography, Midtown, New York, 1994. A major exhibition tentatively titled *Where We Stand*, with work by Hansel Mieth and Otto Hagel, will originate at Santa Barbara Museum, Santa Barbara, California (with tour and book), post 2000. A documentary film on the life of Hansel Mieth, directed by Nancy Schiesari, is scheduled to appear in fall 2000.

LEE MILLER

Born 1907, Poughkeepsie, New York
Died 1977, Chiddingly, England
Documentation, portraits, and fashion. Trained in photography by father, who was engineer and inventor as well as amateur photographer. Visited Paris, 1925. Lived in New York City, 1927. Modeled; appeared on cover of *Vogue*; also photographed by Arnold Genthe, Nickolas Muray, and Edward Steichen. Studied painting, theatrical design, and lighting at Art Students League, 1927–29. Went to Paris, 1929; studied with Man Ray and entered into liaison with him. Also met André Breton, Paul Eluard, and Max Ernst. Appeared as armless statue in Jean Cocteau's film *Le Sang d'un poete* (*Blood of a Poet*), 1931. Returned to United States, 1932; exhibited at Julien Levy Gallery, New York, 1933. Ran own photography studio, 1932–33, and made portraits of Joseph Cornell, Gertrude Lawrence, Virgil Thomson, and others. Married Egyptian businessman Aziz Eloui Bey, 1934; separated, 1939; divorced, 1947; lived in Egypt and Europe, 1934–39. Began liaison with art connoisseur and future author Roland Penrose, 1937, and left Bey to live in England with Penrose. Fashion photographer for *Vogue*, London, 1940; also photographed London during the Blitz for *Vogue*. Became official war correspondent for U.S. forces, 1942; accompanied Allied troops through Europe, photographing liberation of Paris and of Dachau and Buchenwald concentration camps, 1944. Married Penrose, 1947; had Antony, 1947. Free-lance journalist and photographer working for British, French, and American editions of *Vogue*, based in Chiddingly, Sussex, 1946–54. Stopped photographing, 1954. Selected recent solo exhibitions include *The Lives of Lee Miller*, Staley-Wise Gallery, New York, 1985; retrospective at Photographers' Gallery, London, 1986; and a retrospective at San Francisco Museum of Modern Art (and tour), 1987.

MARGARETTA K. MITCHELL

Born 1935, Brooklyn, New York
Resides Berkeley, California
Dance photography, flower studies, and portraits; also nudes. B.A., Smith College, 1957. Attended Boston Museum School, 1958–59, and Escuela de Bellas Artes, Madrid, 1959–60. M.A., University of California, Berkeley, 1985. Set up first darkroom, Berkeley, 1960. Research assistant to Dr. Edwin Land, founder and

president of Polaroid Corporation; experimented with Polaroid process, 1957–59. Discovered the Temple of Wings in Berkeley, where Sulgwynn Quitzow (daughter of Florence Boynton, who had been a close friend of Isadora Duncan) taught Duncan-style dancing, early 1960s; produced body of work on the subject, culminating in portfolio of gravure prints, *Dance for Life*, published by Mitchell's own press, Elysian Editions, Berkeley, 1985. Began flower studies, 1960; produced two portfolios of them: Ed Hill Editions, 1982–83, and Elysian Editions, 1991. Also known as writer, lecturer, and curator on photography. Cowrote *To a Cabin* with DOROTHEA LANGE, 1973. Received National Endowment for the Arts grant, 1978–79, to work on book and traveling exhibition, *Recollections: Ten Women of Photography*, sponsored by International Center of Photography, New York. Recent solo exhibition at Witkin Gallery, New York, 1996; and *English Gardens*, Wave Hill, New York, 1996. Frequently writes photographic criticism and history for magazines. Wrote biography *Ruth Bernhard: Between Art and Life*, 2000.

LISETTE MODEL

Born 1901, Vienna
Died 1983, New York City
Street photographs; also fashion images. Born Elise Amelie Felicie Stern (family changed its name to Seybert, 1903). Father was Austrian-Italian physician and musician; mother was French. Studied music with Arnold Schoenberg and became friend of his family, 1918–20. Continued music and voice studies in Paris, 1922. Began to paint, 1932. Married Russian painter, Evsa Model, 1936. Began photographing and learning darkroom technique with the hope of making a living as a laboratory technician, 1937. Also began photographing for pleasure and produced well-known series about rich people idling on Promenade des Anglais in Nice, France, on eve of war. Visited New York City and decided to stay there, 1938. Photographs published by Ralph Steiner, picture editor of *PM* newspaper, who showed them to Alexey Brodovitch, art director of *Harper's Bazaar*, 1940. Beaumont Newhall put her work in *Sixty Photographs: A Survey of Camera Esthetics*, Museum of Modern Art, New York, 1940, and introduced her to prominent photographers. Free-lance photographer for *Harper's Bazaar*, 1941–53, and other publications. Taught photography at New School for

Social Research, New York, 1951–82, and also taught privately. Students included DIANE ARBUS, 1955–57, and ROSALIND SOLOMON, 1974–76. Guggenheim fellowship, 1965; Creative Artists Public Service (CAPS) grant, 1973. Continued photographing intermittently and lecturing throughout United States and abroad until near end of her life. Husband died, 1976. Honorary doctorate from New School for Social Research, New York, 1981. Retrospectives at New Orleans Museum of Art (and tour), 1981; and National Gallery of Canada, Ottawa (and tour), 1990.

ANDREA MODICA
Born 1960, Brooklyn, New York
Resides Manitou Springs, Colorado
Portraits and landscapes. Attended Brooklyn Museum Art School, Alfred Harcourt Foundation Scholarship Program in the Fine Arts, 1978. B.F.A. in visual arts and art history, with honors, State University of New York College at Purchase, 1982. M.F.A. in photography, Ward Chaney Award for Outstanding Achievement, Yale University School of Art, New Haven, Connecticut, 1985. At Purchase she painted and sculpted; was encouraged by teacher Jed Devine to make palladium and platinum photographic prints from the negatives she created with an 8-by-10-in. view camera, c. 1982. Began career as elementary school teacher, 1983; also, Yale University School of Art, New Haven, teaching assistant for intermediate photography, 1984; Parsons School of Design, New York, instructor of alternative printing processes and life drawing, 1984–85; Colorado College, Colorado Springs, visiting professor for basic photography and intermediate photography, 1995–98; and State University of New York College at Oneonta, associate professor of art, teaching photography and the history of photography, drawing, and two-dimensional design, 1985–98. Began photographing a family in Treadwell (population 200), upstate New York, c. 1985; family moved elsewhere, but Modica continued photographing them, while retaining the name Treadwell for the series. Married Paul Myrow, 1998. Recent grants include New York State Foundation for the Arts fellowship, 1988; Center for Photography at Woodstock Photographer's Fund award, 1988; New York State Council of the Arts, Decentralization grant, 1989 and 1996; Fulbright-Hays Research grant, Italy, 1990; Polaroid Artist

Support Material grant, 1991; Aaron Siskind Foundation Individual Photographer's grant, 1991; Jean Pearce Walker award, 1992; Guggenheim fellowship, 1994; New York Foundation for the Arts, Special Opportunities Stipends, 1995; and Colorado Council on the Arts Visual Arts Fellowship award, 2000. Recent solo exhibitions at Palazzo d'Accursio, Museo Morandi, Bologna, Italy, 1997; Cleveland Museum of Art, 1998; O'Sullivan Arts Center, Regis University Art Museum, Denver, 1999; and Edwynn Houk Gallery, New York, 1999.

TINA MODOTTI
Born 1896, Udine, Italy
Died 1942, Mexico City
Portraits, still lifes, and documentary work. Born Assunta Adelaide Luigia Modotti Mondini (nicknamed Assuntina, hence "Tina"). Father, Giuseppe Modotti, a machinist, emigrated to United States, 1906. Tina worked in textile factory, Udine, 1908–13. Joined father and one sister in San Francisco, 1913. Worked as seamstress, then dressmaker, 1913–17. Debut as theater actress, 1917. Married Roubaix de l'Abrie Richey ("Robo"), American poet and painter, 1917; they moved to Hollywood, 1918. Worked as actress in several films, 1918–21. Met photographer Edward Weston, probably 1920; entered into liaison with him, 1921. Robo left for Mexico, where he died, 1922; Modotti went to Mexico briefly to handle funeral arrangements. She returned to Mexico with Weston, 1923, as his assistant and apprentice, later partner, in joint photographic enterprise. Took her first "serious" photograph in Mexico, 1923, and worked with Weston to provide illustrations for *Idols behind Altars*, by Anita Brenner. Tina published work in *Mexican Folkways* and *Formas* magazines, beginning 1926. Became formal member of Communist Party in Mexico, 1927. Began liaison with Cuban revolutionary Julio Antonio Mella, 1928; he was murdered for political reasons, 1929. Tina accused of his murder; formally acquitted five days after his death. Associated with communist Vittorio Vidali, whom she had met in 1927; possibly did not become his companion until 1933. Persecuted by Mexican government and accused of plotting to kill President Pascual Ortiz Rubio. Deported, 1930. Lived in Berlin six months, 1930; did some photography there, but stopped after 1930. Helped by Vidali, moved to Moscow and worked at head-

quarters of International Red Aid (relief organization), 1931–34. Went to Spain for Red Aid and remained with Vidali as he fought during Spanish Civil War, 1935–38. Returned to Mexico with Vidali, 1939. Modotti died of heart failure in the back seat of a taxi. Major exhibition, Philadelphia Museum of Art, 1995.

LUCIA MOHOLY
Born 1894, Karlin (near Prague), Czechoslovakia
Died 1989, Zurich
Portraits and architectural work, also photograms and films. Born Lucia Schulz. Studied art history and philosophy, Prague University, 1912. Editor for publishing houses, 1915–18; became theater and art critic. Met László Moholy-Nagy, Berlin, 1920. Married him, acquiring Hungarian citizenship, 1921. Collaborated with him on artistic theory and photography, 1922–23. László appointed to Bauhaus; they moved to Weimar, 1923. Lucia apprenticed as photographer at Eckner studio, 1923–24. She and husband made photograms as experiments with light. They moved with Bauhaus to Dessau; she did series of photos of Walter Gropius's new Bauhaus buildings; did series of portraits of Bauhaus teachers and friends, 1925–26. They moved to Berlin, 1928; she did photographic documentation of László's stage designs and worked with Mauritius agency. Helped curate historical section of *Film und Foto* exhibition, Stuttgart, 1929. Separated from László and left Berlin, 1932. Moved to Paris, 1933. Divorced László, 1934; settled in London and opened portrait studio. Wrote photographic history, 1939; free-lanced for publications. Became British citizen, 1940. Commissioned by Unesco to film cultural heritage of Near and Middle Eastern countries, 1946. Became member of Royal Photographic Society of Great Britain, 1948. Moved to Switzerland, 1959.

FRANZISKA MÖLLINGER
Born 1817, Solothurn, Switzerland
Died 1880, Switzerland
Scenic views and landscapes. Known for producing *Daguerreotyped Views of the Capitals and Loveliest Regions of Switzerland, 1844–45*. Only one Möllinger original daguerreotype has survived, a view of the Castle of Thun (see plate 40).

GERALDINE MOODIE
Born 1853, Ottawa
Died 1945, Calgary, Canada
Primarily portraits and ethnographic documentation. Known for photographs of Canadian Indians and Arctic expeditions. Born Geraldine Fitzgibbons. Married John Douglas Moodie, 1877; had five children. Moved to Calgary, 1886, when John became inspector with North-West Mounted Police (NWMP, or "Mounties") Frequently relocated because of his job, 1887–99. Began photographing Cree Indians near Battleford, Saskatchewan, 1890s. Lived in Moosomin, Saskatchewan, while John served in Boer War. He was appointed a governor of Hudson's Bay Company with instructions to claim islands north of Canada for the Dominion; he began to build posts at these locations. Geraldine traveled with him as secretary aboard the ship the *Arctic*, 1904. John, critical of expedition's official photographer, Frank Douglas MacKean, made request that Geraldine be made photographer; request denied. Meanwhile, her photographs were sent to NWMP headquarters in Ottawa, the Department of Marine and Fisheries, and the prime minister. Lived in Arctic, 1904–6; returned to Arctic, 1915–16. Accompanied John to coronation of King George V and photographed, 1911. Family moved to Duncan, British Columbia, 1933; to Calgary, 1943.

SARAH MOON
Born 1940, England
Resides Paris
Fashion. Born Marielle Hadengue in England to family of French origin. Studied drawing in art school. Became a leading fashion model, by 1960. Began fashion photography, c. 1966. Work attracted notice at *Modinsolite* exhibition of avant-garde fashion photography, arranged by Delpire Gallery, Paris, and sponsored by Kodak, 1968. Became known for impressionistic style. Photographed for *Vogue, Nova, Elle, Harper's Bazaar* (Great Britain), *Marie-Claire, Votre Beauté*, and other magazines. J. Arthur Rank gold award, London, 1971. Since 1980 has done more than 150 clips and advertising films for such clients as Bally, Barney's, Courrèges, Danone (Andy Award of Merit, 1983), Dupont, Essel, Purina (Silver Lion, Cannes, 1989), Revlon (Clio award, 1984), and TWA; has done regular fashion campaigns for Cacharel. Created film *Mississippi One*, c. 1990. Showed fashion photographs at Delpire

Gallery, Paris, 1975; Photographers' Gallery, London, 1972; and Zabriskie Gallery, Paris, 1974. International Center of Photography Award for Fashion Photography, New York, 1983. Honored guest at Fashion Festival of Budapest, 1990. Solo exhibition, Staley-Wise Gallery, New York, 1992.

INGE MORATH
Born 1923, Graz, Austria
Resides Roxbury, Connecticut
Portraits, documentation, and photojournalism. Attended school in France and Germany; received degree from Berlin University, 1944, and spent semester at University of Bucharest, Romania. Agricultural worker and later employee at Tempelhof Airport, Berlin, 1944–46. Editor and translator for United States Information Service, Salzburg and Vienna, 1946–49. Did free-lance writing for radio (Red-White-Red Network) and worked for magazine *Der Optimist*, Vienna, 1950. Worked for *Heute* magazine, 1951. Received camera as Christmas present and subsequently bought a Leica, 1952. Began working as photojournalist with Simon Guttman of Report agency, London, 1952. Assistant and researcher for photographer Henri Cartier-Bresson, 1953–54. Became full member of Magnum Photos, 1955; photographs appeared in *Life, Paris Match, Holiday, Saturday Evening Post*, and elsewhere. Traveled to Iran and Tunisia, late 1950s. Married playwright Arthur Miller, 1962; had Rebecca. Became U.S. citizen, 1966. Traveled extensively throughout world, 1964 on: Soviet Union, Europe, Hong Kong, Japan, Thailand, Cambodia, and China. Awarded Great Austrian State Prize for Photography, 1992; Gold Medal, National Arts Club, New York, 1999. Major retrospective exhibitions, 1988, Exhibition Hall of the Union of Photojournalists, Moscow, and Sala de Exposiciones del Canal de Isabel II, Madrid; toured Europe through 1999.

BARBARA MORGAN
Born 1900, Buffalo, Kansas
Died 1992, North Tarrytown, New York
Straight portraits, dance images, landscapes, and experimental work with photomontage and light abstraction. Born Barbara Brooks Johnson. Grew up in Southern California. Studied art at University of California, Los Angeles, 1919–23; became interested in Eastern philosophical ideas about rhythm,

dynamism, and harmony in life. Painted; taught art at San Fernando High School, San Fernando, California, 1923–24. Married photographer and writer Willard D. Morgan, 1925. Member of art department, UCLA, 1925–30; taught design, landscape, and printmaking. Met Edward Weston, 1925, and became convinced that photography could be art. Moved to New York City with husband, 1930; had Douglas, 1932, and Lloyd, 1935. Concentrated on photography, 1935 on. Member of Photo League, New York, 1930s until her resignation in late 1940s. Proposed to Martha Graham that they collaborate on book of photographs, c. 1935; culminated in *Martha Graham: Sixteen Dances in Photographs*, 1941. Photographed other dancers, including Merce Cunningham and José Limon, 1940s. Established studio in Scarsdale, New York, 1941. While working on Graham book, began creating photomontages as metaphors of her impressions of New York, late 1930s; also made abstract light drawings (images of a light source in motion). Second book, *Summer's Children*, consisted of photographs of her own and other children at summer camp, which she said she created as expression of hope and courage in face of World War II events, published 1951. Husband died, 1967. National Endowment for the Arts grant, 1975. Honorary doctorate of fine arts, Marquette University, Milwaukee, Wisconsin, 1978.

LADY OTTOLINE MORRELL
Born 1873, England
Died 1938, Tunbridge Wells, England
Documentation. Born Ottoline Bentinck to Irish mother, Augusta, and English soldier-father, Arthur Bentinck. Father died when Ottoline was four. Family supported by fifth duke of Portland, whose title and wealth were inherited by Ottoline's half-brother Arthur, 1879. Ottoline became Lady Ottoline, 1879. Grew up lonely, shy, and obsessed with religion; taught Bible classes to prostitutes. Became unusual beauty, over six feet tall with red-gold hair; known for theatrical mode of dress. Married solicitor Philip Morrell, 1902; had twins, 1906; boy died, girl, Julian, survived. Became well-known hostess to Bloomsbury set of intellectuals, writers, and artists in London, including Clive and Vanessa Bell, Lytton Strachey, and Virginia Woolf, beginning 1907. Had love affairs with mathematician-philosopher Bertrand Russell and artist Henry Lamb,

beginning 1909. Owned estate, Garsington, outside London, 1915–28, which became gathering place for literati, artists, and pacifists. Kept copious diaries and made informal photographs of friends. Virtually impoverished after war. Died of injections of medical drug Prontosil, improperly administered by doctor.

LADY AUGUSTA MOSTYN

Born 1830, presumably Wales
Died 1912, North Wales

Scenic views. Born Henrietta Augusta. Father, earl of Abergavenny, ensured that his three daughters—Henrietta Augusta, Caroline, and Isabel—received superb education in the areas in which a lady was expected to excel. Augusta sketched, painted, and became interested in photography; most of her photographs were apparently made in first half of 1850s, before and possibly right after her marriage. Concentrated on views at family estates. Married the Honourable Thomas Mostyn, heir to Baron Mostyn and estates in North Wales, 1855; they had two sons. Husband died, 1861. Family finances strained by father-in-law's racing debts. Augusta invested money in creation of Llandudno, a resort, out of a swamp in North Wales; her great-nephew called her "the mother of modern English town planning." Oversaw the running of Llandudno; built churches.

JEANNE MOUTOUSSAMY-ASHE

Born 1951, Chicago
Resides New York City

Documentation and photojournalism. B.F.A. in photography, Cooper Union, New York, 1975. Did eight-month independent study, "West African Polyrhythms and Lifestyles," on west coast of Africa, 1974. Photographer and graphic designer for NBC News Center 4, New York, 1974–77. Has free-lanced for *Life*, *Smithsonian*, *New York Times*, *Sports Illustrated*, *Ebony*, *Black Enterprise*, *World Tennis*, *Tennis*, *Detroit News*, *Louisville Times*, Associated Press, and corporate and government clients, since 1970s. Contributing editor, *Self* magazine, 1982. Photography editor, *PM Magazine*, WNEW-TV Metromedia 5 New York, 1983. Produced and directed *The Sun*, a four-minute film on children, for United Nations' International Year of the Child, 1979. Photographed small community of African-Americans on Daufuskie, a South Carolina sea island, 1977–80. Married tennis star Arthur Ashe, 1977 (he died 1993); had

daughter, Camera, 1986. Wrote *Viewfinders*, first book of biographies of African-American women photographers, 1986. Selected recent solo exhibitions include *Daufuskie Island: A Photographic Essay*, Columbia Museum of Art, Columbia, South Carolina (and tour), 1982; Simmons College Art Gallery, Boston, 1982; Sutton's Black Heritage Gallery, Houston, 1983; Elbow Room, London, 1989; Savannah College of Art and Design, Savannah, Georgia, 1992; *Daddy and Me*, Marymount School, New York, 1993; and Leica Gallery, New York, 1996–97.

JOAN MURRAY

Born 1927, Annapolis, Maryland
Resides Piedmont, California

Portraits, nudes, and landscapes. Grew up on horse farm, Worthington Valley, Maryland. Moved to California, 1946, where she pursued career in public relations with nonprofit organizations. Married Dr. Richard William, 1955; had Mary Elizabeth, 1958; Richard, 1962. Later divorced. Studied photography at California College of Arts and Crafts, San Francisco Art Institute, and department of architecture at University of California, Berkeley, 1960s. Also studied with photographers RUTH BERNHARD and Wynn Bullock. Made portraits of California photographers, 1971–72 and 1991–92; produced a series on her children entitled Brother and Sister, late 1960s; and series of male nudes, Man, 1969, as well as some female nudes. Photography editor of *Artweek*, 1969–89. Wrote for *Popular Photography*, 1973–76, and *American Photographer*, 1978–83. Solo exhibitions at Focus Gallery, San Francisco, 1969, and Photography/Film Center West, Berkeley, 1972. Retrospective at Friends of Photography, Carmel, California, 1972. Photographed landscapes, 1980s; also made self-portraits following breast cancer, 1990. Major retrospective of 125 photographs, *Joan Murray, 1967–92*, Vision Gallery, San Francisco, 1992. Manager, ASUC Art Studio, University of California at Berkeley, 1987–present.

EVELEEN MYERS

Born n.d., presumably England
Died n.d., presumably England

Allegorical studies, portraits, and genre. Active in England, late 1880s perhaps through early 1920s. Born Eveleen Tennant. Married F.W.H. Myers, n.d. Began to study photography at end of 1888 in order to make portraits of her children. Applied herself carefully to technical side of medium as well as to aesthetic aspect. Made genre and religious narrative photographs. Made portraits of well-known British contemporaries such as prime minister William Gladstone and philosopher and statesman Arthur Balfour, 1888–91. Featured in April 1891 issue of *Sun Artists* (England). August 15, 1890, issue of *Photographic Times* (England) reported that she had photographed her sister Dorothy Tennant Stanley as a bride in Westminster Abbey.

MARILYN NANCE

Born 1953, Brooklyn
Resides Brooklyn

Documentation and photojournalism; also films. Attended New York University, with major in journalism, 1971–72. Began studying photography, 1972. B.F.A. in communications and graphic design, Pratt Institute, Brooklyn, 1976. Became free-lance photojournalist for *Village Voice*, New York, 1975. Photographer for FESTAC '77, a cultural festival in Nigeria, 1977. Has photographed the Black Indians of New Orleans; Appalachian folk musicians; Oyotunji Yoruba Village in Sheldon, South Carolina; a Baptist church in Brooklyn; and first black church in America. Work published in *New York Times*, *Village Voice*, *Essence*, *Nueva Luz*, *New York Newsday*, *New York Observer*, and elsewhere. Associate producer of *Voices of the Gods*, a film on Akan and Yoruba, two ancient African religions practiced in United States, 1985. New York State Council on the Arts Individual Artist's grant, 1987; New York Foundation for the Arts fellowship in photography, 1989; New York Foundation for the Arts fellowship in nonfiction literature, 1993; Art Matters, Inc. fellowship, New York, 1994; Catalogue Project, New York Foundation for the Arts, 1995; College Art Association Professional Development fellowship, 1995; and Sheroes in Our Midst award, 4 W Circle of Art and Enterprise, Brooklyn, 1998. Selected recent solo exhibitions at Robert B. Menschel Photography Gallery, Syracuse University,

Syracuse, New York, 1990; Longwood Arts Center, Bronx Council of the Arts, New York, 1998; and elsewhere. Artist in residence at Studio Museum in Harlem, New York, 1993–94.

GENEVIEVE NAYLOR
Born 1915, Springfield, Massachusetts
Died 1989, Dobbs Ferry, New York
Fashion, advertising, and photojournalism. Educated in private elementary schools, then attended Miss Hall's School in Pittsfield, Massachusetts; during junior and senior years studied painting with her future husband, Russian-born painter Misha Reznikoff. Attended Vassar College, Poughkeepsie, New York, leaving in 1935; moved to New York City. Studied at Art Students League and New School for Social Research; taught by BERENICE ABBOTT, who urged her to become a photographer. Worked for Associated Press as one of their first woman photojournalists, 1937–41. For U.S. State Department, photographed Brazilian life under auspices of "Good Neighbor Policy," 1941–43; Museum of Modern Art, New York, organized solo exhibition of this work, 1943. Worked for *Harper's Bazaar* (one of its first female photographers after LOUISE DAHL-WOLFE), 1943–58; art director Alexey Brodovitch was a mentor. Married Reznikoff, 1946; had Michael, 1947; Peter, 1950. Concurrent with job at *Harper's Bazaar*, photographed on free-lance basis for other magazines, including *McCall's*, *Vogue*, *Cosmopolitan*, *Holiday*, and *Fortune*, through 1975. For *Look*, in particular, did many serious photojournalism stories. Advertising accounts included Revlon and Coca-Cola, 1953–63. After retiring in 1975 created abstract and experimental photographs for herself. Solo exhibition, Staley-Wise Gallery, New York, 1995.

MARIE-PAULE NÈGRE
Born 1950, Paris
Resides Paris
Social documentation. Created six films on jazz, 1975–80. Also photographed the music world, New York and Paris, 1975–80; exhibited these works at Musée d'Art Moderne de la Ville de Paris, 1985. Worked with Rush Photo Agency, which placed her photographs with the French and international press, 1980–85. Founding member of Métis Photo Agency, 1989. Subjects of essays have included

Islamic life in Uzbekistan; demise of the industrial era in Pas-de-Calais, northern France; female mutilation in Burkina Faso; and rural life in central France, 1980s–'90s. Work published regularly in *Libération* (the daily and the magazine), and the magazines *Géo*, *Marie-Claire*, and *Cosmopolitain*, among others, 1980s–present. Photographed for annual reports for various corporations, including Renault and Crédit Agricole, 1990s. Received the Prix Nièpce in recognition of career devoted to social documentation and societal issues, 1995. Exhibited at the Rencontres Internationales de la Photographie, Arles, France; participated in the exhibition *Paris la nuit, les photographes de Métis* at Musée Carnavalet, Paris, both 1994. Exhibited first portion of her study of the "new poverty" in France with Galerie FNAC, Paris, 1993; the definitive presentation of this decade of work (c. 1989–99), entitled *Contes des temps modernes ou la misère ordinaire* (Signs of Modern Times or Ordinary Misery), took place at international festival of photojournalism, *Visa pour l'image*, Perpignan, France, 1999.

JOYCE NEIMANAS
Born 1944, Chicago
Resides Chicago
Experimental work in various formats; often applies drawing or painting to print surface; also works with color Polaroid materials. B.A., 1966, and M.F.A., 1969, School of the Art Institute of Chicago; studied with Kenneth Josephson there. Chairperson, photography department, School of the Art Institute of Chicago, 1973 to present; appointed full professor, 1986. National Endowment for the Arts Visual Arts fellowships, 1979, 1983, and 1990; School of the Art Institute of Chicago Instructional Enrichment grants, 1986 and 1990; Illinois Arts Council Artist grant, 1987; and Aaron Siskind Foundation Individual Photographer's fellowship, 1992. Board member, Society for Photographic Education, 1977–82. Selected recent solo exhibitions at Rhode Island School of Design, Providence, 1985; Presentation House, Vancouver, 1988; California State University, Sacramento, 1989; Center for Photography at Woodstock, New York, 1989; Gallery 954, Chicago, 1993; Vernon Ezell Gallery, Chicago, 1995; Notre Dame University, South Bend, Indiana, 1999; and Wood Street Gallery, Chicago, 1999. Published book, *Total Chaos*, Offset Workshop, University of Iowa, Iowa City, 1995.

NELLY
(ELLY SERAÏDARI)
Born 1899, Aydin, Asia Minor (now Turkey)
Died 1998, Athens
Portraits, documentation, nudes, and landscapes. Born Elly Souyoultzoylou. In Dresden, Germany, 1920, studied piano and painting; also studied photography under Hugo Erfurt and Franz Fiedler, through 1925. Showed work with Fiedler at Academy of Fine Arts, Dresden, 1925. At Leipzig Spring Fair, 1925, bought large studio cameras and small Leica, which was being shown for first time; returned to Greece that year to work professionally. In Athens pioneered techniques new to Greece; rejected rigid poses in favor of movement and expressiveness. Documentary work included neighborhood children and scenes of refugee life. Took photographs of Mona Paiva (leading ballerina of Paris Opéra Comique), dancing nude on the Acropolis, 1927; those nudes appeared in print in France, creating uproar in Greek press, 1929. Married pianist Angelos Seraidari (or Seraïdaris), 1929. Exclusive photographer for Delphic Festival, 1930. Continued professional work, 1930–35. Photographed Olympics, Berlin, 1936. First Greek photographer to use color, beginning with autochrome plates. Photographed King George II of Greece and other celebrities and did landscapes to promote tourism. While she traveled in United States with her husband, World War II began, 1939; they decided to remain in U.S. and settled in New York, 1940. Became Greece's unofficial ambassador to United States, marshaling U.S. public opinion against Germany. Returned with husband to Greece, 1966. Greek Ministry of Culture produced film, *Nelly, the Asia Minor Photographer*, made by Vera Palma and Alkis Xanthakis, 1983. Retrospective by the Parallaxis Association at the Vafopoulio Cultural Center in Thessaloniki, 1985. Solo exhibitions: *Nelly, Photographer of the Inter-War Period*, organized by the Association for Studies in Modern Greek Culture and General Education and the Benaki Museum, Athens, 1987; and *Nelly, from Athens to New York*, International Center of Photography, New York, 1997–98.

BEA NETTLES

Born 1946, Gainesville, Florida
Resides Urbana, Illinois
Mixed-media narrative images. B.F.A.,
University of Florida, Gainesville, 1968;
M.F.A., University of Illinois, Champaign-
Urbana, 1970. Instructor in photography,
Nazareth College, Rochester, New York,
1970–71; Rochester Institute of Technology,
1971–72 and 1976–84; Tyler School of Art,
Temple University, Philadelphia, 1972–74;
and Visual Studies Workshop, Rochester,
1974–75. Married Lionel Suntop, 1974; had
Rachel, 1978, and Gavin, 1981. Professor of
photography, University of Illinois, Champaign-
Urbana, 1984 to 1999. Since 1970 mixed-
media photography has incorporated stitchery,
hand coloring, plastics, and drawings; imagery
often dealt with fantasy landscapes alluding to
childhood in Florida. Birth of daughter marked
conceptual shift toward fairly "straight" black-
and-white autobiographical photography inves-
tigating problems of childhood, parenting, and
being a woman. Creative Artists Public Service
(CAPS) grant, New York State Council on
the Arts, 1976; National Endowment for the
Arts fellowships; 1979 and 1988; Polaroid
Corporation Artists Program award (ongoing);
Honored Educator, Society for Photographic
Education, Midwest Region, 1997; and other
awards and grants. Recent selected solo exhibi-
tions include *Retrospective*, Museum of
Contemporary Photography, Chicago, 1986;
Life's Lessons: A Mother's Journal, Chrysler Museum,
Norfolk, Virginia (and tour), 1990; *Photo
Etchings*, Heuser Art Center, Bradley University,
Peoria, Illinois, 1993; *Complexities*, Toledo
Museum of Art, Toledo, Ohio, 1995; and
Turning 50, I-Space Gallery, Chicago, 1996.

JANINE NIEPCE

Born 1921, Meudon, France
Resides Paris
Photojournalism and publicity photography.
Born to a family of vineyard owners; a distant
relative of Nicéphore Niepce, pioneer in history
of photography. Degree in art and archaeology,
Sorbonne, 1945. Became one of first French
women photojournalists. Photographed regions
of France for bureau of tourism, 1947–55.
President of the Prix Niepce, since 1950s.
Joined photo agency Rapho, Paris, 1955.
Participated in five traveling exhibitions orga-
nized by minister of foreign affairs, 1960–68.
Made psychological studies of mothers and

children, 1962. Reportage on India, 1963.
Reportage on Brazil, 1968; also recorded
events of May in Paris, 1968. Reportage on
Cambodia and Japan, 1970. Made photographs
for a book on Simone de Beauvoir, 1978. Solo
exhibition at Musée Nicéphore Niepce,
Chalon-sur-Saône, France, 1979. Designated a
chevalier of the Ordre des Arts et Lettres, 1981.
Solo exhibition, *Des Femmes et des métiers non tradi-
cionnels*, Centre Georges Pompidou, Paris,
1983. Reportage on men and women in the
new technological age, 1981–85. Designated
a *chevalier* of the Légion d'Honneur, 1985.
Retrospective, *Janine Niepce, France, 1947–1992*,
Espace Electra, Paris, 1992.

ANNE NOGGLE

Born 1922, Evanston, Illinois
Resides Albuquerque, New Mexico
Documentation, portraits, and self-portraits.
Received airplane pilot license, 1939. Women's
Air Force Service Pilot (WASP), 1943–44;
flight instructor, air-show stunt pilot, and
cropduster pilot, 1945–53. Held rank of
captain, United States Air Force, 1954–60.
Became college student, 1960–69; B.F.A. in art
and art history, and M.S. in art, University of
New Mexico, Albuquerque. Adjunct professor
of art, University of New Mexico, 1970 to
present. Honorary doctorate of fine arts,
University of New Mexico, 1991. Took up
photography as undergraduate. Early works
were long, narrow, 140-degree photographs
made with 35 mm Panon camera, usually of
middle-age or elderly sitter and surroundings.
Began photographing self, family, and acquain-
tances at closer range, using 35 mm camera
and wide-angle lens, after 1970; her subject is
the process of aging. Curator of photography,
Fine Arts Museum of New Mexico, Santa Fe,
1970–76; panel judge, National Endowment
for the Arts, 1976; Board of Directors, Society
for Photographic Education, 1977–81; mem-
ber, National Endowment for the Arts State
Survey grant, New Mexico, 1982–83, and
honorary member, Union of Photo Artists of
Russia, 1992. National Endowment for the
Arts fellowships in photography, 1975, 1978,
and 1988; Guggenheim fellowship, 1982.
Selected recent solo exhibitions include *Anne
Noggle: Portraits and Self-Portraits*, Photographers'
Gallery, London (and tour), 1988–89; *Women
Air Force Service Pilots in World War II: Photographs by
Anne Noggle*, Amon Carter Museum, Fort
Worth, 1991; *Anne Noggle Photographs*, Artemisia

Gallery, Chicago, 1993; *Anne Noggle: Portraits of
Women*, Boise State University, Boise, Idaho,
1994; *A Dance with Death Portraits*, Andrew Smith
Gallery, Santa Fe, New Meeixo, 1994; and *Out
of the Sky*, Firehouse Gallery, Houston, 1994.

BARBARA NORFLEET

Born 1926, Lakewood, New Jersey
Resides Cambridge, Massachusetts
Documentation. B.A., with high honors in
economics and psychology, Swarthmore
College, Swarthmore, Pennsylvania, 1947;
M.A. in social relations (psychology), Harvard
University, Cambridge, 1950; and Ph.D. in
social relations, Harvard, 1951. Has held
several positions unrelated to photography at
Harvard since 1948, notably that of lecturer
in social sciences, 1960–70. Curator of pho-
tography, Carpenter Center for Visual Arts,
Harvard, 1972–present; senior lecturer,
visual and environmental studies, Harvard,
1981–present; founder and director of pho-
tography collection, Harvard, 1975–present.
Began making photographs when pictures were
needed to convince Cambridge City Council
that a proposed superhighway would destroy
neighborhoods and livability of the whole city,
1967. Obtained National Endowment for the
Humanities research grant to collect and orga-
nize photography archive at Harvard on social
history of America, 1975–77. Found while
working on archive that there were few pictures
of the wealthy and set out to document "all the
right people"; published a book by that title,
1986. Published *Manscape with Beasts*, 1990,
consisting of color photographs documenting
the accidental collision of pets and wildlife with
human culture in Massachusetts. Guggenheim
fellowship, 1984; National Endowment for the
Arts fellowships in photography, 1982 and
1984–85; Massachusetts artist fellowships in
photography, Artists Foundation and
Massachusetts Cultural Council, 1982 and
1987; and Aaron Siskind award, Aaron Siskind
Foundation, New York, 1991; honored for con-
tributions as artist, teacher, and curator, Fifth
National Women in Photography Conference,
1997; and Honorary B.F.A., New Hampshire
Institute of Art, 1997. Recent solo exhibitions
at Robert Klein Gallery, Boston, 1994; Drew
University, Madison, New Jersey, 1995;
Southeast Museum of Photography, Daytona
Beach, Florida (and tour), 1997; Houston
Center for Photography, 1999; and Craven
Gallery, Martha's Vineyard, Massachusetts, 1999.

SONYA NOSKOWIAK
Born 1900, Leipzig, Germany
Died 1975, Greenbrae, California
Portraits, still lifes, landscapes, and architectural work. Spent childhood in Valparaiso, Chile. Moved with family to Sacramento, California, by 1915. Receptionist in studio of Pictorialist photographer Johan Hagemeyer, Carmel, California, late 1920s. At studio met Edward Weston, 1929; they had personal and professional relationship, 1929–34. Became a founding member of Group f/64 and contributed to its first exhibition, at M. H. de Young Memorial Museum, San Francisco, 1932. Opened studio in San Francisco, for commercial, portrait, and fashion photography, 1935; portraits included Jean Charlot, Martha Graham, and John Steinbeck, 1930s–'40s. Photographed for Works Progress Administration (WPA), 1936. Photographed historical architecture in San Francisco and elsewhere, as well as geometric forms in modern industrial landscape, 1930s. Prize in decorative arts, annual exhibition of San Francisco Society of Women Artists, 1936. Represented in *Scenes from San Francisco*, at San Francisco Museum of Art, 1939. Photographed for Oakland army base, 1940. Featured in Oakland Museum's exhibition of photographs from Federal Art Project, WPA, 1965.

LORIE NOVAK
Born 1954, Los Angeles
Resides Brooklyn
Experimental work with photography and installations using slide projection. Attended University of California, Los Angeles, 1971–73. B.A. in art and psychology, Stanford University, Stanford, California, 1975; M.F.A., School of the Art Institute of Chicago, 1979. Began projecting photographic slides (eventually of old family snapshots) into furniture-filled rooms—bedrooms, kitchens, living rooms—and photographing the results, 1979. At artist's colony of Yaddo, Saratoga Springs, New York, began to use white-painted studio as bare stage set, 1983. Started to project slides into the woods at night at MacDowell artist's colony, Peterborough, New Hampshire, 1987. Did site-specific installation, *Traces*, utilizing sound and more than five hundred slide images on eleven projectors, at Museum of Contemporary Art, Chicago, and University Art Museum of California State University, Long Beach, both 1991. Has taught photography at Tisch School of the Arts, New York

University, since 1986, and is chair of Photography and Imaging. Grants and fellowships from Louis Comfort Tiffany Foundation, 1987; National Endowment for the Arts, 1990; Yaddo, 1983 and 1988; MacDowell Colony, 1987 and 1990; and Rockefeller Foundation, Bellagio Center, 1997. Recent solo exhibitions include *Critical Distance*, Addison Gallery of American Art, Phillips Academy, Andover, Massachusetts, 1990; *Projections: Photographs by Lorie Novak, 1983–1990*, Madison Art Center, Madison, Wisconsin, 1990; Jayne H. Baum Gallery, New York, 1992; *Collected Visions: Slide/Music Installation*, Houston Center for Photography, 1993; Southeast Museum of Photography, Daytona Beach, Florida (playback, slide/sound installation), 1992; and Breda Fotografica, the Netherlands, 1993. In 1996 launched Collected Visions Web site— http://evisions. cat.nyu.edu.—an interactive Web project exploring relationship between photographs and memory. This is the basis for *Collected Visions III* (projected installation) at International Center of Photography, New York, 2000.

STARR OCKENGA
Born 1938, Boston
Resides New York City and Livingston, New York
Portraits, figure studies, and still lifes. B.A. in English, Wheaton College, Wheaton, Illinois, 1956–60. Became interested in photography, 1969. Worked as free-lance photographer for newspapers, Massachusetts, 1969–74. Studied with photographer Robert Heinecken, Harvard University, Cambridge, 1972. M.F.A. in photography, Rhode Island School of Design, Providence, 1972–74; studied with Harry Callahan and Aaron Siskind there. Photo editor and chief photographer for *Lawrence (Massachusetts) Eagle-Tribune*, 1974–76. Assistant professor of photography, Massachusetts Institute of Technology, Cambridge, 1976–77; associate professor and director of Creative Photography Laboratory at MIT, 1977–82. National Endowment for the Arts fellowship for series of nudes, some done with infrared photography, 1981. Photographed nineteenth-century porch architecture, northeastern United States, 1981–83. On sabbatical year from MIT, photographed babies, 1982–83. Used 20-by-24-in. Polaroid; made prints in Fresson process. Received grant from Artists Foundation, Boston, and continued baby

series, 1983. Visiting professor at Bennington College, Bennington, Vermont, 1984. Opened studio in Boston, 1983; moved it to New York, 1985, where she does editorial and advertising work. Has second studio in Livingston, New York. Married to Donald H. Forst; has son, Robin Oury.

RUTH ORKIN
Born 1921, Boston
Died 1985, New York City
Photojournalism, portraits, and street photography; films. Attended eight public schools, including Horace Mann Grammar School in Beverly Hills, California, and Beverly Hills High School, 1926–39. Won prize in *Women's Home Companion* photography contest, 1937. Majored in photojournalism, Los Angeles City College, 1939. Spent five months in Women's Auxiliary Army Corps, 1943. Moved to New York, 1944. Intensive career in photojournalism, 1945–52; free-lanced for *Life, Ladies' Home Journal, Cosmopolitan, Coronet, This Week, American*, and other publications, 1947–52. Joined Photo League, 1950. Made photographs of musicians including Leonard Bernstein, Jascha Heifetz, Gregor Piatigorsky, and Isaac Stern, 1945–50. Photographed many well-known actors and actresses, including Woody Allen, Marlon Brando, Montgomery Clift, and Julie Harris. Traveled to Europe and Israel, 1951. Codirected and edited *Little Fugitive* with Morris Engel and Ray Ashley, 1952; it won Silver Lion of San Marco at Venice Film Festival, 1953. Married Morris Engel, 1952; had Andy, 1959, and Mary, 1961. Codirected *Lovers and Lollipops*, 1954–55. Represented in Edward Steichen's *Family of Man* exhibition, Museum of Modern Art, New York, 1955. Began contributing to exhibitions of fine-art photography, New York, 1977; twenty-year retrospective, Witkin Gallery, New York, 1994; and retrospective, Howard Greenberg Gallery, New York, 2000.

JEAN PAGLIUSO
Born 1941, Glendale, California
Resides New York City
Fashion and advertising. B.F.A. in design, University of California, Los Angeles, 1963. Moved to New York City with portfolio of fashion illustrations, 1964. Became assistant art director at *Vogue Patterns* and *Mademoiselle*. Ran boutique in Glendale, California, 1966–68. Began photographing while on vacation in Mexico, 1969, and subsequently took course

in 4-by-5-in. photography at Los Angeles Trade Tech. Worked as interior designer for architecture firm, Los Angeles, 1969. Began using camera to do fashion testing with models, 1969; first professional photography job for Catalina sportswear, 1970. Moved to New York City, 1974. Photographed for *Seventeen, Mademoiselle, Harper's Bazaar* and *Italian Bazaar, Vogue, Esquire, Modern Bride, Rolling Stone,* Saks Fifth Avenue, Bloomingdale's, and others. Still photographer on sets for film director Robert Altman and others, beginning with Altman's *Thieves Like Us,* 1972–present. Has photographed on the set for *Nashville, The Addams Family, Splash, Working Girl, Crimes of the Heart, Heartburn, The Natural, White Palace,* and others. Recent solo exhibitions at G. Ray Hawkins Gallery, Santa Monica, California, 1993; and Stubbs Books and Prints, New York, 1994.

MARION PALFI
Born 1907, Berlin
Died 1978, Los Angeles
Social documentary and portraits. Born to Hungarian parents. Father, Victor Palfi, was important producer-director for German theater. Marion acted in several German films, before 1932. Studied with unknown portrait photographer, Berlin, 1932. Opened own portrait studio, 1934; also free-lanced for industry and magazines like *Deutsche Illustrierte.* Probably married briefly to Erich Abraham, mid-1930s. Settled in Amsterdam and opened portrait studio, 1936. Married Benjamin Weiss of New York and entered United States, 1940; divorced, 1944. Awarded Rosenwald fellowship, 1946; used it to travel throughout U.S. photographing examples of racial discrimination. Represented in important museum exhibitions, 1940s–'50s, including Edward Steichen's *Family of Man,* Museum of Modern Art, New York, 1955. Became member of Photo League; resigned in 1949 because she was afraid she might lose her U.S. citizenship as a result of the group's political direction during the McCarthy era. Produced photo-essay "There Is No More Time," 1949, studying southern system of segregation. Published book *Suffer Little Children,* 1952, on child neglect and juvenile delinquency. Married Martin Magner, Danish-born producer-director in New York, 1955. Photographed conditions of the elderly, 1950s. Received Taconic Foundation grant, 1963; used it to study voter registration of blacks in the South. Received Guggenheim

fellowship to study Native Americans, 1967. Received National Endowment for the Arts grant to study criminal justice system and prison living conditions, 1974. Retrospective exhibition, *Invisible in America,* Spencer Museum of Art, University of Kansas, Lawrence, 1973. Other solo exhibitions at Los Angeles Institute of Contemporary Art, 1978–79; and Center for Creative Photography, University of Arizona, Tucson, 1985.

ESTHER PARADA
Born 1938, Grand Rapids, Michigan
Resides Chicago
Experimental work, using montage and computer-generated images. B.A., Swarthmore College, Swarthmore, Pennsylvania, 1960; M.F.A. in painting and drawing, Pratt Institute, Brooklyn, 1962; M.S. in photography, Institute of Design, Illinois Institute of Technology, Chicago. Peace Corps volunteer instructor in art, Sucre, Bolivia, 1964–66. Graphic designer, Chicago and Philadelphia, 1967–71. Has taught photography at School of Art and Design, University of Illinois, Chicago, since 1972; professor of photography there since 1987. Her writings on photography and cultural politics have appeared in *Afterimage, Aperture,* and elsewhere. National Endowment for the Arts photography fellowships, 1982 and 1988. Since 1986 has worked almost exclusively with a Macintosh computer, using digital technology to create photo-text or photomontage works that offer a revisionist historical perspective. Her 1987 digital photomontage *The Monroe Doctrine: Theme and Variations* has been exhibited and published widely throughout the United States and Europe. In 1991, as one of six international artists invited to reexamine the historical significance of the Königsplatz in Munich, created a large-scale site-specific installation in color titled *Heimat Bayern—für wen? (Homeland Bavaria—for Whom?).*

OLIVIA PARKER
Born 1941, Boston
Resides Manchester, Massachusetts
Constructed still lifes in black-and-white and color. B.A. in art history, Wellesley College, Wellesley, Massachusetts, 1963. Arranges found objects to photograph. First two monographs—*Signs of Life,* 1978, and *Under the Looking Glass,* 1983—reproduced color work; most recent monograph—*Weighing the Planets,* 1987—

utilizes black-and-white and suggests human presence with shadows. Presently working on series called Animal, Vegetable, Mineral, and Something Else. Massachusetts Artist fellowship, Artists Foundation and Massachusetts Cultural Council, 1978; New Works Commission, Photographic Resource Center, Boston, 1981; and Wellesley College Alumni Achievement award, Wellesley, Massachusetts, 1996. Selected recent solo exhibitions at Brent Sikkema Fine Art, New York, 1990 and 1991; Photographers' Gallery, London, 1990; Parco Exposure Gallery, Tokyo, 1991; ICAC/Weston, Tokyo, 1992; Vision Gallery, San Francisco, 1993; Robert Klein Gallery, Boston, 1993 and 1996; Light Impressions, Rochester, New York, 1993; G. Gibson, Seattle, 1996; New York Academy of Sciences, 1997; Isabella Stewart Gardner Museum, Boston (with Jerry N. Uelsmann), 1997; Wright State University, Dayton, Ohio, 1998; and Northlight Gallery, Arizona State University, Tempe, 1998. Participated in important group show, *Digital Frontiers,* at International Museum of Photography at George Eastman House, Rochester, New York, 1998.

EMILY H. PITCHFORD
Born 1878, Gold Hill, Nevada
Died 1956, Berkeley, California
Portraits and genre. Attended Mark Hopkins Institute of Art, San Francisco (now San Francisco Art Institute). Became interested in photography and began sharing studio of Laura Adams Armer, Berkeley, c. 1902. Represented in Fourth Annual Exhibition of Photographs, Worcester Art Museum, Worcester, Massachusetts, 1907; Second Annual Exhibition of Berkeley Art Association, 1908; California Camera Club (with ANNE W. BRIGMAN), 1908; and Alaska-Yukon-Pacific Exposition (bronze medal), Seattle, 1909. Published in *Camera Craft* (1907 and 1908) and *Photograms of the Year,* 1908. Married William Leo Hussey, mining engineer from Johannesburg, 1911. They lived in South Africa, 1911–21; had at least three children. Returned to Berkeley, 1921. Represented in *California Pictorialism,* San Francisco Museum of Modern Art, 1977.

SYLVIA PLACHY
Born 1943, Budapest
Resides New York City
Photojournalism and portraits. Left Hungary after failed popular revolt of 1956. Lived in Vienna, 1956–58. Emigrated to United States, 1958; became U.S. citizen, 1964. B.F.A., Pratt Institute, Brooklyn, 1965. Married Elliott Brody, 1966; had Adrien, 1973. Began photographing, 1964. Has published in *Vogue*, *Connoisseur*, *L.A. Style*, *Camera Arts*, *Grand Street*, *Artforum*, *Granta*, *New York Times Magazine*, *Ms.*, *Stern*, *Newsweek*, *Geo*, and elsewhere. Has photographed for the *Village Voice*, since 1974. Range of themes has included Coney Island, Three Mile Island, children playing on the street, and travels to New Mexico, Montana, Colorado, Sicily, Hungary, Nicaragua, and elsewhere. Her book *Sylvia Plachy's Unguided Tour* received Infinity award, Best Publication of 1990, International Center of Photography, New York, and Maine Photographic Workshop Best Monograph of 1990; also published *Red Light* (about the sex industry), 1996; and *Signs and Relics*, 1999. Guggenheim fellowship, 1977; Page One award for feature essay, Newspaper Guild, 1981; Creative Artists Public Service (CAPS) fellowship, 1982; and MTA (Mass Transit Authority) Arts Transit award, New York, 1999. Solo exhibitions include *Unguided Tour* (two traveling exhibitions) originating at Minneapolis Institute of Arts and Burden Gallery, New York, 1990 (and international tour); *The Danube Isn't Blue*, Arthur Ross Gallery, University of Pennsylvania, Philadelphia, 1992; *The Call of the Street*, Whitney Museum at Philip Morris, New York, 1993; and recent exhibitions at Zentrum für Photographie, Berlin, 1998; Mai Mano Gallery, Budapest, 1999; and Egizio Projects, New York, 1999. Participated in *Indivisible Project*, Center for Documentary Studies, Duke University, Durham, North Carolina, 2000; exhibition and archive, Center for Creative Photography, University of Arizona, Tucson, 2000; and *Identity*, National Millennium Survey grant, College of Santa Fe, New Mexico, 2000.

ROSAMOND W. PURCELL
Born 1942, Boston
Resides Medford, Massachusetts
Figure studies and still lifes; creates constructions to be photographed in color and black-and-white. B.A. in French literature, Boston University, 1964. Married Dennis Purcell, 1969; had Andrew, 1972, and John Henry, 1978. Began to photograph, using Polaroid, 1969–84. Constructs and photographs densely packed still lifes using materials ranging from recycled images (magazine pictures, her own old photographs) to objects from nature (zoological specimens, plant life). Has traveled extensively to select and photograph specimens from natural history museums in continental United States, Honolulu, Leningrad, London, Madrid, 1980s–'90s. Shifted from Polaroid to 2¼-by-2¼-in. and, primarily, 35 mm color transparencies, 1984. Created Half-Life series dealing with metamorphoses of animals and human beings, published 1980. Has published portfolios of photographs in *Smithsonian*, *Omni*, *The Sciences*, and elsewhere. Massachusetts Artist fellowship, Artists Foundation and Massachusetts Cultural Council, 1982; and Mary Ingraham Bunting Institute fellowship, Radcliffe College, Cambridge, Massachusetts, 1987–88. Visiting scholar, Getty Center for the History of Art and Humanities, Santa Monica, California, 1993. Selected recent solo exhibitions at Catherine Edelman, Chicago, 1989; Marcuse Pfeifer Gallery, New York, 1989; DeCordova Museum and Sculpture Park, Lincoln, Massachusetts, 1989; Bishop Museum, Honolulu, 1990; Museo Nacional de Ciencias Naturales, Madrid, 1991; Radcliffe College, 1992; and Akin Gallery, Boston, 1993.

SUSAN RANKAITIS
Born Cambridge, Massachusetts, 1949
Resides Claremont, California
Mixed media. B.F.A. in painting, University of Illinois, Champaign, 1971. M.F.A. in painting and photography, University of Southern California, Los Angeles, 1977. Work has dealt primarily with links between photography and painting, 1976–present. Early work consisted of small, monochromatic, collagelike photographic pieces; explored aspects of technology, such as photograms of microfiche sheets. Married photographer Robbert Flick, 1976. After losing early work in a studio fire, 1980, undertook radical new experiments with aid of fellowship from National Endowment for the Arts, 1980. Present work demonstrates painterly concerns with abstraction, extremely large scale (up to twenty-five feet), and creation of one-of-a-kind pieces. Grants and awards include Graves Award in the Humanities, 1985; National Endowment for the Arts Individual Artists Fellowship in Photography, 1980 and 1988; U.S./France National Endowment for the Arts Visual Artists Residency, Woodside, California, 1989. Full professorship, Fletcher Jones Chair in Art, Scripps College, Claremont, California, 1990–present. Selected recent solo exhibitions at Schneider Museum of Art, Ashland, Oregon, 1990; Center for Creative Photography, University of Arizona, Tucson, 1991; Ruth Bloom Gallery, Santa Monica, California, 1992; Museum of Contemporary Photography, Chicago, 1994; Robert Mann Gallery, New York, 1994 and 1997; Indiana University/Purdue University Cultural Arts Gallery, Indianapolis, 1998; and Museum of Photographic Arts (a ten-year survey focused on her interest in science), San Diego, California, 2000.

JANE REECE
Born c. 1869, near West Jefferson, Ohio
Died 1961, Dayton, Ohio
Portraits; also still lifes and landscapes in black-and-white and color (autochrome). Father fought on Union side during Civil War, 1861–64, and spent time as prisoner of war; wife and children lived in reduced circumstances following war and his death. Jane studied music, sketching, and painting. Became interested in photography, encouraged by her nurse, while recuperating from spinal meningitis in Southern Pines, North Carolina, 1903. Moved to Dayton and opened first of five successful photography studios, 1904. Received first prize for portrait of violinist Jan Kubelik at meeting of Photographers' Association of America, 1907. Closed studio and went to New York to study Photo-Secession movement, 1909; exhibited with Photo-Secession but did not become formal member. Returned to Dayton, 1909, and resumed commercial portrait work. Studio became a center for prominent citizens of Dayton and people interested in the arts. Traveled extensively, 1919–23, photographing in California (where TINA MODOTTI posed for her), North Africa, and Paris. Returned to Dayton, 1923. Stopped photographing due to poor health and eyesight, 1944, but remained actively interested in the arts. Presented her collection of photographs to Dayton Art Institute, 1952; major retrospective there, 1997.

WYNN RICHARDS
Born 1888, Greenville, Mississippi
Died 1960, Greenville
Advertising and fashion. Born Martha Wynn.
Married Dorsey Richards of Canto,
Mississippi, 1907; had son, Harper. Interest
in art and photography inspired her to enter
national photography contest sponsored by
New York Post, 1918; won second prize. Took
photography course with Clarence White,
Canaan, Connecticut, 1918. Early work
included soft-focus nudes, studies of children,
and still lifes. Opened studio in family's car-
riage house, 1919. Marriage ended in divorce,
by 1922. Accepted offer to join photography
staff of *Vogue* and moved to New York, 1922;
after realizing that she needed to study
artificial lighting, left the magazine to attend
White's New York school of photography. Did
free-lance advertising and fashion photography
for department stores, women's magazines, and
manufacturers; accounts included Gulden's
mustard, Elizabeth Arden cosmetics, and Old
Gold cigarettes, 1920s. Used professional
name Wynn Richards to camouflage the fact
that she was a woman. Exhibited at Delphic
Studios, New York, 1931 (gallery owned by
Alma Reed, who had given László Moholy-
Nagy his first American show). Solo show at
Julien Levy Gallery, New York, 1934. Married
George Herbert Taylor, 1932, British naval
officer who became an author and her business
manager; he died, 1945. She returned to
Greenville, 1948. Did work for Cotton Council
of America and photographed families of
governors of cotton-producing states, 1950s.

LENI RIEFENSTAHL
Born 1902, Berlin
Resides Lake Starnberg (near Munich), Germany
Documentation and propaganda films. Grew
up in Berlin; received *Gymnasium* education,
1912–18. Attended Lohmann boarding school
in Thale, Germany, 1919. Began rigorous
study of classical ballet in Berlin, c. 1920; also
studied modern dance with Mary Wigman.
Had successful dancing career in Germany and
abroad until severe knee injuries ended career,
1923. After seeing *Mountain of Destiny* by Dr.
Arnold Fanck, 1923, proposed herself to him
as actress. Played dancer in his film *The Holy
Mountain*, 1926, and acted in other films, in-
cluding *The White Hell of Piz Palü*, 1929, which
she edited. Created plot for, produced, directed,
and acted as Junta in *The Blue Light*, which

premiered 1932; won silver medal at Venice
Biennale, 1932. Heard Adolf Hitler speak,
1932; wrote to him and was invited for visit.
Impressed by *The Blue Light*, he asked her to do
documentary films about Nazi Party; did
Triumph of the Will, finished 1935. Socialized
with Hitler and his circle but did not become
formal Nazi Party member. At Hitler's request,
produced *Olympia*, on the Olympic games,
1936. During much of World War II worked
on own film *Tiefland*, based on opera by Eugen
d'Albert. Married soldier Peter Jakob, 1944;
later divorced. At end of war was held briefly
by United States forces for "rehabilitation,"
1945; French forces and, later, the Germans
held her through 1948. Made still photographs
of the Nuba of the Sudan, starting in 1960s.
Took up scuba diving, 1974; photographed
and filmed underwater coral gardens in the
Maldives. Received Order of Distinction of the
Republic of Sudan, 1976. First solo photo-
graphic exhibition, Seibu Gallery, Tokyo, 1980.

GRACE ROBERTSON
Born 1930, Scotland
Resides Seaford, England
Photojournalism and advertising. Father was
journalist Fyfe Robertson, who worked for
Picture Post in London. Mother afflicted with
rheumatoid arthritis, c. 1946; Grace left
school to care for family. While observing two
women talking and laughing, realized she
wanted to become photographer, 1948. Father
purchased second-hand Leica for her and sent
her to photo agent Simon Guttman at Report
agency; Guttman sold one of her stories to
Picture Post, c. 1949. Grace left Report and
sent a photo story about her sister's way of
doing homework to *Picture Post*; was asked to
photograph regularly for the magazine, 1950.
Published stories included "Sheep Shearing in
Wales," 1951, "Tate Gallery," 1952; "Mother's
Day Off," 1954; and "Childbirth," 1955.
Supplemented income with advertising work,
1950s; did advertising for Cadbury. After
doing story on highly publicized custody battle
over Goldsmith-Patino baby was asked to join
Picture Post staff, 1954; declined. Married pho-
tographer Godfrey Thurston Hopkins, 1954;
had Joanna, 1960, and Robert, 1961. *Life* mag-
azine commissioned her to do another version
of "Mother's Day Off," c. 1954; published
"Labour Party Conference," *Life*, 1956. Turned
down associate staff position at *Life* in United
States. Published in *Picture Post* until its demise,

1957. Continued photographing for other
national magazines on free-lance basis, includ-
ing *Life*; also did advertising work. Interviewed
by Colin Ford for BBC Radio Three series,
"Master Photographers," 1991. Commissioned
by the BBC to take portraits of British people
in their nineties, for use in a television series
called "The Nineties," 1993. Retrospective,
including new work, at Royal National Theatre,
London (and tour), 1993; solo exhibition,
Leica Gallery, New York, 1998. Received OBE
(Order of the British Empire), 1999.

MERIDEL RUBENSTEIN
Born 1948, Detroit
Resides Santa Fe, New Mexico
Landscapes and narrative portraits. B.A., Sarah
Lawrence College, Bronxville, New York,
1970. Special graduate student in photography,
Massachusetts Institute of Technology,
Cambridge, 1972–73; studied with Minor
White there. M.A., 1974, and M.F.A., 1977,
University of New Mexico, Albuquerque.
Associate professor of art, San Francisco State
University, 1985–90. Professor of art, Institute
for American Indian Arts, Santa Fe, 1990–
present. Began La Gente de la Luz (People of
the Light) series, consisting of portraits of
Native Americans montaged with landscapes,
New Mexico, 1976. Other series include The
Lowriders, begun in 1979; Habitats, 1982;
and The Swallows' House, 1984. Began
exploring palladium printing and creation of
copy negatives, 1979. Produced installation
Critical Mass, begun in 1980s, about the inter-
section of scientists and Native Americans
during making of atomic bomb, 1940s.
Installation comprises complex narrative photo
works, in which several prints are arranged
within a single frame; text/optics/video with
Ellen Zweig, and Steina and Woody Vasulka.
Installation traveled, 1993–97, under auspices of
New Mexico Museum of Fine Arts, Santa Fe.
Other solo exhibitions: LewAllen Contemporary,
Santa Fe, New Mexico, 1990, 1992, 1993,
1995, 1996, and 1998; *Joan's Arc/Vietnam*,
Bunting Institute Gallery, Radcliffe College,
Cambridge, Massachusetts, 1999; and Brian
Gross Fine Arts, San Francisco, 1996 and 1999.
Selected grants and fellowships: National
Endowment for the Arts photographer's fellow-
ship, 1992; SITE Santa Fe, New Mexico (artist
installation commission), 1994–95; Artist in
Residence—New Genres, Djerassi Foundation,
Woodside, California, 1997; Pollock Krasner

award, New York, 1998; Mary Ingraham Bunting Institute fellowship, Radcliffe College, Cambridge, Massachusetts, 1998–99; National Millennium Survey grant, College of Santa Fe, New Mexico, 1999–2000.

CHARLOTTE RUDOLPH
Born 1896, Dresden, Germany
Died 1983, Hamburg, Germany
Primarily dance photography. Active in Dresden and Berlin, 1920s–'40s. Photographed German modern dance, which reached peak of activity in 1920s. Photographed Mary Wigman ("high priestess" of German modern dance) extensively through her last solo performance, 1942; also photographed Gret Palucca, Ted Shawn, and many others. Known for action-oriented photography, often stressed leaps as well as subtle nuances of movement. Wrote article entitled "Dance Photography," for *Schrifttanz* journal, May 1929. Broke dance into "principal moments" (moments of greatest tension, relaxation, or suspension) and "transitional moments" (moments of changing from one movement to another).

GALINA SANKOVA
(GALINA SANKO)
Born 1904, Russia
Died 1981, probably Moscow
Documentation and photojournalism. Became active as photographer, 1930s. Began World War II as nurse, then driver and mechanic; not sent to the front until she became correspondent for magazine *Frontovaya Illyustracia* (*The Front Illustrated*). Photographed western, Briansk, and Don fronts near Stalingrad, and northern offensive of 1944 at besieged Leningrad. Went into battle despite orders to the contrary. After one battle nursed about one hundred wounded men. Was seriously injured twice, once in an airplane accident. Day after accident she was photographing in Petrozavodsk, a German concentration camp for Russian children. Titled her body of work during war On the Trail of Horror. Regarded as finest of the five Russian women who photographed World War II (others were Natasha Bode, Olga Ignatovich, Olga Lander, and Yelzaveta Mikulina). Also photographed in Siberia and on construction sites of Five-Year Plan and Seven-Year Plan. After war was on staff of *Ogonyok* magazine.

NAOMI SAVAGE
Born 1927, New Jersey
Resides Princeton, New Jersey
Experimental work and advertising images. Born Naomi Siegler. At age sixteen studied photography with BERENICE ABBOTT at New School for Social Research, New York, 1943. Studied art, photography, and music at Bennington College, Bennington, Vermont, 1944–47. Was apprentice to her uncle, Man Ray, in Los Angeles, 1948–49; encouraged by him to explore new ideas and innovative techniques. Married architect and artist David Savage, 1950; had Michael, 1954, and Lourie, 1957. Lived in Paris with husband, 1950–51; Man Ray returned to Paris and introduced the couple to his contemporaries. Made "straight" photographic portraits of composers for music publications, 1948–49. Also did free-lance commercial photography for *Vogue, Bucks County Traveler*, Elizabeth Arden, Ted Gothelf Advertising Association, and elsewhere, 1950s–'60s. Personal work has taken range of subject matter—from portraits, landscapes, and human figure to sculpture at Versailles, dental tools, masks, toys, and kitchen utensils—as departure point for experimentation with technique. Exhibits metal engravings of photographs as primary works of art; pulls inked and uninked (intaglio) prints from the engravings. Other techniques have included collage, negative/positive combinations, photograms, solarizations, images on silver and gold foil, and double exposures. National Endowment for the Arts grant, 1971. Major commission to create mural on life of former President Johnson for Lyndon Baines Johnson Library at University of Texas, Austin, 1971; work measures eight by fifty feet and consists of five etched panels of magnesium, each eight by ten feet. Has made laser color prints since 1987. Making digitally generated computer imagery in color, 1999–present.

MARY T. S. SCHAEFFER
Born 1861, probably Philadelphia
Died 1939, probably Canada
Plant studies. Born Mary Townsend Sharples. Met husband-to-be, Dr. Charles Schaeffer, on visit to Philadelphia photographers George, William, and Mary Vaux at camp on Lake Louise in Canadian Rockies, 1889. Illustrated husband's catalog of flora of Canadian Rockies with both photographs and watercolors. Represented by three photographs in FRANCES BENJAMIN JOHNSTON's exhibition of

1900–1901. Husband died, 1904. Mary continued exploring Rockies; published articles in *Bulletin of the Geographical Society of Philadelphia*, 1907 and 1908, and *Canadian Alpine Journal*, 1908. Married British guide William Warren, 1915; moved to Banff, Canada.

BASTIENNE SCHMIDT
Born 1961, Munich, Germany
Resides New York City
Documentary. Raised in Munich and Athens. Studied anthropology at Ludwig-Maximilans University, Munich, 1981–83. Moved to Italy, studied painting and photography at Accademia di Belle Arti Pietro Vanucci, Perugia, 1984–88. Moved to New York, 1988. Began work on death rituals in Latin America, c. 1994–present; and series Death in America, 1995–present. Published two books: *Vivir la Muerte: Living with Death in Latin America*, 1996, and *American Dreams*, 1997. Married photographer Philippe Cheng, with whom she now works, 1996; had Max, 1999. Received Award of the Academy of Fine Arts, Bari, Italy, 1987; Second Prize, World Press Photo, 1992; German Photo Prize, Landesgirokasse, Stuttgart, 1993; Photofoerderpreis, Landesgirokasse, Stuttgart, 1994; Kodak Book Award for *Vivir la Muerte*, 1996; Death in America Project, Soros Foundation, New York, 1996; and Irene C. Fromer award, Snug Harbor, Staten Island, New York, 1997. Selected recent solo exhibitions at International Center of Photography, New York, 1995; Blue Sky Gallery, Portland, Maine, 1996 and 1997; Musée de la Photographie, Charleroi, Belgium, 1996; Chapel Art Center, Cologne, Germany, 1996 and 1997; Throckmorton Fine Art, New York, 1996 and 1998; Houston Center of Photography, 1996; Newhouse Gallery, Snug Harbor, Staten Island, 1997.

SARAH C. SEARS
Born 1858, Cambridge, Massachusetts
Died 1935, West Gouldsboro, Maine
Portraits and flower studies. Born Sarah Choate. Studied painting, Cowles Art School and Museum of Fine Arts School, Boston, c. 1876. Married Joshua Montgomery Sears, 1881; had Helen. Prominent in Boston society; also had residence at Wolf Pen Farm, Southborough, Massachusetts. Received prizes for watercolors at World's Columbian Exposition, Chicago, 1893; Exposition Universelle, Paris, 1900; Pan-American Exposition, Buffalo,

1901; Louisiana Purchase Exposition, Saint Louis, 1904. Began photographing, 1890s. F. Holland Day placed five of her prints in his exhibition, *The New American Photography*, which traveled to London and Paris, 1901. Represented by four prints in FRANCES BENJAMIN JOHNSTON's exhibition of 1900–1901. Elected to Linked Ring, London, 1904. Elected fellow of Photo-Secession, 1904; strong supporter of Photo-Secession, frequently contributing money to the cause. Husband died, 1905. Sarah traveled to Paris, 1906; visited Gertrude Stein's salons. Returned to Paris, traveled elsewhere in Europe, 1907–8. Published in *Camera Work*, 1907.

ELLY SERAÏDARI — *see* NELLY

EMMA D. SEWALL
Born 1836, Bath, Maine
Died 1919, Small Point, Maine
Genre, primarily New England subjects; also interiors, sea views, and landscapes. Born Emma Duncan Crooker. Daughter, wife, and mother of shipbuilders in Bath, Maine. Mother, Rachel Sewall Crooker, died when Emma was sixteen; she cared for two younger sisters. Emma went to Ipswich (Massachusetts) Female Seminary, 1854–55; exposed to rigorous scholarly curriculum as well as painting and drawing. Married third cousin, successful shipper, banker, and railroad entrepreneur, Arthur Sewall, 1859; had Harold, 1860; William, 1861; Dummer, 1864 (died at age two). At age forty-eight Emma bought camera; spent ten months traveling by railroad to states as far away as California and Oregon, sometimes with sons or husband, sometimes alone, and started to photograph western landscape. In Maine photographed rural laborers working the land and sea. Her platinum prints began winning prizes in local contests, and she was invited to become first female member of prestigious Boston Camera Club, 1894. Received club's highest award, Diploma for Greatest General Excellence, 1895. Husband became Democratic nominee for vice-president, on ticket with William Jennings Bryan, 1896; after he lost, Arthur retired from politics. He and Emma spent time at summer cottage near Small Point. She exhibited in Paris and Boston, where she won engraved silver bowl, 1898. Arthur died, 1900. Emma stopped photographing; devoted herself to scholarship and writing. Descendant, photographer Abbie Sewall, published Emma's work.

CINDY SHERMAN
Born 1954, Glen Ridge, New Jersey
Resides New York City
Narrative self-portraits and allegorical images. B.F.A., State University of New York College at Buffalo, 1976. Moved to New York City, 1977. Known for self-portraits exploring female identity. Created black-and-white Untitled Film Stills series, 1975–80; switched to color in Rear Screen Projections series, 1980. Created Centerfolds of herself, as if in men's magazines, 1981. Placed herself in Fashion series, 1983–84. Concentrated on nightmarish images in Disasters and Fairy Tales, 1985–90. In Historical Portraits presented herself in both male and female costume, often using fake body parts, 1989. Created Civil War series, 1991; and Sex Pictures series, 1992, in which she began using mannequins in explicit poses. Awards include National Endowment for the Arts, 1977; John Simon Guggenheim Memorial fellowship, 1983; MacArthur fellowship, 1995; Wolfgang-Hahn-Preis, 1997; and Hasselblad Foundation International Award in Photography, 1999. Selected recent solo exhibitions at San Francisco Museum of Modern Art, 1995; Hirshhorn Museum and Sculpture Garden, Smithsonian Institution, Washington, D.C., 1995; Museu de Arte Moderna de São Paulo, Brazil, 1995; PaceWildenstein, Los Angeles, 1996; Museum Boymans-van Beuningen, Rotterdam, the Netherlands (and tour in Spain and Germany), 1996; Museum of Modern Art, Shiga, Japan (and tour in Japan), 1996; Museum of Modern Art, New York, 1997; and Museum of Contemporary Art, Chicago, with Museum of Contemporary Art, Los Angeles (major retrospective, jointly organized, with tour), 1997.

ELSE SIMON — *see* YVA

STELLA SIMON
Born 1878, Charleston, South Carolina
Died 1973, San Francisco
Pictorial, commercial, and advertising work; also landscapes, interiors, and portraits. Born Stella Furchgott. Began as amateur; took up photography more seriously after death of husband, Adolphe Simon, 1917. Studied with Clarence White, 1923–25. Became president, White School Alumni Association, 1926. Made avant-garde film, *Hands,* in Germany, 1926–28. Secretary, Pictorial Photographers of America, 1929–c. 1932. Opened a com-

mercial and advertising studio in New York City, 1931. Solo exhibition, Art Center, New York, 1931.

COREEN SIMPSON
Born 1942, Brooklyn, New York
Resides New York City
Portraits, photojournalism, and fashion images. Took classes at Fashion Institute of Technology, 1970s, and Parsons School of Design, 1980s, both in New York. Studied photography with Frank Stewart, Studio Museum in Harlem, New York, 1977. Became editor for *Unique New York* magazine, 1980; began taking photographs to accompany her articles on life styles in New York. Began freelancing for the *Village Voice, Essence, Ms.,* and other publications, 1980s. One of first black female photographers to cover the European fashion collections, 1980s. Has done B-Boy series, since 1982, consisting of portraits of black and Hispanic youth; set up portable studio in downtown Manhattan clubs, Harlem barbershops, and braiding salons in Jamaica, Queens, New York. Represented in *Mois de la photo* exhibition, Pavillon des Arts, Paris, 1989. Created portraits with collage covering the face in experimental Aboutface series, 1991; exhibition of Aboutface, Jamaica Arts Center, Jamaica, Queens, 1992.

CLARA SIPPRELL
Born 1885, Tillsonburg, Canada
Died 1975, Bennington, Vermont
Portraits, still lifes, landscapes, cityscapes, and advertising images. Born Clara Estelle Sipprell to widowed mother. Spent first ten years in Canada; moved to Buffalo, New York, 1895. Left school, 1904. Assisted brother Francis J. Sipprell (Frank) in his photography studio, c. 1904; later became partner. Showed work at Buffalo Camera Club annual exhibitions, 1910–14. Published in *Photo Era*, 1913. Opened studio in Greenwich Village, New York, 1915; later opened second studio in Thetford, Vermont. Featured in numerous magazines, including *American Magazine of Art, American Girl, Mentor, Revue du vrai et du beau*, 1920s. Exhibited in second and third National Salon of Pictorial Photography, Albright Art Gallery, Buffalo, 1921 and 1922, and International Salon of the Pictorial Photographers of America, New York, 1923. Represented in various other exhibitions in United States as well as Europe, including Constantinople and Florence.

Traveled extensively in U.S. and abroad, including Yugoslavia, Italy, Russia, Sweden, Mexico, and elsewhere, 1920s–'30s. Did many portraits of prominent people in New York and during travels, including King Gustav of Sweden, author Pearl S. Buck, poet Robert Frost, pianist Sergei Rachmaninoff, and photographer Alfred Stieglitz. Joined Pictorial Photographers of America, the Royal Photographic Society of Great Britain, and the Arts Club of Washington, D.C. Moved summer home from Thetford to Manchester, Vermont, 1937; moved to Manchester permanently, mid-1960s. Work rediscovered and put in context in catalog *The Photo-Pictorialists of Buffalo*, with exhibition at Albright-Knox Art Gallery, Buffalo, 1981. Major retrospective, *Clara Sipprell: Pictorial Photographer*, Amon Carter Museum, Fort Worth (and tour), 1990.

SANDY SKOGLUND
Born 1945, Quincy, Massachusetts
Resides New York City
Experimental color work and installations. B.A., Smith College, Northampton, Massachusetts, 1968; spent junior year abroad studying art history at Sorbonne and Louvre, Paris. M.A. and M.F.A., University of Iowa, 1972. Taught at Hartford Art School, University of Hartford, Hartford, Connecticut, 1973–76. Joined faculty of Rutgers University, New Brunswick, New Jersey, 1976. Worked on film about Newark, New Jersey, mid-1970s. Early interest in Conceptualism and Minimalism. During 1980s became known for large (30-by-40-in.) photographs of installations, or "sets," for which she created her own sculptures and into which she inserted human "actors." National Endowment for the Arts grant, 1980. Selected recent solo exhibitions include *Gathering Paradise*, P.P.O.W. Gallery, New York, 1991; *In the Last Hour*, Fred Jones, Jr., Museum of Art, University of Oklahoma, Norman, 1993 (tour through 1996); *The Wedding*, Columbus Museum of Art, Columbus, Ohio, and Janet Borden Gallery, New York, both 1994; *New Work in Progress*, Mississippi Museum of Art, Jackson, 1995; *Retrospective*, Museumverein Arolsen, Arolsen, Germany, 1995; and Smith College Art Museum, Northampton, Massachusetts (traveling retrospective), 1998.

CLARISSA SLIGH
Born Washington, D.C.
Resides New York City
Narrative photographs and installations. B.S., Hampton Institute, Hampton, Virginia; B.F.A., Howard University, Washington, D.C.; and M.B.A., University of Pennsylvania, Philadelphia. Worked as computer programmer for NASA and as financial analyst for Mobil Oil and Goldman Sachs. Devoted herself to artwork full time, 1980s. Family experience forms core of inspiration for work. Uses images from family photo album to restage events from childhood and young adulthood; particularly examines gender relationships. Many of her cyanotype montages are juxtaposed with layers of dialogue from overheard conversations. Large installation *Mississippi Is America*, 1990, deals with civil-rights movement, as does *Witness to Dissent: Remembrance and Struggle*, Washington Project for the Arts, Washington, D.C., 1991. Teaches classes and workshops related to autobiographical issues; coordinator of Coast to Coast: National Women Artists of Color Projects. National Endowment for the Arts grant, 1988–89; New York Foundation for the Arts grant, 1988–89; New York State Council on the Arts grant, 1990; Infinity award, International Center of Photography, New York, 1995. Selected recent solo exhibitions at Afro-American Historical and Cultural Museum, Philadelphia, 1993; Toronto Photographers Workshop, 1994; Galerie Junge Kunst, Trier, Germany, 1995; Edward Bannister Gallery, Rhode Island College Art Center, Providence, 1997; and Mary H. Dana Women Artists Series, Rutgers University, New Brunswick, New Jersey, 2000.

ETHEL M. SMITH
Born 1886, Chippewa Falls, Wisconsin
Died 1964, Minneapolis
Primarily Pictorialist studies with dolls. Taught at vocational high school in Minneapolis. Both she and her brother Elmer A. Smith were Pictorialists. Ethel exhibited every year but one at Minneapolis Photographic Society, 1936–47; first-place winner in 1936 and 1938. Secretary of the society, 1939; meetings held at her home, 1938–41. Exhibited at other salons and camera clubs. Joined Photographic Society of America and its Pictorial Division, 1941. Photographs reproduced occasionally in *American Photography*, *American Annual of Photography*, and *Camera* magazines, 1940–47. Won several honorable mentions in annual competitions of *American Photography*, 1939–46. Made photographs for *Holiday in Doll-Land*, text by Ina E. Lindsley; consisted of twelve full-page photographs opposite short text. Listed in *American Annual of Photography*, "Who's Who in Pictorial Photography," 1936–46.

ROSALIND SOLOMON
Born 1930, Highland Park, Illinois
Resides New York City
Psychological documentation through landscape and portraiture. B.A. in political science, Goucher College, Towson, Maryland, 1951. Lived in Chattanooga, Tennessee, 1953–77. Equal-opportunity-employment recruiter-consultant, Agency for International Development, U.S. Department of State, 1963-65. Director, southern region, Experiment in International Living, 1965–68. Began to photograph on a trip to Japan, 1968. Studied with LISETTE MODEL, 1974–76. Lived in Washington, D.C., 1977–79. Addressed themes of women's repression, relationships, sickness, and death, through images of mannequins and broken dolls found in Kyoto, Japan, and Scottsboro, Alabama, 1972–76; created series from lifelike statues of gods and goddesses in Calcutta, India, 1981–83. Pilgrimages to sacred sites in India and Peru resulted in ongoing project of psychological landscapes. Concerns about persecution of men and women living with AIDS led her to photograph them. Solo exhibition of that series, *Portraits in the Time of AIDS* at Grey Art Gallery and Study Center, New York University, 1988. Focused on survivors of conflict in Cambodia, Latin America, Northern Ireland, former Yugoslavia, South Africa, Tibet, and Israel, 1988–99. Guggenheim fellowship, 1979–80; American Institute for Indian Studies fellowship, 1981–84; and National Endowment for the Arts fellowship, 1988–89. Solo exhibitions include *Journey to India and Nepal*, Neikrug Galleries, New York, 1972; *Dolls and Manikins*, Neikrug Galleries, New York, 1974; *Rosalind Solomon Photographs*, and *Rosalind Solomon*, Sander Gallery, Washington, D.C., 1978 and 1980, respectively; *Rosalind Solomon: Washington*, Corcoran Gallery of Art, Washington, D.C., 1980; *Rosalind Solomon: India*, International Museum of Photography at George Eastman House, Rochester, New York, 1982; *Rosalind Solomon: Earthrites*, Museum of Photographic Arts, San Diego, California, 1986; *Rosalind Solomon: Ritual*, Museum of

Modern Art, New York, 1986; *Rosalind Solomon*, PGI Gallery, Tokyo, 1991; *Disconnections*, Instituto de Estudios Norte-americanos, Barcelona, 1992; *El Perú y otros lugares, Peru and Other Places*, Museo de Arte de Lima, 1996. Began taking video and writing workshops, 1997; completed a video piece, *To Highlands*, 1998. *Rosalind Solomon: Women, Matter, and Spirit*, limited-edition portfolio of eight photographs, 2000.

EVE SONNEMAN

Born 1946, Chicago
Resides New York City
Photographs in color, primarily Cibachrome; pairs two photographs of same scene presented side-by-side, but taken from slightly different viewpoints and at slightly different times. B.F.A. in painting, University of Illinois, Urbana, 1967. M.A. in photography, University of New Mexico, Albuquerque, 1969; studied with Van Deren Coke there. Became free-lance photographer in New York, 1969. Taught at Cooper Union School of Art and School of Architecture, New York, 1970–71 and 1975–78; Rice University, Houston, 1971–72; City University, New York, 1972–75; School of Visual Arts, New York, 1975–89; Institute for Art and Urban Resources, New York, 1977. Has created several 16 mm color films for festivals, universities, and museums, since 1973. Boskop Foundation grant, 1969 and 1970; National Endowment for the Arts grant, 1972 and 1978; grant from Fondation Cartier pour l'Art Contemporain, France, 1989. Exhibited widely in galleries and museums throughout the world. Selected recent solo exhibitions at Sidney Janis Gallery, New York, 1996; Cartier Foundation for Contemporary Art, Paris, 1997 and 1999; Cirrus Gallery, Los Angeles, 1998; Fenimore Art Museum, Cooperstown, New York, 2000; and Metropolitan Museum of Photography, Tokyo, 2000.

CHARLOTTE STAM-BEESE—*see* LOTTE BEESE

MAGGIE STEBER

Born 1949, Electra, Texas
Resides New York City
Documentation and photojournalism. B.S.J. in journalism with a certificate in photojournalism, University of Texas, Austin, 1968–72; studied there with Russell Lee (former Farm Security Administration photographer) and Garry Winogrand. Worked for *Galveston (Texas)*

Daily News, as reporter-photographer, 1972–73. First woman picture editor for Associated Press, New York, 1973–78. Left to cover war in Rhodesia (now Zimbabwe), 1978–80; worked for *New York Times*, Associated Press, and SIPA (French picture agency based in Paris). Photographed in Cuba, 1982–85. Has photographed in Haiti since 1986; work culminated in book *Dancing on Fire*, 1992. Clients include *National Geographic*, *Life*, *New York Times*, *U.S. News and World Report*, *Newsweek*, *Condé Nast Traveler*, and *Observer* (London). Awards of excellence, Pictures of the Year Contest, University of Missouri, Columbia, 1986 and 1990; first prize in magazine news documentary, Pictures of the Year Contest, 1987; Leica Medal for Excellence in Photojournalism, 1987; Alicia Patterson Foundation grant to write and photograph in Haiti, 1988; first Ernst Haas grant from the Maine Photographic Workshop and Eastman Kodak, 1988; Olivier Rebbot award from Overseas Press Club for best photographic reporting from abroad, 1989; and Best Photographic Book in Photojournalism award, Maine Photographic Workshop, 1992.

JUDITH STEINHAUSER—*see* JUDITH HAROLD-STEINHAUSER

GRETE STERN

Born 1904, Wuppertal-Elberfeld, Germany
Died 1999, Buenos Aires
Portraits, advertising, and still lifes. Studied graphics at Kunstgewerbeschule Weisenhof, Stuttgart, Germany, c. 1923–25. Did advertising, layout, and design, 1925. Studied photography privately with Walter Peterhans, c. 1927–28; later at Bauhaus, Dessau, 1929–30. Opened studio with friend Ellen Rosenberg (later ELLEN AUERBACH) called "foto ringl + pit" (based on their childhood nicknames), specializing in avant-garde advertising, 1930. Stern became known for striking portraiture. Won prize for ringl + pit photographic poster, Brussels, 1933. Met Argentinian photographer Horacio Coppola—another student of Peterhans—in Berlin, 1931. Coppola and Stern moved to London, 1933. Stern opened studio; did advertising and portraits. Auerbach joined her, 1935–36. Stern and Coppola moved to Buenos Aires, 1937; married there. Opened studio; worked for publishers and agencies. She photographed architecture by Amancio Williams, 1947; became photographer for the Municipal Architect's Office,

1948–50. Produced forty photomontages for *Buenos Aires* magazine, 1948–51. Photographer and director, Department of Correspondence, Museo Nacional de Bellas Artes, 1956–70. Traveled to do documentation of aboriginal people, 1958. Became Argentinian citizen, 1958. Taught photography, Resistencia University, Chaco, 1959–60. Documented Indian culture in Chaco Norteño, 1964. Konex prize, 1982. Solo exhibitions at Museo de Ciencias Naturales de la Plata and Fra Angelico Museum, both La Plata, Argentina, 1982.

ELISABETH SUNDAY

Born 1958, Cleveland
Resides Oakland, California
Experimental work using lens distortion in single images and sequences. At age fifteen received camera from grandfather, painter Paul Travis. While living in Paris, 1980–84, took inspiration from paintings of elongated African figures done by Travis in 1930s. Bought large distortion mirrors with idea of photographing straight into the mirrors to capture elongated images of subjects; began with flowers and plants, 1982–84. Using this technique, traveled with three hundred pounds of photographic equipment and three 4-by-5-foot Plexiglas mirrors to photograph people in Senegal, Mali, Kenya, Botswana, and Zaire's Ituri rain forests, 1986–90. Received financial support for expeditions from actor Bill Cosby, musician Graham Nash, writer Alice Walker, and Eastman Kodak. Worked on series of portraits entitled Mystics and Healers from Thailand, India, Bali, and Australia, 1994–95. Selected recent solo exhibitions at Bibliothèque Nationale, Paris, 1987; Reese Bullen Gallery, Humboldt State University, Arcata, California, 1987; and Exploratorium Museum, San Francisco, 1990.

JOYCE TENNESON

Born 1945, Boston
Resides New York City
Figures and portraits; also advertising. B.A., Regis College, Weston, Massachusetts, 1967; M.A., George Washington University, Washington, D.C., 1969; and Ph.D., Antioch College, Yellow Springs, Ohio, 1978. Taught at Northern Virginia Community College, Annandale; Corcoran School of Art, Washington, D.C., and Smithsonian Institution, Washington, D.C., 1970–early 1980s. Moved to New York City, 1984. Best known for ethereal

photographs of the female figure, but also photographs men and children. Since 1984 has worked in color, culminating in book *Joyce Tenneson: Transformations*, 1993. Began successful commercial career, 1980s; photographs have appeared in *Esquire*, *New York Times Magazine*, *French Vogue*, *Italian Vogue*, and *L.A. Style*. Received advertising commissions from Kohler Corporation and others. Commissioned to make portraits of dancer Judith Jamison, actress Demi Moore, philanthropist Brooke Astor, and actress Jessica Tandy, among others. Infinity Award in Applied Photography, International Center of Photography, New York, 1989. Named Photographer of the Year by international organization Women in Photography, 1990. Selected recent solo exhibitions at Centre Georges Pompidou, Paris, 1991, and International Center of Photography, New York, 1993.

HARRIET V. S. THORNE

Born 1843, Troy, New York
Died 1926, Bridgehampton, New York
Portraits; also interiors. Active about 1885 to 1919. Born Harriet Smith Van Schoonhoven. Married Jonathan Thorne, a successful businessman and civic leader, 1867; had Josephine, 1869 (died in infancy); Victor Corse, 1871; and Samuel Brinckerhoff ("Brinck"), 1873. They had winter home in New York on Fifth Avenue; summer home called Schoonhoven in Black Rock, Connecticut. At summer home photographed family and visitors, interiors, and beautiful grounds and gardens complete with peacocks. Did own darkroom work. In New York photographed architecture as well as family members. On vacation in Palm Springs, California, photographed alligators, Indians, and exotic gardens; also photographed at Okeetee Club in Ridgeland, South Carolina (a hunting club founded by her brother-in-law, Samuel Thorne). One of first members of New York Camera Club, 1888–89. Husband died, 1920. Harriet, heartbroken, closed studio and asked sons to dispose of contents. Moved to Bridgehampton, Long Island, for summer months. Thirty years after close of studio, Therese Thorne McLane found box of negatives and gave them to the photographer Rosalie (Rollie) McKenna (great-granddaughter of Harriet), who collected more examples from other relatives. Selection shown at Yale University Art Gallery, New Haven, Connecticut, 1979.

RUTH THORNE-THOMSEN

Born 1943, New York City
Resides Philadelphia and Moab, Utah
Experimental work with fabricated landscapes and figures; also collaged profiles and close-ups of statuary faces. F.A. in dance, Columbia College, Columbia, Missouri, 1961–63; B.F.A. in painting, Southern Illinois University, Carbondale, 1966–70; B.F.A. in photography, Columbia College Chicago, 1971–73; M.F.A. in photography, School of the Art Institute of Chicago, 1974–76. Assistant professor, 1983–87; associate professor, 1987–89, and chair, Department of Fine Arts and Theater, since fall 1988, all University of Colorado, Denver. Best known for using pinhole camera with miniature props (pyramids, palm trees, statuary, ships, leaning tower of Pisa) to construct symbolic landscapes and seascapes suggesting both antiquity and twentieth-century Surrealism; most prints are in 4-by-5-in. format. Work can be divided into several series: Expeditions, 1976–84, Door, 1981–83; Prima Materia, 1985–87; Views from the Shoreline, 1986–87; Messengers, 1989–90; and Songs of the Sea, begun in 1991. Traveled widely, to Mexico, 1976; France, 1979 and 1989; Greece, 1983; Italy, 1985, and elsewhere. John Quincy Adams fellowship, School of the Art Institute of Chicago, 1976; National Endowment for the Humanities Summer Seminar award, Paris, 1979; National Endowment for the Arts Emerging Artists fellowship, 1982; NEA Individual Artist fellowship, 1989; Residency award, La Napoule Foundation, La Napoule, France, 1989; Lifetime Achievement award, Columbia College Chicago, 1995; and Bessie Berman Award for Photography, Leeway Foundation, Philadelphia, 1996. Selected recent solo exhibitions at Laurence Miller Gallery, New York, 1991, 1993, and 1998; Cleveland Museum of Art, 1993; Jessica Berwind Gallery, Philadelphia, 1993; Ehlers Caudill Gallery, Chicago, 1993; Jan Kesner Gallery, Los Angeles, 1993; Robischon Gallery, Denver, 1993; University of Wyoming Art Museum, Laramie, 1996; Museum of Contemporary Art, Chicago (and tour), 1993–96; and Jackson Fine Art, Atlanta, 1998.

EDITH HASTINGS TRACY

Born n.d., United States
Died n.d., United States
Primarily portraits; also documentation. Period of peak activity, 1907–15. Became professional portrait photographer, possibly by 1900 and definitely by 1907. Family moved from Plainfield, New Jersey, to New York City, 1907, and lived there until 1915. Joined Camera Club of New York and may have worked in darkroom there. Appears to have taken portraits at subjects' own houses as well as in studio. Accompanied by two female friends, traveled to Panama for two weeks to photograph construction of Panama Canal, 1913. Took with her a large-view camera, a Graflex, and a pocket Premo. Exhibited eighty-four photographs of canal-engineering activities and of surrounding landscape, Folsom Galleries, New York, April 1914; favorably reviewed by *New York Herald*, *New York Globe*, *New York Mail*, and *New York Evening Sun*. Four Panama Canal photographs reproduced in *Collier's National Weekly*, June 14, 1913; work also reproduced in *National Geographic*, probably 1913. Ceased photography at time of World War I, around 1914 or 1915, because she could no longer get supplies from Germany. After war found occupation as a potter.

DEBORAH TURBEVILLE

Born 1937, Boston
Resides New York City
Fashion images. Attended Brimmer and May School, Boston, 1949–54. Moved to New York City, 1956. Design assistant to designer Claire McCardell, 1956–58. Editorial assistant, *Ladies' Home Journal*, 1960–62; fashion editor, *Harper's Bazaar*, 1962–65; associate fashion editor, *Mademoiselle*, 1967–71. Free-lance fashion photographer for *Vogue*, *Marie-Claire*, *Nova*, and others, since 1972. Lived in Europe, 1972–74. Gained widespread attention for series of fashion photographs done in deserted public bathhouse and published in *Vogue*, May 1975. Noted for use of soft focus, brooding atmosphere, muted tones, and locations in a state of ruin or abandonment. Selected recent solo exhibitions at La Remise du Parc, Paris, 1981 and 1982; Centre Georges Pompidou, Paris, 1986; and Staley-Wise Gallery, New York, 1987 and 1992.

JUDITH TURNER
Born Atlantic City
Resides New York City
Architectural documentation. B.F.A., Boston
University. Took up photography, 1972. Began
photographing work by avant-garde formalist
architects, the "New York Five"—Peter
Eisenman, Michael Graves, Charles Gwathmey,
John Hejduk, and Richard Meier—in mid-
1970s. Known for images of architectural
details, shapes, texture, edges against space, and
patterns of light and shadow. Has photographed
around the world, including Israel and Japan
(known for photographs of the Tokio [sic]
Marine Building, and the Spiral Building and
Tepia Building in Tokyo). Graham Foundation
grant for advanced studies in the fine arts,
Chicago, 1982; Lila Acheson Wallace grant,
Lila Acheson Wallace Fund, Reader's Digest
Association, Pleasantville, New York, 1984;
and fellowship from Asian Cultural Council,
1985. Work has been published in several
books and has appeared in and been reviewed
in newspapers and magazines, including
Metropolis, *Space Design*, *Zoom*, *Forum*, *Photo Japan*,
and *Wiederhall*. Selected recent solo exhibitions
at Bertha Urdang Gallery, New York, 1988;
Kajima Gallery, Tokyo (and tour); National
Institute for Architects' Education, New York,
1991; and Printmaking Workshop, New York
(and tour), 1993; Hewlett Gallery, Carnegie
Mellon University, Pittsburgh, 1996; Tokyo
Design Center, 1998; Art Gallery, Williams
Center for the Arts, Lafayette College, Easton,
Pennsylvania, 1999; Erie Art Museum, Erie,
Pennsylvania, 1999; Bienal Internacional de
Arquitectura, São Paulo, Brazil, 1999; and
Avery Hall, Columbia University, New York,
2000.

KAREN TWEEDY-HOLMES
Born 1942, Columbus, Ohio
Resides New York City
Portraits, nudes, architectural work, and
documentation. B.A. in art history, Barnard
College, New York, 1964. Owned Leica at age
sixteen. Interest in architecture resulted in
studies of university and other city buildings.
After graduation began dual career in editing
and photography, working for two science
magazines, *International Science and Technology* and
Space/Aeronautics, as staff photographer and editor, 1967–69. Although primarily a portraitist,
did noted series of male nudes, 1960s. Deeply

involved in architectural projects, since 1970s:
Victorian houses in United States; civic buildings in New York and Europe; temples and
palaces in northern India, 1983; and landmark
courthouses in New Jersey, 1991. From 1970
on, primary interest has been studies of animals,
both domestic and wild. Photographed large
animals in Africa, 1975; snakes and insects in
Africa, 1978 and 1980. Since 1984 has been
photographing landscapes and wildlife in
American Southwest. Married jazz musician
Lou Grassi, 1986. Published in *New York Times*,
Geo, *Animals*, *Boston Globe*, *Art in America*, *Popular
Photography*, and elsewhere. Received grant from
Mindlin Foundation, Bellevue, Washington, to
photograph the endangered Bisti Badlands,
New Mexico, 1999. Recent selected solo exhibitions at Haskell, Newport, Vermont, 1993;
Population Council, New York, 1993 and
2000; Saga, Brookfield, Connecticut, 1995 and
1996; Le Rebelle, New York, 1997 and 1998;
and Holden Art Center, Warren Wilson
College, Asheville, North Carolina, 2000.

DORIS ULMANN
Born 1882, New York City
Died 1934, New York City
Portraits; also still lifes. Born to wealthy family
and lived on Park Avenue. Studied with Lewis
Hine at Ethical Culture School, New York,
1900–1903. In youth traveled abroad with
father; mother had died. Spoke German,
French, Italian. In childhood suffered stomach
ulcer and had several surgical operations;
health remained delicate all her life. Studied
psychology and law, Columbia University,
New York, 1907. Studied photography with
Clarence White at Columbia University, 1907,
and at his school, 1914, when her interest
became serious. LAURA GILPIN was a classmate;
also met MARGARET BOURKE-WHITE and
Ralph Steiner. Married Dr. Charles H. Jaeger,
before 1917; divorced, 1925. Joined Pictorial
Photographers of America, 1918. Published
several books, including *Portraits of the Medical
Faculty of the Johns Hopkins University*, 1922, and *A
Portrait Gallery of American Editors*, 1925. Began
photographing rural life, especially Dunkard,
Mennonite, and Shaker settlements in Virginia,
Pennsylvania, New York, and New England,
1925. Hired folk singer John Jacob Niles to
assist her in travels by automobile to photograph rural people of Appalachia and environs,
1927. Photographed Gullah people in South

Carolina, 1929–30, and published seventy of
the portraits in book *Roll, Jordan, Roll*, 1933.
Collaborated with Allen Henderson Eaton,
photographing those involved in traditional
crafts in Southern Highlands, 1933.

AMELIA C. VAN BUREN
Born n.d., United States
Died n.d., United States
Primarily portraits and figure studies. Student
and friend of Thomas Eakins at Pennsylvania
Academy of the Fine Arts, c. 1880s. Trained
as painter. For a few years tried to run a small
studio and gallery in the country, but rebelled
against the aesthetic compromises required to
sell her painting and determined to work only
in photography. Opened studio with EVA
WATSON-SCHÜTZE, another Eakins student, in
Atlantic City, New Jersey, between 1894 and
1896; did not become as well known as her
studio-mate. Exhibited at Camera Club of
Pittsburgh, 1899, with Watson-Schütze, Emma
Fitz, and MATHILDE WEIL. Represented by six
prints in FRANCES BENJAMIN JOHNSTON's exhibition of 1900–1901. At the time she sent
prints to Johnston in 1900, her address was
"106 Miami Avenue, Detroit, Michigan."

FLORENCE VANDAMM
(VANDAMM STUDIOS)
Born 1883, London
Died 1966, New York City
Theatrical portraits. Surname originally spelled
as two words, but later changed to one. Was
miniaturist and portrait painter in London;
studied photography and opened photographic
portrait studio, 1908. Studio became salon for
many painters, actors, musicians, and writers.
Elected fellow of Royal Photographic Society
of Great Britain, c. 1919. Met American
George R. Thomas in London, 1917; they
married, 1918. Had one son, Robert, who
died during World War II. A year or so after
marriage, husband went into partnership
with her and later called himself "Tommy
Vandamm" professionally. When England was
struck by depression, they moved to New York
City, 1923; barely survived financially.
Rediscovered by *Vogue* and *Vanity Fair*, for whom
the couple had photographed in London, 1925.
Florence specialized in studio portraits of theatrical performers, and Tommy, in "on-stage"
photographs. Theater Guild became important
client. Covered over two thousand Broadway

theater productions, 1925–50. Photographed Judith Anderson, Ethel Barrymore, Katharine Cornell, John Gielgud, Helen Hayes, Eva Le Gallienne, Alfred Lunt and Lynn Fontanne, Burgess Meredith, and others. Husband died, 1944; Florence then began to do photographs on stage as well as in the studio. Donated her archives to New York Public Library, 1961.

DIXIE D. VEREEN

Born 1957, Colorado Springs, Colorado
Resides Arlington, Virginia
Photojournalism. Born to Dixie Lee Vereen and Willie Vereen, staff sergeant in United States Army at time of her birth. Family stationed in Germany; Fort Sheridan, Illinois; Fort Knox, Kentucky; and Fort Bragg, North Carolina. First job in photojournalism for *Fayetteville (North Carolina) Observer-Times* while still in high school, 1974–75. Attended Randolph Technical College, Asheboro, North Carolina, with major in photojournalism, 1975–77. Staff photographer for *Gastonia (North Carolina) Gazette*, 1977, and *Raleigh (North Carolina) News and Observer*, 1977–79; staff photographer, *Newsday*, Long Island, New York, 1980. Staff photographer, *Philadelphia Inquirer*, 1980–82. Staff photo editor and photographer for *USA Today*, Washington, D.C., 1982–85; director of photography, *USA Weekend* magazine, Washington, D.C., 1985–90. Assistant managing editor, *Wilmington News Journal*, Wilmington, Delaware, 1990–91. Design editor of bonus sections, *USA Today*, 1991–92; design editor of page one, *USA Today*, 1991 to present. Fellowship, Institute for Journalism Education, Management Training Center, Kellogg Graduate School of Management, Northwestern University, Evanston, Illinois, 1988. Member of National Association of Black Journalists, White House News Photographers Association, American Society of Magazine Photographers, and National Press Photographers Association. Speaker at first annual Women in Photojournalism conference, Austin, Texas, 1989; National Minority Affairs Chairperson for National Press Photographers Association, 1989.

MICHELLE VIGNES

Born 1926, Reims, France
Resides San Francisco
Documentation and photojournalism. Educated in Reims; studied philosophy. Picture editor for Magnum Photos, Paris, 1953–57; placed in charge of all European assignments and sales. Picture editor at Unesco, Paris, 1957–61. Decided to become photographer, 1961. Moved to New York, 1962; worked on public relations staff, United Nations, 1962–66. Moved to San Francisco, 1966; started working as free-lance photographer. Collaborated with photo agencies Holmes-Lebel in Paris and PIX in New York. First reportages commissioned by *Newsweek*, *Ramparts*, *Der Spiegel*, *Stern*, *Time*, *Le Nouvel Observateur*, and others. Published in *Life*, *Vogue*, *New West*, and *Le Monde*. Did political reportage on Native Americans at Alcatraz and Wounded Knee, and on Black Panthers and Angela Davis, 1969–73. In France did series of portraits of Paris concierges, 1970. Did series of color photographs on the "dream builders" (naive artists) of California, published in *New West* magazine and *L'Express*, 1974–79. Photographed blues musicians in Oakland, California, 1981–87. Photographed gospel churches in Oakland, 1987–89, and artisans at Tarascan pueblo, Mexico, 1988–89. Has taught documentary photography at University of California extension, San Francisco, since 1978. Selected recent solo exhibitions include *Oakland Blues*, Centre de la Photographie, Geneva, 1990; and a retrospective, FNAC Gallery, Paris, 1990.

JEANETTE VOGT
(JEAN BERNARD)

Born c. 1860, United States
Died n.d., United States
Genre and narrative images. Came from artistic family; her brother Adolph Vogt was a painter of some repute. Often worked under her married name, Jean Bernard. Lived with husband in then-rural Far Rockaway, Queens, New York, and many of her platinum prints are of country life. Recorded amateur theatricals, wine drinking in the garden, and days at the beach; specialized in posing people and animals in sentimental scenes. Submitted her photographs of children with cameras to Eastman Kodak Company, which used them as advertisements. Won prizes in amateur competitions.

WANG MIAO

Born 1951, Beijing
Resides Hong Kong
Documentation and landscapes. Started career in photography, 1968. Worked for China News Agency and Historical Press as news photographer. Joined Chinese Photographers Association, 1980. Graduated from People's University of China, 1985. Became member of executive committee of Contemporary Chinese Photography Society, 1985. Editor-in-chief of Hong Kong magazine *China Tourism* and vice-director of Hong Kong China Tourism Press, since c. 1986. Photographs have been published in *Geo*, *Photo*, *Popular Photography*, *Discovery*, *Chinese Photography*, and other magazines. Has photographed landscape of China, the Dunhuang frescoes, Tibet, everyday life in elementary school, and other subjects.

AGNES WARBURG

Born 1872, London
Died 1953, Surrey, England
Interiors, landscapes, and portraits; also worked with early color processes. Third of five children born to Frederick and Emma Warburg. Educated at home by governesses. Elder brother John took up photography, 1880, and Agnes followed suit. Did not become member of Linked Ring but exhibited at Photographic Salon of the Linked Ring, 1900, and continued showing with them through the society's last Photographic Salon, 1909. Exhibited at London Salon of British Photographic Society and the Royal Photographic Society, to which she was elected, 1916. Founding member of Halyon Womens Club; exhibited there, 1914. Early experimenter with autochrome and Raydex color processes. Founding member of Royal Photographic Society's Pictorial Group, 1921; also a founder of Royal Photographic Society's Colour Group, 1927. Lived with mother after other family members married; eventually lived on her own. Left London during World War II; moved to Minehead and later settled in Surrey.

CATHARINE BARNES WARD

Born 1851, Albany
Died 1913, Hadlow, England
Portraits and narrative images; also landscapes and scenic views. Born Catharine Weed Barnes; maternal grandfather was New York politician and journalist Thurlow Weed. Graduated from Albany Female Academy and Friends School of

Providence, Rhode Island, 1860s. Attended Vassar College, 1869–71. Traveled to Russia with parents, 1872. Traveled in United States; cared for ailing mother, 1877. Mother suggested she try photography, 1886. Received diploma in photographic competition, Boston, 1888. Mother died; Catharine became her father's housekeeper. Built studio in attic, 1889. Admitted to Society of Amateur Photographers of New York, 1889. Became associate editor of *American Amateur Photographer*, 1890. Wrote and lectured extensively on photography, becoming known as advocate of women photographers. Became member of the Photographic Society of London, 1893. At age forty-two married Henry Snowden Ward (age twenty-eight), English founder and editor of *Practical Photographer*, 1893; they sailed for England. Founded and edited photographic magazines with husband; helped create links between Anglo and American photographic communities. Published *Shakespeare's Town and Times*, with 110 illustrations, 1896, followed by illustrated books on Dickens, the Canterbury pilgrimages, and the land of Lorna Doone. Toured U.S. with husband, to raise funds for upcoming Dickens centenary. He died in New York, 1911; she returned to England.

MARGARET WATKINS

Born 1884, Hamilton, Canada
Died 1969, Glasgow
Still lifes, portraits, landscapes, nudes, advertising, and documentary work. Born Meta Gladys Watkins to Scottish parents; she later changed her name to Margaret. Began photographing, 1900. Studied with Clarence White in New York, 1914–16; he invited her to be on staff of his school, 1916. Became professional photographer with studio on Jane Street in Greenwich Village, 1916. Produced portraits, landscapes, and nudes, 1916–30; exhibited in numerous Pictorial salons in United States and abroad. Influenced pupils and colleagues, including Anton Bruehl, LAURA GILPIN, Paul Outerbridge, Ralph Steiner, and DORIS ULMANN. Member of Pictorial Photographers of America; edited their journal, 1920. Did advertising photographs for Macy's department store, 1920; worked for ad agency J. Walter Thompson, 1920s. Visited four maiden aunts—her mother's sisters—in Glasgow, 1928, and traveled elsewhere in Europe and Soviet Union; did documentary photographs in Moscow and Leningrad, 1930.

Returned to Glasgow, 1931; remained to care for elderly aunts until last one died, 1939. World War II stranded her in Glasgow; she remained there, leading reclusive life, thirty years. Asked a Glasgow neighbor, Joseph Mulholland, to become executor of her estate; he discovered two hundred photographs after her death.

WENDY WATRISS

Born 1943, San Francisco
Resides Houston
Primarily social documentation and photojournalism. Traveled widely as child with her father, a businessman and diplomat. Attended Universidad Complutense de Madrid; received diploma in Spanish language and civilization, 1961; also studied at Sorbonne, Paris. B.A., honors in English and philosophy, New York University, 1965. Worked as newspaper reporter, *Saint Petersburg (Florida) Times*, 1965–67. Television producer and writer of documentary programs for public television, 1967–70. At same time studied still photography with Hans Namuth and former Photo League member Harold Feinstein, New York. Free-lance photojournalist and writer, 1970 to the present. Married photographer Frederick Baldwin, 1978. Wanting to work in the United States after so much time abroad, researched and photographed rural Texas in collaboration with Baldwin, 1970s on. Has photographed refugee camps, Sahel region of West Africa, 1974; civil-rights activities, Chapel Hill, North Carolina, 1974; debilitating effects of defoliant Agent Orange on Vietnam veterans, 1980, and many other subjects. Photojournalism assignments for *Geo*, *Life*, *Newsweek*, *New York Times*, *Stern*, and others, 1980s. Texas Commission for the Humanities grant, Austin, 1976; Rockefeller Foundation Humanities fellowship, New York, 1976–77; National Endowment for the Humanities grant, 1978–79; National Endowment for the Arts Exhibition award, 1981; World Press Foundation award, the Netherlands, 1982; Mid-Atlantic Arts Alliance/National Endowment for the Arts fellowship, 1987. Solo exhibition, *Texas: Reflections, Rituals*, National Museum of Women in the Arts, Washington, D.C., 1991–92. Curator for FotoFest, International Festival of Photography, Houston, since 1991.

EDITH S. WATSON

Born 1861, New England
Died 1943, probably Canada
Portraits, landscapes, and social documentation. Traveled regularly through Canada, mid-1890s until 1930. Photographed rural Canadians at work: Quebecoises, 1910; the Doukhobors, 1919; Mennonites in the prairies; clam diggers and fishermen in Cape Breton. Work widely published in magazines. Liaison with writer Victoria Hayward (born in Bermuda), 1911–43; they traveled extensively together. Watson's photographs exist in the form of albums (location unknown). Died of ruptured ulcer; burial arranged by Hayward. Inscription on Watson's tombstone (location unknown) reads: "They seek a country."

EVA WATSON-SCHÜTZE

Born 1867, Jersey City, New Jersey
Died 1935, probably Chicago
Portraits and figure studies; also landscapes and still lifes. Born Eva Lawrence Watson. Entered Pennsylvania Academy of the Fine Arts, Philadelphia; studied painting and modeling in the life classes of Thomas Eakins and Thomas Anshutz, 1883. Began work with camera; operated studio with AMELIA C. VAN BUREN, another Eakins student, in Atlantic City, New Jersey, 1894–96. Opened own studio in Philadelphia, 1897. Exhibited six pictures in the important Philadelphia Salon of 1898; Alfred Stieglitz was a juror. She served on jury of second Philadelphia Salon, 1899, and again in 1900. Wrote articles for *American Amateur Photographer*, *Camera Notes*, and later *Camera Work*. Represented in FRANCES BENJAMIN JOHNSTON's exhibition of 1900–1901; was one of seven women Johnston wrote about in "The Foremost Women Photographers of America" series for *Ladies' Home Journal*, 1901–2. Represented in F. Holland Day's exhibition *The New American Photography*, 1901, which traveled to London and Paris. Married German-born lawyer Martin Schütze, 1901. Unable to practice law in the United States, he had acquired Ph.D. in German literature and taught German at Northwestern University, Evanston, Illinois; went to University of Chicago as instructor in German language and literature, 1901. Eva elected to membership in Linked Ring, 1901. Founding member of Photo-Secession, 1902, but in Chicago felt isolated from, and perhaps shut out of, the New York–based movement. Her work appeared in first photographic exhi-

bition at Stieglitz's Little Galleries of the Photo-Secession (291), 1905, but not in subsequent ones. Opened successful studio in Chicago, 1902, and developed strong friendships with other families of University of Chicago faculty. Schützes became associated with Arts and Crafts colony in Byrdcliff (Woodstock), New York, 1902; Eva spent six months a year in her studio there, devoting time to painting.

CARRIE MAE WEEMS
Born 1953, Portland, Oregon
Resides Oakland, California
Narrative photographs; also installations. Since 1978 has used photography as means of confronting issues of race, identity, gender, and class. Early background in modern dance; held various jobs on farms and in restaurants, factories, and offices, 1970s. Involved in grass-roots political work in Californian socialist and feminist organizations, 1975. Began formal studies in photography in her late twenties; entered California Institute of the Arts, Valencia, 1979; received B.F.A., 1981. M.S.A. in photography, University of California, San Diego, 1984. Has done M.S. program coursework in African-American folklore, since 1984. In attempt to understand own family, created series Family Pictures and Stories, suggesting idea of family album and introducing text, 1978–84. First explored implications of racist humor in series Ain't Jokin, 1987. At invitation from Polaroid Corporation, produced first color work, with 20-by-24-in. Polaroid camera, 1990; resulted in installation And 22 Million Very Tired and Very Angry People. Assistant professor, California College of Arts and Crafts, Oakland, since 1991. Awards, fellowships, and residencies include Lewis Comfort Tiffany award, New York, 1992; Artist in residence, Cité des Arts, Paris, 1993–94; National Endowment for the Arts fellowship, 1993–94; Photographer of the Year, Friends of Photography, San Francisco, 1993–94; National Endowment for the Arts Visual Arts grant, 1994–95; Mary Ingraham Bunting Institute fellowship, Radcliffe College, Cambridge, Massachusetts, 1995; Alpert Award for Visual Arts, 1996; Philip Morris Resident, Künstlerhaus Bethanien, Berlin, 1997–98; and National Millennium Survey grant, College of Santa Fe, New Mexico, 2000. Selected recent solo exhibitions include Carrie Mae Weems, National

Museum of Women in the Arts, Washington, D.C. (and tour), 1993; Who What When Where, Whitney Museum of American Art at Philip Morris, New York, 1998; and Carrie Mae Weems: Recent Work, 1992–1998, Everson Museum of Art, Syracuse, New York, 1998–99.

MATHILDE WEIL
Born n.d., presumably Philadelphia
Died n.d., presumably Philadelphia
Primarily portraits. Active late 1890s through first decade of twentieth century in Philadelphia. Studied painting at Decorative Art League, Pennsylvania Academy of the Fine Arts, and Museum School of Industrial Art, all in Philadelphia. Studied painting at Joseph De Camp's summer school in Annisquam, Massachusetts, before turn of the century. Began photographing, 1896–97; after receiving six lessons in photography and help from members of Photographic Society of Philadelphia, established portrait studio. Represented by ten photographs in FRANCES BENJAMIN JOHNSTON's exhibition of 1900–1901; was one of seven women Johnston wrote about in "The Foremost Women Photographers of America" series for Ladies' Home Journal, 1901–2. Did commercial portrait work; sold portrait photographs at what were considered very high prices. Exhibited at Philadelphia Salons, 1898–1900; London Salons, 1898–1901; and Photo-Secession exhibition, 1902, National Arts Club, New York. Ad for her studio at 1730 Chestnut Street shows charge of sixty dollars per dozen. Made exposures in the sitter's home, often of children. Would reproduce work only in the "best magazines," like Camera Notes, early 1900s.

SANDRA WEINER
Born 1921, Drohiczan (near Warsaw), Poland
Resides New York City
Documentation. Born Sandra Smith. Emigrated with parents to United States, 1928. Studied with Paul Strand at Photo League, New York, 1940s, and with photojournalist Dan Weiner, at Photo League and at Moultrie Air Force Base, Georgia, 1942. Married Weiner, 1942; had daughter, Dore, 1951. She and husband worked as a team for Fortune, Life, Collier's, Sports Illustrated, Harper's Bazaar, and McCall's, 1950–59. She originated ideas for photoessays and did research, editing, and captioning

as well as darkroom work. Worked on book South Africa in Transition with husband and Alan Paton, 1956. Husband died in airplane crash, 1959. She had editorial job on staff of Sports Illustrated, 1959–64. Began to write and photograph books for children, beginning with It's Wings That Make Birds Fly, about a boy growing up in Harlem, 1968. Taught photography at New York University, 1970–73, and at City College of the City University of New York, 1975–81. Represented in group exhibitions, The Photo League, Howard Greenberg Gallery, New York, 1993; and The Photo League, Galería Telefónica, Madrid, 1999.

ALICE WELLS
Born 1927, Erie, Pennsylvania
Died 1987, Galisteo, New Mexico
Experimental work with montage and various processing techniques. Attended Pennsylvania State University, University Park, Pennsylvania, n.d. Married Kenneth Carl Meyers; had three children. Moved to Rochester, New York, where Meyers worked for Eastman Kodak. Alice took secretarial job at Kodak, 1952. Divorced from husband, 1959; excommunicated from Roman Catholic Church. Began photographing, 1959. Took a photography workshop with Ansel Adams at Yosemite National Park, California, 1961, and took classes with Nathan Lyons at his house in Rochester, New York, 1961–62. Left Kodak and became Lyons's secretary at George Eastman House (now International Museum of Photography at George Eastman House), Rochester, 1962. Created abstract photographs of forms in nature with large-format cameras. Solo exhibition of these works, Eastman House, 1964. Switched to hand-held 35 mm camera, 1965; photographed densely populated urban environment. Experimented with multiple exposures in camera, negative sandwiches in the darkroom, as well as solarization, toning, and hand coloring. Became interested in Zen Buddhism, 1967. When Lyons created Visual Studies Workshop (initially called Photographic Studies Workshop), Rochester, 1969, Alice was assistant to him until 1972. After moving to New Mexico, 1972, changed name to "Alisa," spelled various ways. Married Richard Witteman, student of Zen, 1974; separated 1980. Married to Roman Attenberger at time of death.

LILY WHITE

(LILY E. WHITE)

Born 1865, Oregon City, Oregon
Died 1944, location unknown

Landscape. Parents were Captain Milton and
Nancy M. White. Father was a pioneer of the
Oregon Territory in 1845; mother a pioneer in
1852. Lily attended school in Portland,
Oregon, and later studied art in San Francisco
and Chicago, n.d. Listed in the Portland City
Directory from 1898 to 1924 (listed as artist,
photographer, or artist-photographer,
1892–1906). Upon return to Oregon, made a
number of portrait paintings, 1890s. Elected
to Oregon Camera Club, 1898; was demon-
strating various photographic techniques as
club instructor by 1900. Became member of
Photo Secession, c. 1902 or 1904. White,
with close friends Maude Ainsworth and Sarah
Hall Ladd (an American photographer,
1857–1927), traveled into Columbia Gorge to
make large-format landscape photographs, by
1902. White used a spacious houseboat, the
Raysark, to travel for extended periods through
the gorge. Created work that emphasized the
effect of changing patterns of weather and
light on the dramatic landscape. No evidence
that White created new work after 1905; is
known to have printed in 1908. White listed
herself as practitioner of Christian Science,
1909–23. Moved to Monterey (Carmel-by-
the-Sea), California, with Sarah Hall Ladd, by
1926. After Ladd's death, White handled
shipping of her friend's art collection to the
Portland Art Museum, 1927.

MYRA ALBERT WIGGINS

Born 1869, Salem, Oregon
Died 1956, Seattle

Portraits, landscapes, travel photographs, and
genre. Active as photographer, 1888–1929.
Studied at Art Students League, New York,
under William Merritt Chase, John
Twachtman, and Frank Vincent Dumond,
1891–93, and always considered herself a
painter by profession. Married Fred Wiggins,
1894; had one daughter. Represented by four
prints in FRANCES BENJAMIN JOHNSTON's exhi-
bition of 1900–1901. Admitted to Photo-
Secession, 1903; was one of three Oregon
members, along with Sarah Hall Ladd and
LILY WHITE. Won over fifty prizes in photo-
graphic exhibitions. Went mountaineering to
photograph the Cascades in Oregon. Family

moved from Salem to Toppenish, Washington,
1907; moved to Seattle, 1932. Photographs
frequently published in national and interna-
tional journals, such as *American Amateur
Photographer, Camera Notes,* and *Photograms of the
Year.* Wrote such articles as "Amateur
Photography Through Women's Eyes" for
Photo-American, 1894, and other publications.
Also wrote poetry and was featured in Frank
Bellemin's book *Our Present Day Poets, Their Lives
and Works,* 1926. Claimed to have pioneered
"Dutch genre" in photography: dressed daugh-
ter and housekeeper in heirloom Dutch cloth-
ing to pose on specially built sets. Wrote book
Letters from a Pilgrim, a photographically illus-
trated description of her journey to Middle
East. Career culminated in retrospectives of
paintings and photographs at Seattle Art
Museum, 1953, and M. H. de Young Memorial
Museum, San Francisco, 1954. Daughter
donated four hundred prints to Portland Art
Museum; major exhibition there, 1994–95.

DOROTHY WILDING

Born 1893, Longford (near Gloucester),
England
Died 1976, England

Portraits; also advertising images and nudes.
Parents sent her, at age four, to live with aunt
and uncle in nearby Cheltenham. Trauma of
early dislocation affected her deeply and con-
tributed to determination to make her own
mark in the world. Purchased first camera,
1909. Moved to London, 1912; became
apprentice retoucher. Gained studio experience
with Marion Neilson and court photographer
Richard Speaight. Saved sixty pounds (three
hundred dollars) and opened first of several
portrait studios, in London, 1914. In consid-
erable demand for theatrical portraits, 1918
on. Began advertising work, 1923. Frequently
published in *Sketch* and *Tatler,* 1920s. Married
Walter Portham, 1920; divorced 1932. Moved
studio to fashionable Bond Street and acquired
chic clientele, 1920s; sitters included Tallulah
Bankhead, Douglas Fairbanks, Jr., Pola Negri,
and many others. Married interior decorator,
painter, and architect, Thomas "Rufus"
Leighton Pearce, 1932. Solo exhibition,
Royal Photographic Society of Great Britain,
1930; made a fellow of the society that year.
Began photographing members of the royal
family, including King George VI and Queen
Elizabeth, 1937. Opened first studio in

New York, 1937. Husband died, 1940. Best-
known portraits of the 1950s were taken for
coronation and accession of Queen Elizabeth
II. Worked through 1957.

ELIZA WITHINGTON

Born 1825, United States
Died 1877, Ione City, California

Portraits and landscapes. Born Elizabeth W.
Kirby; called Eliza. Married George V.
Withington, Monroe, Michigan, 1845; had
Sarah Augusta, c. 1847; Eleanor B., c. 1848;
and Everett, 1861 (died five months later).
George started across plains to California,
1849; settled in Ione Valley, California, 1851.
Eliza and Sarah Augusta traveled overland
from Saint Joseph, Missouri, to Ione, for six
months in 1852; Eleanor B. arrived in Ione,
1857. Eliza spent time on East Coast learning
photography, sometime before 1857; visited
Mathew Brady's portrait gallery in New York
City as well as other portrait businesses in the
Atlantic states. Opened her own "Ambrotype
Gallery" in rented house in Ione City, 1857.
Separated from husband, c. 1871. Made stere-
ographs of scenery, mines, and miners in Silver
Lake, California, 1873. Her article "How
a Woman Makes Landscape Photographs"
published in *Philadelphia Photographer,* 1876
(reprinted in *Photographic Mosaics,* 1877).

MARION POST WOLCOTT

Born 1910, Montclair, New Jersey
Died 1990, Santa Barbara, California

Social documentation. Studied at New School
for Social Research, New York, and New York
University, late 1920s–1930s. Visited Europe,
1932; heard Adolf Hitler speak in Berlin and
observed situation in Europe. Combined with
awareness of racial discrimination at home,
these experiences turned her politics sharply to
left. Sister Helen had been studying photogra-
phy with TRUDE FLEISCHMANN in Vienna;
Marion went to Vienna, 1933. Took classes in
child psychology, Universität Wien. Took first
roll of photographs right before returning to
United States with Helen, 1933. They spon-
sored Fleischmann's emigration to U.S. Marion
began free-lance photography, New York,
1935. Attended Photo League, mid-1930s.
Paul Strand and Ralph Steiner invited her to
be still photographer for their film on labor
organization in the South, *People of the Cumberlands,*
1937. Took job photographing for *Philadelphia*

Evening Bulletin, 1937. Roy Stryker hired her to photograph for Farm Security Administration (FSA), 1938–41; worked in the South, New England, and West. Married widower Lee Wolcott, government official, 1941. Reared stepchildren Gail and John; had Linda, 1942, and Michael, 1945. Family tried farming in Virginia, through 1952. Lee became professor of government, University of New Mexico, 1954–59; he worked for Agency for International Development, in Iran, 1959, and accepted other foreign posts through 1968. Marion traveled with him and photographed intermittently. Retired to California, late 1960s, and eventually settled in Santa Barbara. Her work became known to art world through an influential FSA group exhibition at Witkin Gallery, New York, 1976.

LOUISE DESHONG WOODBRIDGE
Born 1848, probably Chester, Pennsylvania
Died 1925, probably Chester
Primarily landscapes. Married Jonathan Edwards Woodbridge, naval architect and Confederate veteran of Civil War, 1877. Resided in Chester, Pennsylvania, on Delaware River. Prominent clubwoman and society figure. Supported various institutions, including Art Alliance, Atlantic Union, Geographical Society of Philadelphia, Museum School of Industry and Art, Pennsylvania Academy of the Fine Arts, University Museum of Science and Art, and Botanical Society of University of Pennsylvania. Began to photograph, 1884, helped by friends John G. Bullock, Robert S. Redfield, and Henry Troth of the Photographic Society of Philadelphia. Photographs included in Sixth Joint Annual Exhibition of Photography, Philadelphia, and World's Columbian Exposition, Chicago, both 1893. *The Outlet of the Lake* rejected by jury of Philadelphia Salon of 1898 as more "descriptive than evocative." Began series of lectures in Chester entitled Afternoons with Science, 1901; for twenty-five years recruited eminent speakers on history, travel, gardening, botany, and evolution. Left large collection of negatives and prints to Delaware County Historical Society.

BAYARD WOOTTEN
Born 1875, New Bern, North Carolina
Died 1959, New Bern
Portraits, landscapes, documentation, and genre; also some aerial views. Born Mary Bayard Morgan. Entered North Carolina State Normal and Industrial School at Greensboro (now University of North Carolina at Greensboro), 1892; did not graduate. Art teacher at state school for the deaf in Georgia, beginning 1894. Married Charles Thomas Wootten, 1897; had two sons. Separated from husband, 1901. Bayard returned to New Bern. Began photographing, c. 1904; subsequently opened studio in New Bern. Joined Women's Federation of the Photographers' Association of America, 1909 or 1910. Flew over New Bern in Wright Brothers' airplane, 1914; made possibly first aerial photographs in North Carolina and possibly first aerial photographs by a woman anywhere. Opened studio in New York City, 1917; closed it after a few months and returned to New Bern. Traveled throughout much of North Carolina seeking photography business. Opened studio in Chapel Hill to tap market at University of North Carolina, 1928. Exhibited prints widely and lectured throughout eastern United States, 1930s. Photographed landscapes of southeast as well as impoverished black and white inhabitants, whom she portrayed in Pictorialist style. Her photographs used to illustrate books on Appalachian life and crafts for University of North Carolina Press, Houghton Mifflin, and J. B. Lippincott. Retired, 1954.

WANDA WULZ
Born 1903, Trieste, Italy
Died 1984, Italy
Portraits and experimental photographs. Born to family of portrait photographers including grandfather Giuseppe Wulz, in Trieste, Italy. Father, Carlo Wulz, made portraits of city's intellectuals and artists; also photographed carnivals and social events. Wanda, like her father, photographed figures in theater, dance, and music. Associated with late Futurists; during 1930s made experimental photographs involving motion and superimposition of images. First received notice outside Trieste at Biennale Internazionale d'Arte Fotografica di Roma, 1930, where she exhibited six photographs. Exhibited four photographs at Mostra Fotografica Internazionale (part of

Twelfth Milanese Fair), 1931. Her greatest success took place during country-wide cultural celebrations surrounding Tenth Anniversary of the Fascist Revolution, 1932. Her experimental photographs were exhibited in Trieste as part of *Futurist Collection*, including work by Arturo Bragaglia and others. Newspaper *Il Piccolo della Sera* praised her work for its elegance, April 12, 1932.

MARIANA YAMPOLSKY
Born 1925, Chicago
Resides Mexico City
Documentation and architectural photographs. B.A. in humanities, University of Chicago, c. 1945. Moved to Mexico City, 1945. Studied at School of Painting and Sculpture (known as the "Esmeralda") of the Ministry of Public Education, Mexico City, 1945–48. Member of Taller de Gráfica Popular (TGP), 1944–58, which created affordable broadsheets, book illustrations, and posters for a wide popular audience. Yampolsky made engravings and served as curator of exhibitions for TGP, sending numerous shows abroad. Also drew and painted illustrations for magazines, newspapers, and children's books, and designed posters, 1940s–'50s. Began experimenting with photography and publishing photographs, 1948. An official photographer, Mexico City Olympics, 1968. Photographs widely exhibited in group and solo exhibitions in Mexico and abroad, 1960–present. Married Arjen van der Sluis, 1967. Her many books include *La Casa de la tierra*, 1981, on Mexican Indian architecture; *La Casa que canta*, 1982, on vernacular architecture of rural Mexico; and *Estancias del olvido*, 1987, on the fading splendor of the haciendas that produce *pulque* (fermented beverage). Also coauthored and edited numerous books concerning artists, as well as books on health and education for government workers, 1963–present. Selected recent solo exhibitions at Art Center, Brown University, Providence, Rhode Island, 1994; Universidad de Salamanca, Salamanca, Spain, 1995; Williams Center for the Arts, Easton, Pennsylvania, 1995; Stephen L. Clark, Austin, Texas, 1996; Mexican Embassy, San Salvador, El Salvador, 1997; Mexican Fine Arts Center Museum, Chicago, 1997; and Godwin Ternbach Museum, Queens College, New York, 1999.

YANG LING

Born 1922, Shandong Province, China
Resides Beijing

Magazine and publicity photographs. Born in poor village. Joined the Eighth Route Army to fight invasion of Japanese army, 1939. Took photographic courses, 1945; became battle-field photographer, 1947. Lived with various combat units of the People's Liberation Army; was only female photographer working with combat units. Had no darkroom equipment; developed work, without a timer, in darkened houses of villagers. Photographs widely published in magazines and shown in exhibitions. Husband transferred to Ministry of Foreign Affairs, Beijing, 1950, after founding of People's Republic of China. Traveled with husband to India, Afghanistan, Yugoslavia, Cambodia, Mauritania, Belgium, and elsewhere in Europe; photographed diplomatic activities as well as local scenery and customs.

MADAME YEVONDE

Born 1893, London
Died 1975, England

Primarily society portraits and advertising. Born Yevonde Cumbers; also called herself Philonie Yevonde. Due to a researcher's error, has sometimes been incorrectly referred to as Edith Plummer. Educated by governesses, then at boarding schools. While in convent school in Belgium developed lifelong interest in female emancipation, 1909. Joined woman suffrage movement, 1910. Finished education at Sorbonne, Paris, 1910. After returning to London, saw want ad for trainee to photographer Lena Connell in Hampstead, 1911, which gave her idea of pursuing photography as career. Approached Lallie Charles, foremost female portrait photographer of her day, and was apprenticed, 1911–14. Opened own portrait business and after World War I became successful society photographer. Regular sitters included such society notables as Lady Mountbatten, Princess Marina of Kent, and Lady Nancy Astor, and artists and writers including Rebecca West, Elizabeth Jane Howard, and Gertrude Lawrence. Joined Royal Photographic Society of Great Britain, 1921.

Married playwright Edgar Middleton, 1921. Began advertising work, 1925, and started using color, 1930. Produced series called Goddesses, 1935, consisting of debutantes draped in mythological clothing. Husband died, 1939. Went to Ethiopia, photographed Emperor Haile Selassie, 1964. Major retrospective, *Sixty Years a Portrait Photographer*, Royal Photographic Society of Great Britain, 1973; interviewed on television by David Frost on a program about octogenarians, 1973.

YVA (ELSE SIMON)

Born 1900, Berlin
Died 1942, Germany

Fashion, portraits, nudes, and dance photographs. Born Else Simon. Maintained studio in Berlin. Forced by Nazis to give up studio because she was Jewish, but continued as photographer. Became X-ray technician after being forced to give up photography after 1938. Died in a concentration camp.

SELECTED BIBLIOGRAPHY

BY PETER E. PALMQUIST

This bibliography is tailored to document the approximately 255 women still photographers whose work is reproduced in this volume, and it is therefore not representative of photography as a whole. Selected works by and about the featured photographers are provided in the Individual Photographers section; additional sources dealing with multiple photographers are specified in the Histories, Surveys, and Anthologies section and in the Women and Photography section. The latter provides a mix of well-known and obscure writings; it also comprises a number of exhibition catalogs devoted to women photographers. Additional features include a section of biographical and bibliographic directories and another of writings about the history of photography in general. Regional histories and directories appear in several of the sections; many of these have been recently published and are especially useful for the study of women photographers on a world-wide basis. (See Richard Rudisill, "Directories of Photographers: An Annotated World Bibliography," for an overview of these unique resources.)

BIOGRAPHICAL DIRECTORIES AND BIBLIOGRAPHIES

Auer, Michèle, and Michel Auer, eds. *Photographers Encyclopaedia International, 1839 to the Present.* 2 vols. Hermance, Switzerland: Editions Camera Obscura, 1985.

Broecker, William L., ed. *Encyclopedia of Photography.* New York: International Center of Photography; Crown, 1984.

Browne, Turner, and Elaine Partnow. *Macmillan Biographical Encyclopedia of Photographic Artists and Innovators.* New York: Macmillan, 1983. 364 women.

Czech, Marie. *A Directory of Early Illinois Photographers.* Macomb: Western Illinois University, 1977. 100 women.

Darrah, William Culp. "Nineteenth-Century Women Photographers." In *Shadow and Substance: Essays on the History of Photography,* edited by Kathleen Collins, pp. 89–103. Bloomfield Hills, Mich.: Amorphous Institute, 1990. 275 women.

A Directory of Massachusetts Photographers, 1839–1900. Camden, Maine: Picton, 1993. 154 women.

Eskind, Andrew. *International Photography: George Eastman House Index to Photographers, Collections, and Exhibitions.* 3 volumes. Third enlarged edition. New York: G. K. Hall, 1998. Numerous women.

Gagel, Diane VanSkiver. *Ohio Photographers, 1839–1900.* Nevada City, Calif.: Carl Mautz, 1998. 92 women.

Hart, Arthur A. *Camera Eye on Idaho: Pioneer Photography, 1863–1913.* Caldwell, Idaho: Caxton Printers, 1990. 80 women.

Haynes, David. *Catching Shadows: A Directory of Nineteenth-Century Texas Photographers.* Austin: Texas State Historical Association, 1993. 115 women.

Hill, Edwin L. "A History of Photography in La Crosse, Wisconsin, 1853–1930." M.A. thesis, University of Wisconsin–La Crosse, 1978. 55 women.

Johnson, William S. *Nineteenth-Century Photography: An Annotated Bibliography, 1839–1879.* Boston: G. K. Hall and Co., 1990.

Kreisel, Martha. *American Women Photographers: A Selected and Annotated Bibliography.* Westport, Conn.: Greenwood Press, 1999.

Mattison, David. *Camera Workers: The British Columbia Photographers Directory, 1858–1900.* Victoria, Canada: Camera Workers, 1985. 33 women.

Mautz, Carl. *Biographies of Western Photographers: A Reference Guide to Photographers Working in the 19th Century American West.* Nevada City, Calif.: Carl Mautz, 1997. Numerous women.

Moutoussamy-Ashe, Jeanne. *Viewfinders: Black Women Photographers.* New York: Dodd, Mead and Company, 1986. Includes Harleston, Simpson.

Palmquist, Peter E. *Shadowcatchers I: A Directory of Women in California Photography before 1901.* Arcata, Calif.: Peter E. Palmquist, 1990. 850 women.

———. *Shadowcatchers II: A Directory of Women in California Photography, 1900–1920.* Arcata, Calif.: Peter E. Palmquist, 1991. 1,065 women. Includes Fletcher, Freeman, Hanscom, Irvine, Mather, Pitchford.

———. *A Bibliography of Writings by and about Women in Photography, 1850–1990.* Second edition. Arcata, Calif.: published by the author, 1994.

Prichard, Michael. *A Directory of London Photographers, 1841–1908.* Bushey, England: ALLM, 1986. 125 women.

Ries, Linda A., and Jay W. Ruby. *Directory of Pennsylvania Photographers, 1839–1900.* Philadelphia: Commonwealth of Pennsylvania; Pennsylvania Historical and Museum Commission, 1999. 66 women.

Robinson, Thomas. *Oregon Photographers: Biographical History and Directory, 1852–1917.* Portland, Oreg.: published by the author, December 1992. Revised and reprinted, January 1993. 247 women.

Rowe, Jeremy. *Photographers in Arizona: A History and Directory, 1850–1920.* Nevada City, Calif.: Carl Mautz, 1997. 20 women.

Rudisill, Richard. "Directories of Photographers: An Annotated World Bibliography." In *Photographers: A Sourcebook for Historical Research,* edited by Peter E. Palmquist, pp. 51–98. Brownsville, Calif.: Carl Mautz, 1991.

Walsh, George; Michael Held; and Colin Naylor, eds. *Contemporary Photographers.* Second edition. Revised and enlarged by Colin Naylor. Chicago: Saint Martin's Press, 1988.

Willis-Thomas, Deborah. *Black Photographers, 1840–1940: An Illustrated Bio-Bibliography.* New York and London: Garland, 1985. 3 women.

———. *An Illustrated Bio-Bibliography of Black Photographers, 1940–1988.* New York and London: Garland, 1989. 78 women.

Witkin, Lee D., and Barbara London. *The Photograph Collector's Guide.* Boston: New York Graphic Society, 1979.

HISTORIES, SURVEYS, AND ANTHOLOGIES

Bannon, Anthony. *The Photo-Pictorialists of Buffalo.* Buffalo: Media Study; Albright-Knox Art Gallery, 1981. Includes Sipprell.

Barrow, Thomas F., ed. *Light and Substance.* Albuquerque: University Art Museum, University of New Mexico, 1974. Includes Connor, Cowin, Hahn.

Bauhaus Photography. Cambridge and London: MIT Press, 1982. Includes Beese, Moholy.

Bezner, Lili Corbus, and Bruce Lineker. *Women of the Photo League.* Charlotte, N.C.: Light Factory, 1998. Includes Abbott, Kanaga, Lepkoff, Model, Orkin.

Billeter, Erika, ed. *Self-Portrait in the Age of Photography: Photographers Reflecting Their Own Image.* Bern: Benteli Verlag, 1985.

Billeter, Erika, et al. *Fotografie: Lateinamerika von 1860 bis Heute.* Bern: Benteli Verlag, 1981. 12 women. Includes Andujar, Eleta, Facio, Iturbide, Marucha, Stern, Yampolsky.

Boston Now: Photography. Boston: Institute of Contemporary Art, 1985. Includes Cosindas, MacNeil, Norfleet, Ockenga.

California Pictorialism. San Francisco: San Francisco Museum of Modern Art, 1977. 6 women. Includes Brigman, Freeman, Kemmler, Mather, Pitchford.

A Century of Vision: Louisiana Photography, 1884–1984. New Orleans: Louisiana State Museum, 1984. Includes Caffery.

Coke, Van Deren. *Avant-Garde Photography in Germany, 1919–1939.* San Francisco: San Francisco Museum of Modern Art, 1980. Reprint, New York: Pantheon, 1982. Includes Breslauer, Henri, Jacobi, Lex-Nerlinger, Moholy, Yva.

Coke, Van Deren, with Diana C. du Pont. *Photography: A Facet of Modernism.* New York: Hudson Hills Press; San Francisco: San Francisco Museum of Modern Art, 1986. Includes Auerbach, Cunningham, Golden, Noggle, Stern.

Constructed Images: New Photography. New York: Schomburg Center, New York Public Library, 1989. Includes Sligh, Sunday.

Corps: Photographies. Saint-Etienne, France: Musée d'Art et d'Industrie, 1983.

Cuban Photography, 1959–1982. New York: Center for Cuban Studies; Westbeth Gallery, 1983. Includes Marucha.

Dault, Gary Michael. *Children in Photography: 150 Years.* Photographs selected by Jane Corkin. Willowsdale, Canada: Firefly, 1990.

Deconstruction/Reconstruction: The Transformation of Photographic Information into Metaphor. New York: New Museum, 1980. Includes Crane.

Diamondstein, Barbaralee. *Visions and Images: American Photographers on Photography.* New York: Rizzoli, 1981. Includes Morgan.

Eauclaire, Sally. *The New Color Photography.* New York: Abbeville Press, 1981. Includes Callis, Parker, Skoglund.

Facio, Sara. *Fotografía en la Argentina.* Buenos Aires: La Azotea, 1988. Includes Stern.

Fiedler, Jeannine, ed. *Photography at the Bauhaus.* Cambridge: MIT Press, 1990. Includes Auerbach, Beese, Stern.

Fleischauer, Carl, and Beverly W. Brannan, eds. *Documenting America, 1935–1943.* Berkeley and Los Angeles: University of California Press, 1988. Includes Bubley, Collins, Lange, Wolcott.

Flesh and Blood: Photographers' Images of Their Own Families. New York: Picture Project, 1992. Includes Ferrato, MacNeil, Mann, Novak, Parada, Plachy, Sligh, Weems.

Flukinger, Roy. *The Formative Decades: Photography in Great Britain, 1839–1920.* Austin: University of Texas Press, 1985. Includes Atkins, Broom, J. M. Cameron.

Fontanella, Lee. *La historia de la fotografía en España.* Madrid: El Viso, 1981.

Fotografie in Nederland, 1920–1940. The Hague: Staatsuitgeverij, 1979. Includes Andriesse, Besnyö.

Freund, Gisèle. *Photographie et société.* Paris: Editions du Seuil, 1974. Reprint, Munich, Germany: Verlag Rogner und Bernard, 1976; English-language edition published as *Photography and Society.* Boston: David R. Godine, 1980.

Frizot, Michel, ed. *A New History of Photography.* Cologne, Germany: Konemann, 1998.

Fulton, Marianne, ed. *Pictorialism into Modernism: The Clarence H. White School of Photography.* New York: Rizzoli, 1996. Includes Bourke-White, Gilpin, Lange, Reece, Simon, Sipprell, Watkins.

German Photography, 1870–1970: Power of a Medium. Cologne, Germany: DuMont, 1997. Includes Becher, Breslauer, Biermann, Hoch, Jacobi, Moholy, Riefenstahl, Yva.

Gernsheim, Helmut, and Alison Gernsheim. *The History of Photography: From the Earliest Use of the Camera Obscura in the Eleventh Century up to 1914.* New York: McGraw-Hill, 1969.

Goldberg, Vicki. *Photography in Print: Writings from 1916 to the Present.* New York: Simon and Schuster, Touchstone, 1981.

Green, Jonathan. *American Photography: A Critical History, 1945 to the Present.* New York: Harry N. Abrams, 1984. Includes Arbus, Lange, MacNeil.

Greenhill, Ralph, and Andrew Birrell. *Canadian Photography, 1839–1920*. Toronto: Coach House, 1979. Includes Moodie.

Gruber, Renate, and L. Fritz. *The Imaginary Photo Museum*. New York: Crown, 1982. Includes Biermann, Cosindas, D'Ora, Henri, Lendvai-Dircksen, Moholy.

Grundberg, Andy. *Crisis of the Real: Writings on Photography, 1971–1989*. New York: Aperture, 1990.

Grundberg, Andy, and Kathleen McCarthy Gauss. *Photography and Art: Interactions since 1946*. New York: Abbeville Press, 1987. Includes Becher, Blondeau, Callis, Cowin, Golden, Goldin, Hahn, Kasten, Kruger, Neimanas, Skoglund, Thorne-Thomsen, Wells.

Gunther, Thomas Michael, and Marie de Thézy. *Alliance Photo: Agence photographique, 1934–1940*. Paris: Bibliothèque Historique de la Ville de Paris, 1988. Includes Bellon.

Hall-Duncan, Nancy. *The History of Fashion Photography*. Rochester, N.Y.: International Museum of Photography; New York: Alpine, 1979. Includes Dahl-Wolfe, Miller, Moon, Turbeville.

Hambourg, Maria Morris, and Christopher Phillips. *The New Vision: Photography Between the World Wars*. New York: Metropolitan Museum of Art, 1989. Includes Henri, Krull, Model, Wulz.

Hambourg, Maria Morris, et al., eds. *The Waking Dream: Photography's First Century, Selections from the Gilman Paper Company Collection*. New York: Metropolitan Museum of Art, 1993.

Hannavy, John. *A Moment in Time: Scottish Contributions to Photography, 1840–1920*. Glasgow: Third Eye Centre, 1993. Includes Hawarden.

Harker, Margaret. *The Linked Ring: The Secession Movement in Britain, 1892–1910*. London: William Heinemann; Royal Photographic Society, 1979. Includes Cadby, Käsebier, Warburg.

Harrison, Martin. *Appearances: Fashion Photography since 1945*. New York: Rizzoli, 1991.

Hartmann, Sadakichi [Sidney Allan, pseud.]. *The Valiant Knights of Daguerre: Selected Critical Essays on Photography and Profiles of Photographic Pioneers*. Edited by Harry W. Lawton and George Knox. Berkeley: University of California Press, 1978.

Henisch, Heinz K., and Bridget A. Henisch. *The Photographic Experience, 1839–1914: Images and Attitudes*. University Park: Pennsylvania State University Press, 1994.

———. *The Painted Photograph, 1839–1914: Origins, Techniques, Aspirations*. University Park: Pennsylvania State University Press, 1996.

Heyman, Therese Thau, ed. *Seeing Straight: The f.64 Revolution in Photography*. Oakland, Calif.: Oakland Museum, 1992. Includes Cunningham, Kanaga, Lavenson, Noskowiak.

Hill, Paul, and Thomas Cooper, eds. *Dialogue with Photography*. New York: Farrar, Straus and Giroux, 1979.

The Idealizing Vision: The Art of Fashion Photography. Aperture, no. 122. New York: Aperture, 1991. Includes Dahl-Wolfe, Pagliuso.

In/Sight: African Photographers, 1940 to the Present. New York: Guggenheim Museum Publications, 1996.

Jaguer, Edouard. *Les Mystères de la chambre noire: La Surréalisme et la photographie*. Paris: Flammarion, 1982. Includes Agar, Cahun, Eluard, Gérin, Höch, Wulz.

Johnson, Deborah J., ed. *California Photographs*. Providence: Museum of Art, Rhode Island School of Design, 1982. Includes Callis, Connor, Cowin, Johnson, Kasten.

Johnson, Drew Heath, and Marcia Eymann. *Silver and Gold: Cased Images of the California Gold Rush*. Iowa City: University of Iowa Press, 1998.

Johnston, Patricia, ed. "[Native American Photography]." *Exposure* 29 (Fall 1993). Entire issue devoted to the subject.

Klindt, Steven, ed. *New American Photography*. Chicago: Center for Contemporary Photography, Columbia College, 1981. Includes Novak.

Knubben, Thomas. *Simple Life: Photographs from America, 1929–1971*. Stuttgart, Germany: Schmetterling Verlag, 1991. Includes Mieth.

Krauss, Rosalind, and Jane Livingston. *L'Amour fou: Photography and Surrealism*. Washington, D.C.: Corcoran Gallery of Art; New York: Abbeville Press, 1985. Includes Cahun, Eluard, Sherman.

Lemagny, Jean-Claude, and André Rouillé. *A History of Photography*. Cambridge: Cambridge University Press, 1987.

Mellor, David, ed. *Germany: The New Photography, 1927–33*. London: Arts Council of Great Britain, 1978. Includes Biermann, Höch, Krull, Moholy.

Modern British Photography, 1919–39. London: Arts Council of Great Britain, 1980. Includes Ker-Seymer, Wilding, Yevonde.

Mrázková, Daniela. *Masters of Photography*. New York: Exeter Books, 1987.

Mrázková, Daniela, and Vladimir Remes. *The Russian War, 1941–1945*. New York: E. P. Dutton, 1975. Includes Sankova.

———. *Early Soviet Photographers*. Oxford: Council of the Museum of Modern Art, 1982. Includes Sankova (as Sanyko).

Naggar, Carole, and Fred Ritchin. *Mexico Through Foreign Eyes, 1850–1990*. New York and London: W. W. Norton, 1993. Includes Bridges, Connor, Gilpin, Levitt, Modotti, Plachy.

Newhall, Beaumont. *The History of Photography from 1839 to the Present Day*. New York: Museum of Modern Art, 1949; revised editions, 1964, 1982.

Nori, Claude. *French Photography: From Its Origins to the Present*. New York: Pantheon, 1979. Includes Albin-Guillot, Dumas, Franck, Freund, Krull.

Panzer, Mary. *Philadelphia Naturalistic Photography, 1865–1906*. New Haven, Conn.: Yale University Art Gallery, 1982. Includes Schaeffer, Watson-Schütze, Woodbridge.

Perpetual Mirage: Photographic Narratives of the Desert West. New York: Whitney Museum of American Art, 1996. Includes Connor, Gilpin, Lange, Norfleet.

Peterson, Christian A. *Pictorialism in America: The Minneapolis Salon of Photography, 1932–1946*. Minneapolis: Minnesota Institute of Art, 1983. Includes Smith.

———. *After the Photo-Secession: American Pictorial Photography, 1910–1955.* Minneapolis: Minneapolis Institute of Arts; New York and London: W. W. Norton, 1997. Includes Cones, Cunningham, Fletcher, Gilpin, Reece, Sipprell, Ulmann, Watkins.

Photographic Surrealism. Cleveland: New Gallery of Contemporary Art, 1980. Includes Eluard, Gérin.

Photography in Switzerland, 1840 to Today. New York: Hastings, 1974. Includes Möllinger.

The Photography of Invention: American Pictures of the 1980s. Washington, D.C.: National Museum of American Art, Smithsonian Institution; Cambridge and London: MIT Press, 1989. Includes Burson, Callis, Kruger, Rubenstein, Skoglund, Thorne-Thomsen.

Photojournalism in the Eighties. Greenvale, N.Y.: Hillwood Art Gallery, C. W. Post College, 1985. Includes Andujar, Meiselas.

Pictorialism in California: Photographs, 1900–1940. Malibu, Calif.: J. Paul Getty Museum; San Marino, Calif.: Henry E. Huntington Library and Art Gallery, 1994. Includes Brigman, Cunningham, Hanscom, Lange, Lavenson, Mather.

Pictorial Photography in Britain, 1900–1920. London: Arts Council of Great Britain in association with the Royal Photographic Society, 1978. Includes Warburg.

Plattner, Steven W. *Roy Stryker: U.S.A., 1943–1950: The Standard Oil (New Jersey) Photography Project.* Austin: University of Texas Press, 1983. Includes Brooks, Bubley.

Poniatowski, Elena. *Between Worlds: Contemporary Mexican Photography.* New Amsterdam, N.Y.: Impressions, 1990. Includes Yampolsky.

Religion: African American Spiritual Expressions. New York: Menschel Photography Gallery, Syracuse University, 1990. Includes Nance.

Rogers, Malcolm. *Camera Portraits: Photographs from the National Portrait Gallery, London, 1839–1989.* New York: Oxford University Press, 1990. Includes J. M. Cameron, Dahl-Wolfe, Kar, Miller, Moholy, Myers, Wilding, Yevonde.

Rosenblum, Naomi. *A World History of Photography.* Third edition. New York: Abbeville Press, 1997. 134 women.

———. *Photo League.* Madrid: Fundacíon Telefónica, 1999. Includes Abbott, Kanaga, Lepkoff, Morgan, Orkin, Palfi, Weiner.

Seiberling, Grace. *Amateurs: Photography and the Mid-Victorian Imagination.* Chicago and London: University of Chicago Press, 1986. Includes J. M. Cameron, Mostyn.

Severa, Joan L. *Dressed for the Photographer: Ordinary Americans and Fashion, 1840–1900.* Kent, Ohio, and London: Kent State University Press, 1995.

Sobieszek, Robert A. *The Art of Persuasion: A History of Advertising Photography.* New York: Harry N. Abrams, 1988. Includes Moon, Turbeville.

Sobieszek, Robert A., and Deborah Irmas. *The Camera I: Photographic Self-Portraits from the Audrey and Sydney Irmas Collection.* Los Angeles: Los Angeles County Museum of Art; New York: Harry N. Abrams, 1994. Includes Bubley, Burson, Cahun, Cowin, Cunningham, Dahl-Wolfe, Dater, Golden, Henri, Jacobi, Sherman.

Songs of My People: African Americans, A Self-Portrait. Boston, Toronto, and London: Little, Brown and Company, 1992. Includes Moutoussamy-Ashe, Nance, Simpson, Vereen.

Ten Thousand Eyes: The American Society of Magazine Photographers' Celebration of the 150th Anniversary of Photography. Rochester, N.Y.: Eastman Kodak Company; Charlottesville, Va.: Thomasson Grant, 1991.

Thézy, Marie de, with Claude Nori. *La Photographie humaniste: 1930–1960—Histoire d'un mouvement en France.* Paris: Contrejour, 1992. Includes Colomb, Dumas, Gérin.

Through the Looking Glass: Photographic Art in Britain, 1945–1989. London: Barbican Art Gallery, 1989.

Trachtenberg, Alan. *Reading American Photographs: Images as History, Mathew Brady to Walker Evans.* New York: Noonday Press, 1989.

Tsujimoto, Karen. *Images of America: Precisionist Painting and Modern Photography.* Seattle and London: University of Washington Press, 1982. Includes Lavenson, Noskowiak.

Watkins to Weston: 101 Years of California Photography, 1849–1950. Santa Barbara, Calif.: Santa Barbara Museum; Roberts Rinehart, 1992. Includes Brigman, Hanscom.

Watriss, Wendy, and Lois Parkinson Zamora, eds. *Images and Memory: Photography from Latin America, 1866–1994.* Austin: University of Texas Press; FotoFest, 1998. Includes Facio, Stern.

Weaver, Mike, ed. *The Art of Photography, 1839–1989.* New Haven, Conn., and London: Yale University Press; London: Royal Academy of Arts, 1989. Includes Meiselas.

Welling, William. *Photography in America: The Formative Years, 1839–1900.* New York: Thomas Y. Crowell, 1978.

White, Mus. *From the Mundane to the Magical: Photographically Illustrated Children's Books, 1854–1945 and Beyond.* Los Angeles: Dawson's Book Shop, 1999. Includes Abbott, Albin-Guillot, Bartlett, Beals, Bourke-White, Cadby, Cahun, Dahl-Wolfe, Dorr, Eddy, Flaherty, Frissell, Krementz, Krull, Lendvai-Dircksen, Moon, Morgan, Sherman, Watson-Schütze.

Xanthakis, Alkis X. *History of Greek Photography, 1839–1960.* Athens: Hellenic Literary and Historical Archives Society, 1988. Includes Nelly.

WOMEN AND PHOTOGRAPHY

Abel, Juan C. "Women Photographers and Their Work." *Delineator* 58 (September, October, November 1901): 406–11; 574–79; 747–51. 25 women. Includes Frances S. and Mary E. Allen, Austin, Ben-Yusuf, Farnsworth, Johnston, Käsebier, Watson-Schütze, Wiggins.

Adams, Charlotte. "Photo Art among the Studios." *Philadelphia Photographer* 20 (June 1883): 179–83; (July 1883): 194–98; (August 1883): 236–39.

Adams, Laura M. "The Picture Possibilities of Photography." *Overland Monthly* 35 (September 1900): 241–45.

Australian Women Photographers, 1890–1950. Parkville, Australia: George Paton Gallery, Melbourne University Union, 1981.

Baker, Tracey. "Nineteenth-Century Minnesota Women Photographers." *Journal of the West* 28 (January 1989): 15–24. 30 women.

Barnes, Catharine Weed. "Why Ladies Should Be Admitted to Membership in Photographic Societies." *American Amateur Photographer* 1 (December 1889): 223–24.

———. "Photography from a Woman's Standpoint." *Anthony's Photographic Bulletin* 21 (January 1890): 39–42.

Bennett, Edna R. "Woman and Photography." *Universal Photo Almanac and Market Guide* (1937): 25–28. Includes Fletcher.

Bethune, Beverly M., and Mimi Fuller Foster, eds. *Women in Photojournalism.* Durham, N.C.: National Press Photographers Association, 1986. 52 women.

Bezner, Lili Corbus. *Women of the Photo League.* Charlotte, N.C.: Light Factory, 1998. Includes Abbott, Kanaga, Lepkoff, Model, Orkin.

Biren, Joan E. *Seeing Women: One Hundred Years of Women's Photography.* Trumansburg, N.Y.: Crossing Press, 1984.

Bisland, Margaret. "Women and Their Cameras." *Outing* 17 (October 1890): 36–43. 18 women. Includes Appleton, Bartlett.

The Blatant Image: A Magazine of Feminist Photography, nos. 1–3 (1981–83). More than 150 women.

Boffin, Tessa, and Jean Fraser, eds. *Stolen Glances: Lesbians Take Photographs.* London: Pandora, 1991. 30 women.

Boice, Judith, ed. *Mother Earth: Through the Eyes of Women Photographers and Writers.* San Francisco: Sierra Club, 1992.

Bonney, Claire. "The Nude Photograph: Some Female Perspectives." *Women's Art Journal* 6 (Fall 1985–Winter 1986): 9–14.

Bouqueret, Christian. *Les Femmes Photographes: De La Nouvelle Vision en France, 1920–1940.* Paris: Editions Marval, 1998. Includes Abbott, Albin-Guillot, Bing, Breslauer, Cahun, D'Ora, Freund, Henri, Kretschmer, Krull, Miller, Model.

Breck, Henrietta S. "California Women and Artistic Photography." *Overland Monthly* 43 (February 1904): 89–97.

Butler, Susan. "So How Do I Look? Women before and behind the Camera." *Photo Communiqué* 9 (Fall 1987): 24–35. Includes Austen, Brigman, Dater, Henri, Johnston, Noggle.

Cade, Cathy: *A Lesbian Photo Album: The Lives of Seven Lesbian Feminists.* Oakland, Calif.: Waterwomen, 1987.

Chroniques contemporaines: Des Femmes Photographes racontent. Paris: Musée d'Histoire Contemporaine, Publications de la BDIC, 1993. Includes Bonney, Franck, Niepce.

Cohen, Joyce Tenneson, comp. *In/Sights: Self-Portraits by Women.* Boston: David R. Godine, 1978. 70 women. Includes Golden, Heyman, Nettles, Norfleet.

Coman, Carolyn. *Body and Soul: Ten American Women.* Boston: Hill, 1988. Includes Dater.

Conger, Amy. *Campañeras de Mexico: Women Photograph Women.* Riverside: University Art Gallery, University of California, Riverside, 1990.

Crane, Frank W. "American Women Photographers." *Munsey's Magazine* 11 (July 1894): 398–408. 24 women.

Dahl, Olga. "Women in Commercial Photography." *Camera Craft* 31 (December 1924): 577–81.

Davidov, Judith Fryer. *Women's Camera Work: Self, Body, Other in American Visual Culture.* Durham, N.C.: Duke University Press, 1998.

Davie, Helen L. "Women in Photography." *Camera Craft* 5 (August 1902): 130–38. 22 women. Includes Ben-Yusuf, Eddy.

DDR Frauen fotografieren: Lexikon und Anthologie. Berlin: Ex Pose Verlag, 1989.

Defining Eye: Women Photographers of the Twentieth Century: Selections from the Helen Kornblum Collection. Saint Louis: Saint Louis Art Museum, 1997.

Doherty, Amy S. "Women in Focus: Early American Women Photographers." *Picturescope* 31 (Summer 1983): 50–55.

———. "Photography's Forgotten Women." *AB Bookman's Weekly,* November 4, 1985, pp. 3272–3312. 60 women.

Drysdale, William. "Photography." In *Helps for Ambitious Girls,* pp. 485–94. New York: Thomas Y. Crowell, 1900.

Eastlake, Lady Elizabeth. "Photography." *Quarterly Review* (London) 101 (April 1857): 442–68.

Edgerton, Giles [Mary Fanton Roberts]. "Is There a Sex Distinction in Art? The Attitude of the Critic Towards Women's Exhibits." *Craftsman* 14 (June 1908): 239–51.

Edwards, Susan H. "Pretty Babies: Art, Erotica or Kiddie Porn." *History of Photography* 18 (Spring 1994): 38–46.

Eight Visions: Works by Eight Contemporary American Women. Tokyo: Parco, 1988. Includes Burns, Groover, Kasten, Parker, Skoglund.

Esders, Viviane. *Our Mothers: Portraits by Seventy-two Women Photographers.* New York: Stewart, Tabori and Chang, 1996.

Exhibition of Photographs: The Work of the Women Photographers of America. Hartford, Conn.: Camera Club of Hartford, 1906.

Exploring the Unknown Self: Self-Portraits of Contemporary Women. Tokyo: Tokyo Metropolitan Museum of Photography, Metropolitan Culture Foundation, 1991.

Farris, Phoebe. "Racializing Gender: Women Photographers from the Seventies to the Millennium." *Camerawork* 26 (Fall–Winter 1999): 42–45.

Fisher, Andrea. *Let Us Now Praise Famous Women.* London and New York: Pandora, 1987. Includes Bubley, Collins, Wolcott.

———. *Women Photographers of the Farm Security Administration.* London: Pandora, 1987.

Fusco, Coco. "Essential Differences: Photographs of Mexican Women." *Afterimage* 18 (April 1991): 11–13. Includes Grobet, Iturbide.

Gardner, Patricia, ed. "[Special Women in Photography Issue]." *Exposure* 19, no. 3 (1981): entire issue. Includes Burns, Parada.

———. "The Greats: Women in 150 Years of Photography." *Creative Woman* 9 (Spring–Summer 1989): 3–37. 15 women. Includes Abbott, Bourke-White, J. M. Cameron, Cunningham, Käsebier, Lange, Morgan.

Garner, Gretchen, ed. *Reclaiming Paradise: American Women Photograph the Land.* Duluth: Tweed Museum of Art, University of Minnesota, 1987. Includes Abbott, Brigman, Connor, De Cock, Geesaman, Gilpin, Hahn, Lange, Rubenstein, Sipprell, Wolcott.

Gear, Josephine. "The Baby's Picture: Woman as Image Maker in Small Town America." *Feminist Studies* 13 (Summer 1987): 419–42.

Goldberg, Vicki. "Why Can't a Woman Photograph More Like a Man?—Why Should She?" *American Photographer* 1 (June 1978): 40–43. 20 women.

Gomez, Jewelle. "Showing Our Faces: A Century of Black Women Photographed." *Ten.8*, 1985, no. 24.

Goodwin, Judy. "Women and Photography." *British Journal of Photography,* October 19, 1979, p. 1004.

Gover, C. Jane. *The Positive Image: Women Photographers in Turn of the Century America.* Albany: State University of New York Press, 1988. 60 women.

Hall, Barbara, and Jenni Mather. *Australian Women Photographers, 1840–1960.* Richmond, Australia: Greenhouse, 1986. 45 women.

Hayes, Dannielle B., ed. *Women Photograph Men.* New York: William Morrow, 1977. 71 women. Includes Abbe, McLaughlin-Gill, Mark, Morgan, Tweedy-Holmes.

Heathcote, Bernard V., and Pauline F. Heathcote. "The Feminine Influence: Aspects of the Role of Women in the Evolution of Photography in the British Isles." *History of Photography* 12 (July–September 1988): 259–73.

Heron, Liz, and Val Williams, eds. *Illuminations: Women Writing on Photography from the 1850s to the Present.* Durham, N.C.: Duke University Press,

1996. Includes Abbott, Bourke-White, J. M. Cameron, Dahl-Wolfe, Freund, Goldin, Lange, Miller, Modotti, Moholy.

Hines, Richard, Jr. "Women and Photography." *American Amateur Photographer* 11 (March 1899): 118–24; (April 1899): 144–52; reprinted in *Photographic Times* 31 (May 1899): 242–45 (in a shorter version).

———. "Women in Photography." *Photo Era* 17 (September 1906): 141–49.

Holabird, Katharine. *Women on Women.* London: Aurum, 1978. Reprint, London: Arrow, 1980. Includes Moon, Turbeville.

Hopkinson, Amanda, ed. *Desires and Disguises: Five Latin American Photographers* [all women]. London: Serpent's Tail, 1992.

"How Women Won Fame in Photography." *Wilson's Photographic Magazine* 51 (May 1914): 199–209. 16 women.

Hubert, Philip G. "Occupations for Women." In *The Woman's Book.* New York: Charles Scribner's Sons, 1887.

Hughes, Jabez. "Photography as an Industrial Occupation for Women." *Anthony's Photographic Bulletin* 4 (1873): 162–66.

Jacobs, David L. "Gender Engendered." *Camerawork* 26 (Fall–Winter 1999): 39–41.

Johnston, Frances Benjamin. "What a Woman Can Do with a Camera." *Ladies' Home Journal* 14 (September 1897): 6–7.

Jones, Laura. *Rediscovery: Canadian Women Photographers, 1841–1941.* North London, Canada: London Regional Art Gallery, 1983. 13 women. Includes Gunterman, Keene, Maynard, Moodie, Watson.

Jones, Laura; Monique Brunet; and Shelagh Wilkinson, eds. "[Women Photographers]." *Canadian Women's Studies* 2 (1980): 1–112. 45 women.

Kalmus, Yvonne; Sonia Katchian; Rikki Ripp; and Cheryl Wiesenfeld, eds. *Women See Women: A Photographic Anthology by Over 80 Talented Photographers.* New York: Thomas Y. Crowell, 1976.

Kalmus, Yvonne; Rikki Ripp; and Cheryl Wiesenfeld, eds. *Women See Men.* New York: McGraw-Hill, 1977. 73 women. Includes Ockenga, Plachy, Tweedy-Holmes.

Kelley, Etna M. "Women in Photography." *Popular Photography* 16 (June 1945): 20–23, 56–57, 108–14. 44 women.

Kennedy, Martha H. "Nebraska's Women Photographers." *Nebraska History* 72 (Summer 1991): 62–77. 15 women.

Lowe, Sarah M., ed. "[Women in Photography]." *History of Photography* 18 (Autumn 1994): 204–55. Includes Henri, Miller, Modotti, and others.

McEuen, Melissa. "Doris Ulmann and Marion Post Wolcott: The Appalachian South." *History of Photography* 19 (Spring 1995): 4–12.

Mann, Margery, and Anne Noggle. *Women of Photography: An Historical Survey.* San Francisco: San Francisco Museum of Modern Art, 1975. 50 women. Includes Austen, Bernhard, Corpron, Dorr, Emmons, Filmer, Hahn, Hanscom, Henri, Heyman, Palfi, Reece, Savage, Wells.

Martin, Ira W. "Women in Photography." *Pictorial Photography in America* 5 (1929): n.p.

Mitchell, Margaretta K. *Recollections: Ten Women of Photography.* New York: Viking Press, Studio, 1979. Includes Abbott, Bernhard, Corpron, Dahl-Wolfe, Dorr, Frissell, Jacobi, Kanaga, Morgan.

Moeller, Madelyn. *Nineteenth-Century Women Photographers: A New Dimension in Leisure.* Norwalk, Conn.: Lockwood-Mathews Mansion Museum, 1987. 8 women.

Monk, Lorraine, ed. *The Female Eye.* Toronto: National Film Board of Canada; Clarke, Irwin, 1975. 80 women. Includes Cohen.

Moore, Clarence Bloomfield. "Women Experts in Photography." *Cosmopolitan* 14 (March 1893): 580–90. 11 women. Includes Bartlett, Eddy, Johnston, Ward.

Morgan, Margaret Knox. "Women in Photojournalism." M.A. thesis, University of Missouri, 1962.

Morrow, Delores J. "Female Photographers on the Frontier: Montana's Lady Photographic Artists, 1866–1900." *Montana* 32 (Summer 1982): 76–84. 17 women.

Mothers and Daughters, That Special Quality: An Exploration in Photographs. New York: Aperture, 1987.

Motz, Marilyn F. "Visual Autobiography: Photograph Albums of Turn-of-the-Century Midwestern Women." *American Quarterly* 41 (March 1989): 63–93.

Mujer x Mujer: 22 Fotografas: 150 Años de la fotografía, Mexico. Mexico City: Consejo Nacional para la Cultura y las Artes; Instituto Nacional de Bellas Artes; Museo de San Carlos, 1989.

Murray, Janet L. "For Women Only." *Popular Photography* 7 (September 1940): 32–33, 86–87.

Nava, Mica, et al. "The Women in My Life: Photography of Women." *Feminist Review* 36 (Autumn 1990): 42–52.

Neumaier, Diane. *Reframings: New American Feminist Photographies.* Philadelphia: Temple University Press, 1995. Includes Goldin, Kruger, Meiselas, Noggle, Parada, Sherman, Simpson, Sligh, Weems.

Niccolini, Dianora, ed. *Women of Vision: Photographic Statements by Twenty Women Photographers.* Verona, N.J.: Unicorn, 1982. Includes Abbe, McLaughlin-Gill, Morgan, Orkin.

Palmquist, Peter E. "Pioneer Women Photographers in Nineteenth-Century California." *California History* 71 (Spring 1992): 110–27. 36 women. Includes Withington.

Palmquist, Peter E., ed. *Camera Fiends and Kodak Girls: Fifty Selections by and about Women in Photography, 1840–1930.* New York: Midmarch Arts, 1989. 65 women.

———. *Camera Fiends and Kodak Girls II: Sixty Selections by and about Women in Photography, 1855–1965.* New York: Midmarch Arts, 1995. 70 women.

Palmquist, Peter E., and Gia Musso. *Women Photographers: A Selection of Images from the Women in Photography International Archive, 1852–1997.* Kneeland, Calif.: Iaqua Press, 1997. 88 women.

———. *Behind the Redwood Curtain: Women Photographers of Humboldt County, California.* Arcata, Calif.: Women in Photography International Archive, 1999. 73 women.

Pepper, H. Crowell. "Woman's Place in Photography." *Minicam Monthly* I (July 1938): 50–51, 88.

Perrone, Jeff. "Women of Photography: History and Taste." *Artforum* 14 (March 1976): 31–35. 26 women.

"Photographs by Women about Women [Special Women's Issue]." *Image Nation*, no. 11. Ontario, Canada: Coach House, c. 1975. 8 women.

"Photography." *Canadian Women's Studies* 2 (1980). Entire issue devoted to women photographers.

Porter, Allan. "Photographs of Women." *Camera* (Switzerland) 51 (February 1972): 3–43. 10 women. Includes Arbus, Bourke-White, Brigman, Dater, Lange.

Quitslund, Toby. "Her Feminine Colleagues." In Josephine Withers, *Women Artists in Washington Collections.* College Park: University of Maryland Art Gallery; Women's Caucus for Art, 1979. Includes Frances S. and Mary E. Allen, Bartlett, Ben-Yusuf, Eddy, Farnsworth, Johnston, Van Buren.

Rayne, M. L. "Women as Photographers." In *What Can a Woman Do, Or Her Position in the Business and Literary World.* Detroit and Chicago: F. B. Dickerson and Co., 1884. Reprint, New York: Arno, 1974.

Reflections: Women's Self-Image in Contemporary Photography. Oxford, Ohio: Miami University Art Museum, 1988.

Reframing America. Tucson, Ariz.: Center for Creative Photography, 1995. Includes Mieth, Model, Palfi.

Rivera, Sophie, and Martin Hurwitz. "Women—Where Are They in the History of Photography?" *Art and Artists* (New York) (February–March 1984): 13.

Rosenblum, Naomi. "Women in Photography: An Historical Overview." *Exposure* 24 (Winter 1986): 6–26. 65 women.

Self: Neue Selbstbildnisse von Frauen: Fotografien. Bonn: Frauen Museum, 1987.

Shifting Focus: An International Exhibition of Contemporary Women's Photography. Bristol, England: Arnolfini Gallery; London: Serpentine Gallery, 1989. Includes Cohen, Höfer.

Skeel, Adelaide. *My Three-Legged Story Teller.* Philadelphia: Hartranft, 1892.

Slater, Sarah E. "Profitable Industries for Women—Photography." *New Idea Woman's Magazine* 10 (February 1904): 28–31.

Southwell, Bill. "Women in Photography." *Lens on Campus* 4 (April 1982): 9–12.

Stagg, Mildred. "Woman's Place in Photography." *Popular Photography* 5 (September 1939): 26–27, 78, 80. 13 women.

———. "Can a Woman Photograph Women?" *Modern Photography* 17 (May 1953): 44–49, 104.

Steinberg, Jane. "Portrait of the Photographer as a Young Woman." *Mademoiselle*, March 1968, pp. 178–79, 216. 22 women.

Stevens, Frances. "The Camera and Its Devotees." *Home-Maker* 6 (1891): 129–39. 15 women. Includes Ward.

"Successful Photography for Women." *Wilson's Photographic Magazine* 50 (May 1913): 211–13. 9 women.

Sullivan, Constance, ed. *Women Photographers.* New York: Harry N. Abrams, 1990. Essay by Eugenia Parry Janis. 73 women. Includes Biermann, Caffery, Callis, Connor, Content, Filmer, Goldin, Groover, Krull, Moholy, Simmons, Thorne-Thomsen, Watkins, Yevonde.

Thanet, Octave [Alice French]. *An Adventure in Photography.* New York: Charles Scribner's Sons, 1893.

To Collect the Art of Women: The Jane Reese Williams Photography Collection. Santa Fe: Museum of Fine Arts, Museum of New Mexico, 1991.

Tucker, Anne, ed. *The Woman's Eye.* New York: Alfred A. Knopf, 1973. Includes Abbott, Arbus, Bourke-White, Dater, Käsebier, Johnston, Lange, Morgan, Nettles, Wells.

Tucker, Margaret W. "Women with Cameras." *Popular Photography* 13 (September 1943): 38–50, 60, 88–89. 20 women. Includes Gilpin.

Vintage Photographs by Women of the Twenties and Thirties. Chicago: Edwynn Houk Gallery, 1988. Includes Bing, Kanaga, Krull, Lavenson, Moholy, Noskowiak.

Washburne, Marion Foster. "A New Profession for Women." *Godey's Magazine* 134 (February 1897): 123–28.

Whelan, Richard. "Are Women *Better* Photographers Than Men?" *Artnews* 79 (October 1980): 80–88.

"When the Photographer Is a Woman." *Infinity* 22 (January 1973): 5–13. 15 women. Includes Abbe, Brooks, Krementz, McLaughlin-Gill.

Willard, Frances E. "Women as Photographers." In *Occupations for Women*, pp. 242–48. New York: Success Company, 1897.

Williams, Val. *Women Photographers: The Other Observers, 1900 to the Present*. London: Virago Press, 1986. 130 women. Includes Broom, Flaherty, Hawarden, Kar, Ker-Seymer, Robertson, Warburg, Wilding, Yevonde.

Willis-Thomas, Deborah. *Imagining Families: Images and Voices*. Washington, D.C.: National African American Museum; Smithsonian Institution Press, 1994. Includes Novak, Weems.

Withington, Mrs. E. W. "How a Woman Makes Landscape Photographs." *Philadelphia Photographer* 13 (December 1876): 357–60.

Wolf, Sylvia. *Focus: Five Women Photographers*. Morton Grove, Ill.: Albert Whitman and Company, 1994. Includes Bourke-White, Cameron, Garduño, Skoglund.

A Woman's Eye: Black and White Photography. Miami: Inter-American Art Gallery, Mitchell Wolfson New World Center Campus, Miami-Dade Community College, 1988.

"Women by Women." *Photo World* 2 (April 1974): 57–79. 4 women. Includes Dater, Moon.

Women Come to the Front: Journalists, Photographers, and Broadcasters during World War II. Washington, D.C.: Library of Congress, 1995. Includes Bonney, Bubley, Frissell, Lange.

"[Women in Photography]." *Photo Review* 20 (Spring 1997): entire issue. Includes Brigman, Crane, Goldin, Lavenson.

"[Women in Photography]." *American Photo* (March–April 1998): entire issue. Includes Barney, Goldin, Leibovitz, Mann, Mark, Sherman.

Women on the Edge: Twenty Photographers in Europe, 1919–1939. Santa Monica, Calif.: J. Paul Getty Museum, 1993.

Women Photographers in America, 1985: A National Juried Competition of Women Fine Art Photographers. Los Angeles: Women's Building; Women in Photography, 1985. 85 women.

Women Photographers in America, 1987. Los Angeles: Los Angeles Municipal Art Gallery, City of Los Angeles Cultural Affairs Department, 1987.

"[Women Photographers Issue]." *St. Louis and Canadian Photographer* 33 (December 1909). 42 women. Includes Reece, Wootten.

"[Women Photographers Issue]." *Image* 38 (Fall–Winter 1995): entire issue. Includes Sipprell, Sligh.

Wright, Mary. "Women in Photography." *Camera 35* 13 (December 1968–January 1969): 28–43. 6 women.

INDIVIDUAL PHOTOGRAPHERS

KATHRYN ABBE

Abbe, Kathryn. *God Bless You Real Good*. New York: Simon and Schuster, 1967.

Abbe, Kathryn McLaughlin, and Francis McLaughlin Gill. *Twins on Twins*. New York: Clarkson N. Potter, 1980.

Early, Mary Dawn, and Kathryn Abbe. *Stars of the Twenties*. New York: Viking Press, 1975.

Mitchell, Margaretta K. "Photography's Twin Sisters." *Popular Photography* 86 (January 1980): 74–81, 118–19, 182.

BERENICE ABBOTT

Berenice Abbott: Photographs. New York: Horizon, 1970. Reprint, Washington, D.C.: Smithsonian Institution Press, 1990.

Berman, Avis. "The Unflinching Eye of Berenice Abbott." *Artnews* 80 (January 1981): 86–93.

McCausland, Elizabeth, and Berenice Abbott. *Changing New York*. New York: E. P. Dutton, 1939. Revised and reprinted as *New York in the Thirties, as Photographed by Berenice Abbott*. New York: Dover, 1973.

O'Neal, Hank. *Berenice Abbott: American Photographer*. New York: McGraw-Hill, Artpress, 1982.

Valens, E. G. *The Attractive Universe: Gravity and the Shape of Space*. Cleveland: World Publishing Co., 1969. Photographs by Abbott.

Van Haaften, Julia, ed. *Berenice Abbott, Photographer: A Modern Vision*. New York: New York Public Library, 1989.

LAURE ALBIN-GUILLOT

Le Louvre la nuit: Photographies de Laure Albin-Guillot. Grenoble, France: B. Arthaud, 1937.

Micrographie décorative: Laure Albin-Guillot. Paris: Draeger Frères, 1931.

FRANCES S. AND MARY E. ALLEN

Abbott, Katharine M. *Old Paths and Legends of the New England Border—Connecticut, Deerfield, and the Berkshires*. New York: G. P. Putnam's Sons, 1907. Photographs by the Allens.

Crenshaw, Karen. "Images of Childhood: The Photography of Mary and Frances Allen." Paper of the Historic Deerfield Summer Fellowship Program. Historic Deerfield, Deerfield, Massachusetts, 1974.

Douglas, Ed Polk. "The Photographs of Mary and Frances Allen: A Biography." Paper of the Historic Deerfield Summer Fellowship Program. Historic Deerfield, Deerfield, Massachusetts, 1969.

"A Group of Photographic Studies by Frances and Mary Allen." *Craftsman* 8 (May 1905): 217–22.

Johnston, Frances Benjamin. "Frances and Mary Allen." *Ladies' Home Journal* 18 (July 1901): 13.

Warner, Charles Forbes. *Picturesque Franklin*. Northampton, Mass.: Picturesque Publishing Co., 1891. Photographs by the Allens.

EMMY ANDRIESSE

Amsterdam in de Vier Jaargetijden. Amsterdam: Uitgeverij Contact, c. 1949.

Andriesse, Emmy. *The World of Van Gogh.* New York: Holbein, 1953.

Emmy Andriesse. Monographs on Dutch Photographers no. 4. Amsterdam: Focus Publishing, 1995.

Emmy Andriesse: Fotos 1941–52. Amsterdam, 1975.

CLAUDIA ANDUJAR

Andujar, Claudia. *Yanomami.* São Paulo, Brazil: Editorial Praxis, 1978.

Andujar, Claudia, and Sebastião Barborsa. *Brazil tierra mágica.* Düsseldorf: Haur Reigh Verlag; New York: McGraw-Hill, 1974.

Andujar, Claudia, and George Love. *Amazonia.* São Paulo, Brazil: Editorial Praxis, 1979.

Hecho en Latinoamerica: Libros fotográficos de autores latinoamericanos. Mexico: Consejo Mexicano de Fotografía, Instituto Nacional de Bellas Artes, 1981.

DIANE ARBUS

Arbus, Doon, and Marvin Israel, eds. *Diane Arbus: An Aperture Monograph.* Millerton, N.Y.: Aperture; New York: Museum of Modern Art, 1972.

———. *Diane Arbus: Magazine Work.* Millerton, N.Y.: Aperture, 1984.

Bosworth, Patricia. *Diane Arbus: A Biography.* New York: Alfred A. Knopf, 1984.

"[Diane Arbus]." *History of Photography* 19 (Summer 1995): entire issue.

Diane Arbus: Untitled. New York: Aperture, 1995.

Hulick, Diane Emery. "Diane Arbus's Women and Transvestites: Separate Selves." *History of Photography* 16 (Spring 1992): 34–39.

Stevens, Robert B. "The Diane Arbus Bibliography." *Exposure* 15 (September 1977): 10–19.

EVE ARNOLD

Arnold, Eve. *Flashback!: The Fifties.* New York: Alfred A. Knopf, 1978.

———. *In China.* New York: Alfred A. Knopf, 1980.

———. *In America.* New York: Alfred A. Knopf, 1983.

———. *All in a Day's Work.* New York: Bantam, 1989.

———. *Eve Arnold in Britain.* London: National Portrait Gallery; Sinclair-Stevenson, 1991.

———. *The Great British.* New York: Alfred A. Knopf, 1991.

———. *Eve Arnold: In Retrospect.* New York: Alfred A. Knopf, 1995.

ANNA ATKINS

Atkins, Anna. *British Algae: Cyanotype Impressions.* 3 vols. Halstead Place, Sevenoaks, England: privately printed, 1843–53.

Schaaf, Larry J. "Anna Atkins' Cyanotypes: An Experiment in Photographic Publishing." *History of Photography* 6 (April 1982): 151–72.

———. *Sun Gardens: Victorian Photograms by Anna Atkins.* Millerton, N.Y.: Aperture, 1985.

JANE EVELYN ATWOOD

Atwood, Jane Evelyn. *Too Much Time: Women in Prison.* London: Phaidon Press, 2000.

ELLEN AUERBACH

Ellen Auerbach: Berlin, Tel Aviv, London, New York. Munich, Germany, and New York: Prestel Verlag, 1998.

ALICE AUSTEN

"Alice Austen's America." *Holiday* 12 (September 1952): 66–71.

Humphreys, Hugh, and Regina Benedict. "The Friends of Alice Austen: With a Portfolio of Historic Photographs." *Infinity* 16 (July 1967): 4–23, 28–31.

"The Newly Discovered Picture World of Alice Austen: Great Woman Photographer Steps Out of the Past." *Life,* September 24, 1951, pp. 137–44.

Novotny, Ann. *Alice's World: The Life and Photography of an American Original: Alice Austen, 1866–1952.* Old Greenwich, Conn.: Chatham, 1976.

CATHARINE WEED BARNES—*see* **CATHARINE BARNES WARD**

TINA BARNEY

Barney, Tina, and Tina Howe. *Swimming.* New York: Library Fellows of the Whitney Museum of American Art, 1991. Boxed edition.

Blood Relatives: The Family in Contemporary Photography. Milwaukee: Milwaukee Art Museum, c. 1991.

Friends and Relations: Photographs by Tina Barney. Photographers at Work Series. Washington, D.C., and London: Smithsonian Institution Press, in association with Constance Sullivan Editions, 1991.

Squiers, Carol. "Tina Barney: An Insider Look at the Good Life." *American Photographer* 21 (December 1988): 48–53.

Tina Barney: Photographs: Theater of Manners. New York: Scalo, 1997.

MARY BARTLETT
(MRS. N. GRAY BARTLETT)

Bartlett, Mrs. N. Gray. *Old Friends with New Faces.* Boston: Joseph Knight, 1892.

———. *Mother Goose of '93.* Boston: Joseph Knight, 1893.

Humphrey, Marmaduke. "Triumphs of Amateur Photography—Mrs. N. Gray Bartlett." *Godey's Magazine* 136 (April 1898): 368–78.

Wyatt, Marian L. *A Girl I Know.* Boston: Joseph Knight, 1894. Photographs by Bartlett.

EMMA BARTON
(MRS. G. A. BARTON)

Barton, Mrs. G. A. "Picture Studies of Childhood." *Amateur Photographer and Photographic News* (London), May 19, 1908, pp. 499–500.

Dawson, Charles E. "Poem-Pictures by an English Woman Photographer." *American Photography* 6 (April 1912): 186–90.

James, Peter. "Mysteries of Shade and Shadow: Discovering Mrs. G. A. Barton." *Photographica* 22 (July 1993): 7–9.

Redfern, Angeline C. "The Art of Coloring Photographs." *American Photography* 6 (April 1912): 190–96.

Sunlight and Shadow: The Photographs of Emma Barton, 1872–1938. Birmingham, England: Birmingham Museums and Art Gallery, 1995.

LETIZIA BATTAGLIA
Battaglia, Letizia. *Passion, Justice, Freedom: Photographs of Sicily.* New York: Aperture, 1999.

Sambuy, Liva Manera. "In the War Zone of the Sicilian Mafia." *American Photographer* 20 (May 1988): 52–59.

JESSIE TARBOX BEALS
Alland, Alexander, Sr. *Jessie Tarbox Beals: First Woman News Photographer.* New York: Camera Graphic Press, 1978.

———. "Jessie Tarbox Beals: Pioneering Woman Press Photographer." *American Photographer* 1 (August 1978): 52–59.

"Ever Meet Jessie Tarbox Beals?" *Saint Louis Republic,* February 20, 1910, feature sec., p. 2.

HILLA BECHER
Anonyme Skulpturen: Eine Typologie technische bauten. Düsseldorf: Art-Press-Verl; New York: Wittenborn, 1970.

Becher, Hilla, and Bernd Becher. *Gas Tanks.* Cambridge: MIT Press, 1993.

The Bechers: Grundformen. New York: Te Neues, 1999.

Bernd and Hilla Becher. London: Arts Council of Great Britain, 1974.

"Bernhard and Hilla Becher." *Camera* (Switzerland) 51 (June 1972): 14–22.

Framework Houses of the Siegen Industrial Region. Munich, Germany: Schirmer/Mosel, 1977. Photographs by the Bechers.

DENISE BELLON
Gunther, Thomas M. "Denise Bellon." In *Alliance Photo: Agence photographique, 1934–1940,* pp. 37–38. Paris: Bibliothèque Historique de la Ville de Paris, 1988.

NAIR BENEDICTO
Benedicto, Nair. *As melhores fotos.* São Paulo, Brazil: Sver and Boccato, 1988.

Benedicto, Nair, et al. *Brasil: Retratos tradição.* São Paulo, Brazil: Sver and Boccato, 1989.

ZAIDA BEN-YUSUF
Ben-Yusuf, Zaida. "Japan Through My Camera." *Photo Era* 12 (May 1904): 77–79.

———. "Honorable Flowers of Japan." *Century* 73 (March 1907): 697–705.

Hartmann, Sadakichi [Sidney Allan, pseud.]. "Zaida Ben-Yusuf: A Purist." In *The Valiant Knights of Daguerre: Selected Critical Essays on Photography and Profiles of Photographic Pioneers,* edited by Harry W. Lawton and George Knox, pp. 167–72. Berkeley, Los Angeles, and London: University of California Press, 1978. First published in *Photographic Times* 31 (October 1899): 449–55.

Johnston, Francis Benjamin. "Zaida Ben-Yusuf." *Ladies' Home Journal* 18 (November 1901): 13.

Murray, William M. "Miss Zaida Ben-Yusuf's Exhibition." *Camera Notes* 2 (April 1899): 168–72.

Poulson, Elizabeth. *Zaida.* History of Photography Monograph Series, no. 18. Tempe: School of Art, Arizona State University, 1985.

RUTH BERNHARD
Alinder, James. *Collecting Light: The Photographs of Ruth Bernhard.* Untitled, no. 20. Carmel, Calif.: Friends of Photography, 1979.

"American Aces: Ruth Bernhard." *U.S. Camera* 1 (June 1939): 52–55.

Camhi, Morrie. "Q. and A.: Ruth Bernhard." *Photoshow,* no. 2 (1980): n.p.

The Eternal Body: A Collection of Fifty Nudes. Carmel, Calif.: Photography West Graphics, 1986.

Lufkin, Liz. "Ruth Bernhard." *American Photographer* 20 (April 1988): 60–66.

Mitchell, Margaretta K. *Ruth Bernhard: Between Art and Life.* San Francisco: Chronicle Books, 2000.

EVA BESNYÖ
Eva Besnyö: Kinderen, 1930–1987. Rotterdam, the Netherlands: Stichting Uitgeverij DUO/DUO, 1998.

Eva Besnyö: 'n Halve Eeuw Werk. [the Netherlands]: Feministische Uitgeverij Sara, 1982.

Eva Besnyö: Zeeland Toen. [Amsterdam?]: Werkgroep Eva Besnyö, 1990.

AENNE BIERMANN
Aenne Biermann: Photographs, 1925–1933. London: Dirk Nishen, 1988.

Fototek 2: Aenne Biermann. Berlin, 1930.

Roh, Franz. "Mechanism and Expression." In *Foto-auge, oeil et photo, photo-eye.* Paris: Editions du Chêne, 1973. Originally published 1929.

———. *Sechzig Fotos.* Berlin: Klinkhardt und Biermann Verlag, 1930.

ILSE BING
Barrett, Nancy C. *Ilse Bing: Three Decades of Photography.* New Orleans: New Orleans Museum of Art, 1985.

Bing, Ilse. *Words as Visions.* New York: Drigh-Graph, 1974.

———. *Numbers in Images: Illuminations of Numerical Meanings.* New York: Ilkon, 1976.

Ilse Bing: Paris, 1931–1952. Paris: Musée Carnavalet, 1987.

BARBARA BLONDEAU
Blondeau, Barbara. *Vision and Expression.* Rochester, N.Y.: George Eastman House, 1969.

Hagen, Charles. "Barbara Blondeau." *Afterimage* 3 (March 1976): 10–13.

Lebe, David; Joan Redmond; and Ron Walker, eds. *Barbara Blondeau, 1938–1974.* Rochester, N.Y.: Visual Studies Workshop; Philadelphia: Philadelphia College of Art, 1976.

DOROTHY BOHM
Bohm, Dorothy. *A World Observed.* Foreword by Roland Penrose. London: Hugh Evelyn, 1970.

———. *Egypt: Photographs by Dorothy Bohm.* London: Thames and Hudson, 1989.

————. *Sixties London.* London: Photographers' Gallery; Lund Humphries, 1996.

————. *Venice.* London: Thames and Hudson, c. 1992.

————. *Walls and Windows: Colour Photography by Dorothy Bohm.* London: Lund Humphries; Bath: Royal Photographic Society, 1998.

Dorothy Bohm: Colour Photography, 1984–94. London: Photographers' Gallery, c. 1994.

Dorothy Bohm: Photographs. Jerusalem: Israel Museum, c. 1986.

THÉRÈSE BONNEY
Blanch, Lesley. "History in the Taking: Therese Bonney, War Photographer." *Vogue* 102 (July 1943): 52–53, 64.

Bonney, Thérèse. "I Cover Two Wars." *Popular Photography* 8 (March 1941): 22–23, 90–94.

————. *Europe's Children, 1939–1943.* New York: published by the author, 1943. Reprint, New York: Plantin Press, also Rhode Publishing Company, 1943.

Current Biography, 1944, s.v. "Mabel Thérèse Bonney."

Downs, Bruce. "Europe's Children—Thérèse Bonney Photographs Nazi Victims, and Makes a Dramatic Book of Photographs." *Popular Photography* 13 (December 1943): 38–50, 60.

"The Vatican: From a Roman Hill the Pope Rules His Troubled World." *Life,* December 26, 1938, pp. 36–47. Photographs by Bonney.

ALICE BOUGHTON
Boughton, Alice. "Photography: A Medium of Expression." *Scrip* 1 (December 1905): 75–80. Reprinted in *Camera Work* 26 (April 1909): 33–36.

————. "Pictures of the Stage." *Scrip* 1 (April 1906): 204–8.

————. *Photographing the Famous.* New York: Avondale, 1928.

Rosenfeld, Paul. *Port of New York: Essays on Fourteen American Moderns.* New York: Harcourt, Brace and Company, 1924.

Wilcox, Beatrice C. "Alice Boughton—Photographer." *Wilson's Photographic Magazine* 51 (April 1914): 151–69.

MARGARET BOURKE-WHITE
Bourke-White, Margaret. *They Called It "Purple Heart Valley."* New York: Simon and Schuster, 1944.

————. *"Dear Fatherland, Rest Quietly": A Report on the Collapse of Hitler's "Thousand Years."* New York: Simon and Schuster, 1946. Text and photographs by Bourke-White.

————. *Halfway to Freedom.* New York: Simon and Schuster, 1949.

————. *Portrait of Myself.* New York: Simon and Schuster, 1963; London: William Collins, 1964.

Caldwell, Erskine, and Margaret Bourke-White. *You Have Seen Their Faces.* New York: Viking Press, Modern Age Books, 1937. Reprint, New York: Arno, 1975.

————. *Say, Is This the U.S.A.?* New York: Duell, Sloan and Pearce, 1941. Reprint, New York: Da Capo, 1977.

Callahan, Sean, ed. *The Photographs of Margaret Bourke-White.* New York: Bonanza; Greenwich, Conn.: New York Graphic Society, 1972.

Goldberg, Vicki. *Margaret Bourke-White: A Biography.* New York: Harper and Row, 1986.

Silverman, Jonathan. *For the World to See: The Life of Margaret Bourke-White.* New York: Viking Press, 1983.

MARIANNE BRESLAUER
Marianne Breslauer: Photographien, 1927–1937. Berlin: Staatliche Museen Preussischer Kulturbesitz; Nicolaische Verlagsbuchhandlung, 1989.

Retrospektive Fotografie: Marianne Breslauer. Düsseldorf: Edition Marzona, 1979.

MARILYN BRIDGES
Bridges, Marilyn. *Markings: Aerial Views of Sacred Landscapes.* New York: Aperture, 1986.

————. *Planet Peru: An Aerial Journey Through a Timeless Land.* New York: Professional Photography Division of Eastman Kodak Company; Aperture, 1991.

Goldberg, Vicki. "An Intimacy with the Land: The Aerial Photography of Marilyn Bridges." *Archaeology* 44 (November–December 1991): 32–40.

Marilyn Bridges: The Sacred and the Secular: A Decade of Aerial Photography. New York: International Center of Photography, 1990.

ANNE W. BRIGMAN
Brigman, Anne. *Plain Tales from the Piedmont Hills.* Oakland, Calif.: W. Havens, 1907.

————. "Just a Word." *Camera Craft* 15 (March 1908): 87–88.

————. "What [Gallery] 291 Means to Me." *Camera Work* (July 1914): 17–20.

————. "The Glory of the Open." *Camera Craft* 33 (April 1926): 155–63.

————. *Songs of a Pagan.* Caldwell, Idaho: Caxton, 1949.

Ehrens, Susan. *A Poetic Vision: The Photographs of Anne Brigman.* Santa Barbara, Calif.: Santa Barbara Museum of Art, 1995.

Hamilton, Emily J. "Some Symbolic Nature Studies from the Camera of Annie W. Brigman." *Craftsman* 12 (September 1907): 660–66.

Heyman, Therese Thau. *Anne Brigman: Pictorial Photographer/Pagan/Member of the Photo-Secession.* Oakland, Calif.: Oakland Museum, 1974.

Stern, Jenny. "Unleashing the Spirit: The Art of Isadora Duncan and Anne Brigman." M.A. thesis, San Francisco State University, 1991.

CHARLOTTE BROOKS
Arden, Julie. "Girl on Assignment." *Popular Photography* 16 (February 1945): 36–37, 94.

————. "An A to Z Photographer." *Universal Photo Almanac* (1955): 36–41.

CHRISTINA BROOM
(MRS. ALBERT BROOM)
Atkinson, Diane. *Mrs. Broom's Suffragette Photographs: Photographs by Christina Broom, 1908 to 1913.* London: Dirk Nishen, n.d.

ESTHER BUBLEY

Bubley, Esther. "Hey Mom! We're in Pictures." *Minicam Photography* 8 (October 1944): 16–20.

———. *Esther Bubley's World of Children in Photographs.* New York: Dover, 1981.

Dieckmann, Katherine. "A Nation of Zombies: Government Files Contain the Extraordinary, Unpublished Photographs That Esther Bubley Took on One Long Bus Ride across Wartime America." *Art in America* 77 (November 1989): 55–61.

Esther Bubley on Assignment: Photographs since 1939. Buffalo: Bethune Gallery, University at Buffalo, [c. 1989].

"Take a Bus . . . Photographs by Esther Bubley." *Minicam Photography* 7 (June 1944): 58–61.

ELIZABETH BUEHRMANN

Goodman, Helen. "Elizabeth Buehrmann: American Pictorialist." *History of Photography* 19 (Winter 1995): 338–42.

Hartmann, Sadakichi [Sidney Allan, pseud.]. "Bessie Buehrmann: Under the Influence of the Secession." In *The Valiant Knights of Daguerre: Selected Critical Essays on Photography and Profiles of Photographic Pioneers,* edited by Harry W. Lawton and George Knox, pp. 278–82. Berkeley: University of California Press, 1978. First published in *Photographic Times* 39 (November 1907): 435–41.

Miller, Julie. "Elizabeth Buehrmann Letters." *History of Photography* 13 (April–June 1989): 187.

MARSHA BURNS

Cities: Marsha Burns, Photographs; Michael Burns, Photographs; Randy Hayes, Pastels; John Yau, Poems. Seattle: Henry Art Gallery, University of Washington, 1987.

Featherstone, David. *Postures: The Studio Photographs of Marsha Burns.* Untitled, no. 28. Carmel, Calif.: Friends of Photography, 1982.

Guenther, Bruce. *Fifty Northwest Artists.* San Francisco: Chronicle Books, 1983. Photographs by Burns.

NANCY BURSON

Burson, Nancy. *Faces.* Houston: Contemporary Arts Museum, 1992.

Burson, Nancy; Richard Carling; and David Kramlich. *Composites: Computer-Generated Portraits.* New York: Beech Tree, 1986.

Edwards, Owen. "Portraits with Bursonality." *American Photographer* 22 (May 1989): 26–28.

Kaplan, Michael, and Evelyn Roth. "Altered States." *American Photographer* 15 (July 1985): 68–73.

LINDA BUTLER

Bahbah, Bishara, with Linda Butler. *Israel and Latin America: The Military Connection.* Basingstoke, England: Saint Martin's Press; Washington, D.C.: Institute for Palestine Studies, 1986.

Butler, Linda. *Rural Japan: Radiance of the Ordinary.* Washington, D.C., and London: Smithsonian Institution Press, 1992.

———. *Italy: In the Shadow of Time.* New York: Rizzoli, 1998.

Sprigg, June. *Inner Light: The Shaker Legacy.* New York: Alfred A. Knopf, 1985. Photographs by Butler.

CARINE CADBY

Cadby, Will, and Carine Cadby. *Switzerland in Winter.* New York: J. Pott, [c. 1914].

———. *Switzerland in Summer.* London: Mills and Boon, [c. 1922].

"Photographers I Have Met—Carine Cadby." *Amateur Photographer and Photographic News,* August 16, 1910, p. 162.

Lambert, F. C., and Thomas Harrison Cummings, eds. *Floral Photography.* Practical Photographer Series. Chicago: Burke and James, 1905. Photographs and article by Cadby.

DEBBIE FLEMING CAFFERY

Carry Me Home: Louisiana Sugar Country Photographs by Debbie Fleming Caffery. Washington, D.C., and London: Smithsonian Institution Press, 1990.

Hagen, Charles. "Debbie Fleming Caffery: A Land and Its People." *Aperture,* no. 115 (Summer 1989): 10–15.

CLAUDE CAHUN

Cahun, Claude. *Aveux non avenus.* Paris: Editions du Carrefour, 1930.

LaSalle, Honor, and Abigail Solomon-Godeau. "Surrealist Confession: Claude Cahun's Photomontages." *Afterimage* 19 (March 1992): 10–13.

Leperlier, François. *Claude Cahun: L'Ecart et la métamorphose.* Paris: Jean-Michel Place, 1992.

Rice, Shelley. *Inverted Odysseys: Claude Cahun, Maya Deren, Cindy Sherman.* Cambridge: MIT Press, 1999.

JO ANN CALLIS

Jo Ann Callis. Tokyo: Gallery Min, c. 1986.

Jo Ann Callis: Objects of Reverie: Selected Photographs. Des Moines, Iowa: Des Moines Art Center; Santa Rosa, Calif.: Black Sparrow Press, c. 1989.

EVELYN CAMERON

Lucey, Donna M. "The Intimate Vision of Evelyn Cameron." *Geo* 5 (January 1983): 66–79.

———. *Photographing Montana, 1894–1928: The Life and Work of Evelyn Cameron.* New York: Alfred A. Knopf, 1991.

Naglin, Nancy. "A Montana Album." *Americana* 18 (February 1991): 33–37.

Scholl, Jane. "An Extraordinary Look at the Frontier That's Long Gone." *Smithsonian* 21 (November 1990): 54–61.

JULIA MARGARET CAMERON

Cameron, Julia Margaret. *Victorian Photographs of Famous Men and Fair Women.* New York: Harcourt, Brace, 1926. Expanded and reprinted, London: Hogarth Press; Boston: David R. Godine, 1973.

Ford, Colin. *The Cameron Collection.* London: Van Nostrand Reinhold; National Portrait Gallery, 1975.

Gernsheim, Helmut. *Julia Margaret Cameron: Her Life and Photographic Work.* London: Fountain, 1948. Revised and reprinted, Millerton, N.Y.: Aperture; London: Gordon Fraser, 1975.

Hill, Brian. *Julia Margaret Cameron: A Victorian Family Portrait.* London: Peter Owen, 1973.

Howard, Jeremy. *Whisper of the Muse: The World of Julia Margaret Cameron.* London: Colnaghi, 1990.

Julia Margaret Cameron: Photographs from the J. Paul Getty Museum. In Focus Series. Malibu, Calif.: J. Paul Getty Museum, 1997.

Weaver, Mike. *Julia Margaret Cameron, 1815–1879.* London and Boston: New York Graphic Society, 1984.

Wolf, Sylvia. *Julia Margaret Cameron's Women.* Chicago: Art Institute of Chicago; New Haven, Conn., and London: Yale University Press, 1998.

LYNNE COHEN
Cohen, Lynne. *Lost and Found.* Paris: Hotel des Arts, 1992.

Ewing, William A. "Lynne Cohen: Room Readings." *Aperture,* no. 106 (Spring 1987): 24–31.

Ewing, William A., ed. *Lynne Cohen: Occupied Territory.* New York: Aperture, 1987.

Phillips, Carol Corey. "Speaking Through Silence: Female Voice in the Photography of Nina Raginsky, Clara Gutsche and Lynne Cohen." In *Thirteen Essays on Canadian Photography.* Ottawa: Canadian Museum of Contemporary Photography, 1991.

Thomas, Ann. *Environments Here and Now: Three Contemporary Photographers: Lynne Cohen, Robert Del Tredici, Karen Smiley.* Ottawa: National Gallery of Canada, 1985.

MARJORY COLLINS
Collins, Marjory. "Chatham Portraits." *U.S. Camera* 1, no. 15 (1941): 38–39.

"Rough Going on Alaska's Blizzard Route: Marjory Collins' Camera Tells a Story of Below-Zero Railroading on the Toughest 100 Miles of Railroad in the World." *U.S. Camera* 8 (May 1945): 36–37.

DENISE COLOMB
Colomb, Denise. *Les Ponts de Paris.* Paris: Albin Michel, 1951.

———. *Portrait d'artistes, les années 50–60.* Paris, 1987.

NANCY FORD CONES
Blumann, Sigismund. "Nancy Ford Cones: The Work and Personality of a Remarkable Woman." *Wilson's Photographic Magazine* 51 (November 1914): 469–75.

———. "The Work of Nancy Ford Cones." *Camera Craft* 26 (May 1919): 171–77.

Cones, Nancy Ford. "Why I Am a Pictorialist Photographer." *Photo Era* 64 (June 1930): frontispiece, 291–92.

"Loveland Summer: The Forgotten Photographs of Nancy Ford Cones." *American Heritage* 32 (August 1981): 75–81.

Nancy Ford Cones: The Lady from Loveland. Cincinnati: Walt Burton Galleries, 1981.

LINDA CONNOR
Connor, Linda. *Solos.* Millerton, N.Y.: Apeiron Workshops, 1979.

Desmarais, Charles. "Linda Connor." *California Museum of Photography Bulletin* 2 (1983): 1–15.

Landscape Images: Recent Photographs by Linda Connor, Judy Fiskin, and Ruth Thorne-Thomsen. La Jolla, Calif.: La Jolla Museum of Contemporary Art, 1980.

Linda Connor. Washington, D.C.: Corcoran Gallery of Art, 1982.

Linda Connor: Luminance. Carmel, Calif.: Woodrose Publishing, 1994.

Linda Connor: Spiral Journey: Photographs, 1967–1990. Chicago: Museum of Contemporary Photography, Columbia College, 1990.

Linda Connor: Visits. Menschel Gallery publication no. 46. Syracuse, N.Y.: Robert B. Menschel Photography Gallery, Syracuse University, 1996.

MARJORIE CONTENT
Marjorie Content: Photographs, introduction by Jill Quasha, essays by Eugenia Parry Janis, Ben Lifson, and Richard Eldridge. New York: W. W. Norton, c. 1994.

CARLOTTA M. CORPRON
Corpron, Carlotta M. "Designing with Light." *Design* 51 (October 1949): 10–11.

———. "Light as a Creative Medium." *Art Education* 15 (May 1962): 4–7.

Sandweiss, Martha A. *Carlotta Corpron: Designer with Light.* Austin and London: University of Texas Press; Fort Worth: Amon Carter Museum, 1980.

KATE CORY
The Hopi Photographs: Kate Cory, 1905–1912. La Canada, Calif.: Chaco, 1986. Reprint, Albuquerque: University of New Mexico Press, 1988.

MARIE COSINDAS
Marie Cosindas: Color Photographs. Boston: New York Graphic Society, 1978.

"Marie Cosindas: Portfolio." *Infinity* 15 (December 1966): 12–15.

Weiss, Margaret R. "A Show of Color." *Saturday Review* 24 (September 1966): 45–52.

Wolfe, Tom. "The Polychromatic Mini-Microwave Projecting Astral Fantasist." *American Photographer* 1 (August 1978): 28–35.

EILEEN COWIN
Eileen Cowin, John Divola: Recent Work, No Fancy Titles. Los Angeles: California/International Arts Foundation, 1985.

Eileen Cowin: Real Images of an Illusory World. Tokyo and Santa Monica, Calif.: Gallery Min, 1987.

The Photographic: Two Points of View. Fullerton: Visual Arts Center, California State University, Fullerton, 1989.

Spaid, Sue, and Mary Alice Durant. *Still (and all) Eileen Cowin, 1971–1998.* Pasadena, Calif.: Armory Center for the Arts, 2000.

BARBARA CRANE
Barbara Crane: Photographs, 1948–1980. Tucson: Center for Creative Photography, University of Arizona, 1981.

Barbara Crane: The Evolution of a Vision. Baltimore: Kuhn Library and Gallery, University of Maryland, 1983.

Bultman, Janis. "Fresh Angles: An Interview with Barbara Crane." *Darkroom Photography* 6 (July–August 1984): 24–31, 40.

IMOGEN CUNNINGHAM

Cunningham, Imogen. *After Ninety.* Seattle: University of Washington Press, 1977.

Daniel, Edna Tartaul. *Imogen Cunningham; Portraits, Ideas, and Design.* Berkeley: Regional Cultural History Project, General Library, University of California, 1961. Interview transcript.

Dater, Judy. *Imogen Cunningham: A Portrait.* Boston: New York Graphic Society, 1979.

Imogen! Imogen Cunningham Photographs, 1910–1973. Seattle and London: University of Washington Press, 1974.

Lorenz, Richard. *Imogen Cunningham: Ideas Without End: A Life and Photographs.* San Francisco: Chronicle Books, 1993.

Rule, Amy, ed. *Imogen Cunningham: Selected Texts and Bibliography.* World Photography Reference Series, no. 2. Boston: G. K. Hall, 1992.

LOUISE DAHL-WOLFE

Dahl-Wolfe, Louise. *Louise Dahl-Wolfe: A Photographer's Scrapbook.* New York: Saint Martin's Press, Marek, 1984.

Edwards, Owen. "Wit . . . and Wisdom." *American Photographer* 11 (December 1983): 24–31.

Eauclaire, Sally. *Louise Dahl-Wolfe: A Retrospective Exhibition.* Washington, D.C.: National Museum of Women in the Arts, 1987.

Goldberg, Vicki. "Louise Dahl-Wolfe." *American Photographer* 6 (June 1981): 38–47.

JUDY DATER

Coman, Carolyn. *Body and Soul: Ten American Women.* Boston: Hill, 1988. Photographs by Dater.

Dater, Judy, and Jack Welpott. *Women and Other Visions.* Dobbs Ferry, N.Y.: Morgan and Morgan, 1975.

Judy Dater: Cycles. Pasadena, Calif.: Curatorial Assistance, 1994.

Judy Dater: Twenty Years. Tucson: University of Arizona Press; Santa Clara, Calif.: De Saisset Museum, University of Santa Clara, 1986.

Leggett, Jo. "Judy Dater—New Work," *Photo Metro* 17 (1998): 4–9.

Mowbray, Clare. "Interview: Conversation with Judy Dater." *Photographer's Forum* 3 (September 1981): 30–38.

Sentf, Richard. "Masters of Photography: The Many Faces of Judy Dater." *Darkroom Photography* 5 (November 1983): 22–25, 27–31.

LYNN DAVIS

Gates, Henry Louis, Jr. *Wonders of the African World.* New York: Alfred A. Knopf, 1999. Photographs by Lynn Davis.

"Lynn Davis: Interview by Melissa Harris." *Aperture,* no. 146 (Winter 1997): 4–13.

Lynn Davis: Monument. Santa Fe, N.Mex.: Arena, 1999.

LILIANE DE COCK

Liliane De Cock Photographs. Hastings-on-Hudson, N.Y.: Morgan and Morgan; Fort Worth: Amon Carter Museum, 1973.

JENNY DE VASSON

Caujolle, Christian, et al. *Jenny de Vasson: Une Femme Photographe au début de siècle.* Paris: Editions Herscher, 1982.

MINYA DIEZ-DÜHRKOOP

Appel-Heyne, Odette M. "Rudolf Dührkoop: Commercial Portraitist." Ph.D. diss., University of New Mexico, Albuquerque, 1981.

MARY DILLWYN

John Dillwyn Llewelyn, 1810–1882: The First Photographer in Wales. Cardiff, Wales: Welsh Arts Council, 1980.

GENEVIÈVE-ELISABETH FRANCART DISDÉRI

McCauley, Elizabeth Anne. *A.A.E. Disdéri and the Carte-de-Visite Portrait Photograph.* New Haven, Conn., and London: Yale University Press, 1985.

MADAME D'ORA
(DORA KALLMUS)

Faber, Monika. *D'Ora: Vienna and Paris, 1907–1957: The Photographs of Dora Kallmus.* Poughkeepsie, N.Y.: Vassar College Art Gallery, 1987.

"Madame D'Ora on Her Methods." *Wilson's Photographic Magazine* 49 (November 1912): 485–86.

NELL DORR

Dorr, Nell. *In a Blue Moon.* New York: G. P. Putnam's Sons, 1939.

———. *Mother and Child.* New York: Harper Brothers, 1954. Reprint, San Francisco: Scrimshaw, 1972.

———. *The Bare Feet.* Greenwich, Conn.: New York Graphic Society, 1962.

———. *Of Night and Day.* Greenwich, Conn.: New York Graphic Society; San Francisco: Scrimshaw, 1968.

Mayer, Grace M. "Nell Dorr." *Infinity* 12 (December 1963): 5–14, 24–25, 27.

Mitchell, Margaretta K. "Nell Dorr." *Popular Photography* 76 (March 1975): 98–107, 114–15.

SARAH J. EDDY

Eddy, Sarah J. "A Good Use for the Camera." *American Annual of Photography* 8 (1894): 186–87.

———. *Friends and Helpers.* Boston: Ginn, 1902.

———. *Alexander and Some Other Cats.* Boston: Marshall Jones, 1929.

SANDRA ELETA

Cardenal, Ernesto. *Nostalgia del futuro: Pintura y buena noticia en solentiname.* Salamanca, Spain: Longuez Ediciones, 1982. Photographs by Eleta.

Eleta, Sandra. *"Portobelo": Fotografía de Panama.* Buenos Aires: La Azotea, 1985.

Hopkinson, Amanda, ed. *Desires and Disguises: Five Latin American Photographers.* London: Serpent's Tail, 1992.

Renfrew, Nita M. "Sandra Eleta: Portobelo Unseen." *Aperture,* no. 109 (Winter 1987): 48–57, 78.

NUSCH ELUARD

Nusch Eluard's Collages. New York: Editions Nadada, 1978.

CHANSONETTA STANLEY EMMONS
Peladeau, Marcus B. *Chansonetta: The Life and Photographs of Chansonetta Stanley Emmons, 1858–1937.* Waldoboro, Maine: Maine Antique Digest, 1977.

Rosenblum, Naomi. *Documenting a Myth: The South as Seen by Three Women Photographers: Chansonetta Stanley Emmons, Doris Ulmann, Bayard Wootten, 1910–1940.* Portland, Oreg.: Douglas F. Cooley Memorial Art Gallery, Reed College, 1998.

SARA FACIO
Asturias, Miguel Angel. *Actos de fe en Guatemala.* Buenos Aires: La Azotea, 1980. Photographs by Facio and María Cristina Orive.

Cortazar, Julio. *Buenos Aires, Buenos Aires.* Buenos Aires: Editorial Sudamericana, 1968. Photographs by Alicia d'Amico and Facio.

———. *Humanario.* Buenos Aires: La Azotea, 1976. Photographs by Alicia d'Amico and Facio.

Facio, Sara. *Pablo Neruda/Sara Facio.* Buenos Aires: La Azotea, 1988.

———. *Fotografía en la Argentina desde 1840 a nuestros.* Buenos Aires: La Azotea, 1995.

Potenze, Jaime. *Sara Facio.* Fotógrafos argentinos del siglo XX, no. 14. Buenos Aires: Centro Editor de América Latina, 1982.

Retratos y autoretratos: Escritores de América Latina. Buenos Aires: Ediciones Crisis, 1973. Photographs by Alicia d'Amico and Facio.

Sara Facio, Alicia D'Amico: Fotografía Argentina, 1960–1985. Buenos Aires: La Azotea, 1985.

EMMA J. FARNSWORTH
Farnsworth, Emma. *In Arcadia.* New York: George M. Allen, 1892.

Johnston, Frances Benjamin. "Emma J. Farnsworth." *Ladies' Home Journal* 18 (August 1901): I.

SANDI FELLMAN
Ackerman, Diane, and Jerry Aline Flieger. *Sandi Fellman: Open Secret.* Zurich: Edition Stemmle, 1999.

Brown, Susan L. "Against the Grain." *Camera Arts* 2 (September 1982): 64–79.

Fellman, Sandi. *Trick or Treat: A Sequence of Photographs.* Los Angeles: Exposure, 1976.

———. *The Japanese Tattoo.* New York: Abbeville Press, 1986.

Roth, Evelyn. "Exterior Decorations." *American Photographer* 17 (November 1986): 66–71.

DONNA FERRATO
"Donna Ferrato's Women: Under the Skin." *Aperture,* no. 121 (Fall 1990): 36–41.

Ferrato, Donna. *Living with the Enemy.* New York: Aperture, 1991.

Squiers, Carol. "The Long Search for Hope." *American Photo* 2 (September–October 1991): 58–60, 112, 114.

FRANCES HUBBARD FLAHERTY
Flaherty, Frances Hubbard. *Elephant Dance.* New York: Charles Scribner's Sons; London: Faber and Faber, 1937.

———. *The Odyssey of a Film-Maker: Robert Flaherty's Story.* Urbana, Ill.: Beta Phi Mu, 1960. Reprint, New York: Arno, 1972.

Flaherty, Frances Hubbard, and Ursula Leacock. *Sabu, the Elephant Boy.* London: J. M. Dent, 1937.

Flaherty, Robert, with Frances Hubbard Flaherty. *My Eskimo Friends, "Nanook of the North."* Garden City, N.Y.: Doubleday, Page, and Company, 1924.

TRUDE FLEISCHMANN
Auer, Anna. "Trude Fleischmann: Vienna in the Thirties." In *Shadow and Substance,* edited by Kathleen Collins, pp. 339–44. Bloomfield Hills, Mich.: Amorphous Institute, 1990.

Trude Fleischmann, Fotografien, 1918–1938. Vienna: Galerie Faber, 1988.

CHRISTINE B. FLETCHER
Blumann, Sigismund. "Christine B. Fletcher: A Woman Who Found Her Forte." *Photo Art Monthly* 3 (January 1935): 3–10.

Fletcher, Mrs. C. B. "Flower Photography." *Camera Craft* 21 (February 1914): 78–79.

Palmquist, Peter, and Rachel Ihara. *The Life and Still Life of Christine B. Fletcher (c. 1872–1961).* Arcata, Calif.: Women in Photography International Archive, 2000.

Wright, Jack. "Christine B. Fletcher—Pictorialist." *Camera* 57 (December 1938): 402–6.

MARTINE FRANCK
De Temps en temps: Photographies de Martine Franck. Paris: Les Petits Frères, 1988.

Franck, Martine. *Etienne Martin, Sculpteur.* Brussels, 1970.

———. *La Sculpture de Cardenas.* Brussels: La Connaissance, 1971.

"Martine Franck." *Camera* (Switzerland) 55 (June 1976): 4–13.

Martine Franck: One Day to the Next. New York: Aperture, 1998.

EMMA B. FREEMAN
Palmquist, Peter E. *With Nature's Children: Emma B. Freeman (1880–1928)—Camera and Brush.* Eureka, Calif.: Interface California, 1976.

GISÈLE FREUND
Freund, Gisèle. *Le Monde et ma caméra.* Paris: Denoël/Gonthier, 1970. English-language edition published as *The World in My Camera.* New York: Dial, 1974.

———. *Photographie et société.* Paris: Editions du Seuil, 1974. Reprint, Munich, Germany: Verlag Rogner und Bernard, 1976; English-language edition published as *Photography and Society.* Boston: David R. Godine, 1980.

———. *Gisèle Freund, Photographer.* New York: Harry N. Abrams, 1985.

Freund, Gisèle, and Rauda Jamis. *Gisèle Freund, Portrait.* Paris: Des Femmes, 1991.

Gisèle Freund: Fotografien, 1932–1977. Bonn: Rheinisches Landesmuseum; Cologne, Germany: Rheinland-Verlag, 1977.

Gisèle Freund: Portraits von Schriftstellern und Kunstlern. Munich, Germany: Schirmer/Mosel, 1989.

TONI FRISSELL

Crowninshield, Frank. "American Aces: Toni Frissell." *U.S. Camera* 1 (December 1939): 38–42, 63.

Frissell, Toni. "American Red Cross: Assignment to England." *Popular Photography* 12 (May 1943): 20–21, 78–79.

———. *The King Ranch, 1939–1944: A Photographic Essay.* Dobbs Ferry, N.Y.: Morgan and Morgan, 1975.

Stevenson, Robert Louis. *A Child's Garden of Verses.* New York: U.S. Camera Publishing Corp., 1944. Photo-illustrations by Frissell.

Talbot, Michael. "Toni Frissell—Outdoor Specialist." *Popular Photography* 5 (October 1939): 32–33, 108.

Toni Frissell Photographs, 1933–1967. Washington, D.C.: Library of Congress; New York: Doubleday, 1994.

AMÉLIE GALUP

Harmelle, Claude. *Amélie Galup: Une Femme Photographe à la fin du siècle dernier: Albi/Saint-Antonin, 1895–1901.* Paris: Association Orelie; Mission du Patrimoine Photographique, 1984.

———. "Amélie Galup: Une Femme photographique à la fin du siècle dernier." *Zoom,* no. 123 (1986): 19–30.

CRISTINA GARCÍA RODERO

Coad, Emma Dent. "Woman of La Mancha: Interview with Cristina García Rodero." *British Journal of Photography* 16 (August 1993): 16.

"Cristina García Rodero." *American Photo* 3 (March–April 1992): 70–71.

Four Spanish Photographers: Koldo Chamorro, Cristina García Rodero, Joan Fontcuberta, Marta Sentis. Tucson: Center for Creative Photography, University of Arizona, 1988.

Hahn, Betty. *Contemporary Spanish Photography.* Albuquerque: University of New Mexico Press, 1987.

FLOR GARDUÑO

Between Worlds: Contemporary Mexican Photography. New Amsterdam, N.Y.: Impressions, 1990.

"[Flor Garduño]." *Du/Die Zeitschrift der Kultur* (January 1992): entire issue.

Garduño, Flor. *Magia del juego eterno: Fotografías.* Juchitán, Mexico: Publicación Guchá Reza, 1985.

———. *Flor Garduño: Bestiarium.* Zurich: U. Bär, 1987.

———. *Testigos del tiempo/Witnesses of Time.* New York: Thames and Hudson, 1992.

GRETCHEN GARNER

Garner, Gretchen. *An Art History of Ephemera: Gretchen Garner's Catalog, Photographs, 1976–1978.* Chicago: Gretchen Garner, 1982.

Garner, Gretchen, ed. *Reclaiming Paradise: American Women Photograph the Land.* Duluth: Tweed Museum of Art, University of Minnesota, 1987.

LYNN GEESAMAN

Geesaman, Lynn. *Poetics of Place.* New York: Umbrage Editions, 1998.

EDITH GÉRIN

Fontainebleau. Paris: Le Temps, 1967. Photographs by Gérin.

LAURA GILPIN

The Early Work of Laura Gilpin, 1917–1932. The Archive, no. 13. Tucson: Center for Creative Photography, University of Arizona, 1981.

Faris, James C. "Laura Gilpin and the 'Enduring' Navajo." *History of Photography* 21 (Spring 1971): 60–66.

Gilpin, Laura. *The Pueblos: A Camera Chronicle.* New York: Hastings, 1942.

———. *Temples in Yucatán: A Camera Chronicle of Chichén Itzá.* New York: Hastings, 1948.

———. *The Rio Grande: River of Destiny.* New York: Duell, Sloan and Pearce, 1949.

———. *The Enduring Navaho.* Austin: University of Texas, 1968.

Laura Gilpin Retrospective, 1910–1974. Santa Fe: Museum of New Mexico, 1974.

Sandweiss, Martha A. *Laura Gilpin: An Enduring Grace.* Fort Worth: Amon Carter Museum, 1986.

CAROLYN EVEN GLEDHILL

Gledhill, Keith, and David Gledhill. *The Gledhills Portraits: The Artistic Photographic Portraits of Santa Barbara Residents and Visitors by Carolyn and Edwin Gledhill.* Santa Barbara, Calif.: Mission Creek Studios, 1988.

Portfolio of the Work of W. Edwin Gledhill. Santa Barbara, Calif.: Harold Gledhill, 1975.

JUDITH GOLDEN

Judith Golden: Cycles, a Decade of Photographs. Untitled, no. 45. San Francisco: Friends of Photography, 1988.

Photo/Trans/Forms. San Francisco: San Francisco Museum of Modern Art, 1981.

NAN GOLDIN

Goldin, Nan. *The Ballad of Sexual Dependency.* New York: Aperture, 1986.

———. *The Other Side.* D.A.P./Scalo, 1993.

———. *I'll Be Your Mirror.* New York: Whitney Museum of American Art, 1996.

Goldin, Nan, and David Armstrong. *A Double Life.* New York: Scalo, 1994.

Goldin, Nan, and Taka Kawachi. *Couples and Loneliness.* Kyoto: Korinsha Press, 1998.

Holborn, Mark. "Nan Goldin's Ballad of Sexual Dependency." *Aperture,* no. 103 (Summer 1986): 38–47, 78.

Naggar, Carole. "Among Friends: Secrets." *Mother Jones* 17 (January–February 1992): 37–43.

LOIS GREENFIELD

Airborne: The New Dance Photography of Lois Greenfield. San Francisco: Chronicle Books, 1998.

Ewing, William A. *Breaking Bounds: The Dance Photography of Lois Greenfield.* San Francisco: Chronicle Books; London: Thames and Hudson, 1992.

Kirschenbaum, Jill. "Women at Work: Lois Greenfield." *Ms.* 18 (September 1989): 42–44.

Lois Greenfield: Dance Photographs. Philadelphia: University of the Arts; Langhorne, Penn.: Photo Review, 1987.

McLaughlin, Charles. "Urge to the Edge." *American Photographer* 14 (January 1985): 72–77.

LOURDES GROBET
Bodas de sangre: Versión oxoloteca de la obra original de Federico García Lorca. Villahermosa, Mexico: Gobierno del Estado de Tabasco, 1987.

García Canclini, Néstor, and Patricia Safa. *Tijuana: La casa de toda la gente.* Mexico City: INAH-ENAH, Program Cultural de las Fronteras and UAM-Iztapalapa/Conaculta, 1989.

García Canclini, Néstor, and Amparo Sevilla Villalobos. *Notas sobre las máscaras, danzas y fiestas de Michoacán.* Morelia, Mexico: Comité Editorial del Gobierno de Michoacán, 1985.

Mandoki, Katya. "The Double Struggle: Photographing 'La Lucha Libre.'" *Exposure* 22 (Summer 1984): 29–34.

Matos, Eduardo, and Felipe Ehrenberg. *Coyolxauhqui.* Mexico City: Secretaría de Educación Pública, 1979.

JAN GROOVER
Danoff, I. Michael. *Jan Groover: Color Photographs.* Milwaukee: Milwaukee Art Museum, 1980.

Groover, Jan. "The Medium Is the Use." *Artforum* 12 (November 1973): 79–80.

———. *Pure Invention: The Tabletop Still Life.* Photographers at Work Series. Washington, D.C.: Smithsonian Institution Press, 1990.

Jan Groover: Photographs. Boston: Little, Brown, and Company, 1993.

Kismaric, Susan. *Jan Groover.* New York: Museum of Modern Art, 1987.

Livingston, Jane. *Jan Groover: The Nation's Capital in Photographs, 1976.* Washington, D.C.: Corcoran Gallery of Art, 1976.

Three on Technology: New Photographs by Robert Cumming, Lee Friedlander, Jan Groover. Cambridge: List Visual Arts Center; MIT Press, 1988.

MATTIE GUNTERMAN
James, Geoffrey. "Opening Up B.C." *Canadian,* January 28, 1978, pp. 8–11.

The Photographs of Mattie Gunterman. Saskatoon, Canada: Photographers Gallery, 1977.

Robideau, Henri. "Mattie Gunterman." *Canadian Women's Studies* 2 (1980): 16–19.

———. *Flapjacks and Photographs: A History of Mattie Gunterman, Camp Cook and Photographer.* Vancouver: Polestar, 1995.

BETTY HAHN
Hahn, Betty, ed. *Contemporary Spanish Photography.* Albuquerque: University of New Mexico Press, 1987.

Hoy, Anne H. *Fabrications: Staged, Altered, and Appropriated Photographs.* New York: Abbeville Press, 1987.

Yates, Steve. *Betty Hahn: Photography or Maybe Not.* Albuquerque: Museum of Fine Arts, Museum of New Mexico; Santa Fe: University of New Mexico Press, 1995.

ADELAIDE HANSCOM
Adelaide Hanscom Leeson: Pictorialist Photographer, 1876–1932. Carbondale: University Museum, Southern Illinois University, 1981.

Browning, Elizabeth Barrett. *Sonnets from the Portuguese.* New York: Dodge, 1916. Photographs by Hanscom.

FitzGerald, Edward. *The Rubáiyát of Omar Khayyám.* 1859. Reprint, with photographs by Hanscom and Blanche Cumming. New York: Dodge, 1905. Reprinted in several versions, 1905–26.

"A Successful Photographer of Children." *Craftsman* 7 (1904–5): 460–65.

JUDITH HAROLD-STEINHAUSER
Ceremonies and Transitions/Linn Underhill/Judith Steinhauser. Syracuse, N.Y.: Robert B. Menschel Photography Gallery, Syracuse University, 1987.

Steinhauser, Judith. "Women and Their Models." *Center Quarterly* (Catskill Center for Photography, Woodstock, N.Y.) 4 (1983): 5.

LADY CLEMENTINA HAWARDEN
Dodier, Virginia. *Domestic Idylls: Photographs by Clementina Hawarden.* Malibu, Calif.: J. Paul Getty Museum, 1990.

Mavor, Carol. *Becoming: The Photographs of Clementina, Viscountess Hawarden.* Durham, N.C., and London: Duke University Press, 1999.

Ovenden, Graham, ed. *Clementina—Lady Hawarden.* New York: Saint Martin's Press; London: Academy, 1974.

MARÍA EUGENIA HAYA—*see* MARUCHA

FLORENCE HENRI
Bell, Judith. "Florence Henri: Master of Creative Media." *Rangefinder* 40 (December 1991): 50–53, 74.

du Pont, Diana C. *Florence Henri: Artist-Photographer of the Avant-Garde.* San Francisco: San Francisco Museum of Modern Art, 1990.

Florence Henri. New York and Genoa, Italy: Martini and Ronchetti, 1974.

Florence Henri. Milan: Electa, 1995.

Martinez, R. E. "The Woman as Photographer: Florence Henri, a Grande Dame of Photography." *Camera* 46 (September 1967): 4–19.

Seylan, D. "Florence Henri." *Creative Camera* (London) (July 1972): 234–41.

ABIGAIL HEYMAN
"Abigail Heyman." *Creative Camera* (London), no. 157 (July 1977): 236–43.

Heyman, Abigail. *Growing Up Female: A Personal Photo-Journal by Abigail Heyman.* New York: Holt, Rinehart, and Winston, 1974.

———. *Dreams and Schemes: Love and Marriage in Modern Times.* New York: Aperture, 1987.

Saul, Wendy. *Butcher, Baker, Cabinetmaker: Photographs of Women at Work.* New York: Thomas Y. Crowell, 1978. Photographs by Heyman.

HANNAH HÖCH
Collages: Hannah Höch, 1889–1978. Stuttgart, Germany: Institute for Foreign Cultural Relations, 1985.

Dech, Julia. *Hannah Höch: Schnitt mit dem Küchenmesser: Dadurch die Letzte Weimärer Bierbauchkulturepoche Deutschlands.* Frankfurt am Main, Germany: Fischer Taschenbuch Verlag, 1989.

Hannah Höch. London: Marlborough Fine Art, 1966.

Hannah Höch, 1889–1978: Oil Paintings and Works on Paper. London: Fischer Fine Art, 1983.

Hannah Höch: Eine Lebenscollage. Berlin: Argon, 1989.

Lavin, Maud. *Cut with the Kitchen Knife: The Weimar Photomontages of Hannah Höch.* New Haven, Conn., and London: Yale University Press, 1993.

The Photomontages of Hannah Höch. Minneapolis: Walker Art Center, 1997.

CANDIDA HÖFER
Candida Höfer: Innenraum Fotografien, 1979–1984. Xanten, Germany: Regionalmuseum Xanten, 1984.

Candida Höfer: Orte Jahre. Munich, Germany: Schirmer/Mosel, 1999.

Candida Höfer: Photographie. Bonn: VG Bildkunst Bonn, 1998.

Candida Höfer: Raume/Spaces. Cologne, Germany: Verlag der Buchhandlung Walther Konig, c. 1992.

Typologies: Nine Contemporary Photographers. Newport Beach, Calif: Newport Harbor Art Museum; New York: Rizzoli, 1991.

EVELYN HOFER
Barish, Evelyn. *Emerson in Italy.* New York: Henry Holt, 1989. Photographs by Hofer.

Evelyn Hofer. Lausanne, Switzerland: Musée de l'Elysée, 1994.

McCarthy, Mary. *The Stones of Florence.* New York: Harcourt, Brace and Company, 1959. Reprint, San Diego: Harcourt, Brace, and Jovanovich, 1987. Photographs by Hofer.

Pritchett, V. S. *London Perceived.* New York: Harcourt, Brace and World; London: Chatto and Windus, 1962. Photographs by Hofer.

———. *New York Proclaimed.* New York: Harcourt, Brace and World; London: Chatto and Windus, 1965. Photographs by Hofer.

———, *Dublin: A Portrait.* London and Sydney: Bodley Head, 1967. Photographs by Hofer.

Worth, Courtia. "Evelyn Hofer: Irish Portraits." *Modern Photography* 44 (October 1980): 114–19.

EDITH IRVINE
Plunkett, Wilma. "Edith Irvine: Her Life and Photography." M.A. thesis, Brigham Young University, 1989.

———. "Edith Irvine, Forgotten Foothill Photographer." *Las Calaveras* 41 (January 1992): 22–27.

"The Quake of 1906: Dramatic Images of an Unforgettable Event." *National Geographic* 177 (May 1990): 92–95.

GRACIELA ITURBIDE
Barjau, Luis. *Los que viven en la arena.* Mexico City: Instituto Nacional Indigenista; FONAPAS, 1981. Photographs by Iturbide.

External Encounters, Internal Imaginings: Photographs by Graciela Iturbide. San Francisco: San Francisco Museum of Modern Art, 1990.

Graciela Iturbide: La forma y la memoria. Mexico City: Museo de Arte Contemporaneo de Monterrey, 1996.

Iturbide, Graciela. *Sueños de papel.* Mexico City: Fondo de Cultura Económica, 1985.

Matos, Macario. "Graciela Iturbide: Rites of Fertility." *Aperture*, no. 109 (Winter 1987): 14–27, 78.

Poniatowska, Elena. *Juchitán de las mujeres.* Mexico City: Ediciones Toledo, 1989.

Ruiz Abreu, Alvaro. *Tabasco: Una cultura del agua.* Villahermosa, Mexico: Gobierno del Estado de Tabasco, 1985. Photographs by Iturbide.

LOTTE JACOBI
Beckers, Marion, and Elisabeth Moortgat. *Atelier Lotte Jacobi: Berlin/New York.* Berlin: Verborgene Museum; Nicolai, 1998.

Goldberg, Vicki. "Lotte Jacobi." *American Photographer* 2 (March 1979): 22–31.

Lotte Jacobi: A Selection of Vintage and Modern Photographs. Beverly Hills, Calif.: Stephen White Gallery of Photography, 1986.

Lotte Jacobi: Russland 1932/33/Moskau, Tadschikistan, Usbekistan. Berlin: Nishan, 1988.

Lotte Jacobi: Theatre and Dance Photographs. Woodstock, Vt.: Countryman, 1982.

Phillips, Sandra S, "An Interview with Lotte Jacobi." *Center Quarterly* (Catskill Center for Photography, Woodstock, N.Y.) 3 (Fall 1981): n.p. Reprint, *Photographica* 14 (1982): 9–10.

Wise, Kelly, ed. *Lotte Jacobi.* Danbury, N.H.: Addison, 1978.

BERTHA EVELYN JAQUES
Jaques, Bertha Evelyn. *A Country Quest.* Chicago: Libby, 1936.

BELLE JOHNSON
Howd, Dean. "The Photography of Belle Johnson from Monroe City, Missouri." *Western Illinois Regional Studies* 10 (Fall 1987): 35–48.

Johnson, Belle. "The First Annual Meeting of the Federation of Women Photographers." *Wilson's Photographic Magazine* 47 (October 1910): 436–37.

FRANCES BENJAMIN JOHNSTON
Daniel, Pete, and Raymond Smock. *A Talent for Detail: The Photographs of Miss Frances Benjamin Johnston, 1889–1910.* New York: Harmony, 1974.

Doherty, Amy S. "Frances Benjamin Johnston, 1864–1952." *History of Photography* 4 (April 1980): 97–111.

Frances Benjamin Johnston: Women of Class and Station. Long Beach: Art Museum and Galleries, and the Center for Southern California Studies in the Visual Arts, California State University, Long Beach, 1979.

The Hampton Album. New York: Museum of Modern Art, 1966.

"I Won't Make a Picture Unless the Moon Is Right . . .": Early Architectural Photography of North Carolina by Frances Benjamin Johnston and Bayard Wootten. Raleigh, N.C.: Preservation/North Carolina, 1994.

Middlestorb, Frances. *Frances Benjamin Johnston: What a Woman Can Do with a Camera.* York, England: Impressions Gallery of Photography, 1984.

DORA KALLMUS—*see* MADAME D'ORA

CONSUELO KANAGA
Kalina, Judith. "From the Icehouse: A Visit with Consuelo Kanaga." *Camera 35* 16 (December 1972): 52–55, 68, 70.

Millstein, Barbara Head, and Sarah M. Lowe. *Consuelo Kanaga: An American Photographer.* Brooklyn: Brooklyn Museum; Seattle: University of Washington Press, 1992.

Photographs: A Retrospective. New York: Lerner-Heller Gallery; Blue Moon Gallery, 1974.

IDA KAR
Ida Kar: An Exhibition of Artists and Writers in Great Britain, France and the Soviet Union. London: Whitechapel Art Gallery, 1960.

Williams, Val. *Ida Kar: Photographer, 1908–1974.* London: Virago Press, 1989.

GERTRUDE KÄSEBIER
Caffin, Charles H. "Mrs. Gertrude Käsebier and the Artistic Commercial Portrait." In *Photography as a Fine Art*, pp. 55–81. New York: Doubleday, Page and Company, 1901. Reprint, New York: Amphoto, 1972. First published in *Everybody's Magazine* 4 (May 1901): 480–95.

Edgerton, Giles [Mary Fanton Roberts]. "Photography as an Emotional Art: A Study of the Work of Gertrude Käsebier." *Image* 15 (December 1972): 9–12. First published in *Craftsman* 12 (April 1907): 80–93.

Homer, William Innes. *A Pictorial Heritage: The Photographs of Gertrude Käsebier.* Wilmington: Delaware Art Museum, 1979.

Michaels, Barbara L. *Gertrude Käsebier: The Photographer and Her Photographs.* New York: Harry N. Abrams, 1992.

Tighe, Mary Ann. "Gertrude Käsebier." *American Photographer* 8 (May 1982): 66–76.

BARBARA KASTEN
Constructs: Photographs by Barbara Kasten. Boston: New York Graphic Society, Little, Brown and Company, 1985.

London, Barbara. "Public Spaces and Private Places." *American Photographer* 21 (September 1988): 48–53.

Walther, Gary. "Mirror Images." *Camera Arts* 3 (June 1983): 60–67, 90.

MINNA KEENE
Guest, Antony. "Mrs. Minna Keene's Exhibition at 'The A.P. [American Place]' Little Gallery." *Amateur Photographer and Photographic News*, March 30, 1914, p. 306.

ANGELA KELLY
Changing Chicago: A Photodocumentary. Urbana and Chicago: University of Illinois Press, 1989.

Kelly, Angela Mary; Paul Hill; and John Tagg. *Three Perspectives on Photography, Recent British Photography.* London: Arts Council of Great Britain, 1979.

MARIE HARTIG KENDALL
"Biographical Information on Marie Hartig Kendall, as Written by Her Daughter, Carolina (Kay) Vining, in 1975." Typescript, Norfolk, Connecticut, Historical Society.

LEAH KING-SMITH
"Leah King Smith and the Nineteenth-Century Archive." *History of Photography* [London] 23 (Summer 1999): 114–17.

Patterns of Connection: An Exhibition of Photo-Compositions by Leah King-Smith. Sydney: Australian Centre for Photography; Daytona Beach, Fla.: Southeast Museum of Photography, 1992.

MICHIKO KON
An Incomplete History: Women Photographers from Japan, 1864–1997. Rochester, N.Y.: Traveling Exhibition Service; Visual Studies Workshop, 1998.

"Michiko Kon." *Aperture*, no. 130 (Winter 1993): cover, 54–61.

Michiko Kon: Kon Box. Tucson, Ariz.: Nazraeli Press and Photo Gallery International, 1996.

Michiko Kon: Still Lifes. New York: Aperture, 1997.

JILL KREMENTZ
Kalina, Judith Schoener. "Jill Krementz: Portrait of a Photojournalist." *Camera 35* 19 (May 1975): 46–49, 59–60.

Krementz, Jill. *Sweet Pea—a Black Girl Growing Up in the Rural South.* New York: Harcourt, Brace, and World, 1969.

———. *A Very Young Dancer.* New York: Alfred A. Knopf, 1976.

———. *The Writer's Image: Literary Portraits by Jill Krementz.* Boston: David R. Godine, 1980.

———. *A Very Young Musician.* New York: Simon and Schuster, 1991.

———. *How It Feels to Live with a Physical Disability.* New York: Simon and Schuster, 1992.

Livingston, Kathryn. "Diana Walker and Jill Krementz." *American Photographer* 16 (May 1986): 72–78.

ANNELIESE KRETSCHMER
Eskildsen, Ute. *Annelise Kretschmer, Fotografien.* Essen, Germany: Museum Folkwang, 1982.

BARBARA KRUGER
Kruger, Barbara. *We Won't Play Nature to Your Culture.* London: Institute of Contemporary Arts; Basel, Switzerland: Kunsthalle, 1983.

Kruger, Barbara, and Kate Linker. *Love for Sale: The Words and Pictures of Barbara Kruger.* New edition. New York: Harry N. Abrams, 1995.

Slices of Life: The Art of Barbara Kruger. Urbana-Champaign: University of Illinois Press, 1986.

Squiers, Carol. "Barbara Kruger." *Aperture*, no. 138 (Winter 1995): 58–67.

GERMAINE KRULL
Bouqueret, Christian. *Germaine Krull: Photographie, 1924–1936.* Arles, France: Musée Réattu, 1988.

Germaine Krull: Fotografien, 1922–1966. Bonn: Rheinisches Landesmuseum; Cologne, Germany: Rheinland-Verlag, 1977.

Krull, Germaine. *Métal.* Paris: Librairie des Arts Décoratifs, 1927.

———. *100 x Paris.* Berlin: Verlag der Reihe, 1929.

———. *Tibetans in India.* Bombay: Allied, 1968.

MacOrlan, Pierre. *Germaine Krull: Photographies nouveaux.* Paris: Gallimard, 1931.

Sichel, Kim. *Germaine Krull: Photographer of Modernity.* Cambridge and London: MIT Press, 1999.

DOROTHEA LANGE
Coles, Robert. "The Human Factor: The Life and Work of Dorothea Lange." *Camera Arts* 3 (February 1983): 34–49, 83–85.

Dorothea Lange: Archive of an Artist. Oakland, Calif.: Oakland Museum, 1995.

Dorothea Lange Looks at the American Country Woman. Fort Worth: Amon Carter Museum; Los Angeles: Ward Ritchie, 1967.

Dorothea Lange: Photographs of a Lifetime. Millerton, N.Y.: Aperture, 1982.

Heyman, Therese Thau. *Celebrating a Collection: The Work of Dorothea Lange, Documentary Photographer.* Oakland, Calif.: Oakland Museum, 1978.

Lange, Dorothea, and Margaretta K. Mitchell. *To a Cabin.* New York: Grossman, 1973.

Lange, Dorothea, and Paul Taylor. *An American Exodus: A Record of Human Erosion.* New York: Reynal and Hitchcock, 1939.

Meltzer, Milton. *Dorothea Lange: A Photographer's Life.* New York: Farrar, Straus and Giroux, 1978.

Ohrn, Karin Becker. *Dorothea Lange and the Documentary Tradition.* Baton Rouge and London: Louisiana State University Press, 1980.

Photographing the Second Gold Rush: Dorothea Lange and the Bay Area at War, 1941–1945. Berkeley, Calif.: Heyday Books, 1995.

CONSTANCE STUART LARRABEE
"Constance Stuart Larrabee." *Creative Camera* (London) (July–August 1985): 44–49.

Constance Stuart Larrabee: WWII Photo Journal. Washington, D.C.: National Museum of Women in the Arts, 1989.

Go Well, My Child: Photographs by Constance Stuart Larrabee. Washington, D.C.: National Museum of African Art, Smithsonian Institution Press, 1985.

Hoopes, Roy. "Focus on Life." *Modern Maturity,* February–March 1991, pp. 42–47, 92–94.

Sundkler, Bengt. *Bantu Prophets in South Africa.* London: Lutterworth Press, 1948. Photographs by Larrabee.

KRISTINE LARSEN
Fraser, Kennedy. *On the Edge: Images from 100 Years of Vogue.* New York: Random House, 1992.

ALMA LAVENSON
Ehrens, Susan. "Interview with Alma Lavenson." *Photo Metro* 5 (October 1986): 13–20.

———. *Alma Lavenson: Photographs.* Berkeley, Calif.: Wildwood Arts, 1990.

Fuller, Patricia Gleason. *Alma Lavenson.* Riverside: California Museum of Photography, 1979.

Mitchell, Sydney B. *From a Sunset Garden: Essays for Any Adventurous Gardener.* Garden City, N.Y.: Doubleday, Doran, 1932. Photographs by Lavenson.

———. *Your California Garden and Mine.* New York: M. Barrows and Company, 1947. Photographs by Lavenson.

ANNIE LEIBOVITZ
Annie Leibovitz Photographs. New York: Pantheon; Rolling Stone, 1983.

Annie Leibovitz: Photographs, 1970–1990. New York: HarperCollins, 1991.

Dancers: Photographs by Annie Leibovitz. Photographers at Work Series. Washington, D.C.: Smithsonian Institution Press, 1992.

Harris, Melissa. "Annie Leibovitz." *Aperture,* no. 133 (Fall 1993): 4–13.

Leibovitz, Annie. *Olympic Portraits.* Boston: Little, Brown, and Company, 1996.

Marcus, Adrianne, and the editors of Alskog. *The Photojournalist: Mary Ellen Mark and Annie Leibovitz.* Masters of Contemporary Photography Series. Los Angeles: Alskog; London: Thames and Hudson; New York: Thomas Y. Crowell, 1974.

Shames, Laurence. "On the Road with Annie." *American Photographer* 12 (January 1984): 38–55.

Sontag, Susan. *Annie Leibovitz: Women.* New York: Random House, 1999.

ERNA LENDVAI-DIRCKSEN
Lendvai-Dircksen, Erna. *Das deutsche Volksgesicht.* Berlin: Kulturelle Verlagsgesellschaft M.H.B., 1932.

———. *Das deutsche Volksgesicht: Tirol und Vorarlberg.* Bayreuth, Germany: Gauverlag Bayerische Ostmark, 1941.

———. *Das germanische Volksgesichte: Flandern; Mit Siebzig Aufnahmen.* Bayreuth, Germany: Gauverlag Bayreuth, 1942.

———. *Das germanische Volksgesicht: Norwegen; Mit Siebenund-Achtzig Aufnahmen.* Bayreuth, Germany: Gauverlag Bayreuth, 1942.

———. *Urgestalt in Kreide und Granite.* Essen, Germany: Verlag Ernst Heyer, 1960.

———. *Ein deutsches Menschenbild: Antlitz des Volkes.* Frankfurt am Main, Germany: Umschau, 1961.

Philipp, Claudia Gabrielle. "Erna Lendvai-Dircksen: 1883–1962." *Fotogeschichte* 3 (July 1983): 39–54.

REBECCA LEPKOFF
Gardner, Sandra. *Street Gangs.* New York: F. Watts, 1983. Photographs by Lepkoff.

Meyerowitz, Joel, ed. *Street Photography.* Boston: Bulfinch Press, 1994.

HELEN LEVITT
Agee, James. *A Way of Seeing: Photographs of New York by Helen Levitt.* New York: Viking Press, 1965. Enlarged edition published, New York: Horizon, 1981; reprinted with additional photographs, Durham, N.C.: Duke University Press; Center for Documentary Studies, 1989.

Helen Levitt. Washington, D.C.: Corcoran Gallery of Art, 1980.

Helen Levitt. San Francisco: San Francisco Museum of Modern Art, 1991.

Helen Levitt. Munich, Germany: Prestel Verlag, 1998.

Helen Levitt: Color Photographs. El Cajon, Calif.: Grossmont College Gallery, 1980.

Johnston, Mike. "Helen Levitt." *Camera and Darkroom* 15 (February 1993): 32–37.

Levitt, Helen. *In the Street: Chalk Drawings and Messages, New York City, 1938–1948*. Durham, N.C.: Duke University Press, 1987.

ALICE LEX-NERLINGER
Alice Lex-Nerlinger, Oskar Nerlinger. Berlin: Neue Gesellschaft für Bildende Kunst, 1975.

Die Harte Strasse: 1918–1949 Zeichnungen. Weimar, Germany: Thüringer Volksverlags, 1950.

MARTINA LOPEZ
Martina Lopez: Digital Allegory. Contact Sheet no. 100. Syracuse, N.Y.: Robert B. Menschel Photography Gallery, Syracuse University, 1999.

RUTH HARRIET LOUISE
Fahey, David, and Linda Rich. *Masters of Starlight: Photographers in Hollywood*. Los Angeles: Los Angeles County Museum of Art, 1987; New York: Ballantine, 1988.

Kobal, John. *The Art of the Great Hollywood Portrait Photographers*. New York: Alfred A. Knopf, 1980.

Kobal, John, ed. *Hollywood Glamor Portraits*. New York: Dover, 1976.

Woody, Jack. *Lost Hollywood*. Altadena, Calif.: Twin Palms, 1987.

FRANCES MCLAUGHLIN-GILL
Abbe, Kathryn McLaughlin, and Frances McLaughlin Gill. *Twins on Twins*. New York: Clarkson N. Potter, 1980.

Castle, Sue. *Face Talk, Hand Talk, Body Talk*. Garden City, N.Y.: Doubleday, 1977. Photographs by McLaughlin-Gill.

Mitchell, Margaretta K. "Photography's Twin Sisters." *Popular Photography* 86 (January 1980): 74–81, 118–19, 182.

Safer, Jane, and Frances McLaughlin Gill. *Spirals from the Sea: An Anthropological Look at Shells*. New York: Clarkson N. Potter, 1982.

WENDY SNYDER MACNEIL
MacNeil, Wendy, and Eugenia Parry Janis, eds. *Photography within the Humanities*. Danbury, N.H.: Addison, 1977.

Snyder, Wendy. *Haymarket*. Cambridge: MIT Press, 1970.

SALLY MANN
Mann, Sally. *At Twelve: Portraits of Young Women*. New York: Aperture, 1988.

———. *Still Time*. Clifton Forge, Va.: Alleghany Highlands Arts and Crafts Center, 1988.

———. *Immediate Family*. New York: Aperture, 1992.

Second Sight: The Photographs of Sally Mann. Boston: David R. Godine, 1983.

Smith, Rosalind. "I Was Aware of the Ghosts." *View Camera* (September–October 1999): 18–24.

MARY ELLEN MARK
Bultman, Janis. "Street Shooter: An Interview with Mary Ellen Mark." *Darkroom Photography* 9 (January–February 1987): 18–25.

A Cry for Help: Photographs by Mary Ellen Mark. New York: Simon and Schuster, 1996.

Fulton, Marianne. *Mary Ellen Mark: Twenty-five Years*. Boston, Toronto, and London: Little, Brown and Company, 1991.

Mark, Mary Ellen. *Passport*. New York: Lustrum, 1974.

———. *Ward 81*. New York: Simon and Schuster, 1979.

———. *Falkland Road: Prostitutes of Bombay*. London: Thames and Hudson; New York: Alfred A. Knopf, 1981.

———. *Streetwise*. Philadelphia: University of Pennsylvania Press, 1988. Reprint, New York: Aperture, 1991.

———. *Indian Circus*. San Francisco: Chronicle Books, 1993.

Mary Ellen Mark: American Odyssey. Motta Photography Series. New York: Aperture, 1999.

Mary Ellen Mark: Portraits. Washington, D.C.: Smithsonian Institution Press, 1997.

The Photo Essay: Photographs by Mary Ellen Mark. Photographers at Work Series. Washington, D.C.: Smithsonian Institution Press, 1990.

Porter, Allan. "Mary Ellen Mark." *Camera* (Switzerland) 56 (September 1977): 24–32.

MARUCHA
(MARÍA EUGENIA HAYA)
Haya, María Eugenia. *Breve historia de la fotografía cubana*. Havana, 1980.

———. "Photography in Latin America." *Aperture*, no. 109 (Winter 1987): 58–69, 78.

MARGRETHE MATHER
Margrethe Mather. The Archive, no. 11. Tucson: Center for Creative Photography, University of Arizona, 1979.

HANNAH MAYNARD
Mattison, David. "The Multiple Self of Hannah Maynard." *Vanguard* 9 (October 1980): 14–19.

Watson, Petra Rigby. "Hannah Maynard's Multiple Exposures." *History of Photography* [London] 20 (Summer 1996): 155–57.

Wilks, Claire Weissman. *The Magic Box: The Eccentric Genius of Hannah Maynard*. Toronto: Exile, 1980.

SUSAN MEISELAS
Harris, Melissa. "Susan Meiselas." *Aperture*, no. 133 (Fall 1993): 24–33.

Mattison, Harry, ed. *El Salvador: The Work of Thirty Photographers*. New York: Pantheon, 1983.

Meiselas, Susan. *Carnival Strippers*. New York: Farrar, Straus and Giroux, 1976.

———. *Nicaragua*. New York: Pantheon, 1981.

———. *Kurdistan in the Shadow of History*. New York: Random House, 1997.

Ritchin, Fred. "Susan Meiselas: The Frailty of the Frame, Work in Progress." *Aperture*, no. 108 (Fall 1987): 32–41, 79.

Shames, Laurence. "Susan Meiselas." *American Photographer* 6 (March 1981): 42–55.

ANNETTE MESSAGER
"Annette Messager." *Aperture*, no. 130 (Winter 1993): 48–53.

Annette Messager: Comédie, Tragédie, 1971–1989. Grenoble, France: Musée de Grenoble, 1989.

Annette Messager: Faire Parade, 1971–1995. Paris: Musée d'Art Moderne de la Ville de Paris, 1995.

Conkelton, Sheryl, and Carol Eliel. *Annette Messager.* Los Angeles: Los Angeles County Museum of Art, c. 1995.

Christian Boltanski, Jean Le Gac, Annette Messager. Dijon, France: Musée Rue, 1973.

HANSEL MIETH
Brown, Robert W. "Hansel Mieth Gets Them to Pose." *Popular Photography* 8 (April 1941): 22–23, 112–14.

Ehrens, Susan. "Hansel Mieth." *Photo Metro* 5 (May 1987): 5–12.

Hagel, Hansel Mieth. "On the Life and Work of Otto Hagel and Hansel Mieth." *Left Curve,* no. 13 (1988): 4–18.

A Lifetime of Concerned Photography: Hansel Mieth Hagel and Otto Hagel. San Francisco: Eye Gallery, 1990.

LEE MILLER
Carter, Ernestine, ed. *Bloody, but Unbowed: Pictures of Britain under Fire.* New York: Charles Scribner's Sons, 1941. Photographs by Lee Miller and others.

Livingston, Jane. *Lee Miller: Photographer.* London and New York: Thames and Hudson, 1989.

Lyford, Amy J. "Lee Miller's Photographic Impersonations, 1930–1945: Conversing with Surrealism." *History of Photography* (London) 18 (Autumn 1994): 230–41.

Miller, Lee. *Wrens in Camera.* London: Hollis and Carter, 1945.

———. *Lee Miller's War.* Edited by Antony Penrose. Boston, Toronto, and London: Little, Brown and Company, 1992.

Penrose, Antony. *The Lives of Lee Miller.* London: Thames and Hudson; New York: Holt, Rinehart and Winston, 1985.

MARGARETTA K. MITCHELL
Lange, Dorothea, and Margaretta K. Mitchell. *To a Cabin.* New York: Grossman, 1973.

Mitchell, Margaretta K. *Gift of Place.* Berkeley, Calif.: Scrimshaw, 1969.

———. "Nell Dorr." *Popular Photography* 76 (March 1975): 98–107, 114–15.

———. *Recollections: Ten Women of Photography.* New York: Viking Press, 1979.

LISETTE MODEL
Bell, Judith. "Lisette Model: The Art of the Split Second." *Rangefinder* 42 (January 1992): 46–50.

Cravens, R. H. "Notes for a Portrait of Lisette Model." *Aperture,* no. 86 (1982): 52–65.

Lisette Model. Millerton, N.Y.: Aperture, 1979.

Lisette Model: A Retrospective. New Orleans: New Orleans Museum of Art; Essen, Germany: Museum Folkwang, 1981.

Thomas, Ann. *Lisette Model.* Ottawa: National Gallery of Canada; Chicago: University of Chicago Press, 1990.

Vestal, David. "Lisette Model: The Much Admired Photographer/Teacher Talks About Her Long, Illustrious Career, Her Famous Friends, and Her First Book." *Popular Photography* 86 (May 1980): 114–19, 138–40.

ANDREA MODICA
"Andrea Modica." *Contact Sheet* 77 [1993?]: cover, 1–4.

Minor League: Photographs by Andrea Modica. Photographers at Work Series. Washington, D.C., and London: Smithsonian Institution Press, 1993.

Treadwell: Photographs by Andrea Modica. San Francisco: Chronicle Books, 1996.

TINA MODOTTI
Andre, Linda. "Body Language: Frida Kahlo and Tina Modotti." *Exposure* 22 (Summer 1984): 19–28.

Caronia, Maria, and Vittorio Vidali. *Tina Modotti: Photographs.* Westbury, N.Y.: Idea Editions; Belmark Books, 1981.

Constantine, Mildred. *Tina Modotti: A Fragile Life.* New York: Rizzoli, 1983. Reprint, San Francisco: Chronicle Books, 1993.

Gibson, Margaret. *Memories of the Future: The Daybooks of Tina Modotti.* Baton Rouge and London: Louisiana State University Press, 1986.

Hooks, Margaret. *Tina Modotti: Photographer and Revolutionary.* New York: Pandora, 1993.

Lowe, Sarah M. *Tina Modotti Photographs.* Philadelphia: Philadelphia Museum of Art; New York: Harry N. Abrams, 1995.

Stark, Amy, ed. *The Letters from Tina Modotti to Edward Weston.* The Archive, no. 22. Tucson: Center for Creative Photography, University of Arizona, 1986.

LUCIA MOHOLY
"Lucia Moholy." *Camera* (Switzerland) 57 (February 1978): 4–13, 35.

Moholy, Lucia. *One Hundred Years of Photography, 1839–1939.* Harmondsworth, England: Penguin, 1939.

———. *Marginalien Zu Moholy-Nagy: Dokumentarische Ungereimtheiten-Moholy-Nagy.* Krefeld, Germany: Scherpe, 1972.

Sachsse, Rolf. *Lucia Moholy.* Düsseldorf: Edition Marcona, 1985.

SARAH MOON
"Conversation with Sarah Moon." *American Photographer* 10 (May 1983): 102–3.

Moon, Sarah. *Improbable Memories.* Providence, R.I.: Matrix/Delpire, 1981.

Perrault, Charles. *Le Petit Chaperon rouge.* Paris: Grasset/Monsieur Chat, 1983. Photographs by Moon.

Porter, Allan. "Sarah Moon." *Camera* (Switzerland) 49 (February 1970): 24–31.

INGE MORATH
Brynner, Yul, and Inge Morath. *Bring Forth the Children: A Journey to the Forgotten People of Europe and the Middle East.* New York: McGraw-Hill, 1960.

Carlisle, Olga. *Inge Morath.* Lucerne, Switzerland: Bucher Verlag, 1975.

Folie, Sabine, and Gerald Matt, editors. *Inge Morath: Life as a Photographer.* Translated by James Abram. Munich, Germany: Kehayoff, 1999.

Miller, Arthur, and Inge Morath. *In Russia.* New York: Viking Press; London: Secker and Warburg, 1969.

———. *In the Country.* New York: Viking Press, 1977.

———. *Chinese Encounters.* New York: Farrar, Straus and Giroux, 1979. Reprint, Harmondsworth, England: Penguin, 1981.

Morath, Inge. *Portraits.* New York: Aperture, 1986.

———. *Russian Journal.* New York: Aperture, 1991.

BARBARA MORGAN
Barbara Morgan: Photomontage. Dobbs Ferry, N.Y.: Morgan and Morgan, 1980.

Carter, Curtis L., and William C. Agee. *Barbara Morgan: Prints, Drawings, Watercolors and Photographs.* Milwaukee: Haggerty Museum of Art, Marquette University; Dobbs Ferry, N.Y.: Morgan and Morgan, 1988.

Morgan, Barbara. *Martha Graham: Sixteen Dances in Photographs.* New York: Duell, Sloan and Pearce, 1941. Revised edition, Dobbs Ferry, N.Y.: Morgan and Morgan, 1980.

———. *Summer's Children: A Photographic Cycle of Life at Camp.* Scarsdale, N.Y.: Morgan and Morgan, 1951.

LADY OTTOLINE MORRELL
Gathorne-Hardy, Robert, ed. *Memories of Lady Ottoline Morrell: A Study in Friendship, 1873–1915.* New York: Alfred A. Knopf, 1964.

Heilbrun, Carolyn G., ed. *Lady Ottoline's Album.* New York: Alfred A. Knopf, 1976.

Seymour, Miranda. *Ottoline Morrell: Life on the Grand Scale.* New York: Farrar, Straus and Giroux, 1993.

JEANNE MOUTOUSSAMY-ASHE
Moutoussamy-Ashe, Jeanne. *Daufuskie Island.* Columbia: University of South Carolina Press, 1982.

———. *Viewfinders: Black Women Photographers.* New York: Dodd, Mead and Company, 1986.

———. *Daddy and Me: A Photo Story of Arthur Ashe and His Daughter, Camera.* New York: Alfred A. Knopf, 1993.

JOAN MURRAY
Marable, Darwin. "Interview with Joan Murray." *Photo Metro* 11 (April 1992): 24–25.

EVELEEN MYERS
Myers, Eveleen, ed. *Fragments of Prose and Poetry,* by F.W.H. Myers. London, New York, and Bombay: Longmans, Green and Company, 1904.

———. *Collected Poems with Autobiographical and Critical Fragments,* by Frederic William Henry Myers. London: Macmillan, 1921.

Symonds, John Addington. "Mrs. F.W.H. Myers." In *The Literature of Photography.* New York: Arno, 1973. First published in *Sun Artists* 7 (April 1891).

GENEVIEVE NAYLOR
Levine, Robert M. *The Brazilian Photographs of Genevieve Naylor, 1940–1942.* Durham, N.C., and London: Duke University Press, 1998.

Naylor, Genevieve, and Misha Reznikoff. *Faces and Places in Brazil.* São Paulo: Pinacoteca do Estado, 1994.

MARIE-PAULE NÈGRE
"Uprooted Lives: France's New Poverty." *Aperture,* no. 142 (Winter 1996): 40–43.

JOYCE NEIMANAS
Collisions: Joyce Neimanas. North Vancouver, Canada: Presentation House Gallery, 1988.

Moore, Sarah J. *Joyce Neimanas.* Tucson: Center for Creative Photography, University of Arizona, 1984.

BEA NETTLES
Hoy, Anne H. *Fabrications: Staged, Altered, and Appropriated Photographs.* New York: Abbeville Press, 1987.

Nettles, Bea. *Breaking the Rules: A Photo Media Cookbook.* Rochester, N.Y.: Inky Press Productions, 1977. Reprint, Urbana, Ill.: Inky Press Productions, 1987.

———. *Flamingo in the Dark: Images by Bea Nettles.* Rochester, N.Y.: Inky Press Productions, 1979.

———. *Life's Lessons: A Mother's Journal.* Urbana, Ill.: Inky Press Productions, 1990.

———. *The Skirted Garden: Twenty Years of Images by Bea Nettles.* Urbana, Ill.: Inky Press Productions, 1990.

———. *Complexities: Photographs and Text by Bea Nettles.* Urbana, Ill.: Inky Press Productions, 1992.

———. *Grace's Daughter.* Urbana, Ill.: Inky Press Productions, 1994.

———. *Turning 50.* Urbana, Ill.: Inky Press Productions, 1995.

Nettles, Bea, and Grace Nettles. *Corners: Grace and Bea Nettles.* Urbana, Ill.: Inky Press Productions, 1988.

JANINE NIEPCE
Francis, Claude. *Simone de Beauvoir et le cours du monde.* Paris: Klincksieck, 1978.

"Janine Niepce: France." *Camera* (Switzerland) 37 (January 1958): 24–28.

Niepce, Janine. *Le Livre de Paris.* Paris: Arts et Métiers Graphiques, 1957.

———. *La Bourgogne.* Paris: Editions Mondiales, 1959.

———. *Les Jeunes Filles de Paris.* Paris: Editions Bruna, 1961.

———. *Réalité de l'instant.* Paris: Clairefontaine, 1967.

———. *Le Monde qui change.* Paris: n.p., 1970.

———. *Dijon, le temps de vivre.* N.p., 1981.

———. *France/Photographies, Janine Niepce.* Arles, France: Actes Sud, 1992.

ANNE NOGGLE
Asbury, Dana. "Elusive Familiar Mystery: The Photographs of Anne Noggle." *Exposure* 17 (Fall 1979): 6–12.

Grover, Janice Zita. *Silver Lining: Photographs by Anne Noggle.* Albuquerque: University of New Mexico Press, 1983.

Gutsche, Clara. "The Tragedy of Fallen Flesh." *Photo Communiqué* 5 (Fall 1983): 9–17.

Noggle, Anne. *For God, Country, and the Thrill of It.* College Station: Texas A and M University Press, 1990.

BARBARA NORFLEET
Archives and Archetypes: Photographs by Barbara Norfleet. Daytona Beach, Fla.: Daytona Beach Community College; Southeast Museum of Photography, 1997.

Bogre, Michelle. "Among the Hidden Class." *American Photographer* 23 (November 1989): 54–60.

Matthews, Sandra. "Looking Up at the Upper Class: The Photographs of Barbara P. Norfleet." *Exposure* 26 (Fall 1988): 26–30.

Norfleet, Barbara. *The Champion Pig: Great Moments in Everyday Life.* Boston: David R. Godine, 1979.

———. *Killing Time.* Boston: David R. Godine, 1982.

———. *All the Right People.* Boston: New York Graphic Society, Little, Brown and Company, 1986.

———. *Manscape with Beasts.* New York: Harry N. Abrams, 1990.

———. *Looking at Death.* Boston: David R. Godine, 1993.

SONYA NOSKOWIAK
Bender, Donna; Jan Stevenson; and Terence R. Pitts. *Sonya Noskowiak Archive.* Guide Series, no. 5. Tucson: Center for Creative Photography, University of Arizona, 1982.

Sonya Noskowiak. The Archive, no. 9. Tucson: Center for Creative Photography, University of Arizona, 1979.

LORIE NOVAK
du Pont, Diana C. *Lorie Novak.* Centric, no. 42 (Long Beach: University Art Museum, California State University, Long Beach, 1991).

Hart, Russell. "Room with a View." *American Photographer* 21 (November 1988): 66–67.

Novak, Lorie. "Collected Visions," in *The Familial Gaze,* edited by Marianne Hirsch. Hanover, N.H.: Dartmouth College; University Press of New England, 1999.

Piperato, Susan. "Projecting the Past." *Popular Photography* 94 (June 1987): 48–53.

STARR OCKENGA
Doolittle, Eileen. *The Ark in the Attic: An Alphabet Adventure.* Boston: David R. Godine, 1987.

———. *World of Wonders: A Trip Through Numbers.* Boston: Houghton Mifflin, 1988.

———. *A Book of Days: Then and Now.* Boston: Houghton Mifflin, 1989.

Ockenga, Starr. *Mirror after Mirror: Reflections on Woman.* Garden City, N.Y.: Amphoto, 1976.

———. *Dressup: Playacts and Fantasies of Childhood.* Danbury, N.H.: Addison, 1978.

———. *On Women and Friendship: A Collection of Victorian Keepsakes and Traditions.* New York: Stewart, Tabori and Chang, 1993.

RUTH ORKIN
Bultman, Janis. "Candor and Candids: An Interview with Ruth Orkin." *Darkroom Photography* 4 (September–October 1982): 18–25, 29.

Orkin, Ruth. *A World Through My Window.* New York: Harper and Row, 1978.

———. *A Photo Journal.* New York: Viking Press, 1981.

———. *More Pictures from My Window.* New York: Rizzoli, 1983.

Stevens, Nancy. "Ruth Orkin: A Retrospective Look at the Life and Work of a Humanist Magazine Photojournalist." *Popular Photography* 80 (June 1977): 100–109, 144, 158.

JEAN PAGLIUSO
Zwingle, Erla. "Jean Pagliuso." *American Photographer* 3 (September 1979): 32–40.

MARION PALFI
Invisible in America: An Exhibition of Photographs by Marion Palfi. Lawrence: University of Kansas Museum of Art, 1973.

Lindquist-Cook, Elizabeth. *Marion Palfi.* The Archive, no. 19. Tucson: Center for Creative Photography, University of Arizona, 1983.

Palfi, Marion. "Mexican Americans." *Common Ground* 8 (Spring 1948): 53–60.

———. *Suffer Little Children.* New York: Oceana, 1952.

———. "You Have Never Been Old: A Study in Geriatrics." *Transactions of the New York Academy of Sciences,* 2d series, vol. 21 (March 1959): 435–41.

Widoff, Joyce. "Marion Palfi: Trying to Combine an Art Form with Social Research." *Western Photographer* 14 (July 1974): 2–21.

ESTHER PARADA
Define/Defy the Frame: An Unfolding Exhibition by Esther Parada. Binghamton: University Art Museum, State University of New York at Binghamton, 1990.

Tucker, Anne Wilkes, ed. *Target III: In Sequence.* Houston: Museum of Fine Arts, 1982.

OLIVIA PARKER
Edwards, Owen. "Olivia Parker." *American Photographer* 4 (February 1980): 64–71.

Featherstone, David. "Olivia Parker: Shaping Color to Sensibility." *Modern Photography* 44 (March 1980): 94–99, 148.

Horenstein, Henry. "Visions: Olivia Parker's Still Lifes Cast Ordinary Objects in a New Light." *Popular Photography* 93 (December 1986): 60–67.

Parker, Olivia. *Signs of Life: Photographs.* Boston: David R. Godine, 1978.

———. *Weighing the Planets.* Untitled, no. 44. Carmel, Calif.: Friends of Photography, 1987. Reprint, Boston: Little, Brown and Company, 1987; Albuquerque: University of New Mexico Press, 1990.

Under the Looking Glass: Color Photographs by Olivia Parker. Boston: New York Graphic Society, Little, Brown and Company, 1983.

SYLVIA PLACHY
Hager, Steven. "Found Memories." *Camera Arts* 3 (June 1983): 34–45, 82–83.

Plachy, Sylvia. *Signs & Relics.* Introduction by Wim Wenders. New York: Monacelli, Press 1999.

Plachy, Sylvia, in collaboration with James Ridgeway. *Red Light.* New York: powerHouse, 1996.

Sylvia Plachy's Unguided Tour. New York: Aperture, 1990.

ROSAMOND W. PURCELL
Novak, Joe. "Time Frames." *Camera Arts* 3 (February 1983): 68–79, 82–83.

Purcell, Rosamond Wolff. *A Matter of Time.* Contemporary Photographers Series. Boston: David R. Godine, 1975.

———. *Half-Life: Photographs.* Boston: David R. Godine, 1980.

Purcell, Rosamond Wolff, and Stephen Jay Gould. *Illuminations: A Bestiary.* New York: W. W. Norton, 1987.

———. *Finders, Keepers: Eight Collectors.* New York: W. W. Norton, 1992.

Roth, Evelyn. "Animal Magnetism." *American Photographer* 18 (February 1987): 60–65.

SUSAN RANKAITIS
Susan Rankaitis. Santa Monica, Calif.: Gallery Min, c. 1988.

Susan Rankaitis: Jargomatique Series. Santa Monica, Calif.: Meyers/Bloom Gallery, 1990.

JANE REECE
Brannick, John A. "Jane Reece and Her Autochromes." *History of Photography* 13 (January–March 1989): 1–4.

"The Camera, the Paper, and I": A Collection of Photographs by Jane Reece. Dayton, Ohio: Dayton Art Institute, 1952.

Chambers, Karen S. "Jane Reece: A Photographer's View of the Artist." M.A. thesis, University of Cincinnati, 1977.

———. "Jane Reece's Portraits of Artists." *Exposure* 17 (Fall 1979): 13–21.

Vasseur, Dominique H. *The Soul Unbound: The Photographs of Jane Reece.* Dayton, Ohio: Dayton Art Institute, 1997.

WYNN RICHARDS
Albert, Dora. "Experiment Brought Her Success." *Popular Photography* 3 (August 1938): 24–25.

Wynn Richards. New York: Photofind Gallery, 1989.

LENI RIEFENSTAHL
Leni Riefenstahl: Life / Photographer. Tokyo: Kyuryudo Art Publishing Company, 1992.

Leni Riefenstahl: Olympia. New York: Saint Martin's Press, 1994.

Riefenstahl, Leni. *The Last of the Nuba.* New York: Harper and Row, 1974.

———. *The People of Kau.* New York: Harper and Row; London: Collins, 1976.

———. *Leni Riefenstahl's Africa.* London: Collins/Harvill; New York: Harmony, 1982. U.S. edition entitled *Vanishing Africa.*

———. *Wonders under Water / Leni Riefenstahl.* London: Quartet Books, 1991.

———. *The Sieve of Time: The Memoirs of Leni Riefenstahl.* London: Quartet Books, 1992.

———. *Leni Riefenstahl: A Memoir.* New York: Saint Martin's Press, 1993.

GRACE ROBERTSON
"Grace Robertson and Picture Post." *PhotoHistorian* (August 1999): 11–13.

Robertson, Grace. *Grace Robertson: Photojournalist of the Fifties.* London: Virago Press, 1989.

MERIDEL RUBENSTEIN
Bloom, John. "Interview with Meridel Rubenstein." *Photo Metro* 6 (September 1988): 4–11.

"Photographs by Meridel Rubenstein." *Untitled* (Friends of Photography, Carmel, Calif.), no. 14 (1978): 38–41.

Rubenstein, Meridel. *La Gente de la luz: Portraits from New Mexico.* Santa Fe: Museum of New Mexico, 1977.

———. *One Space, Three Visions.* Albuquerque: Museum of New Mexico, 1979.

CHARLOTTE RUDOLPH
Preston-Dunlop, Valerie, and Suzanne Lausan, eds. *Schifttanz: A View of German Dance in the Weimar Republic.* London: Laban Centre for Movement and Dance; Dance Books, 1990.

Rudolph, Charlotte. *Waldorf-Erziehung: Wege zur Versteinerung.* Darmstadt, Germany: Luchterhand, 1987.

Sprung in die Zeit. Berlin: Berlinische Galerie, Museum für Moderne Kunst, Photographie, und Architektur, 1992.

GALINA SANKOVA
"Soviet Cameramen at the Front." *U.S. Camera* 8 (February 1945): 14–17, 54.

NAOMI SAVAGE
Lewis, P. *Two Generations of Photographs: Man Ray and Naomi Savage.* Trenton: New Jersey State Museum, 1969.

"Naomi Savage." *Album* 10 (October 1970): 2–10.

Naomi Savage: Faces, Figures, Forks and the Future. Princeton, N.J.: Princeton Gallery of Fine Art, 1984.

Naomi Savage: Photographic Disclosures. Princeton, N.J.: Squibb Gallery, 1982.

Savage, Naomi. "Visual Answers to Verbal Questions." *Untitled* (Friends of Photography, Carmel, Calif.), nos. 7–8 (1974): 68–79.

MARY T. S. SCHAEFFER
Brown, Stewardson, and Mary T. S. Schaeffer. *Alpine Flora of the Canadian Rocky Mountains.* New York: G. P. Putnam's Sons, 1907.

Schaeffer, Mary T. S. *Old Indian Trails: Incidents of Camp and Trail Life, Covering Two Years' Exploration Through the Rocky Mountains of Colorado.* New York: G. P. Putnam's Sons, 1912.

BASTIENNE SCHMIDT

Schmidt, Bastienne. *Vivir la Muerte: Living with Death in Latin America.* Zurich: Edition Stemmle, 1996.

———. *American Dreams.* Zurich: Edition Stemmle, 1997.

SARAH C. SEARS

"The English Exhibition and the 'American Invasion.'" *Camera Notes* 4 (January 1901): 162–75.

Oliver, Maude I. G. "The Photo-Secession in America." *International Studio* 32 (September 1907): 199–215.

Sears, Sarah C. *Heart Sunshine and Other Poems.* Philadelphia: W. H. Pile's Sons, 1909.

EMMA D. SEWALL

Sewall, Abbie. *Message Through Time: The Photographs of Emma D. Sewall, 1836–1919.* Gardiner, Maine: Harpswell Press, 1989. Reprint, Albuquerque: University of New Mexico Press, 1990.

CINDY SHERMAN

Cindy Sherman. New York: Pantheon, 1984.

Cindy Sherman. New York: Whitney Museum of American Art, 1987.

Cindy Sherman: Retrospective. Chicago: Museum of Contemporary Art; Los Angeles: Museum of Contemporary Art; New York and London: Thames and Hudson, 1997.

Goldsmith, David. "Cindy Sherman." *Aperture,* no. 133 (Fall 1993): 34–43.

Krauss, Rosalind. *Cindy Sherman, 1979–1993.* New York: Rizzoli, 1993.

Melville, Stephen W. "The Time of Exposure: Allegorical Self-Portraiture in Cindy Sherman." *Arts Magazine* 60 (January 1986): 17–21.

Rice, Shelley. *Inverted Odysseys: Claude Cahun, Maya Deren, Cindy Sherman.* Cambridge: MIT Press, 1999.

Sherman, Cindy. *Fitcher's Bird.* New York: Rizzoli, 1992.

ELSE SIMON—*see* YVA

STELLA SIMON

Pauli, Lori. "Stella F. Simon, 1878–1973." *History of Photography* 24 (Spring 2000): 75–83.

COREEN SIMPSON

Wilner, Val. "Coreen Simpson: Taking Care of Business." *Ten.8,* no. 24 (1987): 34–39.

CLARA SIPPRELL

Gaston, Diana. "Picturing Domestic Space: Clara E. Sipprell and the American Arts and Crafts Movement." *Image* 38 (Fall–Winter 1995): 17–29.

Hartmann, Sadakichi [Sidney Allan, pseud.]. "The Light Interpretations of Clara Estella Sipprell." *Photo Era* 30 (June 1913): 267–70.

McCabe, Mary Kennedy. "Clara E. Sipprell (1885–1975): Photo-Pictorialist." M.A. thesis, University of Southern California, 1985.

———. *Clara Sipprell: Pictorial Photographer.* Fort Worth: Amon Carter Museum, 1990.

Moment of Light: Photographs by Clara Sipprell. New York: John Day, 1966.

Sipprell, Clara E. "With a Camera in French Canada." *Country Life* 56 (July 1929): 39–41.

SANDY SKOGLUND

"Camera at Work: Sandy Skoglund." *Life,* October 1987, pp. 122–23.

DiGrappa, Carol. "Close Quarters: Photographs by Sandy Skoglund." *Camera Arts* 1 (May–June 1981): 86–93, 95.

Edwards, Owen. "Maybe Babies." *American Photographer* 11 (August 1983): 59–61.

———. "Seen from Within." *Savvy* 11 (January 1990): 68–71.

Raven, Arlene. *In the Last Hour.* Norman: University of Oklahoma Press, 1993.

Sandy Skoglund. Paris: Espace Photo, 1992.

CLARISSA SLIGH

Clarissa Sligh: The Presence of Memory. Syracuse, N.Y.: Robert B. Menschel Photography Gallery, Syracuse University, 1991.

Sligh, Clarissa. *What's Happening with Momma?* N.p.: Clarissa Sligh, in connection with the Women's Studio Workshop, 1988.

———. *Reading Dick and Jane with Me.* New York: Clarissa Sligh, 1989.

ROSALIND SOLOMON

Kolodny, Rochelle. "Photographs as Artifacts: The Work of Rosalind Solomon." *Photo Communiqué* 7 (Winter 1985–86): 10–17.

Rosalind Solomon, Earth Rites: Photographs from Inside the Third World. San Diego: Museum of Photographic Arts, 1986.

Rosalind Solomon: Photographs, 1976–1987. Tucson, Ariz.: Etherton Gallery, 1988.

Solomon, Rosalind. Essay by Thomas W. Sokolowski. *Portraits in the Time of AIDS.* New York: Grey Art Gallery and Study Center, New York University, 1988.

EVE SONNEMAN

Eve Sonneman: Work from 1968–1981. Yonkers, N.Y.: Hudson River Museum, 1982.

Sonneman, Eve. *Real Time, 1968–1974.* New York: Printed Matter, 1976.

———. *Where Birds Live.* New York: Random House, 1992.

Sonneman, Eve, and Lawrence Weiner. *How to Touch What.* New York: powerHouse, 2000.

Thorpe, Patricia. *America's Cottage Gardens: Imaginative Variations on the Classic Garden Style.* New York: Random House, 1990. Photographs by Sonneman.

MAGGIE STEBER

"New Faces 81: Magazine Photojournalism: Maggie Steber." *American Photographer* 5 [*sic,* read 6] (February 1981): 52.

Steber, Maggie. "An Island of Despair." *American Photographer* 20 (April 1988): 76–77.

———. *Dancing on Fire.* New York: Aperture, 1991.

JUDITH STEINHAUSER—*see* JUDITH HAROLD-STEINHAUSER

GRETE STERN
Grete Stern. Buenos Aires: La Azotea, 1988.

Grete Stern: Sueños. Valencia, Spain: Centro Julio Gonzales, Institut Valencia d'Art Modern, 1995.

Klappenbach, Horacio Raul. *Buenos Aires.* Buenos Aires: Ediciones Peuser, 1956.

Márquez Miranda, Fernando. *Huacos, cultura chancay.* Buenos Aires: Ediciones de la Llanura, 1943.

Primo, Luis. *Grete Stern: Obra Fotografica en la Argentina.* Buenos Aires: Fondo Nacional de las Artes, 1995.

ELISABETH SUNDAY
Convergence: Eight Photographers. Boston: Photographic Resource Center; Visual Studies Workshop, 1990.

Sunday, Elisabeth. *Transitions.* N.p.: Elisabeth Sunday, [1985?].

JOYCE TENNESON
Cohen, Joyce Tenneson, compiler. *In/Sights: Self-Portraits by Women.* Boston: David R. Godine, 1978.

Exposures: Photographs by Joyce Tenneson. Boca Raton, Fla.: Boca Raton Museum of Art, 1988.

Joyce Tenneson: Color Work. Boston: Little, Brown and Company, Bulfinch Press, 1992.

Joyce Tenneson: Photographs. Boston: David R. Godine, 1984.

Joyce Tenneson: Transformations. Boston: Little, Brown and Company, Bulfinch Press, 1993.

Millard, Howard. "The Mythic Quest: Photographs by Joyce Tenneson." *Photo Insider* (October–December 1999): 18–24.

Roth, Evelyn. "Joyce Tenneson." *American Photographer* 19 (September 1987): 64–68.

HARRIET V. S. THORNE
McKenna, Rosalie Thorne, and James D. Burke. *The Photographs of Harriet V. S. Thorne.* New Haven, Conn.: Yale University Art Gallery, 1979.

RUTH THORNE-THOMSEN
Edwards, Owen. "Tripping the Light Fantastic." *American Photographer* 12 (March 1984): 22–23.

Landscape Images: Recent Photographs by Linda Connor, Judy Fiskin, and Ruth Thorne-Thomsen. La Jolla, Calif.: La Jolla Museum of Contemporary Art, 1980.

Within the Garden: Photographs by Ruth Thorne-Thomsen. Chicago: Museum of Contemporary Photography; New York: Aperture, 1993.

EDITH HASTINGS TRACY
Tracy, Edith H. "In the Man-Made Canyons of Culebra—A Woman Camera Artist as Reporter." *Collier's National Weekly,* June 14, 1913, pp. 10–11.

DEBORAH TURBEVILLE
"Deborah Turbeville." *Camera* (Switzerland) 55 (December 1976): 20–26.

Kuboki, Yasuo, ed. *Les Amoureuses du temps passé.* Tokyo: PARCO, 1985. Photographs by Turbeville.

Turbeville, Deborah. *Wallflower.* New York: Congreve, 1978.

———. *Unseen Versailles.* Garden City, N.Y.: Doubleday, 1981.

———. *Newport Remembered: A Photographic Portrait of a Gilded Past.* New York: Harry N. Abrams, 1994.

Turbeville, Deborah, et al. *Women on Women.* New York: A and W Publishers, 1979.

JUDITH TURNER
Annotations on Ambiguity: Judith Turner: Photographs of Architecture. Tokyo: Axis, 1986.

Judith Turner: Photographs, Five Architects. New York: Rizzoli, 1980.

Kafka, Franz. *Parables and Pieces.* New York: Vincent Fitzgerald, 1990. Photogravures by Turner.

Turner, Judith. *Near Sitings: Judith Turner, Photographs, 1975–1995.* Oklahoma City: City Arts Center, c. 1995.

———. *The Parthenon Project.* Easton, Penn.: Williams Center for the Arts, Lafayette College, 1999.

———. *Between Spaces: Smith-Miller and Hawkinson Architecture, Judith Turner Photography.* New York: Princeton Architectural Press, 2000.

White City: International Style Architecture in Israel. Tel Aviv: Tel Aviv Museum, 1984.

KAREN TWEEDY-HOLMES
Coleman, A. D. "Karen Tweedy-Holmes." *Infinity* 19 (June 1970): 6–10.

DORIS ULMANN
The Darkness and the Light: Photographs by Doris Ulmann. Millerton, N.Y.: Aperture, 1974.

Doris Ulmann: Photographs from the J. Paul Getty Museum. In Focus Series. Malibu, Calif.: J. Paul Getty Museum, 1996.

Eaton, Allen H. *Handicrafts of the Southern Highlands.* New York: Russell Sage Foundation, 1937. Photographs by Ulmann.

Featherstone, David. *Doris Ulmann: American Portraits.* Albuquerque: University of New Mexico Press, 1985.

Niles, John Jacob. *The Appalachian Photographs of Doris Ulmann.* Highlands, N.C., and Penland, N.C.: Jargon Society, 1971. Reprint, 1977.

Peterkin, Julia M. *Roll, Jordan, Roll.* New York: R. O. Ballou, 1933. Photographs by Ulmann.

Rosenblum, Naomi. *Documenting a Myth: The South as Seen by Three Women Photographers: Chansonetta Stanley Emmons, Doris Ulmann, Bayard Wootten, 1910–1940.* Portland, Oreg.: Douglas F. Cooley Memorial Art Gallery, Reed College, 1998.

Ulmann, Doris. *Portraits of the Medical Faculty of the Johns Hopkins University.* Baltimore: Johns Hopkins Press, 1922.

———. *A Portrait Gallery of American Editors.* New York: W. E. Rudge, 1925.

FLORENCE VANDAMM
Vandamm, Florence. "There's No Trick to Good Portraiture." *Camera* 64 (January 1942): 17–19.

MICHELLE VIGNES
Leggett, Jo. "Interview with Michelle Vignes." *Photo Metro* 16, no. 149 (1998): 8–21.

"Vignes." *Camera* (Switzerland) 51 (April 1972): 34–42.

Vignes, Michelle. *The Blues.* San Francisco: North Beach Press, 1986.

———. *Oakland Blues.* [N.p.]: Marval, 1990.

Vignes, Michelle, and Lee Hildebrand. *Bay Area Blues.* San Francisco: Pomegranate Artbooks, 1993.

CATHARINE BARNES WARD
Barnes, Catharine Weed. "Why Ladies Should Be Admitted to Membership in Photographic Societies." *American Amateur Photographer* 1 (December 1889): 223–24.

———. "Photography from a Woman's Standpoint." *Anthony's Photographic Bulletin* 21 (January 1890): 39–42.

Blackmore, R. D. *Lorna Doone.* New York and London: Harper and Brothers, 1908. Fifty plates from photographs by Ward.

Palmquist, Peter E. *Catharine Weed Barnes Ward: Pioneer Advocate for Women in Photography.* Arcata, Calif.: Peter E. Palmquist, 1992.

Poulson, Elizabeth. *Catharine Weed Barnes Ward: Another Forgotten Victorian Photographer.* History of Photography Monograph Series, no. 8. Tempe: School of Art, Arizona State University, 1984.

Ward, H. Snowden, and Catharine Weed Barnes Ward. *Shakespeare's Town and Times.* New York: Truslove and Comba; London: Dawbarn and Ward, 1896. Enlarged and reprinted, London: Dawbarn and Ward, 1901.

———. *The Canterbury Pilgrimages.* London: A. and C. Black, 1904, 1905. Reprint, 1927.

MARGARET WATKINS
Margaret Watkins: Photographs, 1917–1930. Glasgow: n.p., 1981.

Watkins, Margaret. "Advertising and Photography." *Pictorial Photography in America* 4 (1926): n.p.

WENDY WATRISS
Robin, Eric, and Blaine Littell. *Africa: Images and Realities.* New York and Washington, D.C.: Praeger, 1971.

Watriss, Wendy. *Coming to Terms: The German Hill Country of Texas.* Texas Photography Series, no. 2. College Station: Texas A and M University Press, 1991.

EDITH S. WATSON
Hayward, Victoria. "Vikings of the North." *Outing* 70 (March 1917): 688–95.

———. *Romantic Canada.* Toronto: Macmillan, 1922.

Rooney, Frances. "Finding Edith S. Watson." *Blatant Image* 1 (1981): 86.

———. *Working Light: The Wandering of Photographer Edith S. Watson.* Ottawa: Carleton University Press, 1996.

Watson, Edith S. "Where Time Stands Still: A Camera Trip [to Newfoundland]." *Outing* (March 1915): 681–88.

EVA WATSON-SCHÜTZE
Block, Jean P. *Eva Watson Schütze: Chicago Photo-Secessionist.* Chicago: University of Chicago Library, 1985.

Dyer, W. B. "Eva L. Watson, Artistic Photographer." *Brush and Pencil* 6 (September 1900): 263–72.

Johnston, Frances Benjamin. "Eva Lawrence Watson (Mrs. Martin Schütze)." *Ladies' Home Journal* 18 (October 1901): 5.

Keiley, Joseph T. "Eva Watson-Schütze." *Camera Work* 9 (January 1905): 23–26.

Watson, Eva Lawrence. "Photography." *Anthony's Photographic Bulletin* 32 (1901): 9–11.

CARRIE MAE WEEMS
Carrie Mae Weems: Recent Work, 1992–1998. Syracuse, N.Y.: Everson Museum of Art, Syracuse University; New York: George Braziller, 1998.

Kirsh, Andrea, and Susan Fisher Sterling. *Carrie Mae Weems.* Washington, D.C.: National Museum of Women in the Arts, 1993.

Weems, Carrie Mae. "Family Pictures and Stories: A Photographic Installation." M.A. thesis, University of California, San Diego, 1984.

———. *Then What? Photographs and Folklore.* Buffalo: CEPA Gallery, 1990.

———. *And Twenty-two Million Very Tired and Very Angry People.* San Francisco: San Francisco Art Institute, 1992.

MATHILDE WEIL
Johnston, Frances Benjamin. "Miss Mathilde Weil." *Ladies' Home Journal* 18 (June 1901): 9.

Weil, Mathilde. "Outdoor Portraiture." *Photo-Miniature* 5 (January 1904): 441–64.

———. "Home Portraiture Book No. 1: Written from the Pictorial Viewpoint." *Photo-Miniature* 6 (August 1904): 278–80.

Yellott, Osborne T. "Mathilde Weil—Artist Photographer." *Photo Era* 3 (June 1899): 323–28.

SANDRA WEINER
Weiner, Sandra. *It's Wings That Make Birds Fly: The Story of a Boy.* New York: Pantheon, 1968.

———. *Small Hands, Big Hands: Seven Profiles of Chicano Migrant Workers and Their Families.* New York: Pantheon, 1970.

———. "Personal Recollections." In *Dan Weiner, 1919–1959,* pp. 92–95. New York: Grossman, 1974.

ALICE WELLS
Cohen, Susan E. *Time after Time: The Photographs of Alice Wells.* Rochester, N.Y.: Visual Studies Workshop, 1990.

LILY WHITE
Davie, Helen L. "Women in Photography." *Camera Craft* 5 (August 1902): 130–38.

Wild Beauty: Photography of the Columbia River Gorge, 1865–1915. Portland, Oreg.: Portland Art Museum, [1984].

MYRA ALBERT WIGGINS
Glauber, Carole. *Witch of Kodakery: The Photography of Myra Albert Wiggins, 1869–1956.* Pullman: Washington State University Press, 1997.

Hull, Roger. "Myra Wiggins and Helen Gatch: Conflicts in American Pictorialism." *History of Photography* 16 (Summer 1992): 152–69.

Wiggins, Myra Albert. "Amateur Photography Through Women's Eyes." *Photo-American* 5 (March 1894): 134.

————. "Alone in Holland." *American Annual of Photography and Photographic Times Almanac* 16 (1902): 227–31.

————. *Letters from a Pilgrim.* Salem, Oreg.: Statesman Pub. Co., c. 1904.

DOROTHY WILDING
"Dorothy Wilding: Glamour Photography for Society and Royalty." *Camera* 66 (May 1944): 65–68.

Pepper, Terence. *Dorothy Wilding: The Pursuit of Perfection.* London: National Portrait Gallery, 1991.

Wilding, Dorothy. *In Pursuit of Perfection.* London: Robert Hale, 1958.

Williams, Val. "Escape into Elegance: Some Notes on Dorothy Wilding." *Photographic Collector* 3 (Spring 1982): 64–73.

ELIZA WITHINGTON
Withington, Mrs. E. W. "How a Woman Makes Landscape Photographs." *Philadelphia Photographer* 13 (December 1876): 357–60.

MARION POST WOLCOTT
Elliott, James, and Marla Westover. *Marion Post Wolcott—FSA Photographs.* Berkeley: University of California Art Museum, 1978.

Hendrickson, Paul. *Looking for the Light: The Hidden Life and Art of Marion Post Wolcott.* New York: Alfred A. Knopf, 1992.

Hurley, F. Jack. *Marion Post Wolcott: A Photographic Journey.* Albuquerque: University of New Mexico Press, 1989.

Murray, Joan. "Marion Post Wolcott." *American Photographer* 4 (March 1980): 86–93.

Raedeke, Paul. "Interview with Marion Post Wolcott." *Photo Metro* 4 (February 1986): 3–17.

BAYARD WOOTTEN
Bezner, Lili Corbus. "Photographer Bayard Wootten in 1930s Appalachia." *Southern Quarterly* 36 (Summer 1998): 3–19.

Cotton, Jerry W. *Light and Air: The Photography of Bayard Wootten.* Chapel Hill and London: University of North Carolina Press, 1998.

"I Won't Make a Picture Unless the Moon Is Right . . .": Early Architectural Photography of North Carolina by Frances Benjamin Johnston and Bayard Wootten. Raleigh, N.C.: Preservation/North Carolina, 1994.

Linquist, Ruth. "Bayard Wootten—Woman, Photographer, and Artist." *Tar Heel Woman* 18 (October 1945): 5–6.

Rosenblum, Naomi. *Documenting a Myth: The South as Seen by Three Women Photographers: Chansonetta Stanley Emmons, Doris Ulmann, Bayard Wootten, 1910–1940.* Portland, Oreg.: Douglas F. Cooley Memorial Art Gallery, Reed College, 1998.

Sheppard, Muriel Earley. *Cabins in the Laurel.* Chapel Hill: University of North Carolina Press, 1935. Reprint, 1991. Photographs by Wootten.

Wilson, Charles Morrow. *Backwoods America.* Chapel Hill: University of North Carolina Press, 1934. Photographs by Wootten.

Wootten, Mrs. Bayard. "My Experience as a Photographer." *St. Louis and Canadian Photographer* 33 (December 1909): 728–30.

————. "The Outlook for Women." *Bulletin of Photography* 6 (June 1910): 360–61.

WANDA WULZ
Guagnini, Elvio, and Italo Zannier. *La Trieste dei Wulz: Volti di una storia fotografica, 1860–1980.* Trieste, Italy: Comune di Trieste; Florence: Fratelli Alinari, 1989.

Lista, Giovanni. *Futurismo e fotografia.* Milan, 1979.

MARIANA YAMPOLSKY
Yampolsky, Mariana. *La casa de la tierra.* Mexico City: National Indigenous Institute, 1981.

————. *La casa que canta: Arquitectura popular mexicana.* Mexico City: Secretaria de Educación Pública, 1982.

————. *La raíz y el camino.* Mexico City: Fondo de Cultura Económica, 1985.

————. *Estancias del olvido.* [Pachuca, Mexico?]: Veracruzan Institute of Culture, Government of the State of Veracruz, 1987.

————. *The Traditional Architecture of Mexico.* New York: Thames and Hudson, 1993.

————. *The Edge of Time: Photographs of Mexico.* Austin: University of Texas Press, 1998.

MADAME YEVONDE
Gibson, Robin, and Pam Roberts. *Madame Yevonde: Colour, Fantasy and Myth.* London: National Portrait Gallery, 1990.

Yevonde, Madame Philonie. "Photographic Portraiture from a Woman's Point of View." *British Journal of Photography,* April 29, 1921, pp. 251–52.

————. *In Camera.* London: Women's Book Club, 1958.

YVA (ELSE SIMON)
"Yva Fotos." *Gebrauchsgraphik* 8 (November 1931): 30–37.

INDEX

monograms, 78

montage, 114, 126, 131–32, *132, 133,* 134, *135,* 139, 220; in contemporary art photography, *18, 20, 26, 27, 31, 34, 266,* 272–74, *273, 277, 278,* 278–81, *279;* feminist vision and, *36,* 246, 257, 280; pastiche and, *20, 31,* 274, 276; sequential imagery and, *25, 28,* 282–83, 286

Monteith, Frances Dunlop, 40

Moodie, Geraldine, 46, 111, **340;** work of, *112*

Moon, Sarah, 236, **340;** bibliography for, 381; work of, *238*

Moonlight on the Columbia (White), *95*

Moore, Clarence Bloomfield, 104

Morath, Inge, 190, 208, 210, **340;** bibliography for, 381–82; work of, *188*

Morgan, Barbara, 134, 137, 168, 187, 227, 270–72, 274, 276, **340;** bibliography for, 382; work of, *270*

Morrell, Lady Ottoline, 96, **340–41;** bibliography for, 382; work of, *96*

Morris, Mary, 207

Morter sisters, 104

Mostyn, Lady Augusta, 45, 49, **341;** work of, *44*

Mother and Daughter (Ockenga), *244*

Mother with Children (Kanaga), *178*

Moutoussamy-Ashe, Jeanne, 188, 208, **341;** bibliography for, 382; work of, *208*

movie industry, 167–68, 229

multimedia projections, 274

multiple exposures, 46, *47, 270,* 272

Munkacsi, Martin, 161

Murray, Joan, 264, **341;** bibliography for, 382; work of, *261*

Muscats (Fletcher), *157*

Muse, A (Farnsworth), *103*

Museum of Modern Art (New York), 8–9, 176, 214, 249, 269

Museum of the City of New York, 176, 269

Muspratt, Helen, 117

Muybridge, Eadweard, 48, 283

Myers, Eveleen (Mrs. F.W.H. Myers), 104, **341;** bibliography for, 382; work of, *105*

Myers, Joan, 288

Nan and Brian in Bed, New York City (Goldin), *33*

Nance, Marilyn, 253, **341–42;** work of, *249*

Nancy Cunard (Ker-Seymer), *136*

Nappelbaum, Ida, 137

Natalya Sergeevna Goncharova (Colomb), *192*

National Academy of Design (New York), 98

National Geographic, 185

National Press Photographers Association (NPPA), 187, 207

National Security Women's Corps, 181

National Union of Hospital and Health Care Workers, 218

Native Americans, 213, 218; photographs of, 85, 87–88, *88, 89,* 111, *112;* women photographers, 220, 253–55

Naturalism, 78, 94–95

Nature's Protection (Boughton), *264*

Naylor, Genevieve, 232, 235, **342;** bibliography

for, 382; work of, *238*

Near Gloucester Road Underground Station (Bohm), *191*

negative images, 134, *136*

Nègre, Marie-Paul, 220, **342;** bibliography for, 382; work of, *227*

Neilson, Marian, 89, 117

Neimanas, Joyce, 282, **342;** bibliography for, 382; work of, *25*

Nelly (Elli Seraïdari), 125, 146, **342;** work of, *146*

Nettles, Bea, 243, 278, **343;** bibliography for, 382; work of, *22*

Neuke-Widman, Angela, 195

Neusüss, Floris, 121

Nevill, Lady Caroline, 45, 49

New American Photography, The (London; 1900), 98

Newcomb, Mrs. H. E., 71

new documentary realism, 172–77, *172–78;* government agencies and, 173, 174–77; shift away from high modernism in, 172, 173–74

Newhall, Beaumont, 7, 128

Newhall, Nancy, 227

news photography, 66–68, *68,* 141, 168, 204–8, *208, 209;* picture agencies and, 145–46; women's advantages in, 207. *See also* photojournalism

Newton, Helmut, 236

"new topographics," 222

"new woman," 56, 126, 132; Johnston's self-portrait as, *54,* 56, 149

New York (Levitt), *233*

New York American, 179

New York Herald-Tribune, 210

New York Public Library, 269

New York Times, 204, 207

Niccolini, Dianora, 264

Nicholls, Arundel Holmes, 164

Nichols, Ruth Alexander, 188

Niclas, Yolla, 141, 187

Niepce, Janine, 193, **343;** bibliography for, 382; work of, *193*

Noggle, Anne, 246, **343;** bibliography for, 382–83; work of, *245*

Nogueiro Borges, Herminia de Mello, 196

Norfleet, Barbara, 289, **343;** bibliography for, 383; work of, *28*

Norman, Dorothy, 107

Northern Photographic Exhibition (Manchester; 1913), 97

Noskowiak, Sonya, 168, 169, 170, **344;** bibliography for, 383; work of, *170*

Nouvelle Histoire de la Photographie (The New History of Photography) (Frizot, ed.), 8

Novak, Lorie, 248, 250, **344;** bibliography for, 383; work of, *248*

Novick, Elizabeth, 236

Nuba Dancer (Riefenstahl), *196*

nudes, 162, *163,* 164; of children, *35, 263–65,* 264–65; feminist vision and, *32, 33,* 255–65, *256–65,* 291; male, *260–62,* 263–64; modernism and, *146,* 146–47, *147,* 255–57, *256, 258;* photographers themselves as models for, 164, 263; Pictorialism and, *96,* 162, 164, 255

No. 37 from the Book "Métal" (Krull), *116*

No. 45006 (Burns), *260*

objectivity, 68

Ockenga, Starr, 246, **344;** bibliography for, 383; work of, *244*

Odor of Pomegranates, The (Ben-Yusuf), 76, *77*

Office of War Information (OWI), 174, 177, 213

Oishi, Yoshino, 204

Older, Maryann, 227

Old Rose (Mitchell), *36*

On the Edge: Images from 100 Years of Vogue, 234

On Walls and Behind Glass (Mandel), *274*

Oppenheim, Meret, 133

Order of the British Empire (OBE), 192, 244

Orkin, Ruth, 187, 188, 227, 228–29, **344;** bibliography for, 383; work of, *234*

"Our Girls" (Stanton), 56

Outerbridge, Paul, 159

Outing, 56, 57

Outlet of the Lake, The (Woodbridge), *94*

Owner of the 711 Bar (Arnold), *188*

Pagliuso, Jean, 236, **344–45;** bibliography for, 383; work of, *17*

Pahokee "Hotel" (Migrant Vegetable Pickers' Quarters, near Homestead, Florida) (Wolcott), *177*

Palfi, Marion, 141, 187, 213, 227, **345;** bibliography for, 383; work of, *217*

Palmquist, Peter, 9

Panama Canal Construction (Tracy), 66, *67*

Paolini, Améris Manzini, 200

Papadakas, Sue, 194

Papaianou, Voula, 194

Papaver Rhoeas (Atkins), *13*

Paper in Water Glass (Stern), *139*

Parada, Esther, 248, 281, **345;** bibliography for, 383; work of, *18*

Parc de Canon (Geesaman), *286*

Paris (Breslauer), 143, *144*

Parker, Olivia, 279, **345;** bibliography for, 383–84; work of, *279*

Parrish, Willamina, 74, 263

Parsons, Sara, 160

Paschall, Mary F. C., 71, 94, 99

Passover Seder (Heyman), *265*

pastiche, *20, 31,* 274, 276

Patterns of Connection (King-Smith), *280*

Paul and Matthias (Tweedy-Holmes), *262*

Paulien (Besnyö), *122*

Pauvre France (A Tale of Modern Times, or Everyday Poverty) (Nègre), *227*

Paysages photographiés (The Landscape Photographed), 193

Peattie, Margaret Rhodes, 109, 154

Pencil of Nature (Talbot), *41*

Penn, Irving, 236

Pennell, Joseph, 66

Pentecost, Claire, 283

People, 188

Percheid, Nicola, 90

Percival, Olive May, 110

performance art, 284

Perry, Jean, 192

PHOTOGRAPHY CREDITS
The sources of photographic material other than those indicated in the captions are as follows: Josh Brash, Fotograffiti, Melbourne: plate 270; reprinted courtesy of Eastman Kodak Company, Rochester, New York: plate 50; David Familian, Santa Monica, California: plate 240; reproduced with the permission of The Robert and Frances Flaherty Study Center, The School of Theology at Claremont, California: plate 223; Richman Haire, Akron, Ohio: plates 14, 30, 208, 261; Courtesy of Sandra Levinson: plate 197; Robert Rubic, Precision Chromes, New York: plates 58, 113, 197; Sheila Spence, Winnipeg Art Gallery, Winnipeg, Canada: plate 223.